2010 35TH ANNUAL EDITION

ARTIST'S & GRAPHIC DESIGNER'S MARKET®

From the Editors of Writer's Digest Books

WRITER'S DIGEST BOOKS
CINCINNATI, OH

Publisher & Editorial Director, Writing Communities: Jane Friedman
Managing Editor, Writer's Digest Market Books: Alice Pope

Writer's Market Web site: www.writersmarket.com
Writer's Digest Web site: www.writersdigest.com

Distributed in Canada by Fraser Direct
100 Armstrong Avenue
Georgetown, ON, Canada L7G 5S4
Tel: (905) 877-4411

Distributed in the U.K. and Europe by David & Charles
Brunel House, Newton Abbot, Devon, TQ12 4PU, England
Tel: (+44) 1626 323200, Fax: (+44) 1626 323319
E-mail: postmaster@davidandcharles.co.uk

Distributed in Australia by Capricorn Link
P.O. Box 704, Windsor, NSW 2756 Australia
Tel: (02) 4577-3555

ISSN: 1075-0894
ISBN-13: 978-1-58297-583-2
ISBN-10: 1-58297-583-3

Cover design by Claudean Wheeler
Production coordinated by Greg Nock

Contents

Reprinted with permssion of James E. Lyle.

Maggie Barnes
Finding Inspiration, Courage & Fulfillment as an Artist
by Erika O'Connell

MARKETS

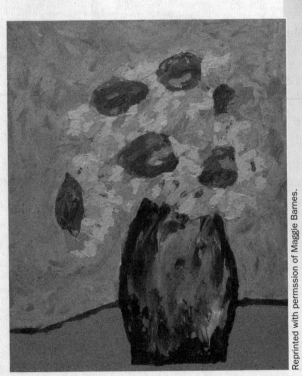

Reprinted with permssion of Maggie Barnes.

Reprinted with permssion of Eric Freitas.

RESOURCES

INDEXES

Mission Packs Buzz has unique trim colors.

1: Buzz original jetpack comes off......

2:and can be replaced with the monkey winch backpack......

3:....or the new projectile backpack!

MISSION PACKS BUZZ

© HASBRO TOYS

How to Use This Book

If you're picking up this book for the first time, you might not know quite how to start using it. Your first impulse might be to flip through and quickly make a mailing list, submitting to everyone with hopes that *someone* might like your work. Resist that urge.

First you have to narrow down the names in this book to those who need your particular art style. That's what this book is all about. We provide the names and addresses of art buyers along with plenty of marketing tips. You provide the hard work, creativity and patience necessary to hang in there until work starts coming your way.

Listings: the heart of this book

The book is divided into market sections, from galleries to art fairs. (See the Table of Contents for complete list.) Each section begins with an introduction containing information and advice to help you break into that specific market.

Listings are the meat of this book. In a nutshell, listings are names, addresses and contact information for places that buy or commission artwork, along with a description of the type of art they need and their submission preferences.

Articles and interviews

Throughout this book you will find helpful articles and interviews with working artists and experts from the art world. These articles give you a richer understanding of the marketplace by sharing the featured artists' personal experiences and insights. Their stories, and the lessons you can learn from other artists' feats and follies, give you an important edge over competition.

HOW *ARTIST'S & GRAPHIC DESIGNER'S MARKET* WORKS

Following the instructions in the listings, we suggest you send samples of your work (not originals) to a dozen (or more) targeted markets. The more companies you send to, the greater your chances of a positive response. Establish a system

to keep track of who you submit your work to and send follow-up mailings to your target markets at least twice a year.

How to read listings

The first thing you'll notice about many of the listings in this book is the group of symbols that appears before the name of each company. (You'll find a quick-reference key to the symbols on the front and back inside covers of the book.) Here's what each symbol stands for:

- **N** Market new to this edition
- **🍁** Canadian market
- **🌐** International market
- **✦** Market prefers to work with local artists/designers

Each listing contains a description of the artwork and/or services the company prefers. The information often reveals how much freelance artwork is used, whether computer skills are needed, and which software programs are preferred.

In some sections, additional subheads help you identify potential markets. Magazine listings specify needs for cartoons and illustrations. Galleries specify media and style.

Editorial comments, denoted by bullets (•), give you extra information about markets, such as company awards, mergers and insight into a company's staff or procedures.

It might take a while to get accustomed to the layout and language in the listings. In the beginning, you will encounter some terms and symbols that might be unfamiliar to you. Refer to the Glossary on page 509 to help you with terms you don't understand.

Working with listings

1. Read the entire listing to decide whether to submit your samples. Do *not* use this book simply as a mailing list of names and addresses. Reading listings carefully helps you narrow your mailing list and submit appropriate material.

2. Read the description of the company or gallery in the first paragraph of the listing. Then jump to the **Needs** or **Media** heading to find out what type of artwork is preferred. Is it the type of artwork you create? This is the first step to narrowing your target market. You should send your samples only to places that need the kind of work you create.

3. Send appropriate submissions. It seems like common sense to research what kind of samples a listing wants before sending off just any artwork you have on hand. But believe it or not, some artists skip this step. Many art

Frequently Asked Questions

1 How do companies get listed in the book? No company pays to be included—all listings are free. Every company has to fill out a detailed questionnaire about their art needs. All questionnaires are screened to make sure the companies meet our requirements. Each year we contact every company in the book and ask them to update their information.

2 Why aren't other companies I know about listed in this book? We may have sent these companies a questionnaire, but they never returned it. Or if they did return a questionnaire, we may have decided not to include them based on our requirements. If you know of a market you'd like to see in the book, send an e-mail request to artdesign@fwpubs.com.

3 I sent some samples to a company that stated they were open to reviewing the type of work I do, but I have not heard from them yet, and they have not returned my materials. What should I do? At the time we contacted the company, they were open to receiving such submissions. However, things can change. It's a good idea to contact any company listed in this book to check on their policy before sending them anything. Perhaps they have not had time to review your submission yet. If the listing states that they respond to queries in one month, and more than a month has passed, you can send a brief e-mail to the company to inquire about the status of your submission. Some companies receive a large volume of submissions, so you must be patient. Never send originals when you are querying—always send copies. If for any reason your samples are never returned, you will not have lost forever the opportunity to sell an important image. It is a good idea to include a SASE (self-addressed, stamped envelope) with your submissions, even if the listing does not specifically request that you do so. This may facilitate getting your work back.

4 A company says they want to publish my artwork, but first they will need a fee from me. Is this a standard business practice? No, it is not a standard business practice. You should never have to pay to have your art reviewed or accepted for publication. If you suspect that a company may not be reputable, do some research before you submit anything or pay their fees. The exception to this rule is art fairs. Most art fairs have an application fee, and sometimes there is a fee for renting booth space. Some galleries may also require a fee for renting space to exhibit your work (see page 71 for more information).

directors have pulled their listings from *Artist's & Graphic Designer's Market* because they've received too many inappropriate submissions. Look under the **First Contact & Terms** heading to find out how to contact the market and what to send. Some companies and publishers are very picky about what kinds of samples they like to see; others are more flexible.

What's an inappropriate submission? I'll give you an example. Suppose you want to be a children's book illustrator. Don't send samples of your cute animal art to *Business Law Today* magazine-they would rather see law-related subjects. Use the Niche Marketing Index on page 529 to find listings that accept children's illustrations. You'd be surprised how many illustrators waste their postage sending the wrong samples—which, of course alienates art directors. Make sure all your mailings are *appropriate* ones.

4. Consider your competition. Under the **Needs** heading, compare the number of freelancers who contact the company with the number they actually work with. You'll have a better chance with listings that use a lot of artwork or work with many artists.

5. Look for what they pay. In most sections, you can find this information under **First Contact & Terms**. Book Publishers list pay rates under headings pertaining to the type of work they assign, such as **Text Illustration** or **Book Design**.

At first, try not to be too picky about how much a listing pays. After you have a couple of assignments under your belt, you might decide to only send samples to medium- or high-paying markets.

6. Be sure to read the Tips. This is where art directors describe their pet peeves and give clues for how to impress them. Artists say the information within the **Tips** helps them get a feel for what a company might be like to work for.

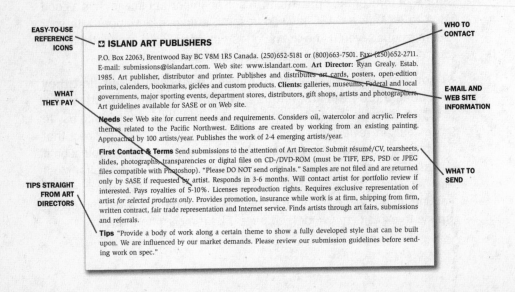

EASY-TO-USE REFERENCE ICONS

WHO TO CONTACT

☐ ISLAND ART PUBLISHERS

P.O. Box 22063, Brentwood Bay BC V8M 1R5 Canada. (250)652-5181 or (800)663-7501. Fax: (250)652-2711. E-mail: submissions@islandart.com. Web site: www.islandart.com. **Art Director:** Ryan Grealy. Estab. 1985. Art publisher, distributor and printer. Publishes and distributes art cards, posters, open-edition prints, calenders, bookmarks, giclées and custom products. **Clients:** galleries, museums, Federal and local governments, major sporting events, department stores, distributors, gift shops, artists and photographers. Art guidelines available for SASE or on Web site.

WHAT THEY PAY

E-MAIL AND WEB SITE INFORMATION

Needs See Web site for current needs and requirements. Considers oil, watercolor and acrylic. Prefers themes related to the Pacific Northwest. Editions are created by working from an existing painting. Approached by 100 artists/year. Publishes the work of 2-4 emerging artists/year.

First Contact & Terms Send submissions to the attention of Art Director. Submit résumé/CV, tearsheets, slides, photographs, transparencies or digital files on CD-/DVD-ROM (must be TIFF, EPS, PSD or JPEG files compatible with Photoshop). "Please DO NOT send originals." Samples are not filed and are returned only by SASE if requested by artist. Responds in 3-6 months. Will contact artist for portfolio review if interested. Pays royalties of 5-10%. Licenses reproduction rights. Requires exclusive representation of artist *for selected products only.* Provides promotion, insurance while work is at firm, shipping from firm, written contract, fair trade representation and Internet service. Finds artists through art fairs, submissions and referrals.

TIPS STRAIGHT FROM ART DIRECTORS

WHAT TO SEND

Tips "Provide a body of work along a certain theme to show a fully developed style that can be built upon. We are influenced by our market demands. Please review our submission guidelines before sending work on spec."

These steps are just the beginning. As you become accustomed to reading listings, you will think of more ways to mine this book for your potential clients. Some of our readers tell us they peruse listings to find the speed at which a magazine pays its freelancers. In publishing, it's often a long wait until an edition or book is actually published, but if you are paid "on acceptance," you'll get a check soon after you complete the assignment and it is approved by the art director.

When looking for galleries, savvy artists often check to see how many square feet of space are available and what hours the gallery is open. These details all factor in when narrowing down your search for target markets.

Pay attention to copyright information

It's also important to consider what rights companies buy. It is preferable to work with companies that buy first or one-time rights. If you see a listing that buys "all rights," be aware you may be giving up the right to sell that particular artwork in the future.

Look for specialties and niche markets

Read listings closely. Most describe their specialties, clients and products within the first paragraph. If you hope to design restaurant menus, for example, target

Complaint Procedure

Important

If you feel you have not been treated fairly by a company listed in *Artist's & Graphic Designer's Market*, we advise you to take the following steps:

- First, try to contact the company. Sometimes one e-mail or letter can quickly clear up the matter.

- Document all your correspondence with the company. If you write to us with a complaint, provide the details of your submission, the date of your first contact with the company, and the nature of your subsequent correspondence.

- We will enter your complaint into our files.

- The number and severity of complaints will be considered in our decision whether to delete the listing from the next edition.

- We reserve the right to not list any company for any reason.

agencies that have restaurants for clients. If you prefer illustrating people, you might target ad agencies whose clients are hospitals or financial institutions. If you like to draw cars, look for agencies with clients in the automotive industry, and so on. Many book publishers specialize, too. Look for a publisher who specializes in children's books if that's the type of work you'd like to do. The Niche Marketing Index on page 529 lists possible opportunities for specialization.

Read listings for ideas

You'd be surprised how many artists found new niches they hadn't thought of by browsing the listings. One greeting card artist read about a company that produces mugs. Inspiration struck. Now this artist has added mugs to her repertoire, along with paper plates, figurines and rubber stamps-all because she browsed the listings for ideas!

Sending out samples

Once you narrow down some target markets, the next step is sending them samples of your work. As you create your samples and submission packets, be aware that your package or postcard has to look professional. It must be up to the standards art directors and gallery dealers expect. There are examples throughout this book of some great samples sent out by other artists. Make sure your samples rise to that standard of professionalism.

See you next year

Use this book for one year. Highlight listings, make notes in the margins, fill it with Post-it notes. In November of 2010, our next edition—the 2011 *Artist's & Graphic Designer's Market*—starts arriving in bookstores. By then, we'll have collected hundreds of new listings and changes in contact information. It is a career investment to buy the new edition every year. (And it's deductible! See page 14 for information on tax deductions.)

Join a professional organization

Artists who have the most success using this book are those who take the time to read the articles to learn about the bigger picture. In our interviews and Insider Reports, you'll learn what has worked for other artists and what kind of work impresses art directors and gallery dealers.

You'll find out how joining professional organizations such as the Graphic Artists Guild (www.gag.org) or the Society of Illustrators (www. societyillustrators.org) can jump start your career. You'll find out the importance of reading trade magazines such as *HOW* (www.howdesign.com), *PRINT* (www. printmag.com) and *Greetings etc.* (www.greetingsmagazine.com) to learn more

about the industries you hope to approach. You'll learn about trade shows, art reps, shipping, billing, working with vendors, networking, self-promotion and hundreds of other details it would take years to find out about on your own. Perhaps most importantly, you'll read about how successful artists overcame rejection through persistence.

Hang in there!

Being professional doesn't happen overnight. It's a gradual process. It may take two or three years to gain enough information and experience to be a true professional in your field. So if you really want to be a professional artist, hang in there. Before long, you'll feel that heady feeling that comes from selling your work or seeing your illustrations on greeting cards or in magazines. If you really want it and you're willing to work for it, it *will* happen.

Business Basics

How to Stay on Track & Get Paid

As you launch your artistic career, be aware that you are actually starting a small business. It is crucial that you keep track of the details, or your business will not last very long. The most important rule of all is to find a system to keep your business organized and stick with it.

YOUR DAILY RECORD-KEEPING SYSTEM

Every artist needs to keep a daily record of art-making and marketing activities. Before you do anything else, visit an office supply store and pick out the items listed below (or your own variations of these items). Keep it simple so you can remember your system and use it on automatic pilot whenever you make a business transaction.

What you'll need:

- A packet of colorful file folders or a basic Personal Information Manager on your computer or Palm Pilot.
- A notebook or legal pads to serve as a log or journal to keep track of your daily art-making and art marketing activities.
- A small pocket notebook to keep in your car to track mileage and gas expenses.

How to start your system

Designate a permanent location in your studio or home office for two file folders and your notebook. Label one red file folder "Expenses." Label one green file folder "Income." Write in your daily log book each and every day.

Every time you purchase anything for your business, such as envelopes or art supplies, place the receipt in your red Expenses folder. When you receive payment for an assignment or painting, photocopy the check or place the receipt in your green Income folder.

Pricing Your Fine Art

Tips

There are no hard-and-fast rules for pricing your fine artwork. Most artists and galleries base prices on market value—what the buying public is currently paying for similar work. Learn the market value by visiting galleries and checking prices of works similar to yours. When you're starting out, don't compare your prices to established artists but to emerging talent in your region. Consider these factors when determining price:

- **Medium.** Oils and acrylics cost more than watercolors by the same artist. Price paintings higher than drawings.

- **Expense of materials.** Charge more for work done on expensive paper than for work of a similar size on a lesser grade paper.

- **Size.** Though a large work isn't necessarily better than a small one, as a rule of thumb you can charge more for the larger work.

- **Scarcity.** Charge more for one-of-a-kind works like paintings and drawings, than for limited editions such as lithographs and woodcuts.

- **Status of artist.** Established artists can charge more than lesser-known artists.

- **Status of gallery.** Prestigious galleries can charge higher prices.

- **Region.** Works usually sell for more in larger cities like New York and Chicago.

- **Gallery commission.** The gallery will charge from 30 to 50 percent commission. Your cut must cover the cost of materials, studio space, taxes and perhaps shipping and insurance, and enough extra to make a profit. If materials for a painting cost $25, matting and framing cost $37, and you spent five hours working on it, make sure you get at least the cost of material and labor back before the gallery takes its share. Once you set your price, stick to the same price structure wherever you show your work. A $500 painting by you should cost $500 whether it is bought in a gallery or directly from you. To do otherwise is not fair to the gallery and devalues your work.

As you establish a reputation, begin to raise your prices—but do so cautiously. Each time you graduate to a new price level, it will be that much harder to revert to former prices.

Keep track of assignments

Whether you're an illustrator or fine artist, you should devise a system for keeping track of assignments and artworks. Most illustrators assign a job number to each assignment they receive and create a file folder for each job. Some arrange these folders by client name; others keep them in numerical order. The important thing is to keep all correspondence for each assignment in a spot where you can easily find it.

Pricing illustration and design

One of the hardest things to master is what to charge for your work. It's difficult to make blanket statements on this topic. Every slice of the market is somewhat different. Nevertheless, there is one recurring pattern: Hourly rates are generally only paid to designers working in house on a client's equipment. Freelance illustrators working out of their own studios are almost always paid a flat fee or an advance against royalties.

If you don't know what to charge, begin by devising an hourly rate, taking into consideration the cost of materials and overhead as well as what you think your time is worth. If you're a designer, determine what the average salary would be for a full-time employee doing the same job. Then estimate how many hours the job will take and quote a flat fee based on these calculations.

There is a distinct difference between giving the client a job estimate and a job quote. An estimate is a ballpark figure of what the job will cost but is subject to change. A quote is a set fee which, once agreed upon, is pretty much carved in stone. Make sure the client understands which you are negotiating. Estimates are often used as a preliminary step in itemizing costs for a combination of design services such as concepting, typesetting and printing. Flat quotes are generally used by illustrators, as there are fewer factors involved in arriving at fees.

For recommended fees for different services, refer to the *Graphic Artists Guild's Handbook of Pricing & Ethical Guidelines* (www.gag.org). Many artists' organizations have standard pay rates listed on their websites.

As you set fees, certain stipulations call for higher rates. Consider these bargaining points:

- **Usage (rights).** The more rights purchased, the more you can charge. For example, if the client asks for a "buyout" (to buy all rights), you can charge more, because by relinquishing all rights to future use of your work, you will be losing out on resale potential.
- **Turnaround time.** If you are asked to turn the job around quickly, charge more.
- **Budget.** Don't be afraid to ask about a project's budget before offering a quote. You won't want to charge $500 for a print ad illustration if the ad

agency has a budget of $40,000 for that ad. If the budget is that big, ask for higher payment.

- **Reputation.** The more well known you are, the more you can charge. As you become established, periodically raise your rates (in small steps) and see what happens.

What goes in a contract?

Contracts are simply business tools used to make sure everyone agrees on the terms of a project. Ask for one any time you enter into a business agreement. Be sure to arrange for the specifics in writing or provide your own. A letter stating the terms of agreement signed by both parties can serve as an informal contract. Several excellent books, such as *Legal Guide for the Visual Artist* and *Business and Legal Forms for Illustrators*, both by Tad Crawford (Allworth Press), contain negotiation checklists and tear-out forms, and provide sample contracts you can copy. The sample contracts in these books cover practically any situation you might encounter.

The items specified in your contract will vary according to the market you're dealing with and the complexity of the project. Nevertheless, here are some basic points you'll want to cover:

Commercial contracts

- **A description** of the service(s) you're providing.
- **Deadlines** for finished work.
- **Rights sold. Your fee.** Hourly rate, flat fee or royalty.
- **Kill fee.** Compensatory payment received by you if the project is cancelled.
- **Changes fees.** Penalty fees to be paid by the client for last-minute changes.
- **Advances.** Any funds paid to you before you begin working on the project.
- **Payment schedule.** When and how often you will be paid for the assignment.
- **Statement regarding return of original art.** Unless you're doing work for hire, your artwork should always be returned to you.

Gallery contracts

- **Terms of acquisition or representation.** Will the work be handled on consignment? What is the gallery's commission?
- **Nature of the show(s).** Will the work be exhibited in group or solo shows or both?
- **Timeframes.** If a work is sold, when will you be paid? At what point will the gallery return unsold works to you? When will the contract cease to be in effect?

Can I Deduct My Home Studio?

Important

If you freelance fulltime from your home and devote a separate area to your business, you may qualify for a home office deduction. If eligible, you can deduct a percentage of your rent or mortgage as well as utilities and expenses like office supplies and business-related telephone calls.

The IRS does not allow deductions if the space is used for purposes other than business. A studio or office in your home must meet three criteria:

- The space must be used exclusively for your business.
- The space must be used regularly as a place of business.
- The space must be your principle place of business.

The IRS might question a home office deduction if you are employed full time elsewhere and freelance from home. If you do claim a home office, the area must be clearly divided from your living area. A desk in your bedroom will not qualify. To figure out the percentage of your home used for business, divide the total square footage of your home by the total square footage of your office. This will give you a percentage to work with when figuring deductions. If the home office is 10% of the square footage of your home, deduct 10% of expenses such as rent, heat and air conditioning.

The total home office deduction cannot exceed the gross income you derive from its business use. You cannot take a net business loss resulting from a home office deduction. Your business must be profitable three out of five years; otherwise, you will be classified as a hobbyist and will not be entitled to this deduction.

Consult a tax advisor before attempting to take this deduction, as its interpretations frequently change.

For additional information, refer to IRS Publication 587, Business Use of Your Home, which can be downloaded at www.irs.gov or ordered by calling (800)829-3676.

- **Promotion.** Who will coordinate and pay for promotion? What does promotion entail? Who pays for printing and mailing of invitations? If costs are shared, what is the breakdown?
- **Insurance.** Will the gallery insure the work while it is being exhibited and/or while it is being shipped to or from the gallery?
- **Shipping.** Who will pay for shipping costs to and from the gallery?

- **Geographic restrictions.** If you sign with this gallery, will you relinquish the rights to show your work elsewhere in a specified area? If so, what are the boundaries of this area?

How to send invoices

If you're a designer or illustrator, you will be responsible for sending invoices for your services. Clients generally will not issue checks without them, so mail or fax an invoice as soon as you've completed the assignment. Illustrators are generally paid in full either upon receipt of illustration or on publication. Most graphic designers arrange to be paid in thirds, billing the first third before starting the project, the second after the client approves the initial roughs, and the third upon completion of the project.

Standard invoice forms allow you to itemize your services. The more you spell out the charges, the easier it will be for your clients to understand what they're paying for. Most freelancers charge extra for changes made after approval of the initial layout. Keep a separate form for change orders and attach it to your invoice.

If you're an illustrator, your invoice can be much simpler, as you'll generally be charging a flat fee. It's helpful, in determining your quoted fee, to itemize charges according to time, materials and expenses. (The client need not see this itemization; it is for your own purposes.)

Most businesses require your social security number or tax ID number before they can cut a check, so include this information in your bill. Be sure to put a due date on each invoice; include the phrase "payable within 30 days" (or other preferred time frame) directly on your invoice. Most freelancers ask for payment within 10-30 days.

Sample invoices are featured in *Business and Legal Forms for Illustrators* and *Business and Legal Forms for Graphic Designers*, both by Tad Crawford (Allworth Press).

If you're working with a gallery, you will not need to send invoices. The gallery should send you a check each time one of your pieces is sold (generally within 30 days). To ensure that you are paid in a timely manner, call the gallery periodically to touch base. Let the director or business manager know that you are keeping an eye on your work. When selling work independently of a gallery, give receipts to buyers and keep copies for your records.

Take advantage of tax deductions

You have the right to deduct legitimate business expenses from your taxable income. Art supplies, studio rent, printing costs and other business expenses are deductible against your gross art-related income. It is imperative to seek the help of an accountant or tax preparation service in filing your return. In the event your deductions exceed profits, the loss will lower your taxable income from other sources.

To guard against taxpayers fraudulently claiming hobby expenses as business losses, the IRS requires taxpayers to demonstrate a "profit motive." As a general rule, you must show a profit for three out of five years to retain a business status. If you are audited, the burden of proof will be on you to validate your work as a business and not a hobby.

The nine criteria the IRS uses to distinguish a business from a hobby are:

- the manner in which you conduct your business
- expertise
- amount of time and effort put into your work
- expectation of future profits
- success in similar ventures
- history of profit and losses
- amount of occasional profits
- financial status
- element of personal pleasure or recreation

If the IRS rules that you paint for pure enjoyment rather than profit, they will consider you a hobbyist. Complete and accurate records will demonstrate to the IRS that you take your business seriously.

Even if you are a "hobbyist," you can deduct expenses such as supplies on a Schedule A, but you can only take art-related deductions equal to art-related income. If you sold two $500 paintings, you can deduct expenses such as art supplies, art books and seminars only up to $1,000. Itemize deductions only if your total itemized deductions exceed your standard deduction. You will not be allowed to deduct a loss from other sources of income.

Figuring deductions

To deduct business expenses, you or your accountant will fill out a 1040 tax form (not 1040EZ) and prepare a Schedule C, which is a separate form used to calculate profit or loss from your business. The income (or loss) from Schedule C is then reported on the 1040 form. In regard to business expenses, the standard deduction does not come into play as it would for a hobbyist. The total of your business expenses need not exceed the standard deduction.

There is a shorter form called Schedule C-EZ for self-employed people in service industries. It can be applicable to illustrators and designers who have receipts of $25,000 or less and deductible expenses of $2,000 or less. Check with your accountant to see if you qualify.

Deductible expenses include advertising costs, brochures, business cards, professional group dues, subscriptions to trade journals and arts magazines, legal and professional services, leased office equipment, office supplies, business travel expenses, etc. Your accountant can give you a list of all 100-percent and 50-percent deductible expenses. Don't forget to deduct the cost of this book!

As a self-employed "sole proprieter," there is no employer regularly taking tax out of your paycheck. Your accountant will help you put money away to meet your tax obligations and may advise you to estimate your tax and file quarterly returns.

Your accountant also will be knowledgeable about another annual tax called the Social Security Self-Employment tax. You must pay this tax if your net freelance income is $400 or more.

The fees of tax professionals are relatively low, and they are deductible. To find a good accountant, ask colleagues for recommendations, look for advertisements in trade publications, or ask your local Small Business Association.

Whenever possible, retain your independent contractor status

Some clients automatically classify freelancers as employees and require them to file Form W-4. If you are placed on employee status, you may be entitled to certain benefits, but a portion of your earnings will be withheld by the client until the end of the tax year and you could forfeit certain deductions. In short, you may end up taking home less than you would if you were classified as an independent contractor.

The IRS uses a list of 20 factors to determine whether a person should be classified as an independent contractor or an employee. This list can be found in IRS Publication 937. Note, however, that your client will be the first to decide how you'll be classified.

Report all income to Uncle Sam

Don't be tempted to sell artwork without reporting it on your income tax. You may think this saves money, but it can do real damage to your career and credibility—even if you are never audited by the IRS. Unless you report your income, the IRS will not categorize you as a professional, and you won't be able to deduct expenses. And don't think you won't get caught if you neglect to report income. If you bill any client in excess of $600, the IRS requires the client to provide you with a Form 1099 at the end of the year. Your client must send one copy to the IRS and a copy to you to attach to your income tax return. Likewise, if you pay a freelancer over $600, you must issue a 1099 form. This procedure is one way the IRS cuts down on unreported income.

Register with the state sales tax department

Most states require a two to seven percent sales tax on artwork you sell directly from your studio or at art fairs, or on work created for a client. You must register with the state sales tax department, which will issue you a sales permit or a resale number and send you appropriate forms and instructions for collecting the tax. Getting a sales permit usually involves filling out a form and paying a

Business Basics

small fee. Reporting sales tax is a relatively simple procedure. Record all sales taxes on invoices and in your sales journal. Every three months, total the taxes collected and send it to the state sales tax department.

In most states, if you sell to a customer outside of your sales tax area, you do not have to collect sales tax. However, this may not hold true for your state. You may also need a business license or permit. Call your state tax office to find out what is required.

Save money on art supplies

As long as you have the above sales permit number, you can buy art supplies without paying sales tax. You will probably have to fill out a tax-exempt form with your permit number at the sales desk where you buy materials. The reason you do not have to pay sales tax on art supplies is that sales tax is only charged on the final product. However, you must then add the cost of materials into the cost of your finished painting or the final artwork for your client. Keep all receipts in case of a tax audit. If the state discovers that you have not collected sales tax, you will be liable for tax and penalties.

If you sell all your work through galleries, they will charge sales tax, but you still need a sales permit number to get a tax exemption on supplies.

Some states claim "creativity" is a non-taxable service, while others view it as a product and therefore taxable. Be certain you understand the sales tax laws to avoid being held liable for uncollected money at tax time. Contact your state auditor for sales tax information.

Save money on postage

When you send out postcard samples or invitations to openings, you can save big bucks by mailing in bulk. Fine artists should send submissions via first class mail for quicker service and better handling. Package flat work between heavy cardboard or foam core, or roll it in a cardboard tube. Include your business card or a label with your name and address on the outside of the packaging material in case the outer wrapper becomes separated from the inner packing in transit.

Protect larger works—particularly those that are matted or framed—with a strong outer surface, such as laminated cardboard, masonite or light plywood. Wrap the work in polyfoam, heavy cloth or bubble wrap, and cushion it against the outer container with spacers to keep it from moving. Whenever possible, ship work before it is glassed. If the glass breaks en route, it may destroy your original image. If shipping large framed work, contact a museum in your area for more suggestions on packaging.

The U.S. Postal Service will not automatically insure your work, but you can purchase up to $600 worth of coverage. Artworks exceeding this value should be sent by registered mail. Certified packages travel a little slower but are easier to track.

Consider special services offered by the post office, such as Priority Mail, Express Mail Next Day Service and Special Delivery. For overnight delivery, check to see which air freight services are available in your area. Federal Express automatically insures packages for $100 and will ship art valued up to $500. Their 24-hour computer tracking system enables you to locate your package at any time.

The United Parcel Service automatically insures work for $100, but you can purchase additional insurance for work valued as high as $25,000 for items shipped by air (there is no limit for items sent on the ground). UPS cannot guarantee arrival dates but will track lost packages. It also offers Two-Day Blue Label Air Service within the U.S. and Next Day Service in specific zip code zones.

Before sending any original work, make sure you have a copy (photocopy, slide or transparency) in your files. Always make a quick address check by phone before putting your package in the mail.

Send us your business tips

If you've used a business strategy we haven't covered, please e-mail us at artdesign@fwpubs.com. We may feature you and your work in a future edition.

Business Basics

Promoting Your Work

So you're ready to launch your freelance art or gallery career. How do you let people know about your talent? One way is by introducing yourself to them by sending promotional samples. Samples are your most important sales tool, so put a lot of thought into what you send. Your ultimate success depends largely on the impression they make.

We divided this article into three sections, so whether you're a fine artist, illustrator or designer, check the appropriate heading for guidelines. Read individual listings and section introductions thoroughly for more specific instructions.

As you read the listings, you'll see the term SASE, short for self-addressed, stamped envelope. Enclose a SASE with your submissions if you want your material returned. If you send postcards or tearsheets, no return envelope is necessary. Many art directors want only nonreturnable samples, because they are too busy to return materials, even with SASEs. So read listings carefully and save stamps.

ILLUSTRATORS & CARTOONISTS

You will have several choices when submitting to magazines, book publishers and other illustration and cartoon markets. Many freelancers send a cover letter and one or two samples in initial mailings. Others prefer a simple postcard showing their illustrations. Here are a few of your options:

Postcard. Choose one (or more) of your illustrations or cartoons that represent your style, then have the image(s) printed on postcards. Have your name, address, phone number, e-mail and website printed on the front of the postcard or in the return address corner. Somewhere on the card should be printed the word "Illustrator" or "Cartoonist." If you use one or two colors, you can keep the cost below $200. Art directors like postcards because they are easy to file or tack on a bulletin board. If the art director likes what she sees, she can always call you for more samples.

Promotional sheet. If you want to show more of your work, you can opt for an 8½ × 11 color or black and white photocopy of your work. No matter what size sample you send, never fold the page. It is more professional to send flat sheets, in a 9 × 12 envelope, along with a typed query letter, preferably on your own professional stationery.

Tearsheets. After you complete assignments, acquire copies of any printed pages on which your illustrations appear. Tearsheets impress art directors because they are proof that you are experienced and have met deadlines on previous projects.

Photographs. Some illustrators have been successful sending photographs, but printed or photocopied samples are preferred by most art directors. It is not practical or effective to send slides.

Query or cover letter. A query letter is a nice way to introduce yourself to an art director for the first time. One or two paragraphs stating your desire and availability for freelance work is all you need. Include your phone number and e-mail address.

E-mail submissions. E-mail is another great way to introduce your work to potential clients. When sending e-mails, provide a link to your website or JPEGs of your best work.

DESIGNERS & DIGITAL ARTISTS

Plan and create your submission package as if it were a paying assignment from a client. Your submission piece should show your skill as a designer. Include one or both of the following:

Cover letter. This is your opportunity to show you can design a beautiful, simple logo or letterhead for your own business card, stationery and envelopes. Have these all-important pieces printed on excellent-quality bond paper. Then write a simple cover letter stating your experience and skills.

Sample. Your sample can be a copy of an assignment you've completed for another client, or a clever self-promotional piece. Design a great piece to show off your capabilities. For ideas and inspiration, browse through *Designers' Self-Promotion: How Designers and Design Companies Attract Attention to Themselves*, edited by Roger Walton (HBI).

Stand out from the crowd

You may have only a few seconds to grab art directors' attention as they make their way through the "slush pile" (an industry term for unsolicited submissions). Make yourself stand out in simple, effective ways:

Tie in your cover letter with your sample. When sending an initial mailing to a potential client, include a cover letter of introduction with your sample. Type it on a great-looking letterhead of your own design. Make your sample tie in with your cover letter by repeating a design element from your sample onto your letterhead. List some of your past clients within your letter.

Send artful invoices. After you complete assignments, a well-designed invoice (with one of your illustrations or designs strategically placed on it, of course) will make you look professional and help art directors remember you—and hopefully, think of you for another assignment.

Follow up with seasonal promotions. Many illustrators regularly send out holiday-themed promo cards. Holiday promotions build relationships while reminding past and potential clients of your services. It's a good idea to get out your calendar at the beginning of each year and plan some special promos for the year's holidays.

Are portfolios necessary?

You do not need to send a portfolio when you first contact a market. But after buyers see your samples they may want to see more, so have a portfolio ready to show.

Many successful illustrators started their careers by making appointments to show their portfolios. But it is often enough for art directors to see your samples.

Some markets in this book have drop-off policies, accepting portfolios one or two days a week. You will not be present for the review and can pick up the work a few days later, after they've had a chance to look at it. Since things can get lost, include only duplicates that can be insured at a reasonable cost. Only show originals when you can be present for the review. Label your portfolio with your name, address and phone number.

Portfolio pointers

The overall appearance of your portfolio affects your professional presentation. It need not be made of high-grade leather to leave a good impression. Neatness and careful organization are essential whether you're using a three-ring binder or a leather case. The most popular portfolios are simulated leather with puncture-proof sides that allow the inclusion of loose samples. Choose a size that can be handled easily. Avoid the large, "student-size" books, which are too big to fit easily on an art director's desk. Most artists choose 11 × 14 or 18 × 24. If you're a fine artist and your work is too large for a portfolio, bring slides of your work and a few small samples.

- **Don't include everything you've done in your portfolio.** Select only your best work, and choose pieces relevant to the company you are approaching. If you're showing your book to an ad agency, for example, don't include greeting card illustrations.
- **Show progressives.** In reviewing portfolios, art directors look for consistency of style and skill. They sometimes like to see work in different stages (roughs, comps and finished pieces) to examine the progression of ideas and how you handle certain problems.

Print and Mail Through the USPS

Tip

If you're looking for a convenient, timesaving and versatile service for printing and mailing promotional postcards, consider the U.S. Postal Service. USPS offers a postcard service through their website (www.cardstore.com). You can have promotional postcards printed on 4X6 or 6X9 glossy cardstock and buy as many or as little as you need.

One drawback of going through the USPS is that you can't order a certain amount of postcards to keep on hand—cards must be addressed through the website and are mailed out for you automatically. But you can essentially create a personal database and simply click on an address and mail a promo card whenever needed. You can upload different images to the site and create postcards that are geared to specific companies.)

- **Your work should speak for itself.** It's best to keep explanations to a minimum and be available for questions if asked. Prepare for the review by taking along notes on each piece. If the buyer asks a question, take the opportunity to talk a little bit about the piece in question. Mention the budget, time frame and any problems you faced and solved. If you're a fine artist, talk about how the piece fits into the evolution of a concept and how it relates to other pieces you've shown.

- **Leave a business card.** Don't ever walk out of a portfolio review without leaving the buyer a sample to remember you by. A few weeks after your review, follow up by sending a small promo postcard or other sample as a reminder.

GUIDELINES FOR FINE ARTISTS

Send a 9 × 12 envelope containing whatever materials galleries request in their submission guidelines. Usually that means a query letter, slides and resume, but check each listing for specifics. Some galleries like to see more. Here's an overview of the various components you can include:

- **Slides.** Send 8-12 slides of similar work in a plastic slide sleeve (available at art supply stores). To protect slides from being damaged, insert slide sheets between two pieces of cardboard. Ideally, slides should be taken by a professional photographer, but if you must take your own slides, refer to *The Quick & Easy Guide to Photographing Your Artwork* by Roger Saddington (North Light Books) or *Photographing Your Artwork* by Russell Hart and Nan Star (Amherst Media). Label each slide with your name,

the title of the work, media and dimensions of the work, and an arrow indicating the top of the slide. Include a list of titles and suggested prices gallery directors can refer to as they review slides. Make sure the list is in the same order as the slides. Type your name, address, phone number, e-mail and website at the top of the list. Don't send a variety of unrelated work. Send work that shows one style or direction.

- **Query letter or cover letter.** Type one or two paragraphs expressing your interest in showing at the gallery, and include a date and time when you will follow up.
- **Résumé or bio.** Your résumé should concentrate on your art-related experience. List any shows your work has been included in, with dates. A bio is a paragraph describing where you were born, your education, the work you do and where you have shown in the past.
- **Artist's statement.** Some galleries require a short statement about your work and the themes you're exploring. Your statement should show you have a sense of vision. It should also explain what you hope to convey in your work.
- **Portfolios.** Gallery directors sometimes ask to see your portfolio, but they can usually judge from your slides whether your work would be appropriate for their galleries. Never visit a gallery to show your portfolio without first setting up an appointment.
- **SASE.** If you need material returned to you, don't forget to include a SASE.

Leveraging Social Media as a Creative

by EC (Lisa) Stewart

> *I'd rather be looked over than overlooked.*
> —Mae West

The landscape of traditional marketing is rapidly changing, and traditional publishing is eroding due to the flood of social media (SM) and new, online competition. Small business owners are embracing this change and establishing a presence in the growing world of online business. And the savvy creative entrepreneur knows to go and grow where their customers are and they're discovering that social media platforms are very low-cost way to establish a meaningful dialog with customers.

How does this affect me?

Social networking is growing.

> *QuickFact:* There are 152 million U.S. Internet users.
> *QuickFact:* 3 out of 4 Americans use social technology.

Social media provides creative businesses with online access to current and future customers and allows them to connect virtually across miles. Web 2.0, the latest generation of the Internet, allows small businesses and creative entrepreneurs to interact and engage directly with customers, enlivening traditional print advertisement into a one-to-one personal service. As a creative entrepreneur, people *love* knowing they're interacting directly with the artist and social media enables us to readily connect.

EC (LISA) STEWART is an award-winning designer and illustrator with a degree in Graphic Design and Fine Arts from Western Michigan University. She's held a variety of positions including display artist, interior designer, accessory buyer, and print/Web designer before starting ECStewart Design Studio in 1998. In addition to the agency, she has returned to her first love, illustration, and now her CalligraphyPets form the foundation of the ECStewart Collections, an expanded line of pen and ink illustrations. She finds inspiration in travelling, indulging in her hobbies that include photography, painting, illustration and relaxing at home with Andrew and their three cats. Visit www.ecstewart.com.

In addition to your website, consider enlisting a number of popular social media tools as key components of your marketing program to augment your online presence. Blogs, videos, and social networks are a powerful combination and play to the strengths of small businesses by fostering meaningful relationships through links to other sites, resources, and people.

Simply being active on the social media platforms can help provide transparency that today's customers are looking for and lets you directly engage with your biggest supporters. Remember, 78% of people trust recommendations from other consumers and one of the best ways to get those recommendations is through direct engagement.

The benefits of social media—build, protect & grow your reputation

Social Media can help you build a presence and generate new ways to be found easily. And online opportunities are typically less expensive than traditional marketing, but you should be aware that they often involve more planning and time-intensive work. Shifting money to social media to augment your traditional print advertising budget will allow you to:

- Make connections, even if you're typically shy;
- Build your persona and business brand awareness;
- Manage your brand's reputation.

Social media community & tools

Social media can take many different forms including blogs, forums, wikis, podcasts, pictures and video.

> *QuickFact:* 6.8 million people between age 15 and 24 visited social networking sites in June 2009, up 13 percent year-on-year and roughly in line with increased usage of the Internet overall by this age group.

The fundamental categories of social media include:

- **Communication:** This includes tools such as blogs, micro-blogging, social networking, social aggregation, and events. Examples include, Wordpress, Blogger, Typepad, Twitter, Plurk, Facebook, LinkedIn, MySpace, Friendfeed, Upcoming, and Meetup.com all of which allow you to find and link to other people and activities. Once linked or connected to someone, you can keep up to date on that person's contact info, interests, posts, birthdays, etc.
- **Collaboration:** Includes tools such as wikis, social bookmarking, social news, and opinion sites. Wikipedia, Delicious, StumbleUpon, GoogleReader, Digg, Reddit, and Yelp are examples of some of the applications that are available.

Cross-Pollinate & Automate

There's a danger that social networking can turn in to a terrific time sucker. Be smart in your approach. Spend only about an hour a day on Social Media, but be disciplined about keeping your content fresh. Whenever you can, cross-pollinate your link feeds from your Twitter account to your blog to and to your Facebook account. Use automation tools to schedule tweets.

Articles & Interviews

- **Multimedia:** Includes tools such as photo and video sharing, audio and music sharing, and livecasting. Flickr, Photobucket, YouTube, Vimeo, Ustream.tv, and Last.fm are all sites that allow you to create, upload, share videos, photos, and music with anyone and everyone.
- **Social bookmarking:** Includes sites such as Delicious, StumbleUpon, and Kaboodle to help you find and bookmark sites and information of interest. You can save and access your bookmarks anywhere online and choose to share them with others.
- **Reviews/opinions:** Includes sites like epinions and ask.com where you can learn what other consumers think of products and services.
- **Entertainment:** Includes sites like Second Life, The Sims Online, and Miniclip for game sharing and entertainment platforms.

Tip: For every tool, there is a cult following. Depending on your business, it may focus more in one of these areas than in others. For example, I find myself focusing at least 80% of my time on Communications through WordPress, Facebook, LinkedIn and FriendFeed and supplement my activities with other categories. I'd recommend one tool from each category to keep your sanity. The key is to cross pollinate your Social Media tools with each other. Any new product, service, or news you share on these tools, will be amplified that much further.

What's a Blog? Isn't my website enough?

QuickFact: By 2012, more than 145 million people, or 67 percent of Web users in the U.S., are projected to read blogs on a monthly basis and the number of blogs also will grow. There were 22.6 million bloggers in the U.S. in 2007, and that number is projected to reach 34.7 million by 2012!

Blogging is a way of bringing life to your static website. A traditional Web presence is a passive broadcast of your work that often discourages engagement with your customer. Imagine that your website is like a house where the door

What Are Your First Steps?

Here are a few things you can accomplish today:

1 Claim your name on Twitter, Facebook, LinkedIn, YouTube, Friendfeed, etc.

Be sure to complete your profiles as much as possible as this highlights another level of transparency.

Be sure to include a photo of yourself on each of these tools where encouraged.

It's a known fact that people only converse with people who display this level of information. Using your pet, your child, or your art for your avatar often prevents connection as it creates a veil between you and your new friends—*people want to talk with you.* Including your art and your family is strongly encouraged in other areas on your platform and you can choose to share as much or as little as you want.

2 Join the social media conversation.

- **Watch, listen, and pay attention to what your audience needs.**
- **Follow the 80/20 rule**

Take it easy at first as you engage your own wants, needs, and interests. The 80/20 rule means giving out information 80% of the time you're online (sharing tips, helpful links to same industry sites, moral support) and spending the other 20% on self-promotion. This ratio helps demonstrate that you are a fruitful part of the family. Remember to build your own stories, share works-in-progress, inspiration, and case studies on your blog and encourage enthusiasts to visit by funneling traffic via Twitter, Facebook, LinkedIn, and YouTube.

remains closed and locked. This prevents your enthusiasts from seeing anything more than just your front yard. As a result they often don't stay around very long or absorb much about your lifestyle as an artist.

Now imagine that your blog as a garden around your website house where you fertilize, plant, and harvest your new and ongoing online relationships. Your blog is now the hub of your Web presence. Cultivating your blog with your art and activities helps nourish your artist's soul. When you tap into a poignant moment and express it in one of your blog entries, a personal connection happens and a relationship begins to form. Your blog is a welcome mat for a new member of your online family.

Blogging allows you to engage your followers on a number of different levels.

They can learn about your style, get a sneak peak into new designs you're creating, and gain a better understanding of your philosophy as an artist. For instance, when they discover you're a fun-loving artist who has a penchant for raspberries on chocolate ice cream in the middle of winter, they can begin to connect with you. And this is just the beginning of building your rapport with your clients.

Blogging strategy: It doesn't matter how long and involved your entries are, but that they vary to nourish the inquisitive visitor. Describing the influence that, say, the red raspberry has on your painting begins to foster a visual experience. Then, including the recipe to a wonderful raspberry cobbler to celebrate your finished painting deepens the intimacy. These are the kinds of wonderful things you can share on your blog that are impossible on a traditional website.

Tip: Frequency is key if you want to continue to have visitors. To socially engage with your devotees online, 3-5 posts per week is a good number to plan for. Crafting a personal editorial calendar will also make it easier to summon great ideas. Also, to make it easy on yourself, you could dedicate a different topic to each post on separate days. These should include things that are educating (what you do), entertaining (how you do it), and enriching for your readers in order to and keep them coming back for more.

For example:

- Monday—Inspiration Found on Weekend Field Trip
- Wednesday—Behind the Scenes in my Studio
- Friday—Finished Art Project

Facebook

Facebook is one of the best tools available to go and grow where your customers are, and it's growing everyday—more of the key art buying demographic are spending their time and attention on this adaptable social networking tool. As a result it only makes sense to seek out guerrilla marketing opportunities in on Facebook to promote your business and engage new fans and customers.

QuickFact: Facebook grew from 200 million to 250 million in just over 3 months

QuickFact: Among 14 key new media tools, Facebook leads by 24% in sharing.

Facebook strategy: Create and keep a separate personal page and Fan Page. By keeping the Fan Page strictly focused on the business, one doesn't risk tarnishing one's own brand.

Tip: If you decide to use Facebook as a hub of your Web presence, be sure to take advantage of the free tools available. The Wall, Galleries, Discussions, Videos, Events, Polls, Notes are just the beginning of creating an enriching experience for your fan base.

Articles & Interviews

Video

YouTube is becoming a new marketing channel for many companies and more people are watching videos to see product demonstrations to help with their purchasing decisions. Videos are a great way to present to your consumer time and again without feeling the pressure of performing live where a single slip of the tongue or misspoken word can cost you a sale.

> *QuickFact:* YouTube was far and away the top online destination by video streams, with more than 6 billion total streams during the month, and more than 95 million unique viewers on YouTube.com in June 2009.

Video strategy: Peppering videos throughout your social media platforms will also give your brand vitality and possibly create a viral buzz. People love to be entertained, and video is a great channel for that. Exploring features and benefits of a product, demonstrating a DIY project, or vlogging on the daily life of an artist captures attention more quickly than text.

Tip: Each time you upload content to a specific site (ie. video on YouTube) also pull the video into your blog, website, Facebook Page, even Flickr to showoff your new idea. Cross-pollination is key because not all of your enthusiasts visit all of your venues.

Twitter

As a micro-blogging tool, Twitter (among others) is another vehicle to connect and manage your brand online.

> *QuickFact:* Growth rate of Twitter from June 2008 through June 2009 was 1928%, reaching 21 million monthly users.

This unique tool only allows 140 characters to make your point, so be sure to use highly targeted phrases when you're looking to connect with your product or service's online audience. Micro-blogging will definitely make you a better, more concise writer.

Twitter strategy: Make sure your messages (called "tweets") work out of context and ask yourself if your tweet has value. Use conversations already in progress as content inspiration. It's a good suggestion to compose an idea list of topics that might be of interest to your followers that include:

- Your New Blog Entry (include link)
- New Art Posted in Your Store (include link)
- Photos of Your Work-in-Progress Art Project (include link)

Tip: There are several automated tools to augment your social media experience. Schedule your automated business-like tweets on a recurring basis so that you don't have to remember to do it yourself. Scheduling automation allows you to continue to conduct your online relationship on a personal level.

A few repeating topics include:

- Thanks for following me! You can find more info on what I do here (insert link to site)
- Top 3 Reasons to join my club (include link to site)
- Personalized messages to your followers at specific times (include link to promotions)

Flickr

A photo sharing site, Flickr is another way to broaden the reach of your art. Upload, edit, organize, share, geotag, and make products from your photos all through this new-media tool.

> *QuickFact:* As of June 2009, 3,600,000,000 photos are archived on Flickr.com

As with many tools, Flickr is free to upload and host your photos. The site also has an annual fee service that allows one to create more than two categories. This can be advantageous for the creative entrepreneur. Additionally, one can create password protected categories—great for works-in-progress and client related material.

Friendfeed

As a sharing service, Friendfeed also serves an aggregator for all of the social media tools you have employed. It is a good idea to claim your name on Friendfeed and then pull in all of your tools by adding them within the feed. Due to the most recent purchase by Facebook, Friendfeed will now become a more powerful and valuable search tool.

Social Marketing Strategy

These days, one must use technology to remain agile and Social Media tools can help you get ahead and stay in the game. Understanding your target market will help you better understand what tools you will need to successfully engage with your customer. When you know your goals, you can build your strategy around them and prevent getting overwhelmed by the very tools that are supposed to help you.

Design a strategy will enable you to:

- Measure visiting traffic
- Measure the effectiveness of your content long tail
- Hold you accountable for content

Sharing, growing, and engaging through trial and error is part of being the creative entrepreneur. Continuing to listen, engaging in dialog—not monologue—and collaborating, is the reward of staying in business.

Single Image, Multiple Opportunities

by EC (Lisa) Stewart

As a creative entrepreneur, my illustrations and fine art and gift designs are the foundation of my business. As I design fine art and gifts, I'm inspired by the beauty of animals and the artistic heritage of other cultures. Incorporating both traditional and innovative techniques with today's modern applications allows me to extend my image in many different directions while remaining unique in the market and fresh for my audience.

My imagery begins with brush and ink gestural line work which I then edit to its most fundamental form. Once edited, the illustration evolves to suit my end use. "Bacchus & the Ball of Yarn," my showcase cat, is the perfect example. Originally, Bacchus was illustrated in full as the capricious cat that chased the ball of yarn around the composition.

Once I had the marvelous illustration, I naturally wanted to do more with Bacchus than just sell pen and ink copies and prints. I wanted to create additional products so that my enthusiasts could continue to enjoy him wherever they were. Once the illustration was created, I looked for more ways to take advantage of the piece of art and transform it into fine gifts.

Now, whenever I am designing a new product, I frequently run through a few questions when designing gifts. Here are a few you might want to ask when looking for ways to do more with your artwork: Who is my audience? What do they do for a living? What do they do for leisure activities? Do they even like _____? (For me it's cats) What kinds of gifts do they purchase for others (for themselves)? Where do they go to purchase gifts? If I were them, what would I like to see as the next new gift item from me—the artist?

EC (LISA) STEWART is an award-winning designer and illustrator with a degree in Graphic Design and Fine Arts from Western Michigan University. She's held a variety of positions including display artist, interior designer, accessory buyer, and print/Web designer before starting ECStewart Design Studio in 1998. In addition to the agency, she has returned to her first love, illustration, and now her CalligraphyPets form the foundation of the ECStewart Collections, an expanded line of pen and ink illustrations. She finds inspiration in travelling, indulging in her hobbies that include photography, painting, illustration and relaxing at home with Andrew and their three cats. Visit www.ecstewart.com.

Creating a product plan

Begin with what you know. In my case, I knew paper. Immediately upon creating Bacchus, I thought that the illustration of the fully poised feline would be great to sell as prints and note cards.

Since my desired customers were affluent and tend to be discerning, I had to evaluate several aspects of possible prints and note cards: What kind of paper would go best with the CalligraphyCats? How would I source the paper, printing, and packaging? How and when do I see my customer using my note cards?

Tip: Go where graphic designers shop for paper—the Paper Companies. The reps at the suppliers are great at educating you when it comes to helping you understand all that you need to know about paper.

Creating a marketing plan based on your first product

By initially asking friends and family their opinions on my note cards I gained the confidence to talk to small shop owners. When one shop owner decided to try the cards, I'd move to the next shop owner and ask for their business as well. I continued growing my business this way until I felt comfortable enough talking about my artwork to participate in a local art show.

The great thing about shop owners and buyers is that they understand their customers and the market very well. A couple of things to remember when peddling your work to small shops and boutiques: Evaluate the store before approaching the owner or buyer. Be sure your product is of similar quality and style to other products on the shelves. When the shop owner talks to you, be very considerate of her time.

Tip: Send a postcard to the store before making your introduction. This helps introduce your products to them and gives them time to evaluate and visualize them on their customers before you set up your first appointment.

The gracious idea generator

When people embrace your work, they become very generous with their ideas. As people fell in love with my art, they'd make suggestions to me at shows regarding other items on which they could see my art. It is important to listen to what they are saying because, ultimately, they are the ones who are going to buy your art. However, that doesn't mean you have to implement every suggestion or application.

If they suggest jewelry, ask them what kind. Often, I'll take notes when having these discussions, making sure to include key words that I'll remember a week later when I'm able to take the time to reflect on past conversations and new ideas.

Tip: If you're at a loss for ideas, create an online poll on your website or blog to determine your most popular imagery or hold a contest for the best caption

Articles & Interviews

if you're a cartoonist. You can also provide an incentive to your customers to generate ideas such as a free print or set of cards for the best idea.

Gathering customer testimonials

Early on, when I was talking to customers, I learned that they thought of their friends when they saw my art and thus, it immediately became gifts. On several occasions, customers bought an original for themselves and a print or set of cards for a friend. Later, they would stop by at the next show and tell me how they created a wall collage using a framed print and individually framed note cards.

Remember, there are many ways your customers are going to use your product. So keep an open mind when you receive an unexpected suggestion or a customer reveals something that never occurred to you.

Tip: Use customer testimonials and reviews to help market your products throughout your website, blog, and other platforms.

Developing smart derivatives

As I sought feedback from customers, including large retail partners, I found that Bacchus & the Ball of Yarn was everyone's favorite feline illustration. With this in mind, I began to investigate other categories that would be appropriate for applying Bacchus.

During this process I realized the Bacchus in his original form was not appropriate for all applications. As a result I developed what I call the abbreviated Bacchus that includes only part of the original illustration. The abbreviated illustration is more flexible than the original, but still maintains the critical elements of his head, reaching paw and ball of yarn. This illustration is also more flexible when it comes to applying the image to numerous different products.

If you have complex image or one that is not appropriately shaped for some applications or products consider creating your own abbreviated version. Here is how to get started determining what that area might be: What area within your illustration or painting do you love best? What part of that painting are you most drawn to? What section(s) of the painting are your customers drawn to? Can you see this section condensed and then edified elsewhere?

Tip: If you're not sure how much of the area to highlight, take any size cut art matte and move it over select areas to reveal key features.

Deciding on the next product

Since I had already produced and sold wall art and greeting cards with Bacchus, I wanted to explore other areas that people would want to purchase for themselves or as gifts. Because my wall art was so successful, it seemed only natural for me to continue exploring home decor.

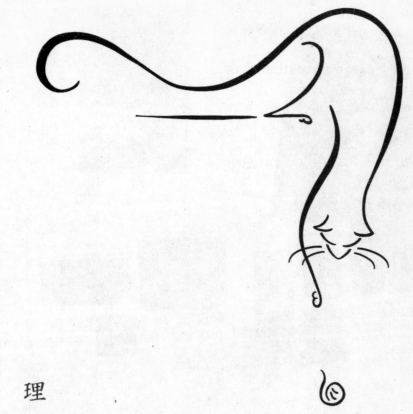

理

EC (Lisa) Stewart's "Bacchus & the Ball of Yarn" was the inspiration for myriad gift products.

To appraise multiple options for my product, the next questions to ponder were: What are today's trends? What are my customers doing? How are my customers living? How are my customers decorating their homes?

The result was a series of products including pillows and other Home decor items that all featured the abbreviated Bacchus.

Tip: Be sure to develop your designs into something you'd be proud to wear and show off. The glow of your enthusiasm and passion for your product will become evident when you're talking with others—and you never know who that will be!

Recognizing A-ha! moments

My husband, Andrew, and I tend to walk a lot of trade shows and often find that the small sourcing shows and exhibits that accompany the shows introduce us to new technologies and opportunities. At one show, we connected with a company that manufactures die-cutting machines and precut dies for scrapbookers. After a brief discussion, we discovered they also sell custom dies

Articles & Interviews

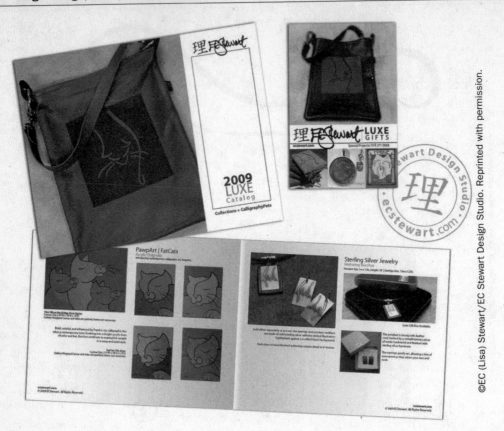

Here are a few of the Bacchus designs in EC (Lisa) Stewart's line. Her product offerings include stationery, home decor, jewelry, and accessories.

and that these dies could cut just about everything from paper to leather to fabric. Suddenly a new world of opportunity opened up for us.

Coupled with innovative product concepts, this new process allowed us to consistently cut the abbreviated Bacchus into a range of offerings including suede pillows and press kits! While the technique isn't new, the application and the way we create products for our customers does present new opportunities. Moreover, we can now grow our customer base by providing gifts at several price points. The die cutting process has also allowed us to create journal covers, mouse pads, and leather totes.

When you find new ways to apply art to different products and surfaces it significantly broadens your opportunities. To help broaden the uses of your artwork, ask yourself: How can this be applied to personal accessories? How can this be applied to home accessories? How can this be applied to both baby and pet industry? Will this be a seasonal item only?

Tip: The most mundane household items that we often take for granted can be repurposed for new projects. Try this: Start with the scissors. Cut up your

painting, or a print of your painting and piece it back together on fabric—suddenly it becomes a quilt. How about wood? Suddenly it's an inlay!

Finding beautiful solutions

Analyze your life to see if there is some area where you could make marked improvements through function or aesthetics. For example, if you feel there are no attractive notebooks, can your desire to design your own product fill that need? In my case, I was on the constant hunt for journals. They had to be of a certain size to fit into my handbag and also rugged enough to go on trips in my backpack. And because I am forever creating colorways on the fly, the paper had to take light washes.

An area that feels incomplete and requires a beautiful solution could be your ticket to starting a new product line with your art. As you begin to finalize your new product specs to fit into your own life, ask yourself a few questions. Will this product also: Fill a friend's need? How about a neighbor's need? Your current customers?

Tip: Everybody loves art they can touch. Getting close to art used to be forbidden, but now as artists, we can allow our customers to get as intimate as they want. Think about adding a special touch that will encourage your customers to share their new coveted possessions with others.

Making accessories personal

In addition to home decor, my customers were asking for more products in other categories. Jewelry was a new field for me and was definitely an area I wanted to include in my product lineup. Reviewing the trends, however, I was overwhelmed with the possibilities. I knew what I loved but I also had to make sure I matched what my customers expected from me.

Though my self-taught jewelry making skills were growing, researching publications, manuals by the masters of the art, websites, and talking with others, I knew my limitations.

After reading about how to etch metal at home, I hesitated to try it because of the chemicals involved and the potential of having to compromise the Bacchus images graceful lines. Talking to another manufacturer at a trade show we learned that the pieces they made were etched and it was then I realized I could out-source this process to a U.S. manufacturer. I still like to apply my artist hand to each product, however, so I have created a proprietary process for finishing each of the etched pieces.

There are numerous options for designing your own jewelry and it's up to you to determine which solution or combination is going to exemplify your art. The choices can be narrowed by asking a few simple questions: What are today's trends? What are my customers wearing? Will my art jewelry match their expectations? What jewelry style will best show off my work?

Articles & Interviews

Tip: If you're unwilling or unable to bring somewhat dangerous equipment into your home studio, you can usually find a local jewelry studio that rents equipment in their space to assist your needs.

Producing products

When I begin to actualize a product, whether fine art or gift, I look at three distinct possibilities of how it will be produced: In-House Product Partnerships Licensing Partnership

In-house products directly involve me sourcing materials, building the product, and shipping the piece to the customer. This often involves commissions (illustrations, paintings, logos, design work), limited editions, and small runs. Additionally, I will often build a small inventory of the more popular pieces when we have an upcoming show or before the holiday season. Otherwise, I wait to make the product until an order is placed. When an item becomes so popular that neither I nor my husband are able to build enough in a timely manner, we will opt for hiring a freelancer to produce an aspect of the job in order to stay on deadline.

Saving precious resource materials (suedes, leathers, sterling silver) ensures that upon receiving an order I feel confident that the order can be filled in a timely fashion. A sampling of the in-house products we build includes the handbags, jewelry, journal covers, pillows, mouse pads, scarves, frames, and more.

When I want to create a specific type of product and there are aspects that I cannot or will not make myself, I find a partner who can build the units for me to my specifications. Typically, these include paper goods like prints and note cards (giclées, digital, offset), jewelry findings, wool, leather/suede, and book inserts. When the units are created, they are sent back to the studio where they are generally held in inventory or used to make the final, beautiful products I sell.

The final option is licensing partnerships. I generally look for licensing partners to develop and create products that I are beyond my ability to make, hold in inventory and/or distribute. In a licensing partnership the only thing I supply to the manufacturer is the image. They are responsible for the rest according to the terms of our licensing agreement. In return they will pay me a percentage royalty on each piece they sell.

Each of these partnership types has its benefits and its pitfalls, and I have found that it is best to use a mix of all three to balance my business. This balance is also a terrific way to take full advantage of all of the opportunities that a single image and its derivatives have to offer.

Managed correctly you can realize a significant number of opportunities from a single image. These extend beyond traditional art markets to include products ranging from fashion accessories to home decor, fabrics and more. Once you understand how to leverage that single image across categories and through partnerships the sky's the limit.

Making the Most of Fine Art & Craft Shows

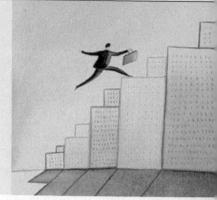

by Paul Grecian

For artists whose primary interest is in selling works for people's homes or offices, fine art and craft shows offer many opportunities. There are many things to consider, however, if shows are to become a serious and profitable endeavor for an artist. A successful show requires a strong body of work, a professional display, and an artist with a proper state of mind and people skills. A lot can be learned about what makes for a successful show by visiting good shows and watching the way experienced artists work at shows, you may get a sense of what needs to be in place before you participate in your own first show.

Why do shows?

Shows as a means of selling your artwork have many challenges and rewards. Fine art and craft shows offer the artist direct access and interaction with many kinds of buyers of art. There are people who are looking for works for their homes, offices, or as gifts for family, friends, or co-workers. Ideally, people will respond emotionally to your work and want to make it a part of their lives even if they did not specifically come to the show for new artwork. There are also other types of professional people walking through shows who may find your work appropriate for annual reports, company holiday cards, advertising, and myriad other business applications. The truth is, you do not know who may see your work when you exhibit at a public venue like an art or fine craft show.

One benefit of doing shows is you can exhibit your work in a way you feel best represents who you are as an artist. This is not something most artists can do when working with editors, businesses, stock agencies, or galleries. It can be both totally fulfilling and daunting to have this control on how your work is presented to the public. In addition, you will receive direct feedback from those who see your work. This communication between you and the customer is highly valuable marketing research that costs nothing additional beyond your show fees.

Being able to bring your work directly to the public in different locations allows an elevated level of exposure to your work not typically experienced with a gallery. Shows exist throughout the United States. Even exhibiting in several locations within your own state, you may access potential buyers whom you would never have found otherwise. There are many resources both in print and on the Internet which provide information about shows. Important contact information for show promoters, attendance figures, jurying processes, and fees are all listed in these sources so you can decide whether a specific show is appropriate for you and your work.

How do you choose?

One of the most difficult decisions to make is determining in which shows to exhibit and sell your work. This requires a level of self-honesty about where you fit into the variety of show types that exist. The quality of a show will be of paramount interest to you. Show quality will determine who else will be selling their work at the show and often what kind of customer will attend. Here again, visiting a show before deciding to apply to it will provide additional information to help determine if it is the right venue for you. The highest quality shows are usually juried events. This means applicants need to submit photographic slides or digital images of their work for consideration by a panel of judges. These judges will select appropriate participants for the show which they are jurying. The type of work you do and the quality of it and of your jurying images will determine if your application is successful.

It is generally the case that sales are better at quality juried shows than at lower-end non-juried shows. However, sales success can be dependent on many things, such as, the price of your work, geographic location of the show, and what the competition at the show is offering. It is entirely possible to have very good sales at a non-juried show (which also usually have lower entry fees) and to have mediocre or poor sales at a very well-regarded juried show. Finding profitable shows for your work is part of the learning curve in this kind of business.

Another thing to consider when choosing a venue for your work is whether the show has a theme. Shows may be restricted to specific genres (e.g., western, wildlife, nautical), may have "originals only" requirements, or may allow only hand-made crafts, any of which could make it the wrong venue for your work. Promoters provide this information in their listings in the Art Fairs section, so read them carefully. You do not want to go through the time and expense of applying to a show for which your work is inappropriate.

Some may find that their work is best offered at shows during certain times of year. If your work is themed to the holidays, or is most often purchased as holiday gifts, then fall and winter shows may be your best bet. The geographic location of the show may also be a determining factor as to whether it is

advantageous for you to apply. Tourist spots where buyers are looking to bring home something of the location they visited will likely want work with a local flavor. Shows in areas which have a robust economy or shows which have a history of strong show sales will have the most competition for available spaces.

Of course, the cost of the show itself may be a driving factor for many applicants. The fees both for application and for the show itself vary widely. And, as with show quality, higher show fees do not necessarily equate with higher show earnings. As in all things related to this business, research and an honest evaluation of your goals is necessary. Speaking of money, some shows also offer awards to their exhibitors. These awards may be in several categories and can sometimes offer quite a bit of money. Indeed, applicants who think they have a good chance to win an award may apply to such a show for just that reason. In addition to the monetary prizes, award winners gain prestige and sometimes media coverage.

It's all about the presentation

Presentation of your work, and your physical appearance, can be as important as the art which you are offering for sale. Your display setup will need to fulfill the requirements laid down by the show and should serve to draw people into your booth. Attractive display walls, a clean and organized space, a floor covering, and sufficient lighting are all necessary components of an effective display. The work itself should be placed in sturdy and attractive bins and placed on the walls neatly and in an uncluttered arrangement. Matting and framing should be clean, defect-free, and not compete for attention with your imagery. People are going to connect with your work if they feel comfortable in your space and are able to concentrate on your creations.

To further connect with patrons, provide easy-to-read signs including prices and the forms of payment you accept. Don't forget to display information about you as an artist. People are interested in the way you create and the motivation behind your work. They want to know your creative approach from both a technical and an aesthetic perspective. The more you can tell them about your methods and artistic philosophy, the more likely they will become engaged.

Your personal appearance will tell potential buyers as much about you as does your artwork. Dressing appropriately in clean, respectful attire will communicate to others that you are a serious person and respect yourself and what you do. Some shows have specific dress requirements (e.g., themed events where historic period clothing is needed), but most do not. Dressing professionally and comfortably should be your goal. That does not mean you cannot express your style or wear jeans, but consider the impact of how you dress on the way people will evaluate you and your work.

Another aspect of personal appearance is your posture and position in your

booth. If you are able to stand during the show, this is the preferable way to present yourself. If sitting is a requirement for you, find a seat which enables you to sit high enough to be at eye-level with patrons. Remember to allow for your chair when you design your booth space, as most shows will not allow a chair outside of the specific dimensions of your allotted booth. Eating in front of patrons is a frowned-upon practice, and you certainly do not want to be caught talking with your mouth full. A friendly greeting, eye contact, and the ability to speak about your work freely, will get your interaction with potential customers off to a good start.

Follow through

Doing shows can be immediately rewarding, or they can require some time before people who enjoy your work find you. A commitment of several years may be necessary to truly evaluate whether shows are right for you and your work. Be prepared to offer business cards, biographical sheets, and postcards to upcoming shows to maximize your future sales. Having a website, a blog, and a professional presence on social networks can all be useful in establishing a following of customers who will want to see you and buy your work at an upcoming show.

Are shows right for you?

The show life is not for everyone. There are significant physical, emotional, and time demands upon the artist who engages in shows. Doing shows can be quite physically demanding. Carrying work to and from a show may mean dealing with boxes of substantial weight. The act of setting up a display may require carrying heavy display walls and regular bending and lifting. If the show is an outdoor event, there is the additional task of carrying and setting up a canopy. Good quality canopies are usually heavy and may be complex to set up.

Shows are time consuming events, both in their duration and in the time required to prepare for them. In addition, a show which is not close to where you live may require substantial driving time to and from the venue. A weekend event may require a commitment of at least the day before and the day after if you need to travel.

Emotionally, shows can be inspiring and joyful, but also draining. You will need to be prepared for rejection as most customers attending a show will not likely be interested in your work. At large shows thousands of people may walk past your booth without even looking to see the work you have created. Remember, your target customers are those few who connect with your imagery and to whom your work speaks directly.

Beyond dealing with rejection, be prepared to deal with every sort of personality that may engage you at a show. Some folks will seem rude, some a bit odd, and some overly enthusiastic about your work; some will even want to tell you all

about their own artistic endeavors. Keeping these few guidelines in mind will get you through most situations: (1) never escalate a disagreement; (2) never discuss religion, politics, or any other subject that may become uncomfortable; and (3) always try to keep the discussion focused on your work.

Shows are places of business, and when you establish this understanding with your patrons, they will respect you. Some patrons may become great fans of your work. These customers will come back to you on a regular basis to add work to their collection or to buy gifts for others. Some of these buyers will even become friends and help promote your work. Friendships will also be made with artists who offer their work at the same shows as you do. These relationships can be long lasting and result in important professional alliances.

A personality trait required to succeed in this business is patience. Sometimes a show just does not work out for you. Variables such as the weather, the economy, competing local events, or even the location of your booth on the show floor can all work against you. Evaluate your results after each show to determine whether you could have controlled some negative aspect, improved some part of your own effort, or it just was not the right venue for your work.

Shows are physically and emotionally draining but also can be very rewarding. If you can evaluate the positives and negatives, commit to a reasonable time period to test the waters, and be honest with yourself about all that is required for success, you may find shows the most gratifying and enjoyable work in which you have ever engaged.

Eric Freitas

*Creating a Niche in Hand-Made
'Horological Contradictions'*

by Vanessa Wieland

The word "timeless" is a curious choice to describe a series of clocks, but when the works are those of Michigan-based artist Eric Freitas, "timeless" begins to make sense. Described on his website as "dark mechanical curiosities and horological contradictions," his work hints at a universe where machines assimilate the traits of organic life.

Steampunk, an aesthetic found in art, fiction, and fashion, combines period settings with anachronistic technological elements where humans and machines combine in fantastic, improbable ways. Inspired by the fiction of H.G. Wells and Mary Shelley, steam-powered airplanes are run via analog computers, dirigibles dot the sky, and creatures are made of both metal and flesh. Often set either the Victorian era or American Old West, pocket watches, clocks, exposed gears and mechanics play a prominent role.

"In the world of steampunk, things are handmade, personal, and possess an eccentric quality that could only exist in the absence of mass production," Freitas says. The handmade quality is something he takes seriously, designing and cutting every piece individually—even cutting the packaging he uses to send those pieces to exhibitions overseas. While Freitas may use old-fashioned methods to create his pieces, he's no stranger to the advantages of the Internet, blogging about the various stages of his work on his website (www.ericfreitas. com) and displaying his work on DeviantArt (http://ericfreitas.deviantart. com), and Flickr.

Here Freitas talks more about his art, paying the bills and the relationship with his fans. His work will also be on display from October 13, 2009 through February 10, 2010 at The Museum of History and Science, University of Oxford, UK.

VANESSA WIELAND is a part of the Writer's Digest Books team. She can also be found working on her portfolio of collage and mixed media paintings, writing stories, and exploring her hometown. Visit her blog, Across the River, at http://acrossriver1.blogspot.com.

Tell us a little bit about your background. What kind of formal training do you have?

I go back a little further than expected for this question, because I think my environment growing up very much contributes to what I create now. I grew up on a dirt road, with lots of trees around. My father was a Ford engineer, and had the distinctively quirky, but logical personality that typically comes with this profession. My older brother had M.C. Escher posters and Salvador Dali books around. I got a very nice calligraphy set when I was in second or third grade, and became pretty good at that; even got paid to do some high school diplomas when I was still in elementary school. Then you add the Victorian, noir, gothic, and anachronistic styles that I've latched onto, and out comes these strange clock designs.

From 1995-1999, I attended Center for Creative Studies, a four-year art school located in downtown Detroit. Illustration was my major, and at the time was grouped with the graphic design department. I wanted to draw and paint, so the graphic design classes I had to take in the first two years seemed like a waste of time to me. Computers weren't being used for everything just yet, so I learned how to do a lot of things by hand. I even had a hand-lettering class, where we learned to precisely draw Helvetica and the like. In retrospect, those basic design skills are very important to my style.

Why horology? What is it about time or time pieces that inspire you? How did learning to create clocks differ from the process of creating art?

All of the pieces just kind of fit for me. There's a nice balance between my innately strange style, and the perfect gear teeth in a clock. Clocks are conceptually and physically very structured things. The idea of throwing a little disorder into to them is interesting.

Also, I have to admit, I like the almost insane idea of a painter learning how to meticulously machine clock parts because of an idea he had. Mixing pure, ungoverned, abstracted forms with such a disciplined and traditional craft seems like an undertaking no one else would bother with. I couldn't help myself.

How did you sell your first piece? Are you able to make a living off the sales of your work?

Back when I was making them out of rusty steel, before I knew how to machine gears, I had a one night show in a very small Detroit gallery. Mike Mikos, one of my previous instructors at CCS, saw the flyer that I distributed for the show, and made an appearance. He bought my first piece. He was probably the teacher I respected the most at that school, so his purchase meant a lot to me.

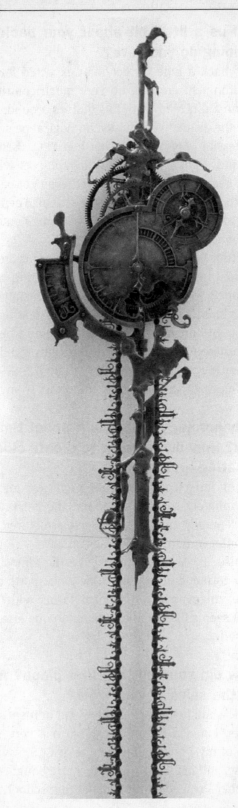

Articles & Interviews

Eric Freitas' Mechanical No. 6. To see more of
his work visit www.ericfreitas.com

I'm not able to support myself off of my work just yet. I work in a casino, which feels like the polar opposite of who I am. The 8 p.m. to 4 a.m. hours aren't too fun either, but you do what you have to.

You are displaying work in a steampunk show in Oxford. Do you have any advice for booking exhibitions?

I've always been approached to do shows, so I've never had to handle the booking myself. The only advice I would offer is not to be afraid of the business stuff. Before your work hangs make sure you have all of your prices, contracts, and agreements in line. It's important to be professional, and upfront. A good gallery or agent shouldn't hesitate on these things, it should be automatic.

Steampunk is defined by the anachronism between technology and old-fashioned or period aesthetics. Why do you think this is so intriguing, both to you as the artist, but also to the people who buy your work? And do you think steampunk is gaining in popularity?

I think people need things that are personal. Lately, a new thing comes out and before you know it, everyone has it. There's a growing compulsion to have something in your life that isn't like everything else. Also, in the throwaway age, everything is designed to sell to as many people as possible. People are sick of design that's dumbed down for the masses. They want to see the maker behind the machine again.

The sudden popularity of steampunk is cracking me up a little. The look has been around long before it had the title attached. Now it's blowing up, and it's

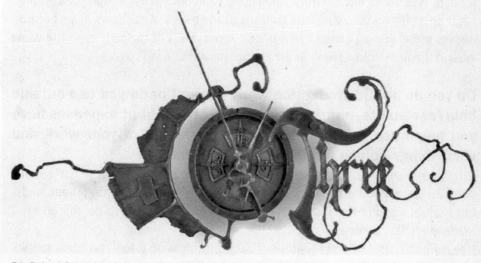

Eric Freitas' Quartz No. 6. To see more of his work visit www.ericfreitas.com

running the risk of becoming the next swing dancing. I don't think this look will ever completely disappear, though. If you strip out the fads and trends, even ditch the overused word "steampunk," you're left with a very beautiful aesthetic that can be tastefully woven into things far into the future.

On your website, you mention making your own tools to create these works because many of the tools are not produced anymore. How is using "old-fashioned" technology important to the overall production and aesthetic of your work?

It's huge! Being able to draw something, glue it onto a piece of sheet metal, and start cutting is what gives me that connection with what I'm making. I unload my personality on those jewelers saw cuts, and that's me in the crags and curls of my clocks. If I had to plot those shapes out for a machine to read, I would disappear from my work entirely. Besides, as hard as it may be to believe, I think it might be faster this way. There are fewer steps, because you just do it. You don't have to think of a shape, map it out, send it to be cut, and then fake the human touch anyway.

Besides your shop on your website, what other methods do you use to market your work? Do you use any social networking sites?

I currently use Flickr and Deviantart. These sites are less e-socializing, and more art sharing. Deviant in particular gave me a lot of exposure, and linked a lot of people back to my site. If I dedicated more time to the net, I could probably get two or three times the exposure. It's a very powerful tool that's drastically changing the way the art world works. The best marketing tool has been the popular blog sites though. When sites like I09 (http://io9.com/) and boingboing (http://boingboing.net/) do a post on you, your hits go through the roof. Doing shows helps because it gives these sites an actual event to talk about. Most of my web exposure came around the time I did a show in the Hamptons about a year ago.

Do you do all the production work yourself or do you use outside help (assistants, printing companies, etc.)? What expenses have you found are worth paying in the marketing of your work and what things do you prefer to handle yourself?

I have to make everything on my clocks myself. There are a few parts that I wind up making hundreds of, and I'd probably be better off getting them made, but I doubt I'll ever bring myself to do it. It's too important to be able to say I made every last piece.

I also handle my own photography. Taking professional-looking photographs is not an easy task, and the equipment can get expensive, but for me, it's

worth it. If I had to hire someone every time I finished a piece I'd go broke. For everything else, including graphic design and web programming, I let the pros handle it. I would love to be able to do everything myself, to ensure it's just the way I want, but you have to know your limitations.

With the economy hit so hard, do you feel any effects in the number of exhibitions or pieces sold?

It's hard to tell. For the first time, I put a couple of quartz pieces up for sale and they didn't disappear right away like they used to. My work is becoming significantly more elaborate though, so I have to charge more than before. It's possible that cheaper price points are becoming out of reach for the once compulsive-spending middle class. If that's the case, than I'll gladly focus on making some elaborate and mind blowing mechanical work and everyone can pick up the book instead.

Articles & Interviews

You don't just sell clocks—you also sell prints and cards of the concept drawings, which are works of art in their own right. How much of your business do these kinds of sales account for and how does that benefit you? Aside from cost, do you find there is a separate market that these items appeal to where the sculptural pieces wouldn't?

Seeing the sketches and concept drawings gives people a glimpse of your creation process, and how your head works. This is just as interesting as the finish to some people. I definitely need to put more of that kind of thing up for sale. A book focusing on the drawings is certainly something that I'd like to do, but I have to become a little more established first and save up the money to properly execute a project like that. I'm not making a lot off of the printed goods yet, but I figure if all I do is sell enough to break even, I'm still getting my name out there.

Your fans seem pretty passionate about your work, going so far as to get tattoos of your art. How important is the relationship with your fans?

I believe there are five people now that have my clock designs inked on them. This is indeed very flattering, but also a little strange. You almost feel responsible when you realize that it's your artwork they may be sick of and stuck with in 10 years. One thing's for sure—this is one type of compliment that's sincere. If there are people out there who feel that strongly about my work, then I must be doing something right. If I'm trying to create things with a personal feel to them, then this is a pretty good indication that I'm hitting that mark.

Being decent to the hardcore fans of your work is one of the most important

things as an artist. They're the ones that are telling everyone, enthusiastically, to look at your stuff. They're the ones sending links of your site to their friends, or even telling people all about you when they explain the tattoo they just got. It's the most positive and genuine advertising you can get. When I first thought of making these curious mechanical clocks, I was very excited. When I see such a strong response to the things I've created, it lets me know that other people are getting a dose of that excitement as well. That's what it's all about: working to make your ideas real so that you can put them out there, share them with people.

What kind of "beginner" mistakes do you think you made that others starting out could learn from, especially when it comes to getting your work known?

Not that long ago, I was letting people use my photos for just about anything as long as I was mentioned. My mentality was just to get it out there, get it to as many eyes as possible. While that's not a bad way to think, I had my work slapped on a lot of really poorly designed posters. These days, I don't let other people use my photos unless I have complete control over how it's used. It's too easy to be misrepresented.

Another thing, and perhaps thing I most regret, is not being ready for the press when it came. In the beginning, I had a few magazines approach me, and ask for more information about my work, along with high quality photos. One magazine even offered to run a full page ad for free! I missed out on many of these opportunities because the information wasn't prepared and the photos didn't meet the standard of the magazines.

Any words of advice for people just starting to market their work?

When you're starting out or going to school, think about the big picture. Think about all of the things you're going to have to do when you dive into the art world, because it involves a lot more than the art. I wish I'd taken several creative writing classes to more effectively convey my ideas on paper. Speaking about your work informally and from many different perspectives is something you'll want to be *very* effective at, because there are going to be times when you're on the spot, and there's nothing worse than misrepresenting yourself because you can't talk to people. These things, along with some basic business skills, are a must for survival as an artist.

Finally, just keep going. The recognition won't come overnight, so try not to get too frustrated, and just keep learning, re-evaluating, creating. If your job pays well, keep it for awhile. It's allowing you to make mistakes and take risks artistically. If you need to sell your work to live, you may become safe, sell-out so to speak, and then the really brilliant stuff may never emerge.

James E. Lyle

Comic Book Nerd Turned
Successful Illustrator

by Erika O'Connell

James E. Lyle (aka "Doodle") was fortunate enough to discover his passion for art early in life. "From around the age of three, my family started noticing my artistic aspirations and encouraged them," says Lyle. "I can't recall a time when I wasn't drawing things, and I get very cranky if I go more than a few days without drawing something. So by sixth grade I'd settled on 'artist' as a life's work."

One might assume such a firm decision would lead down a definite path of carefully planned objectives to reach that goal. But such was not the case with Lyle. Although he does have a degree in Commercial Art and Advertising Design, he considers himself mostly self-taught in terms of actual drawing skill and technique. He's one of the lucky ones—the artists who are simply born with talent. This is not to say he didn't have to work at it; those countless hours of drawing as a child certainly confirm the notion of "practice makes perfect."

Formal training came through Southwestern Community College in North Carolina, which Lyle first attended while still in his teens. But he quit twice and didn't finish the degree until after he was married and ready to concentrate on studying. "I used to say that I was the only student there who took 10 years to complete the two-year program—but apparently someone has surpassed that record now," he says. Regardless of how long it took Lyle to earn his degree, he had already begun to establish himself as a working artist. In between bouts of school, he did freelance work on various comic books and commercial jobs. Although he "learned a lot of things along the way," Lyle says going back to school was a great advantage in that he learned how to train himself. "It also de-mystified a lot of techniques that we [students] used to think were 'cheating.' The idea of illustration and cartooning is to get the point across, not to prove yourself by doing everything the hard way."

ERIKA O'CONNELL *is former editor of* Artist's & Graphic Designer's Market, *as well as a freelance editor/writer and aspiring artist.*

Long before gaining steady freelance work that paid, a younger Lyle had performed odd jobs at his Dad's gas station, "painting signs and stuff like that," and he eventually moved up to painting billboards (back when people still actually painted on billboards) with his older brother. But his big break in comics and illustration came from answering a classified ad in a comics fan magazine. "I had no way of knowing that the fellow who was advertising for an artist was just 15 and that he'd scraped together the money to self-publish his comic by mowing lawns! All I cared about was getting paid to draw comics," Lyle recalls. The young comic-book publisher was Phil Hwang, now a movie producer in Los Angeles.

Lyle had previously been lucky enough to mix hobby with employment by landing a job as a clerk in a comics and record shop, "which was great except I spent so much money on comics and records that I basically broke even," he says. Of course, like most of us, he endured his fair share of non-artistic jobs while trying to get established as an illustrator. After becoming engaged to his wife, he worked a couple of "awful" jobs in Chicagoland—at a giant hardware store, and washing dishes at a chain restaurant. Once married, Lyle moved back home to the mountains of North Carolina and worked very briefly in the print room of the local newspaper before taking a job in the art department of a T-shirt company. That job lasted longest of any "real job" outside of freelancing. It also offered "the opportunity to work on a number of licensed characters that still get mentioned on my résumé," he says. Learning a lot about the needs of screen-printing firms has also helped fill out his schedule over the years.

"About twice a year," says Lyle, "I tell my wife that I'm going to go get a job at a 'big box' and she talks me out of it. A day or two will pass, and another assignment that's interesting comes in and the feeling goes away." Being fortunate enough to truly love what he does for a living—and for it to live up to his childhood dream—has surely contributed to Lyle's willingness to share the dream with younger generations, and to support the arts and comics industries and communities. In recent years, he has made multiple visits to Black Mountain Elementary School in North Carolina to brainstorm and draw with fourth- and fifth-grade boys during library time. According to Erin Brethauer of the *Asheville Citizen-Times*, the school's library and media center administrator found that "comic books were of high interest to the boys and invited Lyle to help let their imaginations run wild."

Lyle's work is gaining attention from parents as well as kids. His custom comic book invitation designs for Egba Originals (www.egbaoriginals.com/comic.html) were praised as a "Cool Mom Pick" at coolmompicks.com, and also made the "GeekDad" blog section of *Wired* online (www.wired.com/geekdad, April 29, 2009). No wonder he prefers freelancing to working at a "real job!" Lyle is also the Vice Chairman of the Southeast Chapter of the National Cartoonists Society (www.reuben.org), and a frequent exhibitor at the annual

Heroes Convention in Charlotte, North Carolina. In addition to comic book illustration, he has achieved freelance success through multiple assignments for the Weekly Reader group of kids' school magazines (www.weeklyreader. com), one of which was featured in the 2008 edition of this book.

On top of all this, Lyle can now add packaging design to his growing catalog of experience, after having recently completed work on a Seattle Seahawks-based promotional campaign for Jones Soda Co. (www.jonessoda. com) through SuperBig Creative (www.superbigcreative.com), both located in Seattle, Washington. "After 25 years of doing this non-stop, I'm still waiting for my 'big break,'" says Lyle. Maybe he hasn't achieved fame or even widespread recognition, but it's safe to say Lyle has succeeded in making "artist" his "life's work"—and isn't living up to our own expectations the biggest "break" life can give us?

Here, Lyle shares some of the wisdom he's acquired through living the dream.

Do you have an agent/rep? (If not, do you wish you did?)

No rep at this time. A couple of friends in related fields (advertising, surface design) have tried to work as a part-time agent from time to time, but so far it hasn't really panned out.

The advantage I see in an agent is that a person who isn't involved in the actual process of making a particular work has the ability to look at it and see its value—and be able to communicate that value to a client. Too often as artists we look at our work and see only what we wish we'd done better. This tends to translate into insecurity when bidding on future jobs. We need a good cheerleader or two.

What do you do to promote yourself and your work?

Besides my professional website (www.jameslyle.net), I send out samples—via e-mail and snail mail—several times a year. Of course, I am constantly referring to *Artist's & Graphic Designer's Market* for new additions to my list.

I've recently added Facebook to my process and found a lot of old friends who are interested in my work. So far these have not resulted in much more than the occasional, "Hey, I really liked that drawing!"—but you never know.

The Southeast Chapter of the National Cartoonists Society keeps me pretty busy, and our local sub-group has resulted in a number of jobs over the past several years—never underestimate the power of local networking!

Oh, and with that in mind, I just signed up to be on the local tour of artists' studios put on by Haywood County Arts Council, and am working toward a show at their Main Street gallery (after being pretty much anonymous in my hometown since high school).

What do you like/dislike most freelancing?

I like the ever-changing needs. It's not easy to get bored if you have enough different types of assignments coming in.

Somewhere in the middle of like/dislike is having to deal with nomenclature that changes from one industry to another. For example, a "panel" in comic books is one drawing on a full page, while in packaging design a "panel" is one side of a box. So you have to be ready for that sort of terminology shift when dealing with different clients or you can really mess up a quote for a job.

A multi-panel example of James E. Lyle's promotional campaign for Jones Soda Co. For more visit www.jameslyle.net.

© James E. Lyle. Reprinted with permission.

As for the down side of freelance…dealing with clients who either don't recognize the value of the work (in terms of willingness to pay reasonable rates), or who wait forever to pay the balance once the job is complete.

What inspires you?

Pop culture seems to inspire me most—trying to make an image that reminds me of something that grabbed my attention as a child. I was recently asked to give a short artist statement about my work, and this was my quote: "James E.

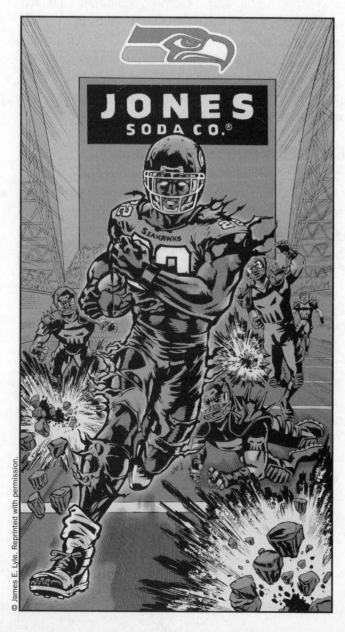

A single-panel example of James E. Lyle's promotional campaign for Jones Soda Co. For more visit www.jameslyle.net.

Lyle has been exploiting the icons and idioms of a misspent youth for over 25 years as a professional cartoonist and illustrator." I think that sums it up.

Although, lately I've been looking for more ways to incorporate classical art into the work; it usually ends up as a pop art piece, classically posed.

Who are your best clients?

Fans of my work are usually the best. I don't have a long list of people who could be called "fans," but of those few some are good friends. One in particular will come through around once a year with a big wad of cash and commission a bunch of illustrations (and if I'm really strapped for cash for some reason, he usually has some side project that he has had in mind).

Also, clients who are willing to set a good price up front. If they say, "We can pay you this much," and it's several times what I've been getting for similar work, then I'm more than willing to take the job. That doesn't happen too often, but it's been happening more frequently lately.

What are some of your favorite projects you've done?

I think my all-time favorite would have to be an issue of *T.H.U.N.D.E.R. Agents* I inked over Paul Gulacy [of DC Comics and Marvel Comics fame]. I didn't get paid that much, but I love the characters, and it was a real honor to work with one of my heroes in comics. I learned a lot about drawing and storytelling while working over his pencils, and have tried to apply those lessons to subsequent work. Unfortunately, the story still hasn't been printed. Some day, perhaps, it will see the light of day.

It may be a little too early to say if it's an all-time favorite, but the recently completed assignment for Jones Soda Co. was a lot of fun. It combined a lot of inspirations into one job: super-heroic depictions of the subjects, comics storytelling, pop art elements, over-the-top coloring techniques—and it paid well enough that it was worth working in a very short deadline!

What projects are you working on now?

At present I'm working on a webcomic, *The PLUS* (www.thepluscomic.com), which, hopefully, will be launched by the time this article is printed. I'm planning to do some of the stories solo (writing and drawing), and others in collaboration with friends whose work I admire.

I'm also deep into illustrating a novel set in the "golden age of piracy" (*Tales of the Sea: Brothers of the Winds*, by Timothy Chandler). I have something along the lines of 17 out of 66 illustrations finished. So that's going to be occupying a lot of my time. I'm also getting tooled up to do a comic set in the 1920s, and I've been asked to do another story set in the middle ages. My niece's boyfriend wants to collaborate on a story…there's always something.

In comics, that seems to be about par for the course: you throw a bunch of ideas around, and in 10 years or so they hopefully develop into an actual project. Sometimes it happens really quickly, but usually it's a lot of waiting. So you have a bunch of irons—if not actually in the fire—sitting close to the fire.

What's your ultimate dream/goal for your art?

With all the changes in how artwork is being used and delivered to markets, it's hard to answer with specifics like I might have 10 years ago. My ultimate goal (vaguely) is to find jobs that inspire me creatively and pay well so that I can concentrate on being more creative and not worry about finances. More comics projects would be nice, but the commercial work seems to pay better. At present, there seem to be fewer opportunities available for high-profile work in comics—at least for a fellow of my particular worldview.

As a Christian (of the reform variety), I'd like to be involved with projects that will have a more lasting value. But quite honestly, I've been burned by a number of projects that were supposed to be edifying and turned out to be fiascos.

I find myself a man stuck somewhere in the middle: wanting to say more with my work, but bound to the realities of making a living; wanting to work with characters that excited me when I was growing up, but not fitting in with the editorial policy of the companies that own those characters; wanting to build a body of lasting work, but not finding collaborators that understand just how demanding that can be.

Yet the work keeps coming, and I'm thankful for that. I'll take what providence offers.

Any advice for beginners/struggling artists?

Most artists (particularly the beginners) undervalue their work, and very often art buyers will see this as a weakness and use it to manipulate the beginner into practically giving their work away. Learn the value of your work and get a fair return for it. Don't have an attitude, but have the guts to walk out of a negotiation if the client isn't willing to offer a fair price.

Those who want to pay the least are invariably those who want you to make the most arbitrary of changes. These clients come back time and again with ridiculous revisions at the last minute, and excuses about why they shouldn't have to pay the royalties that are specified in the contract they signed. Better to just avoid those types all together. You can recognize them by the promises they make about how much this project will do for your career. The serious client generally doesn't have time for such nonsense. They usually just say, "We can pay such and such, and we need it in X amount of time."

Take joy in your work. I don't say "pride" because nobody likes an egotist; but if you enjoy what you are doing, it will show. And people do like joy.

Also, be aware that sometimes you have to produce multiple drafts to please clients. While I like to think of myself as an artist who can get it in one try, I also take pride in the fact that I'm willing to work with clients when something needs tweaking.

And it never hurts to get help from someone who's been around a little bit in the industry. Having a mentor has been a real advantage for me. My father-in-law (Ernie Guldbeck) drew the Keebler Elves for 20-plus years, and he's been able to give me all sorts of advice that has helped me along the way. Now I try to pass along some of my experience to younger artists. You haven't really learned the lesson until you can pass it along to someone else, and a lot of my happiest moments in recent years have been giving advice to up-and-coming artists. It's even more enjoyable to recommend one of them for an assignment.

The phrase "pay it forward" has become something of a cliché recently, but it's still a good practice.

Carlo LoRaso

*One Artist's Leap from Disney
into the Freelance World*

by Laura Atchinson

A rtist and illustrator Carlo LoRaso met with me for this interview wearing a nicely draping button-down shirt, the sort any man might wear to the office, except that his was emblazoned with cartoon images of The Incredible Hulk. His basement studio is a bright and creative space that looks like it was decorated by a very organized child. Built-in shelves climb the walls, filled with toys and packaging that he has designed over the years. Pinned to his spacious bulletin board are renderings of current projects: caricatures, new toy designs, and book illustrations. And on his desk is a curious and absorbing drawing that is part of a personal endeavor, a children's book that he is writing and illustrating himself. His work is varied, but there are distinct elements of exuberance and whimsy that seem to inhabit all of his creations; it's very easy to imagine him thriving at Disney.

Originally from Toronto, Canada, LoRaso modestly describes himself as someone who just grew up liking to scribble and draw spaceship doodles. But an extreme amount of talent and skill is evident in his work. When I pressed him on it, he admitted, "I drew a lot of spaceship doodles."

LoRaso had an established career as a Character Artist with Disney Consumer Products and had risen to the position of Character Art Director at their Burbank, California studios. When the familiarity of Ohio and the comfort of the changing seasons beckoned his wife home, he decided to make the bold leap into freelancing. He opened Carlo LoRaso Studios in 2001 and now runs a successful freelance business from his home in Granville, Ohio. While he still does toy and character design, his work also consists of children's book illustration, packaging illustration and storyboarding. He counts Hasbro, The

LAURA ATCHINSON is a freelance writer and photographer living in Newark, Ohio. She's have written for *The Ohio State Engineer* magazine and spent many years as a Courseware Developer, writing and editing text for computer-based training software. For the past nine years she's run a portrait photography business out of her home and has recently begun to focus her efforts back on writing.

Walt Disney Company, Bob Evans Restaurants, HarperCollins, and Scholastic Books among his clients.

Leaving a full-time, salaried—and let's face it, very cool—job with benefits and security might seem like a big decision, but it's one he has not regretted. As with any new venture there were challenges and obstacles, but LoRaso said, "even when I've come off a few days of working insane hours, and I'm scraping myself off the floor, I do not dread coming down to work." Here he talks about his background, his decision to go out on his own, and the realities and rewards of life as a freelance artist. To see more of LoRaso's work visit his website, www.carloloraso.com.

How did you go from a kid drawing spaceship doodles to being a professional artist?

As a kid I was always drawing. It was how I entertained myself. Then after high school I attended Sheridan College in Ontario, Canada, which has an outstanding illustration and animation department. We often had recruiters from major studios and companies coming there. One time John Lasseter from Pixar came to talk to us. They were working on a new form of 3D computer animation, but it was top secret and he couldn't tell us much more about it. Not long after that *Toy Story* came out.

What did you work on at Disney? Anything we might recognize?

I never worked on any animation stuff. I was always in product design and packaging illustration. But I worked on merchandise and packaging for everything from *Robots* and *Tarzan* to *Lilo & Stitch*.

How difficult was it to make the decision to leave Disney?

Maybe I'm crazy, but it was actually a surprisingly easy decision to make. I was making a really good salary at Disney, but I think that we were ready. My wife and I had both been living in southern California for a while. That's where we met, but neither of us was from there originally. I think we were ready for a change. Janice was from Granville and still had family in the area. I had been here with her—we got married here—and I fell in love with the place. So we decided, why not?

Did you look for a job in Ohio or was it always the plan to freelance?

The plan was to start my own business, but to keep an eye out in case it didn't work out. It's probably not something that I'd recommend. Looking back, it probably wasn't as well thought out as it could have been. It could have turned out badly, but knock on wood, it worked out well. I've spent a lot of time in my life just working off my gut, and I've gotten to the point where I feel

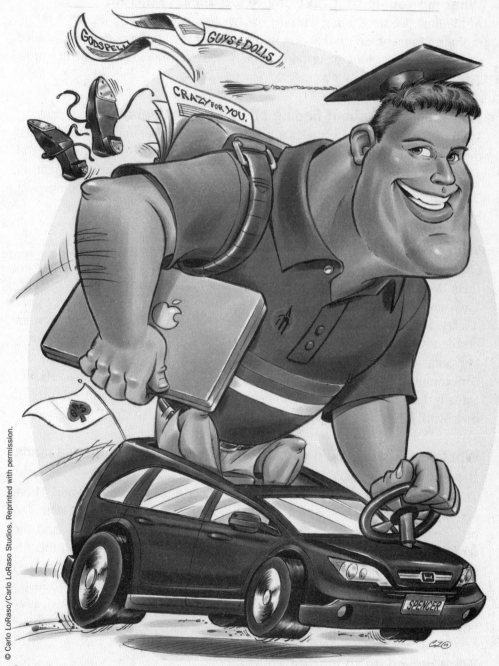

Carlo LaRaso created this caricature for his friends when their son Spencer graduated high school. "I was able to get a really fun image together that captures all his interests and personality," says LoRaso.

Articles & Interviews

fairly comfortable doing that. The wisdom of doing that is debatable, but it has served me well.

It's day one at Carlo LoRaso Studios, and you're on your own. What did you do that first day to get things started?

At the time, we were living with my in-laws temporarily. I had an office set up in their basement. So on day one I probably got my cup of coffee and headed downstairs to the ping-pong table, which was my drawing desk at the time. Then I started making calls.

How did you go about finding clients in the beginning?

I had made a lot of good contacts in the industry while working at Disney. When they heard what I was doing a lot of them gave me their names and numbers and said to call them when I got set up. So that's what I did. It's one of the benefits of spending time in the business. You get to make contacts that will help you in your career.

Who was your first client?

First client probably had to be Hasbro toys, and I still regularly do stuff for them. My first jobs for them were some ideas for toy concepts for *Toy Story 2*. Then they asked if I'd ever drawn *My Little Pony* before. I hadn't, but I gave it a try. For a number of years I was doing all the *My Little Pony* art that went on the toy packaging. It ended up on puzzles, clothes, backpacks, everything. My name got floated around to different toy design groups within Hasbro too. For example, I worked on toy packaging for some of the *Star Wars* toys. Hasbro actually has an artist resource website where freelancers upload samples of their work. They deal with a lot of freelance artists.

What do you wish you'd known about freelancing before you made the leap?

The business end took a lot of work. Like, how much do you charge? There are days that I still feel like "what is this worth?" It's hard to put a dollar sign on this type of work. You don't want to price yourself out of work. And the whole idea of finding work, and networking, and putting yourself out there is sort of a whole skill set that I didn't have. It's not in my DNA. Having worked in California and Disney, and being in the board meetings—it's an industry town—everyone networked, but I never did. I still don't know if I'm savvy enough.

What do you do to market yourself?

I send out a lot of cold call e-mails to current clients, just to check in and see

if they need anything from me. I've also had some new clients see my website, which I just put up last year. A friend helped me put the website together, because I had no clue how to do it, and it's been great because I've finally had something I could point people to. There have been friends who have gotten me work by referring companies to my website. So that has been very valuable for marketing my services to new clients.

How do you approach a new client?

When you see them running, you chase after them and slug them over the head and drag them back to your cave. No, not really. I've done searches for various toy companies and entertainment companies. Once in a while I send e-mails out to contacts at different places to see if they're accepting sample submissions or accepting portfolios. Or I can refer them to my website. I should probably do it more than I do.

© HASBRO TOYS

Since he began work as a freelance illustrator, Carlo LoRaso has created a number of My Little Pony illustrations such as this one for packaging and products.

You also work with a publishing rep. Is that similar to having an agent?

My publishing rep is an agent, but in my case he specializes in working between publishers and artists for children's books. He reps other artists for other things as well, but we have an arrangement that he gets me publishing work as I already have established connections directly with toy companies for that kind of work.

So do you generally work for the same clients most of the time?

Yeah, I have a regular stable of clients and every so often a new one pops in.

What's a typical day like for you?

You'll always catch me coming down here with my cup of coffee and I'll start at my drawing desk or my computer. At the very minimum it's an eight-hour day. More often than not it tends to be 10 hours or more. I'll work after the kids are in bed, or I'll get up extra early. Sometimes I feel like a vampire with the hours I put in, but deadlines wait for no man.

Mission Packs Buzz has unique trim colors.

1: Buzz original jetpack comes off......

2:and can be replaced with the monkey winch backpack......

3:....or the new projectile backpack!

MISSION PACKS BUZZ

© HASBRO TOYS

Carlo LoRaso has done a lot of freelance work for Hasbro over the years such as these package illustrations for a Buzz Lightyear toy.

How is it working from home?

It's wonderful, is what it is, from the perspective of being a dad. I get to eat lunch with my kids in the summers. I don't have to worry about the drive home. Once I'm done, I'm done. I wouldn't give that up for anything.

What's the downside of working from your home?

The kids have been suitably trained to not come down when I work here. But it's the artist interaction thing that is the biggest negative. I'm slightly a hermit by nature so it's fine, but sometimes you need to see what other people are doing to get the creative juices going. You need that back and forth of ideas. At Disney, there were always other artists to work with and bounce ideas off of. So the daily interaction between the nutcases that we were is something that I miss.

Are you naturally self-disciplined?

God no. I know artists who are extremely self-disciplined, and I'm so envious. I really should be. If you're going to do this you really should be. I just try to stay focused on the work.

If there was anything you could change about freelancing, what would it be?

The one thing I would change about freelancing is getting regular pay. It is so irregular. Publishing jobs pay at a certain interval. Toy design jobs pay at a different interval. And the bizarre thing is sometimes when one is slow the other one picks up. I try to juggle a variety of things so that money is coming in steadily, but it is what it is.

What advice would you give to someone just starting out, trying to get their first clients or assignments?

It depends on what type of business they want to get into. Make sure every image in your portfolio grabs someone's attention. All your work needs to be really strong. Your portfolio is only as strong as your weakest piece. And you have to be diligent and persistent. You'll get rejections. That'll happen a lot. Anyone who wants to do this seriously better make sure they enjoy it. And frankly speaking, you wouldn't really go out on your own unless you enjoyed it and you wanted to be your own boss. Some people are wired that way. Some people aren't. I like being able to call my own shots. Maybe it's a Napoleon complex.

For the dreamers who think that working from home is all sleeping late and working in your pajamas, what would you say to bring them back down to earth?

It's sink or swim. While there are no guarantees with anything, when you

work with a company there's a certain level of security. You make decisions—buy your house, pay for your car or whatever—with a regular paycheck. With freelancing, you have to want to do it bad enough that you will make the effort of organizing yourself so that you invoice on time, have your accounting aspects in a row. You'll figure out how to use excel and be on top of who owes you money. There is that whole aspect of it. And if you're going to be successful at it, you have to put the time, commitment and the energy into that end of it. There's no bail out for you. If you sink and fold up, where do you go?

What other business aspects are there to think about?

Where do I start? Taxes. Unless you're a whiz at doing your own taxes, make sure you find a decent tax person and meet with them a couple of times a year, so you can learn what deductions you can and can't take. Depending on what state you live in there are different regulations about collecting sales tax, incorporating yourself, and licensing your business. I'm incorporated as an LLC. You're a small business and you should treat it that way. I know a lot of artists who are great but work for peanuts and don't know how to manage their money.

Is there a dream assignment out there that you would love to have?

My dream would actually be to have something happen with this children's book that I'm working on that I could continue with. It's my own personal project, and in my mind it's open for all kinds of little adventures and continuations and things to happen with these characters. It would just be the cat's pajamas if I could do more and go somewhere with it.

Do you have any other words of wisdom for aspiring freelance artists?

You have to have a good temperament and try not to take things personally. The old saw is that you have to divorce yourself from it, but that's really hard. When something comes back with changes or criticisms, often you'll see what they're talking about, but other times you have to take a step back, distance yourself from the work, look at it with a clear eye, and realize you need to address what the client wants. Sometimes it's really difficult. And a good freelancer will take what they're given and work with it and making something unique and fun and entertaining. And hopefully the client will see that. More often than not a client can tell when you've given them what they've asked for and more, and they appreciate that.

Maggie Barnes

Finding Inspiration, Courage
& Fulfillment as an Artist

by Erika O'Connell

Maggie Barnes never planned on being an artist. But that's what she's become, through a series of serendipitous events, and now she can't imagine her life as anything else. With a bachelor's degree in English, and a master's in Secondary Education, this Cincinnati, Ohio, native was (or at least seemed) destined to be an English teacher. And that's what she was for a few years—until she had children and became a stay-at-home mom. "I was originally planning to go back to teaching when the kids went to school full-time," she says. "And while I very much enjoy teaching, I'm so grateful that my career as an artist sort of took off on its own."

The inspiration to begin painting took hold of Barnes during a difficult time in her life when she was grieving the death of her close friend Mark. "He was an artist and had always encouraged my creative side, so it felt like a good way to pay tribute," she recalls. "Also, as a recovering alcoholic, I knew it was important to find a healthy way to process my feelings. And just like when I had gotten sober, I knew there was no human power that could relieve me. I knew I had to find a power greater than myself. I found then, and still find today, that greater power in art."

Although she had made it a point to sign up for an assortment of high school art electives such as ceramics, metals, photography, etc., she never took any drawing or painting classes in her youth. "For whatever reason, I never felt like I was a 'good enough' artist to take those," she says. Barnes felt more comfortable in the performing arts—playing violin and piano—or at craftier pursuits like painting second-hand furniture with "funky designs" for her kids, which she thought of as decorating rather than art. Her friend Mark suggested she try her designs on canvas, but she couldn't see the point given that she

ERIKA O'CONNELL *is former editor of* Artist's & Graphic Designer's Market, *as well as a freelance editor/writer and aspiring artist.*

felt inadequate at drawing. "Anytime I've tried to copy something or draw something realistically, it turns out very choppy and just plain awful," she claims. "I took a couple drawing classes in college, and I enjoyed them, but I still felt a bit like a poser." For some reason she had never considered abstract art as something she could do for a hobby, let alone a career. That's what other people (artists) did—she was a musician; and a teacher; and a mom.

But in January 2005, when dealing with the first "big thing" in life after getting sober, Barnes heard something or someone whispering to her spirit: "Pick up a paintbrush instead of a drink." She had never painted before and was quite surprised by her sudden, unquestionable need to do so. The first thing she ever painted, other than that old furniture, was done with her toddler's acrylic paints on an old address book. Then she got some canvas and painted at least one piece a day for more than a month. She made her first sale after only a couple months, to a friend who happened to come by and see her work in the dining room (her temporary studio). Barnes hadn't really thought about the idea of trying to sell her work; she was doing it as a sort of therapy, and saw the money she made simply as a means to buy more paint.

Shortly thereafter, a fortuitous get-together with another friend led to an exhibit (in London of all places!), and she began to see a pattern of "billboards" unfolding in her life, as if somehow the universe had magically detoured her onto the path to her true destiny. The next push from fate came as her youngest child started going to school full-time, when she was given the opportunity to be a guest artist at Essex Studios (www.essexstudios.com). "After looking into it, my husband and I decided perhaps it was time to get a studio space of my own," says Barnes.

Since then, she's sold countless pieces to collectors for their homes, has participated in various outdoor art shows, and has exhibited work in a number of local venues including A.R.T. Gallery (www.ArtResourceTeam.com), The Edge Yoga Studio (www.yogaedge.net), and Kennedy Heights Arts Center (www.kennedyarts.com), where she is a Guild member. Barnes also dabbles in photography, and has recently received several inquiries about whether she plans to exhibit/sell her photos (she's working on it). One of the most humbling experiences she's had so far was being invited to take part in a panel discussion following the screening of the documentary *Who Does She Think She Is?* (www. whodoesshethinksheis.net), about what it means to be an artist and a woman, especially in a society that doesn't always take women artists seriously.

In a short time, Barnes has come a long way from her preconceived notions about what it means to be an artist. She's opened herself up to the boundless possibilities, and has become more than willing to trust the calling. Here, she talks about her hardships, her triumphs, and why she can't imagine *not* being an artist. To learn more about Maggie Barnes, and to view more of her artwork, visit www.ArtworkByMaggie.com.

What inspires you?

Everything—nature; painterly art; life; love; music; van Gogh's letters...

I still have a studio at the Essex, and I enjoy the fellowship that comes from being part of a community of other artists. I paint because it offers me indescribable balance and relief. It allows me to accept and resolve the things

Maggie Barnes' painting "Katy's Birthday" is 16" × 20" work in acrylic.

that I perceive to be chaotic and imperfect, and, through grace, find an authentic purpose, a harmonious arrangement to it all. When I am able to trust that grace, that creative energy, it simply becomes a matter of showing up at the canvas to quiet the chatter in my head.

While working on my master's degree, I came across Julia Cameron's *The Artist's Way: A Spiritual Path to Higher Creativity* (www.theartistsway.com) in a creative writing class. I practiced it pretty regularly for a few years, and then went back to it when I began painting. I can't say enough wonderful things about the book. It has freed me to feel comfortable doing my own work, and has disciplined me into understanding that there is power in showing up day after day regardless of inspiration or direction. I currently facilitate a weekly study of *The Artist's Way* at Kennedy Heights Arts Center.

Another book that has been powerful to me is *Art & Fear* (by David Bayles and Ted Orland). It echoes what I learned in *The Artist's Way*, and has helped solidify the idea that hard work equals success—that it is possible to make a living as an artist if you're willing to work hard.

What do you consider your first "success"?

A few months after I started painting, a friend from high school who had moved to England came home to visit. Our families spent a few days together, talking art, swimming and enjoying good food. After she and her husband got back to England, they called with an opportunity…long story short, they agreed to pay for half of my painting supplies for a year, flew me and my paintings to London, and arranged for my work to be shown at One (www.only0ne.com), a funky high-end boutque in Notting Hill. The success from that experience—and most especially their strong belief in my work—gave me the courage to take this new hobby seriously. There is no doubt that without the help of Nikki and Richard Conway, I might not have painted for any longer than a few months. I am so grateful for their support and encouragement!

This experience also gave me the courage to ask for what, at the time, seemed to me like a lot of money for my paintings. I tested the waters with these prices at local fundraisers. Being present when multiple people are bidding on your work can be a bit intimidating, but in the end, it has been an incredible experience. I do several of these each year, and I'm always astonished and grateful. It's a way for me to give back to the community, not to mention I get to do something I'm passionate about. It really blows my mind that I can essentially use my paintings as currency—getting paid for doing something I was going to do anyway!

So would you say "doing what you love" is the best thing about freelancing?

There are so many things I like about it, but the biggest has to be that I get to

set my own schedule, which allows me to be flexible with my family's needs. Having a studio of my own gives me a place to go to work (and I work very hard at what I love), but I'm also able to spend time with those who are most important to me—my family and friends. It's a pretty good deal. It feels like I've been given a free pass. Sometimes it's hard to believe that this is my life!

Is there a downside to freelancing?

The balance between home life and being an artist is sometimes tricky. Even though I know I have the full support of my friends and family, I still cringe at the occasional use of the word "hobby" for my artistic endeavors. I know they don't understand: *I have to paint*; it's what I'm here to do. Yet from time to time, I still feel the need to defend, even to myself, the time spent at the studio. And while I know that being creative is my purpose here, it's easy to lose sight of it when the issue of money enters the conversation. I have found some peace in the acceptance that these tend to be semantic issues. And since art is my direct line to my higher power, it is far too important for me to let semantics get in the way.

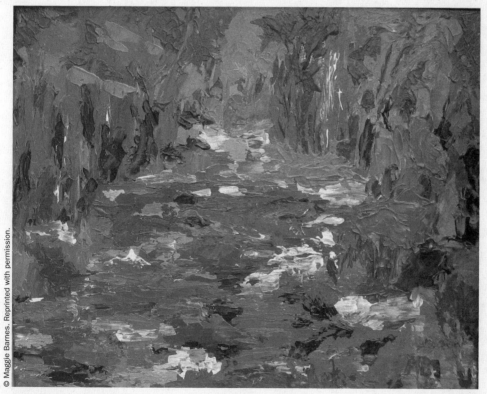

"River Walk" by Maggie Barnes shows off her signature impressionistic style with textural paint in blues and greens.

How do you promote your work? Do you have an agent/rep?

I don't have an agent but do dream of it. The business side of things isn't my strong suit. Not that I don't understand it, or even the importance of it, but, quite frankly, I'd rather be painting. On the other hand, when I work with someone else on putting things like business cards and brochures together, I do tend to have solid ideas of what I want. So I tend to go back and forth a bit about whether I really need an agent.

I used to send postcards for my art shows, but now I mostly rely on people seeing my work at the studio—we have "art walks" throughout the year.

What do you hope to achieve with your art?

My hope for my art is that it moves people in a healing way. For me, painting is about healing, and about being in touch with my higher power. When I begin my day, I pray that I can be of use through this gift I've been given. I call it a gift because it's something that keeps me sober and allows me to give back.

My hope for myself, in terms of my relationship with my art, is that I will always be willing to show up and do the work, whether I feel like it or not, and to remember something I learned from *The Artist's Way*—that it is far easier to do the work than it is to be a blocked artist.

What projects are you working on now?

I've been reading a lot lately about plein air work, and have been feeling the itch to get out there and do a bit of that. I have two pieces I've been commissioned to do by Christmas. And I recently began painting in oils (rather than acrylics). When I was diagnosed with melanoma in December 2008, I made the decision to begin something I had always wanted to do. I have some beautiful oil paints that I had "put away for a rainy day," so I took them out and have been using them exclusively since. The paintings are still similar in style: expressionist, impressionist, and some abstract.

Do you have any advice for beginning/struggling artists?

Get copies of *The Artist's Way* and *Art & Fear*. Read them, practice them, and share them with friends. Keep showing up!

Galleries

Most artists dream of seeing their work in a gallery. It's the equivalent of "making it" in the art world. That dream can be closer than you realize. The majority of galleries are actually quite approachable and open to new artists. Though there will always be a few austere establishments manned by snooty clerks, most are friendly places where people come to browse and chat with the gallery staff.

So don't let galleries intimidate you. The majority of gallery curators will be happy to take a look at your work if you make an appointment or mail your slides to them. If they feel your artwork doesn't fit their gallery, most will steer you toward a more appropriate one.

A few guidelines

- **Never walk into a gallery without an appointment,** expecting to show your work to the director. When we ask gallery directors about their pet peeves, they always mention the talented newcomer walking into the gallery with paintings in hand. Send a polished package of about eight to 12 neatly labeled, mounted duplicate slides of your work in plastic slide sheets. (Refer to the listings for more specific information on each gallery's preferred submission method.) Do not send original slides, as you will need them to reproduce later. Send a SASE, but realize your packet may not be returned.
- **Seek out galleries that show the type of work you create.** Most galleries have a specific "slant" or mission. A gallery that shows only abstract works will not be interested in your realistic portraits.
- **Visit as many galleries as you can.** Browse for a while and see what type of work they sell. Do you like the work? Is it similar to yours in quality and style? What about the staff? Are they friendly and professional? Do they seem to know about the artists the gallery represents? Do they have convenient hours? If you're interested in a gallery outside your city and

Types of Galleries

As you search for the perfect gallery, it's important to understand the different types of spaces and how they operate. The route you choose depends on your needs, the type of work you do, your long-term goals and the audience you're trying to reach.

Retail or commercial galleries. The goal of the retail gallery is to sell and promote the work of artists while turning a profit. Retail galleries take a commission of 40 to 50 percent of all sales.

Co-op galleries. Co-ops exist to sell and promote artists' work, but they are run by artists. Members exhibit their own work in exchange for a fee, which covers the gallery's overhead. Some co-ops also take a small commission of 20 to 30 percent to cover expenses. Members share the responsibilities of gallery-sitting, sales, housekeeping and maintenance.

Rental galleries. The rental gallery makes its profit primarily through renting space to artists and therefore may not take a commission on sales (or will take only a very small commission). Some rental spaces provide publicity for artists, while others do not. Showing in this type of gallery is risky. Rental galleries are sometimes thought of as "vanity galleries" and, consequently, do not have the credibility other galleries enjoy.

Nonprofit galleries. Nonprofit spaces will provide you with an opportunity to sell your work and gain publicity but will not market your work aggressively, because their goals are not necessarily sales-oriented. Nonprofits generally take a small commission of 20 to 30 percent.

Museums. Though major museums primarily show work by established artists, many small museums are open to emerging artists.

Art consultancies. Consultants act as liaisons between fine artists and buyers. Most take a commission on sales (as would a gallery). Some maintain small gallery spaces and show work to clients by appointment.

you can't manage a personal visit before you submit, read the listing carefully to make sure you understand what type of work is shown there. Check out the gallery's website to get a feel for what the space is like, or ask a friend or relative who lives in that city to check out the gallery for you.

- **Attend openings.** You'll have a chance to network and observe how the best galleries promote their artists. Sign each gallery's guest book or ask to be placed on galleries' mailing lists. That's also a good way to make sure the gallery sends out professional mailings to prospective collectors.

Showing in multiple galleries

Most successful artists show in several galleries. Once you've achieved representation on a local level, you might be ready to broaden your scope by querying galleries in other cities. You may decide to be a "regional" artist and concentrate on galleries in surrounding states. Some artists like to have East Coast and West Coast representation.

If you plan to sell work from your studio, or from a website or other galleries, be up front with each gallery that shows your work. Negotiate commission arrangements that will be fair to you and all involved.

Pricing your fine art

A common question of beginning artists is "What do I charge for my paintings?" There are no hard and fast rules. The better known you become, the more collectors will pay for your work. Though you should never underprice your work, you must take into consideration what people are willing to pay. Also keep in mind that you must charge the same amount for a painting sold in a gallery as you would for work sold from your studio.

Juried shows, competitions and other outlets

It may take months, maybe years, before you find a gallery to represent you. But don't worry; there are plenty of other venues in which to show your work. Get involved with your local art community. Attend openings and read the arts section of your local paper. You'll see there are hundreds of opportunities.

Enter group shows and competitions every chance you get. Go to the art department of your local library and check out the bulletin board, then ask the librarian to direct

Helpful Resources

For More Info

Look for lists of galleries and information about dealing with galleries in the following publications:

- *Art Calendar* (www.artcalendar.com)

- *Art in America* (www.artinamericamagazine.com; each August issue is an annual Guide to Museums, Galleries and Artists)

- *Art New England* (www.artnewengland.com; East Coast)

- *ART PAPERS* (www.artpapers.org)

- *The Artist's Magazine* (www.artistsmagazine.com)

- *ARTnews* (www.artnews.com) *Artweek* (www.artweek.com; West Coast)

you to magazines that list "calls to artists" and other opportunities to exhibit your work. Subscribe to the Art Deadlines List, available in hard copy or online (www. artdeadlineslist.com). Join a co-op gallery and show your work in a space run by artists for artists.

Another opportunity to show your work is through local restaurants and retail shops that exhibit the work of local artists. Ask the managers how you can get your art on their walls. Become an active member in an arts group. It's important to get to know your fellow artists. And since art groups often mount exhibitions of their members' work, you'll have a way to show your work until you find a gallery to represent you.

ACA GALLERIES

529 W. 20th St., 5th Floor, New York NY 10011. (212)206-8080. Fax: (212)206-8498. E-mail: info@acagalleries.com. Website: www.acagalleries.com. **Vice President:** Dorian Bergen. For-profit gallery. Estab. 1932. Exhibits mid-career and established artists. Approached by 200 artists/year; represents 35 artists/year. Exhibited artists include Faith Ringgold (painting, drawing, soft sculpture) and Judy Chicago (painting, drawing, sculpture). Sponsors 8 exhibits/year. Average display time: 6-7 weeks. Open Tuesday through Saturday, 10:30-6. Closed last 2 weeks of August. Clients include local community, tourists, upscale. 25% of sales are to corporate collectors. Overall price range: $1,000-1,000,000.

Media Considers all media except photography. Most frequently exhibits acrylic, ceramics, collage, drawing, fiber, mixed media, oil, paper, pastel, pen & ink, sculpture, watercolor.

Style Considers all styles, all genres. Most frequently exhibits color field, expressionism, impressionism, postmodernism, surrealism.

Terms Artwork is accepted on consignment (10-50% commission). Retail price set by both artist and gallery. Gallery provides insurance, promotion, contract. Accepted work should be framed. Requires exclusive representation locally.

Submissions Send query letter with bio, artist's statement, résumé, brochure, photocopies, photographs, slides, reviews and SASE. Mail portfolio for review. Returns material with SASE. Responds to queries in 1-2 months. We handle established, mid-career artists that have had solo museum exhibitions and have major books or catalogues written about them that are not self-published.

ACADEMY GALLERY

8949 Wilshire Blvd., Beverly Hills CA 90211. (310)247-3000. Fax: (310)247-3610. E-mail: gallery@oscars.org. Website: www.oscars.org. **Contact:** Ellen Harrington.

Nonprofit gallery. Estab. 1992. Exhibitions focus on all aspects of the film industry and the filmmaking process. Sponsors 3-5 exhibitions/year. Average display time: 3 months. Open all year; Tuesday-Friday, 10-5; weekends, 12-6. Gallery begins in building's Grand Lobby and continues on the 4th floor. Total square footage is approx. 8,000. Clients include students, senior citizens, film aficionados and tourists.

Submissions Call or write to arrange a personal interview to show portfolio of photographs, slides and transparencies. Must be film process or history related.

ADDISON/RIPLEY FINE ART

1670 Wisconsin Ave. NW, Washington DC 20007. (202)338-5180. Fax: (202)338-2341. E-mail: romyaddisonrip@aol.com. Website: www.addisonripleyfineart.com. **Assistant Director:** Romy Silverstein. For-profit gallery and art consultancy. Estab. 1981. Approached by 100 artists/year. Represents 25 emerging, mid-career and established artists. Sponsors 13 exhibits/year. Average display time: 6 weeks. Open all year; Tuesday-Saturday, 11-6. Closed end of summer. Clients include local community, tourists and upscale. 20% of sales are to corporate collectors. Overall price range: $500-80,000; most work sold at $2,500-5,000.

Media Considers acrylic, ceramics, collage, drawing, fiber, glass, installation, mixed media, oil, paper, pastel, sculpture and watercolor. Most frequently exhibits oil and acrylic. Types of prints include etchings, linocuts, lithographs, mezzotints, photography and woodcuts.

Style Considers all styles and genres. Most frequently exhibits painterly abstraction, color field and expressionism.

Terms Retail price set by the gallery and the artist. Gallery provides insurance, promotion and contract. Accepted work should be framed, mounted and matted. No restrictions regarding art or artists.

Submissions Mail portfolio for review. Send query letter with artist's statement, bio, photocopies, résumé and SASE. Returns material with SASE. Responds in 1 month. Finds artists through word of mouth, submissions, and referrals by other artists.

Tips "Submit organized, professional-looking materials."

AGORA GALLERY

530 W. 25th St., New York NY 10001. (212)226-4151, ext. 206. Fax: (212)966-4380. E-mail: Angela@Agora-Gallery.com. Website: www.Agora-Gallery.com. **Director:** Angela Di Bello. For-profit gallery. Estab. 1984. Approached by 1,500 artists/year. Exhibits 100 emerging, mid-career and established artists. Sponsors 10 exhibits/year. Average display time: 3 weeks. Open all year; Tuesday-Saturday, 11-6. Closed national holidays. Located in Soho between Prince and Spring; landmark building with 2,000 sq. ft. of exhibition space; exclusive gallery block. Clients include upscale. 10% of sales are to corporate collectors. Overall price range: $550-10,000; most work sold at $3,500-6,500.

Media Considers acrylic, collage, digital, drawing, mixed media, oil, pastel, photography, sculpture, watercolor.

Style Considers all styles.

Terms There is a representation fee. There is a 35% commission to the gallery; 65% to the artist. Retail price set by the gallery and the artist. Gallery provides insurance and promotion.

Submissions Guidelines available on website (www.agora-gallery.com/artistinfo/GalleryRep resentation.aspx). Send 5-15 slides or photographs with cover letter, artist's statement, bio and SASE; include Portfolio Submission form from website, or submit all materials through online link. Responds in 3 weeks. Files bio, slides/photos and artist statement. Finds artists through word of mouth, submissions, portfolio reviews, art exhibits, Internet and referrals by other artists.

Tips "Follow instructions!"

ALASKA STATE MUSEUM

395 Whittier St., Juneau AK 99801-1718. (907)465-2901. Fax: (907)465-2976. E-mail: bruce_kato@eed.state.ak.us. Website: www.museums.state.ak.us/asmhome.html. **Chief Curator:** Bruce Kato. Museum. Estab. 1900. Approached by 40 artists/year; exhibits 4 emerging, mid-career and established artists. Sponsors 10 exhibits/year. Average display time: 6-10 weeks. Downtown location—3 galleries exhibiting temporary exhibitions.

Media Considers all media. Most frequently exhibits painting, photography and mixed media. Considers engravings, etchings, linocuts, lithographs, mezzotints, serigraphs and woodcuts.

Style Considers all styles.

Submissions Finds Alaskan artists through submissions and portfolio reviews every two years. Register for e-mail notification at: http://list.state.ak.us/guest/RemoteListSummary/Museum_Exhibits_Events_Calendar.

JEAN ALBANO GALLERY

215 W. Superior St., Chicago IL 60610. (312)440-0770. Fax: (312)440-3103. E-mail: jeanalbano@aol.com. Website: jeanalbano-artgallery.com. **Director:** Jean Albano Broday. Retail gallery. Estab. 1985. Represents 24 mid-career artists. Somewhat interested in seeing the work of emerging artists. Exhibited artists include Martin Facey and Jim Waid. Average display time 5 weeks. Open all year. Located downtown in River North gallery district; 1,600 sq. ft. 60% of space for special exhibitions; 40% of space for gallery artists. Clientele 80% private collectors, 20% corporate collectors. Overall price range $1,000-20,000; most work sold at $2,500-6,000.

Media Considers oil, acrylic, sculpture and mixed media. Most frequently exhibits mixed media, oil and acrylic. Prefers nonrepresentational, nonfigurative and abstract styles.

Terms Accepts artwork on consignment (50% commission). Retail price set by gallery and artist; shipping costs are shared.

Submissions Send query letter with résumé, bio, SASE and well-labeled slides "size, name, title, medium, top, etc." Write for appointment to show portfolio. Responds in 6 weeks. "If interested, gallery will file bio/résumé and selected slides."

Tips "We look for artists whose work has a special dimension in whatever medium. We are interested in unusual materials and unique techniques."

THE ALBUQUERQUE MUSEUM OF ART & HISTORY

2000 Mountain Rd. NW, Albuquerque NM 87104. (505)243-7255. E-mail: dfairfield@ cabq.gov. Website: www.cabq.gov/museum. **Curator of Art:** Douglas Fairfield. Nonprofit museum. Estab. 1967. Sponsors 7-10 exhibits/year. Average display time: 3-4 months. Open Tuesday-Sunday, 9-5. Closed Mondays and city holidays. Located in Old Town, west of downtown.

Style Mission is to collect, promote, and showcase art and artifacts from Albuquerque, the state of New Mexico, and the Southwest. Sponsors mainly group shows and work from the permanent collection.

Submissions Artists may send portfolio for exhibition consideration: slides, photos, disk, artist statement, résumé, SASE.

ALEX GALLERY

2106 R St. NW, Washington DC 20008. (202)667-2599. E-mail: alexgallerydc@gmail. com. Website: www.alexgalleries.com. **Contact:** Victor Gaetan. Retail gallery and art consultancy. Estab. 1986. Represents 20 emerging and mid-career artists. Exhibited artists include Willem de Looper, Gunter Grass and Olivier Debre. Sponsors 8 shows/ year. Average display time: 1 month. Open all year. Located in the heart of a "gallery" neighborhood; "two floors of beautiful turn-of-the-century townhouse; a lot of exhibit space." Clientele: diverse; international and local. 50% private collectors; 50% corporate collectors. Overall price range: $1,500-60,000.

Media Considers oil, acrylic, watercolor, pastel, mixed media, collage, sculpture, photography, original handpulled prints, lithographs, linocuts and etchings. Most frequently exhibits painting, sculpture and works on paper.

Style Exhibits expressionism, abstraction, color field, impressionism and realism; all genres. Prefers abstract and figurative work.

Terms Accepts artwork on consignment. Retail price set by gallery and artist. Gallery provides insurance, promotion and contract; shipping costs are shared.

Submissions Send query letter with résumé, slides, bio, SASE and artist's statement. Write for appointment to show portfolio, which should include slides and transparencies. Responds in 2 months.

Ⓝ ALL AMZIE ALL THE TIME

830 & 832 Royal St, New Orleans LA 70116.(504)701-8852. E-mail: insleyartgallery@aol.com. Website: www.neworleansinsleyart.com; www.allamzieallthetime.com. **Director**: Charlene Insley. Estab. 2008.

Media All kinds of artwork considered. Approached by hundreds of artists, potentially represent tens in special exhibits. Work should be prepared and ready for display.

Style Exhibit paintings by Mr. Amzie Adams, artist and celebrity of New Orleans. Also carry paintings "with portals" by Charlene Insley and special exhibits by visiting artists presenting artworks of and about Amzie Adams or special subjects for specific shows.

Terms Represent only local artists. Work accepted is on consignment. Visiting artist sets his/her price and other terms are worked out individually.

Submissions Contact us by E-mail or come on in and visit.

CHARLES ALLIS ART MUSEUM

1801 N. Prospect Ave., Milwaukee WI 53202. (414)278-8295. Fax: (414)278-0335. E-mail: mcostello@cavtmuseums.org . Website: http://cavtmuseums.org/ca/home.html. **Manager of Exhibitions & Collections:** Maria Costello. Museum. Estab. 1947. Approached by 20 artists/year. Represents 6 emerging, mid-career and established artists that have lived or studied in Wisconsin. Exhibited artists include Anne Miotke (watercolor); Evelyn Patricia Terry (pastel, acrylic, multi-media). Sponsors 6-8 exhibits/year. Average display time: 2 months. Open all year; Wednesday-Sunday, 1-5. Located in an urban area, historical home, 3 galleries. Clients include local community, students and tourists. 10% of sales are to corporate collectors. Overall price range: $200-6,000; most work sold at $300.

Media Considers acrylic, collage, drawing, installation, mixed media, oil, pastel, pen & ink, sculpture, watercolor and photography. Print types include engravings, etchings, linocuts, lithographs, serigraphs and woodcuts. Most frequently exhibits acrylic, oil and watercolor.

Style Considers all styles and genres. Most frequently exhibits realism, impressionism and minimalism.

Terms Artwork is accepted on consignment. Artwork can be purchased during run of an exhibition. There is a 30% commission. Retail price set by the artist. Museum provides insurance, promotion and contract. Accepted work should be framed. Does not require exclusive representation locally. Accepts only artists from or with a connection to Wisconsin.

Submissions Send query letter with artist's statement, bio, business card, résumé, reviews, SASE and slides. Material is returned if the artist is not chosen for exhibition. Responds to queries in 1 year. Finds artists through art exhibits, referrals by other artists, submissions and word of mouth.

Tips "All materials should be typed. Slides should be labeled and accompanied by a complete checklist."

ALVA GALLERY

54 State St., New London CT 06320. (860)437-8664. Fax: (860)437-8665. E-mail: Alva@Alvagallery.com. Website: www.alvagallery.com. For-profit gallery. Estab. 1999. Approached by 50 artists/year. Represents 30 emerging, mid-career and established artists. Exhibited artists include Maureen McCabe (assemblage), Sol LeWitt (gouaches) and Judith Cotton (paintings). Average display time: 6 weeks. Open all year; Tuesday-Saturday, 11-5. Closed between Christmas and New Year and last 2 weeks of August. Clients include local community, tourists and upscale. 5% of sales are to corporate collectors. Overall price range: $250-10,000; most work sold at $1,500.

Media Considers acrylic, collage, drawing, fiber, glass, mixed media, oil, paper, pastel, pen & ink, sculpture and watercolor. Most frequently exhibits oil, photography and mixed media. Considers all types of prints.

Style Considers all styles and genres.

Terms Artwork is accepted on consignment, and there is a 50% commission. Retail price set by the artist. Gallery provides insurance and promotion. Does not require exclusive representation locally.

Submissions Mail portfolio for review. Responds in 2 months. Finds artists through word of mouth, portfolio reviews and referrals by other artists.

THE AMERICAN ART COMPANY

1126 Broadway Plaza, Tacoma WA 98402. (253)272-4327. E-mail: craig@americanartco. com. Website: www.americanartco.com. **Director:** Craig Radford. Retail gallery. Estab. 1889. Represents/exhibits 150 emerging, mid-career and established artists/ year. Exhibited artists include Art Hansen, Michael Ferguson, Danielle Desplan, Doug Granum, Oleg Koulikov, Yoko Hara and Warren Pope. Sponsors 10 shows/year. Open all year; Tuesday-Friday, 10-5:30; Saturday, 10-5. Located downtown; 3,500 sq. ft. 60% of space for special exhibitions; 40% of space for gallery artists. Clientele: local community. 90% private collectors, 10% corporate collectors. Overall price range: $500-15,000; most work sold at $1,800.

Media Considers oil, fiber, acrylic, sculpture, glass, watercolor, mixed media, quilt art, pastel, collage, woodcuts, wood engravings, linocuts, engravings, mezzotints, etchings, lithographs, serigraphs, contemporary baskets, contemporary sculptural wood. Most frequently exhibits contemporary wood sculpture and original paintings.

Style Exhibits all styles. Genres include landscapes, Chinese and Japanese.

Terms Artwork is accepted on consignment (50% commission) or bought outright for 50% of retail price; net 30 days. Retail price set by the gallery and the artist. Gallery provides insurance and promotion; shipping costs are shared. Prefers artwork unframed.

Submissions Send query letter with résumé, slides, bio and SASE. Write for

appointment to show portfolio of slides. Responds in 3 weeks. Finds artists through word of mouth, referrals by other artists, visiting art fairs and exhibitions, submissions.

AMERICAN PRINT ALLIANCE

302 Larkspur Turn, Peachtree City GA 30269-2210. E-mail: director@printalliance.org. Website: www.printalliance.org. **Director:** Carol Pulin. Nonprofit arts organization with online gallery and exhibitions, travelling exhibitions, and journal publication; Print Bin: a place on website that is like the unframed, shrink-wrapped prints in a bricks-and-mortar gallery's "print bin." Estab. 1992. Approached by hundreds of artists/year; represents dozens of artists/year. "We only exhibit original prints, artists' books and paperworks." Usually sponsors 2 travelling exhibits/year—all prints, paperworks and artists' books. Most exhibits travel for 2 years. Hours depend on the host gallery/museum/arts center. "We travel exhibits throughout the U.S. and occasionally to Canada." Overall price range for Print Bin: $150-3,200; most work sold at $300-500.

Media Considers and exhibits original prints, paperworks, artists' books. Also all original prints including any combination of printmaking techniques; no reproductions/posters.

Style Considers all styles, genres and subjects; the decisions are made on quality of work.

Terms Individual subscription: $30-37. Print Bin is free with subscription. "Subscribers have free entry to juried travelling exhibitions but must pay for framing and shipping to and from our office." Gallery provides promotion.

Submissions Subscribe to journal, *Contemporary Impressions* (www.printalliance. org/alliance/al_ subform.html). Send one slide and signed permission form (www. printalliance.org/gallery/ printbin_info.html). Returns slide if requested with SASE. Usually does not respond to queries from non-subscribers. Files slides and permission forms. Finds artists through submissions to the gallery or Print Bin, and especially portfolio reviews at printmakers conferences. "Unfortunately, we don't have the staff for individual portfolio reviews, though we may—and often do—request additional images after seeing one work, often for journal articles. Generally about 100 images are reproduced per year in the journal."

Tips "See the Standard Forms area of our website (www.printalliance.org/library/ li_forms.html) for correct labels on slides and much, much more about professional presentation."

AMERICAN SOCIETY OF ARTISTS, INC.

P.O. Box 1326, Palatine IL 60078. (847)991-4748 or (312)751-2500. E-mail: asoa@webtv. net. Website: www.americansocietyofartists.org. **Membership Chair:** Helen Del Valle.

Terms Members and nonmembers may exhibit. "Our members range from internationally known artists to unknown artists—quality of work is the important factor." Accepted work should be framed, mounted or matted.

Submissions To jury on line (only at asoaartists@aol.com) submit four images of your work- resume/show listing helpful or send SASE and 4 slides/photographs that represent your work; request membership information and application. Responds in 2 weeks. Accepted members may participate in lecture and demonstration service. Member publication: *ASA Artisan.*

THE ANN ARBOR CENTER/GALLERY SHOP

117 W. Liberty, Ann Arbor MI 48104. (734)994-8004. Fax: (734)994-3610. E-mail: info@annarborartcenter.org. Website: www.annarborartcenter.org. **Gallery Shop Director:** Terry Browning, Shop Assistant Director: Cindy Marr. Estab. 1978. Represents over 350 artists, primarily Michigan and regional. Gallery Shop purchases support the Art Center's community outreach programs.

• The Ann Arbor Art Center also has exhibition opportunities for Michigan artists in its Exhibition Gallery and Art Consulting Program.

Media Considers original work in virtually all 2- and 3-dimensional media, including jewelry, prints and etchings, ceramics, glass, fiber, wood, photography and painting.

Style The gallery specializes in well-crafted and accessible artwork. Many different styles are represented, including innovative contemporary.

Terms Accepts work on consignment. Retail price set by artist. Offers member discounts and payment by installments. Exclusive area representation not required. Gallery provides contract; artist pays for shipping.

Submissions "The Art Center seeks out artists through the exhibition visitation, wholesale and retail craft shows, networking with graduate and undergraduate schools, word of mouth, in addition to artist referral and submissions."

A.R.C. GALLERY/EDUCATIONAL FOUNDATION

832 W. Superior St., #204, Chicago, IL 60622. (312)733-2787. E-mail: info@arcgallery.org. Website: www.arcgallery.org. **President:** Patricia Otto. Nonprofit gallery. Estab. 1973. Exhibits emerging, mid-career and established artists. 21 members review work for solo and group shows on an ongoing basis. Visit website for prospectus. Exhibited artists include Miriam Schapiro. Average display time: 1 month. Located in the West Town Neighborhood; 1,600 sq. ft. Clientele: 80% private collectors, 20% corporate collectors. Overall price range: $50-40,000; most work sold at $200-4,000.

Media Considers all media. Most frequently exhibits painting, sculpture (installation) and photography.

Style Exhibits all styles and genres. Prefers postmodern and contemporary work.

Terms There is a rental fee for space. Rental fee covers 1 month. No commission taken on sales. Gallery provides promotion; artist pays shipping costs. Prefers framed artwork.

Submissions See website (www.arcgallery.org/invitationals.html) for info or send e-mail query. Reviews are ongoing. Call for deadlines. Slides or digital images are accepted.

ARIZONA STATE UNIVERSITY ART MUSEUM

ASU Art Museum, P.O. Box 87291, Tempe AZ 85287-2911. (480)965-2787. Fax: (480)965-5254. Website: asuartmuseum.asu.edu. **Director:** Marilyn Zeitlin. Estab. 1950. Presents mid-career, established and emerging artists. Sponsors 12 shows/year. Average display time 2 months. Open all year; Tuesday, 10-9 (school year); Tuesday, 10-5 (summer); Wednesday-Saturday, 10-5; Closed Sunday, Monday and Holidays. Located downtown Tempe ASU campus. Nelson Fine Arts Center features award-winning architecture, designed by Antoine Predock. "The Ceramics Research Center, located just next to the main museum, features open storage of our 3,000 works plus collection and rotating exhibitions. The museum also presents an annual short film and video festival."

Media Considers all media. Greatest interests are contemporary art, crafts, video, and work by Latin American and Latin artists.

Submissions "Interested artists should submit slides to the director or curators."

Tips "With the University cutbacks, the museum has scaled back the number of exhibitions and extended the average show's length. We are always looking for exciting exhibitions that are also inexpensive to mount."

ARKANSAS STATE UNIVERSITY FINE ARTS CENTER GALLERY

P.O. Drawer 1920, State University AR 72467. (870)972-3050. E-mail: csteele@astate. edu. Website: http://finearts.astate.edu/art/art.html. **Chair, Department of Art:** Curtis Steele. University Art Department Gallery. Estab. 1968. Represents/exhibits 3-4 emerging, mid-career and established artists/year. Sponsors 3-4 shows/year. Average display time 1 month. Open fall, winter and spring; Monday-Friday, 10-4. Located on university campus; 1,600 sq. ft.; 60% of time devoted to special exhibitions; 40% to faculty and student work. Clientele: students/community.

Media Considers all media. Considers all types of prints. Most frequently exhibits painting, sculpture and photography.

Style Exhibits conceptualism, photorealism, neo-expressionism, minimalism, hard-edge geometric abstraction, painterly abstraction, postmodern works, realism, impressionism and pop. "No preference except quality and creativity."

Terms Exhibition space only; artist responsible for sales. Retail price set by the artist. Gallery provides insurance, promotion and contract; shipping costs are shared. Prefers artwork framed.

Submissions Send query letter with résumé, CD/DVD and SASE. Portfolio should be submitted on cd/dvd only. Responds only if interested within 2 months. Files résumé. Finds artists through call for artists published in regional and national art journals.

Tips "Show us 20 digital images of your best work. Don't overload us with lots of collateral materials (reprints of reviews, articles, etc.). Make your vita as clear as possible."

ARNOLD ART

210 Thames, Newport RI 02840. (401)847-2273. (401)848-0156. E-mail: info@ arnoldart.com. Website: www.arnoldart.com. **President:** William Rommel. Retail gallery. Estab. 1870. Represents 40 emerging, mid-career and established artists. Exhibited artists include John Mecray, Willard Bond. Sponsors 4 exhibits/year. Average display time: 1 month. Open Monday-Saturday, 9:30-5:30; Sunday, 12-5. Clientele: local community, students, tourists and Newport collectors. 1% of sales are to corporate clients. Overall price range: $100-35,000; most work sold at $600.

Media Considers oil, acrylic, watercolor, pastel, pen & ink, drawings, mixed media. Most frequently exhibits oil and watercolor.

Style Genres include marine sailing, classic yachts, America's cup, yachting/sailing.

Terms Accepts work on consignment (40% commission). Retail price set by artist. Exclusive area representation not required. Gallery provides promotion.

Submissions Send e-mail. Call or e-mail for appointment to show portfolio of originals. Returns materials with SASE.

Tips To make your submissions professional you must "Frame them well."

THE ARSENAL GALLERY

The Arsenal Bldg., Central Park, 830 Fifth Ave., New York NY 10065. (212)360-8163. Fax: (212)360-1329. E-mail: adrian.sas@parks.nyc.gov. Website: www.nyc.gov/ parks. **Public Art Curator:** Adrian Sas. Nonprofit gallery. Estab. 1971. Approached by 100 artists/year. Exhibits 8 emerging, mid-career and established artists. Sponsors 10 exhibits/year. Average display time 1 month. Open all year; Monday-Friday, 9-5. Closed holidays and weekends. 100 linear feet of wall space on the 3rd floor of the Administrative Headquarters of the Parks Department located in Central Park. Clients include local community, students, tourists and upscale. Overall price range $100-1,000.

Media Considers all media and all types of prints except 3-dimensional work.

Style Considers all styles. Genres include florals, landscapes and wildlife.

Terms Artwork is accepted on consignment and there is a 15% commission. Retail price set by the artist. Gallery provides promotion. Does not require exclusive representation locally.

Submissions Mail portfolio for review. Send query letter with artist's statement, bio, brochure, business card, photocopies, résumé, reviews and SASE. Returns material with SASE. Responds only if interested within 6 months. Files résumé and photocopies. Finds artists through word of mouth, portfolio reviews, art exhibits and referrals by other artists.

Tips Appear organized and professional.

🌐 ART@NET INTERNATIONAL GALLERY

E-mail: artnetg@yahoo.com. Website: www.designbg.com. **Director:** Yavor Shopov. For-profit Internet gallery. Estab. 1998. Approached by 150 artists/year. Represents 20 emerging, mid-career and established artists. Exhibited artists include Nicolas Roerich (paintings) and Yavor Shopov (photography). Sponsors 15 exhibits/year. Average display time: permanent. Open all year; Monday-Sunday, 24 hours. "Internet galleries like ours have a number of unbelievable advantages over physical galleries and work far more efficiently, so they are expanding extremely rapidly and taking over many markets held by conventional galleries for many years. Our gallery exists only online, giving us a number of advantages both for our clients and artists. Our expenses are reduced to the absolute minimum, so we charge our artists lowest commission in the branch (only 10%) and offer to our clients lowest prices for the same quality of work. Unlike physical galleries, we have over 100 million potential Internet clients worldwide and are able to sell in over 150 countries without need to support offices or representatives everywhere. We mount cohesive shows of our artists, which are unlimited in size and may be permanent. Each artist has individual 'exhibition space' divided to separate thematic exhibitions along with bio and statement. We are just hosted in the Internet space, otherwise our organization is the same as of a traditional gallery." Clients include collectors and business offices worldwide; 30% corporate collectors. Overall price range: $150-50,000.

Media Considers ceramics, crafts, drawing, oil, pastel, pen & ink, sculpture and watercolor. Most frequently exhibits photos, oil and drawing. Considers all types of prints.

Style Considers expressionism, geometric abstraction, impressionism and surrealism. Most frequently exhibits impressionism, expressionism and surrealism. Also considers Americana, figurative work, florals, landscapes and wildlife.

Terms Artwork is accepted on consignment, and there is a 10% commission and a rental fee for space of $1/image per month or $5/image per year (first 6 images are displayed free of rental fee). Retail price set by the gallery or the artist. Gallery provides promotion. Accepted work should be matted. Does not require exclusive representation locally. "Every exhibited image will contain your name and copyright as watermark and cannot be printed or illegally used, sold or distributed anywhere."

Submissions E-mail portfolio for review. E-mail attached scans of 900 × 1200 pixels (300 dpi for prints or 900 dpi for 36mm slides) as JPEG files for IBM computers.

"We accept only computer scans; no slides, please." E-mail artist's statement, bio, résumé, and scans of the work. Cannot return material. Responds in 6 weeks. Finds artists through submissions, portfolio reviews, art exhibits, art fairs, and referrals by other artists.

Tips "E-mail us or send a disk or CD with a tightly edited selection of less than 20 scans of your best work. All work must be very appealing and interesting, and must force any person to look over it again and again. Main usage of all works exhibited in our gallery is for limited edition (photos) or original (paintings) wall decoration of offices and homes. Photos must have the quality of paintings. We like to see strong artistic sense of mood, composition, light and color, and strong graphic impact or expression of emotions. We exhibit only artistically perfect work in which value will last for decades. We would like to see any quality work facing these requirements on any media, subject or style. No distractive subjects. For us only quality of work is important, so new artists are welcome. Before you send us your work, ask yourself, 'Who and why will someone buy this work? Is it appropriate and good enough for this purpose?' During the exhibition, all photos must be available in signed limited edition museum quality 8 × 10 or larger matted prints."

ART ENCOUNTER

5720 S. Arville St., Suit 119, Las Vegas NV 89118. (702)227-0220. Fax: (702)227-3353. E-mail: rod@artencounter.com. Website: www.artencounter.com. **Director of Artist Relations:** Sharon Darcy. Gallery Director: Rod Maly. Retail gallery. Estab. 1992. Represents 100 emerging and established artists/year. Exhibited artists include Jennifer Main, Jan Harrison and Vance Larson. Sponsors 4 shows/year. Open all year; Tuesday-Friday, 10-6; Saturday and Monday, 12-5. Located near the famous Las Vegas strip; 13,000 sq. ft. Clients include upscale tourists, locals, designers and casino purchasing agents. 95% of sales are to private collectors, 5% corporate collectors. Overall price range: $200-20,000; most work sold at $500-2,500.

Media Considers all media and all types of prints. Most frequently exhibits watercolor, oil, acrylic, and sculpture.

Style Exhibits all styles and genres.

Terms Rental fee for space; covers 6 months. Retail price set by the gallery and artist. Gallery provides promotion and contract; artist pays for shipping. Prefers artwork framed.

Submissions E-mail JPEGs or mail photographs and SASE. Appointments will be scheduled according to selection of juried artists. Responds within 2 weeks, only if interested. Files artist bios and résumés. Finds artists by advertising in *The Artist's Magazine* and *American Artist*, art shows and word of mouth.

Tips "Poor visuals, attempted walk-in without appointment, and no SASE are common mistakes."

THE ART EXCHANGE

17 East Brickel Street., Columbus OH 43215. (614)464-4611. Fax: (614)464-4619. E-mail: kristin@theartexchangeltd.com. Website: www.theartexchangeltd.com. **Principal:** Kristin Meyer. Art consultancy. Estab. 1978. Represents 150+ emerging, mid-career and established artists/year. Exhibited artists include LaVon Van Williams, Frank Hunter, Mary Beam and Carl Krabill. Open all year; Monday-Friday, 9-5. Located downtown in the historic Short North Arts Distirct neighborhood; 2,000 sq. ft. 100% of space for gallery artists. Clientele: corporate leaders; 20% private collectors; 80% corporate collectors. "We work directly with interior designers and architects." Overall price range: $150-8,000; most work sold at $1,000-4,000.

Media Considers oil, acrylic, watercolor, pastel, mixed media, collage, sculpture, ceramics, fiber, glass, photography and all types of prints. Most frequently exhibits oil, acrylic, watercolor.

Style Exhibits painterly abstraction, urban landscapes, impressionism, realism, folk art. Genres include florals and landscapes. Prefers impressionism, painterly abstraction, urban landscapes, realism.

Terms Accepts work on consignment. Retail price set by the gallery and the artist.

Submissions Send query letter or e-mail with résumé and CD, slides or photographs. Write for appointment to show portfolio. Responds in 2 weeks. Files CD, slides or photos and artist information. Finds artists through word of mouth, referrals by other artists, visiting art fairs and exhibitions, submissions.

Tips "Our focus is to provide high-quality artwork and consulting services to the corporate, design and architectural communities. Our works are represented in corporate offices, healthcare facilities, hotels, restaurants and private collections throughout the country."

ART GUILD OF BURLINGTON/THE ARTS FOR LIVING CENTER

620 Washington, Burlington IA 52601-5145. Fax: (319)754-4731. E-mail: arts4living@ aol.com. Website: www.artguildofburlington.org. **Executive Director:** Ann Distelhorst. Nonprofit gallery. Estab. 1974. Exhibits the work of mid-career and established artists. May consider emerging artists. Sponsors 10 shows/year. Average display time 3 weeks. Open all year; Tuesday-Saturday, 12-6,. Located in Heritage Hill Historic District, near downtown; 2,500 sq. ft.; In former 1868 German Methodist church. 35% of space for special exhibitions. Overall price range $25-1,000; most work sold at $75-500.

Media Considers all visual media. Most frequently exhibits two-dimensional work.

Style Exhibits all styles.

Terms Accepts work on consignment (25% commission). Retail price set by artist. Gallery provides insurance, promotion and contract; artist pays for shipping. Prefers artwork framed.

Submissions Send query letter with résumé, slides, bio, brochure, photographs, SASE and reviews.

ARTISTS' COOPERATIVE GALLERY

405 S. 11th St., Omaha NE 68102. (402)342-9617. Website: www.artistsco-opgallery. com. Estab. 1974. Sponsors 11 exhibits/year. Average display time: 1 month. Gallery sponsors all-member exhibits and outreach exhibits; individual artists sponsor their own small group exhibits throughout the year. Overall price range: $100-500.

Media Considers oil, acrylic, watercolor, pastel, drawings, mixed media, collage, paper, sculpture, ceramic, fiber, glass, photography, woodcuts, serigraphs. Most frequently exhibits sculpture, acrylic, oil and ceramic.

Style Exhibits all styles and genres.

Terms Charges no commission. Reviews transparencies. Accepted work should be framed work only. "Artist must be willing to work 13 days per year at the gallery. We are a member-owned-and-operated cooperative. Artist must also serve on one committee."

Submissions Send query letter with résumé, SASE. Responds in 2 months.

Tips "Write for membership application. Membership committee screens applicants August 1-15 each year. Responds by September 1. New membership year begins October 1. Members must pay annual fee of $325. Our community outreach exhibits include local high school photographers and art from local elementary schools."

ARTLINK

437 E. Berry St., Suite 202, Fort Wayne IN 46802-2801. (219)424-7195. Fax: (219)424-8453. E-mail: submissions@artlinkfw.com. Website: www.artlinkfw.com. **Executive Director:** Deb Washler. Nonprofit gallery. Estab. 1979. Exhibits emerging and mid-career artists. 670 members. Sponsors 18 shows/year, 2 galleries. Average display time 5-6 weeks. Open all year. Located in downtown Fort Wayne, 2 blocks from art museum and Arts United Center; in same building as a Fort Wayne Cinema Center, Fort Wayne Dance Collective and ARCH; 1,600 sq. ft. 100% of space for special exhibitions. Overall price range $100-500; most artwork sold at $200.

- Publishes a quarterly newsletter, *Genre*, which is distributed to members. Includes features about upcoming shows, profiles of members and other news. Some artwork shown at gallery is reproduced in b&w in newsletter. Send SASE for sample and membership information.

Media Considers all media, including prints. Prefers work for annual print show and annual photo show, sculpture and painting.

Style Contemporary art form emerging and mid-career artists.

Terms 35% commission on works sold, work is insured while in the gallery and artists are responsible for shipping, work must be framed.

Submissions Please view the web site, www.artlinkfw.com to view our upcoming calls for entry. Please do not send unsolicited portfolios.

Tips Thoroughly review or organizations web site and then call the gallery with further inquiries.

THE ARTS COMPANY

215 Fifth Ave., Nashville TN 37219. (615)254-2040. Fax: (615)254-9289. E-mail: art@ theartscompany.com. Website: www.theartscompany.com. **Owner:** Anne Brown. Art consultancy, for-profit gallery. Estab. 1996. Over 6,000 sq. ft. of gallery space on 2 floors. Overall price range: $10-35,000; most work sold at $300-3,000.

Media Considers all media. Most frequently exhibits painting, photography and sculpture.

Style Exhibits all styles and genres. Frequently exhibits contemporary outsider art.

Terms Artwork is accepted on consignment. Gallery provides insurance and contract. Accepted work should be framed. Requires exclusive representation locally.

Submissions "We prefer an initial info packet via e-mail." Send query letter with artist's statement, bio, brochure, business card, photocopies, résumé, reviews, SASE, CD. Returns material with SASE. Finds artists through word of mouth, art fairs/ exhibits, submissions, referrals by other artists.

Tips "Provide professional images on a CD along with a professional bio, résumé."

ARTS IOWA CITY

103 E. College St., Iowa City IA 52240. (319)337-7447. E-mail: members@artsiowacity. com. Website: www.artsiowacity.com. **Gallery director:** Elise Kendrot. Nonprofit gallery. Estab. 1975. Approached by 65± artists/year. Represents 30± emerging, mid-career and established artists. Sponsors 11 exhibits/year. Average display time 1 month. Open all year; Monday-Friday, 11 to 6; weekends, 12-4. Several locations include: AIC Center & Gallery—129 E. Washington St.; Starbucks Downtown Iowa City; Melrose Meadows Retirement Community in Iowa City; Englert Civic Theatre Gallery, Iowa City. Satellite Galleries: local storefronts, locations vary. Clients include local community, students and tourists. 10% of sales are to corporate collectors. Overall price range $200-6,000; most work sold at $500.

Media Considers all media, types of prints, and all genres. Most frequently exhibits painting, drawing and mixed media.

Terms Artwork is accepted on consignment and there is a 50% commission. Retail price set by the artist. Gallery provides insurance (in gallery, not during transit to/ from gallery), promotion and contract. Accepted work should be framed, mounted and matted. Does not require exclusive representation locally.

Submissions "We represent artists who are members of Arts Iowa City; to be a member one must pay a membership fee. Most people are from Iowa and surrounding states." Call or write to arrange personal interview to show portfolio of photographs, slides and transparencies. Send query letter with artist's statement, bio, brochure, business card, photographs, résumé, reviews, SASE and slides. Returns material with SASE. Responds to queries in 1 month. Files printed material and CDs. Slides sent back to artist after review. Finds artists through referrals by other artists, submissions and word of mouth.

Tips "We are a nonprofit gallery with limited staff. Most work is done by volunteers. Artists interested in submitting work should visit our website at www.artsiowacity. com to gain a better understanding of the services we provide and to obtain membership and show proposal information. Please submit applications according to the guidelines on the website."

ARTS ON DOUGLAS

123 Douglas St., New Smyrna Beach FL 32168. (386)428-1133. Fax: (386)328-5008. E-mail: mail@artsondouglas.net. Website: www.artsondouglas.net. **Gallery Director:** Meghan Martin. For-profit gallery. Estab. 1996. Represents 56 professional Florida artists and exhibits 12 established artists/year. Average display time: 1 month. Open all year; Tuesday-Friday, 11-6; Saturday, 10-2. 5,000 sq. ft. of exhibition space. Clients include local community, tourists and upscale. Overall price range varies.

Media Considers all media except installation.

Style Considers all styles and genres.

Terms Artwork is accepted on consignment (50% commission). Retail price set by the artist. Gallery provides insurance and promotion. Accepted work should be framed. Requires exclusive representation locally. Accepts only professional artists from Florida.

Submissions Returns material with SASE. Files slides, bio and résumé. Artists may want to call gallery prior to sending submission package—not always accepting new artists.

Tips "We want current bodies of work—please send slides of what you're presently working on."

ART SOURCE L.A., INC.

2801 Ocean Park Blvd., #7, Santa Monica CA 90405. (310)452-4411. Fax: (310)452-0300. E-mail: info@artsourcela.com. Website: www.artsourcela.com. **Artist Liason:** Dina Dalby. Estab. 1980. Submission guidelines available on website.

• See additional listing in the Artists' Reps section.

Media Considers fine art in all media, including works on paper/canvas, sculpture, giclée and a broad array of accessories handmade by American artists. Considers all types of prints.

Terms Artwork is accepted on consignment (50% commission). No geographic restrictions.

Submissions "Send minimum of 20 slides or photographs (laser copies are not acceptable) clearly labeled with your name, title and date of work, size and medium. Catalogs and brochures of your work are welcome. Also include a résumé, price list and SASE. We will not respond without a return envelope." Also accepts e-mail submissions. Responds in 6-8 weeks. Finds artists through art fairs/exhibitions, submissions, referrals by other artists, portfolio reviews and word of mouth.

Tips "Be professional when submitting visuals. Remember, first impressions can be critical! Submit a body of work that is consistent and of the highest quality. Work should be in excellent condition and already photographed for your records. Framing does not enhance presentation to the client."

ART WITHOUT WALLS, INC.

P.O. Box 341, Sayville NY 11782. Phone/fax: (631)567-9418. E-mail: artwithoutwalls@ webtv.net. **Executive Director:** Sharon Lippman. Nonprofit gallery. Estab. 1985. Approached by 300 artists/year. Represents 100 emerging, mid-career and established artists. Sponsors 10 exhibits/year. Average display time: 1 month. Open daily, 9-5. Closed December 22-January 5 and Easter week. Overall price range: $1,000-25,000; most work sold at $3,000-5,000.

Media Considers all media and all types of prints. Most frequently exhibits painting, sculpture and drawing.

Style Considers all styles and genres. Most frequently exhibits impressionism, expressionism, postmodernism.

Terms Artwork is accepted on consignment (20% commission). Retail price set by the artist. Gallery provides promotion and contract. Accepted work should be framed, mounted and matted.

Submissions Mail portfolio for review. Send query letter with artist's statement, brochure, photographs, résumé, reviews, SASE and slides. Returns material with SASE. Responds in 1 month. Files artist résumé, slides, photos and artist's statement. Finds artists through submissions, portfolio reviews and art exhibits.

Tips "Work should be properly framed with name, year, medium, title and size."

ARTWORKS GALLERY

811 Race St., Cincinnati OH 45202. (513)333-0388. Fax: (513)333-0799. E-mail: allen@ artworkscincinnati.com. Website: www.ArtWorksCincinnati.com. **Coordinator:** Allen Cochran. Alternative space; cooperative, nonprofit, rental gallery. Estab. 2003. Exhibits emerging, mid-career and established artists. Approached by 75-100 artists/ year; represents or exhibits 50-75 artists. Exhibited artists include Brian Joiner (painting), Tiffany Owenby (sculpture, doll art), Pam Kravetz (fiber) and Frank Herrmann (painting). Sponsors 11-12 exhibits/year. Average display time: 4 weeks or 1½ months. Open Monday-Friday, 9-5; also by appointment. "Generally we are closed during the month of January." Located in downtown Cincinnati; 1,500 sq. ft.; available for event rentals and small private parties. Clients include local community, students, tourists, upscale. 20% of sales are to corporate collectors. Overall price range: $200-15,000; most work sold at $500-1,200.

Media Considers all media. Most frequently exhibits painting, drawing and small sculpture. Considers all types of prints.

Style Considers all styles and genres. Most frequently exhibits abstract, realistic and figurative work.

Terms Artwork is accepted on consignment (30% commission). Retail price set by both artist and gallery. Gallery provides promotion and contract. Accepted work should be "finished and exhibition ready. We have the right to jury the works coming into the space."

Submissions Call or mail portfolio for review. Send query letter with résumé, artist's statement, slides or digital images via CD or e-mail. Cannot return material; "We hold on to materials for future exhibition opportunities. We have many opportunities beyond just exhibiting in our gallery." Responds to queries in 3-4 weeks. Finds artists through submissions, art fairs/exhibits, portfolio reviews, art competitions, referrals by other artists, word of mouth.

Tips "ArtWorks is looking for strong artists who are not only talented in terms of their ability to make and create, but who also can professionally present themselves and show a genuine interest in the exhibition of their artwork. In regards to this, ArtWorks is looking for concise statements that the artists themselves have written about their own work, as well as résumés of exhibitions to help back up their written statements. We do ask that communication is top on the list. Artists and interested parties should continue to communicate with us beyond exhibitions and further down the line just to let us know what they're up to or how they've grown."

ATLANTIC CENTER FOR THE ARTS, INC.

1414 Arts Center Ave., New Smyrna Beach FL 32168. (386)427-6975. Fax: (386)427-5669. E-mail: program@atlanticcenterforthearts.org. Website: www. atlanticcenterforthearts.org. Nonprofit interdisciplinary, international artists-in-residence program. Estab. 1977. Sponsors 5-6 residencies/year. Located on secluded bayfront3½ miles from downtown.

- This location accepts applications for residencies only, but they also run Harris House of Atlantic Center for the Arts, which accepts Florida artists only for exhibition opportunities. Harris House is located at 214 S. Riverside Dr., New Smyrna Beach FL 32168. (386)423-1753.

Media Most frequently exhibits paintings/drawings/prints, video installations, sculpture, photographs.

Style Contemporary.

Terms Call Harris House for more information.

Submissions Call Harris House for more information.

ATLANTIC GALLERY

135 W. 29th, Suite 601, New York NY 10001. (212)219-3183. Website: www. atlanticgallery.org. Cooperative gallery. **President:** Pamela Talese. Estab. 1974. Approached by 50 artists/year. Represents 40 emerging, mid-career and established artists. Exhibited artists include Carol Hamann (watercolor); Sally Brody (oil, acrylic);

Richard Lincoln (oil). Average display time 3 weeks. Open Tuesday-Saturday, 12-6. Closed August. Located in Soho. Has kitchenette. Clients include local community, tourists and upscale. 2% of sales are to corporate collectors. Overall price range $100-13,000; most work sold at $1,500-5,000.

Media Considers all media. Considers all types of prints. Most frequently exhibits watercolor, acrylic and oil.

Style Considers all styles and genres. Most frequently exhibits impressionism, realism, imagism.

Terms Artwork is accepted on consignment and there is a 20% commission. There is a co-op membership fee plus a donation of time. There is a 10% commission. Rental fee for space covers 3 weeks. Retail price set by the artist. Gallery provides promotion and contract. Accepted work should be framed. Does not require exclusive representation locally. Prefers only East Coast artists.

Submissions Call or write to arrange a personal interview to show portfolio of slides. Send query letter with artist's statement, bio, brochure, SASE and slides. Returns material with SASE. Responds in 2 weeks. Files only accepted work. Finds artists through word of mouth, submissions, art exhibits and referrals by other artists.

Tips Submit an organized folder with slides, bio, and 3 pieces of actual work; if we respond with interest, we then review again.

AUSTIN MUSEUM OF ART

823 Congress Ave., Austin TX 78701 (512)495-9224. E-mail: info@amoa.org. Website: www.amoa.org. **Director:** Elizabeth Ferrer. Museum. Estab. 1961. Downtown and Laguna Gloria locations. Interested in emerging, mid-career and established artists. Sponsors 2-3 solo and 6 group shows/year. Average display time 1½ months. Clientele tourists and Austin and central Texas citizens.

Media Currently exhibits 20th-21st Century art of the Americas and the Caribbean with an emphasis on two-dimensional and three-dimensional contemporary artwork to include experimental video, mixed media and outdoor site-specific installations.

Style Exhibits all styles and genres. No commercial cliched art.

Terms Retail price set by artist. Gallery provides insurance and contract; shipping costs to be determined. Exhibitions booked 2 years in advance. "We are not a commercial gallery."

Submissions Send query letter with résumé, slides and SASE attn: Artist Submission. Responds only if interested within 3 months. Files slides, résumé and bio. Material returned only when accompanied by SASE. Common mistakes artists make are "not enough information—poor slide quality, too much work covering too many changes in their development."

ALAN AVERY ART COMPANY,

formerly TRINITY GALLERY 315 E. Paces Ferry Rd., Atlanta GA 30305. (404)237-0370. Fax: (404)240-0092. E-mail: info@alanaveryartcompany.com. Website: www.alanaveryartcompany.com. **President:** Alan Avery. Retail gallery and corporate sales consultants. Estab. 1983. Represents/exhibits 67 mid-career and established artists and old masters/year. Exhibited artists include Roy Lichtenstein, Jim Dine, Robert Rauschenberg, Andy Warhol, Larry Gray, Ray Donley, Robert Marx, Lynn Davison and Russell Whiting. Sponsors 6-8 shows/year. Average display time: 6 weeks. Open all year; Tuesday-Friday, 10-6; Saturday, 11-5 and by appointment. Located mid-city; 6,700 sq. ft.; 25-year-old converted restaurant. 50-60% of space for special exhibitions; 40-50% of space for gallery artists. Clientele: upscale, local, regional, national and international. 70% private collectors, 30% corporate collectors. Overall price range: $2,500-100,000; most work sold at $2,500-5,000.

Media Considers all media and all types of prints. Most frequently exhibits painting, sculpture and work on paper.

Style Exhibits expressionism, conceptualism, color field, painterly abstraction, postmodern works, realism, impressionism and imagism. Genres include landscapes, Americana and figurative work. Prefers realism, abstract and figurative.

Terms Artwork is accepted on consignment (negotiable commission). Retail price set by gallery. Gallery pays promotion and contract. Shipping costs are shared. Prefers framed artwork.

Submissions Send query letter with résumé, at least 20 slides, bio, prices, medium, sizes and SASE. Reviews every 6 weeks. Finds artists through submissions, word of mouth and referrals by other artists.

Tips "Be as complete and professional as possible in presentation. We provide submittal process sheets listing all items needed for review. Following these sheets is important."

SARAH BAIN GALLERY

184 Center Street Promenade, Anaheim CA 92805. (714)758-0545. E-mail: info@sarahbain gallery.com. Website: www.sarahbaingallery.com. For-profit gallery. Exhibits emerging and mid-career artists. Approached by 200 artists/year; represents or exhibits 24 artists. Sponsors 12 total exhibits/year. Average display time: 1 month. Clients include local community, students, tourists and upscale. Overall price range: $700-15,000; most work sold at $4,000.

Media Considers acrylic, drawing, mixed media, oil. Most frequently exhibits drawing, mixed media, paintings in representational or figurative style.

Style Exhibits representational or figurative.

Terms Artwork is accepted on consignment. Retail price set by the gallery. Gallery provides promotion. Accepted work should be framed and mounted. Prefers only representational or figurative art.

Submissions Mail portfolio for review. Send query letter with slides. Returns material with SASE. Responds to queries in 1 month.

Tips "Show a consistent, comprehensive body of work as if it were its own show ready to be hung."

BARRON ARTS CENTER

1 Main St., Woodbridge NJ 07095. (732)634-4500. Fax: (732)634-8633. E-mail: barronarts@twp.woodbridge.nj.us. Website: www.twp.woodbridge.nj.us. **Director:** Cynthia Knight. Nonprofit gallery. Estab. 1977. Interested in emerging, mid-career and established artists. Sponsors several solo and group shows/year. Average display time is 1 month. Clients include culturally minded individuals mainly from the central New Jersey region. 80% of sales are to private collectors, 20% corporate clients. Overall price range $200-5,000. Gallery hours during exhibits: Monday-Friday 11-4; Sunday 2-4; Closed holidays.

Media Considers oil, acrylic, watercolor, pastel, pen & ink, drawings, mixed media, collage, works on paper, sculpture, ceramic, craft, fiber, glass, installation, photography, performance and original handpulled prints. Most frequently exhibits water color, oils, photography and mixed media.

Style Exhibits painterly abstraction, impressionism, photorealism, realism and surrealism. Genres include landscapes and figurative work. Prefers painterly abstraction, photorealism and realism.

Terms Accepts work on consignment. Retail price set by artist. Exclusive area representation not required. Gallery provides insurance, promotion and contract; artist pays for shipping.

Submissions Send query letter, résumé and slides. Call for appointment to show portfolio. Résumés and slides are filed.

Tips Most common mistakes artists make in presenting their work are "improper matting and framing and poor quality slides. There's a trend toward exhibition of more affordable pieces—pieces in the lower end of price range."

BARUCCI GALLERY

8101 Maryland Ave., St. Louis MO 63105. (314)727-2020. E-mail: barucci2@sbcglobal.net. Website: www.baruccigallery.com. **Owner/Director:** Shirley Taxman Schwartz. Retail gallery and art consultancy specializing in hand-blown glass by national juried artists. Estab. 1977. Represents 40 artists. Interested in emerging and established artists. Sponsors 3-4 solo and 4 group shows/year. Average display time: 6 weeks. Located in an "affluent, young area;" corner location featuring 3 large display windows. 70% private collectors, 30% corporate clients. Overall price range: $100-10,000; most work sold at $1,000.

Media Considers oil, acrylic, watercolor, pastel, collage and works on paper. Most frequently exhibits watercolor, oil, acrylic and hand-blown glass.

Style Exhibits painterly abstraction and impressionism. Currently seeking contemporary works; abstracts in acrylic and fiber; some limited edition serigraphs.
Terms Accepts work on consignment (50% commission). Retail price set by gallery or artist. Sometimes offers payment by installment. Gallery provides contract.
Submissions Send query letter with résumé, slides and SASE. Portfolio review requested if interested in artist's work. Slides, bios and brochures are filed.
Tips "More clients are requesting discounts or longer pay periods."

MARY BELL GALLERIES

311 West Superior St., Chicago IL 60610. (312)642-0202. Fax: (312)642-6672. E-mail: info@gallerykh.com. Website: www.marybell.com. **President:** Mary Bell. Retail gallery. Estab. 1975. Represents mid-career artists. Interested in seeing the work of emerging artists. Exhibited artists include Mark Dickson. Sponsors 4 shows/year. Average display time: 6 weeks. Open all year. Located downtown in gallery district; 5,000 sq. ft. 25% of space for special exhibitions. Clientele: corporations, designers and individuals. 50% private collectors, 50% corporate collectors. Overall price range: $500-15,000.
Media Considers oil, acrylic, pastel, mixed media, collage, paper, sculpture, ceramic, fiber, glass, original handpulled prints, offset reproductions, woodcuts, engravings, lithographs, pochoir, posters, wood engravings, mezzotints, serigraphs, linocuts and etchings. Most frequently exhibits canvas, unique paper and sculpture.
Style Exhibits expressionism, painterly abstraction, impressionism, realism and photorealism. Genres include landscapes and florals. Prefers abstract, realistic and impressionistic styles. Does not want "figurative or bizarre work."
Terms Accepts artwork on consignment (50% commission). Retail price set by gallery and artist. Offers customer discounts and payment by installments. Gallery provides insurance and contract; shipping costs are shared. Prefers artwork unframed.
Submissions Send query letter with slides and SASE. Portfolio review requested if interested in artist's work. Portfolio should include slides or photos.

CECELIA COKER BELL GALLERY

All mail to Larry Merriman, Coker College, 300 East College Ave., Hartsville, SC 29550. (843)383-8156. E-mail: lmerriman@pascal.coker.edu. Website: www.coker.edu/art/gallery.html for prospectus. **Director:** Larry Merriman. "A campus-located teaching gallery that exhibits a variety of media and styles to expose students and the community to the breadth of possibility for expression in art. Exhibits include regional, national and international artists with an emphasis on quality and originality. Shows include work from emerging, mid, and late career artists." Sponsors 5 solo shows/year, with a 4-week run for each show.
Media Considers all media including installation and graphic design. Most frequently

exhibits painting, photograpy, sculpture/installation and mixed media.

Style Considers all styles. Not interested in conservative/commercial art.

Terms Retail price set by artist (sales are not common). Exclusive area representation not required. Gallery provides insurance, promotion and contract; shipping costs are shared.

Submissions Send résumé, 10 slides (or JPEGs on CD), and SASE by October 27. Visits by artists are welcome; however, the exhibition committee will review and select all shows from the slides and JPEGs submitted by the artists.

BELL STUDIO

3428 N. Southport Ave., Chicago IL 60657. Website: www.bellstudio.net. **Director:** Paul Therieau. For-profit gallery. Estab. 2001. Approached by 60 artists/year; represents or exhibits 10 artists. Sponsors 10 exhibits/year. Average display time: 6 weeks. Open all year; Monday-Friday, 12-7; weekends, 12-5. Located in brick storefront with high traffic; 750 sq. ft. of exhibition space. Overall price range: $150-3,500; most work sold at $600.

Media Considers acrylic, collage, drawing, mixed media, oil, paper, pastel, pen & ink and watercolor. Considers all types of prints except posters. Most frequently exhibits watercolor, oils and photography.

Style Exhibits minimalism, postermodernism and painterly abstraction. Genres include figurative work and landscapes.

Terms Artwork is accepted on consignment (50% commission). Retail price set by the gallery. Gallery provides insurance, promotion and contract. Accepted work should be framed. Requires exclusive representation locally.

Submissions Write to arrange a personal interview to show portfolio; include bio and résumé. Responds to queries within 3 months, only if interested. Finds artists through referrals by other artists, submissions, word of mouth.

Tips "Type submission letter and include your show history, résumé and a SASE."

BENNETT GALLERIES

5308 Kingston Pike, Knoxville TN 37919. (865)584-6791. Fax: (865)588-6130. E-mail: info@bennettgalleries.com. Website: www.bennettgalleries.com. **Director:** Marga Hayes. Owner: Rick Bennett. Retail gallery. Represents emerging and established artists. Exhibited artists include Richard Jolley, Carl Sublett, Scott Duce, Andrew Saftel and Tommie Rush, Akira Blount, Scott Hill, Marga Hayes Ingram, John Boatright, Grace Ann Warn, Timothy Berry, Cheryl Warrick, Dion Zwirne. Sponsors 10 shows/year. Average display time: 1 month. Open all year; Monday-Thursday, 10-6; Friday-Saturday, 10-5:30. Located in West Knoxville. Clientele: 80% private collectors, 20% corporate collectors. Overall price range: $200-20,000; most work sold at $2,000-8,000.

Media Considers oil, acrylic, watercolor, pastel, drawing, mixed media, works on paper, sculpture, ceramic, craft, photography, glass, original handpulled prints. Most frequently exhibits painting, ceramic/clay, wood, glass and sculpture.

Style Exhibits contemporary works in abstraction, figurative, narrative, realism, contemporary landscape and still life.

Terms Accepts artwork on consignment (50% commission). Retail price set by the gallery and the artist. Sometimes offers customer discounts and payment by installments. Gallery provides insurance on works at the gallery, promotion and contract. Prefers artwork framed. Shipping to gallery to be paid by the artist.

Submissions Send query letter with résumé, no more than 10 slides, bio, photographs, SASE and reviews. Finds artists through agents, visiting exhibitions, word of mouth, various art publications, sourcebooks, submissions/self-promotions and referrals.

BENT GALLERY AND MUSEUM

117 Bent St., Box 153, Taos NM 87571. (505)758-2376. E-mail: web-dev@laplaza. org. Website: www.laplaza.org/art/museums_bent.php3. **Owner:** Tom Noeding. Retail gallery and museum. Estab. 1961. Represents 15 emerging, mid-career and established artists. Exhibited artists include E. Martin Hennings, Charles Berninghaus, C.J. Chadwell and Leal Mack. Open all year; 9-5 (summer); 10-4 (winter). Located 1 block off of the Plaza; "in the home of Charles Bent, the first territorial governor of New Mexico." 95% of sales are to private collectors, 5% corporate collectors. Overall price range $100-10,000; most work sold at $500-1,000.

Media Considers oil, acrylic, watercolor, pastel, pen & ink, drawings, sculpture, original handpulled prints, woodcuts, engravings and lithographs.

Style Exhibits impressionism and realism. Genres include traditional, landscapes, florals, southwestern and western. Prefers impressionism, landscapes and western works. "We continue to be interested in collectors' art deceased Taos artists and founders' works."

Terms Accepts work on consignment (331/3-50% commission). Retail price set by gallery and artist. Artist pays for shipping. Prefers artwork framed.

Submissions Send query letter with brochure and photographs. Write for appointment to show portfolio of originals and photographs. Responds if applicable.

Tips "It is best if the artist comes in person with examples of his or her work."

MONA BERMAN FINE ARTS

78 Lyon St., New Haven CT 06511. (203)562-4720. Fax: (203)787-6855. E-mail: info@ monabermanfinearts.com. Website: www.monabermanfinearts.com. **Director:** Mona Berman. Art consultant. Estab. 1979. Represents 100 emerging and mid-career artists. Exhibited artists include Tom Hricko, David Dunlop, Pierre Dardignac and S. Wind-Greenbaum. Sponsors 1 show/year. Open all year by appointment. Located near

downtown; 1,400 sq. ft. Clientele: 25% private collectors, 75% corporate collectors. Overall price range: $400-20,000; most artwork sold at $500-7,000.

Media Considers all media except installation. Shows very little sculpture. Considers all limited edition prints except posters and photolithography. Also considers limited and carefully selected, well-priced, high-quality digital media. Most frequently exhibits works on paper, painting, relief and ethnographic arts.

Style Exhibits most styles. Prefers abstract, landscape and transitional. Little figurative, little still life.

Terms Accepts work on consignment (50% commission; net 30 days). Retail price is set by gallery and artist. Retail prices must be consistent regardless of venue. Customer discounts and payment by installment are available. Gallery provides insurance; artist pays for shipping. Prefers artwork unframed.

Submissions Accepts digital submissions by e-mail and links to websites- please include retail prices with all inquiries; or send query letter, résumé, CD, bio, SASE, reviews and "retail price list." Portfolios are reviewed only after images have been reviewed. Responds in 1 month. Include e-mail address for faster response. CDs and supporting material returned only if SASE is included. Finds artists through word of mouth, art publications and sourcebooks, submissions and self-promotions and other professionals' recommendations.

Tips "We will not carry artists who do not maintain consistent retail pricing. We are not a gallery, although we do a few exhibits; so please do not submit if you are looking for an exhibition venue. We are primarily art consultants. We continue to be busy selling high-quality art and related services to the corporate, architectural, design and private sectors. A follow-up e-mail is preferable to a phone call."

BERTONI GALLERY

1392 Kings Hwy., Sugar Loaf NY 10981. (845)469-0993. Fax: (845)469-6808. E-mail: bertoni@optonline.net. Website: www.bertonigallery.com. **Owner:** Rachel Bertoni. For-profit gallery, rental gallery, art consultancy. Estab. 2000. Exhibits emerging, mid-career and established artists. Approached by 15 artists/year; represents 5 artists/year. Exhibited artists include Mae Bertoni (watercolor) and Mike Jarosko (oil). Sponsors 5 exhibits/year. Average display time: 2 months. Open Thursday-Sunday, 11-6. Clients include local community, tourists. 10% of sales are to corporate collectors. Overall price range: $100-1,500; most work sold at $400.

Media Considers all media. Most frequently exhibits watercolor, oil, mixed media. Considers all types of prints

Style Exhibits all styles and genres.

Terms Artwork is accepted on consignment (40% commission); or artwork is bought outright for 50% of retail price. There is a rental fee for space; rental fee covers 2 months. Retail price set by the artist. Accepted work should be framed, mounted, matted.

Submissions Send query letter with artist's statement, résumé and photographs. Returns material with SASE. Responds to queries in 2 weeks. Finds artists through word of mouth and referrals by other artists.

Tips "Submit materials in a neat manner with SASE for easy return."

TOM BINDER FINE ARTS

825 Wilshire Blvd. #708, Santa Monica CA 90401. (800)332-4278. Fax: (800)870-3770. E-mail: info@artman.net. Website: www.artman.net. **Owner:** Tom Binder. For-profit gallery. Exhibits established artists. Also has a location in Marina Del Rey. Clients include local community, tourists and upscale. Overall price range: $200-2,000.

• See additional listing in the Posters & Prints section.

Media Considers all media; types of prints include etchings, lithographs, posters and serigraphs.

Style Considers all styles and genres.

Terms Artwork is accepted on consignment or bought outright. Retail price set by the gallery. Gallery provides insurance. Accepted work should be mounted.

Submissions Write to arrange a personal interview to show portfolio. Returns material with SASE. Responds in 2 weeks.

▣ BLUE SPIRAL 1

38 Biltmore Ave., Asheville NC 28801. (828)251-0202. Fax: (828)251-0884. E-mail: info@bluespiral1.com. Website: www.bluespiral1.com. **Director:** John Cram. Retail gallery. Estab. 1991. Represents emerging, mid-career and established artists living in the Southeast. Over 100 exhibited artists including Julyan Davis, John Nickerson, Suzanne Stryk, Greg Decker and Will Henry Stephens. Sponsors 15-20 shows/year. Average display time: 6-8 weeks. Open all year; Monday-Saturday, 10-6; Sunday, 12-5 (May-October). Located downtown; 15,000 sq. ft.; historic building. 50% of space for special exhibitions; 50% of space for gallery artists. Clientele "across the range;" 90% private collectors, 10% corporate collectors. Overall price range: less than $100-50,000; most work sold at $100-2,500.

Media Considers all media. Most frequently exhibits painting, clay, sculpture and glass.

Style Exhibits all styles, all genres.

Terms Accepts work on consignment (50% commission). Retail price set by the artist. Gallery provides insurance, promotion and contract; artist pays shipping costs to and from gallery. Prefers framed artwork.

Submissions Accepts only artists from Southeast. Send query letter with résumé, slides, prices, statement and SASE. Responds in 3 months. Files slides, name and address. Finds artists through word of mouth, referrals and travel.

Tips "Work must be technically well executed and properly presented."

BOCA RATON MUSEUM OF ART

501 Plaza Real, Boca Raton FL 33432. (561)392-2500. Fax: (561)391-6410. E-mail: info@bocamuseum.org. Website: www.bocamuseum.org. **Executive Director:** George S. Bolge. Museum. Estab. 1950. Represents established artists. 5,500 members. Exhibits change every 2-3 months. Open all year; Tuesday, Thursday and Friday, 10-5; Wednesday, 10-9; Saturday and Sunday, 12-5. Located one mile east of I-95 in Mizner Park; 44,000 sq. ft.; national and international temporary exhibitions and impressive second-floor permanent collection. Three galleries—one shows permanent collection, two are for changing exhibitions. 66% of space for special exhibitions.

Media Considers all media. Exhibits modern masters including Braque, Degas, Demuth, Glackens, Klee, Matisse, Picasso and Seurat; 19th and 20th century photographers; Pre-Columbian and African art; contemporary sculpture.

Submissions "Contact executive director in writing."

Tips "Photographs of work of art should be professionally done if possible. Before approaching museums, an artist should be well-represented in solo exhibitions and museum collections. Their acceptance into a particular museum collection, however, still depends on how well their work fits into that collection's narrative and how well it fits with the goals and collecting policies of that museum."

THE BOULDER MUSEUM OF CONTEMPORARY ART

1750 13th St., Boulder CO 80302. (303)443-2122. Fax: (303)447-1633. E-mail: info@bmoca.org. Website: www.bmoca.org. **Contact:** Exhibitions Committee. Nonprofit museum. Estab. 1972. Exhibits contemporary art and performance. Programs regional, national and international emerging and established artists. 10,000 sq. ft. of exhibition and performance spaces. "Located in a historically landmarked two-story, red-brick building in heart of downtown Boulder."

Media Considers all media.

Style Exhibits new art forms in the work of emerging and established artists.

Submissions Accepts work by invitation only, after materials have been reviewed by Exhibitions Committee. Send query letter, artist statement, résumé, approximately 20 high-quality slides or CD, outline of logistics if installation and SASE. Portfolio review requested if interested in artist's work. Submission review in January. Responds in 6 months. Submissions are filed. Additional materials appropriate to submission are accepted.

⊕ BRACKNELL GALLERY; MANSION SPACES

South Hill Park Arts Centre, Berkshire RG12 7PA United Kingdom. (44)(0)1344-416240. E-mail: outi.remes@southhillpark.org.uk. Website: www.southhillpark.org.uk. **Visual Arts & Exhibitions Officer:** Dr. Outi Remes. Alternative space/nonprofit gallery. Estab. 1991. Approached by at least 50 artists/year; exhibits several shows

of emerging, mid-career and established artists. "Very many artists approach us for the Mansion Spaces; all applications are looked at." Exhibited artists include Billy Childish (painting), Paul Russell (photography) and Matt Sherratt (ceramic). Average display time: 2 months. Open all year; call or check website for hours. Located "within a large arts centre that includes theatre, cinema, studios, workshops and a restaurant; one large room and one smaller with high ceilings, plus more exhibiting spaces around the centre." Clients include local community and students.

Media Considers all media. Most frequently exhibits painting, sculpture, live art, installations, group shows, video-digital works, craftwork (ceramics, glasswork, jewelry). Considers all types of prints.

Style Considers all styles and genres.

Terms Artwork is accepted on consignment, and there is a 20% commission. Retail price set by the artist. Gallery provides insurance, promotion and contract.

Submissions Send query letter with artist's statement, bio and photographs. Returns material with SAE. Responds to queries only if interested. Files all material "unless return of slides/photos is requested." Finds artists through invitations, art exhibits, referrals by other artists, submissions and word of mouth.

Tips "We have a great number of applications for exhibitions in the Mansion Spaces. Make yours stand out! Exhibitions at the Bracknell Gallery are planned 2-3 years in advance."

RENA BRANSTEN GALLERY

77 Geary St., San Francisco CA 94108. (415)982-3292. Fax: (415)982-1807. E-mail: info@renabranstengallery.com or rena@renabranstengallery.com. Website: www. renabransten gallery.com. **Director:** Leigh Markopoulos. For-profit gallery. Estab. 1974. Exhibits emerging, mid-career and established artists. Approached by 200 artists/year. Exhibits 12-15 artists/year. Average display time: 4-5 weeks. Open Tuesday-Friday, 10:30-5:30; Saturday, 11-5; usually closed the last week of August and the first week of September.

Media Considers all media except craft and fiber. Considers all types of prints.

Style Considers all styles of contemporary art.

Terms Retail price set by the gallery and the artist.

Submissions Send JPEGs or website link via e-mail. Mailed submissions must include SASE if return of materials is required. Files cover letter from artist. Finds artists through art fairs and exhibits, portfolio reviews, referrals by curators and other artists, studio visits and word of mouth.

BROOKFIELD CRAFT CENTER

286 Whisconier Rd., (Route 25), P.O. Box 122, Brookfield CT 06804-0122. E-mail: info@brookfieldcraftcenter.org. Website: www.brookfieldcraftcenter.org. **Contact:**

Gallery Director. Nonprofit gallery. Estab. 1954. Exhibits emerging, mid-career and established craft artists. Approached by 100 artists/year; represents 400+ craft artists.

Media Considers functional and sculptural ceramics, fiber arts, jewelry and fine metals, forged metals, glass, mixed media and wood. Most frequently exhibits clay, metal, wood, fiber.

Style Original, handmade work by American artisans, one-of-a-kind or very limited production.

Terms Work is accepted on consignment (50% commission); net 30 days. Retail price of the art set by the artist. Gallery provides insurance, promotion and contract.

Submissions E-mail photographs and/or web site links, or send query letter with brochure to P.O. Box. Returns material with SASE. Responds to queries in 2 weeks to 1 month. Finds artists through art fairs/exhibits, portfolio reviews, referrals by other artists, submissions and word of mouth.

BROOKLYN BOTANIC GARDEN—STEINHARDT CONSERVATORY GALLERY

1000 Washington Ave., Brooklyn NY 11225. (718)623-7200. Fax: (718)622-7839. E-mail: emilycarson@bbg.org. Website: www.bbg.org. **Public Programs Associate:** Emily Carson. Nonprofit botanic garden gallery. Estab. 1988. Represents emerging, mid-career and established artists. 20,000 members. Sponsors 10-12 shows/year. Average display time: 4-6 weeks. Open all year; Tuesday-Sunday, 10-4. Located near Prospect Park and Brooklyn Museum; 1,200 sq. ft.; part of a botanic garden, gallery adjacent to the tropical, desert and temperate houses. Clients include BBG members, tourists, collectors. 100% of sales are to private collectors. Overall price range: $75-7,500; most work sold at $75-500.

Media Considers all media and all types of prints. Most frequently exhibits watercolor, oil and photography.

Style Exhibits all styles. Genres include landscapes, florals and wildlife.

Terms Accepts work on consignment (20% commission). Retail price set by the artist. Gallery provides insurance, promotion and contract; artist pays shipping costs to and from gallery. Artwork must be framed or ready to display unless otherwise arranged. Artists hang and remove their own shows.

Submissions Work must reflect the natural world. Send query letter with résumé, slides, bio, brochure, photographs, SASE, business card and reviews for review.

Tips "Artists' groups contact me by submitting résumé and slides of artists in their group. We favor seasonal art which echoes the natural events going on in the garden. Large format, colorful works show best in our multi-use space."

BRUNNER GALLERY

215 N. Columbia St., Covington LA 70433. (985)893-0444. Fax: (985)893-4332. E-mail: sbrunner@brunnergallery.com. Website: www.brunnergallery.com. **Owner/Director:** Susan Brunner. For-profit gallery. Estab. 1997. Approached by 400 artists/year. Exhibits 45 emerging, mid-career and established artists. Sponsors 10-12 exhibits/year. Average display time: 1 month. Open all year; Tuesday-Saturday, 10-5; weekends, 10-5. Closed major holidays. Located 45 minutes from metropolitan New Orleans, one hour from capital of Baton Rouge and Gulf Coast; 2,500 sq. ft. Building designed by Rick Brunner, artist and sculptor, and Susan Brunner, designer. Clients include local community, tourists, upscale and professionals. 20% of sales are to corporate collectors. Overall price range: $200-10,000; most work sold at $1,500-3,000.

Media Considers all media. Types of prints include etchings and monoprints.

Style Considers all styles and genres. Most frequently exhibits abstraction, expressionism and conceptualism.

Terms Artwork is accepted on consignment (50% commission) or bought outright for 90-100% of retail price (net 30 days). Retail price set by the gallery and the artist. Gallery provides insurance, promotion and contract. Accepted work should be framed. Requires exclusive representation locally.

Submissions Preliminary review: E-mail artist's statement, bio, résumé, 3 JPEG files (no larger than 72 dpi) or URL. Submissions are reviewed quarterly. Will contact for portfolio review if interested. (See website for additional information regarding "secondary review" guidelines.) Finds artists through word of mouth, submissions, portfolio reviews, art fairs/exhibits, and referrals by other artists.

Tips "In order for us to offer representation to an artist, it is necessary for us to consider whether the artist will be a good fit for the private and corporate collectors who make up our client base. We request that each image include not only the title, dimensions and medium, but also the retail price range."

BUNNELL STREET GALLERY

106 W. Bunnell, Suite A, Homer AK 99603. (907)235-2662. Fax: (907)235-9427. E-mail: asia@bunnellstreetgallery.org. Website: www.bunnellstreetgallery.org. **Director:** Asia Freeman. Nonprofit gallery. Estab. 1990. Approached by 50 artists/year. Represents 35 emerging, mid-career and established artists. Sponsors 12 exhibits/year. Average display time: 1 month. Open Monday-Saturday, 10-6; Sunday, 12-4 (summer only). Closed January. Located on corner of Main and Bunnell Streets, Old Town, Homer; 30 × 25 exhibition space; good lighting, hardwood floors. Clients include local community and tourists. 10% of sales are to corporate collectors. Overall price range: $50-2,500; most work sold at $500.

Media Considers all media. Most frequently exhibits painting, ceramics and installation. No prints; originals only.

Style Considers all styles and genres. Most frequently exhibits painterly abstraction, impressionism, conceptualism.

Terms Artwork is accepted on consignment (35% commission). A donation of time is requested. Gallery provides insurance, promotion and contract. Accepted work should be framed. Does not require exclusive representation locally.

Submissions Call or write to arrange a personal interview to show portfolio of slides or mail portfolio for review. Returns material with SASE. Responds in 1 month. Finds artists through word of mouth, submissions, art exhibits and referrals by other artists.

CADEAUX DU MONDE

26 Mary St., Newport RI 02835. (401)848-0550. Fax: (401)849-3225. E-mail: info@ cadeauxdumonde.com. Website: www.cadeauxdumonde.com. **Owners:** Jane Dyer and Katie Dyer. Retail gallery. Estab. 1987. Represents emerging, mid-career and established artists. Exhibited artists include John Lyimo and A.K. Paulin. Sponsors 7 changing shows and 1 ongoing show/year. Average display time: 3-4 weeks. Open all year; daily, 10-6 and by appointment. Located in "the Anna Pell House (circa 1840), recently restored with many original details intact including Chiswick tiles on the fireplace and an outstanding back stairway 'Galerie Escalier' (the servant's staircase), which has rotating exhibitions from June to December;" historic, commercial district; 1,300 sq. ft. 15% of space for special exhibitions; 85% of space for gallery artists. Clients include tourists, upscale, local community and students. 95% of sales are to private collectors, 5% corporate collectors. Overall price range: $20-5,000; most work sold at $100-300.

Media Considers all media suitable for display in a stairway setting for special exhibitions. No prints.

Style Exhibits folk art. "Style is unimportant; quality of work is deciding factor. We look for unusual, offbeat and eclectic."

Terms Accepts work on consignment (30% commission). Retail price set by the artist. Gallery provides insurance. Artist pays shipping costs and promotional costs of opening. Prefers framed artwork.

Submissions Send query letter with résumé, 10 slides, bio, photographs and business card. Call for appointment to show portfolio of photographs or slides. Responds within 2 weeks, only if interested. Finds artists through submissions, word of mouth, referrals by other artists, visiting art fairs and exhibitions.

Tips Artists who want gallery representation should "present themselves professionally; treat their art and the showing of it like a small business; arrive on time and be prepared; and meet deadlines promptly."

Galleries

THE CANTON MUSEUM OF ART

1001 Market Ave. N., Canton OH 44702. (330)453-7666. Fax: (330)453-1034. E-mail: al@cantonart.org. Website: www.cantonart.org. **Executive Director:** M. Joseph Albacete. Nonprofit gallery. Estab. 1935. Represents emerging, mid-career and established artists. "Although primarily dedicated to large-format touring and original exhibitions, the CMA occasionally sponsors solo shows by local and original artists, and one group show every 2 years featuring its own 'Artists League.'" Average display time: 6 weeks. Overall price range: $50-3,000; few sales above $300-500.

Media Considers all media. Most frequently exhibits oil, watercolor and photography.

Style Considers all styles. Most frequently exhibits painterly abstraction, post-modernism and realism.

Terms "While every effort is made to publicize and promote works, we cannot guarantee sales, although from time to time sales are made, at which time a 25% charge is applied." One of the most common mistakes in presenting portfolios is "sending too many materials. Send only a few slides or photos, a brief bio and a SASE."

Tips There seems to be "a move back to realism, conservatism and support of regional artists."

CANTRELL GALLERY

8206 Cantrell Rd., Little Rock AR 72227. (501)224-1335. E-mail: cantrellgallery@ sbcglobal.net. Website: www.cantrellgallery.com. **President:** Helen Scott. Director: Cindy Huisman. Wholesale/retail gallery. Estab. 1970. Represents/exhibits 120 emerging, mid-career and established artists/year. Exhibited artists include Boulanger, Dali, G. Harvey, Warren Criswell, N. Scott and Robin Morris. Sponsors 8-12 shows/year. Average display time 1 month. Open all year; Monday-Saturday, 10-5. Located in the strip center; 5,000 sq. ft.; "we have several rooms and different exhibits going at one time." Clientele collectors, retail, decorators, museums. Overall price range $100-10,000; most work sold at $250-3,000.

Media Considers oil, acrylic, watercolor, pastel, pen & ink, drawing, mixed media, collage, paper, sculpture, woodcut, engraving, lithograph, wood engraving, mezzotint, serigraphs, linocut, etching. Most frequently exhibits etchings, watercolor, mixed media, oils and acrylics. Looking for outsider art.

Style Exhibits eclectic work, all genres.

Terms Gallery provides insurance and promotion; shipping costs are shared. Prefers artwork unframed.

Submissions Send query letter with résumé, 5 photos and bio. Write for appointment to show portfolio of originals. Responds in 2 months. Files all material. Finds artists through agents, by visiting exhibitions, word of mouth, art publications and sourcebooks, artists' submissions.

Tips "Be professional. Be honest. Place a retail price on each piece, rather than only knowing what 'you need to get' for the piece. Don't spread yourself too thin in any particular area—only show in one gallery in any area."

CAPITOL ARTS ALLIANCE GALLERIES

416 E. Main St., Bowling Green KY 42101-2241. (270)782-2787. E-mail: gallery@ capitolarts.com. Website: www.capitolarts.com. **Gallery Director:** Lynn Robertson. Nonprofit gallery. Approached by 30-40 artists/year. Represents 16-20 emerging, mid-career and established artists. Sponsors 10 exhibits/year. Average display time: 3-4 weeks. Open daily,. 9-5 Closed Christmas-New Year's Day. Clients include local community and tourists.

Media Considers all media except crafts; all types of prints except posters.

Style Considers all styles.

Terms Artwork is accepted on consignment (30% commission). Retail price set by the artist. Gallery provides promotion and contract. Accepted work should be framed, wired and ready to hang. Accepts only artists within a 100-mile radius.

Submissions Contact Capitol Arts to be added to Call to Artists List. Finds artists through submissions and word of mouth.

CEDARHURST CENTER FOR THE ARTS

Richview Rd., Mt. Vernon IL 62864. (618)242-1236. Fax: (618)242-9530. E-mail: mitchellmuseum@cedarhurst.org. Website: www.cedarhurst.org. **Director of Visual Arts:** Rusty Freeman. Museum. Estab. 1973. Exhibits emerging, mid-career and established artists. Average display time: 6 weeks. Open all year; Tuesday through Saturday, 10-5; Sunday, 1-5; closed Mondays and federal holidays.

Submissions Call or send query letter with artist's statement, bio, resume, SASE and slides.

CENTRAL MICHIGAN UNIVERSITY ART GALLERY

Wightman 132, Art Department, Mt. Pleasant MI 48859. (989)774-3800. Fax: (989)774-2278. E-mail: goche1as@cmich.edu. Website: www.uag.cmich.edu. **Director:** Anne Gochenour. Nonprofit academic gallery. Estab. 1970. Exhibits emerging, mid-career and established contemporary artists. Past artists include Sandy Skoglund, Michael Ferris, Blake Williams, John Richardson, Valerie Allen, Randal Crawford. Sponsors 2-7 exhibits/year. Average display time: 1 month. Open all year while exhibits are present; Tuesday through Friday, 11-6; Saturday, 11-3. Clients include local community, students and tourists.

Media Considers all media and all types of prints. Most frequently exhibits sculpture, painting and photography.

Style Considers all styles.

Terms Buyers are referred to the artist. Gallery provides insurance, promotion and contract. Accepted work should be framed. Does not require exclusive representation locally.

Submissions Write to arrange a personal interview to show portfolio of slides. Mail or e-mail portfolio for review. Send query letter with artist's statement, bio, résumé, reviews, SASE and slides. Returns material with SASE. Responds within 2 months, only if interested. Finds artists through word of mouth, submissions, portfolio reviews, art exhibits, and referrals by other artists.

THE CHAIT GALLERIES DOWNTOWN

218 E. Washington St., Iowa City IA 52240. (319)338-4442. Fax: (319)338-3380. E-mail: info@thegalleriesdowntown.com. Website: www.thegalleriesdowntown. com. **Director:** Benjamin Chait. For-profit gallery. Estab. 2003. Approached by 300 artists/year. Represents 50 emerging, mid-career and established artists. Exhibited artists include Benjamin Chait (giclee), Corrine Smith (painting), John Coyne (cast metal sculpture), Mary Merkel-Hess (fiber sculpture) and Ulfert Wilke (ink on paper). Sponsors 12 exhibits/year. Average display time: 90 days. Open all year; Monday-Friday, 11-6; Saturday, 11-5; Sunday by chance or appointment. Located in a downtown building restored to its original look (circa 1882), with 14-ft. molded ceiling and original 9-ft. front door. Professional museum lighting and scamozzi-capped columns complete the elegant gallery. Clients include local community, students, tourists, upscale. Overall price range: $50-10,000; most work sold at $500-1,000.

Style Considers all media, all types of prints, all styles and all genres. Most frequently exhibits painting, sculpture and ceramic.

Terms Artwork is accepted on consignment, and there is a 50% commission. Retail price set by the gallery and the artist. Gallery provides insurance, promotion and contract. Accepted work should be framed. Requires exclusive representation locally.

Submissions Call; mail portfolio for review. Returns material with SASE. Responds to queries in 2 weeks. Finds artists through art fairs, exhibits, portfolio reviews and referrals by other artists.

CHAPMAN FRIEDMAN GALLERY

624 W. Main St., Louisville KY 40202. E-mail: cheryl_chapman@bellsouth.net. Website: www.chapmanfriedmangallery.com; www.imagesol.com. **Owner:** Julius Friedman. For-profit gallery. Estab. 1992. Approached by 100 or more artists/year. Represents or exhibits 25 artists. Sponsors 7 exhibits/year. Average display time: 1 month. Open Wednesday-Saturday, 10-5. Closed during August. Located downtown; approximately 3,500 sq. ft. with 15-ft. ceilings and white walls. Clients include local

community and tourists. 5% of sales are to corporate collectors. Overall price range: $75-10,000; most work sold at more than $1,000.

Media Considers all media except craft. Types of prints include engravings, etchings, lithographs, posters, serigraphs and woodcuts. Most frequently exhibits painting, ceramics and photography.

Style Exhibits color field, geometric abstraction, primitivism realism, painterly abstraction. Most frequently exhibits abstract, primitive and color field.

Terms Artwork is accepted on consignment (50% commission). Retail price set by the artist. Gallery provides insurance, promotion and contract. Accepted work should be framed. Requires exclusive representation locally.

Submissions Send query letter with artist's statement, bio, brochure, photographs, résumé, slides and SASE. Returns material with SASE. Responds to queries in 1 month. Finds artists through portfolio reviews and referrals by other artists.

CINCINNATI ART MUSEUM

953 Eden Park Dr., Cincinnati OH 45202. (513)639-2995. Fax: (513)639-2888. E-mail: information@cincyart.org. Website: www.cincinnatiartmuseum.org. **Deputy Director:** Anita J. Ellis. Estab. 1881. Exhibits 6-10 emerging, mid-career and established artists/year. Sponsors 20 exhibits/year. Average display time: 3 months. Open all year; Tuesday-Sunday, 11-5 (Wednesday open until 9). Closed Mondays, Thanksgiving, Christmas, New Year's Day and Fourth of July. General art museum with a collection spanning 6,000 years of world art. Over 100,000 objects in the collection with exhibitions on view annually. Clients include local community, students, tourists and upscale.

Media Considers all media and all types of prints. Most frequently exhibits paper, mixed media and oil.

Style Considers all styles and genres.

Submissions Send query letter with artist's statement, photographs, reviews, SASE and slides.

CLAMPART

531 W. 25th Street, New York NY 10001. (646)230-0020. E-mail: info@clampart.com. Website: www.clampart.com. **Director:** Brian Paul Clamp. For-profit gallery. Estab. 2000. Approached by 1200 artists/year. Represents 15 emerging, mid-career and established artists. Exhibited artists include Arthur Tress (photography), and John Dugdale (photography). Sponsors 6-8 exhibits/year. Average display time: 5 weeks. Open Tuesday-Saturday from 11 to 6; closed last two weeks of August. Located on the ground floor on Main Street in Chelsea. Small exhibition space. Clients include local community, tourists and upscale. 5% of sales are to corporate collectors. Overall price range: $300-50,000; most work sold at $2,000.

Media Considers acrylic, collage, drawing, mixed media, oil, paper, pastel, pen & ink and watercolor. Considers all types of prints. Most frequently exhibits photo, oil and paper.

Style Exhibits conceptualism, geometric abstraction, minimalism and postmodernism. Considers genres including figurative work, florals, landscapes and portraits. Most frequently exhibits postmodernism, conceptualism and minimalism.

Terms Artwork is accepted on consignment (50% commission). Retail price set by the gallery. Gallery provides insurance, promotion and contract. Accepted work should be framed, mounted and matted. Does not require exclusive representation locally.

Submissions E-mail query letter with artist's statement, bio and JPEGs. Cannot return material. Responds to queries in 2 weeks. Finds artists through portfolio reviews, referrals by other artists and submissions.

Tips "Include a bio and well-written artist statement. Do not submit work to a gallery that does not handle the general kind of work you produce."

CLAY CENTER'S AVAMPATO DISCOVERY MUSEUM

One Clay Square, 300 Leon Sullivan Way, Charleston WV 25301. (304)561-3500. Fax: (304)561-3598. E-mail: info@theclaycenter.org. Website: www.theclaycenter. org. **Curator:** Ric Ambrose. Museum gallery. Estab. 1974. Represents emerging, mid-career and established artists. Sponsors 6 shows/year. Average display time: 2-3 months. Open all year; contact for hours. Located inside the Clay Center for the Arts & Sciences—West Virginia.

Media Considers oil, acrylic, watercolor, pastel, pen & ink, drawings, mixed media, collage, works on paper, sculpture, installations, photography and prints.

Style Considers all styles and genres.

Terms Retail price set by artist. Gallery pays shipping costs. Prefers framed artwork.

Submissions Send query letter with bio, résumé, brochure, slides, photographs, reviews and SASE. Write for appointment to show portfolio of slides. Responds within 2 weeks, only if interested. Files everything or returns in SASE.

▣ COAST GALLERIES

P.O. Box 223519, Carmel CA 93922. (831)625-8688. Fax: (831)625-8699. E-mail: gary@coastgalleries.com. Website: www.coastgalleries.com. **Owner:** Gary Koeppel. Retail galleries. Estab. 1958. Represents 300 emerging, mid-career and established artists. Sponsors 3-4 shows/year. Open daily, all year. Locations in Big Sur and Carmel, California; Hana, Hawaii (Maui). No two Coast Galleries are alike. Each gallery was designed specifically for its location and clientele. The Hawaii gallery features Hawaiiana; the Big Sur gallery is constructed of redwood water tanks and is the one of the largest galleries of American Crafts in the United States." Square footage of each location varies from 1,500 to 3,000 sq. ft. 100% of space for special

exhibitions. Clientele: 90% private collectors, 10% corporate collectors. Overall price range: $25-60,000; most work sold at $400-4,000.

Media Considers all media; engravings, lithographs, posters, etchings, wood engravings and serigraphs. Most frequently exhibits bronze sculpture, art glass limited edition prints, watercolor and oil on canvas.

Style Exhibits impressionism and realism. Genres include landscape, marine, abstract and wildlife.

Terms Accepts fine art and master crafts on consignment (commission varies), or buys master crafts outright (net 30 days). Retail price set by gallery. Gallery provides insurance, promotion and contract; artist pays for shipping. Requires framed artwork.

Submissions Accepts only artists from Hawaii for Hana gallery; coastal and wildlife imagery for California galleries; California painting for Carmel gallery and American crafts for Big Sur gallery. Send query letter with résumé, slides, bio, brochure, photographs, business card and reviews; SASE mandatory if materials are to be returned. Write or e-mail info@coastgalleries.com for appointment. Owner responds to all inquiries.

COLEMAN FINE ART

79 Church St., Charleston SC 29401. (843)853-7000. Fax: (843)722-2552. E-mail: info@colemanfineart.com. Website: www.colemanfineart.com. **Gallery Director:** Katherine Wright. Retail gallery; gilding, frame making and restoration. Estab. 1974. Represents 8 emerging, mid-career and established artists/year. Exhibited artists include John Cosby, Marc Hanson, Glenna Hartmann, Joe Paquet, Jan Pawlowski, Don Stone, George Strickland, Mary Whyte. Hosts 2 shows/year. Average display time: 1 month. Open all year; Monday, 10-4; Tuesday-Saturday, 10-6, and by appointment. "Both a fine art gallery and restoration studio, Coleman Fine Art has been representing regional and national artists for over 30 years. Located on the corner of Church and Tradd streets, the gallery reinvigorates one of the country's oldest art studios." Clientele: tourists, upscale and locals. 95-98% private collectors, 2-5% corporate collectors. Overall price range: $1,000-50,000; most work sold at $3,000-8,000.

Media Considers oil, watercolor, pastel, pen & ink, drawing, mixed media, sculpture. Most frequently exhibits watercolor, oil and sculpture.

Style Exhibits expressionism, impressionism, photorealism and realism. Genres include portraits, landscapes, still lifes and figurative work. Prefers figurative work/ expressionism, realism and impressionism.

Terms Accepts work on consignment (45% commission); net 30 days. Retail price set by the gallery and the artist. Gallery provides promotion and contract. Shipping costs are shared. Prefers artwork framed.

Submissions Send query letter with brochure, 20 slides/digital CD of most recent

work, reviews, bio and SASE. Write for appointment to show portfolio of photographs, slides and transparencies. Responds within 1 month, only if interested. Files slides. Finds artists through submissions.

Tips "Do not approach gallery without an appointment."

🏳 COLOR CONNECTION GALLERY

2050 Utica Square, Tulsa OK 74114. (918)742-0515. E-mail: info@colorconnectiongallery. com. Website: www.colorconnectiongallery.com. Retail and cooperative gallery. Estab. 1991. Represents 11 established artists. Sponsors 12 shows/year. Average display time 1 month. Open all year; Tuesday-Saturday, 10-5:30. Located in midtown. Clientele: upscale, local community. 85% private collectors, 15% corporate collectors. Overall price range $100-5,000; most work sold at $250-1,500.

Media Considers oil, acrylic, watercolor, pastel, pen & ink, drawing, mixed media, collage, paper, sculpture, ceramics, glass, linocuts and etchings. Most frequently exhibits watermedia.

Style Exhibits expressionism, neo-expressionism, painterly abstraction, impressionism and realism. Genres include florals, portraits, southwestern, landscapes and Americana. Prefers impressionism, painterly abstraction and realism.

Terms Seeking 3-D work, no membership fee or work time, 50% commission. Retail price set by the artist. Gallery provides promotion and contract.

Submissions Accepts regional artists. Send query letter with résumé, slides and bio. Call for appointment to show portfolio of photographs, slides and sample of 3-D work. Does not reply. Artist should contact in person. Finds artists through word of mouth, referrals by other artists, visiting art fairs and exhibitions and artist's submissions.

CONTEMPORARY ART MUSEUM OF ST. LOUIS

3750 Washington Blvd., St. Louis MO 63108. (314)535-4660. Fax: (314)535-1226. E-mail: info@contemporarystl.org. Website: www.contemporarystl.org. **Contact:** Paul Ha. Nonprofit museum. Estab. 1980. Is a noncollecting museum dedicated to exhibiting contemporary art from international, national and local established and emerging artists. Open Tuesday-Saturday, 10-5; Thursday, 10-7; Sunday, 11-4. Located mid-town, Grand Center; 27,200 sq. ft. building designed by Brad Cloepfil, Allied Works.

CONTEMPORARY ARTS CENTER

900 Camp St., New Orleans LA 70130. (504)528-3805. Fax: (504)528-3828. E-mail: info@cacno.org. Website: cacno.org. **Curator of Visual Arts:** David S. Rubin. Alternative space, nonprofit gallery. Estab. 1976. Exhibits emerging, mid-career and established artists. Open all year; Tuesday-Sunday, 11-5; weekends 11-5. Closed

Mardi Gras, Christmas and New Year's Day. Located in Central Business District of New Orleans; renovated/converted warehouse. Clients include local community, students, tourists and upscale.

Media Considers all media and all types of prints. Most frequently exhibits painting, sculpture, installation and photography.

Style Considers all styles. Exhibits anything contemporary.

Terms Artwork is accepted on loan for curated exhibitions. Retail price set by the artist. CAC provides insurance and promotion. Accepted work should be framed. Does not require exclusive representation locally. The CAC is not a sales venue, but will refer inquiries. CAC receives 20% on items sold as a result of an exhibition.

Submissions Send query letter with bio, SASE and slides or CDs. Responds in 4 months. Files letter and bio—slides when appropriate. Finds artists through word of mouth, submissions, art exhibits, art fairs, referrals by other artists, professional contacts and periodicals.

Tips "Use only one slide sheet with proper labels (title, date, medium and dimensions)."

CONTEMPORARY ARTS COLLECTIVE

107 East Charleston Blvd., Suite 120, Las Vegas NV 89104. (702)382-3886. Fax: (702)598-3886. E-mail: info@lasvegascac.org. Website: www.lasvegascac.org. **Contact:** Natalia Ortiz. Nonprofit gallery. Estab. 1989. Sponsors more than 9 exhibits/year. Average display time: 1 month. Gallery open Tuesday-Saturday, 12-4. Closed Thanksgiving, Christmas, New Year's Day. 1,200 sq. ft. Clients include tourists, local community and students. 75% of sales are to private collectors, 25% corporate collectors. Overall price range: $200-4,000. Most work sold at $400.

Media Considers all media and all types of prints. Most frequently exhibits painting, photography and mixed media.

Style Exhibits conceptualism, group shows of contemporary fine art. Genres include all contemporary art/all media.

Terms Artwork is accepted through annual call for proposals of self-curated group shows; there is a 30% requested donation. Gallery provides insurance, promotion, contract.

CONTRACT ART INTERNATIONAL, INC.

P.O. Box 629, Old Lyme CT 06371-0629. (860)434-9799. Fax: (860)434-6240. E-mail: info@contract artinternational.com. Website: www.contractartinternational.com. **President:** K. Mac Thames. In business approximately 38 years. "We contract artwork for hospitality, blue-chip, and specialized businesses." Collaborates with emerging, mid-career and established artists. Assigns site-specific commissions to artists based on project design needs, theme and client preferences. Studio is open

all year to corporate art directors, architects, designers, and faculty directors. 1,600 sq. ft. studio. Clientele 98% commercial. Overall price range $500-500,000.

Media Places all types of art mediums.

Terms Pays for design by the project, negotiable; 50% up front. Rights purchased vary according to project.

Submissions Send letter of introduction with résumé, slides, bio, brochure, photographs, DVD/video and SASE. If local, write for appointment to present portfolio; otherwise, mail appropriate materials, which should include slides and photographs. "Show us a good range of your talent. Also, we recommend you keep us updated if you've changed styles or media." Responds in 1 week. Files all samples and information in registry library.

Tips "We exist mainly to art direct commissioned artwork for specific projects."

COOS ART MUSEUM

235 Anderson Ave., Coos Bay OR 97420. (541)267-3901. E-mail: info@coosart.org. Website: www.coosart.org. Not-for-profit corporation; 3rd-oldest art museum in Oregon. Estab. 1950. Mounts 4 juried group exhibitions/year of 85-150 artists; 20 curated single/solo exhibits/year of established artists; and 6 exhibits/year from the Permanent Collection. 5 galleries allow for multiple exhibits mounted simultaneously, averaging 6 openings/year. Average display time: 6-9 weeks. Open Tuesday-Friday, 10-4; Saturday, 1-4. Closed Sunday, Monday and all major holidays. Free admission during evening of 2nd Thursday (Art Walk), 5-8. Clients include local community, students, tourists and upscale.

Media For curated exhibition, considers all media including print, engraving, litho, serigraph. Posters and giclées not considered. Most frequently exhibits paintings (oil, acrylic, watercolor, pastel), sculpture (glass, metal, ceramic), drawings, etchings and prints.

Style Considers all styles and genres. Most frequently exhibits primitivism, realism, postmodernism and expressionism.

Terms No gallery floor sales. All inquiries are referred directly to the artist. Retail price set by the artist. Museum provides insurance, promotion and contract. Accepted work should be framed, mounted and matted. Accepts only artists from Oregon or Western United States.

Submissions Send query letter with artist's statement, bio, résumé, SASE, slides or digital files on CD or links to Web address. Responds to queries in 6 months. Never send 'only copies' of slides, résumés or portfolios. Exhibition committee reviews 2 times/year—schedule exhibits 2 years in advance. Files proposals. Finds artists through portfolio reviews and submissions.

Tips "Have complete files electronically on a website or CD. Have a written positioning statement and proposal of show as well as letter(s) of recommendation from a producer/curator/gallery of a previous curated exhibit. Do not expect us to

produce or create exhibition. You should have all costs figured ahead of time and submit only when you have work completed and ready. We do not develop artists. You must be professional."

CORPORATE ART SOURCE

2960-F Zelda Rd., Montgomery AL 36106. (334)271-3772. E-mail: casjb@mindspring. com. Website: casgallery.com. For-profit gallery, art consultancy. Estab. 1985. Exhibits mid-career and established artists. Approached by 40 artists/year; exhibits 50 artists/year. Exhibited artists include George Taylor and Lawrence Mathis. Open Monday-Friday, 10-5:30; closed weekends. Located in an upscale shopping center; small gallery walls, but walls are filled; 50-85 pieces on display. Clients include corporate clients. Overall price range: $200-40,000; most work sold at $1,000.
Media Considers all media and all types of prints. Most frequently exhibits paintings, glass and watercolor.
Style Considers all styles and genres. Most frequently exhibits painterly abstraction, impressionism and realism.
Terms Artwork is accepted on consignment (50% commission). Retail price set by artist.
Submissions Call, e-mail, or write to arrange a personal interview to show portfolio of photographs, slides, transparencies or CD, résumé and reviews. Returns material with SASE.
Tips "Have good photos of work, as well as websites with enough work to get a feel for the overall depth and quality."

COURTHOUSE GALLERY, LAKE GEORGE ARTS PROJECT

1 Amherst St., Lake George NY 12845. (518)668-2616. Fax: (518)668-3050. E-mail: mail@lake georgearts.org. **Gallery Director:** Laura Von Rosk. Nonprofit gallery. Estab. 1986. Approached by 200 artists/year. Exhibits 10-15 emerging, mid-career and established artists. Sponsors 5-8 exhibits/year. Average display time 5-6 weeks. Open all year; Tuesday-Friday, 12-5; Saturday, 12-4. Closed mid-December to mid-January. Clients include local community, tourists and upscale. Overall price range $100-5,000; most work sold at $500.
Media Considers all media and all types of prints. Most frequently exhibits painting, mixed media and sculpture.
Style Considers all styles and genres.
Terms Artwork is accepted on consignment and there is a 25% commission. Retail price set by the artist. Gallery provides insurance, promotion and contract. Accepted work should be framed, mounted and matted.
Submissions Mail portfolio for review. Deadline always January 31st. Send query letter with artist's statement, bio, résumé, SASE and slides. Returns material with

SASE. Responds in 2 months. Finds artists through word of mouth, submissions, portfolio reviews, art exhibits, art fairs and referrals by other artists.

JAMES COX GALLERY AT WOODSTOCK

4666 Rt. 212, Willow NY 12495. (845)679-7608. Fax: (845)679-7627. E-mail: info@ james coxgallery.com. Website: www.jamescoxgallery.com. Retail gallery. Estab. 1990. Represents 15 mid-career and established artists. Exhibited artists include Leslie Bender, Bruce North, Paola Bari and Mary Anna Goetz. Represents estates of 7 artists including James Chapin, Margery Ryerson, Joseph Garlock and Elaine Wesley. Sponsors 5 shows/year. Average display time 1 month. Open all year; Tuesday-Friday, 10-5; weekends, 12-5 April- November. Elegantly restored Dutch barn. 50% of space for special exhibitions. Clients include New York City and tourists, residents of 50-mile radius. 95% of sales are to private collectors. Overall price range $500-50,000; most work sold at $1,000-10,000.

Media Considers oil, watercolor, pastel, drawing, ceramics and sculpture. Considers "historic Woodstock, art." Most frequently exhibits oil paintings, watercolors, sculpture.

Style Exhibits impressionism, realism. Genres include landscapes and figurative work. Prefers expressive or evocative realism, painterly landscapes and stylized figurative work.

Terms Accepts work on consignment (40% commission). Retail price set by the artist. Gallery provides promotion; artist pays shipping costs to and from gallery. Prefers artwork framed.

Submissions Prefers only artists from New York region. Send query letter with résumé, slides, bio, brochure, photographs, SASE and business card. Responds in 3 months. Files material on artists for special, theme or group shows.

Tips "Be sure to enclose SASE and be patient for response. Also, please include information on present pricing structure."

DALES GALLERY

Fisgard St., Victoria BC V8W 1R3 Canada. (250)383-1552. E-mail: dalesgallery@ shaw.ca. Website: www.dalesgallery.ca. **Contact:** Alison Trembath: Art Gallery and framing studio. Estab. 1976. Approached by 50 artists/year, Sponsors 10 exhibits/ year. Average display time: 4 weeks. Open all year; Monday-Friday 10-5; Saturday, 11-4. Gallery situated in Chinatown (Old Town); approximately 650 sq. ft. of space-warm and inviting with brick wall and large white display wall. Clients include local community, students, tourists and upscale. Overall price range: $100-4000; most work sold at $800.

Media Considers all media including photography. Most frequently exhibits oils, photography and sculpture.

Style Exhibits both solo and group artists.

Terms Accepts work on consignment (40% commission) Retail price set by both gallery and artist. Accepted work should be framed by professional picture framers. Does not require exclusive representation locally.

Submissions Please email images and Portfolio should include, contact number and prices. Responds within 2 months, only if interested. Finds artists through word of mouth, art exhibits, submissions, art fairs, portfolio reviews and referral by other artists.

THE DALLAS CENTER FOR CONTEMPORARY ART

2801 Swiss Ave., Dallas TX 75204. (214)821-2522. Fax: (214)821-9103. E-mail: info@ thecontemporary.net. Website: www.thecontemporary.net. **Director:** Joan Davidow. Nonprofit gallery. Estab. 1981. Sponsors 10 exhibits/year. Average display time: 6-8 weeks. Gallery open Tuesday-Saturday, 10-5.

Media Considers all media.

Style Exhibits all styles and genres.

Terms Charges no commission. "Because we are nonprofit, we do not sell artwork. If someone is interested in buying art in the gallery, they get in touch with the artist. The transaction is between the artist and the buyer."

Submissions Reviews slides/CDs. Send material by mail for consideration; include SASE. Responds October 1 annually.

Tips "We offer a lot of information on grants, commissions and exhibitions available to Texas artists. We are gaining members as a result of our in-house resource center and non-lending library. Our Business of Art seminar series provides information on marketing artwork, presentation, museum collection, tax/legal issues and other related business issues. Memberships available starting at $50. See our website for info and membership levels."

DALLAS MUSEUM OF ART

1717 N. Harwood St., Dallas TX 75201. (214)922-1200. Fax: (214)922-1350. Website: www.dallasmuseumofart.org. Museum. Estab. 1903. Exhibits emerging, mid-career and established artists. Average display time: 3 months. Open Tuesday-Sunday, 11-5; open until 9 on Thursday. Closed Monday, Thanksgiving, Christmas and New Year's Day. Clients include local community, students, tourists and upscale.

Media Exhibits all media and all types of prints.

Style Exhibits all styles and genres.

Submissions Does not accept unsolicited submissions.

MARY H. DANA WOMEN ARTISTS SERIES

Douglass Library, Rutgers, 8 Chapel Dr., New Brunswick NJ 08901. E-mail: olin@rci.

rutgers.edu. Website: www.libraries.rutgers.edu/rul/exhibits/dana_womens.shtml. **Curator:** Dr. Ferris Olin. Alternative space for juried exhibitions of works by women artists. Estab. 1971. Sponsors 4 shows/year. Average display time: 5-6 weeks. Located on college campus in urban area. Clients include students, faculty and community.
Media Considers all media.
Style Exhibits all styles and genres.
Terms Retail price by the artist. Gallery provides insurance and promotion; arranges transportation.
Submissions Does not accept unsolicited submissions. Write or e-mail with request to be added to mailing list.

HAL DAVID FINE ART

10358 Chimney Rock Drive #8., St. Louis MO 63146. (314)409-7884. E-mail: mscharf@sbcglobal.net. Website: www.maxrscharf.com. **Director:** Max Scharf. For-profit private art dealer. Estab. 1991. Exhibits established artists. Approached by 30 artists/year; represents 3 artists/year. Exhibited artists include Max R. Scharf (acrylic on canvas) Sandy Kaplan (terra cotta sculpture) and JosephOppenheim (acrylic on paper). Sponsors 3 exhibits/year. Average display time: 2 months. Open all year. Clients include upscale. 30% sales are to corporate collectors. Overall price range: $2,000-30,000; most work sold at $10,000.
Style Exhibits expressionism, impressionism, painterly abstraction. Most frequently exhibits impressionism and expressionism.
Terms Artwork is accepted on consignment (50% commission). Retail price set by the artist. Accepted work should be framed. Does not require exclusive representation locally.
Submissions No new artists for 2009.
Tips "Have a good website to look at."

THE DAYTON ART INSTITUTE

456 Belmonte Park North, Dayton OH 45405-4700. (937)223-5277. Fax: (937)223-3140. E-mail: info@daytonartinstitute.org. Website: www.daytonartinstitute.org. Museum. Estab. 1919. Open all year; Monday-Wednesday, 10-4; Thursday, 10-8; Friday-Sunday, 10-4. Open 365 days of the year! Clients include local community, students and tourists.
Media Considers all media.
Submissions Send query letter with artist's statement, reviews and slides.

DELAWARE CENTER FOR THE CONTEMPORARY ARTS

200 S. Madison St., Wilmington DE 19801. (302)656-6466. Fax: (302)656-6944. E-mail: info@thedcca.org. Website: www.thedcca.org. **Executive Director:** Neil Watson.

Alternative space, nonprofit gallery, museum retail shop. Estab. 1979. Approached by more than 800 artists/year; exhibits 50 artists. Sponsors 30 exhibits/year. Average display time: 6 weeks. Open Tuesday, Thursday and Friday, 10-6; Wednesday, 12-5; Saturday, 10-5; Sunday, 12-5. Closed major holidays. Seven galleries located along rejuvenated Wilmington riverfront; very versatile. Overall price range: $500-50,000.
Media Considers all media, including contemporary crafts.
Style Exhibits contemporary, abstract, figurative, conceptual, representational and nonrepresentational, painting, sculpture, installation and contemporary crafts.
Terms Accepts work on consignment (35% commission). Retail price is set by the gallery and the artist. Gallery provides insurance and promotion; shipping costs are shared. Prefers contemporary art.
Submissions Send query letter with artist's statement, bio, SASE, 10 slides. Returns material with SASE. Responds within 6 months. Finds artists through word of mouth, submissions, portfolio reviews, art exhibits, referrals by other artists.

DISTRICT OF COLUMBIA ARTS CENTER (DCAC)

2438 18th St. NW, Washington DC 20009. (202)462-7833. Fax: (202)328-7099. E-mail: info@dcartscenter.org. Website: www.dcartscenter.org. **Executive Director:** B. Stanley. Nonprofit gallery and performance space. Estab. 1989. Exhibits emerging and mid-career artists. Sponsors 7-8 shows/year. Average display time 1-2 months. Open Wednesday-Sunday, 2-7; Friday-Saturday, 2-10; and by appointment. Located "in Adams Morgan, a downtown neighborhood; 132 running exhibition feet in exhibition space and a 52-seat theater." Clientele: all types. Overall price range $200-10,000; most work sold at $600-1,400.
Media Considers all media including fine and plastic art. "No crafts." Most frequently exhibits painting, sculpture and photography.
Style Exhibits all styles. Prefers "innovative, mature and challenging styles."
Terms Accepts artwork on consignment (30% commission). Artwork only represented while on exhibit. Retail price set by the gallery and artist. Offers payment by installments. Gallery provides promotion and contract; artist pays for shipping. Prefers artwork framed.
Submissions Send query letter with résumé, slides, bio and SASE. Portfolio review not required. Responds in 4 months. More details are available on website.
Tips "We strongly suggest the artist be familiar with the gallery's exhibitions and the kind of work we show strong, challenging pieces that demonstrate technical expertise and exceptional vision. Include SASE if requesting reply and return of slides!"

DOLPHIN GALLERIES

230 Hana Highway, Suite 12, Kahalui HI 96732. (800)669-5051, ext. 207. Fax: (808)873-0820. E-mail: ChristianAdams@DolphinGalleries.com. Website: www.dolphingalleries.

com. **Director of Sales and Artist Development:** Christian Adams. For-profit galleries. Estab. 1976. Exhibits emerging, mid-career and established artists. Exhibited artists include Alexei Butirskiy, Jia Lu and Thomas Avrid. Sponsors numerous exhibitions/year, "running at all times through 4 separate fine art or fine jewelry galleries." Average display time "varies from one-night events to a 30-day run." Open 7 days/week, 9 a.m. to 10 p.m. Located in luxury resort, high-traffic tourist locations thoughout Hawaii. Gallery locations on Maui arre at Whalers Village in Kaanapali and in Wailea at the Shops at Wailea. On the Big Island of Hawaii, Dolphin Galleries is located at the Kings Shops at Waikoloa. Clients include local community and upscale tourists. Overall price range: $100-100,000; most work sold at $1,000-5,000.

- The above address is for Dolphin Galleries' corporate offices. Dolphin Galleries has 4 locations throughout the Hawaiian islands.

Media Considers all media. Most frequently exhibits oil and acrylic paintings and limited edition works of art. Considers all types of prints.

Style Most frequently exhibits impressionism, figurative and abstract art. Considers American landscapes, portraits and florals.

Terms Artwork is accepted on consignment with negotiated commission, promotion and contract. Retail price set by the gallery. Gallery provides insurance, promotion and contract. Accepted work should be framed, mounted and matted. Requires exclusive representation locally.

Submissions E-mail submissions to ChristianAdams@DolphinGalleries.com. Finds artists mainly through referrals by other artists, art exhibits, submissions, portfolio reviews and word of mouth.

▓ THE DONOVAN GALLERY

3895 Main Rd., Tiverton Four Corners RI 02878. (401)624-4000. E-mail: kebartlett@gmail.com; art@donovangallery.com. Website: www.donovangallery.com. **Owner:** Kris Donovan. Retail gallery. Estab. 1993. Represents 50 emerging, mid-career and established artists/year. Average display time: 1 month. Open all year; Monday-Saturday, 10-5; Sunday, 12-5; shorter winter hours. Located in a rural shopping area; 1750s historical home; 2,000 sq. ft. 100% of space for gallery artists. Clientele: tourists, upscale, local community and students. 90% private collectors, 10% corporate collectors. Overall price range: $100-6,500; most work sold at $250-800.

Media Considers oil, acrylic, watercolor, pastel, mixed media, collage, paper, ceramics, some craft, fiber and glass; and limited edition prints. Most frequently exhibits watercolors, oils and pastels.

Style Exhibits conceptualism, impressionism, photorealism and realism. Exhibits all genres. Prefers realism, impressionism and representational.

Terms Accepts work on consignment (45% commission). Retail price set by the artist. Gallery provides limited insurance, promotion and contract; artist pays for shipping. Prefers artwork framed.

Submissions Accepts only artists from New England. Send query letter with résumé, 6 slides, bio, brochure, photographs, SASE, business card, reviews and artist's statement. Call or write for appointment to show portfolio of photographs or slides or transparencies. Responds in 1 week. Files material for possible future exhibition. Finds artists through networking and submissions.

Tips "Do not appear without an appointment. Be professional, make appointments by telephone, be prepared with résumé, slides and (in my case) some originals to show. Don't give up. Join local art associations and take advantage of show opportunities there."

DOT FIFTYONE GALLERY

51 NW 36 St., Miami FL 33127. Phone/fax: (305)573-3754. E-mail: dot@dotfiftyone. com. Website: www.dotfiftyone.com. **Directors:** Isaac Perelman and Alfredo Guzman. For-profit gallery. Estab. 2004. Approached by 40+ artists/year. Represents or exhibits 10 artists. Sponsors 9 exhibits/year. Average display time: 40 days. Open Monday-Friday, 12-7; Saturdays and private viewings available by appointment. Located in the Wynwood Art District; approximately 7,000 sq. ft.; 2 floors. Overall price range: $600-30,000; most work sold at $6,000.

Media Considers all media, serigraphs and woodcuts; most frequently exhibits acrylic, installation, mixed media and oil.

Style Exhibits color field, conceptualism, expression, geometric abstraction, minimalism. Exhibits all genres including figurative work.

Terms Artwork is accepted on consignment (50% commission). Retail price set by the gallery and the artist. Gallery provides promotion and contract. Requires exclusive representation locally.

Submissions E-mail link to website. Write to arrange a personal interview to show portfolio. Mail portfolio for review. Finds artists through art fairs, portfolio reviews, referrals by other artists.

Tips "Have a good presentation. Contact the gallery first by e-mail. Never try to show work during an opening, and never show up at the gallery without an appointment."

DUCKTRAP BAY TRADING COMPANY

37 Bayview St., Camden ME 04843. (207)236-9568. Fax: (207)236-0950. E-mail: info@ducktrapbay.com. Website: www.ducktrapbay.com. **Owners:** Tim and Joyce Lawrence. Retail gallery. Estab. 1983. Represents 200 emerging, mid-career and established artists/year. Exhibited artists include Sandy Scott, Stefane Bougie, Yvonne Davis, Beki Killorin, Jim O'Reilly and Gary Eigenberger. Open all year; Monday-Saturday, 9-5, Sunday, 11-4. Located downtown waterfront; 2 floors 3,000 sq. ft. 100% of space for gallery artists. Clientele: tourists, upscale. 70% private collectors,

30% corporate collectors. Overall price range $250-120,000; most work sold at $250-2,500.

Media Considers watercolors, oil, acrylic, pastel, pen & ink, drawing, paper, sculpture, bronze and carvings. Types of prints include lithographs. Most frequently exhibits woodcarvings, watercolor, acrylic and bronze.

Style Exhibits realism. Genres include nautical, wildlife and landscapes. Prefers marine and wildlife.

Terms Accepts work on consignment (40% commission) or buys outright for 50% of the retail price (net 30 days). Retail price set by the artist. Gallery provides insurance and minimal promotion; artist pays for shipping. Prefers artwork framed.

Submissions Send query letter with 10-20 slides or photographs. Call or write for appointment to show portfolio of photographs. Files all material. Finds artists through word of mouth, referrals by other artists and submissions.

Tips "Find the right gallery and location for your subject matter. Have at least eight to ten pieces or carvings or three to four bronzes."

DURHAM ART GUILD

120 Morris St., Durham NC 27701-3242. (919)560-2713. E-mail: artguild1@yahoo.com. Website: www.durhamartguild.org. **Gallery Director:** Jennifer Collins. Nonprofit gallery. Estab. 1948. Represents/exhibits 500 emerging, mid-career and established artists/year. Sponsors more than 20 shows/year, including an annual juried art exhibit. Average display time: 6 weeks. Open all year; Monday-Saturday, 9-9; Sunday, 1-6. Free and open to the public. Located in center of downtown Durham in the Arts Council Building; 3,600 sq. ft.; large, open, movable walls. 100% of space for special exhibitions. Clientele: general public; 80% private collectors, 20% corporate collectors. Overall price range: $100-14,000; most work sold at $200-1,200.

Media Considers all media. Most frequently exhibits painting, sculpture and photography.

Style Exhibits all styles, all genres.

Terms Artwork is accepted on consignment (30-40% commission). Retail price set by the artist. Gallery provides insurance and promotion. Artist installs show. Prefers artwork framed.

Submissions Artists must be 18 years or older. Send query letter with résumé, slides and SASE. "We accept slides for review by February 1 for consideration of a solo exhibit or special projects group show." Finds artists through word of mouth, referral by other artists, call for slides.

Tips "Before submitting slides for consideration, be familiar with the exhibition space to make sure it can accommodate any special needs your work may require."

PAUL EDELSTEIN STUDIO AND GALLERY

540 Hawthorne St, Memphis TN 38112. (901)496-8122 fax: (901) 276-1493. E-mail: henrygrove@yahoo.com. Website: www.askart.com. **Director/Owner:** Paul R. Edelstein. Estab. 1985. "Shows are presented continually throughout the year." Overall price range: $300-10,000; most work sold at $1,000.

Media Considers all media and all types of prints. Most frequently exhibits oil, watercolor and prints.

Style Exhibits hard-edge geometric abstraction, color field, painterly abstraction, minimalism, postmodern works, feminist/political works, primitivism, photorealism, expressionism and neo-expressionism. Genres include florals, landscapes, Americana and figurative. Most frequently exhibits primitivism, painterly abstraction and expressionism.

Terms Charges 50% commission. Accepted work should be framed or unframed, mounted or unmounted, matted or unmatted work. There are no size limitations.

Submissions Send query letter with résumé, 20 slides, bio, brochure, photographs, SASE and business card. Cannot return material. Responds in 3 months. Finds artists mostly through word of mouth, *Art in America*, and also through publications like *Artist's & Graphic Designer's Market*.

Tips "Most artists do not present enough slides or their biographies are incomplete. Professional artists need to be more organized when presenting their work."

EMEDIALOFT.ORG

55 Bethune St., A-269, New York NY 10014-2035. E-mail: abc@emedialoft.org. Website: www.eMediaLoft.org. **Co-Director:** Barbara Rosenthal. Alternative space. Estab. 1982. Exhibits mid-career artists. Sponsors 4 exhibits/year. Average display time: 3 months. Open by appointment. Located in the West Village of New York City. Overall price range: $5-50,000; most work sold at $500-2,000.

Media Considers installation, mixed media, oil, watercolor. Most frequently exhibits performance videos, artists' books, photography. Considers Xerox, offset, digital prints ("if used creatively").

Style Exhibits conceptualism, primitivism realism, surrealism. Genres include Americana, figurative work, landscapes.

Terms Artwork is accepted on consignment (50% commission). Accepts work from artists over age 30.

Submissions E-mail 250 words and 5 JPEGs (72 dpi max, 300 px on longest side). Or send query letter with "anything you like, but no SASE—sorry, we can't return anything. We may keep you on file, but please do not telephone." Responds to queries only if interested.

Tips "Create art from your subconscious, even if it ooks like something recognizable; don't illustrate ideas. No political art. Be sincere and probably misunderstood. Be hard to categorize. Show me art that nobody 'gets,' but please, nothing 'psychadelic.'

Intrigue me: Show me something I really haven't seen in anything like your way before. Don't start your cover letter with 'my name is...' Take a hard look at the artists' pages on our website before you send anything."

ETHERTON GALLERY

135 S. Sixth Ave., Tucson AZ 85701. (520)624-7370. Fax: (520)792-4569. E-mail: info@ethertongallery.com. Website: www.ethertongallery.com. **Contact:** Terry Etherton. Retail gallery and art consultancy. Specializes in vintage and contemporary photography. Estab. 1981. Represents 50+ emerging, mid-career and established artists. Exhibited artists include Holly Roberts, Rocky Schenck, Kate Breakey, James G. Davis and Mark Klett. Sponsors 4 shows/year. Average display time 8 weeks. Open year round. Located "downtown; 3,000 sq. ft.; in historic building—wood floors, 16 ft. ceilings." 75% of space for special exhibitions; 10% of space for gallery artists. Clientele: 50% private collectors, 25% corporate collectors, 25% museums. Overall price range $500-50,000; most work sold at $1,000-4,000.
Media Considers all types of photography, oil, acrylic, drawing, mixed media, collage, sculpture, ceramic, original handpulled prints, woodcuts, wood engravings, linocuts, engravings, mezzotints, etchings and lithographs. Most frequently exhibits photography and painting.
Style Exhibits expressionism, neo-expressionism, primitivism, postmodern works. Genres include landscapes, portraits and figurative work. Prefers expressionism, primitive/folk and post-modern. Interested in seeing work that is "cutting-edge, contemporary, issue-oriented, political."
Terms Accepts work on consignment (50% commission). Buys outright for 50% of retail price (net 30 days). Retail price set by gallery and artist. Gallery provides insurance and promotion; shipping costs are shared. Prefers framed artwork.
Submissions Only "cutting-edge contemporary—no decorator art." No "unprepared, incomplete works or too wide a range—not specific enough." Send résumé, brochure, disk, slides, photographs, reviews, bio and SASE. Call or write to schedule an appointment to show a portfolio, which should include disk. Responds in 6 weeks only if interested.
Tips "Become familiar with the style of our gallery and with contemporary art scene in general."

FARMINGTON VALLEY ARTS CENTER'S FISHER GALLERY

25 Arts Center Lane, Avon CT 06001. (860)678-1867. Fax: (860)674-1877. E-mail: info@fvac.net. Website: www.artsfvac.org. **Executive Director:** Marty Rotblatt. Nonprofit gallery. Estab. 1972. Exhibits the work of 100 emerging, mid-career and established artists. Open all year; Wednesday-Saturday, 11-5; Sunday, 12-5; extended hours November-December. Located in Avon Park North just off Route

44; 850 sq. ft.; "in a beautiful 19th-century brownstone factory building once used for manufacturing." Clientele: upscale contemporary art craft buyers. Overall price range: $35-500; most work sold at $50-100.

Media Considers "primarily crafts," also some mixed media, works on paper, ceramic, fiber, glass and small prints. Most frequently exhibits jewelry, ceramics and fiber.

Style Exhibits contemporary, handmade craft.

Terms Accepts artwork on consignment (50% commission). Retail price set by the artist. Gallery provides promotion and contract; shipping costs are shared. Requires artwork framed where applicable.

Submissions Send query letter with résumé, bio, digital images, SASE. Responds only if interested.

THE FLYING PIG LLC

N6975 State Hwy. 42, Algoma WI 54201. (920)487-9902. Fax: (920)487-9904. E-mail: theflyingpig@charterinternet.com. Website: www.theflyingpig.biz. **Owner/Member:** Susan Connor. For-profit gallery. Estab. 2002. Exhibits approximately 150 artists. Open daily, 9-6 (May 1st-October 31st); Thursday-Sunday, 10-5 (winter). Clients include local community, tourists and upscale. Overall price range: $5-3,000; most work sold at $300.

Media Considers all media.

Style Exhibits impressionism, minimalism, painterly abstraction and primitivism realism. Most frequently exhibits primitivism realism, impressionism and minimalism. Genres include outsider and visionary.

Terms Artwork is accepted on consignment (40% commission) or bought outright for 50% of retail price, net 15 days. Retail price set by the artist. Gallery provides insurance, promotion and contract. Accepted work should be framed. Does not require exclusive representation locally.

Submissions Send query letter with artist's statement, bio and photographs. Returns material with SASE. Responds to queries in 3 weeks. Files artist's statement, bio and photographs if interested. Finds artist's through art fairs and exhibitions, referrals by other artists, submissions, word of mouth and Online.

GANNON & ELSA FORDE GALLERIES

1500 Edwards Ave., Bismarck ND 58501. (701)224-5520. Fax: (701)224-5550. E-mail: Michelle_Lind blom@bsc.nodak.com. Website: www.bismarckstate.com. **Gallery Director:** Michelle Lindblom. College gallery. Represents emerging, mid-career and established art exhibitions. Sponsors 6 shows/year. Average display time 6 weeks. Open all year; Monday-Thursday, 9-9; Friday, 9-4; Sunday, 6-9. Summer exhibit is college student work (May-August). Located on Bismarck State College campus; high traffic areas on campus. Clientele all. 80% private collectors, 20% corporate collectors. Overall price range $50-10,000; most work sold at $50-3,000.

Media Considers oil, acrylic, watercolor, pastel, drawing, mixed media, collage, paper, sculpture, ceramics, fiber, photography, woodcut, engraving, lithograph, wood engraving, mezzotint, serigraphs, linocut and etching. Most frequently exhibits painting media (all), mixed media and sculpture.

Style Exhibits expressionism, neo-expressionism, painterly abstraction, surrealism, impressionism, photorealism, hard-edge geometric abstraction and realism, all genres.

Terms Accepts work on consignment (20% commission). Retail price set by the artist. Gallery provides insurance on premises, promotion, contract and shipping costs from gallery; artist pays shipping costs to gallery. Prefers artwork framed.

Submissions Send query letter with résumé, slides, bio and SASE. Call or write for appointment to show portfolio of photographs and slides. Responds in 2 months. Files résumé, bio, photos if sent. Finds artists through word of mouth, art publications, artists' submissions, visiting exhibitions.

Tips "Because our gallery is a university gallery, the main focus is to expose the public to art of all genres. However, we do sell work, occasionally."

FOSTER/WHITE GALLERY

220 Third Avenue South, Suite 100, Seattle WA 98104. (206)622-2833. Fax: (206)622-7606. E-mail: seattle@fosterwhite.com. Website: www.fosterwhite.com. **Owner/Director:** Phen Huang. Retail gallery. Estab. 1973. Represents 60 emerging, mid-career and established artists. Interested in seeing the work of local emerging artists. Exhibited artists include Mark Tobey, George Tsutakawa, Morris Graves, and William Morris. Average display time 1 month. Open all year; Tuesday-Saturday, 10am-6pm; closed Sunday. Located historic Pioneer Square; 7,500 sq. ft. Clientele private, corporate and public collectors. Overall price range $300-35,000; most work sold at $2,000-8,000.

- Gallery has additional spaces at Ranier Square, 1331 Fifth Ave., Seattle WA 98101, (206)583-0100. Fax: (206)583-7188.

Media Considers oil, acrylic, watercolor, pastel, pen & ink, drawing, mixed media, collage, paper, sculpture, ceramics, craft, fiber, glass and installation. Most frequently exhibits glass sculpture, works on paper and canvas and ceramic and metal sculptures.

Style Contemporary Northwest art. Prefers contemporary Northwest abstract, contemporary glass sculpture.

Terms Gallery provides insurance, promotion and contract.

Submissions E -mail submissions are prefered. Responds in 2 months.

FOXHALL GALLERY

3301 New Mexico Ave. NW, Washington DC 20016. (202)966-7144. Fax: (202)363-2345. E-mail: foxhallgallery@foxhallgallery.com. Website: www.foxhallgallery.com.

Director: Jerry Eisley. Retail gallery. Represents emerging and established artists. Sponsors 6 solo and 6 group shows/year. Average display time 3 months. Overall price range $500-20,000; most artwork sold at $1,500-6,000.

Media Considers oil, acrylic, watercolor, pastel, sculpture, mixed media, collage and original handpulled prints (small editions).

Style Exhibits contemporary, abstract, impressionistic, figurative, photorealistic and realistic works and landscapes.

Terms Accepts work on consignment (50% commission). Retail price set by gallery and artist. Customer discounts and payment by installment are available. Exclusive area representation required. Gallery provides insurance.

Submissions Send résumé, brochure, slides, photographs and SASE. Call or write for appointment to show portfolio. Finds artists through agents, by visiting exhibitions, word of mouth, various art publications and sourcebooks, artists' submissions, self promotions and art collectors' referrals.

Tips To show in a gallery artists must have "a complete body of work—at least 30 pieces, participation in a juried show and commitment to their art as a profession."

THE FRASER GALLERY

7700 Wisconsin Ave., Suite E, Bethesda MD 20814. (301)718-9651. E-mail: info@ thefraser gallery.com. Website: www.thefrasergallery.com. **Director:** Catriona Fraser. For-profit gallery. Estab. 1996. Approached by 500 artists/year; represents 25 artists and sells the work of an additional 75 artists. Average display time: 1 month. Open Tuesday-Saturday, 11:30-6. Closed Sunday and Monday except by appointment. Overall price range: $200-20,000; most work sold at under $5,000.

Media Considers acrylic, drawing, mixed media, oil, paper, pastel, pen & ink, sculpture and watercolor. Most frequently exhibits oil, photography and drawing. Types of prints include engravings, etchings, linocuts, mezzotints and woodcuts.

Style Most frequently exhibits contemporary realism. Genres include figurative work and surrealism.

Terms Artwork is accepted on consignment (50% commission). Gallery provides insurance, promotion, contract. Accepted work should be framed, matted to full conservation standards. Requires exclusive representation locally.

Submissions Send query letter with bio, reviews, slides or CD-ROM, SASE. Responds in 1 month. Finds artists through submissions, portfolio reviews, art fairs/exhibits.

Tips "Research the background of the gallery, and apply to galleries that show your style of work. All work should be framed or matted to full museum standards."

FRESNO ART MUSEUM

2233 N. First St., Fresno CA 93703. (559)441-4221. Fax: (559)441-4227. E-mail: info@ fresno artmuseum.org. Website: www.fresnoartmuseum.org. **Executive Director:** Eva

Torres. Curator: Jacquelin Pilar. Estab. 1948. Exhibitions change approximately every 4 times a year. Open Tuesday-Sunday, 11-5; and until 8 on Thursdays. Accredited by AAM.

Media Considers acrylic, ceramics, collage, drawing, glass, installation, mixed media, oil, paper, pastel, pen & ink, sculpture and watercolor. Most frequently exhibits painting, sculpture and prints. Types of prints include engravings, etchings, linocuts, lithographs, serigraphs, woodcuts and fine books.

Style Exhibits contemporary and modernist art.

Terms Museum does not take commission. Retail price set by the artist. Gallery provides insurance.

Submissions Write to arrange a personal interview to show portfolio of transparencies and slides or mail portfolio for review. Send query letter with bio, résumé and slides. Files letters and bio/résumé. Finds artists through portfolio reviews and art exhibits. Be sure to include *"Artist's & Graphic Designers Market"* on correspondence.

🌐 GALERIA VERTICE

Lerdo de Tejada #2418 Col. Laffayette, C.P. 44140, Guadalajara, Jalisco, México. (5233) 36160078. Fax: (5233) 33160079. E-mail: grjsls@mail.udg.mx. Website: www.verticegaleria.com. **Director:** Luis Garca Jasso. Estab. 1988. Approached by 20 artists/year; exhibits 12 emerging, mid-career and established artists/year. Sponsors 10 exhibitions/year. Average display time: 20 days. Open all year. Clients include local community, students and tourists. Overall price range: $5,000-100,000.

Media Considers all media except installation. Considers all types of prints.

Style Considers all styles. Most frequently exhibits abstraction, new-figurativism and realism. Considers all genres.

Terms Artwork is accepted on consignment (40% commission). Retail price set by the gallery. Gallery provides insurance, promotion and contract. Accepted work should be framed. Requires exclusive representation locally.

Submissions Mail portfolio for review or send artist's statement, bio, brochure, photocopies, photographs and résumé. Responds to queries in 3 weeks. Finds artists through art fairs, art exhibits and portfolio reviews.

GALERIE BONHEUR

10046 Conway Rd., St. Louis MO 63124. (314)993-9851. Fax: (314)993-9260. E-mail: gbonheur@aol .com. Website: www.galeriebonheur.com. **Owner:** Laurie Griesedieck Carmody. Private retail and wholesale gallery. Focus is on international folk art. Estab. 1980. Represents 60 emerging, mid-career and established artists/year. Exhibited artists include Milton Bond and Justin McCarthy. Sponsors 6 shows/year. Average display time: 1 year. Open all year; by appointment. Located in Ladue (a suburb of St. Louis); 3,000 sq. ft.; art is displayed all over very large private home. 75% of sales to private collectors. Overall price range: $25-25,000; most work sold at $50-1,000.

Media Considers oil, acrylic, watercolor, pastel, pen & ink, drawing, mixed media, collage, paper, sculpture, ceramics and craft. Most frequently exhibits oil, acrylic and metal sculpture.

Style Exhibits expressionism, primitivism, impressionism, folk art, self-taught, outsider art. Genres include landscapes, florals, Americana and figurative work. Prefers genre scenes and figurative.

Terms Accepts work on consignment (50% commission). Retail price set by the gallery and the artist. Gallery provides promotion; artist pays shipping costs to and from gallery. Prefers artwork framed.

Submissions Prefers only self-taught artists. Send query letter with bio, photographs and business card. Write for appointment to show portfolio of photographs. Responds within 6 weeks, only if interested. Finds artists through agents, visiting exhibitions, word of mouth, art publications, sourcebooks and submissions.

Tips "Be true to your inspirations. Create from the heart and soul. Don't be influenced by what others are doing; do art that you believe in and love and are proud to say is an expression of yourself. Don't copy; don't get too sophisticated or you will lose your individuality!"

⚅ GALLERY 54, INC.

54 Upham, Mobile AL 36607. (251)473-7995. E-mail: gallery54art1@aol.com. **Owner:** Leila Hollowell. Retail gallery. Estab. 1992. Represents 35 established artists/year. May be interested in seeing the work of emerging artists in the future. Exhibited artists include Charles Smith and Lee Hoffman. Sponsors 5 shows/year. Average display time: 1 month. Open all year; Tuesday-Saturday, 11-4:30. Located in midtown, about 560 sq. ft. Clientele: local; 70% private collectors, 30% corporate collectors. Overall price range: $20-6,000; most work sold at $200-1,500.

Media Considers oil, acrylic, watercolor, pastel, pen & ink, drawing, mixed media, collage, sculpture, ceramics, glass, photography, woodcuts, serigraphs and etchings. Most frequently exhibits acrylic/abstract, watercolor and pottery.

Style Exhibits expressionism, painterly abstraction, impressionism and realism. Prefers realism, abstract and impressionism.

Terms Accepts work on consignment (40% commission) or buys outright for 50% of retail price (net 30 days). Retail price set by the artist. Gallery provides contract. Artist pays shipping costs. Prefers framed artwork.

Submissions Southern artists preferred (mostly Mobile area). "It's easier to work with artist's work on consignment." Send query letter with slides and photographs. Write for appointment to show portfolio of photographs and slides. Responds in 2 weeks. Files information on artist. Finds artists through art fairs, referrals by other artists and information in mail.

Tips "Don't show up with work without calling and making an appointment."

GALLERY 110 COLLECTIVE

110 S. Washington St., Seattle WA 98104. E-mail: director@gallery110.com. Website: www.gallery 110.com. **Director:** Sarah Dillon. Estab. 2002. Represents 28 artists. "Our exhibits change monthly and consist of curated group and solo shows by gallery artists. We also display intimate solo shows in our Loft Space." Open Wednesday-Saturday, 12-5; hosts receptions every First Thursday of the month, 6-8 pm. Located in the historic gallery district of Pioneer Square. Overall price range: $125-3,000; most work sold at $500-800.

Media Considers all media.

Style Exhibits all styles and genres.

Terms Artwork by gallery artists only is accepted on consignment (consignment options selected by artists individually within the contract); Gallery provides insurance, promotion, contract (nonexclusive).

Submissions Please follow directions on the Submission page of our website if you are interested in becoming an artist member. New members considered yearly or on a space available basis. Some membership duties apply.

Tips "We want to know that the artist has researched us. We want to see original and creative works that shows the artist is aware of both contemporary art and art history. We seek artists who intend to actively contribute and participate as a gallery member."

GALLERY 400

College of Architecture and the Arts, University of Illinois at Chicago, 400 S. Peoria St. (MC 034), Chicago IL 60607. (312)996-6114. Fax: (312)355-3444. E-mail: uicgallery400@gmail.com. Website: http://gallery400.aa.uic.edu. **Director:** Lorelei Stewart. Nonprofit gallery. Estab. 1983. Approached by 500 artists/year; exhibits 80 artists. Sponsors 8 exhibits/year. Average display time: 4-6 weeks. Open Tuesday-Friday, 10-6; Saturday, 12-6. Clients include local community, students, tourists and upscale.

Media Considers drawing, installation, painting, photography, design, architecture, mixed media and sculpture.

Style Exhibits conceptualism, minimalism and postmodernism. Most frequently exhibits contemporary conceptually based artwork.

Terms Gallery provides insurance and promotion.

Submissions Check info section of web site for guidelines. Responds in 5 months. Finds artists through word of mouth, art exhibits, referrals by other artists.

Tips "Check our website for guidelines for proposing an exhibition and follow those proposal guidelines. Please do not e-mail, as we do not respond to e-mails."

GALLERY 1988: LOS ANGELES

7020 Melrose Ave., Los Angeles CA 90038. (323)937-7088. Fax: (323)937-8756. E-mail: gallery1988@ aol.com. Website: www.gallery1988.com. For-profit gallery. Estab. 2004. Exhibits emerging artists. Approached by 300 artists/year; represents or exhibits 100 artists. Sponsors 15 exhibits/year. Average display time: 3 weeks. Open Tuesday-Sunday, 11-6. Closed Monday and national holidays. Located in the heart of Hollywood; 1,250 sq. ft. with 20-ft.-high walls. Clients include local community, students, upscale. Overall price range: $75-15,000; most work sold at $750.

• Second location: 1173 Sutter St., San Francisco CA 94109.

Media Considers acrylic, drawing, oil, paper, pen & ink. Most frequently exhibits acrylic, oil, pen & ink. Types of prints include limited edition giclées.

Style Exhibits surrealism and illustrative work. Prefers character-based works.

Terms Artwork is accepted on consignment. Retail price set by both the artist and gallery. Gallery provides insurance, promotion, contract. Accepted work should be framed.

Submissions Accepts e-mail submissions only. Send query e-mail (subject line: "submission") with link to website or 3-4 JPEG samples. Keeps website addresses on file. Cannot return material. Responds to queries within 4 weeks, only if interested. Finds artists through art exhibits, submissions, referrals by other artists, word of mouth.

Tips "Keep your e-mail professional and include prices. Stay away from trying to be funny, which you'd be surprised to know happens a *lot*. We are most interested in the art."

GALLERY@49

322 W. 49th St., New York NY 10019. (212)581-0867. E-mail: info@gallery49.com. Website: www.gallery49.com. **Contact:** Monica or Coca Rotaru.

• Gallery is now closed. Works can still be purchased by contacting us directly.

THE GALLERY AT 910

910 Santa Fe Dr., Denver CO 80204. (303)815-1779. Fax: (303)333-2820. E-mail: info@thegalleryat910.com. Website: www.thegalleryat910.com. **Curator:** Michele Renée Ledoux. Alternative space; for-profit gallery; nonprofit gallery; rental gallery; community educational outreach. Estab. 2007. Exhibits emerging, mid-career and established artists. Sponsors 6 exhibits/year in main gallery; 6/year in community; 2/year in sculpture garden. Average display time: 2 months in gallery/community; 6 months in sculpture garden. Open Tuesday-Friday, 12-6; Saturday, 10-2; Monday by appointment. "Gallery hours may vary. Hours as listed unless otherwise posted. Please check website." Located in Denver's Art District on Santa Fe at Nine10Arts, Denver's only green-built creative artist community; 1,300 sq. ft.; 105 linear ft.;

additional 76 linear ft. of movable walls. Clients include local community, students, tourists, upscale.

Media Considers all media, including performance art. Considers all types of prints except posters.

Style Considers all styles and genres.

Terms Artwork is accepted on consignment (35% commission); or there is a rental fee for space. Retail price set by the artist. Gallery provides insurance, promotion, contract.

Submissions See website or contact for guidelines. Responds to queries "as soon as possible." Cannot return material. Keeps all submitted materials on file if interested. Finds artists through submissions, art fairs/exhibits, portfolio reviews, art competitions, referrals by other artists, word of mouth.

Tips "Adhere to submission guidelines. Visit website prior to submitting to ensure work fits gallery's mission."

GALLERY BERGELLI

483 Magnolia Ave., Larkspur CA 94939. (415)945-9454. Fax: (415)945-0311. E-mail: gallery@bergelli.com. Website: www.gallerybergelli.com. **Owner:** Robin Critelli. For-profit gallery. Estab. 2000. Approached by 200 artists/year; exhibits 15 emerging artists/year. Exhibited artists include Jeff Faust and James Leonard (acrylic painting). Sponsors 8-9 exhibits/year. Average display time: 6 weeks. Open daily, 10-4. "We're located in affluent Marin County, just across the Golden Gate Bridge from San Francisco. The Gallery is in the center of town, on the main street of Larkspur, a charming village known for its many fine restaurants. It is spacious and open with 2,500 square feet of exhibition space with large window across the front of the building. Moveable hanging walls (see the home page of our website) give us great flexibility to customize the space to best show the current exhibition." Clients include local community, upscale in the Marin County & Bay Area. Overall price range is $2,000-26,000; most work sold at $4,000-10,000. Also publishes Jeff Faust through Bergelli Limited. Seeking other artists for publishing: www.bergellilimited. com.

Media Considers acrylic, collage, mixed media, oil, pastel, sculpture. Most frequently exhibits acrylic, oil and sculpture.

Style Exhibits geometric abstraction, imagism, new-expressionism, painterly abstraction, postmodernism, surrealism. Most frequently exhibits painterly abstraction, imagism and neo-expressionism.

Terms Artwork is accepted on consignment (50% commission). Retail price set by the artist with gallery input. Gallery provides insurance and promotion. Accepted work should be matted, stretched, unframed and ready to hang. Requires exclusive representation locally. Artwork evidencing geographic and cultural differences is viewed favorably.

Submissions E-mail portfolio for review or send query letter with artist's statement, bio, and low resolution jpegs. Returns material with SASE. Responds to queries in 1 month. Files material not valuable to the artist (returns slides) that displays artist's work. Finds artists through art exhibits, portfolio reviews, referrals by other artists, submissions and word of mouth.

Tips "Your submission should be about the artwork, the technique, the artist's accomplishments, and perhaps the artist's source of creativity. Many artist's statements are about the emotions of the artist, which is irrelevant when selling paintings."

GALLERY M

2830 E. Third Ave., Denver CO 80206. (303)331-8400. Fax: (303)331-8522. E-mail: newartists@gallerym.com. Website: www.gallerym.com. **Contact:** Managing Partner. For-profit gallery. Estab. 1996. Average display time: 6-12 weeks. Overall price range: $1,000-75,000.

Media Considers acrylic, collage, drawing, glass, installation, mixed media, oil, paper, pastel, pen & ink, watercolor, engravings, etchings, linocuts, lithographs, mezzotints, serigraphs, woodcuts, photography and sculpture.

Style Exhibits color field, expressionism, geometric abstraction, neo-expressionism, postmodernism, primitivism, realism and surrealism. Considers all genres.

Terms Retail price set by the gallery and the artist. Gallery provides insurance and promotion. Requires exclusive local and regional representation.

Submissions "Artists interested in showing at the gallery should visit the Artist Submissions section of our website (under Site Resources). The gallery provides additional services for both collectors and artists, including our quarterly newsletter, *The Art Quarterly.*"

☓ GALLERY NAGA

67 Newbury St., Boston MA 02116. (617)267-9060. Fax: (617)267-9040. E-mail: mail@gallerynaga.com. Website: www.gallerynaga.com. **Director:** Arthur Dion. Retail gallery. Estab. 1977. Represents 30 emerging, mid-career and established artists. Sponsors 9 shows/year. Average display time: 1 month. Open Tuesday-Saturday, 10-5:30. Closed during August. Located on "the primary street for Boston galleries;" housed in a 1,500-sq.-ft historic neo-gothic church. Clientele: 90% private collectors, 10% corporate collectors. Overall price range: $500-60,000; most work sold at $2,000-10,000.

Media Considers oil, acrylic, mixed media, photography, studio furniture. Most frequently exhibits painting and furniture.

Style Exhibits expressionism, painterly abstraction, postmodern works and realism. Genres include landscapes, portraits and figurative work. Prefers expressionism, painterly abstraction and realism.

Terms Accepts work on consignment (50% commission). Retail price set by gallery and artist. Gallery provides insurance and promotion; artist pays for shipping. Prefers artwork framed.

Submissions "Not seeking submissions of new work at this time." See website for updates.

Tips "We focus on Boston and New England artists. We exhibit the most significant studio furniture makers in the country. Become familiar with any gallery to see if your work is appropriate before you make contact."

THE FANNY GARVER GALLERY

230 State St., Madison WI 53703. (608)256-6755. E-mail: art@fannygarvergallery. com. Website: www.fannygarvergallery.com. **President:** Jack Garver. Retail Gallery. Estab. 1972. Represents 100 emerging, mid-career and established artists/year. Exhibited artists include Lee Weiss, Jaline Pol. Sponsors 11 shows/year. Average display time: 1 month. Open all year; Monday-Thursday, 10-6; Friday, 10-8; Saturday, 10-6; Sunday, 12-4 (closed Sundays Jan-April). Located downtown; 3,000 sq. ft.; older refurbished building in unique downtown setting. 33% of space for special exhibitions; 95% of space for gallery artists. Clientele: private collectors, gift-givers, tourists. 40% private collectors, 10% corporate collectors. Overall price range: $100-10,000; most work sold at $100-1,000.

Media Considers oil, pen & ink, paper, fiber, acrylic, drawing, sculpture, glass, watercolor, mixed media, ceramics, pastel, collage, craft, woodcuts, wood engravings, linocuts, engravings, mezzotints, etchings, lithographs and serigraphs. Most frequently exhibits watercolor, oil and glass.

Style Exhibits all styles. Prefers landscapes, still lifes and abstraction.

Terms Accepts work on consignment (50% commission) or buys outright for 50% of retail price (net 30 days). Retail price set by gallery. Gallery provides promotion and contract, artist pays shipping costs both ways. Prefers artwork framed.

Submissions Send query letter with résumé, 8 slides, bio, brochure, photographs and SASE. Write for appointment to show portfolio, which should include originals, photographs and slides. Responds within 1 month, only if interested. Files announcements and brochures.

Tips "Don't take it personally if your work is not accepted in a gallery. Not all work is suitable for all venues."

GERING & LOPEZ GALLERY

730 Fifth Ave., New York NY 10019. (646)336-7183. Fax: (646)336-7185. E-mail: info@gering lopez.com. Website: www.geringlopez.com. **Partner:** Sandra Gering. For-profit gallery. Estab. 2006. Exhibits emerging, mid-career and established artists. Open Tuesday-Saturday, 10-6 (June 22 through Labor Day: Tuesday-Friday, 10-6; Saturday and Monday by appointment). Located in the historic Crown Building.

- This is a new gallery created through the partnership of Sandra Gering (formerly of Sandra Gering Gallery, New York) and Javier López (formerly of Galeriía Javier López, Madrid).

Media Considers mixed media, oil, sculpture and digital. Most frequently exhibits computer-based work, electric (light) sculpture and video/DVD.

Style Exhibits geometric abstraction. Most frequently exhibits cutting edge.

Terms Artwork is accepted on consignment.

Submissions Send e-mail query with link to website and JPEGs. Cannot return material. Responds within 6 months, only if interested. Finds artists through word of mouth, art fairs/exhibits, and referrals by other artists.

GRAND RAPIDS ART MUSEUM

101 Monroe Center, Grand Rapids MI 49503. (616)831-1000. E-mail: pr@gr-artmuseum.org. Website: www.gramonline.org. Museum. Estab. 1910. Exhibits established artists. Sponsors 3 exhibits/year. Average display time 4 months. Open all year; Tuesday-Thursday, 10-5; Friday, 10-8:30; Sunday, 12-5. Closed Mondays and major holidays. Located in the heart of downtown Grand Rapids, the Grand Rapids Art Museum presents exhibitions of national caliber and regional distinction. The museum collection spans Renaissance to modern art, with particular strength in 19th and 20th century paintings, prints and drawings. Clients include local community, students, tourists, upscale.

Media Considers all media and all types of prints. Most frequently exhibits paintings, prints and drawings.

Style Considers all styles and genres. Most frequently exhibits impressionist, modern and Renaissance.

GREATER LAFAYETTE MUSEUM OF ART

102 S. Tenth St., Lafayette IN 47905. (765)742-1128. E-mail: glenda@glmart.org. Website: http://glmart.org. **Executive Director:** Les Reker. Museum. Estab. 1909. Temporary exhibits of American and Indiana art as well as work by emerging, mid-career and established artists from Indiana and the midwest. 1,340 members. Sponsors 5-7 shows/year. Average display time 10 weeks. Located 6 blocks from city center; 3,318 sq. ft.; 4 galleries. Clientele includes Purdue University faculty, students and residents of Lafayette/West Lafayette and 14 county area.

Style Exhibits all styles. Genres include landscapes, still life, portraits, abstracts, non-objective and figurative work.

Terms Accepts some crafts for consignment in gift shop (35% mark-up).

Submissions Send query letter with résumé, slides, artist's statement and letter of intent.

Tips "Indiana artists specifically encouraged to apply."

HALLWALLS CONTEMPORARY ARTS CENTER

341 Delaware Ave., Buffalo NY 14202. (716)854-1694. Fax: (716)854-1696. E-mail: john@ hallwalls.org. Website: www.hallwalls.org. **Visual Arts Curator:** John Massier. Nonprofit multimedia organization. Estab. 1974. Sponsors 10 exhibits/year. Average display time: 6 weeks.

Media Considers all media.

Style Exhibits all styles and genres. "Contemporary cutting edge work which challenges traditional cultural and aesthetic boundaries."

Terms Retail price set by artist. "Sales are not our focus. If a work does sell, we suggest a donation of 15% of the purchase price." Gallery provides insurance.

Submissions Send material by mail for consideration. Work may be kept on file for additional review for 1 year.

HAMPTON UNIVERSITY MUSEUM

11 Frissell Av., Hampton VA 23669. (757)727-5308. Fax: (757)727-5170. E-mail: museum@hamptonu.edu. Website: www.hamptonu.edu. **Director:** Mary Lou Hultgren. Museum. Estab. 1868. Represents/exhibits established artists. Exhibited artists include Elizabeth Catlett and Jacob Lawrence. Sponsors 3-4 shows/year. Average display time 12-18 weeks. Open all year; Monday-Friday, 8-5; Saturday, 12-4; closed on Sunday, major and campus holidays. Located on the campus of Hampton University.

Media Considers all media and all types of prints. Most frequently exhibits oil or acrylic paintings, ceramics and mixed media.

Style Exhibits African-American, African and/or Native American art.

Submissions Send query letter with résumé and a dozen or more slides. Portfolio should include photographs and slides.

Tips "Familiarize yourself with the type of exhibitions the Hampton University Museum typically mounts. Do not submit an exhibition request unless you have at least 35-45 pieces available for exhibition. Call and request to be placed on the Museum's mailing list so you will know what kind of exhibitions and special events we're planning for the upcoming year(s)."

THE HARWOOD MUSEUM OF ART

238 Ledoux St., Taos NM 87571-6004. (505)758-9826. Fax: (505)758-1475. E-mail: harwood@unm .edu. Website: www.harwoodmuseum.org. **Curator:** Margaret Bullock. Estab. 1923. Approached by 100 artists/year; represents or exhibits more than 200 artists. Sponsors 10 exhibits/year. Average display time: 3 months. Open Tuesday-Saturday, 10-5; Sunday, 12-5. Consists of 7 galleries, 2 of changing exhibitions. Clients include local community, students and tourists. 1% of sales are to corporate collectors. Overall price range: $1,000-5,000; most work sold at $2,000.

Media Considers all media and all types of prints.

Style Considers all styles and genres.

Terms Artwork is accepted on consignment (40% commission). Gallery provides insurance, contract. Accepted work should be framed, mounted, matted. "The museum exhibits work by Taos, New Mexico, artists as well as major artists from outside our region."

Submissions Mail portfolio for review. Send query letter with artist's statement, bio, brochure, résumé, reviews, SASE, slides. Responds in 3 months. Finds artists through word of mouth, submissions, art exhibits, referrals by other artists.

Tips "The gift shop accepts some art on consignment, but the museum itself does not."

JANE HASLEM GALLERY

2025 Hillyer St. NW, Washington DC 20009-1005. (202)232-4644. Fax: (202)387-0679. E-mail: haslem@artline.com. Website: www.JaneHaslemGallery.com. For-profit gallery. Estab. 1960. Approached by hundreds of artists/year; exhibits 75-100 emerging, mid-career and established artists/year. Exhibited artists include Garry Trudeau (cartoonist), Mark Adams (paintings, prints, tapestry), Nancy McIntyre (prints). Sponsors 6 exhibits/year. Average display time 7 weeks. Open by appointment. Located at DuPont Circle across from Phillips Museum; 2 floors of 1886 building; 3,000 square feet. Clients include local community, students, upscale and collectors worldwide. 5% of sales are to corporate collectors. Overall price range is $30-30,000; most work sold at $500-2,000.

Media Considers acrylic, collage, drawing, mixed media, oil, paper, pastel, pen & ink, watercolor. Most frequently exhibits prints and works on paper. Considers engravings, etchings, linocuts, lithographs, mezzotints, serigraphs, woodcuts and digital images.

Style Exhibits expressionism, geometric abstraction, neo-expressionism, pattern painting, painterly abstraction, postmodernism, surrealism. Most frequently exhibits abstraction, realism and geometric. Genres include figurative work, florals and landscapes.

Terms Artwork is accepted on consignment and there is a 50% commission. Retail price set by the artist and the gallery. Gallery provides promotion and contract. Accepts only artists from the US. Prefers only prints, works on paper and paintings.

Submissions Artists should contact via e-mail. Returns material with SASE. Responds to queries only if interested in 3 months. Finds artists through art fairs and exhibits, referrals by other artists and word of mouth.

Tips "100% of our sales are Internet generated. We prefer all submissions initially by e-mail."

⊞ WILLIAM HAVU GALLERY

1040 Cherokee St., Denver CO 80204 (303)893-2360. Fax: (303)893-2813. E-mail: bhavu@mho.net. Website: www.williamhavugallery.com. **Owner:** Bill Havu. Gallery Administrator: Nick Ryan. For-profit gallery. Estab. 1998. Exhibits 50 emerging, mid-career and established artists. Exhibited artists include Emilio Lobato (painter and printmaker) and Amy Metier (painter). Sponsors 7-8 exhibits/year. Average display time: 6-8 weeks. Open all year; Tuesday-Friday, 10-6; Saturday, 11-5. Closed Sundays, Christmas and New Year's Day. Located in the Golden Triangle Arts District of downtown Denver; the only gallery in Denver designed as a gallery; 3,000 sq. ft., 18-ft.-high ceilings, 2 floors of exhibition space; sculpture garden. Clients include local community, students, tourists, upscale, interior designers and art consultants. Overall price range: $250-18,000; most work sold at $1,000-4,000.

Media Considers acrylic, ceramics, collage, drawing, mixed media, oil, paper, pastel, pen & ink, sculpture and watercolor. Most frequently exhibits painting, prints. Considers etchings, linocuts, lithographs, mezzotints, woodcuts, monotypes, monoprints and silkscreens.

Style Exhibits expressionism, geometric abstraction, impressionism, minimalism, postmodernism, surrealism and painterly abstraction. Most frequently exhibits painterly abstraction and expressionism.

Terms Artwork is accepted on consignment (50% commission). Retail price set by the gallery and the artist. Gallery provides insurance, promotion and contract. Accepted work should be framed. Primarily accepts only artists from Rocky Mountain/Southwestern region.

Submissions Mail portfolio for review. Send query letter with artist's statement, bio, brochure, résumé, SASE and slides. Returns material with SASE. Files slides and résumé, if interested in the artist. Responds within 1 month, only if interested. Finds artists through word of mouth, submissions and referrals by other artists.

Tips "Always mail a portfolio packet. We do not accept walk-ins or phone calls to review work. Explore our website or visit gallery to make sure work would fit with the gallery's objective. Archival-quality materials play a major role in selling fine art to collectors. We only frame work with archival-quality materials and feel its inclusion in work can 'make' the sale."

HEAVEN BLUE ROSE CONTEMPORARY GALLERY

LLC934 Canton St, Roswell GA 30075 (770-642-7380). E-mail: info@heavenbluerose. com. Website: www.heavenbluerose.com. **Contact:** Director Catherine Moore. Estab. 1991. Showing fresh, original contemporary art of established and emerging artists from Metropolitan Atlanta. Exhibited artists include owner Catherine Moore (interpretive water color, mixed media on paper and canvas), Ron Pircio (" famous" pear paintings in oil and pastel), Leslie Cohen (unique figurative executions in oil on wood, handmade paper and beeswax) and Faith Tatum (vibrant life scapes in acrylic

and oil). Average exhibit run is 6 weeks. Open all year; Tuesday-Saturday 11-5:30; Sunday 1-4; closed Monday. "Located in the Historic Art and Cultural District of Roswell GA. One-of-a-kind, carefully selected 2 and 3 dimensional works tastefully placed in a two-level gallery, creating inviting spaces with fantastic energy! Artfully curated for each exhibit. Exemplary reputation both from artists and buyers." 10% of sales from corporate collectors. Overall price range $200 - $7000; most work average $1100.

Media Considers contemporary acrylic, collage, drawing, fiber, glass, mixed media, oil, paper, pastel, sculpture, watercolor, photography, wood.

Style Exhibits color field, nontraditional works of conceptualism, expressionism, geometric abstraction, minimalism, neo-expressionism, surrealism and painterly abstraction. Considers all genres.

Terms Artwork is accepted based on submission guidelines. 50% commission. Gallery provides contract. Work must be properly finished/framed, ready to hang. 25 mile radius non-compete clause.

Submissions Call for guidelines or view online. Artists also selected by invitation through referrals.

Tips "Properly framed /finished art is crucial. Consistency of work, available inventory, quality and integrity of artist and work are imperative."

MARIA HENLE STUDIO

55 Company St., Christiansted, St. Croix VI 00820. E-mail: mariahenle@earthlink. net. Website: www.mariahenlestudio.com. **Owner:** Maria Henle. For-profit gallery. Estab. 1993. Exhibits mid-career and established artists. Approached by 4 artists/ year; represents or exhibits 7 artists. Sponsors 4 exhibits/year. Average display time: 1 month. Open Monday-Friday, 11-5; weekends, 11-3. Closed part of September/ October. Located in an 18th-century loft space in historical Danish West Indian town; 750 sq. ft. Clients include local community, tourists, upscale. 10% of sales are to corporate collectors. Overall price range: $600-6,000; most work sold at $600.

Media Considers all media. Most frequently exhibits painting, photography, printmaking. Types of prints include etchings, mezzotints.

Style Considers all styles. Most frequently exhibits realism, primitive realism, impressionism. Genres include figurative work, landscapes, Caribbean.

Terms Artwork is accepted on consignment (40% commission). Retail price set by the artist. Gallery provides promotion. Accepted work should be matted. Requires exclusive representation locally.

Submissions Call or send query letter with artist's statement, bio, brochure. Returns material with SASE. Responds in 4 weeks. Files promo cards, brochures, catalogues. Finds artists through art exhibits, referrals by other artists, submissions.

Tips "Present good slides or photos neatly presented with a clear, concise bio."

THE HENRY ART GALLERY

15th Ave. NE and NE 41st St., Seattle WA 98195-1410. (206)543-2280. Fax: (206)685-3123. E-mail: info@henryart.org. Website: www.henryart.org. **Curatorial Associate**: Misa Jeffereis. Contemporary Art Museum. Estab. 1927. Exhibits emerging, mid-career, and established artists. Presents 18 exhibitions/year. Open Thursday-Friday, 11-9; Saturday-Sunday, 11-4. Located "on the western edge of the University of Washington campus. Parking is often available in the underground Central Parking garage at NE 41st St. On Sundays, free parking is usually available. The Henry Art Gallery can be reached by over twenty bus routes. Call Metro at (206)553-3000 (http://transit.metroke.gov) or Community Transit at (425)778-2785 for additional information." Clients include local community, students, and tourists.

Media Considers all media. Most frequently exhibits photography, video, and installation work. Exhibits all types of prints.

Style Exhibits contemporary art.

Terms Does not require exclusive representation locally.

Submissions Send query letter with artist statement, résumé, SASE, 10-15 images. Returns material with SASE. Responds to queries quarterly. Finds artists through art exhibitions, exhibition announcements, individualized research, periodicals, portfolio reviews, referrals by other artists, submissions, and word of mouth.

MARTHA HENRY INC. FINE ART

400 E. 57th St., Suite 7L, New York NY 10022. (212)308-2759. Fax: (212)754-4419. E-mail: info@marthahenry.com. Website: www.marthahenry.com or www.artnet.com/marthahenry.html. **President:** Martha Henry. Estab. 1987. Art consultancy. Exhibits emerging, mid-career and established artists, specializing in art by African Americans. Approached by over 200 artists/year; exhibits over 12 artists/year. Exhibited artists include Jan Muller (oil paintings), Mr. Imagination (sculpture), JAMA (acrylic paintings) and Bob Thompson (oil paintings). Sponsors 6 exhibits/year. Average display time: 4 days to 6 weeks. Open all year; by appointment only. Located in a private gallery in an apartment building. 5% of sales are to corporate collectors. Overall price range: $5,000-200,000; most work sold under $50,000.

Terms Accepts all artists, with emphasis on African-American artists.

Submissions Mail portfolio for review or send query letter with artist's statement, bio, photocopies, photographs, slides and SASE. Returns material with SASE. Responds in 3 months. Files slides, bio or postcard. Finds artists through art fairs and exhibits, portfolio reviews, referrals by other artists, submissions, word of mouth and press.

HENRY STREET SETTLEMENT/ABRONS ART CENTER

265 Henry St., New York NY 10002. (212)766-9200. E-mail: info@henrystreet.org. Website: www.henrystreet.org. **Visual Arts Coordinator:** Martin Dust. Estab. 1970.

Alternative space, nonprofit gallery, community center. Sponsors 5-6 exhibits/year. Average display time: 1-2 months. Open Monday-Friday, 9-6; weekends, 12-6. Closed major holidays.

Media Considers all media and all types of prints. Most frequently exhibits mixed media, sculpture and painting.

Style Considers all styles and genres.

Terms Artwork is accepted on consignment (20% commission). Gallery provides insurance and contract.

Submissions Send query letter with artist's statement, résumé and SASE. Returns material with SASE. Files résumés. Finds artists through word of mouth, submissions and referrals by other artists.

HERA EDUCATIONAL FOUNDATION AND ART GALLERY

23 North Road, Lily Pads Office Complex, Bldg A, Suite 24, Peace Dale RI 02879 or P.O. Box 336, Wakefield RI 02880. (401)789-1488. E-mail: info@heragallery.org. Website: www.heragallery.org. **Director:** Chelsea Heffner. Cooperative gallery. Estab. 1974. Sponsors 9-10 shows/year. Average display time: 6 weeks. Open Wednesday-Friday, 1-5; Saturday, 10-4. Closed during January. Sponsors openings; provides refreshments and entertainment or lectures, demonstrations and symposia for some exhibits. Overall price range: $100-10,000.

Media Considers all media and original handpulled prints.

Style Exhibits installations, conceptual art, expressionism, neo-expressionism, painterly abstraction, surrealism, conceptualism, postmodern works, realism and photorealism, basically all styles. "We are interested in innovative, conceptually strong, contemporary works that employ a wide range of styles, materials and techniques." Prefers "a culturally diverse range of subject matter which explores contemporary social and artistic issues important to us all."

Terms Co-op membership. Gallery charges 25% commission. Retail price set by artist. Sometimes offers customer discount and payment by installments. Gallery provides promotion; artist pays for shipping and shares expenses such as printing and postage for announcements. Works must fit inside a 6'6" × 2'6" door.

Submissions Inquire about membership and shows. Responds in 6 weeks. Membership guidelines and application available on website or mailed on request. Finds artists through word of mouth, advertising in art publications, and referrals from members.

Tips "Hera exhibits a culturally diverse range of visual and emerging artists. Please follow the application procedure listed in the Membership Guidelines. Applications are welcome at any time of the year."

GERTRUDE HERBERT INSTITUTE OF ART

506 Telfair St., Augusta GA 30901-2310. (706)722-5495. Fax: (706)722-3670. E-mail: ghia@ghia.org. Website: www.ghia.org. Nonprofit gallery. Estab. 1937. Exhibits 40 emerging, mid-career and established artists in 5 solo/group shows annually. Exhibited artists include John Kingerlee, Luis Cruz Azaceta, Tom Nakashima. Sponsors 5 exhibits/year. Average display time: 6-8 weeks. Open Tuesday-Friday, 10-5; Saturdays by advance appointment only; closed first week in August, December 20-31. Located in historic 1818 Ware's Folly mansion. Clients include local community, tourists and upscale. Approx. 5% of sales are to corporate collectors. Overall price range: $100-5,000; most work sold at $500.

Media Considers all media except craft. Considers all types of prints.

Style Exhibits all styles.

Terms Artwork is accepted on consignment (35% commission). Retail price set by the artist. Gallery provides insurance and promotion. Accepted works on paper must be framed and under Plexiglass. Does not require exclusive representation locally.

Submissions Send query letter with artist statement, bio, brochure, résumé, reviews, SASE, slides or CD of current work. Returns material with SASE. Responds to queries quarterly after expeditions review committee meets. Finds artists through art exhibits, referrals by other artists and submissions.

THE HIGH MUSEUM OF ART

1280 Peachtree St. NE, Atlanta GA 30309. (404)733-4444. Fax: (404)733-4529. E-mail: highmuseum@woodruffcenter.org. Website: www.high.org. Museum. Estab. 1905. Exhibits emerging, mid-career and established artists. Has over 11,000 works of art in its permanent collection. The museum has an extensive anthology of 19th and 20th century American art; significant holdings of European paintings and decorative art; a growing collection of African-American art; and burgeoning collections of modern and contemporary art, photography and African art. Open Tuesday, Wednesday, Friday, Saturday, 10-5; Thursday, 10-8; Sunday, 12-5; closed Mondays and national holidays. Located in Midtown Atlanta. The Museum's building, designed by noted architect Richard Meier, opened to worldwide acclaim in 1983 and has received many design awards, including 1991 citation from the American Institute of Architects as one of the "ten best works of American architecture of the 1980s." Meier's 135,000-sq.-ft. facility tripled the Museum's space, enabling the institution to mount more comprehensive displays of its collections. In 2003, to celebrate the twentieth anniversary of the Richard Meier-designed building, the High unveiled enhancements to its galleries and interior, and a new, chronological installation of its permanent collection. Three new buildings, designed by Italian architect Renzo Piano, more than double the Museum's size to 312,000 sq. ft. This allows the High to display more of its growing collection, increase educational and exhibition programs, and offer new visitor amenities to address the needs of larger and more diverse

audiences. The expansion strengthens the High's role as the premier art museum in the Southeast and allows the Museum to better serve its growing audiences in Atlanta and from around the world. Clients include local community, students, tourists and upscale.

Media Considers all media and prints.

Style Considers all styles and genres.

Terms Retail price is set by the gallery and the artist. Gallery provides insurance, promotion and contract.

Submissions Call, e-mail or write to arrange a personal interview to show portfolio of slides, artist's statement, bio, résumé and reviews. Returns materials with SASE.

HILLEL JEWISH STUDENT CENTER GALLERY

2615 Clifton Ave., Cincinnati OH 45220. (513)221-6728. Fax: (513)221-7134. E-mail: email@hillelcincinnati.org. Website: www.hillelcincinnati.org. **Director:** Elizabeth Harold. Nonprofit gallery, museum. Estab. 1982. Represents 5 emerging artists/ academic year. Exhibited artists include Gordon Baer, Irving Amen and Lois Cohen. Sponsors 5 shows/year. Average display time 5-6 weeks. Open fall, winter, spring; Monday-Thursday, 9-5; Friday, 9-3; other hours in conjunction with scheduled programming. Located uptown (next to University of Cincinnati); 1,056 sq. ft.; features the work of Jewish artists in all media; listed in AAA Tourbook; has permanent collection of architectural and historic Judaica from synagogues. 20% of space for special exhibitions; 80% of space for gallery artists. Clientele upscale, community, students. 90% private collectors, 10% corporate collectors. Overall price range $150-3,000; most work sold at $150-800.

Media Considers all media except installations. Considers all types of prints. Most frequently exhibits prints/mixed media, watercolor, photographs.

Style Exhibits all styles. Genres include landscapes, figurative work and Jewish themes. Avoids minimalism and hard-edge geometric abstraction.

Terms Artwork accepted for exhibit and there is a 30% commission. Retail price set by the artist. Gallery provides insurance, promotion, contract, opening reception; shipping costs are shared. Prefers artwork framed.

Submissions "With rare exceptions, we feature Jewish artists." Send query letter with slides, bio or photographs, SASE. Call or write for appointment to show portfolio. Responds in 1 week. Files bios/résumés, description of work.

HONOLULU ACADEMY OF ARTS

900 S. Beretania St., Honolulu HI 96814. (808)532-8700. Fax: (808)532-8787. E-mail: academypr@honoluluacademy.org. Website: www.honoluluacademy.org. **Director:** Stephen Little, Ph.D. Nonprofit museum. Estab. 1927. Exhibits emerging, mid-career and established Hawaiian artists. Interested in seeing the work of emerging artists.

Sponsors 40-50 shows/year. Average display time 6-8 weeks. Open all year; Tuesday-Saturday 10-4:30, Sunday 1-5. Located just outside of downtown area; 40,489 sq. ft. 30% of space for special exhibition. Clientele general public and art community.

Media Considers all media. Most frequently exhibits painting, works on paper, sculpture.

Style Exhibits all styles and genres. Prefers traditional, contemporary and ethnic.

Terms "On occasion, artwork is for sale." Retail price set by artist. Museum provides insurance and promotion; museum pays for shipping costs. Prefers artwork framed.

Submissions Exhibits artists of Hawaii. Send query letter with résumé, slides and bio directly to curator(s) of Western and/or Asian art. Curators are Jennifer Saville, Western art; Julia White, Asian art. Write for appointment to show portfolio of slides, photographs and transparencies. Responds in 3-4 weeks. Files resumes, bio.

Tips "Be persistent but not obnoxious." Artists should have completed a body of work of 50-100 works before approaching galleries.

EDWARD HOPPER HOUSE ART CENTER

82 North Broadway, Nyack NY 10960. (845)358-0774. E-mail: info@hopperhouse. org. Website: www.hopperhouse.org. **Director:** Carole Perry. Nonprofit gallery, historic house. Estab. 1971. Approached by 200 artists/year. Exhibits 100 emerging, mid-career and established artists. Sponsors 9 exhibits/year. Average display time 5 weeks. Open all year; Thursday-Sunday from 1-5. The house was built in 1858. There are four gallery rooms on the first floor. Clients include local community, students, tourists, upscale. Overall price range $100-12,000; most work sold at $750.

Media Considers all media and all types of prints except posters. Most frequently exhibits watercolor, photography, oil.

Style Considers all styles and genres. Most frequently exhibits realism, abstraction, expressionism.

Terms Artwork is accepted on consignment and there is a 35% commission. Retail price set by the artist. Gallery provides insurance, promotion and contract. Accepted work should be framed, mounted and matted. Does not require exclusive representation locally.

Submissions Call or check web site for submission guidelines. Send query letter with artist's statement, bio, brochure, business card, photocopies, photographs, résumé, reviews, SASE and slides. Returns material with SASE. Files all materials unless return specified and paid. Finds artists through art fairs, art exhibits, portfolio reviews, referrals by other artists, submissions and word of mouth.

Tips "When shooting slides, don't have your artwork at an angle and don't have a chair or hands in the frame. Make sure the slides look professional and are an accurate representation of your work."

HYDE PARK ART CENTER

5020 S. Cornell Av., Chicago IL 60615. (773)324-5520. Fax: (773)324-6641. E-mail: generalinfo@hydeparkart.org. Website: http://hydeparkart.org. **Executive Director:** Allison Peters, Director of Exhibitions. Nonprofit gallery. Estab. 1939. Exhibits emerging artists. Sponsors 8 group shows/year. Average display time is 4-6 weeks. Office/Gallery open Monday-Thursday, 9-8; Friday-Saturday, 9-5; Sunday, 12-5. "Primary focus on Chicago area artists not currently affiliated with a retail gallery." Clientele: general public. Overall price range $100-10,000.

Media Considers all media. Interested in seeing "innovative work by new artists; also interested in proposals from curators, groups of artists."

Terms Accepts work "for exhibition only." Retail price set by artist. Sometimes offers payment by installment. Exclusive area representation not required. Gallery provides insurance and contract.

Submissions Send cover letter, resume, CD with 10-15 slides, artist's statement of 250-400 words, and SASE attn: Allison Peters, Director of Exhibitions.

Tips "Do not bring work in person."

ICEBOX QUALITY FRAMING & GALLERY

1500 Jackson St. NE, Suite 443, Minneapolis MN 55413. (612)788-1790. Fax: (612)788-6947. E-mail: icebox@bitstream.net. Website: www.iceboxminnesota.com. **Owner:** Howard M. Christopherson. Exhibition, promotion and sales gallery. Estab. 1988. Represents photographers and fine artists in all media, predominantly photography. "A sole proprietorship gallery, Icebox sponsors installations and exhibits in the gallery's 2,200-sq.-ft. space in the Minneapolis Arts District." Overall price range: $200-2,500; most work sold at $200-800.

Media Considers mostly photography, with the door open for other fine art with some size and content limitations.

Style Exhibits photos of multicultural, environmental, landscapes/scenics, rural, adventure, travel and fine art photographs from artists with serious, thought-provoking work. Interested in alternative process, documentary, erotic, historical/vintage.

Terms Charges 50% commission.

Submissions "Send letter of interest telling why and what you would like to exhibit at Icebox. Include only materials that can be kept at the gallery and updated as needed. Check website for more details about entry and gallery history."

Tips "Be more interested in the quality and meaning of your artwork than in a way to make money. Unique thought provoking artwork of high quality is more likely suited." Not interested in wall decor art.

☒ ILLINOIS STATE MUSEUM CHICAGO GALLERY

100 W. Randolph, Suite 2-100, Chicago IL 60601. (312)814-5322. Fax: (312)814-3471. E-mail: jstevens@museum.state.il.us. Website: www.museum.state.il.us. **Assistant Administrator:** Jane Stevens. Museum. Estab. 1985. Exhibits emerging, mid-career and established artists. Sponsors 2-3 shows/year. Average display time: 5 months. Open all year. Located "in the Chicago loop, in the James R. Thompson Center designed by Helmut Jahn." 100% of space for special exhibitions.

Media All media considered, including installations.

Style Exhibits all styles and genres, including contemporary and historical work.

Terms "We exhibit work but do not handle sales." Gallery provides insurance and promotion; artist pays for shipping. Prefers artwork framed.

Submissions Accepts only artists from Illinois. Send résumé, 10 high-quality slides or CD, bio and SASE.

☒ INDIANAPOLIS ART CENTER

820 E. 67th St., Indianapolis IN 46220. (317)255-2464. Fax: (317)254-0486. E-mail: exhibs@indplsartcenter.org. Website: www.indplsartcenter.org. **Director of Exhibitions:** David Kwasigroh. Estab. 1934. Nonprofit art center. Prefers emerging artists. Sponsors 10-15 exhibits/year. Average display time: 8 weeks. Overall price range: $50-5,000; most work sold at $500.

Media Considers all media and all types of original prints. Most frequently exhibits painting, sculpture installations and fine crafts.

Style Exhibits all styles. "In general, we do not exhibit genre works. We do maintain a referral list, though." Prefers postmodern works, installation works, conceptualism, large-scale outdoor projects.

Terms Charges 35% commission. One-person show: $300 honorarium; 2-person show: $200 honorarium; 3-person show: $100 honorarium; plus $0.32/mile travel stipend (one way). Accepted work should be framed (or other finished-presentation formatted). Prefers artists who live within 250 miles of Indianapolis.

Submissions Send minimum of 20 digital images with résumé, reviews, artist's statement and SASE between July 1 and December 31.

Tips "Research galleries thoroughly; get on their mailing lists, and visit them in person at least twice before sending materials. Find out the 'power structure' of the targeted galleries and use it to your advantage. Most artists need to gain experience exhibiting in smaller or nonprofit spaces before approaching a traditional gallery. Work needs to be of consistent, dependable quality. Have slides done by a professional if possible. Stick with one style—no scattershot approaches. Have a concrete proposal with installation sketches (if it's never been built). We book two years in advance—plan accordingly. Do not call. Put me on your mailing list one year before sending application so I can be familiar with your work and record. Ask to be put on my mailing list so you know the gallery's general approach. It works!"

INDIAN UPRISING GALLERY™

25 S. Tracy Ave., Bozeman MT 59715. (406)586-5831. Fax: (406)582-9848. E-mail: www.indian uprisinggallery@msn.com Website: www.indianuprisinggallery. com. **Owner:** Iris Model. Retail gallery "dedicated exclusively to American Indian contemporary art featuring the unique beauty and spirit of the Plains Indians." The gallery specializes in ledger drawings, painted hides, jewelry. Artists include Linda Haukaas, Donald Montileaux, Dwayne Wilcox, Pauls Szabo, Jackie Bread. Open all year,

Media Considers all media. Most frequently exhibits contemporary works by gallery artists..

Terms Buys outright at wholesale price. On occasion takes consignments. Gallery provides

Submissions Accepts only Native American artists of the Plains region. Send resume, slides, bio and artist's statement. Write for appointment to show portfolio of photographs. Responds in 2 weeks. Finds artists through visiting museums and juried art shows.

INDIVIDUAL ARTISTS OF OKLAHOMA

P.O. Box 60824, 811 N. Broadway, Oklahoma City OK 73146. (405)232-6060. Fax: (405)232-6061. E-mail: stokes@iaogallery.org. Website: www.IAOgallery.org. **Director:** Jeff Stokes, executive director. Alternative space. Founding member of NAAO. Estab. 1979. Approached by 60 artists/year. Represents 30 emerging, mid-career and established artists/year. Sponsors 30 exhibits/year. Average display time 3-4 weeks. Open all year; Tuesday-Friday, 11-4; Saturday, 1-4. Located in downtown arts district; 2,300 sq. ft.; 10 foot ceilings; track lighting. Clients include local community, students, tourists and upscale. 33% of sales are to corporate collectors. Overall price range $100-1,000; most work sold at $400.

Media Considers all media. Most frequently exhibits photography, painting, installation.

Style Considers all styles. Most frequently exhibits "bodies of work with cohesive style and expressed in a contemporary viewpoint." Considers all genres.

Submissions Mail portfolio for review. Send artist's statement, bio, photocopies or slides, résumé and SASE. Returns material with SASE. Responds in 3 months. Finds artists through word of mouth, art exhibits and referrals by other artists.

Tips "Individual Artists of Oklahoma is committed to sustaining and encouraging emerging and established artists in all media who are intellectually and aesthetically provocative or experimental in subject matter or technique."

THE JAMESON ART GROUP

377 Cumberland Avenue, PO Box 8702, Portland ME 04104. (207)772-5522. Fax: (941)

527-1435. E-mail info@jamesongallery.com. **Gallery Director:** Michael Rancourt. Retail gallery, restoration, appraisals, consultation. Estab. 1992. Jameson Gallery represents mid-career and established artists. Exhibited artists include William Manning, Jason Berger, Charles DuBack, Denis Boudreau, Nathaniel Larrabee, Jon A. Marshall, Leo Brooks, Geoff Smith; the estates of Lynne Drexler, Edward Christiana. Mounts 4 - 6 shows/year. Average display time 3-4 weeks. Open all year; Thursday-Saturday, 12pm - 5:30pm. The gallery also deals in late 19th and early 20th century paintings and in mid to late twentieth century Abstract Expressionism and American Modernism. Clientele consists of local community, corporate, upscale, summer residents. Overall price range most work sold at $1,500-100,000. Most frequently exhibited: oil, watercolor, photographs and sculpture. Retail price set by the gallery. Gallery DOES NOT provide insurance; artist pays shipping costs. Prefers artwork unframed, but will judge on a case by case basis. Artists may buy framing contract with gallery's affiliated, off-site frame shop. Send CV and artist's statement, a sampling of images on a PC-compatible CD and SASE if you would like the materials returned.

MADELYN JORDON FINE ART

14 Chase Rd., Scarsdale NY 10583. (914)472-4748. E-mail: mrjart@aol.com. Website: www.madelynjordanfineart.com. **Contact:** Madelyn Jordon. Art consultancy, for-profit gallery. Estab. 1991. Approached by 50 artists/year. Exhibits 40 mid-career and established artists. Exhibited artists include Ted Larsen and Lawrence Kelsey. Clients include local community and upscale. 10% of sales are to corporate collectors. Overall price range $500-30,000; most work sold at $3,000-10,000.

Media Considers all media and all types of prints. Most frequently exhibits paintings, works on paper and sculpture.

Style Considers all styles and genres.

Terms Gallery provides insurance and promotion. Requires exclusive representation locally.

Submissions Send artist's statement, bio, photographs, SASE or slides. Returns material with SASE.

KAVANAUGH ART GALLERY

131 Fifth St., W. Des Moines IA 50265. (515)279-8682. Fax: (515)279-7609. E-mail: kagallery@ aol.com. Website: www.kavanaughgallery.com. **Director:** Carole Kavanaugh. Retail gallery. Estab. 1990. Represents 100 mid-career and established artists/year. May be interested in seeing the work of emerging artists in the future. Exhibited artists include Kati Roberts, Don Hatfield, Dana Brown, Gregory Steele, August Holland, Ming Feng and Larry Guterson. Sponsors 3-4 shows/year. Averge display time 3 months. Open all year; Monday-Saturday, 10-5. Located in Valley

Junction shopping area; 10,000 sq. ft. 70% private collectors, 30% corporate collectors. Overall price range $300-20,000; most work sold at $800-3,000.

Media Considers all media and all types of prints. Most frequently exhibits oil, acrylic and pastel.

Style Exhibits color field, impressionism, realism, florals, portraits, western, wildlife, southwestern, landscapes, Americana and figurative work. Prefers landscapes, florals and western.

Terms Accepts work on consignment (50% commission). Retail price set by the artist. Gallery provides insurance, promotion and contract. Shipping costs are shared. Prefers artwork unframed.

Submissions Send query letter with resume, bio and photographs. Portfolio should include photographs. Responds in 3 weeks. Files bio and photos. Finds artists through word of mouth, referrals by other artists, visiting art fairs and exhibitions, artist's submissions.

Tips "Get a realistic understanding of the gallery/artist relationship by visiting with directors. Be professional and persistent."

THE KENTUCK ART CENTER

503 Main Ave., Northport AL 35476-4483. (205)758-1257. Fax: (205)758-1258. E-mail: Kentuck @kentuck.org. Website: www.kentuck.org. **Executive Director:** Sara Anne Gibson. Nonprofit gallery. Estab. 1980. Exhibits emerging artists. Approached by 400 artists/year. Represents 100 artists/year. Sponsors 18 exhibits/year. Average display time 1 month. Open all year; Monday-Friday, 9-5; weekends 10-4:30. Closed major holidays. Clients include local community. 5% of sales are to corporate collectors. Overall price range $150-10,000; most work sold at $400.

Media Considers all media. Most frequently exhibits mixed media, oil and pastel. Considers all types of prints except posters.

Style Exhibits Considers all styles. Most frequently exhibits painterly abstraction, expressionism, conceptualism.

Terms Artwork is accepted on consignment and there is a 40% commission. Artwork is bought outright for 50% of retail price; net 30 days. Retail price set by the artist. Gallery provides insurance, promotion and contract. Accepted work should be mounted. Requires exclusive representation locally.

Submissions Write to arrange a personal interview to show portfolio of slides. Mail portfolio for review. Returns material with SASE. Responds in 6 months. Finds artists through word of mouth, submissions, portfolio reviews, art exhibits and referrals by other artists.

Tips "Submit professional slides."

KENTUCKY MUSEUM OF ART AND CRAFT

715 West Main, Louisville KY 40202. (502)589-0102. Fax: (502)589-0154. E-mail: admin@ kentuckyarts.org. Website: www.kentuckyarts.org. **Contact:** Brion Clinkingbeard, deputy director of programming/curator. Nonprofit gallery, museum. Estab. 1981. Approached by 300 artists/year. Represents 100 emerging, mid-career and established artists. Sponsors 20 exhibits/year. Average display time 4-6 weeks. Open all year; Monday-Friday, 10-5; Saturday, 11-5. Located in downtown Louisville, one block from the river; 3 galleries, one on each floor. Clients include local community, students, tourists, upscale. 10% of sales are to corporate collectors. Overall price range $50-40,000; most work sold at $200.

Media Considers all media and all types of prints. Most frequently exhibits ceramics, glass, craft.

Style Exhibits primitivism realism.

Terms Artwork is accepted on consignment and there is a 50% commission. Retail price set by the artist. Gallery provides insurance, promotion and contract. Accepted work should be framed and matted. Does not require exclusive representation locally.

Submissions Send query letter with artist's statement, bio, photocopies, photographs, SASE and slides. Returns material with SASE. Responds to queries in 1 month. Files bio, artist's statement and copy of images. Finds artists through art fairs, art exhibits, portfolio reviews, referrals by other artists and submissions.

Tips "Clearly identify reason for wanting to work with KMAC. Show a level of professionalism and a proven track record of exhibitions."

KIRSTEN GALLERY, INC.

5320 Roosevelt Way NE, Seattle WA 98105. (206)522-2011. E-mail: kirstengallery@ qwest.net. Website: www.kirstengallery.com. **President:** R. Kirsten. Retail gallery. Estab. 1974. Represents 60 emerging, mid-career and established artists. Exhibited artists include Birdsall and Daiensai. Sponsors 4 shows/year. Average display time 1 month. Open all year. Open Monday-Sunday, 11-5. 3,500 sq. ft.; outdoor sculpture garden. 40% of space for special exhibitions; 60% of space for gallery artists. 90% private collectors, 10% corporate collectors. Overall price range $75-15,000; most work sold at $75-2,000.

Media Considers oil, acrylic, watercolor, mixed media, sculpture, glass and offset reproductions. Most frequently exhibits oil, watercolor and glass.

Style Exhibits surrealism, photorealism and realism. Genres include landscapes, florals, Americana. Prefers realism.

Terms Accepts work on consignment (50% commission). Retail price set by artist. Offers payment by installments. Gallery provides promotion; artist pays shipping costs. "No insurance; artist responsible for own work."

Submissions Send query letter with résumé, slides and bio. Write for appointment

to show portfolio of photographs and/or slides. Responds in 2 weeks. Files bio and résumé. Finds artists through visiting exhibitions and word of mouth.

Tips "Keep prices down. Be prepared to pay shipping costs both ways. Work is not insured (send at your own risk). Send the best work—not just what you did not sell in your hometown. Do not show up without an appointment."

⊕ ♦ MARIA ELENA KRAVETZ ART GALLERY

San Jerónimo 448, 5000 Córdoba Argentina. (54)351 4221290. Fax: (54)351 4271776. E-mail: mek@mariaelenakravetzgallery.com. Website: www.mariaelenakravetzgallery.com. **Director:** Maria Elena Kravetz. For-profit gallery. Estab. 1998. Approached by 30 artists/year; exhibits 16 emerging and mid-career artists/year. Exhibited artists include Sol Halabi (paintings) and Paulina Ortiz (fiber art). Average display time: 25 days. Open Monday-Friday, 4:30pm-8:30pm; Saturday, by appointment. Closed Sunday. Closed January and February. Located in the main downtown of Cordoba city; 170 square meters, 50 spotlights and white walls. Clients include local community and tourists. Overall price range: $500-10,000; most work sold at $1,500-5,000.

Media Considers all media. Most frequently exhibits glass sculpture and mixed media. Considers etchings, linocuts, lithographs and woodcuts.

Style Considers all styles. Most frequently exhibits new-expressionism and painterly abstraction. Considers all genres.

Terms Artwork is accepted on consignment (30% commission). Retail price set by the artist. Requires exclusive representation locally. Prefers only artists from South America and emphasizes sculptors.

Submissions Mail portfolio for review. Cannot return material. Responds to queries in 1 month. Finds artists through art fairs and exhibits, portfolio reviews, referrals by other artists, submissions and word of mouth.

Tips Artists "must indicate a Web page to make the first review of their works, then give an e-mail address to contact them if we are interested in their work."

LAKE GEORGE ARTS PROJECT / COURTHOUSE GALLERY

1 Amherst St., Lake George NY 12845. (518)668-2616. E-mail: mail@lakegeorgearts.org. Website: www.lakegeorgearts.org. **Gallery Director:** Laura Von Rosk. Alternative space; nonprofit gallery. Estab. 1986. Exhibits emerging, mid-career and established artists. Approached by 200 artists/year; exhibits 8-15 artists/year. Average display time: 5 weeks. Open Tuesday-Friday, 12-5; Saturday, 12-4.

Media "We show work in any media."

Style Considers all styles.

Terms Artwork is accepted on consignment (25% commission). Retail price set by the artist. Gallery provides insurance, promotion, contract.

Submissions Annual deadline for open call is January 31. Send artist's statement, résumé, 10-12 images (slides or CD), image script and SASE. Guidelines available on website. Returns material with SASE. Finds artists through art exhibits, portfolio reviews, referrals by other artists, submissions, word of mouth.

Tips Do not send e-mail submissions or links to websites. Do not send original art. Review guidelines on website.

LANCASTER MUSEUM OF ART

135 N. Lime St., Lancaster PA 17602. (717)394-3497. Fax: (717)394-0101. E-mail: info@lmapa.org. Website: www.lmapa.org. **Executive Director:** Cindi Morrison. Nonprofit organization. Estab. 1965. Represents over 100 emerging, mid-career and established artists/year. 900+ members. Sponsors 12 shows/year. Average display time 6 weeks. Open all year; Monday-Saturday, 10-4; Sunday, 12-4. Located downtown Lancaster; 4,000 sq. ft.; neoclassical architecture. 100% of space for special exhibitions. 100% of space for gallery artists. Overall price range $100-25,000; most work sold at $100-10,000.

Media Considers all media.

Terms Accepts work on consignment (30% commission). Retail price set by the artist. Gallery provides insurance; shipping costs are shared. Artwork must be ready for presentation.

Submissions Send query letter with résumé, slides, photographs or CDs, SASE, and artist's statement for review by exhibitions committee. Annual deadline February 1st.

Tips Advises artists to submit quality slides and well-presented proposal. "No phone calls."

LANDING GALLERY

7956 Jericho Turnpike, Woodbury NY 11797. (516)364-2787. Fax: (516)364-2786. E-mail: landinggallery@aol.com. **President:** Bruce Busko. For-profit gallery. Estab. 1985. Approached by 40 artists/year. Exhibits 50 emerging, mid-career and established artists. Exhibited artists include Bruce Busko, mixed media; Edythe Kane, watercolor. Sponsors 2 exhibits/year. Average display time: 2-3 months. Open all year; Monday-Saturday, 10-6; Sunday, 11-4. Closed Tuesdays all year, Sundays in summer. Located in the middle of Long Island's affluent North Shore communities, 30 miles east of New York City. 3,000 sq. ft. on 2 floors with 19-ft. ceilings. The brick building is on the corner of a major intersection. Clients include local community, tourists and upscale. 5% of sales are to corporate collectors. Overall price range: $100-12,000; most work sold at $1,500-2,000.

Media Considers all media. Most frequently exhibits paintings, prints and sculpture. Considers engravings, etchings, lithographs, mezzotints and serigraphs.

Style Considers all styles. Most frequently exhibits realism, abstract and impressionism. Considers figurative work, florals and landscapes.

Terms Artwork is accepted on consignment (50% commission). Retail price set by the gallery. Gallery provides insurance, promotion and contract. Accepted work should be framed. Requires exclusive representation locally.

Submissions Call to arrange a personal interview to show portfolio of photographs, slides and transparencies. Mail portfolio for review. Send query letter with artist's statement, bio, brochure, business card, photocopies, photographs, résumé, reviews, SASE and slides. Returns material with SASE. Responds in 2 weeks. Files photos, slides, photocopies and information. Finds artists through word of mouth, submissions, portfolio reviews, art exhibits, art fairs and referrals by other artists.

Tips "Permanence denotes quality and professionalism."

LATINO ARTS, INC.

1028 S. Ninth, Milwaukee WI 53204. (414)384-3100. Fax: (414)649-2849. E-mail: info@latinoartsinc.org. Website: www.latinoartsinc.org. **Visual Artist Specialist:** Zulay Oszkay. Nonprofit gallery. Represents emerging, mid-career and established artists. Sponsors up to 5 individual and group exhibitions/year. Average display time 2 months. Open all year; Monday-Friday, 9-8. Located in the near southeast side of Milwaukee; 1,200 sq. ft.; one-time church. Clientele: the general Hispanic community. Overall price range $100-2,000.

Media Considers all media, all types of prints. Most frequently exhibits original 2- and 3-dimensional works and photo exhibitions.

Style Exhibits all styles, all genres. Prefers artifacts of Hispanic cultural and educational interests.

Terms "Our function is to promote cultural awareness (not to be a sales gallery)." Retail price set by the artist. Artist is encouraged to donate 15% of sales to help with operating costs. Gallery provides insurance, promotion, contract, shipping costs to gallery; artist pays shipping costs from gallery. Prefers artwork framed.

Submissions Send query letter with résumé, slides, bio, business card and reviews. Call or write for appointment to show portfolio of photographs and slides. Responds in 2 weeks. Finds artists through recruiting, networking, advertising and word of mouth.

LEEPA-RATTNER MUSEUM OF ART

600 Klosterman Rd., Tarpon Springs FL 34689. (727)712-5762. E-mail: lrma@ spcollege.edu. Website: www.spcollege.edu/museum. **Contact**: Lynn Whitelaw, Director. Museum. Estab. 2002. Exhibits mid-career and established artists. "We do not sell. We exhibit art from 20th century artists, alive and deceased." Average display time 8-10 weeks. Open Tuesday, Wednesday, Friday, 10-5; Thursday, 10-9; Sundays,

1-5; closed Mondays. Located on Tarpon Springs Campus of St. Petersburg College. Clients include local community, students, tourists and upscale.

Media Considers all types of media and prints. Mostly exhibits 20th-century artwork.

Style Considers all genres.

RICHARD LEVY GALLERY

514 Central Ave. SW, Albuquerque NM 87102. (505)766-9888. E-mail: info@ levygallery.com. Website: www.levygallery.com. **Director:** Viviette Hunt. Estab. 1992. Open Tuesday-Saturday, 11-4. Closed during art fairs (always noted on voice message). Located on Central Ave. between 5th and 6th. Clients include upscale.

Media Considers all media. Most frequently exhibits paintings, prints and photography.

Style Contemporary art.

Submissions Submissions by e-mail preferred. "Please include images and any other pertinent information (artist's statment, bio, etc.). When sending submissions by post, please include slides or photographs and SASE for return of materials."

Tips "Portfolios are reviewed at the gallery by invitation or appointment only."

LIMITED EDITIONS & COLLECTIBLES

697 Haddon Ave., Collingswood NJ 08108. (856)869-5228. Fax: (856)869-5228. E-mail: jdl697ltd@juno.com. Website: www.ltdeditions.net. **Owner:** John Daniel Lynch, Sr. For-profit gallery. Estab. 1997. Approached by 24 artists/year. Exhibited artists include Richard Montmurro, James Allen Flood and Gino Hollander. Open all year. Located in downtown Collingswood; 700 sq. ft. Overall price range: $190-20,000; most work sold at $450.

Media Considers all media and all types of prints. Most frequently exhibits acrylic, watercolors and oil.

Style Considers all styles and genres.

Terms Artwork is accepted on consignment, and there is a 30% commission. Retail price set by the artist. Gallery provides insurance, promotion and contract. Accepted work should be framed, mounted and matted. Does not require exclusive representation locally.

Submissions Call or write to arrange a personal interview to show portfolio. Send query letter with bio, business card and résumé. Responds in 1 month. Finds artists through word of mouth, portfolio reviews, art exhibits, and referrals by other artists.

LOS ANGELES ART ASSOCIATION/GALLERY 825

825 N. La Cienega Blvd., Los Angeles CA 90069. (310)652-8272. Fax: (310)652-9251.

E-mail: gallery825@laaa.org. Website: www.laaa.org. **Executive Director:** Peter Mays. Nonprofit gallery. Estab. 1925. Sponsors 16 exhibits/year. Average display time: 4-5 weeks. Open Tuesday-Saturday, 10-5. Overall price range: $200-5,000; most work sold at $600.

Media Considers all media and original handpulled prints. "Fine art only. No crafts." Most frequently exhibits mixed media, oil/acrylic and watercolor.

Style Exhibits all styles.

Terms Retail price set by artist. Gallery provides promotion.

Submissions Submit 2 pieces during biannual screening date. Responds immediately following screening. Call for screening dates.

Tips "Bring work produced in the last three years. No commercial work (i.e., portraits /advertisements)."

MAIN AND THIRD FLOOR GALLERIES

Department of Visual Arts, Northern Kentucky University, Nunn Dr., Highland Heights KY 41099. (859)572-5148. Fax: (859)572-6501. E-mail: knight@nku.edu. Website: www.nku.edu/~art/ galleries.html. **Director of Exhibitions and Collections:** David Knight. University galleries. Program established 1975. Represents emerging, mid-career and established artists. Sponsors 10 shows/year. Average display time: 1 month. Open Monday-Friday, 9-9 or by appointment; closed major holidays and between Christmas and New Year's. Located 8 miles from downtown Cincinnati; 3,000 sq. ft.; 2 galleries—one small and one large space with movable walls. 100% of space for special exhibitions. 90% private collectors, 10% corporate collectors. Overall price range: $25-3,000; most work sold at $500.

Media Considers all media and all types of prints. Most frequently exhibits painting, printmaking and photography.

Style Exhibits all styles, all genres.

Terms Retail price set by the artist. Gallery provides insurance, promotion and contract; shipping costs are shared. Prefers framed artwork, "but we are flexible." Commission rate is 20%.

Submissions "Proposals from artists must go through our art faculty to be considered." Unsolicited submissions/proposals from outside the NKU Department of Visual Arts are not accepted. Unsolicited submissions will be returned to sender.

MAIN STREET GALLERY

105 Main Street, P.O. Box 161, Groton NY 13073. (607)898-9010. E-mail: maingal@ localnet.com. Website: www.mainstreetgal.com. **Directors:** Adrienne Smith and Roger Smith. For-profit gallery, art consultancy. Estab. 2003. Exhibits 15 emerging, mid-career and established artists. Sponsors 7 exhibits/year. Average display time: 5-6 weeks. Open all year; Thursday/Saturday 12-6; Sunday 1-5; closed January and

February. Located in the village of Groton in the Finger Lakes Region of New York, 20 minutes to Ithaca; 900 sq. ft. Clients include local community, tourists, upscale. Overall price range: $120-5,000.

Media Considers all media. Considers prints, including engravings, etchings, linocuts, lithographs, mezzotints and woodcuts. Most frequently exhibits painting, sculpture, ceramics, prints.

Style Considers all styles and genres.

Terms Artwork is accepted on consignment (40% commission). Retail price set by the artist. Gallery provides insurance, promotion and contract. Accepted work should be framed, mounted and matted. Requires exclusive representation locally.

Submissions Write to arrange personal interview to show portfolio of photographs and slides. Send query letter with artist's statement, bio, brochure, photographs, résumé, reviews, SASE and slides. Returns material with SASE. Responds to queries in 4 weeks, only if interested. Finds artists through art exhibits, portfolio reviews, referrals by other artists, submissions and word of mouth.

MALTON GALLERY

3804 Edwards Rd., Cincinnati OH 45209. (513)321-8614. Fax: (513)321-8716. E-mail: srombis@maltonartgallery.com. Website: www.maltonartgallery.com. **Director:** Sylvia Rombis. Retail gallery. Estab. 1974. Represents about 100 emerging, mid-career and established artists. Exhibits 20 artists/year. Exhibited artists include Carol Henry, Mark Chatterley, Terri Hallman and Esther Levy. Sponsors 7 shows/year (2-person shows alternate with display of gallery artists). Average display time: 1 month. Open all year; Tuesday-Saturday, 11-5. Located in high-income neighborhood shopping district; 2,500 sq. ft. Clientele: private and corporate. Overall price range: $250-10,000; most work sold at $400-2,500.

Media Considers oil, acrylic, drawing, sculpture, watercolor, mixed media, pastel, collage and original handpulled prints.

Style Exhibits all styles. Genres include contemporary landscapes, figurative and narrative and abstractions work.

Terms Accepts work on consignment (50% commission). Retail price set by artist (sometimes in consultation with gallery). Gallery provides insurance, promotion, contract and shipping costs from gallery; artist pays shipping costs to gallery. Prefers framed works for canvas; unframed works for paper.

Submissions Send query letter with résumé, slides or photographs, reviews, bio and SASE. Responds in 4 months. Files résumé, review or any printed material. Slides and photographs are returned.

Tips "Never drop in without an appointment. Be prepared and professional in presentation. This is a business. Artists themselves should be aware of what is going on, not just in the 'art world,' but with everything."

BEN MALTZ GALLERY

Otis College of Art & Design, 9045 Lincoln Blvd., Los Angeles CA 90045. (310)665-6905. Fax: (310)665-6908. E-mail: galleryinfo@otis.edu. Website: www.otis.edu. **Director:**Meg Linton. Nonprofit gallery. Estab. 1957. Represents emerging and mid-career artists. Sponsors 4-6 exhibits/year. Average display time: 1-2 months. Open Tuesday-Saturday, 10-5 (Thursday, 10-7); closed Mondays and major holidays. Located near Los Angeles International Airport (LAX); approximately 3,520 sq. ft.; 14-ft. walls. Clients include local community, students, tourists, upscale and artists.
Media Considers all media and all types of prints. Most frequently exhibits painting, mixed media.
Submissions Follow submission guidelines that are available on web site. Only accepts materials digitally. Do not send 35mm slides, Disks, DVD's, catalogues of artwork unless specifically requested by the gallery after you initial submission has been reviewed.
Tips "Follow submission guidelines and be patient."

▣ MARKEIM ART CENTER

Lincoln Ave. and Walnut St., Haddonfield NJ 08033. (856)429-8585. Fax: (856)429-8585. E-mail: markeim@verizon.net. Website: www.markeimartcenter.org. **Executive Director:** Elizabeth Madden. Nonprofit gallery. Estab. 1956. Sponsors 10-11 exhibits/year. Average display time: 4 weeks. Overall price range: $75-1,000; most work sold at $350.
Media Considers all media. Must be original. Most frequently exhibits paintings, photography and sculpture.
Style Exhibits all styles and genres.
Terms Charges 30% commission. Accepted work should be framed, mounted or unmounted, matted or unmatted. "Artists from New Jersey and Delaware Valley region are preferred. Work must be professional and high quality."
Submissions Send slides by mail for consideration. Include SASE, résumé and letter of intent. Responds in 1 month.
Tips "Be patient and flexible with scheduling. Look not only for one-time shows, but for opportunities to develop working relationships with a gallery. Establish yourself locally and market yourself outward."

NEDRA MATTEUCCI GALLERIES

1075 Paseo De Peralta, Santa Fe NM 87501. (505)982-4631. Fax: (505)984-0199. E-mail: inquiry@matteucci.com. Website: www.matteucci.com. **Director of Advertising/Public Relations:** Cynthia Laureen Vogt. For-profit gallery. Estab. 1972. Main focus of gallery is on deceased artists of Taos, Sante Fe and the West. Approached by 20 artists/year. Represents 100 established artists. Exhibited artists include Dan

Ostermiller and Glenna Goodacre. Sponsors 3-5 exhibits/year. Average display time 1 month. Open all year; Monday-Saturday, 830-5. Clients include upscale.

Media Considers drawing, oil, pen & ink, sculpture and watercolor. Most frequently exhibits oil, watercolor and bronze sculpture.

Style Exhibits impressionism. Most frequently exhibits impressionism, modernism and realism. Genres include Americana, figurative work, landscapes, portraits, Southwestern, Western and wildlife.

Terms Artwork is accepted on consignment. Retail price set by the gallery and the artist. Requires exclusive representation within New Mexico.

Submissions Write to arrange a personal interview to show portfolio of transparencies. Send query letter with bio, photographs, resume' and SASE.

MAXWELL FINE ARTS

1204 Main St., Peekskill NY 10566-2606. (914)737-8622. Fax: (914)788-5310. E-mail: devitomax@aol.com. **Partner/Co-Director:** W. Maxwell. For-profit gallery and outdoor sculpture garden. Estab. 2000. Approached by 25 artists/year. Exhibits 18 emerging and established artists. Exhibited artists include Ruth Hardinger and Leslie Lew. Sponsors 5-6 exhibits/year. Average display time 8 weeks. Open all year; Friday-Saturday, 12-5. Closed July/August. Located in Peekskill, NY downtown artist district; 800 sq. ft. in 1850s carriage house. Clients include local community and upscale. 10% of sales are to corporate collectors. Overall price range $100-10,000; most work sold at $600.

Media Considers acrylic, ceramics, collage, drawing, glass, mixed media, oil, paper, pastel, pen & ink, indoor and outdoor sculpture and watercolor. Most frequently exhibits paintings, drawings and prints. Considers all types of prints.

Style Considers all styles and genres. Most frequently exhibits abstract, conceptual and representational.

Terms Artwork is accepted on consignment and there is a 40% commission. Retail price set by the gallery in consultation with the artist. Gallery provides promotion. Accepted work should be framed. Does not require exclusive representation locally.

Submissions Mail portfolio for review. Send query letter with artist's statement, bio, photocopies, résumé, SASE and slides. Returns material with SASE. Responds in 1 month. Files résumé and photos. Finds artists through word of mouth, submissions, art exhibits and referrals by other artists.

Tips "Take a workshop on Business of Art."

MAYANS GALLERIES, LTD.

601 Canyon Rd., Santa Fe NM 87501. (505)983-8068. E-mail: arte2@aol.com. **Director:** Ernesto Mayans, Anya Maria Maynans and Pablo Mayans. Publishers, retail gallery and art consultancy. Estab. 1977. Publishes books, catalogs and portfolios. Overall price range: $200-5,000.

Media Considers oil, acrylic, watercolor, pastel, pen & ink, drawings, mixed media, sculpture, photography and original handpulled prints. Most frequently exhibits oil, photography, and lithographs.

Style Exhibits 20th century American and Latin American art. Genres include landscapes and figurative work.

Terms Accepts work on consignment (50% commission). Retail price set by gallery and artist. Exclusive area representation required. Size limited to 11 × 20 maximum.

Submissions Arrange a personal interview to show portfolio. Send query by mail with SASE for consideration. Responds in 2 weeks.

Tips "Please call before submitting."

MCGOWAN FINE ART, INC.

10 Hills Ave., Concord NH 03301. (603)225-2515. Fax: (603)225-7791. E-mail: art@ mcgowanfineart.com. Website: www.mcgowanfineart.com. **Gallery Director:** Sarah Chaffee. Owner/Art Consultant: Mary McGowan. Retail gallery and art consultancy. Estab. 1980. Represents emerging, mid-career and established artists. Sponsors 8 shows/year. Average display time 1 month. Located just off Main Street. 50% of space for special exhibitions. Clients include residential and corporate. Most work sold at $125-9,000.

Media Considers oil, acrylic, watercolor, pastel, mixed media, collage, works on paper, sculpture, woodcuts, wood engravings, linocuts, engravings, mezzotints, etchings, lithographs and serigraphs. Most frequently exhibits sculpture, watercolor and oil/acrylic.

Style Exhibits painterly abstraction, landscapes, etc.

Terms Accepts work on consignment (50% commission). Retail price set by artist. Gallery provides insurance and promotion; negotiates payment of shipping costs. Prefers artwork unframed.

Submissions Send query letter with résumé, 5-10 slides and bio. Responds in 1 month. Files materials.

Tips "I am interested in the number of years you have been devoted to art. Are you committed? Do you show growth in your work?"

MCLEAN PROJECT FOR THE ARTS

McLean Community Center, 1234 Ingleside Ave., McLean VA 22101. (703)790-1953. Fax: (703)790-1012. E-mail: nsausser@mpaart.org. Website: www.mpaart. org. **Exhibitions Director:** Nancy Sausser. Nonprofit visual arts center; alternative space. Estab. 1962. Represents emerging, mid-career and established artists from the mid-Atlantic region. Exhibited artists include Yuriko Yamaguchi and Christopher French. Sponsors 12-15 shows/year. Average display time: 5-6 weeks. Open Tuesday-Friday, 10-4; Saturday, 1-5. Luminous "white cube" type of gallery, with moveable

walls; 3,000 sq. ft. 85% of space for special exhibitions. Clientele: local community, students, artists' families. 100% private collectors. Overall price range: $200-15,000; most work sold at $800-1,800.

Media Considers all media except graphic design and traditional crafts; all types of prints except posters. Most frequently exhibits painting, sculpture and installation.

Style Exhibits all styles, all genres.

Terms Artwork is accepted on consignment (25% commission). Retail price set by the artist. Gallery provides insurance and promotion. Artist pays for shipping costs. Prefers framed artwork (if on paper).

Submissions Accepts only artists from Maryland, District of Columbia, Virginia and some regional mid-Atlantic. Send query letter with résumé, slides, reviews and SASE. Responds within 4 months. Artists' bios, slides and written material kept on file for 2 years. Finds artists through referrals by other artists and curators, and by visiting exhibitions and studios.

Tips Visit the gallery several times before submitting proposals, so that the work you submit fits the framework of art presented.

MCMURTREY GALLERY

3508 Lake St., Houston TX 77098. (713)523-8238. Fax: (713)523-0932. E-mail: info@ mcmurtreygallery.com. **Owner:** Eleanor McMurtrey. Retail gallery. Estab. 1981. Represents 20 emerging and mid-career artists. Exhibited artists include Robert Jessup and Jean Wetta. Sponsors 10 shows/year. Average display time: 1 month. Open all year. Located near downtown; 2,600 sq. ft. Clients include corporations. 75% of sales are to private collectors, 25% corporate collectors. Overall price range: $400-17,000; most work sold at $1,800-6,000.

Media Considers oil, acrylic, pastel, drawings, mixed media, collage, works on paper, photography and sculpture. Most frequently exhibits mixed media, acrylic and oil.

Style Exhibits figurative, narrative, painterly abstraction and realism.

Terms Accepts work on consignment (50% commission). Retail price set by gallery and artist. Prefers artwork framed.

Submissions Send query letter with résumé, images and SASE. Call for appointment to show portfolio of originals and slides.

Tips "Be aware of the work the gallery exhibits and act accordingly. Please make an appointment."

☗ MERIDIAN MUSEUM OF ART

628 25th Ave., Meridian MS 39302. (601)693-1501. E-mail: meridianmuseum@ bellsouth.net. Website: www.meridianmuseum.org. **Director:** Kate Cherry. Museum. Estab. 1970. Represents emerging, mid-career and established artists. Interested in seeing the work of emerging artists. Exhibited artists include Jere Allen, Patt Odom,

James Conner, Bonnie Busbee, Charlie Busler, Terry Cherry, Alex Loeb and Gary Chapman. Sponsors 15 shows/year. Average display time: 5 weeks. Open all year; Tuesday-Sunday, 1-5. Located downtown; 3,060 sq. ft. This figures refers to exhibit spaces only. The entire museum is about 6,000 sq. ft.; housed in renovated Carnegie Library building, originally constructed 1912-13. 50% of space for special exhibitions. Clientele: general public. Overall price range: $150-2,500; most work sold at $300-1,000.

• Sponsors annual Bi-State Art Competition for Mississippi and Alabama artists.

Media Considers all media.

Style Exhibits all styles, all genres.

Terms Work available for sale during exhibitions (25% commission). Retail price set by the artist. Gallery provides insurance and promotion; shipping costs are shared. Prefers framed artwork.

Submissions Prefers artists from Mississippi, Alabama and the Southeast. Send query letter with résumé, slides, bio and SASE. Responds in 3 months. Finds artists through submissions, referrals, work included in competitions and visiting exhibitions.

MIKHAIL ZAKIN GALLERY AT OLD CHURCH

561 Piermont Rd., Demarest NJ 07627. (201)767-7160. Fax: (201)767-0497. E-mail: gallery@tasoc.org. Website: www.tasoc.org. **Contact:** Rachael Faillace, gallery director. Nonprofit gallery. Established. 1974. 10-exhibition season includes contemporary emerging and established regional artist, NJ Annual Small Works Show, student and faculty group exhibitions, among others; Gallery hours:9:30 A.M.- 5:30 P.M, Monday through Friday. Call for weekend and evening hours.

Media The gallery shows work in all media.

Style All styles and genres are considered.

Terms 35% commission fee charged on all gallery sales. Gallery provides promotion and contract.

Submissions Submission guidelines are available on the gallery's web site. Small Works prospectus available online. Mainly finds artists through referrals by other artists and artist registries.

Tips "Follow guidelines available online."

MILL BROOK GALLERY & SCULPTURE GARDEN

236 Hopkinton Rd., Concord NH 03301. (603)226-2046. E-mail: artsculpt@mindspring. com. Website: www.themillbrookgallery.com. For-profit gallery. Estab. 1996. Exhibits 70 artists. Sponsors 7 exhibits/year. Average display time: 6 weeks. Open Tuesday-Saturday, 11-5 (April 1 to December 24); open by appointment December 25 to March 31. Outdoor juried sculpture exhibit; 3 rooms inside for exhibitions; 1,800 sq. ft. Overall price range: $8-30,000; most work sold at $500-1,000.

Media Considers acrylic, ceramics, collage, drawing, glass, mixed media, oil, pastel, sculpture, watercolor, etchings, mezzotints, serigraphs and woodcuts. Most frequently exhibits oil, acrylic and pastel.

Style Considers all styles. Most frequently exhibits color field/conceptualism, expressionism. Genres include landscapes. Prefers more contemporary art.

Terms Artwork is accepted on consignment (50% commission). Retail price set by the artist. Gallery provides insurance, promotion and contract. Accepted work should be framed and matted.

Submissions Write to arrange a personal interview to show portfolio of photographs, slides. Send query letter with artist's statement, bio, photocopies, photographs, résumé, slides, SASE. Submission of art work: Accept CD's, web sites, slides, and digital images. Responds to all artists within month, only if interested. Finds artists through word of mouth, submissions, art exhibits, referrals by other artists.

PETER MILLER GALLERY

118 N. Peoria St., Chicago IL 60607. (312)226-5291. Fax: (312)226-5441. E-mail: info@peter millergallery.com. Website: petermillergallery.com. **Director:** Natalie R. Domchenko. Retail gallery. Estab. 1979. Represents 15 emerging, mid-career and established artists. Sponsors 9 solo and 3 group shows/year. Average display time is 1 month. Clientele: 80% private collectors, 20% corporate clients. Overall price range $500-30,000; most artwork sold at $5,000 and up.

Media Considers oil, acrylic, mixed media, collage, sculpture, installations and photography. Most frequently exhibits oil and acrylic on canvas and mixed media.

Style Exhibits abstraction, conceptual and realism.

Terms Accepts work on consignment (50% commission). Retail price set by gallery and artist. Exclusive area representation required. Insurance, promotion and contract negotiable.

Submissions Send a sheet of 20 slides of work done in the past 18 months with a SASE. Slides, show card are filed.

MOBILE MUSEUM OF ART

4850 Museum Dr., Mobile AL 36608-1917. (251)208-5200. E-mail: prichelson@mobile museumofart.com. Website: www.MobileMuseumOfArt.com. **Director:** Tommy McPherson. Clientele tourists and general public. Sponsors 6 solo and 12 group shows/year. Average display time 6-8 weeks. Interested in emerging, mid-career and established artists. Overall price range $100-5,000; most artwork sold at $100-500.

Media Considers all media and all types of visual art.

Style Exhibits all styles and genres. "We are a general fine arts museum seeking a variety of styles, media and time periods." Looking for "historical significance."

Terms Accepts work on consignment (20% commission). Retail price set by artist.

Exclusive area representation not required. Gallery provides insurance, promotion, contract; shipping costs are shared. Prefers framed artwork.

Submissions Send query letter with résumé, brochure, business card, slides, photographs, bio and SASE. Write to schedule an appointment to show a portfolio, which should include slides, transparencies and photographs. Replies only if interested within 3 months. Files résumés and slides. All material is returned with SASE if not accepted or under consideration.

Tips "Be persistent but friendly!"

NEVADA MUSEUM OF ART

160 W. Liberty St., Reno NV 89501. (775)329-3333. Fax: (775)329-1541. E-mail: art@nevadaart.org. Website: www.nevadaart.org. **Curator:** Ann Wolfe. Estab. 1931. Sponsors 12-15 exhibits/year. Average display time: 2-3 months.

Media Considers all media.

Style Exhibits all styles and genres.

Terms Acquires art "by committee following strict acquisition guidelines per the mission of the institution."

Submissions Send query letter with slides. Write to schedule an appointment to show a portfolio. "No phone calls and no e-mails, please."

Tips "The Nevada Museum of Art is a private, nonprofit institution dedicated to providing a forum for the presentation of creative ideas through its collections, educational programs, exhibitions and community outreach. We specialize in art addressing the environment and the altered landscape."

NEW VISIONS GALLERY, INC.

1000 N. Oak Ave., Marshfield WI 54449. (715)387-5562. E-mail: newvisions.gallery@ verizon.net. Website: www.newvisionsgallery.org. **Executive Director:** Mary Peck. Nonprofit educational gallery. Represents emerging, mid-career and established artists. Organizes a variety of group and thematic shows, sponsors Marshfield Art Fair; "Culture and Agriculture" annual invitational exhibit of art with agricultural themes. Does not represent artists on a continuing basis but does accept exhibition proposals. Average display time: 6 weeks. Open all year; Monday-Friday, 9-5:30; Saturday 11-3. 1,500 sq. ft. Price range varies with exhibit. Small gift shop with original jewelry, notecards and crafts at $10-50. "We do not show 'country crafts.' "

Media Considers all media.

Style Exhibits all styles and genres.

Terms Accepts work on consignment (35% commission). Retail price set by artist. Gallery provides insurance and promotion. Prefers artwork framed.

Submissions Send query letter with résumé, high-quality slides or digital images and SASE. Label slides with size, title, media.

NORTHWEST ART CENTER

Minot State University, 500 University Ave. W., Minot ND 58707. (701)858-3264. Fax: (701)858-3894. E-mail: nac@minotstateu.edu. Website: www.minotstateu.edu/nac. **Director:** Avis R. Veikley. Nonprofit gallery. Estab. 1970. Represents emerging, mid-career and established artists. Sponsors 18-20 shows/year. Average display time: 4-6 weeks. Open all year. Two galleries—Hartnett Hall Gallery: Monday-Friday, 8-4:30; The Library Gallery: Sunday-Thursday, 8-9. Located on university campus; 1,000 sq. ft. 100% of space for special exhibitions. 100% private collectors. Overall price range: $100-40,000; most work sold at $100-4,000.

Media Considers all media. Emphasis on contemporary works on paper.

Style Exhibits all styles, all genres.

Terms Retail price set by the artist. 30% commission. Gallery provides insurance, promotion and contract; shipping costs are shared. Prefers framed artwork.

Submissions Send query letter with résumé, bio, artist's statement, slides and SASE. Sponsors 2 national juried shows each year; prospectus available on website. Call for appointment to show portfolio of originals, photographs, slides and transparencies. Responds in 4 months. Files all material. Finds artists through submissions, visiting exhibitions, word of mouth.

NOYES ART GALLERY

119 S. Ninth St., Lincoln NE 68508. (402)475-1061. E-mail: julianoyes@aol.com. Website: www.noyesartgallery.com. **Director:** Julia Noyes. For-profit gallery. Estab. 1992. Exhibits 150 emerging artists. Has 25 members. Average display time: 1 month minimum. ("If mutually agreeable this may be extended or work exchanged.") Open all year. Located downtown, near historic Haymarket District; 3,093 sq. ft.; renovated 128-year-old building. 25% of space for special exhibitions. Clientele: private collectors, interior designers and decorators. 90% private collectors, 10% corporate collectors. Overall price range: $100-5,000; most work sold at $200-750.

Media Considers oil, acrylic, watercolor, pastel, pen & ink, drawings, mixed media, collage, paper, sculpture, ceramic, fiber, glass and photography; original handpulled prints, woodcuts, wood engravings, linocuts, engravings, mezzotints, etchings, lithographs and serigraphs. Most frequently exhibits oil, watercolor and mixed media.

Style Exhibits expressionism, neo-expressionism, impressionism, realism, photorealism. Genres include landscapes, florals, Americana, wildlife, figurative work. Prefers realism, expressionism, photorealism.

Terms Accepts work on consignment (10-35% commission). Retail price set by artist (sometimes in conference with director). Gallery provides promotion and contract; artist pays for shipping. Prefers artwork framed.

Submissions Send query letter with résumé, slides, bio, SASE; label slides concerning size, medium, price, top, etc. Submit at least 6-8 slides. Reviews submissions monthly.

Responds in 1 month. Files résumé, bio and slides of work by accepted artists (unless artist requests return of slides).

☘ OPENING NIGHT FRAMING SERVICES & GALLERY

2836 Lyndale Ave. S., Minneapolis MN 55408-2108. (612)872-2325. Fax: (612)872-2385. E-mail: deen@onframe-art.com. Website: www.openingnightframing.com. **Contact:** Deen Braathen. Estab. 1974. Exhibits 15 emerging and mid-career artists. Sponsors 4 exhibits/year. Open all year; Monday-Friday, 8:30-5; Saturday, 10:30-4.

Media Considers acrylic, ceramics, collage, drawing, fiber, glass, oil, paper, sculpture and watercolor.

Style Exhibits local and regional art.

Terms Artwork is accepted on consignment, and there is a 50% commission. Retail price set by the gallery. Gallery provides insurance, promotion and contract.

Submissions "E-mail Deen with cover letter, artist statement, and visuals."

☘ ORANGE COUNTY CENTER FOR CONTEMPORARY ART

117 N. Sycamore St., Santa Ana CA 92701. (714)667-1517. E-mail: info.occca@ gmail.com. Website: www.occca.org. **Exhibitions Director:** Pamela Grau Twena. Cooperative, nonprofit gallery. Exhibits emerging and mid-career artists. 26 members. Sponsors 12 shows/year. Average display time: 1 month. Open all year; Thursday and Sunday, 12-5; Friday and Saturday, 12-9; Monday-Wednesday by appointment. Opening receptions first Saturday of every month, 7-10 pm. Gallery space: 5,500 sq. ft. 25% of time for special exhibitions; 75% of time for gallery artists. Membership fee: $30/month.

Media Considers all media—contemporary work.

Terms Co-op membership fee plus a donation of time. Retail price set by artist.

Submissions Accepts artists generally in and within 50 miles of Orange County. Send query letter with SASE. Responds in 1 week.

Tips "This is an artist-run nonprofit. Send SASE for application prospectus. Membership involves 10 hours per month of volunteer work at the gallery or gallery-related projects."

THE PARTHENON

Centennial Park, Nashville TN 37201. (615)862-8431. Fax: (615)880-2265. E-mail: susan@ parthenon.org. Website: www.parthenon.org. **Curator:** Susan E. Shockley. Nonprofit gallery in a full-size replica of the Greek Parthenon. Estab. 1931. Exhibits the work of emerging to mid-career artists. Sponsors 10-12 shows/year. Average display time: 3 months. Clientele: general public, tourists. Overall price range: $300-2,000. "We also house a permanent collection of American paintings (1765-1923)."

Media Considers "nearly all" media.

Style "Interested in both objective and non-objective work. Professional presentation is important."

Terms " Sales request a 20% donation." Retail price set by artist. Gallery provides a contract and limited promotion. The Parthenon does not represent artists on a continuing basis.

Submissions Send images via CD, résumé and artist's statement addressed to curator.

Tips "We plan our gallery calendar at least one year in advance."

DEBORAH PEACOCK GALLERY

Austin TX 78703. (512)970.9024. E-mail: photo@deborahpeacock.com. Website: www.deborah peacock.com or www.art-n-music.com **Proprietor/Photographer/ Public Relations**: Deborah Peacock. Alternative space, for-profit gallery, public relations, promotions, photography and art consultancy. Estab. 1997. Approached by 100 artists/year. Represents 15 emerging, mid-career and established artists. Exhibited artists include Nicolas Herrera and Ava Brooks. Sponsors 6-8 exhibits/ year. Average display time 1 month. Open by appointment. Located in downtown Austin off 6th Street near Loop 1. The studio/gallery photographs art, helps artists with promotional materials, portfolios, advertising and exhibits. Clients include local community and tourists. 20% of sales are to corporate collectors. Overall price range $150-6,000; most work sold at $500.

- Deborah Peacock Photography & Public Relations promotes artists and also caters to businesses, actors and musicians; product photography, special events, videography and graphic/web design.

Media Considers all media and all types of prints. Most frequently exhibits oil, sculpture and photography.

Style Considers all styles and genres. Most frequently exhibits conceptualism, expressionism and surrealism

Terms Artwork is accepted on consignment and there is a 50% commission. Retail price set by the artist. Gallery provides insurance, promotion and contract. Accepted work should be framed and mounted. Does not require exclusive representation locally.

Submissions Write to arrange a personal interview to show portfolio of photographs and slides; or mail portfolio for review; or send query letter with artist's statement, bio, photographs, resume, SASE and digital files. Returns material with SASE. Responds only if interested within 1 month. Files artists statements, bios, review, etc. Finds artists through portfolio reviews.

Tips Use of archival-quality materials is very important to collectors.

PENTIMENTI GALLERY

145 N. Second St., Philadelphia PA 19106. (215)625-9990. E-mail: mail@pentimenti. com. Website: www.pentimenti.com. **Director:** Christine Pfister. Commercial gallery. Estab. 1992. Represents 20-30 emerging, mid-career and established artists. Sponsors 7-9 exhibits/year. Average display time: 4-6 weeks. Open all year; Wednesday-Friday, 11-5; weekends, 12-5. Closed Sundays, August, Christmas and New Year. Located in the heart of Old City Cultural district in Philadelphia. Overall price range: $250-12,000; most work sold at $1,500-7,000.

Media Considers all media. Most frequently exhibits paintings of all media.

Style Exhibits conceptualism, minimalism, postmodernism, painterly abstraction, and representational works. Most frequently exhibits postmodernism, minimalism and conceptualism.

Terms Artwork is accepted on consignment (50% commission). Retail price set by the gallery and the artist. Gallery provides insurance and promotion. Requires exclusive representation locally.

Submissions Please review our guidelines in our website at http://www.pentimenti. com.

THE PHOENIX GALLERY

210 11th Ave. at 25th St., Suite 902, New York NY 10001. (212)226-8711. Fax: (212)343-7303. E-mail: info@phoenix-gallery.com. Website: www.phoenix-gallery. com. **Director**: Linda Handler. Nonprofit gallery. Estab. 1958. 32 members. Exhibits the work of emerging, mid-career and established artists. Exhibited artists include Gretl Bauer and Jae Hi Ahn. Sponsors 10-12 shows/year. Average display time: 1 month. Open Tuesday-Saturday, 11:30-6. Located in Chelsea; 180 linear ft. "We have a movable wall that can divide the gallery into two large spaces." 100% of space for special exhibitions. 75% of sales are to private collectors, 25% corporate clients, also art consultants. Overall price range: $50-20,000; most work sold at $300-10,000.

- The Phoenix Gallery actively reaches out to the members of the local community, scheduling juried competitions, dance programs, poetry readings, book signings, plays, artists speaking on art panels and lectures. A special exhibition space, The Project Room, has been established for guest-artist exhibits.

Media Considers oil, acrylic, watercolor, pastel, pen & ink, drawings, mixed media, collage, works on paper, sculpture, ceramic, photography, original handpulled prints, woodcuts, engravings, wood engravings, linocuts, etchings and photographs. Most frequently exhibits oil, acrylic and watercolor.

Style Exhibits painterly abstraction, minimalism, realism, photorealism, hard-edge geometric abstraction and all styles.

Terms Co-op membership fee plus donation of time for active members, not for inactive or associate members (25% commission). Retail price set by gallery. Offers customer discounts and payment by installment. Gallery provides promotion and

contract; artist pays for shipping. Prefers framed artwork.

Submissions Send query letter with résumé, slides and SASE. Call for appointment to show portfolio of slides. Responds in 1 month. Only files material of accepted artists. The most common mistakes artists make in presenting their work are "incomplete résumé, unlabeled slides and an application that is not filled out properly. We find new artists by advertising in art magazines and art newspapers, word of mouth, and inviting artists from our juried competition to be reviewed for membership."

Tips "Come and see the gallery-meet the director."

PIERRO GALLERY OF SOUTH ORANGE

Baird Center, 5 Mead St., South Orange NJ 07079. (973)378-7755, ext. 3. Fax: (973)378-7833. E-mail: pierrogallery@southorange.org. Website: www.pierrogallery. org. **Director:** Judy Wukitsch. Nonprofit gallery. Estab. 1994. Approached by 75-185 artists/year; represents or exhibits 25-50 artists. Average display time: 7 weeks. Open Friday-Sunday, 1-4; by appointment. Closed mid-December through mid-January and during August. Overall price range: $100-10,000; most work sold at $800.

Media Considers all media and prints, except posters—must be original works. Most frequently exhibits painting, mixed media/collage/sculpture.

Style Considers all styles and genres.

Terms Artwork is accepted on consignment (15% commission). Retail price set by the artist. Gallery provides insurance, promotion and contract. Accepted work should be framed.

Submissions Mail portfolio for review; 3 portfolio reviews/year: January, June, October. Send query letter with artist's statement, résumé, slides. Responds in 2 months from review date. Finds artists through word of mouth, submissions, portfolio reviews, referrals by other artists.

Tips "Send legible, clearly defined, properly identified slides."

POLK MUSEUM OF ART

800 E. Palmetto St., Lakeland FL 33801-5529. (863)688-7743. Fax: (863)688-2611. E-mail: info@polk museumofart.org. Website: www.polkmuseumofart.org. **Curator of Art:** Todd Behrens. Estab. 1966. Approached by 75 artists/year; represents or exhibits 3 artists. Sponsors 15 exhibits/year. Open Tuesday-Saturday, 10-5; Sunday, 1-5. Closed major holidays. Four different galleries of various sizes and configurations.

Media Considers all media. Most frequently exhibits prints, photos and paintings. Considers all types of prints except posters.

Style Considers all styles and genres, provided the artistic quality is very high.

Terms Gallery provides insurance, promotion and contract. Accepted work should be framed.

Submissions Mail portfolio for review. Send query letter with artist's statement, bio,

résumé and SASE. Returns material with SASE. Reviews 2-3 times/year and responds shortly after each review. Files slides and résumé.

PORTFOLIO ART GALLERY

2007 Devine St., Columbia SC 29205. (803)256-2434. E-mail: info@portfolioartgal. com. Website: www.portfolioartgal.com. **Owner:** Judith Roberts. Retail gallery and art consultancy. Estab. 1980. Represents 40-50 emerging, mid-career and established artists. Exhibited artists include Juko Ono Rothwell, Sigmund Abeles and Shannon Bueker. Sponsors 3 shows/year. Average display time: 3 months. Open all year. Located in a 1930s shopping village, 1 mile from downtown; 2,000 sq. ft.; features 12-ft. ceilings. 100% of space for work of gallery artists. "A unique feature is glass shelves where matted and small to medium pieces can be displayed without hanging on the wall." Clientele: professionals, collectors, corporations; 70% professionals and collectors, 30% corporate. Overall price range: $150-12,500; most work sold at $600-$3,000.

- Art Gallory Director, Judith Roberts has a fine arts degree with an intensive in printmaking and is a former art teacher. Also named " A Top 100 Retailer of American Crafts."

Media Considers oil, acrylic, watercolor, pastel, mixed media, collage, works on paper, sculpture, ceramic, glass, original handpulled prints, woodcuts, wood engravings, linocuts, engravings, mezzotints, etchings, lithographs and serigraphs. Most frequently exhibits oils, acrylics, ceramics and sculpture, and original jewelry.

Style Exhibits neo-expressionism, painterly abstraction, imagism, minimalism, color field, impressionism, and realism. Genres include landscapes and figurative work. Prefers landscapes/seascapes, painterly abstraction and figurative work. "I especially like mixed media pieces, original prints and oil paintings. Pastel medium and watercolors are also favorites, as well as kinetic sculpture and whimsical clay pieces."

Terms Accepts work on consignment (40% commission). Retail price set by gallery and artist. Offers payment by installments. Gallery provides insurance, promotion and contract; artist pays for shipping. Artwork may be framed or unframed.

Submissions Send query letter with bio and images via e-mail, CD or slides. Write for appointment to show portfolio of originals, slides, photographs and transparencies. Responds within 1 month, only if interested. Files tearsheets, brochures and slides. Finds artists through visiting exhibitions and referrals.

Tips "The most common mistake beginning artists make is showing all the work they have ever done. I want to see only examples of recent best work—unframed, originals (no copies)—at portfolio reviews."

POSNER FINE ART

1215 ½ S. Point View St., Los Angeles, CA 90092. (323)934-6664. Fax: (323)934-3417. E-mail: info@posnerfineart.com. Website: www.posnerfineart.com. **Director:** Wendy Posner. Private fine art dealer and art publisher. Estab. 1994. Represents 200 emerging, mid-career and established artists. By appointment only. Clientele: upscale and collectors; 50% private collectors, 50% corporate collectors. Overall price range: $25-50,000; most work sold at $500-10,000.

• See additional listing in the Posters & Prints section.

Media Considers oil, acrylic, watercolor, pastel, mixed media, collage, works on paper, sculpture, ceramics, original hand-pulled prints, engravings, etchings, lithographs, posters and serigraphs. Most frequently exhibits paintings, sculpture and original prints.

Style Exhibits painterly abstraction, minimalism, impressionism, realism, photorealism, pattern painting and hard-edge geometric abstraction. Genres include florals and landscapes. Prefers abstract, trompe l'oeil, realistic.

Terms Accepts work on consignment (50% commission). Retail price set by the gallery. Gallery provides insurance and promotion; shipping costs are shared. Prefers unframed artwork.

Submissions Send query letter with résumé and i mages via e-mail to info@posnerfineart.com. Responds in 2 weeks, only if interested. Finds artists through submissions and art collectors' referrals.

Tips " Are looking for artists for corporate collections."

THE PRINT CENTER

1614 Latimer St., Philadelphia PA 19103. (215)735-6090. Fax: (215)735-5511. E-mail: info@printcenter.org. Website: www.printcenter.org. Nonprofit gallery. Estab. 1915. Exhibits emerging, mid-career and established artists. Approached by 500 artists/year. Sponsors 11 exhibits/year. Average display time: 2 months. Open all year; Tuesday-Saturday, 11-5:30. Closed December 21-January 6. Gallery houses 3 exhibit spaces as well as a separate Gallery Store. Located in historic Rittenhouse area of Philadelphia. Clients include local community, students, tourists and high end collectors. 30% of sales are to corporate collectors. Overall price range: $15-15,000; most work sold at $200.

Media Considers all forms of printmaking, photography and digital printing. Accepts original artwork only—no reproductions.

Style Considers all styles and genres.

Terms Accepts artwork on consignment (50% commission). Retail price set by the artist. Gallery provides insurance, promotion and contract. Accepted work should be framed and matted for exhibitions; unframed for Gallery Store. Does not require exclusive representation locally. Only accepts prints and photos.

Submissions Must be member to submit work—member's work is reviewed by

Curator and Gallery Store Manager. See website for membership application. Finds artists through submissions, art exhibits and membership.

N THE PROPOSITION

1178 Broadway, Suite 312, New York NY 10001. BY APPOINTMENT ONLY. **Phone**: (212)242-0035. E-mail: info@theproposition.com. **website**: www.theproposition. com. **Director**: Ronald Sosinski. For-profit gallery. Estab. 2002. Exhibits emerging and mid-career artists. Represents or exhibits 20 + artists/year. Exhibited artists include: Balint Zsako (drawing, collage, works on paper); Dane Patterson (drawing, painting, works on paper); Megan Burns (painting); Jason Gringler (mixed media, painting, work on paper); Mike Park (painting, video); Tim Evans (painting, video, works on paper); Huang Yan (sculpture); Mickalene Thomas (paintings, photos); Shinique Smith (multimedia, works on paper, installation, video, conceptual); Kyung Jeon (drawing, painting); Alfredo Martinez (sculpture, drawing, painting, performance). Average display time: 1 month. Overall price range: $0-20,000; most works on paper sold at $3,000; most paintings sold at $6,000.

PUMP HOUSE CENTER FOR THE ARTS

P.O. Box 1613, Chillicothe OH 45601. Phone/fax: (740)772-5783. E-mail: info@ pumphouseartgal lery.com. Website: www.pumphouseartgallery.com. **Director**: Priscilla V. Smith. Nonprofit gallery. Estab. 1991. Approached by 6 artists/year; represents or exhibits more than 50 artists. Sponsors 8 exhibits/year. Average display time: 6 weeks. Open Tuesday-Friday, 11-4; weekends, 1-4. Closed Mondays and major holidays. Overall price range: $150-600; most work sold at $300. Facility is also available for rent (business meetings, reunions, weddings, wedding receptions or rehearsals, etc.).

Media Considers all media and all types of prints. Most frequently exhibits oil, acrylic and watercolor.

Style Considers all styles and genres.

Terms Artwork is accepted on consignment (30% commission). Gallery provides insurance and promotion. Accepted work should be framed, matted and wired for hanging. The Pump House reserves the right to reject any artwork deemed inappropriate.

Submissions Call or stop in to show portfolio of photographs, slides, originals or prints. Send query letter with bio, photographs, SASE and slides. Returns material with SASE. Responds in 1 month. Finds artists through word of mouth, submissions, portfolio reviews, art fairs/exhibits, and referrals by other artists.

Tips "All artwork must be original designs, framed, ready to hang (wired—no sawtooth hangers)."

QUEENS COLLEGE ART CENTER

Benjamin S. Rosenthal Library, Queens College, Level Six, 65-30 Kissena Blvd., Flushing NY 11367-1597. (718)997-3770. Fax: (718)997-3536. E-mail: artlibrary@ qc.cuny.edu. **Website**: qcpages.qc.cuny .edu/Art_Library/calendar.html. **Director:** Suzanna Simor. Curator: Alexandra de Luise. Assistant Curator: Tara Tye Mathison. Estab. 1955. Average display time: 6 weeks. Overall price range: $100-3,000. Under renovation during the 2008-09 season.

Media Considers all media.

Style Open to all styles and genres; decisive factors are originality and quality.

Terms Charges 40% commission. Accepted work can be framed or unframed, mounted or unmounted, matted or unmatted. Sponsors openings. Artist is responsible for providing/arranging refreshments and cleanup.

Submissions Send query letter with resume, samples and SASE. Responds in 1 month.

◩ MARCIA RAFELMAN FINE ARTS

10 Clarendon Ave., Toronto ON M4V 1H9 Canada. (416)920-4468. Fax: (416)968-6715. E-mail: info@ mrfinearts.com. Website: www.mrfinearts.com. · **President:** Marcia Rafelman. Gallery Director: Meghan Richardson. Semi-private gallery. Estab. 1984. Average display time: 1 month. Gallery is centrally located in Toronto; 2,000 sq. ft. on 2 floors. Clients include local community, tourists and upscale. 40% of sales are to corporate collectors. Overall price range: $800-25,000; most work sold at $1,500.

Media Considers all media. Most frequently exhibits photography, painting and graphics. Considers all types of prints.

Style Exhibits geometric abstraction, minimalism, neo-expressionism, primitivism and painterly abstraction. Most frequently exhibits high realism paintings. Considers all genres except Southwestern, Western and wildlife.

Terms Artwork is accepted on consignment (50% commission); net 30 days. Retail price set by the gallery and the artist. Gallery provides insurance, promotion and contract. Requires exclusive representation locally.

Submissions Mail or e-mail portfolio for review; include bio, photographs, reviews. Responds within 2 weeks, only if interested. Finds artists through word of mouth, submissions, art fairs, referrals by other artists.

RAIFORD GALLERY

1169 Canton St., Roswell GA 30075. (770)645-2050. Fax: (770)992-6197. E-mail: raifordgallery@ mindspring.com. Website: www.raifordgallery.com. For-profit gallery. Estab. 1996. Approached by many artists/year. Represents 400 mid-career and established artists. Exhibited artists include Cathryn Hayden (collage, painting

and photography) and Richard Jacobus (metal). Sponsors 4 exhibits/year. Average display time: 4 weeks. Open all year; Tuesday- Saturday, 10-5. Located in historic district of Roswell; 4,500 sq. ft. in an open 2-story timber-frame space. Clients include local community, tourists and upscale. Overall price range: $10-2,000; most work sold at $200-300.

Media Considers all media except installation. Most frequently exhibits painting, sculpture and glass.

Style Exhibits contemporary American art & craft.

Terms Artwork is accepted on consignment, and there is a 50% commission. Retail price set by the artist. Gallery provides insurance, promotion and contract. Accepted work should be framed. Requires exclusive representation locally.

Submissions Call or write to show to review board original work, portfolio of photographs. Send query letter with artist's statement, web site, bio, brochure, photocopies, photographs, SASE. Returns material with SASE. Finds artists through submissions, portfolio reviews, art exhibits and art fairs.

THE RALLS COLLECTION INC.

1516 31st St. NW, Washington DC 20007. (202)342-1754. Fax: (202)342-0141. E-mail: maralls@ aol.com. Website: www.rallscollection.com. **Owner:** Marsha Ralls. For-profit gallery. Estab. 1991. Approached by 125 artists/year; represents or exhibits 60 artists. Sponsors 10 exhibits/year. Average display time: 1 month. Open Tuesday-Saturday, 11-4 and by appointment. Closed Thanksgiving and Christmas. Clients include local community and tourists. 30% of sales are to corporate collectors. Overall price range: $1,500-50,000; most work sold at $2,500-5,000.

Media Considers acrylic, collage, drawing, mixed media, oil, sculpture and watercolor. Most frequently exhibits photography, oil and acrylic. Considers lithographs.

Style Exhibits geometric abstraction, neo-expressionism and painterly abstraction. Most frequently exhibits painterly abstraction.

Terms Artwork is accepted on consignment (50% commission). Retail price set by the gallery and the artist. Gallery provides insurance, promotion and contract. Accepted work should be framed and matted. Requires exclusive representation locally. Accepts only American artists.

Submissions Mail portfolio for review. Send query letter with artist's statement, bio, brochure, business card, photocopies, photographs, résumé, reviews, slides, SASE. Responds in 2 months. Finds artists through word of mouth, submissions, portfolio reviews, art fairs/exhibits, referrals by other artists.

ROGUE GALLERY & ART CENTER

40 S. Bartlett, Medford OR 97501. (541)772-8118. Fax: (541)772-0294. E-mail: judy@ roguegallery.org. Website: www.roguegallery.org. **Executive Director:** Judy Barnes.

Nonprofit sales rental gallery. Estab. 1961. Represents emerging, mid-career and established artists. Sponsors 8 shows/year. Average display time 6 weeks. Open all year; Tuesday-Friday, 10-5; Saturday, 11-3. Located downtown; main gallery 240 running ft. (2,000 sq. ft.); rental/sales and gallery shop, 1,800 sq. ft.; classroom facility, 1,700 sq. ft. "This is the only gallery/art center/exhibit space of its kind in the region, excellent facility, good lighting." 33% of space for special exhibitions; 33% of space for gallery artists. 95% of sales are to private collectors. Overall price range $100-5,000; most work sold at $400-1,000.

Media Considers all media and all types of prints. Most frequently exhibits mixed media, drawing, installation, painting, sculpture, watercolor.

Style Exhibits all styles and genres.

Terms Accepts work on consignment (35% commission to members; 40% non-members). Retail price set by the artist. Gallery provides insurance, promotion and contract; in the case of main gallery exhibit.

Submissions Send query letter with résumé, 10 slides, bio and SASE. Call or write for appointment. Responds in 1 month.

Tips "The most important thing an artist needs to demonstrate to a prospective gallery is a cohesive, concise view of himself as a visual artist and as a person working with direction and passion."

ALICE C. SABATINI GALLERY

1515 SW 10th Ave., Topeka KS 66604-1374. (785)580-4516. Fax: (785)580-4496. E-mail: sbest@ tscpl.org. Website: www.tscpl.org. **Gallery Director:** Sherry Best. Nonprofit gallery. Estab. 1976. Exhibits emerging, mid-career and established artists. Sponsors 6-8 shows/year. Average display time: 6 weeks. Open all year; Monday-Friday, 9-9; Saturday, 9-6; Sunday, 12-9. Located 1 mile west of downtown; 2,500 sq. ft.; security, track lighting, plex top cases; 5 moveable walls. 100% of space for special exhibitions and permanent collections. Overall price range: $150-$5,000.

Media Considers oil, fiber, acrylic, sculpture, glass, watercolor, mixed media, ceramic, pastel, collage, metal work, woodcuts, wood engravings, linocuts, engravings, mezzotints, etchings, lithographs, photography, and installation. Most frequently exhibits ceramic, oil and prints.

Style Exhibits neo-expressionism, painterly abstraction, postmodern works and realism. Prefers painterly abstraction, realism and neo-expressionism.

Terms Retail price set by artist. Gallery provides insurance; artist pays for shipping costs. Prefers artwork framed. Does not handle sales.

Submissions Usually accepts regional artists. Send query letter with résumé and 12-24 images. Call or write for appointment to show portfolio. Responds in 2 months. Files résumé. Finds artists through visiting exhibitions, word of mouth and submissions.

Tips "Find out what each gallery requires from you and what their schedule for reviewing artists' work is. Do not go in unannounced. Have good-quality images. If

reproductions are bad, they probably will not be looked at. Have a dozen or more to show continuity within a body of work. Your entire body of work should be at least 50 pieces. Competition gets heavier each year. We look for originality."

SAN DIEGO ART INSTITUTE

(SDAI: Museum of the Living Artist, San Diego Art Dept. & COVA: Combined Organizations for the Visual Arts) 1439 El Prado, San Diego CA 92101. (619)236-0011. Fax: (619)236-1974. E-mail: admin@sandiego-art.org. Website: www.sandiego-art. org. **Executive Director:** Timothy J. Field. Administrative Director: Kerstin Robers. Art Director: K.D. Benton. Nonprofit gallery. Estab. 1941. Represents 600 emerging and mid-career member/artists. 2,400 artworks juried into shows each year. Sponsors 11 all-media exhibits/year. Average display time: 4-6 weeks. Open Tuesday-Saturday, 10-4; Sunday 12-4. Closed major holidays and all Mondays. 10,000 sq. ft., located in the heart of Balboa Park. Clients include local community, students and tourists. 10% of sales are to corporate collectors. Overall price range: $100-4,000; most work sold at $800.

Media Considers all media and all types of prints. Most frequently exhibits oil, mixed media, pastel, digital.

Style Considers all styles and genres. No craft or installations.

Submissions Request membership packet and information about juried shows. Membership not required for submission in monthly juried shows, but fee required. Returns material with SASE. Finds artists through word of mouth and referrals by other artists.

Tips "All work submitted must go through jury process for each monthly exhibition. Work required to be framed in professional manner."

SAPER GALLERIES

433 Albert Ave., East Lansing MI 48823. (517)351-0815. E-mail: roy@sapergalleries. com. Website: www.sapergalleries.com. **Director:** Roy C. Saper. Retail gallery. Estab. in 1978; in 1986 designed and built new addition. Displays the work of 150 artists, mostly mid-career, and artists of significant national prominence. Exhibited artists include Picasso, Peter Max, Rembrandt. Sponsors 2 shows/year. Average display time: 2 months. Open all year. Located downtown; 5,700 sq. ft. 50% of space for special exhibitions. Clients include students, professionals, experienced and new collectors. 80% of sales are to private collectors, 20% corporate collectors. Overall price range: $100-100,000; most work sold at $1,000.

Media Considers oil, acrylic, watercolor, pastel, drawings, mixed media, collage, paper, sculpture, ceramic, craft, glass and original handpulled prints. Considers all types of prints except offset reproductions. Most frequently exhibits intaglio, serigraphy and sculpture. "Must be of highest professional quality."

Style Exhibits expressionism, painterly abstraction, surrealism, postmodern works, impressionism, realism, photorealism and hard-edge geometric abstraction. Genres include landscapes, florals, southwestern and figurative work. Prefers abstract, landscapes and figurative. Seeking extraordinarily talented, outstanding artists who will continue to produce exceptional work.

Terms Accepts work on consignment (negotiable commission); or buys outright for negotiated percentage of retail price. Retail price set by the artist. Offers payment by installments. Gallery provides insurance, promotion and contract; shipping costs are shared. Prefers artwork unframed (gallery frames).

Submissions Prefers digital pictures e-mailed to roy@sapergalleries.com. Call for appointment to show portfolio of originals or photos of any type. Responds in 1 week. Files any material the artist does not need returned. Finds artists mostly through New York Artexpo.

Tips "Present your very best work to galleries that display works of similar style, quality and media. Must be outstanding, professional quality. Student quality doesn't cut it. Must be great. Be sure to include prices and SASE."

WILLIAM & FLORENCE SCHMIDT ART CENTER

2500 Carlyle Av., Belleville IL 62221. (618)222-5278. E-mail: libby.reuter@swic.edu. Website: www.schmidtartcenter.com. **Contact:** Libby Reuter, executive director. Nonprofit gallery. Estab. 2001. Exhibits emerging, mid-career and established artists. Sponsors 10-12 exhibits/year. Average display time 6-8 weeks. Open Tuesday-Saturday, 11-5. Closed during college holidays. Clients include local community, students and tourists.

Media Considers all media. Most frequently exhibits oil, ceramics, photography. Considers all types of prints.

Style Considers all styles.

Submissions Mail or e-mail portfolio for review. Send query letter with artist's statement, bio and slides or digital images. Returns material with SASE. Finds artists through art fairs and exhibits, portfolio reviews, referrals by other artists, submissions and word of mouth.

SCOTTSDALE MUSEUM OF CONTEMPORARY ART

7380 E. Second St., Scottsdale AZ 85251. (480)874-4630. Fax: (480)874-4655. E-mail: smoca@ sccarts.org. Website: www.smoca.org. **Contact:** Pat Evans, director. Museum. Approached by 30-50 artists/year. "Arizona's only museum devoted to the art, architecture and design of our time." Sponsors 12 exhibits/year. Average display time 10 weeks. Open Tuesday, Wednesday, Friday, Saturday, 10-5; Thursday, 10-8; Sunday, 12-5. Closed Monday. Located in downtown Scottsdale; more than 20,000 sq. ft. of exhibition space. Clients include local community, students and tourists.

Media Considers all media.

Style Considers works of contemporary art, architecture and design.

Submissions Send query letter with artist's statement, bio, photocopies, résumé, reviews and SASE. Returns material with SASE. Responds in 3 weeks.

Tips Make your submission clear and concise. Fully identify all slides. All submission material, such as artist's statement and slide labels should be typed, not handwritten.

ANITA SHAPOLSKY GALLERY

152 E. 65th St., (patio entrance), New York NY 10065. (212)452-1094. Fax: (212)452-1096. E-mail: ashapolsky@nyc.rr.com. Website: www.anitashapolskygallery.com. For-profit gallery. Estab. 1982. Exhibits established artists. Exhibited artists include Ernest Briggs, painting; Michael Loew, painting; Buffie Johnson, painting; William Manning, painting; Mark Gibian, sculpture; Betty Parsons, painting and sculpture and others. Open all year; Wednesday-Saturday, 11-6. Call for summer hours. Clients include local community and upscale.

Media Considers acrylic, collage, drawing, mosaic, mixed media, oil, paper, sculpture, etchings, lithographs, serigraphs. Most frequently exhibits oil, acrylic and sculpture.

Style Exhibits expressionism and geometric abstraction and painterly abstraction.

Terms Prefers only 1950s and 1960s abstract expressionism.

Submissions Mail portfolio for review in May and October only. Send query letter with artist's statement, bio, SASE and slides. Returns material with SASE.

SILVERMINE GUILD GALLERY

1037 Silvermine Rd., New Canaan CT 06840. (203)966-9700. Fax: (203)972-7236. E-mail: sgac@silvermineart.org. Website: www.silvermineart.org. **Director:** Helen Klisser During. Nonprofit gallery. Estab. 1922. Represents 300 emerging, mid-career and established artists/year. Sponsors 24 shows/year. Average display time 1 month. Open all year; Tuesday-Saturday, 11-5; Sunday, 1-5. 5,000 sq. ft. 95% of space for gallery artists. Clientele: private collectors, corporate collectors. Overall price range $250-10,000; most work sold at $1,000-2,000.

Media Considers all media and all types of prints. Most frequently exhibits paintings, sculpture and ceramics.

Style Exhibits all styles.

Terms Accepts guild member work on consignment (50% commission). Co-op membership fee plus donation of time (50% commission.) Retail price set by the gallery and the artist. Gallery provides insurance, promotion and contract. Prefers artwork framed.

Submissions Send query letter.

SOUTH DAKOTA ART MUSEUM

South Dakota State University, Box 2250, Brookings SD 57007. (605)688-5423 or (866)805-7590. Fax: (605)688-4445. Website: www.SouthDakotaArtMuseum.com. **Curator of Exhibits:** John Rychtarik. Estab. 1970. Sponsors 15 exhibits/year. Average display time: 4 months. Open Monday-Friday, 10-5; Saturday, 10-4; Sunday, 12-4. Closed state holidays. Seven galleries offer 26,000 sq. ft. of exhibition space. Overall price range: $200-6,000; most work sold at $500.

Media Considers all media and all types of prints. Most frequently exhibits painting, sculpture and fiber.

Style Considers all styles.

Terms Artwork is accepted on consignment (30% commission). Retail price set by the artist. Gallery provides insurance and promotion. Accepted 2D work must be framed and ready to hang.

Submissions Send query letter with artist's statement, bio, résumé, slides, SASE. Responds within 3 months, only if interested. Finds artists through word of mouth, portfolio reviews, art exhibits, referrals by other artists.

SPACES

2220 Superior Viaduct, Cleveland OH 44113. (216)621-2314. E-mail: info@ spacesgallery.org. Website: www.spacesgallery.org. Artist-run alternative space. Estab. 1978. "Exhibitions feature artists who push boundaries by experimenting with new forms of expression and innovative uses of media, presenting work of emerging artists and established artists with new ideas. SPACE Lab is open to all artists, including students who wish to create a short-term experimental installation in the gallery. The SPACES World Artist Program gives visiting national and international artists the opportunity to create new work and interact with the Northeast Ohio community." Sponsors 4-5 shows/year. Average display time: 8 weeks. Open all year; Tuesday-Sunday. Located in Cleveland; 6,000 sq. ft.; "warehouse space with row of columns."

Media Considers all media. Most frequently exhibits installation, painting, video and sculpture.

Style "Style not relevant; presenting challenging new ideas is essential."

Terms Artists are provided honoraria, and 20% commission is taken on work sold. Gallery provides insurance, promotion and contract.

Submissions Contact SPACES for deadline and application. Also seeking curators interested in pursuing exhibition ideas.

SPAIGHTWOOD GALLERIES, INC.

P.O. Box 1193, Upton MA 01568-6193. (508)529-2511. E-mail: sptwd@verizon.net. Website: www.spaightwoodgalleries.com. **President:** Sonja Hansard-Weiner. Vice

President: Andy Weiner. For-profit gallery. Estab. 1980. Exhibits mostly established artists. 'Artists' page on our Website: http://spaightwoodgalleries.com/Pages/Artists. html (almost 10,000 works from late 15th century to present in inventory)." Sponsors 4 exhibits/year. Average display time: 3 months. Open by appointment. Located in a renovated ex-Unitarian Church; basic space is 90x46 ft; ceilings are 25 ft. high at center, 13 ft. at walls. See http://spaightwoodgalleries.com/Pages/Upton.html for views of the gallery. Clients include mostly Internet and visitors drawn by Internet; we are currently trying to attract visitors from Boston and vicinity via advertising and press releases." 2% of sales are to corporate collectors. Overall price range: $175-125,000; most work sold at $1,000-4,000.

Media Considers all media except installations, photography, glass, craft, fiber. Most frequently exhibits original prints, drawing and ceramic sculpture, occasionally paintings.

Style Exhibits old master to contemporary; most frequently impressionist and post-impressionist (Cassatt, Renoir, Cezanne, Signac, Gauguin, Bonnard), Fauve (Matisse, Rouault, Vlaminck, Derain) modern (Picasso, Matisse, Chagal, Miro, Giacometti), German Expressionist (Heckel, Kollwitz, Kandinsky, Schmidt-Rottluff), Surrealist (Miro, Fini, Tanning, Ernst, Lam, Matta); COBRA (Alechinsky, Appel, Jorn), Abstract Expressionist (Tapies, Tal-Coat, Saura, Lledos, Bird, Mitchell, Frankenthaler, Olitski), Contemporary (Claude Garache, Titus-Carmel, Joan Snyder, John Himmelfarb, Manel Lledos, Jonna Rae Brinkman). Most frequently exhibits modern, contemporary, impressionist and post-impressionist. Work shown is part of our inventory; we buy mostly at auction. In the case of some artists, we buy directly from the artist or the publisher; in a few cases we have works on consignment."

Terms Retail price set by both artist and gallery. Accepted work should be unmatted and unframed. Requires exclusive representation locally.

Submissions Prefers link to website with bio, exhibition history and images. Returns material with SASE. Responds to queries only if interested. Finds artists through art exhibits (particularly museum shows), referrals by other artists, books.

Tips high-quality art."

⊞ THE STATE MUSEUM OF PENNSYLVANIA

300 North St., Harrisburg PA 17120-0024. (717)783-9904. Fax: (717)783-4558. E-mail: hpollman@ state.pa.us. Website: www.statemuseumpa.org. **Senior Curator of Art Collections:** N. Lee Stevens. Museum established in 1905; current Fine Arts Gallery opened in 1993. Number of exhibits varies. Average display time: 2 months. Overall price range: $50-3,000.

Media Considers all media and all types of prints.

Style Exhibits all styles and genres.

Terms Work is sold in gallery, but not actively. Connects artists with interested buyers. No commission. Accepted work should be framed. Art must be created by a native or

resident of Pennsylvania, or contain subject matter relevant to Pennsylvania.

Submissions Send material by mail for consideration; include SASE. Responds in 1 month.

Tips "Have the best visuals possible. Make appointments. Remember most curators are also overworked, underpaid and on tight schedules."

STATE OF THE ART GALLERY

120 W. State St., Ithaca NY 14850. (607)277-1626 or (607)277-4950. E-mail: gallery@ soag.org. Website: www.soag.org. Cooperative gallery. Estab. 1989. Sponsors 12 exhibits/year. Average display time: 1 month. Open Wednesday-Friday, 12-6; weekends, 12-5. Located in downtown Ithaca; 2 rooms; about 1,100 sq. ft. Overall price range: $100-6,000; most work sold at $200-500.

Media Considers all media and all types of prints. Most frequently exhibits sculpture, paintings, mixed media.

Style Considers all styles and genres.

Terms There is a co-op membership fee plus a donation of time. There is a 10% commission for members, 30% for nonmembers. Retail price set by the artist. Gallery provides promotion and contract. Accepted work must be ready to hang.

Submissions Write for membership application. Finds artists through word of mouth, submissions, portfolio reviews, art exhibits, referrals by other artists.

STUDIO 7 FINE ARTS

77 West Angela St., Pleasanton CA 94566. (925)846-4322. Fax: (925)846-2249. E-mail: info@studio7 finearts.com. Website: www.studio7finearts.com. **Owners:** Jaime Dowell. Retail gallery. Estab. 1981. Represents/exhibits established artists. Sponsors 10 shows/year. Average display time 3 weeks. Open all year. Located in historic downtown Pleasanton; 5,000 sq. ft.; excellent lighting from natural and halogen sources. 30% of space for special exhibitions; 70% of space for gallery artists. Clientele "wonderful, return customers." 99% private collectors, 1% corporate designer collectors. Overall price range $100-80,000; most work sold at under $2,000-3,000.

Media Considers oil, acrylic, watercolor, pastel, drawing, mixed media, collage, paper, sculpture, ceramics, fine craft, glass, woodcuts, engravings, lithographs, mezzotints, serigraphs and etchings. Most frequently exhibits oil, acrylic, etching, watercolor, handblown glass, jewelry and sculpture.

Style Exhibits painterly abstraction and impressionism. Genres include landscapes and figurative work. Prefers landscapes, figurative and abstract.

Terms Work only on consignment. Retail price set by the artist. Gallery provides promotion and contract and shares in shipping costs.

Submissions Prefers artists from the Bay Area. Send query e-mail with several

examples of work representing current style. Call for appointment to show portfolio of originals. Responds only if interested within 1 month. Finds artists through word of mouth and "my own canvassing."

Tips "Be prepared! Please come to your appointment with an artist statement, an inventory listing including prices, a résumé, and artwork that is ready for display."

STUDIO GALLERY

2108 R Street NW, Washington DC 20008. (202)232-8734. E-mail: info@studiogallerydc. com. Website: www.studiogallerydc.com. **Director:** Adah Rose Bitterbaum. Cooperative and nonprofit gallery. Estab. 1964. Exhibits the work of 30 emerging, mid-career and established local artists. Sponsors 11 shows/year. Average display time 1 month. Gallery for rent the last of August. Located downtown in the Dupont Circle area; 700 sq. ft.; "gallery backs onto a courtyard, which is a good display space for exterior sculpture and gives the gallery an open feeling." Clientele: private collectors, art consultants and corporations. 85% private collectors; 8% corporate collectors. Overall price range $300-10,000; most work sold at $500-3,000.

Media Considers glass, oil, acrylic, watercolor, pastel, pen & ink, drawings, mixed media, collage, works on paper, sculpture, ceramic, fiber, original handpulled prints, woodcuts, lithographs, monotypes, linocuts and etchings. Most frequently exhibits oil, acrylic and paper.

Style Considers all styles. Most frequently exhibits Abstract and Figurative Paintings, Landscapes, Indoor and Outdoor Sculpture and Mixed Media.

Terms Co-op membership fee plus a donation of time (65% commission).

Submissions Send query letter with SASE. Artists must be local or willing to drive to Washington for monthly meetings and receptions. Artist is informed as to when there is a membership opening and a selection review. Files artist's name, address, telephone.

Tips "This is a cooperative gallery. Membership is decided by the gallery membership. Ask when the next review for membership is scheduled. An appointment for a portfolio review with the director is required before the jurying process, however. Dupont Circle is an exciting gallery scene with a variety of galleries. First Fridays from 6-8 for all galleries of DuPont Circle."

SWOPE ART MUSEUM

25 S. 7th St., Terre Haute IN 47807-3604. (812)238-1676. Fax: (812)238-1677. E-mail: info@swope .org. Website: www.swope.org. Nonprofit museum. Estab. 1942. Approached by approximately 10 artists/year. Represents 1-3 mid-career and established artists. Average display time 4-6 weeks. Open all year; Tuesday-Friday, 10-5; Saturday, 12-5; Closed Sunday, Mondays and national holidays. Located in downtown Terre Haute in a Renaissance-revival building with art deco interior.

Media Considers all media. Most frequently exhibits paintings, sculpture, and works on paper. Considers all types of prints except posters.

Style Exhibits American art of all genres. Exhibits permanent collection with a focus on mid 20th century regionalism and Indiana artists but includes American art from all 50 states from 1800's to today.

Terms Focuses on local and regional artists (size and weight of works are limited because we do not have a freight elevator).

Submissions Send query letter with artist's statement, brochure, CD or slides, resume and SASE (if need items returned). Returns material with SASE. Responds in 5 months. Files only what fits the mission statement of the museum for special exhibitions. Finds artists through word of mouth, and annual juried exhibition at the museum.

Tips The Swope has physical limitations due to its historic interior but is willing to consider newer media unconventional media and installations.

SYNCHRONICITY FINE ARTS

106 W. 13th St., New York NY 10011. (646)230-8199. Fax: (646)230-8198. E-mail: synchspa@ bestweb.net. Website: www.synchronicityspace.com. Nonprofit gallery. Estab. 1989. Approached by several hundred artists/year. Exhibits 12-16 emerging and established artists. Sponsors 6 exhibits/year. Average display time: 1 month. Open Tuesday-Saturday, 12-6. Closed for 2 weeks in August. Clients include local community, students, tourists and upscale. 20% of sales are to corporate collectors. Overall price range: $1,500-10,000; most work sold at $3,000-5,000.

Media Considers acrylic, collage, drawing, mixed media, oil, paper, pastel, pen & ink, sculpture, watercolor, engravings, etchings, mezzotints and woodcuts. Most frequently exhibits oil, sculpture and photography.

Style Exhibits color field, expressionism, impressionism, postmodernism and painterly abstraction. Most frequently exhibits semi-abstract and semi-representational abstract. Genres include figurative work, landscapes and portraits.

Terms Retail price set by the gallery. Gallery provides insurance, promotion and contract. Accepted work should be framed, mounted and matted.

Submissions Write or call to arrange a personal interview to show portfolio of photographs, slides and transparencies. Send query letter with photocopies, photographs, résumé, SASE and slides. Returns material with SASE. Responds in 3 weeks. Files materials unless artist requests return. Finds artists through submissions, portfolio reviews, art exhibits and referrals by other artists.

JOHN SZOKE EDITIONS

166 Mercer St., 3rd Floor, New York NY 10012. (212)219-8300. Fax: (212)966-3064. E-mail: info@johnszokeeditions.com. Website: www.johnszokeeditions.

com. **President:** Michael Lisi. Retail gallery and art dealer/publisher. Estab. 1974. Specializing in works on paper and prints by 20th century masters as well as contemporary artists; with special emphasis on Picasso. Contemporary artists include: Christo, Jim Dine, Helen Frankenthaler, Richard Haas, Damien Hirst, Jasper Johns, Alex Katz, Ellsworth Kelly, Jeff Koons, Peter Milton, Julian Opie, Robert Rauschenber, Larry Rivers, Donald Sultan, and Wayne Thiebaud. Modern Masters include: Picasso, Cocteau and Matisse. Catalogues Raisonne Published: Janet Fish, Richard Haas and Jeannette Pasin Sloan and most recently Will Barnet. Open all year. Located downtown in Soho. Clients include other dealers and collectors. 20% of sales are to private collectors.

TEW GALLERIES INC.

The Galleries of Peachtree Hills, 425 Peachtree Hills Ave., Unit 24, Atlanta GA 30305. (404)869-0511. Fax: (404) 869-0512. E-mail: jules@twegalleries.com. Website: www. timothytew.com. **Contact:** Jules Bekker, Director. For-profit gallery. Estab. 1989. Exhibits selected emerging and mid-career artists. Approached by 100 artists/year; represents or exhibits 17-20 artists/year. Exhibited artists include Deedra Ludwig, encaustic, mixed media, oil, pastel painting; Kimo Minton, polychrome on Cottonwood, bronze sculptures. Sponsors 8 exhibits/year. Average display time 28 days. Open Monday-Friday, 9-6; Saturdays, 11-5. Located in a prestigious arts and antiques complex. Total of 3,600 sq. ft. divided over three floors. Clients include upscale and corporate. 15% of sales are to corporate collectors. Overall price range: $1,800-40,000; most work sold at $4,500 or less.

Media Considers all media except craft and photography. Most frequently exhibits oil on canvas, works on paper and small to medium scale sculptures.

Style Considers all styles.

Terms Artwork is accepted on consignment and there is a 50% commission. Retail price set by the gallery and the artist. Requires exclusive representation locally.

Submissions Send digital PDF by e-mail. Mail CD of portfolio with bio, artist statement and resume for review. Returns material with SASE. Responds to queries only if interested within 8 weeks. Files digital files only if interested. Finds artists through art exhibits, portfolio review, referrals by other artists and submissions.

Tips A minimum of 12 good quality images of recent work on digital media. Include all biographical material on the CD along with image.

NATALIE AND JAMES THOMPSON ART GALLERY

School of Art Design, San Jose CA 95192-0089. (408)924-4723. Fax: (408)924-4326. E-mail: Thompson gallery@cadre.sjsu.com. Website: www.sjsu.edu. **Director:** Jo Farb Hernandez. Nonprofit gallery. Approached by 100 artists/year. Sponsors 6 exhibits/year of emerging, mid-career and established artists. Average display time:

1 month. Open during academic year; Tuesday, 11-4, 6-7:30; Monday, Wednesday-Friday, 11-4. Closed semester breaks, summer and weekends. Clients include local community, students and upscale.

Media Considers all media and all types of prints.

Style Considers all styles and genres.

Terms Retail price set by the artist. Gallery provides insurance, transportation and promotion. Accepted work should be framed and/or ready to display. Does not require exclusive representation locally.

Submissions Send query letter with artist's statement, bio, résumé, reviews, SASE and slides. Returns material with SASE.

THORNE-SAGENDORPH ART GALLERY

Keene State College, Wyman Way, Keene NH 03435-3501. (603)358-2720. E-mail: thorne@keene.edu. Website: www.keene.edu/tsag. **Director:** Maureen Ahern. Nonprofit gallery. Estab. 1965. In addition to exhibitions of national and international art, the Thorne shows local artist as well as KSC faculty and student work. 600 members. Exhibited artists include Jules Olitski and Fritz Scholder. Sponsors 5 shows/year. Average display time 4-6 weeks. Open Saturday-Wednesday, 12-4; Thursday and Friday evenings till 7, summer s, Wednesday-Sunday, 12-4, closed Monday & Tuesday. Follows academic schedule. Located on campus; 4,000 sq. ft.; climate control, security. 50% of space for special exhibitions. Clients include local community and students.

Media Considers all media and all types of prints.

Style Exhibits Considers all styles.

Terms Gallery takes 40% commission on sales. Retail price set by the artist. Gallery provides insurance, promotion and contract; shipping costs are shared. Artwork must be framed.

Submissions Artist's portfolio should include photographs and transparencies. Responds only if interested within 2 months. Returns all material.

THROCKMORTON FINE ART

145 E. 57th St., 3rd Floor, New York NY 10022. (212)223-1059. Fax: (212)223-1937. E-mail: throckmorton@earthlink.net. Website: www.throckmorton-nyc.com. **Contact:** Kraige Block, director. For-profit gallery. Exhibits 15 emerging, mid-career and established artists/year. Exhibited artists include Ruven Afanador and Flor Garpuno. Average display time 1 month. Open all year; Tuesday-Saturday, 11-5. Located in the Hammacher Schlemmer Building; 4,000 square feet; 1,000 square feet exhibition space. Clients include local community and upscale. Overall price range $1,000-75,000; most work sold at $2,500.

Media Most frequently exhibits photography, antiquities. Also considers gelatin, platinum and albumen prints.

Style Exhibits expressionism. Genres include Latin American.

Terms Retail price of the art set by the gallery. Gallery provides insurance and promotion. Requires exclusive representation locally. Accepts only artists from Latin America. Prefers only b&w and color photography.

Submissions Call or write to arrange personal interview to show portfolio of photographs. Returns material with SASE. Responds to queries only if interested within 2 weeks. Files bios and résumés. Finds artists through portfolio reviews, referrals by other artists and submissions.

TOUCHSTONE GALLERY

406 7th St. NW, 2nd Floor, Washington DC 20004-2217. (202)347-2787. Fax: (202)347-3339. E-mail: info@touchstonegallery.com. Website: www.touchstonegallery.com. Contact: Ksenia Grishkova, Director. Artist owned gallery. Estab. 1976. Represents emerging and established artists. Approached by 100+ artists a year; represents over 30 artists. Open Wednesday-Saturday from 11-5; Sundays from 12-5. Located downtown Washington, DC. Large main gallery with several additional exhibition areas. High ceilings. Clients include local community, designer, corporations and tourists. Overall price range $100 - $8,000.

Style All media, including engravings, etchings, linocuts, lithographs, mezzotints, serigraphs and woodcuts.

Terms To be a member artists there is a membership fee plus a donation of time. Gallery takes 40-60% commission on sales. Rental option is available to rent Annex A, $1000/month; Annex B, $900/month or Annex C, $700. No commission taken on Annex sales. Retail price set by artist. Gallery provides contract and promotion. Accepted work should be framed and matted. Exclusive area representation not required.

Submissions The gallery juries for new members meet the 4th Wednesday of each month. All interested artists may apply. No fee required. See gallery website for details.

Tips Visit gallery's website first to learn about renting Annex rooms and how to become an artist member. Please call with additional questions. Show 10-25 images that are cohesive in subject, style and presentation."

ULRICH MUSEUM OF ART

Wichita State University, 1845 Fairmount St., Wichita KS 67260-0046. (316)978-3664. Fax: (316)978-3898. E-mail: ulrich@wichita.edu. Website: www.ulrich.wichita.edu. **Director:** Dr. Patricia McDonnell. Estab. 1974. Wichita's premier venue for modern and contemporary art. Presents 6 shows/year. Open Tuesday-Friday, 11-5; Saturday and Sunday, 1-5; closed Mondays and major holidays. Admission is always free.

Media "Exhibition program includes all range of media."

Style "Style and content of exhibitions aligns with leading contemporary trends."
Submissions "For exhibition consideration, send cover letter with artist's statement, bio, sample printed material and visuals, SASE." Responds in 3 months.

UNIVERSITY ART GALLERY IN THE D.W. WILLIAMS ART CENTER

New Mexico State University, MSC 3572, P.O. Box 30001, Las Cruces NM 88003-8001. (575)646-2545. Fax: (575)646-8036. E-mail: artglry@nmsu.edu. Website: www.nmsu.edu/~ artgal. **Director:** Preston Thayer, Ph.D. Estab. 1973. Sponsors 5-6 exhibits/year. Average display time: 2 months. Overall price range: $300-2,500.
Media Considers all media and all types of prints.
Style Exhibits all styles and genres.
Submissions Send e-mail with representative images and statement.
Tips "The gallery does mostly curated, thematic exhibitions; very few one-person exhibitions."

VALE CRAFT GALLERY

230 W. Superior St., Chicago IL 60654. (312)337-3525. Fax: (312)337-3530. E-mail: peter@ valecraftgallery.com. Website: www.valecraftgallery.com. **Owner:** Peter Vale. Retail gallery. Estab. 1992. Represents 100 emerging, mid-career artists/year. Exhibited artists include Tana Acton, Mark Brown, Tina Fung Holder, John Neering and Kathyanne White. Sponsors 4 shows/year. Average display time: 3 months. Open all year; Tuesday-Friday, 10:30-5:30; Saturday, 11-5. Located in River North gallery district near downtown; 2,100 sq. ft.; lower level of prominent gallery building; corner location with street-level windows provides great visibility. Clientele: private collectors, tourists, people looking for gifts, interior designers and art consultants. Overall price range: $50-2,000; most work sold at $100-500.
Media Considers paper, sculpture, ceramics, craft, fiber, glass, metal, wood and jewelry. Most frequently exhibits fiber wall pieces, jewelry, glass, ceramic sculpture and mixed media.
Style Exhibits contemporary craft. Prefers decorative, sculptural, colorful, whimsical, figurative, and natural or organic.
Terms Accepts work on consignment (50% commission). Retail price set by the artist. Gallery provides insurance, promotion, contract and shipping costs from gallery; artist pays shipping costs to gallery.
Submissions Accepts only craft media. No paintings, prints, or photographs. By mail: send query letter with résumé, bio or artist's statement, reviews if available, 10-20 slides, CD of images (in JPEG format) or photographs (including detail shots if possible), price list, record of previous sales, and SASE if you would like materials returned to you. By e-mail: include a link to your website or send JPEG images, as well as any additional information listed above. Call for appointment to show portfolio of

originals and photographs. Responds in 2 months. Files résumé (if interested). Finds artists through submissions, art and craft fairs, publishing a call for entries, artists' slide registry and word of mouth.

Tips "Call ahead to find out if the gallery is interested in showing the particular type of work that you make. Try to visit the gallery ahead of time or check out the gallery's website to find out if your work fits into the gallery's focus. I would suggest you have at least 20 pieces in a body of work before approaching galleries."

VIENNA ARTS SOCIETY—ART CENTER

115 Pleasant St., Vienna VA 22180. (703)319-3971. E-mail: teresa@tlcillustration.com. Website: www.viennaartssociety.org. **Director:** Teresa Ahmad. Nonprofit rental gallery and art center. Estab. 1969. Exhibits emerging, mid-career and established artists. Approached by 100-200 artists/year; exhibits 50-100 artists. " Anyone to become a member of the Vienna Arts Society has the opportunity to exhibit their work." Sponsors 3 exhibits/year. Average display time: 3-4 weeks. Open Tuesday-Saturday, 10-4. Closed Federal holidays. Located off Route 123, approximately 3 miles south of Beltway 495; historic building in Vienna; spacious room with modernized hanging system; 3 display cases for 3D, glass, sculpture, jewelry, etc. Clients include local community, students and tourists. Overall price range: $100-1,500; most work sold at $200-500.

Media Considers all media except basic crafts. Most frequently exhibits watercolor, acrylic and oil.

Style Considers all styles.

Terms Artwork is accepted on consignment, and there is a 25% commission. There is a rental fee that covers 1 month, "based on what we consider a 'featured artist' exhibit." Gallery handles publicity with the artist. Retail price set by the artist. Gallery provides promotion and contract. Accepted work must be framed or matted. "We do accept 'bin pieces' matted and shrink wrapped." VAS members can display at any time. Non-members will be asked for a rental fee when space is available.

Submissions Call. Responds to queries in 2 weeks. Finds artists through art fairs and exhibits, referrals by other artists and membership.

VIRIDIAN ARTISTS, INC.

530 W. 25th St., #407, New York NY 10001. (212)414-4040. Fax: (212)414-4040. E-mail: info@viridianartists.com. Website: www.viridianartists.com. **Director:** Barbara Neski. Estab. 1968. Sponsors 11 exhibits/year. Average display time: 4 weeks. Overall price range: $175-10,000; most work sold at $1,500.

Media Considers oil, acrylic, watercolor, pastel, pen & ink, drawings, mixed media, collage, works on paper, sculpture, installation, photography and limited edition prints. Most frequently exhibits works on canvas, sculpture, mixed media, works on paper and photography.

Style Exhibits hard-edge geometric abstraction, color field, painterly abstraction, conceptualism, postmodern works, primitivism, photorealism, abstract, expressionism, and realism. "Eclecticism is Viridian's policy. The only unifying factor is quality. Work must be of the highest technical and aesthetic standards."

Terms Accepts work on consignment (30% commission). Retail price set by gallery and artist. Sometimes offers customer discounts and payment by installment. Gallery provides promotion, contract and representation.

Submissions Will review transparencies and CDs only if submitted as part of membership application for representation with SASE. Request information for representation via phone or e-mail, or check website.

Tips "Artists often don't realize that they are presenting their work to an artist-owned, professionally run gallery. They must pay each month to maintain their representation. We feel a need to demand more of artists who submit work. Because of the number of artists who submit work, our criteria for approval has increased as we receive stronger work than in past years, due to commercial gallery closings."

VISUAL ARTS CENTER, WASHINGTON PAVILION OF ARTS & SCIENCE

301 S. Main, Sioux Falls SD 57104. (605)367-6000. Fax: (605)367-7399. E-mail: info@washingtonpavilion.org. Website: www.washingtonpavilion.org. Nonprofit museum. Estab. 1961. Open Monday-Saturday, 10-5; Sundays 12-5.

Media Considers all media.

Style Exhibits local, regional and national artists.

Submissions Send query letter with résumé and slides.

⚡ VOLCANO ART CENTER GALLERY

P.O. Box 129, Volcano HI 96785. (808)967-7565. Fax: (808) 967-7511. E-mail: info@ volcanoartcenter.org or gallery@volcanoartscenter.org. Website: www. volcanoartcenter.org. **Gallery Manager:** Fia Mattice. Nonprofit gallery to benefit arts education; nonprofit organization. Estab. 1974. Represents 300 emerging, mid-career and established artists/year. 1,400 member organization. Exhibited artists include Dietrich Varez and Brad Lewis. Sponsors 8 shows/year. Average display time 6 weeks. Open all year; daily 9-5 except Christmas. Located Hawaii Volcanoes National Park; 3,000 sq. ft.; in the historic 1877 Volcano House Hotel. 15% of space for special exhibitions; 85% of space for gallery artists. Clientele affluent travelers from all over the world. 95% private collectors, 5% corporate collectors. Overall price range $20-12,000; most work sold at $50-400.

Media Considers all media, all types of prints. Most frequently exhibits wood, ceramics, glass and 2 dimensional.

Style Prefers traditional Hawaiian, contemporary Hawaiian and contemporary fine crafts.

Terms "Artists must become Volcano Art Center members." Accepts work on consignment (50% commission). 10% discount to VAC members is absorbed by the organization. Retail price set by the gallery. Gallery provides promotion and contract; artist pays shipping costs to gallery.

Submissions Prefers work relating to the area and by Hawaii resident artists. Call for appointment to show portfolio. Responds only if interested within 1 month. Files "information on artists we represent."

WASHINGTON COUNTY MUSEUM OF FINE ARTS

P.O. Box 423, City Park, Hagerstown MD 21741. (301)739-5727. Fax: (301)745-3741. E-mail: info@wcmfa.org. Website: www.wcmfa.org. **Contact:** Curator. Estab. 1929. Approached by 30 artists/year. Average display time: 6-8 weeks. Open Tuesday-Friday, 9-5; Saturday, 9-4; Sunday, 1-5. Closed legal holidays. Overall price range: $50-7,000. **Media** Considers all media except installation and craft. Most frequently exhibits oil, watercolor and ceramics. Considers all types of prints except posters.

Style Exhibits impressionism. Genres include florals, landscapes, portraits and wildlife.

Terms Museum provides artist's contact information to potential buyers. Accepted work should not be framed.

Submissions Write to show portfolio of photographs, slides. Mail portfolio for review. Responds in 1 month. Finds artists through word of mouth, portfolio reviews, art exhibits, referrals by other artists.

WASHINGTON PRINTMAKERS GALLERY

1732 Connecticut Ave. NW, 2nd Floor, Washington DC 20009. (202)332-7757. E-mail: info@washingtonprintmakers.com. Website: www.washingtonprintmakers.com. **Director:** Karisa Senavitis. Cooperative gallery. Estab. 1985. Exhibits 40 emerging and mid-career artists/year. Exhibited artists include Lee Newman, Max-Karl Winkler, Trudi Y. Ludwig and Margaret Adams Parker. Sponsors 12 exhibitions/year. Average display time 1 month. Open all year; Tuesday-Thursday, 12-6; Friday, 12-9; Saturday-Sunday, 12-5. Located downtown in Dupont Circle area. 100% of space for gallery artists. Clientele varied. 90% private collectors, 10% corporate collectors. Overall price range $65-1,500; most work sold at $200-400.

Media Considers all types of original prints, hand pulled by artist. No posters. Most frequently exhibits etchings, lithographs, serigraphs, relief prints.

Style Considers all styles and genres.

Terms Co-op membership fee plus donation of time (40% commission). Retail price set by artist. Gallery provides promotion. Purchaser pays shipping costs of work sold.

Submissions Send query letter. Call for appointment to show portfolio of original prints. Responds in 1 month.

Tips "There is a monthly jury for prospective members. Call to find out how to present work. We are especially interested in artists who exhibit a strong propensity for not only the traditional conservative approaches to printmaking, but also the looser, more daring and innovative experimentation in technique."

MARCIA WEBER/ART OBJECTS, INC.

1050 Woodley Rd., Montgomery AL 36106. (334)262-5349. Fax: (334)567-0060. E-mail: weberart@mindspring.com. Website: www.marciaweberartobjects.com. **Owner:** Marcia Weber. Retail, wholesale gallery. Estab. 1991. Represents 21 emerging, mid-career and established artists/year. Exhibited artists include Woodie Long, Jimmie Lee Sudduth, Michael Banks, Mose Tolliver, Mary Whitfield, Malcah Zeldis. Open all year by appointment or by chance, weekday afternoons. Located in Old Cloverdale near downtown in older building with hardwood floors. 100% of space for gallery artists. Clientele: tourists, upscale. 90% private collectors, 10% corporate collectors. Overall price range: $300-20,000; most work sold at $300-4,000.

- This gallery owner specializes in the work of self-taught, folk, or outsider artists. This gallery shows each year in New York, Chicago and Atlanta.

Media Considers all media except prints. Must be original one-of-a-kind works of art. Most frequently exhibits acrylic, oil, found metals, found objects and enamel paint.

Style Exhibits genuine contemporary folk/outsider art, self-taught art and some Southern antique original works.

Terms Accepts work on consignment (variable commission) or buys outright. Gallery provides insurance, promotion and contract if consignment is involved. Prefers artwork unframed so the gallery can frame it.

Submissions "Folk/outsider artists usually do not contact dealers. They have a support person or helper, who might write or call, send query letter with photographs, artist's statement." Call or write for appointment to show portfolio of photographs, original material. Finds artists through word of mouth, other artists and "serious collectors of folk art who want to help an artist get in touch with me." Gallery also accepts consignments from collectors.

Tips "An artist is not a folk artist or an outsider artist just because their work resembles folk art. They have to *be* folks who began creating art without exposure to fine art. Outsider artists live in their own world outside the mainstream and create art. Academic training in art excludes artists from this genre." Prefers artists committed to full-time creating.

WEST END GALLERY

5425 Blossom, Houston TX 77007. (713)861-9544. E-mail: kpackl1346@aol.com. **Owner:** Kathleen Packlick. Retail gallery. Estab. 1991. Exhibits emerging and mid-career artists. Open all year. Located 5 minutes from downtown Houston; 800 sq. ft.;

"The gallery shares the building (but not the space) with West End Bicycles." 75% of space for special exhibitions; 25% of space for gallery artists. Clientele: 100% private collectors. Overall price range: $30-2,200; most work sold at $300-600.

Media Considers oil, pen & ink, acrylic, drawings, watercolor, mixed media, pastel, collage, woodcuts, wood engravings, linocuts, engravings, mezzotints, etchings, lithographs and serigraphs. Prefers collage, oil and mixed media.

Style Exhibits conceptualism, minimalism, primitivism, postmodern works, realism and imagism. Genres include landscapes, florals, wildlife, portraits and figurative work.

Terms Accepts work on consignment (40% commission). Retail price set by artist. Payment by installment is available. Gallery provides promotion; artist pays shipping costs. Prefers framed artwork.

Submissions Accepts only artists from Houston area. Send query letter with slides and SASE. Portfolio review requested if interested in artist's work.

PHILIP WILLIAMS POSTERS

122 Chambers St, New York NY 10007. (212)513-0313. E-mail: philipwilliamsposters@gmail.com. Website: www.postermuseum.com. **Contact:** Philip Williams. Retail and wholesale gallery. Represents/exhibits vintage posters 1870-1960. Open all year; Monday-Sunday, 11-7.

Terms Prefers artwork unframed.

Submissions Prefers vintage posters and outsider artist. Send query letter with photographs.

WINDHAM FINE ARTS

5380 Main Street, Windham NY 12496. (518)734-6850. E-mail: info@windhamfinearts.com. Website: www.windhamfinearts.com. **Director: Marie Christine Case**. For-profit gallery, art consultancy. Estab. 2001. Exhibits around 40 emerging, mid-career and established artists. Exhibited artists include Michael Kessler (Nature based / Geometric Abstract), Lizbeth Mitty (Contemporary), and Kevin Cook (Hudson River School). Sponsors 10-12 exhibits/year. Average display time 1 month. Open all year; Friday-Monday from 11-5; Clients include upscale second home owners, tourists and private clients. 5% of sales are to corporate collectors. Most work sold at $3,000-15,000.

Media Considers all media. Considers print types including etchings and woodcuts.

Style Exhibits new contemporary realism, nature-based abstraction, impressionism, postmodernism. Genres include figurative work, cityscapes, and landscapes.

Terms Artwork is accepted on consignment and there is a 50% commission. Gallery provides insurance, promotion and contract. Accepted work should be framed, mounted and matted. Requires exclusive representation locally.

Submissions Call or e-mail to arrange personal interview to show portfolio of photographs and CDs. Send query letter with artist's statement, bio, photocopies, photographs, resume, reviews and CD. Responds to queries in 2 -4 weeks. Files name, contact information and images. Finds artists through internet search, print catalog, art exhibits, portfolio reviews, referrals by other artists, submissions and word of mouth.

THE WING GALLERY

13636 Ventura Blvd., Sherman Oaks CA 91423 (mailing address only). (818)981-WING and (800)422-WING. Fax: (805)955-0440. E-mail: robin@winggallery.com. Website: www.winggallery.com. **Director:** Robin Wing. Retail gallery. Estab. 1975. Represents 100+ emerging, mid-career and established artists. Clientele: 80% private collectors, 20% corporate collectors. Overall price range: $50-$50,000; most work sold at $150-$5,000.

Media Considers oil, acrylic, watercolor, drawings, original handpulled prints, offset reproductions, engravings, lithographs, monoprints and serigraphs.

Style Exhibits primitivism, impressionism, realism and photorealism. Genres include landscapes, Americana, Southwestern, Western, Asian, wildlife and fantasy.

Terms Accepts work on consignment (40-50% commission). Retail price set by gallery and artist. Sometimes offers customer discounts and payment by installments. Only accepts unframed artwork.

Tips Artists should have a "professional presentation" and "consistent quality."

WOMEN & THEIR WORK ART SPACE

1710 Lavaca St., Austin TX 78701. (512)477-1064. Fax: (512)477-1090. E-mail: info@women andtheirwork.org. Website: www.womenandtheirwork.org. **Associate Director:** Katherine McQueen. Alternative space and nonprofit gallery. Estab. 1978. Approached by more than 200 artists/year. Sponsors 8-10 solo and seasonal juried shows of emerging and mid-career Texas women. Exhibited artists include Margarita Cabrera, Misty Keasler, Karyn Olivier, Angela Fraleigh and Liz Ward. Average display time: 5 weeks. Open Monday-Friday, 9-6; Saturday, 12-5. Closed holidays. Located downtown; 2,000 sq. ft. Clients include local community, students, tourists and upscale. 10% of sales are to corporate collectors. Overall price range: $500-5,000; most work sold at $800-1,000.

Media Considers all media. Most frequently exhibits photography, sculpture, installation and painting.

Style Exhibits contemporary works of art.

Terms Selects artists through an Artist Advisory Panel and Curatorial/Jury process. Pays artists to exhibit. Takes 25% commission if something is sold. Retail price set by the gallery and the artist. Gallery provides insurance, promotion and contract.

Accepted work should be framed, mounted and matted. Accepts Texas women in solo shows only; all other artists, male or female, in one annual curated show. See website for more information.

Submissions See website for current Call for Entries. Returns materials with SASE. Filing of material depends on artist and if he/she is a member. Online Slide Registry on website for members. Finds artists through submissions and annual juried process.

Tips Send quality slides/digital images, typed résumé, and clear statement with artistic intent. 100% archival material required for framed works.

WOODWARD GALLERY

133 Eldridge St., Ground Floor, New York NY 10002. (212)966-3411. Fax: (212)966-3491. E-mail: art@woodgallery.net. Website: www.WoodwardGallery.net. **Director:** John Woodward. **Owner:** Kristine Woodward. For-profit gallery. Estab. 1994. Exhibits emerging, mid-career and established artists. Approached by more than 2,000 artists/year; represents 10 artists in their stable. Exhibited artists include Cristina Vergano (oil on canvas/wood panel), Susan Breen (oil on wood or paper), Margaret Morrison (oil on canvas/wood panel and paper). Also features work by Andy Warhol, Richard Hambleton, Jean-Michel Basquiat and Robert Indiana. Sponsors 6 exhibits/year. Average display time: 2 months. Open Tuesday-Saturday, 11-6; August by private appointment only. Clients include local community, tourists, upscale, and other art dealers. 20% of sales are to corporate collectors. Overall price range: $1,000-5,000,000; most work sold at $10,000-200,000.

Media Considers acrylic, collage, drawing, mixed media, oil, paper, pastel, pen ink, sculpture, watercolor. Most frequently exhibits canvas, paper and sculpture. Considers all types of prints.

Style Most frequently exhibits realism/surrealism, pop, abstract and landscapes, graffiti. Genres include figurative work, florals, landscapes and portraits.

Terms Artwork is bought outright (net 30 days) or consigned. Retail price set by the gallery.

Submissions Call before sending anything! Send query letter with artist's statement, bio, brochure, photocopies, photographs, reviews and SASE. Returns material with SASE. Finds artists through referrals or submissions.

Tips artist must follow our artist review criteria, which is available every new year (first or second week of January) with updated policy from our director."

WORLD FINE ART GALLERY

511 W. 25th St., Suite 507, New York NY 10001-5501. (646)336-1677. Fax: (646) 478-9361. E-mail: info@worldfineart.com. Website: www.worldfineart.com. **Contact:** O'Delle Abney, director. Cooperative gallery. Estab. 1992. Approached by 1,500 artists/year; represents or exhibits 50 artists. Average display time 1 month. Open

Tuesday through Saturday from 12 to 6. Closed August. Located in Chelsea, NY; 1,000 sq. ft. Overall price range: $500-5,000. Most work sold at $1,500.
Media Considers all media. Most frequently exhibits acrylic, oil and mixed media. Types of prints include lithographs, serigraphs and woodcuts.
Style Exhibits color field. Considers all styles and genres. Most frequently exhibits painterly abstraction, color field and surrealism.
Terms There is a rental fee for space that covers 1 month or 1 year. Retail price set by the artist. Gallery provides insurance, promotion and contract. Accepted work should be framed; must be considered suitable for exhibition.
Submissions Write to arrange a personal interview to show portfolio, or e-mail JPEG images. Responds to queries in 1 week. Finds artists through the Internet.
Tips "Have website available for review."

YEISER ART CENTER INC.

200 Broadway, Paducah KY 42001. (270)442-2453. E-mail: info@theyeiser.org. Website: www.theyeiser.org. **Contact:** Ms. Landee Bryant, executive director, or Ms. Trish Boyd, administrative specialist. Nonprofit gallery. Estab. 1957. Exhibits emerging, mid-career and established artists. 450 members. Sponsors 8-10 shows/year. Average display time: 6-8 weeks. Open all year. Located downtown; 1,800 sq. ft.; "in historic building that was farmer's market." 90% of space for special exhibitions. Clientele: professionals and collectors. 90% private collectors. Overall price range: $200-8,000; most artwork sold at $200-1,000.
Media Considers all media. Prints considered include original handpulled prints, woodcuts, wood engravings, linocuts, mezzotints, etchings, lithographs and serigraphs.
Style Exhibits all styles and genres.
Terms Gallery takes 40% commission on all sales (60/40 split). Expenses are negotiated.
Submissions Send résumé, slides, bio, SASE and reviews. Responds in 3 months.
Tips "Do not call. Give complete information about the work—media, size, date, title, price. Have good-quality slides of work, indicate availability, and include artist statement. Presentation of material is important."

YELLOWSTONE GALLERY

216 W. Park St., P.O. Box 472, Gardiner MT 59030. (406)848-7306. E-mail: info@yellow stonegallery.com. Website: yellowstonegallery.com. **Owner:** Jerry Kahrs. Retail gallery. Estab. 1985. Represents 20 emerging and mid-career artists/year. Exhibited artists include Mary Blain and Nancy Glazier. Sponsors 2 shows/year. Average display time: 2 months. Located downtown; 3,000 sq. ft. 25% of space for special exhibitions; 50% of space for gallery artists. Clientele: tourist and regional.

90% private collectors, 10% corporate collectors. Overall price range: $25-8,000; most work sold at $75-600.

Media Considers oil, acrylic, watercolor, ceramics, craft and photography; types of prints include wood engravings, serigraphs, etchings and posters. Most frequently exhibits watercolors, oils and limited edition, signed and numbered reproductions.

Style Exhibits impressionism, photorealism and realism. Genres include Western, wildlife and landscapes. Prefers wildlife realism, Western and watercolor impressionism.

Terms Accepts work on consignment (45% commission). Retail price set by the artist. Gallery provides contract; artist pays for shipping. Prefers artwork framed.

Submissions Send query letter with brochure or 10 slides. Write for appointment to show portfolio of photographs. Responds in 1 month. Files brochure and biography. Finds artists through word of mouth, regional fairs and exhibits, mail and periodicals.

Tips "Don't show up unannounced without an appointment."

LEE YOUNGMAN GALLERIES

1316 Lincoln Ave., Calistoga CA 94515. (707)942-0585. Fax: (707)942-6657. E-mail: leeyg@sbcglobal.net. Website: www.leeyoungmangalleries.com. **Owner:** Ms. Lee Love Youngman. Retail gallery. Estab. 1985. Represents 40 established artists. Exhibited artists include Ralph Love and Paul Youngman. Sponsors 3 shows/year. Average display time 1 month. Open all year. Located downtown; 3,000 sq. ft.; "contemporary decor." Clientele 100% private collectors. Overall price range $500-24,000; most artwork sold at $1,000-3,500.

Media Considers oil, acrylic, watercolor and sculpture. Most frequently exhibits oils, bronzes and alabaster.

Style Exhibits impressionism and realism. Genres include landscapes, Figurative, Western and still life. Interested in seeing American realism. No abstract art.

Terms Accepts work on consignment (50% commission). Retail price set by gallery. Customer discounts and payment by installment are available. Gallery provides insurance and promotion. Artist pays for shipping to and from gallery. Prefers framed artwork.

Submissions Accepts only artists from Western states. "No unsolicited portfolios." Portfolio review requested if interested in artist's work. "The most common mistake artists make is coming on weekends, the busiest time, and expecting full attention." Finds artists through publication, submissions and owner's knowledge.

Tips "Don't just drop in—make an appointment. No agents."

ZENITH GALLERY

P.O. Box 55295, Washington DC 20040. (202)783-2963. E-mail: art@zenithgallery.

com. Website: www.zenithgallery.com. **Owner/Director:** Margery E. Goldberg. For-profit gallery. Estab. 1978. Exhibits emerging, mid-career and established artists. Open Tuesday-Friday, 11-6; Saturday, 11-7; Sunday, 12-5. Three rooms; 2,400 sq. ft. of exhibition space. Clients include local community, tourists and upscale. 50% of sales are to corporate collectors. Overall price range: $5,000-15,000.

Media Considers all media.

Terms Requires exclusive representation locally for solo exhibitions.

Submissions Send query letter with artist's statement, bio, résumé, reviews, brochures, images on CD, SASE. Returns material with SASE. Responds to most queries if interested. Finds artists through art fairs/exhibits, portfolio reviews, referrals by other artists, submissions and word of mouth.

Tips "The review process can take anywhere from one month to one year. Please be patient and do not call the gallery for acceptance information." Visit website for detailed submission guidelines before sending any materials.

Magazines

Magazines are a major market for freelance illustrators. The best proof of this fact is as close as your nearest newsstand. The colorful publications competing for your attention are chock-full of interesting illustrations, cartoons and caricatures. Since magazines are generally published on a monthly or bimonthly basis, art directors look for dependable artists who can deliver on deadline and produce quality artwork with a particular style and focus.

Art that illustrates a story in a magazine or newspaper is called editorial illustration. You'll notice that term as you browse through the listings. Art directors look for the best visual element to hook the reader into the story. In some cases this is a photograph, but often, especially in stories dealing with abstract ideas or difficult concepts, an illustration makes the story more compelling. A whimsical illustration can set the tone for a humorous article, or an edgy caricature of movie stars in boxing gloves might work for an article describing conflicts within a film's cast. Flip through a dozen magazines in your local drugstore and you will quickly see that each illustration conveys the tone and content of articles while fitting in with the magazine's "personality."

The key to success in the magazine arena is matching your style to appropriate publications. Art directors work to achieve a synergy between art and text, making sure the artwork and editorial content complement each other.

TARGET YOUR MARKETS

Read each listing carefully. Knowing how many artists approach each magazine will help you understand how stiff your competition is. (At first, you might do better submitting to art directors who aren't swamped with submissions.) Look at the preferred subject matter to make sure your artwork fits the magazine's needs. Note the submission requirements and develop a mailing list of markets you want to approach.

Visit newsstands and bookstores. Look for both magazines listed and

not listed in *Artist's & Graphic Designer's Market*. Check the cover and interior; if illustrations are used, flip to the masthead (usually a box in one of the beginning pages) and note the art director's name. The circulation figure is also relevant; the higher the circulation, the higher the art director's budget (generally). When art directors have a good budget, they tend to hire more illustrators and pay higher fees.

Look at the credit lines next to each illustration. Notice which illustrators are used often in the publications you wish to work with. You will see that each illustrator has a very definite style. After you have studied dozens of magazines, you will understand what types of illustrations are marketable.

Although many magazines can be found at a newsstand or library, some of your best markets may not be readily available. If you can't find a magazine, check the listing in *Artist's & Graphic Designer's Market* to see if sample copies are available. Keep in mind that many magazines also provide artists' guidelines on their websites.

CREATE A PROMO SAMPLE

Focus on one or two *consistent* styles to present to art directors in sample mailings. See if you can come up with a style that is different from every other illustrator's style, if only slightly. No matter how versatile you may be, limit styles you market to one or two. That way, you'll be more memorable to art directors. Choose a style or two that you enjoy and can work in relatively quickly. Art directors don't like surprises. If your sample shows a line drawing, they expect you to work in that style when they give you an assignment. It's fairly standard practice to mail nonreturnable samples: either postcard-size reproductions of your work, photocopies or whatever is requested in the listing. Some art directors like to see a résumé; some don't.

MORE MARKETING TIPS

• **Don't overlook trade magazines and regional publications.** While they may not be as glamorous as national consumer magazines, some trade and regional publications are just as lavishly produced. Most pay fairly well, and the competition is not as fierce. Until you can get some of the higher-circulation magazines to notice you, take assignments from smaller magazines. Alternative weeklies are great markets as well. Despite their modest payment, there are many advantages to working with them. You learn how to communicate with art directors, develop your signature style, and learn how to work quickly to meet deadlines. Once the assignments are done, the tearsheets become valuable samples to send to other magazines.

• **Develop a spot illustration style in addition to your regular style.** "Spots"—illustrations that are half-page or smaller—are used in magazine layouts as interesting visual cues to lead readers through large articles or to make filler articles more appealing. Though the fee for one spot is less than for a full layout, art directors often assign five or six spots within the same issue to the same artist. Because spots are

Helpful Resources

For More Info

• **A great source for new magazine leads is in the business section of your local library.** Ask the librarian to point out the business and consumer editions of the *Standard Rate and Data Service (SRDS)* and *Bacon's Magazine Directory*. These huge directories list thousands of magazines and will give you an idea of the magnitude of magazines published today. Another good source is a yearly directory called *Samir Husni's Guide to New Consumer Magazines*, also available in the business section of the public library and online at www.mrmagazine.com. *Folio* magazine provides information about new magazine launches and redesigns.

• **Each year the Society of Publication Designers sponsors a juried competition, the winners of which are featured in a prestigious exhibition.** For information about the annual competition, contact the Society of Publication Designers at (212)223-3332 or visit their website at www.spd.org.

• **Networking with fellow artists and art directors will help you find additional success strategies.** The Graphic Artists Guild (www.gag.org), The American Institute of Graphic Artists (www.aiga.org), your city's Art Directors Club (www.adcglobal.org) or branch of the Society of Illustrators (www.societyillustrators.org) hold lectures and networking functions. Attend one event sponsored by each organization in your city to find a group you are comfortable with, then join and become an active member.

small in size, they must be all the more compelling. So send art directors a sample showing a few powerful small pieces along with your regular style.

• **Be prepared to share your work electronically.** Art directors often require illustrators to fax or email sketched or preliminary illustrations so layouts can be reviews and suggestion can be offered. Invest in a scanner if you arent' already working digitally.

• **Get your work into competition annuals and sourcebooks.** The term "sourcebook" refers to the creative directories published annually to showcase the work of freelancers. Art directors consult these publications when looking for new styles. Many listings mention if an art director uses sourcebooks. Some directories like *The Black Book*, *American Showcase* and *RSVP* carry paid advertisements costing several thousand dollars per page. Other annuals, like the *PRINT Regional Design Annual* or *Communication Arts Illustration Annual*, feature award winners

of various competitions. An entry fee and some great images can put your work in a competition directory and in front of art directors across the country.

• **Consider working with a rep.** If after working successfully on several assignments you decide to make magazine illustration your career, consider contracting with an artists' representative to market your work for you. (See the Artists' Reps section, beginning on page 414.)

AARP THE MAGAZINE

601 E St. NW, Washington DC 20049. (202)434-2277. Fax: (202)434-6451. Website: www.aarpmagazine.org. **Design Director:** Eric Seidman. Art Director: Courtney Murphy-Price. Estab. 2002. Bimonthly 4-color magazine emphasizing health, lifestyles, travel, sports, finance and contemporary activities for members 50 years and over. Circ. 21 million.

Illustration Approached by 200 illustrators/year. Buys 30 freelance illustrations/issue. Assigns 60% of illustrations to well-known or "name" illustrators; 30% to experienced but not well-known illustrators; 10% to new and emerging illustrators. Works on assignment only. Considers digital, watercolor, collage, oil, mixed media and pastel.

First Contact & Terms Samples are filed "if I can use the work." Do not send portfolio unless requested. Portfolio can include original/final art, tearsheets, slides and photocopies and samples to keep. Originals are returned after publication. Buys first rights. Pays on completion of project: $700-3,500.

Tips "We generally use people with strong conceptual abilities. I request samples when viewing portfolios."

ABA BANKING JOURNAL

American Bankers Association, 345 Hudson St., 12th Floor, New York NY 10014-4502. (212)620-7256. Fax: (212)633-1165. E-mail: wwilliams@sbpub.com. Website: www.ababj.com. **Creative Director:** Wendy Williams. Associate Creative Director: Phil Desiere. Estab. 1908. Monthly association journal; 4-color with contemporary design. Emphasizes banking for middle and upper level banking executives and managers. Circ. 31,440.

Illustration Buys 4-5 illustrations/issue from freelancers. Features charts & graphs, computer, humorous and spot illustration. Assigns 20% of illustrations to new and emerging illustrators. Themes relate to stories, primarily financial, from the banking industry's point of view; styles vary, realistic, surreal. Uses full-color illustrations.

Works on assignment only.

First Contact & Terms Illustrators: Send finance-related postcard sample and follow-up samples every few months. To send a portfolio, send query letter with brochure and tearsheets, promotional samples or photographs. Negotiates rights purchased. **Pays on acceptance**; $250-950 for color cover; $250-450 for color inside; $250-450 for spots. Accepts previously published material. Returns original artwork after publication.

Tips Must have experience illustrating for business or financial publications.

⊕ ACTIVE LIFE

Windhill Manor, Leeds Rd., Shipley, W. Yorkshire BD18 1BP United Kingdom. 0800-560900. E-mail: info@activelife.co.uk. Website: www.activelife.co.uk. **Managing Editor:** Helene Hodge. Estab. 1990. Bimonthly consumer magazine emphasizing lively lifestyle for people over age 50. Circ. 240,000.

Illustration Approached by 200 illustrators/year. Buys 12 illustrations/issue. Features humorous illustration. Prefers family-related themes, pastels and bright colors. Assigns 20% of illustration to well-known or "name" illustrators; 60% to experienced, but not well-known illustrators; 20% to new and emerging illustrators.

First Contact & Terms Send nonreturnable samples. Accepts Mac-compatible disk submissions. Samples are filed. Responds within 1 month. Will contact artist for portfolio review if interested. Buys all rights. Pays on publication. Finds illustrators through promotional samples.

Tips "We use all styles, but more often 'traditional' images."

ADVANSTAR LIFE SCIENCES

24950 Country Club Blvd, North Olmsted, OH 44070. E-mail: pseltzer@advanstar.com. Website: www.advanstar.com. Estab. 1909. Publishes 15 health-related publications and special products. Uses freelance artists for "most editorial illustration in the magazines."

Cartoons Prefers general humor topics (workspace, family, seasonal); also medically related themes. Prefers single-panel b&w drawings and washes with gagline.

Illustration Interested in all media, including 3D, electronic and traditional illustration. Needs editorial and medical illustration that varies "but is mostly on the conservative side." Works on assignment only.

First Contact & Terms Cartoonists: Send unpublished cartoons only with SASE to Pete Seltzer, Group Art Director. Buys first world publication rights. Illustrators: Send samples to Peter Seltzer. Samples are filed. Responds only if interested. Write for portfolio review. Buys nonexclusive worldwide rights. Pays $1,000-1,500 for color cover; $250-800 for color inside; $200-600 for b&w. Accepts previously published material. Originals are returned at job's completion.

ADVENTURE CYCLIST

150 E. Pine St., Missoula MT 59802. (406)721-1776. Fax: (406)721-8754. E-mail: gsiple@adventurecycling.org. Website: www.adventurecycling.org. **Art Director:** Greg Siple. Estab. 1974. Journal of adventure travel by bicycle, published 9 times/ year. Circ. 43,000.

Illustration Buys 1 illustration/issue. Has featured illustrations by Margie Fullmer, Ludmilla Tomova and Anita Dufalla. Works on assignment only.

First Contact & Terms Illustrators: Send printed samples. Samples are filed. Will contact artist for portfolio review if interested. Pays on publication, $50-350. Buys one-time rights. Originals returned at job's completion.

ADVOCATE, PKA'S PUBLICATION

1881 Co. Rt. 2, Prattsville NY 12468. (518)299-3103. **Art Editor:** C.J. Karlie. Estab. 1987. Bimonthly b&w literary tabloid. "Advocate provides aspiring artists, writers and photographers the opportunity to see their works published and to receive byline credit toward a professional portfolio so as to promote careers in the arts." The Gaited Horse Association Newsletter is published within the pages of Advocate. Circ. 10,000. Sample copies with guidelines available for $4 with SASE.

Cartoons Open to all formats.

Illustration Buys 10-15 illustrations/issue. Considers pen & ink, charcoal, linoleum-cut, woodcut, lithograph, pencil or photos, "either black & white or color prints (no slides). We are especially looking for horse-related art and other animals." Also needs editorial and entertainment illustration.

First Contact & Terms Cartoonists: Send query letter with SASE and submissions for publication. Illustrators: Send query letter with SASE and photos of artwork (b&w or color prints only). "Good-quality photocopy or stat of work is acceptable as a submission." No simultaneous submissions. Samples are not filed and are returned by SASE. Portfolio review not required. Responds in 6 weeks. Buys first rights. Pays cartoonists/illustrators in contributor's copies. Finds artists through submissions and from knowing artists and their friends.

Tips "No postcards are acceptable. Many artists send us postcards to review their work. They are not looked at. Artwork should be sent in an envelope with a SASE."

THE ADVOCATE

10960 Wilshire Blvd., Suite 1050, Los Angeles CA 90024. (323)871-1225. Fax: (323)467-6805. E-mail: gstoll@advocate.com. Website: www.advocate.com. **Contact:** Art Director. Estab. 1967. Biweekly. National gay and lesbian 4-color consumer news magazine.

Illustration Approached by 20 illustrators/year. Buys 1-2 illustrations/issue. Has featured illustrations by Alexander Munn, Sylvie Bourbonniere and Tom Nick

Cocotos. Features caricatures of celebrities and politicians, computer illustration, realistic illustration and medical illustration. Preferred subjects men, women, gay and lesbian topics. Considers all media. Assigns 90% of illustrations to experienced, but not well-known illustrators; 10% to new and emerging illustrators.

First Contact & Terms Send postcard sample or nonreturnable samples. Accepts disk submissions. Art guidelines available on website. Samples are filed. Responds only if interested. Portfolio review not required. Buys one-time rights. Pays on publication.

Tips "We are happy to consider unsolicited illustration submissions to use as a reference for making possible assignments to you in the future. Before making any submissions to us, please familiarize yourself with our magazine. Keep in mind that *The Advocate* is a news magazine. As such, we publish items of interest to the gay and lesbian community based on their newsworthiness and timeliness. We do not publish unsolicited illustrations or portfolios of individual artists. Any illustration appearing in *The Advocate* was assigned by us to an artist to illustrate a specific article."

AGING TODAY

833 Market St., San Francisco CA 94103. (415)974-9619. Fax: (415)974-0300. Website: www.asaging.org. **Editor:** Paul Kleyman. Estab. 1979. "Aging Today is the bimonthly black & white newspaper of The American Society on Aging. It covers news, public policy issues, applied research and developments/trends in aging." Circ. 10,000. Accepts previously published artwork. Originals returned at job's completion if requested. Sample copies available on request.

Cartoons Approached by 50 cartoonists/year. Buys 1-2 cartoons/issue. Prefers political and social satire cartoons; single, double or multiple panel with or without gagline, b&w line drawings. Samples returned by SASE. Responds only if interested. Buys one-time rights.

Illustration Approached by 50 illustrators/year. Buys 1 illustration/issue. Works on assignment only. Prefers b&w line drawings and some washes. Considers pen & ink. Needs editorial illustration.

First Contact & Terms Cartoonists: Send query letter with brochure and roughs. Illustrators: Send query letter with brochure, SASE and photocopies. Pays cartoonists $25, with fees for illustrations, $25-50 for b&w covers or inside drawings. Samples are not filed and are returned by SASE. Responds only if interested. To show portfolio, artist should follow up with call and/or letter after initial query. Buys one-time rights.

Tips "Send brief letter with two or three applicable samples. Don't send hackneyed cartoons that perpetuate ageist stereotypes."

AGONYINBLACK, VARIOUS COMIC BOOKS

E-mail: editor@chantingmonks.com. Website: www.chantingmonks.com. **Editor:** Pamela Hazelton. Estab. 1994. Bimonthly "illustrated magazine of horror" for mature readers. Circ. 4-6,000. Art guidelines for #10 SASE with first-class postage.

Illustration Approached by 200-300 illustrators/year. Buys 5 illustrations/issue. Has featured illustrations by Bernie Wrightson, Louis Small and Ken Meyer. Features realistic and spot illustration. Assigns 50% of illustrations to well-known or "name" illustrators; 30% to experienced but not well-known illustrators; 20% to new and emerging illustrators. Prefers horror, disturbing truth. Considers all media.

First Contact & Terms All submission correspondence should be sent via e-mail. "Do not send attachments and no need to doublespace."

Tips "We publish comic books and occasionally pinup books. We mostly look for panel and sequential art. Please have a concept of sequential art. Please inquire via e-mail for all submissions."

AIM: AMERICA'S INTERCULTURAL MAGAZINE

P.O. Box 390, Milton WA 98354-0390. (253)815-9030. E-mail: apiladoone@aol.com. Website: www.aimmagazine.org. **Contact:** Ruth Apilado. Estab. 1973. Quarterly b&w magazine with 2-color cover. Readers are those "wanting to eliminate bigotry and desiring a world without inequalities in education, housing, etc." Circ. 7,000. Sample copy available for $5; art submission guidelines free for SASE.

Cartoons Approached by 12 cartoonists/week. Buys 10-15 cartoons/year. Uses 1-2 cartoons/issue. Prefers themes related to education, environment, family life, humor in youth, politics and retirement; single-panel with gagline. Especially needs "cartoons about the stupidity of racism."

Illustration Approached by 4 illustrators/week. Uses 4-5 illustrations/issue; half from freelancers. Prefers pen & ink. Subjects include current events, education, environment, humor in youth, politics and retirement.

First Contact & Terms Cartoonists: Send samples with SASE. Illustrators: Provide brochure to be kept on file for future assignments. Samples are not returned. Responds in 3 weeks. Buys all rights on a work-for-hire basis. Pays on publication. Pays cartoonists $5-15 for b&w line drawings. Pays illustrators $25 for b&w cover illustrations. Accepts previously published, photocopied and simultaneous submissions.

Tips "We could use more illustrations and cartoons with people from all ethnic and racial backgrounds in them. We also use material of general interest. Artists should show a representative sampling of their work and target the magazine's specific needs. Nothing on religion."

ALASKA MAGAZINE

301 Arctic Slope Ave., Suite 300, Anchorage AK 99518-3035. (907)272-6070. Fax: (907)275-2117. Website: www.alaskamagazine.com. **Art Director:** Tim Blum. Estab. 1935. Monthly 4-color regional consumer magazine featuring Alaskan issues, stories and profiles exclusively. Circ. 200,000.

Illustration Approached by 200 illustrators/year. Buys 1-4 illustrations/issue. Has featured illustrations by Bob Crofut, Chris Ware, Victor Juhaz and Bob Parsons. Features humorous and realistic illustrations. Works on assignment only. Assigns 50% to new and emerging illustrators. 50% of freelance illustration demands knowledge of Illustrator, Photoshop and QuarkXPress.

First Contact & Terms Send postcard or other nonreturnable samples. Accepts Mac-compatible disk submissions. Samples are not returned. Responds only if interested. Will contact artist for portfolio review if interested. Buys first North American serial rights and electronic rights; rights purchased vary according to project. Pays on publication. Pays illustrators $125-300 for color inside; $400-600 for 2-page spreads; $125 for spots.

Tips "We work with illustrators who grasp the visual in a story quickly and can create quality pieces on tight deadlines."

ALL ANIMALS MAGAZINE

700 Professional Dr., Gaithersburg, MD 20879. (301)258-3192. Fax: (301)721-6468. E-mail: jcork@humanesociety.org. Website: humanesociey.org. **Chief Design Director:** Jennifer Cork. Estab. 1954. Bi-Monthly 4-color magazine focusing on The Humane Society of the United States news and animal protection issues. Circ. 450,000.

First Contact & Terms Features natural history, realistic and spot illustration. Accepts previously published artwork. Originals are returned at job's completion. Art guidelines not available. Work by assignment only. Themes vary. E-mail portfolio web site link or mail query letter with samples. Responds in 1 month. **Pays on acceptance**; $300-500 for full page inside; $400-700 for 2-page spreads; $75-200 for spots.

ALTERNATIVE THERAPIES IN HEALTH AND MEDICINE

InnoVision Communications Health Media, 2995 Wilderness Place, Suite 205, Boulder CO 80301. (303)440-7402. Fax: (303)440-7446. E-mail: lee@innovisionhm.com. Website: www.alternative-therapies.com. **Creative Director:** Lee Dixson. Estab. 1995. Bimonthly trade journal. "Alternative Therapies is a peer-reviewed medical journal established to promote integration between alternative and cross-cultural medicine with conventional medical traditions." Circ. 25,000. Sample copies available.

Illustration Buys 6 illustrations/year. Purchases fine art for the covers, not graphic art or cartoons.

First Contact & Terms Send e-mail with samples or link to web site. Responds within 10 days. Will contact artist if interested. Samples should include subject matter consistent with impressionism, expressionism, and surrelaism. Buys one-time and reprint rights. Pays on publication; negotiable. Accepts previously published artwork. Originals returned at job's completion. Finds artists through web sites, galleries, and word of mouth.

AMERICA

106 W. 56th St., New York NY 10019. (212)581-1909. Fax: (212)399-3596. Website: www.americamagazine.org. **Associate Editor:** James Martin. Estab. 1904. Weekly Catholic national magazine published by US Jesuits. Circ. 46,000.

Illustration Buys 3-5 illustrations/issue. Has featured illustrations by Michael O'Neill McGrath, William Hart McNichols, Tim Foley, Stephanie Dalton Cowan. Features realistic illustration and spot illustration. Assigns 45% of illustrations to new and emerging illustrators. Considers all media.

First Contact & Terms Illustrators: Send printed samples and tearsheets. Buys first rights. Pays on publication; $300 for color cover; $150 for color inside.

Tips "We look for illustrators who can do imaginative work for religious, educational or topical articles. We will discuss the article with the artist and usually need finished work in two to three weeks. A fast turnaround is extremely valuable."

AMERICAN AIRLINES NEXOS

4333 Amon Carter Blvd., Ft. Worth TX 76155. (817)967-1804. Fax: (817)963-9976. E-mail: marco.rosales@aa.com. Website: www.nexosmag.com. **Art Director**: Marco Rosales. Bimonthly inflight magazine published in Spanish and Portuguese that caters to "the affluent, highly-educated Latin American frequent traveler residing in the U.S. and abroad." Circ. 270,400.

Illustration Approached by 300 illustrators/year. Buys 50 illustrations/year. Features humorous and spot illustrations of business and families.

First Contact & Terms Send postcard sample. After introductory mailing, send follow-up postcard sample every 6 months. Pays $100-250 for color inside. Pays on publication. Buys one-time rights. Finds freelancers through submissions.

AMERICAN FITNESS

15250 Ventura Blvd., Suite 200, Sherman Oaks CA 91403. (818)905-0040, ext. 200. Fax: (818)990-5468. E-mail: americanfitness@afaa.com. Website: www.americanfitness. com; www.afaa.com. **Editor:**Meg Jordan. Bimonthly magazine for fitness and health professionals. Official publication of the Aerobics and Fitness Association of America, the world's largest fitness educator. Circ. 42,900.

Illustration Approached by 12 illustrators/month. Assigns 2 illustrations/issue. Works

on assignment only. Prefers "very sophisticated" 4-color line drawings. Subjects include fitness, exercise, wellness, sports nutrition, innovations and trends in sports, anatomy and physiology, body composition.

First Contact & Terms Send postcard promotional sample. Acquires one-time rights. Accepts previously published material. Original artwork returned after publication.

Tips "Excellent source for never-before-published illustrators who are eager to supply full-page lead artwork."

AQUARIUM FISH INTERNATIONAL

(formerly Aquarium Fish Magazine), P.O. Box 6050, Mission Viejo CA 92690. (949)855-8822. Fax: (949)855-3045. E-mail: aquariumfish@bowtieinc.com. Website: www.aquariumfish.com. **Editor:** Russ Case. Estab. 1988. Monthly magazine covering fresh and marine aquariums. Photo guidelines available for SASE with first-class postage or on website.

Cartoons Approached by 30 cartoonists/year. Themes should relate to aquariums and ponds.

First Contact & Terms Buys one-time rights. Pays $35 for b&w and color cartoons.

THE ARTIST'S MAGAZINE

F+W Media Inc., 4700 E. Galbraith Rd., Cincinnati OH 45236. E-mail: tamedit@ fwmedia.com. Website: www.artistsmagazine.com. **Art Director:** Daniel Pessell. Emphasizes the techniques of working artists for the serious beginning, amateur and professional artist. Published 10 times/year. Circ. 160,000. Sample copy available for $4.99 U.S., $7.99 Canadian or international; remit in U.S. funds.

• Sponsors 3 annual contests. Send SASE for more information.

Cartoons Buys 4-6 cartoons/year. Must be related to art and artists.

Illustration Buys 2-3 illustrations/year. Has featured illustrations by Penelope Dullaghan, A. Richard Allen, Robert Carter, Chris Sharp and Brucie Rosch. Features concept-driven illustration. Works on assignment only.

First Contact & Terms Cartoonists: Contact Cartoon Editor. Send query letter with brochure, photocopies, photographs and tearsheets to be kept on file. Prefers photostats or tearsheets as samples. Samples not filed are returned by SASE. Buys first rights. **Pays on acceptance.** Pays cartoonists $65. Pays illustrators $350-1,000 for color inside, $100-500 for spots. Occasionally accepts previously published material. Returns original artwork after publication.

Tips "Research past issues of publication and send samples that fit the subject matter and style of target publication."

☷ ASCENT MAGAZINE

837 Rue Gilford, Montreal QC H2J 1P1 Canada. (514)499-3999. Fax: (514)499-3904.

E-mail: assistant_editor@ascentmagazine.com. Website: www.ascentmagazine. com. **Assistant Editor:** Luna Allison. Estab. 1999. Quarterly consumer magazine focusing on yoga and engaged spirituality; b&w with full-color cover. Circ. 7,500. Sample copies are available for $7. Art guidelines available on website or via e-mail (design@ascentmagazine.com).

Illustration Approached by 20-40 illustrators/year. Prefers b&w, or color artwork that will reproduce well in b&w. Assigns 50% to new and emerging illustrators. 50% of freelance illustration demands knowledge of Illustrator, InDesign and Photoshop.

First Contact & Terms Send postcard sample or query letter with b&w photocopies, samples, URL. Accepts e-mail submissions with link to website or image file. Prefers Mac-compatible TIFF files. Samples are filed. Responds in 2 months. Will contact artist for portfolio review if interested. Portfolio should include b&w and color, finished art, photographs and tearsheets. Pays $200-500 for color cover; $50-350 for b&w inside. Pays on publication. Buys first rights, electronic rights. Original artwork returned upon request. Finds freelancers through agents, submissions, magazines and word of mouth.

Tips "We encourage artwork that is abstract, quirky and unique. It should connect with the simplicity of the magazine's design, and be accessible and understandable to our readers, who vary greatly in age and artistic appreciation. For commissioned artwork, the piece should relate to the narrative style of the article it will illustrate."

ASTRONOMY

21027 Crossroads Circle, Waukesha WI 53186-4055. (262)796-8776. Fax: (262)796-6468. E-mail: onlineeditor@astronomy.com. Website: www.astronomy.com. **Art Director:** Carole Ross. Estab. 1973. Monthly consumer magazine emphasizing the study and hobby of astronomy. Circ. 200,000.

- Published by Kalmbach Publishing. Also see listings for *Classic Toy Trains*, *Finescale Modeler*, *Model Railroader*, *Model Retailer*, *Bead and Button*, *Birder's World*, *Trains*, *The Writer* and *Dollhouse Miniatures*.

Illustration Approached by 20 illustrators/year. Buys 2 illustrations/issue. Has featured illustrations by James Yang, Gary Baseman. Considers all media. 10% of freelance illustration demands knowledge of Photoshop, Illustrator, QuarkXPress.

First Contact & Terms Illustrators: Send query letter with duplicate slides. Do not send originals. Accepts submissions on disk compatible with above software. Samples are filed and not returned. Buys one-time rights. Finds illustrators through word of mouth and submissions.

AUTOMOBILE MAGAZINE

120 E. Liberty St., 2nd Floor, Ann Arbor MI 48104-4193. (734)994-3500. Website: www.automobilemag.com. **Art Director:** Molly Jean. Estab. 1986. Monthly 4-color

automobile magazine for upscale lifestyles. Circ. 650,000. Art guidelines are specific for each project.

Illustration Buys illustrations mainly for spots and feature spreads. Works with 5-10 illustrators/year. Buys 2-5 illustrations/issue. Works on assignment only. Considers airbrush, mixed media, colored pencil, watercolor, acrylic, oil, pastel and collage. Needs editorial and technical illustrations.

First Contact & Terms Send query letter with brochure showing art style, résumé, tearsheets, slides, photographs or transparencies. Show automobiles in various styles and media. "This is a full-color magazine; illustrations of cars and people must be accurate." Samples are returned only if requested. "I would like to keep something in my file." Responds to queries/submissions only if interested. Buys first rights and one-time rights. Pays $200 and up for color inside. Pays $2,000 maximum depending on size of illustration. Finds artists through mailed samples.

Tips "Send samples that show cars drawn accurately with a unique style and imaginative use of medium."

BABYBUG®

Cricket Magazine Group, Carus Publishing, 70 E. Lake St., Suite 300, Chicago IL 60601. Website: www.cricketmag.com. **Contact:** Art Submissions Coordinator. Managing Art Director: Suzanne Beck. Estab. 1994. A listening and looking magazine for infants and toddlers ages 6 months to 2 years. Published monthly except for combined May/June and July/August issues. Art guidelines available on website.

- See also listings in this section for other magazines published by the Cricket Magazine Group: *Ladybug*, *Spider*, *Cricket* and *Cicada*.

Illustration Buys 23 illustrations/issue. Works on assignment only.

First Contact & Terms Send photocopies, photographs or tearsheets to be kept on file. Samples are returned by SASE if requested. Responds in 3 months. Buys all rights. **Pays 45 days after acceptance**: $750 for color cover; $250 for color full page; $100 for color spots; $50 for b&w spots.

Tips "Before attempting to illustrate for *Babybug*, be sure to familiarize yourself with this age group, and read several issues of the magazine. Please do not query first."

BACKPACKER MAGAZINE

Rodale, Inc., 33 E. Minor St., Emmaus PA 18098. (610)967-8296. E-mail: mbates@backpacker.com. Website: www.backpacker.com. **Art Director:** Matthew Bates. Estab. 1973. Consumer magazine covering nonmotorized wilderness travel. Circ. 306,500.

Illustration Approached by 200-300 illustrators/year. Buys 10 illustrations/issue. Considers all media. 60% of freelance illustration demands knowledge of FreeHand, Photoshop, Illustrator, QuarkXPress.

First Contact & Terms Send query letter with printed samples, photocopies and/or tearsheets. Send follow-up postcard sample every 6 months. Accepts disk submissions compatible with QuarkXPress, Illustrator and Photoshop. Samples are filed and are not returned. Art director will contact artist for portfolio review of color photographs, slides, tearsheets and/or transparencies if interested. Buys first rights or reprint rights. Pays on publication. Finds artists through submissions and other printed media.

Tips *Backpacker* does not buy cartoons. "Know the subject matter, and know *Backpacker Magazine*."

BALTIMORE MAGAZINE

1000 Lancaster St., Suite 400, Baltimore MD 21202-4382. (410)752-4200. Fax: (410)625-0280. E-mail: wamanda@baltimoremagazine.net. Website: www.baltimoremagazine. net. **Art Director:** Amanda White-Iseli. Associate Art Director: Kathryn Mychailysyzn. Estab. 1908. Monthly city magazine featuring news, profiles and service articles. Circ. 57,000. Sample copies available for $3.95 each.

Illustration Approached by 600 illustrators/year. Buys 4 illustrations/issue. Works on assignment only. Considers all media, depending on assignment. 10% of freelance work demands knowledge of InDesign, FreeHand, Illustrator or Photoshop, or any other program that is saved as a TIFF or PICT file.

First Contact & Terms Illustrators: Send postcard sample. Accepts disk submissions. Samples are filed. Will contact for portfolio review if interested. Originals returned at job's completion. Buys one-time rights. Pays on publication: $200-1,500 for color inside; 60 days after invoice. Finds artists through sourcebooks, publications, word of mouth, submissions.

Tips All art is freelance—humorous front pieces, feature illustrations, etc. Does not use cartoons.

BARTENDER MAGAZINE

P.O. Box 158, Liberty Corner NJ 07938-0158. (908)766-6006. Fax: (908)766-6607. E-mail: BarMag@aol.com. Website: www.bartender.com. **Art Director:** Doug Swenson. Editor: Jackie Foley. Estab. 1979. Quarterly 4-color trade journal emphasizing restaurants, taverns, bars, bartenders, bar managers, owners, etc. Circ. 150,000.

Cartoons Approached by 10 cartoonists/year. Buys 3 cartoons/issue. Prefers bar themes; single-panel.

Illustration Approached by 5 illustrators/year. Buys 1 illustration/issue. Works on assignment only. Prefers bar themes. Considers any media.

First Contact & Terms Cartoonists: Send query letter with finished cartoons. Buys first rights. Illustrators: Send query letter with brochure. Samples are filed. Negotiates rights purchased. Pays on publication. Pays cartoonists $50 for b&w and $100 for color inside. Pays illustrators $500 for color cover.

BAY WINDOWS

46 Plympton St., 5th Floor, Boston MA 02118. (617)266-6670, ext. 204. Fax: (617)266-5973.. E-mail: mmaguire@baywindows.com. Website: www.baywindows.com. **Editorial Design Manager**: Matt Maguire. Estab. 1983. Weekly newspaper "targeted to politically-aware lesbians, gay men and other political allies publishing non-erotic news and features"; b&w with 2-color cover. Circ. 60,000. Sample copies available.

Cartoons Approached by 25 cartoonists/year. Buys 1-2 cartoons/issue. Buys 50 cartoons/year. Preferred themes include politics and lifestyles. Prefers double and multiple panel, political and editorial cartoons with gagline; b&w line drawings.

Illustration Approached by 60 illustrators/year. Buys 1 illustration/issue. Buys 50 illustrations/year. Works on assignment only. Preferred themes include politics; "humor is a plus." Considers pen & ink and marker drawings. Needs computer illustrators familiar with Illustrator or FreeHand.

First Contact & Terms Cartoonists: Send query letter with roughs. Samples are returned by SASE if requested by artist. Illustrators: Send query letter with photostats and SASE. Samples are filed. Responds in 6 weeks, only if interested. Portfolio review not required. Rights purchased vary according to project. Pays on publication. Pays cartoonists $50-100 for b&w only. Pays illustrators $100-125 for cover; $75-100 for b&w inside; $75 for spots. Accepts previously published artwork. Original artwork returned after publication.

THE BEAR DELUXE

P.O. Box 10342, Portland OR 97296. (503)242-1047. E-mail: bear@orlo.org. Website: www.orlo.org. **Art Director**: Kristin Rogers. Editor-in-Chief: Tom Webb. Estab. 1993. Semi-annual consumer magazine emphasizing environmental writing and visual art. Circ. 46,000. Sample copy available for $5. Art guidelines available for SASE with first-class postage.

Cartoons Approached by 50 cartoonists/year. Buys 5 cartoons/issue. Prefers work related to environmental, outdoor, media, arts. Prefers single-panel, political, humorous, b&w line drawings.

Illustration Send postcard sample and nonreturnable samples. Accepts Mac-compatible disk submissions. Send EPS or TIFF files. Samples are filed or returned by SASE. Responds only if interested. Portfolios may be dropped off by appointment. Buys first rights. Pays on publication. Pays cartoonists $10-50 for b. Pays illustrators $200 for b or color cover; $15-75 for b or color inside; $15-75 for 2-page spreads; $20 for spots. Finds illustrators through word of mouth, gallery visits and promotional samples.

Tips are actively seeking new illustrators and visual artists, and we encourage people to send samples. Most of our work (besides cartoons) is assigned out as editorial illustration or independent art. Indicate whether an assignment is possible for you. Indicate your fastest turn-around time. We sometimes need people who can work with two- to three-week turn-around or faster."

BIRD WATCHER'S DIGEST

P.O. Box 110, Marietta OH 45750. (740)373-5285. Fax: (740)373-8443. E-mail: editor@birdwatchersdigest.com. Website: www.birdwatchersdigest.com. Estab. 1978. Bimonthly magazine covering birds and bird watching for bird watchers and birders (backyard and field; veteran and novice). Circ. 90,000. Sample copies available for $3.99. Art guidelines available on website or free for SASE.

Illustration Buys 1-2 illustrations/issue. Has featured illustrations by Julie Zickefoose, Tom Hirata, Kevin Pope and Jim Turanchik. Assigns 15% of illustrations to new and emerging illustrators.

First Contact & Terms Send samples or tearsheets. Responds in 2 months. Buys one-time rights. Pays $50 minimum for b $100 minimum for color. Previously published material OK. Original work returned after publication.

BIRMINGHAM PARENT

Evans Publishing LLC, 115-C Hilltop Business Dr., Pelham AL 35124. (205)739-0090. Fax: (205)739-0073. E-mail: Info@BirminghamParent.com. Website: www.birminghamparent.com. Estab. 2004. Monthly magazine serving parents of families in Central Alabama/Birmingham with news pertinent to them. Circ. 40,000 + . Art guidelines free with SASE or on website.

Cartoons Approached by 2-3 cartoonists/year. Buys 12 cartoons/year. Prefers fun, humorous, parenting issues, nothing controversial. Format: single panel. Media: color washes.

Illustration Approached by 2 illustrators/year. Assigns 5% of illustrations to new and emerging illustrators. 95% of freelance work demands computer skills. Freelancers should be familiar with InDesign, QuarkXPress, Photoshop.

First Contact & Terms E-mail submissions accepted with link to website. Portfolio not required. Pays cartoonists $0-25 for b&w or color cartoons. Pays on publication. Buys electronic rights, first North American serial rights.

Tips "We do very little freelance artwork. We are still a small publication and don't have space or funds for it. Our art director provides the bulk of our needs. It would have to be outstanding for us to consider purchasing right now."

BITCH: FEMINIST RESPONSE TO POP CULTURE

2904 NE Alberta St. #N, Portland OR 97211-7034. E-mail: bitch@bitchmagazine.com. Website: www.bitchmagazine.com. **Contact:** Art Director. Estab. 1996. Quarterly b&w magazine "devoted to incisive commentary on our media-driven world. We examine popular culture in all its forms for women and feminists of all ages." Circ. 80,000.

Illustration Approached by 300 illustrators/year. Buys 3-7 illustrations/issue. Features caricatures of celebrities, conceptual, fashion and humorous illustration.

Work on assignment only. Prefers b&w ink drawings and photo collage. Assigns 90% of illustrations to experienced but not well-known illustrators; 8% to new and emerging illustrators; 2% to well-known or "name" illustrators.

First Contact & Terms Send postcard sample, nonreturnable samples. Accepts Mac-compatible disk submissions. Samples are filed and are not returned. Will contact artist for portfolio review if interested. Finds illustrators through magazines and word of mouth.

Tips "We have a couple of illustrators we work with regularly, but we are open to others. Our circulation has been doubling annually, and we are distributed internationally. Read our magazine and send something we might like."

BLOOMBERG MARKETS MAGAZINE

731 Lexington Ave., New York NY 10022-1331. (212)617-8591. Fax: (646)268-5523. E-mail: egood@bloomberg.net. **Deputy Art Director**: Evelyn Good. Monthly Financial/Business Magazine. Circ. 300,000.

Illustration Has featured Doug Ross, Steven Biver and Lisa Ferlic.

First Contact & Terms Illustrators: Send non-returnable postcard sample. After introductory mailing, send follow-up postcard sample every 6 months. Responds only if interested. Pays illustrators $450 for color inside. Buys one-time rights. Find freelancers through artists' submissions.

BOW & ARROW HUNTING MAGAZINE

2400 E Katella Ave., Suite 300, Anaheim CA 92806. (714)939-9991. Fax: (714)939-9909. E-mail: editorial@bowandarrowhunting.com. Website: www.bowandarrowhunting.com. **Editor:** Joe Bell. Emphasizes the sport of bowhunting. Circ. 97,000. Published 9 times per year. Art guidelines free for SASE with first-class postage. Original artwork returned after publication.

Cartoons Buys occasional cartoon. Prefers single panel with gag line; b&w line drawings.

Illustration Buys 2-6 illustrations/issue; all from freelancers. Has featured illustrations by Tes Jolly and Cisco Monthay. Assigns 25% of illustrations to new and emerging illustrators. Prefers live animals/game as themes.

First Contact & Terms Cartoonists: Send finished cartoons. Illustrators: Send samples. Prefers photographs or original work as samples. Especially looks for perspective, unique or accurate use of color and shading, and an ability to clearly express a thought, emotion or event. Samples returned by SASE. Responds in 2 months. Portfolio review not required. Buys first rights. Pays on publication; $500 for color cover; $100 for color inside; $50-100 for b&w inside.

BREWERS ASSOCIATION

736 Pearl St., Boulder CO 80302. (303)447-0816, ext. 127. Fax: (303)447-2825. E-mail: kelli@brewersassociation.org. Website: www.beertown.org. **Magazine Art Director:** Kelli Gomez. Estab. 2005 (merger of the Association of Brewers and the Brewers' Assocation of America). "Our nonprofit organization hires illustrators for two magazines, *Zymurgy* and *The New Brewer*, each published bimonthly. *Zymurgy* is the journal of the American Homebrewers Association. The goal of the AHA division is to promote public awareness and appreciation of the quality and variety of beer through education, research and the collection and dissemination of information." Circ. 10,000. "*The New Brewer* is the journal of the Brewers Association. It offers practical insights and advice for breweries that range in size from less than 500 barrels per year to more than 500,000. Features articles on brewing technology and problem solving, pub and restaurant management, and packaged beer sales and distribution, as well as important industry news and industry sales and market share performance." Circ. 3,000.

Illustration Approached by 50 illustrators/year. Buys 3-6 illustrations/year. Prefers beer and homebrewing themes. Considers all media.

Design Prefers local design freelancers with experience in Photoshop, QuarkXPress, Illustrator.

First Contact & Terms Illustrators: Send postcard sample or query letter with printed samples, photocopies, tearsheets; follow-up sample every 3 months. Accepts disk submissions with EPS, TIFF or JPEG files. "We prefer samples we can keep." No originals accepted; samples are filed. Responds only if interested. Art director will contact artist for portfolio review if interested. Buys one-time rights. Pays 60 days net on acceptance. Pays illustrators $700-800 for color cover; $200-300 for b&w inside; $200-400 for color inside. Pays $150-300 for spots. Finds artists through agents, sourcebooks and magazines (Society of Illustrators, *Graphis*, *PRINT*, *Colorado Creative*), word of mouth, submissions. Designers: Send query letter with printed samples, photocopies, tearsheets.

Tips "Keep sending promotional material for our files. Anything beer-related for subject matter is a plus. We look at all styles."

BUGLE

5705 Grant Creek Road, Missoula MT 59808. (406)523-4500. Fax: (406)523-4550. E-mail: cs@rmef.org. Website: www.elkfoundation.org. Estab. 1984. Bimonthly 4-color outdoor conservation and hunting magazine for a nonprofit organization. Circ. 150,000.

Illustration Approached by 10-15 illustrators/year. Buys 3-4 illustrations/issue. Has featured illustrations by Pat Daugherty, Cynthie Fisher, Joanna Yardley and Bill Gamradt. Features natural history illustration, humorous illustration, realistic illustrations and maps. Preferred subjects wildlife and nature. "Open to all styles."

Assigns 60% of illustrations to well-known or "name" illustrators; 20% to experienced but not well-known illustrators; 20% to new and emerging illustrators.

First Contact & Terms Illustrators: E-mail with query letter and pdf of samples or link to portfolio. Will contact artist for portfolio review if interested. **Pays on acceptance**; $250-400 for b&w, $250-400 for color cover; $100-150 for b&w, $100-200 for color inside; $150-300 for 2-page spreads; $50 for spots. Finds illustrators through existing contacts and magazines.

Tips "We are looking for elk, other wildlife and habitat. Attention to accuracy and realism."

BULLETIN OF THE ATOMIC SCIENTISTS

77 W. Washington Street, Suite 2120., Chicago IL 60602. (312) 364-9710. Fax: (312) 364-9715. Website: www.thebulletin.org. **Managing Editor:** John Rezek. Art Director: Joy Olivia Miller. Estab. 1945. Bimonthly magazine of international affairs and nuclear security. Circ. 15,000.

Cartoons Approached by 15-30 cartoonists/year. Buys 2 cartoons/issue. Prefers single panel, humor related to global security, b&w/color washes and line drawings.

Illustration Approached by 30-40 illustrators/year. Buys 2-3 illustrations/issue.

First Contact & Terms Send postcard sample and photocopies. Buys one-time and digital rights. Responds only if interested. **Pays on acceptance.**

Tips "We're eager to see cartoons that relate to our editorial content, so it's important to take a look at the magazine before submitting items."

BUSINESS LAW TODAY

321 N. Clark St., 20th Floor, Chicago IL 60610. (312)988-5000. Fax: (312)988-5444. E-mail: tedhamsj@staff.abanet.org. Website: www.abanet.org/buslaw/blt. **Art Director:** Jill Tedhams. Estab. 1992. Bimonthly magazine covering business law. Circ. 60,291. Art guidelines not available.

Cartoons Buys 20-24 cartoons/year. Prefers business law and business lawyers themes. Prefers single panel, humorous, b&w line drawings with gaglines. Use of women and persons of color in contemporary settings is important. Prefer cartoons submitted electronically by e-mail.

Illustration Buys 6-9 illustrations/issue. Has featured illustrations by Dave Klug, Doug Thompson and Amy Young. Features whimsical, realistic and computer illustrations. Assigns 10% of illustrations to new and emerging illustrators. Prefers editorial illustration. Considers all media. 10% of freelance illustration demands knowledge of Photoshop, Illustrator and QuarkXPress.

First Contact & Terms Cartoonists: Send to tedhamsj@staff.abanet.org or palmerj@ staff.abanet.org. Responds only if interested. Illustrators: "We will accept work compatible with InDesign CS3. Send JPG, EPS or TIFF files." Samples are filed and are not returned. Responds only if interested. Buys one-time rights. Pays on publication.

Pays cartoonists $200 minimum for b&w. Pays illustrators $850 for color cover; $520 for b&w inside, $650 for color inside; $175 for b&w spots.

Tips "Although our payment may not be the highest, accepting jobs from us could lead to other projects, since we produce many publications at the ABA. Sending samples (three to four pieces) works best to get a sense of your style; that way I can keep them on file.

BUSINESS TRAVEL NEWS

770 Broadway, New York NY 10003. (646)654-4439. Fax: (646)654-4455. E-mail: ewong@btnonline.com Website: www.btnonline.com. **Art Director:** Eric Wong. Estab. 1984. Bimonthly 4-color trade publication focusing on business and corporate travel news/management. Circ. 50,000.

Illustration Approached by 300 illustrators/year. Buys 4-8 illustrations/month. Features charts & graphs, computer illustration, conceptual art, informational graphics and spot illustrations. Preferred subjects: business concepts, electronic business and travel. Assigns 30% of illustrations to well-known, experienced and emerging illustrators.

First Contact & Terms Illustrators: Send postcard or other nonreturnable samples. Samples are filed. Buys first rights. **Pays on acceptance**: $600-900 for color cover; $250-350 for color inside. Finds illustrators through artists' promotional material and sourcebooks.

Tips "Send your best samples. We look for interesting concepts and print a variety of styles. Please note we serve a business market."

CAT FANCY

P.O. Box 6050, Mission Viejo CA 92690-6050 (for UPS or overnight deliveries: 3 Burroughs Dr., Irvine CA 92618). (949)855-8822. E-mail: catsupport@catchannel.com. Website: www.catchannel.com. **Contact:** Art Editor. Monthly 4-color consumer magazine dedicated to the love of cats. Circ. 290,000. Sample copy available for $5.50. Art guidelines available for SASE or on website.

Cartoons Occasionally uses single-panel cartoons as filler. Cartoons must feature a cat or cats and should fit single-column width (2¼) or double-column width (4½).

Illustration Needs editorial, medical and technical illustration and images of cats. Works on assignment only.

First Contact & Terms Send query letter with brochure, high-quality photocopies (preferably color), tearsheets and SASE. Responds in 6-8 weeks. Buys one-time rights. Pays on publication. Pays cartoonists $35 for b&w line drawings. Pays illustrators $35-75 for spots; $75-150 for color inside; more for packages of multiple illustrations.

Tips "Seeking creative and innovative illustrators that lend a modern feel to our magazine. Please review a sample copy of the magazine before submitting your work to us."

CATHOLIC FORESTER

P.O. Box 3012, Naperville IL 60566-7012. (630)983-4900. Fax: (630)983-4057. E-mail: magazine@catholicforester.com. Website: www.catholicforester.com. **Contact:** Art Director. Estab. 1883. "Catholic Forester is the national member magazine for Catholic Order of Foresters,a not-for-profit fraternal insurance organization. We use general-interest articles, art and photos. Audience is small town and urban middle-class, patriotic, Roman Catholic and traditionally conservative." National quarterly 4-color magazine. Circ. under 100,000. Accepts previously published material. Sample copy for 9.5 × 11 SASE with 3 first-class stamps.

Illustration Buys and commissions editorial illustration. No gag or panel cartoons.

First Contact & Terms Illustrators: Will contact for portfolio review if interested. Requests work on spec before assigning job. Buys one-time rights, North American serial rights or reprint rights. Pays on publication. Pays $30 for b&w, $75-300 for color. Turn-around time for completed artwork usually 2 weeks.

Tips "Know the audience; always read the article and ask art director questions. Be timely."

CED (COMMUNICATIONS, ENGINEERING & DESIGN MAGAZINE)

Advantage Business Media, 6041 S. Syracuse Way, Suite 310, Greenwood Village CO 80111-9402. (973)920-7709. E-mail: don.ruth@advantagemedia.com. Website: www.cedmagazine.com. **Senior Art Director:** Don Ruth. Estab. 1978. Monthly trade journal; "the premier magazine of broadband technology." Circ. 25,000. Sample copies and art guidelines available.

Illustration Buys 1 illustration/issue. Works on assignment only. Features caricatures of celebrities; realistic illustration; charts and graphs; informational graphics and computer illustrations. Prefers cable TV industry themes. Considers watercolor, airbrush, acrylic, colored pencil, oil, charcoal, mixed media, pastel, computer disk formatted in Photoshop, Illustrator or FreeHand. Assigns 10% of illustrations to new and emerging illustrators.

First Contact & Terms Contact only through artist rep. Samples are filed. Call for appointment to show portfolio. Portfolio should include final art, b&w/color tearsheets, photostats, photographs and slides. Rights purchased vary according to project. **Pays on acceptance.** Pays illustrators $400-800 for color cover; $125-400 for b&w and color inside; $250-500 for 2-page spreads; $75-175 for spots. Accepts previously published work. Original artwork not returned at job's completion.

Tips "Be persistent; come in person if possible. Be willing to change in mid course; be willing to have finished work rejected. Make sure you can draw and work fast."

CHARLOTTE MAGAZINE

127 W. Worthington Ave., Suite 208, Charlotte NC 28203-4474. (704)335-7181. Fax:

(704)335-3739. E-mail: carrie.campbell@charlottemagazine.com. Website: www. charlottemagazine.com. **Art Director:** Carrie Campbell. Estab. 1995. Monthly 4-color city-based consumer magazine for Charlotte and surrounding areas. Circ. 40,000. Sample copy free for #10 SAE with first-class postage.

Illustration Approached by many illustrators/year. Buys 1-5 illustrations/issue. Features caricatures of celebrities and politicians; computer illustration; humorous illustration; natural history, realistic and spot illustration. Prefers wide range of media/conceptual styles. Assigns 20% of illustrations to new and emerging illustrators.

First Contact & Terms Illustrators: Send postcard sample and follow-up postcard every 6 months. Send non-returnable samples. Accepts e-mail submissions. Send EPS or TIFF files. Samples are filed. Responds only if interested. Portfolio review not required. Finds illustrators through promotional samples and sourcebooks.

Tips "We are looking for diverse and unique approaches to illustration. Highly creative and conceptual styles are greatly needed. If you are trying to get your name out there, we are a great avenue for you."

CHESAPEAKE BAY MAGAZINE

1819 Bay Ridge Ave., Annapolis MD 21403. (410)263-2662. Fax: (410)267-6924. E-mail: kashley@cbmmag.net. Website: www.cbmmag.net. **Art Director:** Karen Ashley. Estab. 1972. Monthly 4-color magazine focusing on the boating environment of the Chesapeake Bay—including its history, people, places, events, environmental issues and ecology. Circ. 45,000. Original artwork returned after publication upon request. Sample copies free for SASE with first-class postage. Art guidelines available.

Illustration Approached by 12 illustrators/year. Buys 2-3 technical and editorial illustrations/issue. Has featured illustrations by Jim Paterson, Kim Harroll, Jan Adkins, Tamzin B. Smith, Marcy Ramsey, Peter Bono, Stephanie Carter and James Yang. Assigns 50% of illustrations to new and emerging illustrators. Considers pen & ink, watercolor, collage, acrylic, marker, colored pencil, oil, charcoal, mixed media and pastel. Also digital. Usually prefers watercolor or acrylic for 4-color editorial illustration. "Style and tone are determined by the artist after he/she reads the story."

First Contact & Terms Illustrators: Send query letter with résumé, tearsheets and photographs. Samples are filed. Make sure to include contact information on each sample. Responds only if interested. Publication will contact artist for portfolio review if interested. Portfolio should include "anything you've got." No b&w photocopies. Buys one-time rights. "Price decided when contracted." Pays illustrators $75-200 for quarter-page or spot illustrations; up to $500-800 for spreads—four-color inside.

Tips "Our magazine design is relaxed, fun, oriented toward people who enjoy recreation on the water. Boating interests remain the same. But for the Chesapeake Bay boater, water quality and the environment are more important now than in the past. Colors brighter. We like to see samples that show the artist can draw boats and

understands our market environment. Send tearsheets or send website information. We're always looking. Artist should have some familiarity with the appearance of different types of boats, boating gear and equipment."

CHESS LIFE

P.O. Box 3967, Crossville TN 38557. (931)787-1234. Fax: (931)787-1200. Website: www.uschess.org. **Editor:** Daniel Lucas. **Art Director:** Frankie Butler. Estab. 1939. Official publication of the United States Chess Federation. Contains news of major chess events with special emphasis on American players, plus columns of instruction, general features, historical articles, personality profiles, tournament reports, cartoons, quizzes, humor and short stories. Monthly b&w with 4-color cover. Design is "heavy with chess games". Circ. 70,000/month. Accepts previously published material and simultaneous submissions. Sample copy for SASE with 6 first-class stamps; art guidelines for SASE with first-class postage.

- Also publishes children's magazine, *Chess Life For Kids,* every other month. Same submission guidelines apply.

Cartoons Approached by 5-10 cartoonists/year. Buys 0-12 cartoons/year. All cartoons must be chess related. Prefers single panel with gagline; b&w line drawings.

Illustration Approached by 30-50 illustrators/year. Works with 4-5 illustrators/year from freelancers. Buys 4-5 illustrations/year. Uses artists mainly for cartoons and covers. Works on assignment, but will also consider unsolicited work.

First Contact & Terms Send query letter with samples or e-mail Frankie Butler at fbutler@uschess.org. Responds in 2 months. Negotiates rights purchased. Pays on publication. *Chess Life* commisioned cover rate $400; inside full page $100; half page $50; quarter page $25.

CHRISTIAN HOME & SCHOOL

3350 E. Paris Ave. SE, Grand Rapids MI 49512. (616)957-1070. Fax: (616)957-5022. E-mail: rogers@csionline.org. Website: www.CSIonline.org. **Senior Editor:** Roger W. Schmurr. Quarterly 4-color magazine emphasizing current, crucial issues affecting the Christian home for parents who support Christian education. Circ. 66,000. Sample copy for 9 × 12 SASE with 4 first-class stamps; art guidelines for SASE with first-class postage.

Cartoons Prefers family and school themes.

Illustration Buys approximately 2 illustrations/issue. Has featured illustrations by Patrick Kelley, Rich Bishop and Pete Sutton. Features humorous, realistic and computer illustration. Assigns 75% of illustrations to experienced but not well-known illustrators; 25% to new and emerging illustrators. Prefers pen & ink, charcoal/pencil, colored pencil, watercolor, collage, marker and mixed media. Prefers family or school life themes. Works on assignment only.

First Contact & Terms Illustrators: Send query letter with résumé, tearsheets, photocopies or photographs. Show a representative sampling of work. Samples returned by SASE, or "send one or two samples art director can keep on file." Will contact if interested in portfolio review. Buys first rights. Pays on publication. Pays cartoonists $75 for b&w. Pays illustrators $300 for 4-color full-page inside. Finds most artists through references, portfolio reviews, samples received through the mail and artist reps.

CICADA®

Cricket Magazine Group, Carus Publishing, 70 E. Lake St., Suite 300, Chicago IL 60601. Website: www.cricketmag.com. **Contact:** Art Submissions Coordinator. Managing Art Director: Suzanne Beck. Estab. 1998. Bimonthly literary magazine for teenagers. Art guidelines available on website.

- See also listings in this section for other magazines published by the Cricket Magazine Group: *Babybug*, *Ladybug*, *Spider* and *Cricket*.

First Contact & Terms "We at The Cricket Magazine Group know that teenagers' interests and tastes constantly evolve, and we want *Cicada* to evolve with them. Therefore we are re-examining the scope, focus, and format of *Cicada*, and are no longer accepting submissions for the magazine in its current format. Please check our website periodically for updates on our submission guidelines."

CINCINNATI CITYBEAT

811 Race St., 5th Floor, Cincinnati OH 45202. (513)665-4700. Fax: (513)665-4369. E-mail: jcobb@citybeat.com. Website: www.citybeat.com. **Art Director:** J. Cobb. Estab. 1994. Weekly alternative newspaper emphasizing issues, arts and events. Circ. 50,000.

- Please research alternative weeklies before contacting this art director. He reports receiving far too many inappropriate submissions.

Cartoons Approached by 30 cartoonists/year. Buys 1 cartoon/year.

Illustration Buys 1-3 illustrations/issue. Features caricatures of celebrities and politicians, computer and humorous illustration. Prefers work with a lot of contrast. Assigns 40% of illustrations to new and emerging illustrators. 10% of freelance illustration demands knowledge of Illustrator, Photoshop, FreeHand, QuarkXPress.

First Contact & Terms Cartoonists: Send query letter with samples. Illustrators: Send postcard sample or query letter with printed samples and follow-up postcard every 4 months. Accepts Mac-compatible disk submissions. Send EPS, TIFF or PDF files. Samples are filed. Responds in 2 weeks, only if interested. Buys one-time rights. Pays on publication. Pays cartoonists $10-100 for b&w, $30-100 for color, $10-35 for comic strips. Pays illustrators $75-150 for b&w cover, $150-250 for color cover, $10-50 for b&w inside, $50-75 for color inside, $75-150 for 2-page spreads. Finds illustrators through word of mouth and artists' samples.

CINCINNATI MAGAZINE

441 Vine St., Suite 200, Cincinnati OH 45202. (513)421-4300. Fax: (513)562-2746. E-mail: gsaunders@cintimag.emmis.com. Website: www.cincinnatimagazine.com. **Art Director**: Grace Saunders. Estab. 1960. Monthly 4-color lifestyle magazine for the city of Cincinnati. Circ. 30,000.

Illustration Approached by 200 illustrators/year. Works on assignment only.

First Contact & Terms Send digital samples only. Responds only if interested. Buys one-time rights or reprint rights. Accepts previously published artwork. Original artwork returned at job's completion. Pays on publication: $500-800 for features; $200-450 for spots.

Tips Prefers traditional media with an interpretive approach. No cartoons or mass-market computer art.

CITY SHORE MAGAZINE

200 E. Las Olas Blvd., Ft. Lauderdale FL 33301-2299. (954)356-4685. Fax: (954)356-4612. E-mail: gcarannante@sun-sentinel.com. Website: www.cityandshore.com. **Art Director**: Greg Carannante. Estab. 2000. Bimonthly "luxury lifestyle magazine published for readers in South Florida." Circ. 42,000. Sample copies available for $4.95.

Illustration "We rarely use illustrations, but when we do, we prefer sophisticated, colorful styles, with lifestyle-oriented subject matter. We don't use illustration whose style is dark or very edgy."

First Contact & Terms Accepts e-mail submissions with image file.

CKI MAGAZINE

Kiwanis International, 3636 Woodview Trace, Indianapolis IN 46268. (317)875-8755. Fax: (317)879-0204. E-mail: ckimagazine@kiwanis.org. Website: www.circlek.org. **Art Director**: Maria Malandrakis. Estab. 1968. Magazine published 1 time/year for college-age students, emphasizing service, leadership, etc. Circ. 12,000. Free sample copy for SASE with 3 first-class postage stamps.

- Kiwanis International also publishes *Kiwanis* and *Key Club* magazines; see separate listings in this section.

Illustration Approached by more than 30 illustrators/year. Buys 1-2 illustrations/issue. Works on assignment only. Needs editorial illustration. "We look for variety."

First Contact & Terms Send query letter with photocopies, photographs, tearsheets and SASE. Samples are filed. Will contact for portfolio review if interested. Portfolio should include tearsheets and slides. Originals and sample copies returned to artist at job's completion. **Pays on acceptance**: $100 for b&w cover; $250 for color cover; $50 for b&w inside; $150 for color inside.

CLARETIAN PUBLICATIONS

205 W. Monroe, Chicago IL 60606. (312)236-8682. Fax: (312)236-8207. E-mail: wrightt@claretians.org. **Art Director:** Tom Wright. Estab. 1960. Monthly magazine "covering the Catholic family experience and social justice." Circ. 40,000. Sample copies and art guidelines available.

Illustration Approached by 20 illustrators/year. Buys 4 illustrations/issue. Considers all media.

First Contact & Terms Illustrators: Send postcard sample and query letter with printed samples and photocopies or e-mail with an attached website to visit. Accepts disk submissions compatible with EPS or TIFF. Samples are filed. Responds only if interested. Art director will contact artist for portfolio review if interested. Negotiates rights purchased. **Pays on acceptance.** $100-400 for color inside.

Tips "We like to employ humor in our illustrations and often use clichés with a twist and appreciate getting art in digital form."

CLEANING BUSINESS

3693 E. Marginal Way S., Seattle WA 98111. (206) 682- 9748. Fax: (206)622-6876. E-mail: wgriffin@cleaningconsultants.com. Website: www.cleaning business. com. **Publisher:** Bill Griffin. Submissions Editor: Bill S. Quarterly e-magazine with technical, management and human relations emphasis for self-employed cleaning and maintenance service contractors and workers. Internet publication. Prefers to purchase all rights. Simultaneous submissions OK "if sent to noncompeting publications." Original artwork returned after publication if requested by SASE.

Cartoons Buys 1-2 cartoons/issue. Must be relevant to magazine's readership. Prefers b&w line drawings.

Illustration Buys approximately 12 illustrations/year including some humorous and cartoon-style illustrations.

First Contact & Terms Illustrators: Send query letter with samples. *"Don't send samples unless they relate specifically to our market."* Samples returned by SASE. Buys all rights. Responds only if interested. Pays for illustration by project $3-15. Pays on publication.

Tips "Our budget is limited. Those who require high fees are wasting their time. We are interested in people with talent and ability who seek exposure and publication. Our readership is people who work for and own businesses in the cleaning industry, such as maid services; janitorial contractors; carpet, upholstery and drapery cleaners; fire, odor and water damage restoration contractors; etc. If you have material relevant to this specific audience, we would definitely be interested in hearing from you. We are also looking for books, games, videos, software, jokes and reports related to the cleaning industry."

THE CLERGY JOURNAL

6160 Carmen Ave. E., Inver Grove Heights MN 55076-4422. (800)328-0200. Fax: (888)852-5524. E-mail: sfirle@logosstaff.com. Website: www.logosproductions. com. **Editor:** Sharon Firle. Magazine for professional clergy and church business administrators; 2-color with 4-color cover. Bi-monthly. Circ. 4,000. This publication is one of many published by Logos Productions.

Cartoons Buys cartoons from freelancers on religious themes.

First Contact & Terms Send SASE. Pays $25 on publication.

CLEVELAND MAGAZINE

1422 Euclid Ave., Suite 730, Cleveland OH 44115. (216)771-2833. Fax: (216)781-6318. E-mail: miller@clevelandmagazine.com. Website: www.clevelandmagazine.com. **Contact:** Gary Sluzewski. Monthly city magazine, with 4-color cover, emphasizing local news and information. Circ. 45,000.

Illustration Approached by 100 illustrators/year. Buys 3-4 editorial illustrations/issue on assigned themes. Sometimes uses humorous illustrations. 40% of freelance work demands knowledge of InDesign, Illustrator or Photoshop.

First Contact & Terms Illustrators: Send postcard sample with brochure or tearsheets.

Tips "Artists are used on the basis of talent. We use many talented college graduates just starting out in the field. We do not publish gag cartoons but do print editorial illustrations with a humorous twist. Full-page editorial illustrations usually deal with local politics, personalities and stories of general interest. Generally, we are seeing more intelligent solutions to illustration problems and better techniques. The economy has drastically affected our budgets; we pick up existing work as well as commissioning illustrations."

COBBLESTONE, DISCOVER AMERICAN HISTORY

Cobblestone Publishing, Inc., 30 Grove St., Suite C, Peterborough NH 03458-1438. (603)924-7209. Fax: (603)924-7380. E-mail: adillon@caruspus.com. Website: www. cobblestonepub.com. **Art Director:** Ann Dillon. Publishes 9 times a year. Our magazine emphasizes on American history; features nonfiction, supplemental nonfiction, fiction, biographies, plays, activities and poetry for children ages 8-14. Circ. 38,000. Accepts previously published material and simultaneous submissions. Sample copy $5.97 plus $2 shipping; art guidelines on website. Material must relate to theme of issue; subjects and topics published in guidelines for SASE. Freelance work demands knowledge of Illustrator, Photoshop and QuarkXPress.

- Other magazines published by Cobblestone include *Calliope* (world history), *Dig* (archaeology for kids), *Faces* (cultural anthropology), *Odyssey* (science), all for kids ages 8-15, and *Appleseeds* (social studies), for ages 7-9.

Illustration Buys 2-5 illustrations/issue. Prefers historical theme as it pertains to a specific feature. Works on assignment only. Has featured illustrations by Annette Cate, Beth Stover, David Kooharian. Features caricatures of celebrities and politicians, humorous, realistic illustration, informational graphics, computer and spot illustration. Assigns 15% of illustrations to new and emerging illustrators.

First Contact & Terms Send query letter with brochure, résumé, business card and b&w photocopies or tearsheets to be kept on file or returned by SASE. Write for appointment to show portfolio. Buys all rights. Pays on publication; $20-125 for b&w inside; $40-225 for color inside. Artists should request illustration guidelines.

Tips "Study issues of the magazine for style used. Send update samples once or twice a year to help keep your name and work fresh in our minds. Send nonreturnable samples we can keep on file; we're always interested in widening our horizons."

COLLEGE PARENT MAGAZINE

P.O. Box 888, Liberty Corner NJ 07938-0888. (908)542-1700 x 304. Fax: (908)542-1702. E-mail: jjohnston@couchbraunsdorf.com. Website: www.collegeparentmagazine. com. **Art Director:** Ken Bruzenak. Estab. 2003. Bimonthly consumer magazine written by parents of college and college-bound students. Circ. 100,000. Guidelines available on website.

Cartoons Approached by 100 cartoonists/year. Buys 10 cartoons/year. Prefers college themes; single-panel.

Illustration Approached by 100 illustrators/year. Buys 20 illustrations/year. Features teens, college students and parents; caricatures of celebrities/politicians; humorous illustration and spot illustrations. Assigns 10% to new and emerging illustrators.

First Contact & Terms Cartoonists: Send photocopies. Illustrators: Send postcard sample with URL. Responds only if interested. Pays cartoonists $50-100 for b&w. Pays illustrators $100-200 for color inside. Pays on publication. Buys one-time rights. Finds freelancers through submissions.

COMMON GROUND

#204-4381 Fraser St., Vancouver BC V5V 4G4 Canada. (604)733-2215. Fax: (604)733-4415. E-mail: admin@commonground.ca. Website: www.commonground.ca. **Contact:** Art Director. Estab. 1982. Monthly consumer magazine focusing on health and cultural activities and holistic personal resource directory. Circ. 70,000. Accepts previously published artwork and cartoons. Original artwork is returned at job's completion. Sample copies for SASE with first-class Canadian postage or International Postage Certificate.

Illustration Approached by 20-40 freelance illustrators/year. Buys 1-2 freelance illustrations/issue. Prefers all themes and styles. Considers cartoons, pen & ink, watercolor, collage and marker.

First Contact & Terms Illustrators: Send query letter with brochure, photographs, SASE and photocopies. Samples are filed or are returned by SASE if requested by artist. Responds only if interested. Buys one-time rights. Payment varies.

Tips "Send photocopies of your top one-three inspiring works in black & white or color. Can have all three on one sheet of 8½ × 11 paper or all in one color copy. I can tell from that if I am interested."

COMMONWEAL

475 Riverside Drive., Suite 405, New York NY 10115. (212) 662-4200. Fax: (212) 662-4183. E-mail: editors@commonwealmagazine.org. Website: www. commonwealmagazine.org. **Editor:** Paul Baumann. Established 1924. Journal of opinion edited by Catholic laypeople concerning public affairs, religion, literature and the arts, primarily b/w, with some color ads and illustrations and a 4-color cover. Biweekly. Circulation 19,000. Please see our website to order complimentary copies and and for submission guidelines.

First Contact & Terms Cartoonists: Send query letter with finished cartoons. Illustrators: Send query letter with tearsheets, photographs. Send SASE and photocopies to Tina Aleman, production editor. Samples are filed or returned by SASE if requested by artist. Responds in 4 weeks. To show a portfolio, mail tearsheets, photographs and photocopies. Buys non-exclusive rights. Pays cartoonists $15. Pays illustrators $15. Pays on publication.

Cartoons Approached by 20 + cartoonists/year. Buys 1-2 cartoons/issue from freelancers. Prefers simple lines and high-contrast styles. Prefers single panel, with or without gagline. Has featured cartoons by Baloo.

Illustration Approached by 20 + illustrators/year. Buys 1-2 illustrations/issue from freelancers. Prefers high-contrast illustrations that speak for themselves.

Tips Become familiar with publication before mailing submissions.

CONSTRUCTION EQUIPMENT OPERATION AND MAINTENANCE

Construction Publications, Inc., 829 2nd Avenue SE, Cedar Rapids IA 52406. (319)366-1597. E-mail: chuckparks@constpub.com. Website: www.constructionpublications. com. **Editor-in-Chief:** Chuck Parks. Estab. 1948. Bimonthly b&w tabloid with 4-color cover. Covers heavy construction and industrial equipment for contractors, machine operators, mechanics and local government officials involved with construction. Circ. 67,000. Free sample copy.

Cartoons Buys 8-10 cartoons/issue. Interested in themes "related to heavy construction industry" or "cartoons that make contractors and their employees 'look good' and feel good about themselves"; single -panel.

First Contact & Terms Cartoonists: Send finished cartoons and SASE. Responds in 2 weeks. Original artwork not returned after publication. Buys all rights, but may reassign rights to artist after publication. Pays $5 0 for b&w. Reserves right to rewrite captions.

DAVID C. COOK

(formerly Cook Communications Ministries), 4050 Lee Vance View, Colorado Springs CO 80918-7100. (719)536-0100. Website: www.cookministries.org. **Design Manager:** Jeff Barnes. Publisher of teaching booklets, books, take-home papers for Christian market, "all age groups." Art guidelines available for SASE with first-class postage only.

Illustration Buys about 10 full-color illustrations/month. Has featured illustrations by Richard Williams, Chuck Hamrick and Ron Diciani. Assigns 5% of illustrations to new and emerging illustrators. Features realistic illustration, Bible illustration, computer and spot illustration. Works on assignment only.

First Contact & Terms Illustrators: Send tearsheets, color photocopies of previously published work; include self-promo pieces. No samples returned unless requested and accompanied by SASE. **Pays on acceptance**: $400-700 for color cover; $250-400 for color inside; $150-250 for b&w inside; $500-800 for 2-page spreads; $50-75 for spots. Considers complexity of project, skill and experience of artist, and turnaround time when establishing payment. Buys all rights.

Tips "We do not buy illustrations or cartoons on speculation. Do *not* send book proposals. We welcome those just beginning their careers, but it helps if the samples are presented in a neat and professional manner. Our deadlines are generous but must be met. Fresh, dynamic, the highest of quality is our goal; art that appeals to everyone from preschoolers to senior citizens; realistic to humorous, all media."

COPING WITH CANCER

P.O. Box 682268, Franklin TN 37068. (615)790-2400. Fax: (615)794-0179. E-mail: editor@copingmag.com. Website: www.copingmag.com. **Editor:** Laura Shipp. Estab. 1987. "Coping with Cancer is a bimonthly, nationally-distributed consumer magazine dedicated to providing the latest oncology news and information of greatest interest and use to its readers. Readers are cancer survivors, their loved ones, support group leaders, oncologists, oncology nurses and other allied health professionals. The style is very conversational and, considering its sometimes technical subject matter, quite comprehensive to the layman. The tone is upbeat and generally positive, clever and even humorous when appropriate, and very credible." Circ. 90,000. Sample copy available for $3. Art guidelines for SASE with first-class postage. Guidelines are available at www.copingmag.com/author_guidelines.

COSMOGIRL!

300 W. 57th St., New York NY 10019. Website: www.cosmogirl.com. **Contact:** Art Department. Estab. 1996. Monthly 4-color consumer magazine designed as a cutting-edge lifestyle publication exclusively for teenage girls. Circ. 1.5 million.

Illustration Approached by 350 illustrators/year. Buys 6-10 illustrations/issue. Features caricatures of celebrities and music groups, fashion, humorous and spot

illustration. Preferred subject is teens. Assigns 10% of illustrations to well-known or "name" illustrators; 80% to experienced but not well-known illustrators; 10% to new and emerging illustrators.

First Contact & Terms Send postcard sample and follow-up postcard every 6 months. Samples are filed. Responds only if interested. Buys first rights. **Pays on acceptance.** Pay varies. Finds illustrators through sourcebooks and samples.

COSMOPOLITAN

300 W. 57th St., New York NY 10019-3741. E-mail: cosmo@hearst.com. Website: www.cosmopolitan.com. **Art Director:** John Lanuza. Estab. 1886. Monthly 4-color consumer magazine for contemporary women covering a broad range of topics including beauty, health, fitness, fashion, relationships and careers. Circ. 3,021,720.

Illustration Approached by 300 illustrators/year. Buys 10-12 illustrations/issue. Features beauty, humorous and spot illustration. Preferred subjects include women and couples. Prefers trendy fashion palette. Assigns 5% of illustrations to new and emerging illustrators.

First Contact & Terms Send postcard sample and follow-up postcard every 4 months. Samples are filed. Responds only if interested. Buys first North American serial rights. **Pays on acceptance**: $1,000 minimum for 2-page spreads; $450-650 for spots. Finds illustrators through sourcebooks and artists' promotional samples.

CRICKET®

Cricket Magazine Group, Carus Publishing, 70 E. Lake St., Suite 300, Chicago IL 60601. Website: www.cricketmag.com. **Contact:** Art Submissions Coordinator. Senior Art Director: Karen Kohn. Estab. 1973. Monthly literary magazine for young readers, ages 9-14. Art guidelines available on website.

- See also listings in this section for other magazines published by the Cricket Magazine Group: *Babybug*, *Ladybug*, *Spider* and *Cicada*.

Illustration Works with 75 illustrators/year. Buys 600 illustrations/year. Considers pencil, pen & ink, watercolor, acrylic, oil, pastels, scratchboard, and woodcut. "While we need humorous illustration, we cannot use work that is overly caricatured or 'cartoony.' We are always looking for strong realism. Many assignments will require artist's research into a particular scientific field, world culture, or historical period." Works on assignment only.

First Contact & Terms Send photocopies, photographs or tearsheets to be kept on file. Samples are returned by SASE if requested. Responds in 3 months. Buys all rights. **Pays 45 days after acceptance**: $750 for color cover; $250 for color full page; $100 for color spots; $50 for b&w spots.

Tips "Before attempting to write for *Cricket*, be sure to familiarize yourself with this age group, and read several issues of the magazine. Please do not query first."

DAKOTA COUNTRY

P.O. Box 2714, Bismarck ND 58502. (701)255-3031. Fax: (701)255-5038. E-mail: dcmag@btinet.net. Website: www.dakotacountrymagazine.com. **Publisher:** Bill Mitzel. Estab. 1979. Dakota Country is a monthly hunting and fishing magazine with readership in North and South Dakota. Features stories on all game animals and fish and outdoors. Basic 3-column format, full-color throughout magazine, 4-color cover, feature layout. Circ. 14,200. Accepts previously published artwork. Original artwork is returned after publication. Sample copies for $2; art guidelines for SASE with first-class postage.

Cartoons Likes to buy cartoons in volume. Prefers outdoor themes, hunting and fishing. Prefers multiple or single panel cartoon with gagline; b&w line drawings.

Illustration Features humorous and realistic illustration of the outdoors. Portfolio review not required.

First Contact & Terms Send query letter with samples of style. Samples not filed are returned by SASE. Responds to queries/submissions within 2 weeks. Negotiates rights purchased. **Pays on acceptance.** Pays cartoonists $10-20, b&w. Pays illustrators $20-25 for b&w inside; $12-30 for spots.

Tips "Always need good-quality hunting and fishing line art and cartoons."

DC COMICS

AOL-Time Warner, Dept. AGDM, 1700 Broadway, 5th Floor, New York NY 10019. (212)636-5990. Fax: (212)636-5977. Website: www.dccomics.com. **Vice President Design and Retail Product Development:** Georg Brewer. Monthly 4-color comic books for ages 7-25. Circ. 6,000,000. Original artwork is returned after publication.

- See DC Comics's listing in Book Publishers section. *DC Comics* does not read or accept unsolicited submissions of ideas, stories or artwork.

DERMASCOPE

Geneva Corporation,310 E. I-30, Ste. 107, Garland TX 75043. (469)429-9300. Fax: (469)429-9301. E-mail: saundra@dermascope.com. Website: www.dermascope. com. **Production Manager:** Saundra Brown. Estab. 1978. Monthly magazine/trade journal, 128-page magazine for aestheticians, plastic surgeons and stylists. Circ. 15,000. Sample copies and art guidelines available.

Illustration Approached by 5 illustrators/year. Prefers illustrations of "how-to" demonstrations. Considers digital media. 100% of freelance illustration demands knowledge of Photoshop, Illustrator, InDesign, Fractil Painter.

First Contact & Terms Accepts disk submissions. Samples are not filed. Responds only if interested. Rights purchased vary according to project. Pays on publication.

THE EAST BAY MONTHLY

1301 59th St., Emeryville CA 94608. (510)658-9811. Fax: (510)658-9902. E-mail: artdirector@themonthly.com. Website: www.themonthly.com. **Art Director:** Andreas Jones. Estab. 1970. Monthly consumer tabloid; b&w with 4-color cover. Editorial features are general interests (art, entertainment, business owner profiles) for an upscale audience. Circ. 81,000. Sample copy and guidelines available for SASE with 5 oz. first-class postage.

Cartoons Approached by 75-100 cartoonists/year. Buys 3 cartoons/issue. Prefers single-panel, b&w line drawings; "any style, extreme humor."

Illustration Approached by 150-200 illustrators/year. Buys 2 illustrations/issue. Prefers pen & ink, watercolor, acrylic, colored pencil, oil, charcoal, mixed media and pastel. No nature or architectural illustrations.

Design Occasionally needs freelancers for design and production. 100% of freelance design requires knowledge of PageMaker, Macromedia FreeHand, Photoshop, QuarkXPress, Illustrator and InDesign.

First Contact & Terms Cartoonists: Send query letter with finished cartoons. Illustrators: Send postcard sample or query letter with tearsheets and photocopies. Designers: Send query letter with résumé, photocopies or tearsheets. Accepts submissions on disk, Mac-compatible with Macromedia FreeHand, Illustrator, Photoshop, PageMaker, QuarkXPress or InDesign. Samples are filed or returned by SASE. Responds only if interested. Write for appointment to show portfolio of thumbnails, roughs, b&w tearsheets and slides. Buys one-time rights. Pays 15 days after publication. Pays cartoonists $35 for b&w. Pays illustrators $100-200 for b&w inside; $25-50 for spots. Pays for design by project. Accepts previously published artwork. Originals returned at job's completion.

EMERGENCY MEDICINE MAGAZINE

7 Century Dr., Suite 302, Parsippany NJ 07054-4609. (973)206-3434. Website: www. emedmag.com. **Art Director:** Karen Blackwood. Estab. 1969. Emphasizes emergency medicine for emergency physicians, emergency room personnel, medical students. Monthly. Circ. 80,000. Returns original artwork after publication. Art guidelines not available.

Illustration Works with 10 illustrators/year. Buys 1-2 illustrations/issue. Has featured illustrations by Scott Bodell, Craig Zuckerman and Steve Oh. Features realistic, medical and spot illustration. Assigns 70% of illustrations to well-known or "name" illustrators; 30% to experienced, but not well-known illustrators. Works on assignment only.

First Contact & Terms Send postcard sample or query letter with brochure, photocopies, photographs, tearsheets to be kept on file. Samples not filed are not returned. Accepts disk submissions. To show a portfolio, mail appropriate materials. Responds only if interested. Buys first rights. Pays $1,200-1,700 for color cover; $200-500 for b&w inside; $500-800 for color inside; $250-600 for spots.

⚇ EVENT

Douglas College, New Westminster BC V3L 5B2 Canada. (604)527-5293. Fax: (604)527-5095. E-mail: event@douglas.bc.ca. Website: event.douglas.bc.ca. **Editor:** Rick Maddocks. Managing Editor: Ian Cockfield. Estab. 1971. For " those interested in literature and writing" b&w with 4-color cover. Published 3 times/year. Circ. 1,150. Art guidelines available on website. Sample back issue for $9. Current issue for $12.

Illustration Buys approximately 3 photographs/year. Has featured photographs by Mark Mushet, Lee Hutzulak and Anne de Haas. Assigns 50% of illustrations to new and emerging photographers. Uses freelancers mainly for covers. "We look for art that is adaptable to a cover, particularly images that are self-sufficient and don't lead the reader to expect further artwork within the journal. Please send photography/ artwork (no more than 10 images) to Event, along with a self-addressed stamped envelope (Canadian postage or IRCs only) for return of your work. We also accept email submissions of cover art. We recommend that you send low-res versions of your photography/art as small jpeg or pdf attachments. If we are interested, we will request hi-resolution files. We do not buy the actual piece of art; we only pay for the use of the image."

First Contact & Terms Reponse time varies; generally 4 months. Buys first North American serial rights. Pays on publication, $150 for color cover, 2 free copies plus 10 extra covers.150 for color cover, 2 free copies plus 10 extra covers.

F+W MEDIA

4700 E. Galbraith Rd., Cincinnati OH 45236. Website: www.fwmedia.com. Publishes special interest magazines and books in a broad variety of consumer enthusiast categories. Also operates book clubs, conferences, trade shows, websites and education programs—all focused on the same consumer hobbies and enthusiast subject areas where the magazines and book publishing programs specialize.

- Magazines published by F+W include *The Artist's Magazine, Horticulture, HOW, PRINT, Watercolor Artist* and *Writer's Digest*. See separate listings in this section as well as F+W's listing in the Book Publishers section for more information and specific guidelines.

FEDERAL COMPUTER WEEK

3141 Fairview Park Dr., Suite 777, Falls Church VA 22042. (703)876-5131. Fax: (703)876-5126. E-mail: jeffrey_langkau@1105govinfo.com . Website: www.fcw.com. **Creative Director:** Jeff Langkau. Estab. 1987. Trade publication for federal, state and local government information technology professionals. Circ. 120,000.

Illustration Approached by 50-75 illustrators/year. Buys 5-6 illustrations/month. Features charts & graphs, computer illustrations, informational graphics, spot illustrations of business subjects. Assigns 5% of illustrations to well-known or

"name" illustrators; 85% to experienced but not well-known illustrators; 10% to new and emerging illustrators.

First Contact & Terms Send postcard or other nonreturnable samples. Accepts Mac-compatible disk submissions. Samples are filed. Will contact artist for portfolio review if interested. Rights purchased vary according to project. Pays $800-1,200 for color cover; $600-800 for color inside; $200 for spots. Finds illustrators through samples and sourcebooks.

Tips "We look for people who understand 'concept' covers and inside art, and very often have them talk directly to writers and editors."

GEORGIA MAGAZINE

P.O. Box 1707, Tucker GA 30085-1707. (770)270-6950. Fax: (770)270-6995. E-mail: aorowski@georgiaemc.com. Website: www.georgiamagazine.org. **Editor:** Ann Orowski. Estab. 1945. Monthly consumer magazine promoting electric co-ops (largest read publication by Georgians for Georgians). Circ. 480,000 members.

Cartoons Approached by 10 cartoonists/year. Buys 2 cartoons/year. Prefers electric industry theme. Prefers single-panel, humorous, b&w washes and line drawings.

Illustration Approached by 10 illustrators/year. Prefers electric industry theme. Considers all media. 50% of freelance illustration demands knowledge of Illustrator and QuarkXPress.

Design Uses freelancers for design and production. Prefers local designers with magazine experience. 80% of design demands knowledge of Photoshop, Illustrator, QuarkXPress and InDesign.

First Contact & Terms Cartoonists: Send query letter with photocopies. Samples are filed and not returned. Illustrators: Send postcard sample or query letter with photocopies. Designers: Send query letter with printed samples and photocopies. Accepts disk submissions compatible with QuarkXPress 7.5. Samples are filed or returned by SASE. Responds in 2 months if interested. Rights purchased vary according to project. **Pays on acceptance.** Pays cartoonists $50 for b&w, $50-100 for color. Pays illustrators $50-100 for b&w, $50-200 for color. Finds illustrators through word of mouth and submissions.

GIRLFRIENDS MAGAZINE

PMB 30, 3181 Mission St., San Francisco CA 94110-4515. E-mail: staff@girlfriendsmag. com. Website: www.girlfriendsmag.com. **Contact:** Art Director. Estab. 1994. Monthly lesbian magazine. Circ. 30,000. Sample copies available for $4.95. Art guidelines available for #10 SASE with first-class postage.

Illustration Approached by 50 illustrators/year. Buys 3-4 illustrations/issue. Features caricatures of celebrities and realistic, computer and spot illustration. Considers all media and styles. Assigns 40% of illustrations to new and emerging illustrators. 10% of freelance illustration demands knowledge of Illustrator, QuarkXPress.

First Contact & Terms Send query letter with printed samples, tearsheets, résumé, SASE and color copies. Accepts disk submissions compatible with QuarkXPress (JPEG files). Samples are filed or returned by SASE on request. Responds in 6-8 weeks. To show portfolio, artist should follow up with call and/or letter after initial query. Portfolio should include color, final art, tearsheets, transparencies. Rights purchased vary according to project. Pays on publication: $50-200 for color inside; $150-300 for 2-page spreads; $50-75 for spots. Finds illustrators through word of mouth and submissions.

Tips "Read the magazine first. We like colorful work; ability to turn around in two weeks."

GLASS FACTORY DIRECTORY

Box 2267, Hempstead NY 11551. (516)481-2188. E-mail: manager@glassfactorydir. com. Website: www.glassfactorydir.com. **Manager:** Liz Scott. Annual listing of glass manufacturers in US, Canada and Mexico.

Cartoons Receives an average of 1 submission/month. Buys 5-10 cartoons/issue. Cartoons should pertain to glass manufacturing (flat glass, fiberglass, bottles and containers; no mirrors). Prefers single and multiple panel b&w line drawings with gagline. Prefers roughs or finished cartoons. "We do not assign illustrations. We buy from submissions only."

First Contact & Terms Send SASE. Usually gets a review and any offer back to you within a month. Buys all rights. **Pays on acceptance**; $30.

Tips "We don't carry cartoons about broken glass, future, past or present. We can't use stained glass cartoons—there is a stained glass magazine. We will not use any cartoons with any religious theme. Since our directory is sold world-wide, caption references should consider that we do have a international readership."

THE GOLFER

516 Fifth Ave., Suite 304, New York NY 10036-7510. (212)867-7070. Fax: (212)867-8550. E-mail: webmaster@thegolfermag.com. Website: www.thegolfermag.com. **Contact:** Art Director. Estab. 1994. Bimonthly "sophisticated golf magazine with an emphasis on travel and lifestyle." Circ. 254,865.

Illustration Approached by 200 illustrators/year. Buys 6 illustrations/issue. Considers all media.

First Contact & Terms Send postcard sample. "We will accept work compatible with QuarkXPress 3.3. Send EPS files." Samples are not filed and are not returned. Responds only if interested. Rights purchased vary according to project. Pays on publication. Payment to be negotiated.

Tips "I like sophisticated, edgy, imaginative work. We're looking for people to interpret sport, not draw a picture of someone hitting a ball."

GOLFWEEK

1500 Park Center Dr., Orlando FL 32835. Fax: (407)563-7077. E-mail: jlusk@ golfweek.com. Website: www.golfweek.com. **Art Director**: Jason Lusk. Weekly golf magazine for the accomplished golfer. Covers the latest golfing news and all levels of competitive golf from amateur and collegiate to juniors and professionals. Includes articles on golf course architecture as well as the latest equipment and apparel. Circ. 119,000.

Illustration Approached by 200 illustrators/year. Buys 20 illustrations/year. Has featured illustrations by Roger Schillerstrom. Features caricatures of golfers and humorous illustrations of golf courses and golfers. Assigns 20% to new and emerging illustrators. 5% of freelance illustration demands knowledge of Photoshop.

First Contact & Terms Send postcard sample. After introductory mailing, send follow-up postcard sample every 3-6 months. Accepts e-mail submissions with link to website. Prefers JPEG files. Samples are filed. Responds only if interested. Pays illustrators $400-1,000 for color cover; $400-500 for color inside. Pays on publication. Buys one-time rights. Finds freelancers through submissions and sourcebooks.

Tips "Look at our magazine. Know golf."

THE GREEN MAGAZINE

222 W. 37th St., Floor 3, New York NY 10018-6605. (212)629-4920. Fax: (212)629-4932. E-mail: info@thegreenmagazine.com. Website: www.thegreenmagazine.com. **Art Director**: Kanan Whited. Estab. 2002. Bimonthly consumer magazine for the affluent multicultural golf enthusiast featuring articles on personalities, travel and leisure, business and etiquette. Circ.: 150,000.

Illustration Few used, but will consider solicitations.

First Contact & Terms Illustrators: Send postcard sample or photocopies. After sending introductory mailing, send follow-up postcard sample every 2-3 months. Company will contact artist for portfolio review if interested. Pays illustrators $100-350 for color inside. Buys one-time rights. Finds freelancers through artists submissions.

GREENPRINTS

P.O. Box 1355, Fairview NC 28730. (828)628-1902. E-mail: pat@greenprints.com. Website: www.greenprints.com. **Editor:** Pat Stone. Estab. 1990. Quarterly magazine "that covers the personal, not the how-to, side of gardening." Circ. 13,000. Sample copy for $5; art guidelines available on website or free for #10 SASE with first-class postage.

Illustration Approached by 46 illustrators/year. Works with 15 illustrators/issue. Has featured illustrations by Claudia McGehee, P. Savage, Marilynne Roach and Jean Jenkins. Assigns 30% of illustrations to emerging and 5% to new illustrators. Prefers plants and people. Considers b&w only.

First Contact & Terms Illustrators: Send query letter with photocopies, SASE and tearsheets. Samples accepted by US mail only. Accepts e-mail queries without attachments. Samples are filed or returned by SASE. Responds in 2 months. Buys first North American serial rights. Pays on publication; $250 maximum for color cover; $100-125 for b&w inside; $25 for spots. Finds illustrators through word of mouth, artist's submissions.

Tips "Read our magazine and study the style of art we use. Can you do both plants and people? Can you interpret as well as illustrate a story?"

GUITAR PLAYER

1111 Bayhill Dr., Suite 125, San Bruno CA 94066. (650)238-0300. Fax: (650)238-0261. E-mail: phaggard@musicplayer.com. Website: www.guitarplayer.com. **Art Director:** Paul Haggard. Estab. 1975. Monthly 4-color magazine focusing on technique, artist interviews, etc. Circ. 150,000.

Illustration Approached by 15-20 illustrators/week. Buys 5 illustrations/year. Works on assignment only. Features caricatures of celebrities; realistic, computer and spot illustration. Assigns 33% of illustrations to new and emerging illustrators. Prefers conceptual, "outside, not safe" themes and styles. Considers pen & ink, watercolor, collage, airbrush, digital, acrylic, mixed media and pastel.

First Contact & Terms Send query letter with brochure, tearsheets, photographs, photocopies, photostats, slides and transparencies. Accepts disk submissions compatible with Mac. Samples are filed. Responds only if interested. Will contact artist for portfolio review if interested. Buys first rights. Pays on publication: $200-400 for color inside; $400-600 for 2-page spreads; $200-300 for spots.

HARPER'S MAGAZINE

666 Broadway, 11th Floor, New York NY 10012. (212)420-5720. Fax: (212)228-5889. E-mail: stacey@harpers.org. Website: www.harpers.org. **Art Director:** Stacey D. Clarkson. Estab. 1850. Monthly 4-color literary magazine covering fiction, criticism, essays, social commentary and humor.

Illustration Approached by 250 illustrators/year. Buys 5-10 illustrations/issue. Has featured illustrations by Ray Bartkus, Steve Brodner, Tavis Coburn, Hadley Hooper, Ralph Steadman, Raymond Verdaguer, Andrew Zbihlyj, Danijel Zezelj. Features intelligent concept-oriented illustration. Preferred subjects: literary, artistic, social, fiction-related. Prefers intelligent, original thought and imagery in any media. Assigns 25% of illustrations to new and emerging illustrators.

First Contact & Terms Send nonreturnable samples by post or e-mail. Accepts Mac-compatible disk submissions. Samples are filed and are not returned. Will contact artist for portfolio review if interested. Portfolios may be dropped off for review the last Wednesday of any month. Buys first North American serial rights. Pays on

publication: $450-1,000 inside. Finds illustrators through samples, annuals, reps, other publications.

Tips "Intelligence, originality and beauty in execution are what we seek. A wide range of styles is appropriate; what counts most is content."

HEARTLAND BOATING MAGAZINE

319 N. Fourth St., Suite 650, St. Louis MO 63102. (314)241-4310. Fax: (314)241-4207. E-mail: info@heartlandboating.com. Website: www.heartlandboating.com. **Art Director:** John R. "Jack" Cassady. Estab. 1989. Specialty magazine published 8 times/ year devoted to power (cruisers, houseboats) and sail boating enthusiasts throughout Middle America. The content is both informative and humorous and reflects "the challenge, joy and excitement of boating on America's inland waterways." Circ. 10,000. Sample copies available by going to the web site and clicking on the bottom of the left hand column saying "3 FREE ISSUES". Fill out and submit the form. The latest issue should arrive in about two weeks. Art guidelines available for SASE with first-class postage or on website.

Cartoons On assignment only.

Illustration On assignment only. Prefers boating-related themes. Considers pen & ink.

First Contact & Terms Send postcard sample or query letter with SASE, photocopies and tearsheets. Samples are filed or returned by SASE. Responds in about 2 months. Portfolio review not required. First North American Reproduction and Web rights normally purchased. Pays on publication. Rates negotiated. Originals are returned at job's completion.

HEAVY METAL

100 N. Village Rd., Suite 12, Rookville Center NY 11570. Website: www.metaltv.com. **Contact:** Submissions. Estab. 1977. Consumer magazine. "Heavy Metal is the oldest illustrated fantasy magazine in U.S. history."

• See additional listing in the Book Publishers section.

HIEROGLYPHICS MAGAZINE

24272 Sunnybrook Circle, Lake Forest CA 92630-3853. (949)215-4319. Fax: (949)215-4792. **President:** Deborah Boldt. Estab. 2007. Monthly and online literary magazine. "Hieroglyphics is a new and developing children's educational, science, and history magazine. It's mission is to present Africa's ancient history from the pre-written history period forward, traveling back and forth through time and history. Hieroglyphics is dedicated to children and empowering them with a positive self image. Our readers can explore achievements in science and history through wholesome adventure stories that will develop reading skills and increase critical thinking skills." Sample copies and art submission guidelines available for SASE.

Cartoons Buys 20-30 cartoons/year. Needs 4-6 cartoons/issue. Interested in "upbeat, positive vocabulary for children ages 2-12; cartoons involving concept of black children, family life, science and historical Egypt/Africa, modern science, and morality." Prefers humorous cartoons; single or multiple panel color washes.

Illustration Buys more than 200 illustrations/year. Features realistic, scientific and natural history illustrations, "from child's point of view; more graphic than cartoon; upbeat." Subjects include children, families, pets, games and puzzles, "black characters (especially children) within a background environment in ancient Africa/ Egypt, science, sailing, carpentery, hunting, fishing, farming, mining and the arts; also in modern times." Prefers watercolor, pen & ink, colored pencil, mixed media. 15% of assignments are given to new and emerging illustrators.

First Contact & Terms Cartoonists: Send samples, photocopies, roughs, SASE. Illustrators: Send query letter with photocopies, tearsheets, SASE. After introductory mailing, send follow-up postcard every 4 months. Accepts e-mail submissions with link to website or Windows-compatible image files (JPEG or TIFF). Samples are kept on file or are returned by SASE. Responds in 2 months. Will contact artist for portfolio review if interested. Portfolio should include original, finished art. Pays cartoonists $20-100 for color cartoons; $50-500 for comic strips. Pays illustrators $600-2,000 for color cover; $50-2,000 for color inside. **Pays on acceptance.** Buys all rights (work for hire basis). Finds freelancers through submissions, word of mouth magazines and Internet.

Tips "We look for professional-level drawing and the ability to interpret a juvenile story. Drawings of children are especially needed. We like attention to detail. Please research history for details and ideas."

HIGH COUNTRY NEWS

119 Grand Ave., P.O. Box 1090, Paonia CO 81428-1090. (970)527-4898. Fax: (970)527-4897. E-mail: cindy@hcn.org. Website: www.hcn.org. **Art Director:** Cindy Wehling. Estab. 1970. Biweekly nonprofit newspaper. High Country News covers environmental, public lands and community issues in the 10 western states. Circ. 24,000. Art guidelines at www.hcn.org/about/guidelines.jep.

Cartoons Buys 1 editorial cartoon/issue. Only issues affecting Western environment. Prefers single panel, political, humorous on topics currently being covered in the paper. Color or b&w. Professional quality only.

Illustration Considers all media if reproducible.

First Contact & Terms Cartoonists: Send query letter with finished cartoons and photocopies. Illustrators: Send query letter with printed samples and photocopies. Accepts e-mail and disk submissions compatible with QuarkXPress and Photoshop. Samples are filed or returned by SASE. Responds only if interested. Rights purchsed vary according to project. Pays on publication. Pays cartoonists $50-125 depending on size used. Pays illustrators $100-200 for color cover; $35-100 for inside. Finds illustrators through magazines, newspapers and artist's submissions.

HIGHLIGHTS FOR CHILDREN

803 Church St., Honesdale PA 18431. (570)253-1080. Fax: (570)253-0179. Website: www.highlights.com. **Art Director:** Cynthia Faber Smith. Editor-in-Chief: Christine French Clark. Monthly 4-color magazine for children up to age 12. Circ. approx. 2 million. Art guidelines available for SASE with first-class postage.

Cartoons Receives 20 submissions/week. Buys 2-4 cartoons/issue. Interested in upbeat, positive cartoons involving children, family life or animals; single or multiple panel. "One flaw in many submissions is that the concept or vocabulary is too adult, or that the experience necessary for its appreciation is beyond our readers. Frequently, a wordless self-explanatory cartoon is best."

Illustration Buys 30 illustrations/issue. Works on assignment only. Prefers "realistic and stylized work; upbeat, fun, more graphic than cartoon." Pen & ink, colored pencil, watercolor, marker, cut paper and mixed media are all acceptable. Discourages work in fluorescent colors.

First Contact & Terms Cartoonists: Send roughs or finished cartoons and SASE. Illustrators: Send query letter with photocopies, SASE and tearsheets. Samples are kept on file. Responds in 10 weeks. Buys all rights on a work-for-hire basis. **Pays on acceptance.** Pays cartoonists $20-40 for line drawings. Pays illustrators $1,400 for color front and back covers; $50-$700 for color inside. "We are always looking for good hidden pictures. We require a picture that is interesting in itself and has the objects well-hidden. Usually an artist submits pencil sketches. In no case do we pay for any preliminaries to the final hidden pictures. Hidden pictures should be submitted to Juanita Galuska."

Tips "We have a wide variety of needs, so I would prefer to see a representative sample of an illustrator's style."

HISPANIC MAGAZINE

6355 NW 36th St., Virginia Gardens FL 33166. (305)774-3550. Fax: (305)774-3578. E-mail: David.montero@page1media.com. Website: www.hispanicmagazine.com. **Art Director:** David Montero. Estab. 1987. Monthly 4-color consumer magazine for Hispanic Americans. Circ. 250,000.

Illustration Approached by 100 illustrators/year. Buys 5 illustrations/issue. Has featured illustrations by Will Terry, A.J. Garces and Sonia Aguirre. Features caricatures of politicians, humorous illustrations, realistic illustrations, charts & graphs, spot illustrations and computer illustration. Prefers business subjects, men and women. Prefers pastel and bright colors. Assigns 80% of illustrations to experienced, but not well-known illustrators; 20% to new and emerging illustrators.

First Contact & Terms Illustrators: Send nonreturnable postcard samples. Accepts Mac-compatible disk submissions. Send EPS or TIFF files. Samples are filed. Responds only if interested. Will contact artist for portfolio review if interested. Buys one-time rights. Pays on publication: $500-1,000 for color cover; $800 maximum for color inside; $300 maximum for b&w inside; $250 for spots.

Tips "Concept is very important—to take an idea or a story and to be able to find a fresh perspective. I like to be surprised by the artist."

HORSE ILLUSTRATED

P.O. Box 8237, Lexington KY 40533. E-mail: horseillustrated@bowtieinc.com. Website: www.horseillustrated.com. **Editor:** Elizabeth Moyer. Estab. 1976. Monthly consumer magazine providing "information for responsible horse owners." Circ. 192,000. Art guidelines available on website.

Cartoons Approached by 200 cartoonists/year. Buys 1 or 2 cartoons/issue. Prefers satire on horse ownership ("without the trite clichés"); single-panel b&w line drawings with gagline.

Illustration Approached by 60 illustrators/year. Buys 1 illustration/issue. Prefers realistic, mature line art; pen & ink spot illustrations of horses. Assigns 10% of illustrations to new and emerging illustrators.

First Contact & Terms Cartoonists: Send query letter with brochure, roughs and finished cartoons. Illustrators: Send query letter with SASE and photographs. Samples are not filed and are returned by SASE. Responds in 6 weeks. Portfolio review not required. Buys first rights or one-time rights. Pays on publication. Pays cartoonists $40 for b&w. Finds artists through submissions.

Tips "We only use spot illustrations for breed directory and classified sections. We do not use much, but if your artwork is within our guidelines, we usually do repeat business. *Horse Illustrated* needs illustrators who know equine anatomy, as well as human anatomy with insight into the horse world."

HORTICULTURE MAGAZINE

4700 E. Galbraith Rd., Cincinnati OH 45236. (513)531-2690. Fax: (513)891-7153. E-mail: edit@hortmag.com. Website: www.hortmag.com. **Contact:** Joan Moyers. Estab. 1904. Monthly magazine for all levels of gardeners (beginners, intermediate, highly skilled). "Horticulture strives to inspire and instruct avid gardeners of every level." Circ. 300,000. Art guidelines available.

Illustration Approached by 75 freelance illustrators/year. Buys 10 illustrations/issue. Works on assignment only. Features realistic illustration; informational graphics; spot illustration. Assigns 20% of illustrations to new and emerging illustrators. Prefers tight botanicals; garden scenes with a natural sense to the clustering of plants; people; hands and "how-to" illustrations. Considers all media.

First Contact & Terms Send query letter with brochure, résumé, SASE, tearsheets, slides. Samples are filed or returned by SASE. Art Director will contact artist for portfolio review if interested. Buys one-time rights. Pays 1 month after project completed. Payment depends on complexity of piece; $800-1,200 for 2-page spreads; $150-250 for spots. Finds artists through word of mouth, magazines, submissions/ self-promotions, sourcebooks, agents/reps, art exhibits.

Tips "I always go through sourcebooks and request portfolio materials if a person's work seems appropriate and is impressive."

HOUSE BEAUTIFUL

300 W. 57th St., 24th Floor, New York NY 10019-3741. Website: www.housebeautiful. com. **Contact:** Art Director. Estab. 1896. Monthly consumer magazine about interior decorating. Emphasis is on classic and contemporary trends in decorating, architecture and gardening. The magazine is aimed at both the professional and nonprofessional interior decorator. Circ. 1.3 million. Sample copies available.

Illustration Approached by 75-100 illustrators/year. Buys 2-3 illustrations/issue. Works on assignment only. Prefers contemporary, conceptual, interesting use of media and styles. Considers all media.

First Contact & Terms Send postcard-size sample. Samples are filed only if interested and are not returned. Will contact artist for portfolio review of final art, photographs, slides, tearsheets and good quality photocopies if interested. Buys one-time rights. Pays on publication: $600-700 for color inside; $600-700 for spots (99% of illustrations are done as spots).

Tips "We find most of our artists through submissions of either portfolios or postcards. Sometimes we will contact an artist whose work we have seen in another publication. Some of our artists are found through reps and annuals."

HOW MAGAZINE

F+W Media, Inc., 4700 E. Galbraith Rd., Cincinnati OH 45236. E-mail: editorial@ howdesign.com. Website: www.howdesign.com. **Art Director:** Bridgid McCarren. Estab. 1985. Bimonthly trade journal covering creativity, business and technology for graphic designers. Circ. 40,000. Sample copy available for $8.50.

- Sponsors 2 annual conferences for graphic artists, as well as annual Promotion, International, Interactive and In-House Design competitions. See website for more information.

Illustration Approached by 100 illustrators/year. Buys 4-8 illustrations/issue. Works on assignment only. Considers all media, including photography and computer illustration.

First Contact & Terms Illustrators: Send nonreturnable samples. Accepts disk submissions. Responds only if interested. Buys first rights or reprint rights. Pays on publication: $350-1,000 for color inside. Original artwork returned at job's completion.

Tips "Send good samples that reflect the style and content of illustration commonly featured in the magazine. Be patient; art directors get a lot of samples."

HR MAGAZINE

1800 Duke St., Alexandria VA 22314. (800)283-7476. Fax: (703)535-6490. E-mail: janderson@shrm.org. Website: www.shrm.org. **Art Director:** John Anderson Jr. Estab. 1948. Monthly trade journal dedicated to the field of human resource management. Circ. 200,000.

Illustration Approached by 70 illustrators/year. Buys 6-8 illustrations/issue. Prefers people, management and stylized art. Considers all media.

First Contact & Terms Illustrators: Send query letter with printed samples. Accepts disk submissions. Illustrations can be attached to e-mails. *HR Magazine* is Macintosh based. Samples are filed. Art director will contact artist for portfolio review if interested. Rights purchased vary according to project. Requires artist to send invoice. Pays within 30 days. Pays $700-2,500 for color cover; $200-1,800 for color inside. Finds illustrators through sourcebooks, magazines, word of mouth and artist's submissions.

IDEALS MAGAZINE

Published by Ideals Publications, A Guideposts Company, 2636 Elm Hill Pike., Suite 120, Nashville TN 37214. (615)333-0478. Fax: (888)815-2759. Website: www. idealspublications.com. **Editor:** Melinda Rathjen. Estab. 1944. 4-color quarterly general interest magazine featuring poetry and text appropriate for the family. Circ. 25,000. Sample copy $4. Art guidelines free with #10 SASE with first-class postage or view on website.

Illustration Approached by 100 freelancers/year. Buys 4 or less illustrations/issue. Uses freelancers mainly for flowers, plant life, wildlife, realistic people illustrations and botanical (flower) spot art. Prefers seasonal themes. Prefers watercolors. Assigns 90% of illustrations to experienced illustrators; 10% to new and emerging illustrators. "Are not interested in computer generated art. No electronic submissions."

First Contact & Terms Illustrators: Send nonreturnable samples or tearsheets. Samples are filed. Responds only if interested. Do not send originals. Buys artwork for hire. Pays on publication; payment negotiable.

Tips "For submissions, target our needs as far as style is concerned, but show representative subject matter. Artists are strongly advised to be familiar with our magazine before submitting samples of work."

THE INDEPENDENT WEEKLY

P.O. Box 2690, Durham NC 27715. (919)286-1972. Fax: (919)286-4274. E-mail: mbshain@indyweek.com. Website: www.indyweek.com. **Art Director:** Maria Bilinski Shain. Estab. 1982. Weekly b&w with 4-color cover tabloid; general interest alternative. Circ. 50,000. Original artwork is returned if requested. Sample copies for SASE with first-class postage.

Illustration Buys 10-15 illustrations/year. Prefers local (North Carolina) illustrators. Has featured illustrations by Tyler Bergholz, Keith Norvel, V. Cullum Rogers, Nathan Golub. Works on assignment only. Considers pen & ink; b&w, computer generated art and color.

First Contact & Terms Samples are filed or are returned by SASE if requested. Responds only if interested. E-mail for appointment to show portfolio or mail tearsheets. Pays on publication; $150 for cover illustrations; $25-$50 for inside illustrations.

Tips "Have a political and alternative 'point of view.' Understand the peculiarities of newsprint. Be easy to work with. No prima donnas."

IT'S TIME PUBLICATIONS, LLC

P.O. Box 16422, St. Louis Park MN 55416. (952)922-6186. E-mail: aobrien@ familytimesinc.com. Website: www.familytimesinc.com. **Editor/Art Director:** Annie O-Brien. Estab. 1991. Bimonthly tabloid. Circ. 60,000. Sample copies available with SASE. Art guidelines available—e-mail for guidelines.

• Publishes *Family Times, Baby Times, Grand Times* and *Best of Times.*

Illustration Approached by 6 illustrators/year. Buys 33 illustrations/year. Has featured illustrations by primarily local illustrators. Preferred subjects: children, families, teen. Preferred all media. Assigns 2% of illustrations to new and emerging illustrators. Freelancers should be familiar with Illustrator, Photoshop. E-mail submissions accepted with link to website, accepted with image file at 72 dpi. Mac-compatible. Prefers JPEG. Samples are filed. Responds only if interested. Portfolio not required. Company will contact artist for portfolio review if interested. Pays illustrators $300 for color cover, $100 for b&w inside, $225 for color inside. Pays on publication. Buys one-time rights, electronic rights. Finds freelancers through artists' submissions, sourcebooks, online.

First Contact & Terms Illustrators: Send query via email with samples or link to samples.

Tips "Looking for fresh, family friendly styles and creative sense of interpretation of editorial."

JUDICATURE

2700 University Ave., Des Moines IA 50311. E-mail: drichert@ajs.org. Website: www. ajs.org. **Contact:** David Richert. Estab. 1917. Journal of the American Judicature Society. 4-color bimonthly publication. Circ. 6,000. Accepts previously published material and computer illustration. Original artwork returned after publication. Sample copy for SASE with $1.73 postage; art guidelines not available.

Cartoons Approached by 10 cartoonists/year. Buys 1-2 cartoons/issue. Interested in "sophisticated humor revealing a familiarity with legal issues, the courts and the administration of justice."

Illustration Approached by 20 illustrators/year. Buys 1-2 illustrations/issue. Has featured illustrations by Estelle Carol, Mary Chaney, Jerry Warshaw and Richard Laurent. Features humorous and realistic illustration; charts & graphs; computer and spot illustration. Works on assignment only. Interested in styles from "realism to light humor." Prefers subjects related to court organization, operations and personnel. Freelance work demands knowledge of Quark and FreeHand.

Design Needs freelancers for design. 100% of freelance work demands knowledge of Quark and FreeHand.

First Contact & Terms Cartoonists: Send query letter or e-mail with samples of style and SASE. Responds in 2 weeks. Illustrators: Send query letter, SASE, photocopies, tearsheets or brochure showing art style (can be sent electronically). Publication will contact artist for portfolio review if interested. Portfolio should include roughs and printed samples. Wants to see "black & white and color, along with the title and synopsis of editorial material the illustration accompanied." Buys one-time rights. Negotiates payment. Pays cartoonists $35 for unsolicited b&w cartoons. Pays illustrators $250-375 for 2-, 3- or 4-color cover; $250 for b&w full page, $175 for b&w half page inside; $75-100 for spots. Pays designers by the project.

Tips "Show a variety of samples, including printed pieces and roughs."

KALEIDOSCOPE

Exploring the Experience of Disability Through Literature and the Fine Arts701 S. Main St., Akron OH 44311-1019. (330)762-9755. E-mail: mshiplett@udsakron.org. Website: www.udsakron.org. **Editor-in-Chief:** Gail Willmott. Estab. 1979. Black & white with 4-color cover. Semiannual. "Elegant, straightforward design. Explores the experiences of disability through lens of the creative arts. Specifically seeking work by artists with disabilities. Work by artists without disabilities must have a disability focus." Circ. 1,500. Accepts previously published artwork. Sample copy $6; art guidelines for SASE with first-class postage.

Illustration Freelance art occasionally used with fiction pieces. More interested in publishing art that stands on its own as the focal point of an article. Approached by 15-20 artists/year. Has featured illustrations by Dennis J. Brizendine, Deborah Vidaver Cohen and Sandy Palmer. Features humorous, realistic and spot illustration.

First Contact & Terms Illustrators: Send query letter with résumé, photocopies, photographs, SASE and slides. 6-12 pieces maximum. Do not send originals. Prefers high contrast, b&w glossy photos, but will also review color photos or 35mm slides. Include sufficient postage for return of work. Samples are not filed. Publication will contact artist for portfolio review if interested. Acceptance or rejection may take up to a year. Pays $25-100 for color covers; $10-25 for b&w or color insides. Rights revert to artist upon publication. Finds artists through submissions/self-promotions and word of mouth.

Tips "Inquire about future themes of upcoming issues. Considers all mediums, from pastels to acrylics to sculpture. Must be high-quality art."

KENTUCKY LIVING

P.O. Box 32170, Louisville KY 40232. (502)451-2430. Fax: (502)459-1611. E-mail: e-mail@kentuckyliving.com. Website: www.kentuckyliving.com. **Editor:** Paul Wesslund. Monthly 4-color magazine emphasizing Kentucky-related and general feature material for Kentuckians living outside metropolitan areas. Circ. 500,000. Sample copies available.

Cartoons Approached by 10-12 cartoonists/year.

Illustration Buys occasional illustrations. Works on assignment only. Prefers b&w line art.

First Contact & Terms Illustrators: Send query letter with résumé and samples. Samples not filed are returned only if requested. Buys one-time rights. **Pays on acceptance.** Pays cartoonists $30 for b&w. Pays illustrators $50 for b&w inside. Accepts previously published material. Original artwork returned after publication if requested.

KEY CLUB MAGAZINE

(formerly *Keynoter*), Kiwanis International, 3636 Woodview Trace, Indianapolis IN 46268. (317)875-8755. Fax: (317)879-0204. E-mail: magazine@kiwanis.org. Website: www.keyclub.org. **Art Director:**Maria Malandrakis. Quarterly 4-color magazine with "contemporary design for mature teenage audience." Circ. 170,000. Free sample copy for SASE with 3 first-class postage stamps.

- Kiwanis International also publishes *Circle K* and *Kiwanis* magazines; see separate listings in this section.

Illustration Buys 3 editorial illustrations/issue. Works on assignment only.

First Contact & Terms Include SASE. Responds in 2 weeks. "Freelancers should call our Production and Art Department for interview." Previously published, photocopied and simultaneous submissions OK. Original artwork is returned after publication by request. Buys first rights. **Pays on receipt of invoice**: $100 for b&w cover; $250 for color cover; $50 for b&w inside; $150 for color inside.

KID ZONE

2923 Troost Ave., Kansas City MO 64109. (816)931-1900. Fax: (816)412-8306. E-mail: vlfolsom@wordaction.com. **Editor:** Virginia L. Folsom. Estab. 1974. Weekly 4-color story paper; "for 8-10 year olds of the Church of the Nazarene and other holiness denominations. Material is based on everyday situations with Christian principles applied." Circ. 40,000. Originals are not returned at job's completion. Sample copies and guidelines for SASE with first-class postage.

Cartoons Approached by 15 cartoonists/year. Buys 52 cartoons/year. "Cartoons need to be humor for children—not about them." Spot cartoons only. Prefers artwork with children and animals; single panel.

First Contact & Terms Cartoonists: Send finished cartoons. Samples not filed are returned by SASE. Responds in 2 months. Buys all rights. Pays $15 for b&w.

Tips No "fantasy or science fiction situations or children in situations not normally associated with Christian attitudes or actions."

KIPLINGER'S PERSONAL FINANCE

1729 H St. NW, Washington DC 20006. (202)887-6416. Fax: (202)331-1206. Website: www.kiplinger.com. **Art Director:** Cynthia L. Currie. Estab. 1947. Monthly 4-color magazine covering personal finance issues such as investing, saving, housing, cars, health, retirement, taxes and insurance. Circ. 800,000.

Illustration Approached by 350 illustrators/year. Buys 4-6 illustrations/issue. Works on assignment only. Has featured illustrations by Lloyd Miller, Nick Dewar, Alison Sieffer and James O'Brien. Features computer, conceptual editorial and spot illustration. Assigns 5% of illustrations to new and emerging illustrators. Interested in editorial illustration in new styles, including computer illustration.

First Contact & Terms Illustration: Send postcard samples. Accepts Mac-compatible CD submissions. Samples are filed or returned by SASE if requested by artist. Will contact artist for portfolio review if interested. Buys one-time rights. Pays on publication: $400-1,200 for color inside; $250-500 for spots. Finds illustrators through reps, online, magazines, *Workbook* and award books. Originals are returned at job's completion.

KIWANIS MAGAZINE

Kiwanis International, 3636 Woodview Trace, Indianapolis IN 46268. (317)875-8755. Fax: (317)879-0204. E-mail: magazine@kiwanis.org. Website: www.kiwanis.org. **Art Director:** Maria Malandrakis. Estab. 1918. Bimonthly 4-color magazine emphasizing civic and social betterment, business, education and domestic affairs for business and professional persons. Circ. 240,000. Free sample copy for SASE with 4 first-class postage stamps.

- Kiwanis International also publishes *Circle K* and *Key Club* magazines; see separate listings in this section.

Illustration Buys 1-2 illustrations/issue. Assigns themes that correspond to themes of articles. Works on assignment only. Keeps material on file after in-person contact with artist.

First Contact & Terms Illustration: Include SASE. Responds in 2 weeks. To show a portfolio, mail appropriate materials (out of town/state) or call or write for appointment. Portfolio should include roughs, printed samples, final reproduction/product, color and b&w tearsheets, photostats and photographs. Original artwork returned after publication by request. Buys first rights. **Pays on acceptance**; $600-1,000 for cover; $400-800 for inside; $50-75 for spots. Finds artists through talent sourcebooks, references/word of mouth and portfolio reviews.

Tips "We deal direct—no reps. Have plenty of samples, particularly those that can be left with us. Too many student or unassigned illustrations in many portfolios."

LADIES' HOME JOURNAL

125 Park Ave., New York NY 10017. (212)455-1293. Fax: (212)455-1313. E-mail: lhj@meredith.com. Website: www.lhj.com. **Art Director**: Donni Alley. Estab. 1883. Monthly consumer magazine celebrating the rich values of modern family life. Topics include beauty, fashion, nutrition, health, medicine, home decorating, parenting, self-help, personalities and current events. Circ. 412,087.

Illustration Features caricatures of celebrities, humorous illustration and spot illustrations of families, women and pets.

First Contact & Terms Send postcard sample with URL. After introductory mailing, send follow-up postcard sample every 3-6 months. Samples are filed. Responds only if interested. Pays $200-500 for color inside. Buys one-time rights. Finds freelancers through submissions and sourcebooks.

LADYBUG®

Cricket Magazine Group, Carus Publishing, 70 E. Lake St., Suite 300, Chicago IL 60601. Website: www.cricketmag.com. **Contact:** Art Submissions Coordinator. Managing Art Director: Suzanne Beck. Estab. 1990. Monthly 4-color magazine emphasizing literature and activities for children ages 2-6. Circ. 140,000. Art guidelines available on website.

- See also listings in this section for other magazines published by the Cricket Magazine Group: *Babybug*, *Spider*, *Cricket* and *Cicada*.

Illustration Buys 200 illustrations/year. Prefers realistic styles (animal, wildlife or human figure); occasionally accepts caricatures. Works on assignment only.

First Contact & Terms Send photocopies, photographs or tearsheets to be kept on file. Samples are returned by SASE if requested. Responds in 3 months. Buys all rights. **Pays 45 days after acceptance**: $750 for color cover; $250 for color full page; $100 for color spots; $50 for b&w spots.

Tips "Before attempting to illustrate for *Ladybug*, be sure to familiarize yourself with this age group, and read several issues of the magazine. Please do not query first."

L.A. PARENT MAGAZINE

443 E. Irving Dr., Suite A, Burbank CA 91504-2447. (818)846-0400. Fax: (818)841-4380. E-mail: carolyn.graham@parenthood.com. Website: www.laparent.com. **Editor:** Carolyn Graham. Estab. 1979. Magazine. A monthly regional magazine for parents. 4-color throughout; "bold graphics and lots of photos of kids and families." Circ. 120,000. Accepts previously published artwork. Originals are returned at job's completion.

Illustration Buys 2 freelance illustrations/issue. Assigns 50% of illustrations to experienced but not well-known illustrators; 50% to new and emerging illustrators. Works on assignment only.

First Contact & Terms Send postcard sample. Accepts disk submissions compatible with Illustrator 5.0 and Photoshop 3.0. Samples are filed or returned by SASE. Responds in 2 months. To show a portfolio, mail thumbnails, tearsheets and photostats. Buys one-time rights or reprint rights. **Pays on publication**: $300 color cover; $75 for b&w inside; $50 for spots.

Tips "Show an understanding of our publication. Since we deal with parent/child relationships, we tend to use fairly straightforward work. Also looking for images and photographs that capture an L.A. feel. Read our magazine and find out what we're all about."

THE LOOKOUT

8805 Governor's Hill Drive Suite 400, Cincinnati OH 45249. (513)728-6866. Fax: (513)931-0950. E-mail: lookout@standardpub.com. Website: www.lookoutmag. com. **Administrative Assistant:** Sheryl Overstreet. Weekly 4-color magazine for conservative Christian adults and young adults. Circ. 85,000. Sample copy available for $1.

Illustration Prefers both humorous and serious, stylish illustrations featuring Christian families. "We no longer publish cartoons."

First Contact & Terms Illustrators: Send postcard or other nonreturnable samples.

Tips Do not send e-mail submissions.

NA'AMAT WOMAN

350 Fifth Ave., Suite 4700, New York NY 10118. (212)563-5222. Fax: (212)563-5710. E-mail: judith@naamat.org. Website: www.naamat.org. **Editor:** Judith Sokoloff. Estab. 1926. Quarterly magazine for Jewish women, covering a wide variety of topics that are of interest to the Jewish community. Affiliated with NA'AMAT USA (a nonprofit organization). Sample copies available for $1 each.

Illustration Approached by 30 illustrators/year. Buys 2-3 illustrations/issue. We publish in 4-color through out the issue. Has featured illustrations by Julie Delton, Ilene Winn-Lederer, Avi Katz and Yevgenia Nayberg.

First Contact & Terms Illustrators: Send query letter with tearsheets. Samples are filed or are returned by SASE if requested by artist. Responds only if interested. Will contact artist for portfolio review if interested. Portfolio should include tearsheets and final art. Rights purchased vary according to project. Pays on publication. Pays illustrators $150-250 for cover; $75-100 for inside. Finds artists through sourcebooks, publications, word of mouth, submissions. Originals are returned at job's completion.

Tips "Give us a try! We're small, but nice."

THE NATION

33 Irving Place, 8th Floor, New York NY 10003. (212)209-5400. Fax: (212)982-9000. Website: www.thenation.com. **Art Director:** Steven Brower. Estab. 1865. Weekly journal of "left/liberal political opinion, covering national and international affairs, literature and culture." Circ. 100,000. Sample copies available.

- *The Nation*'s art director works out of his design studio at Steven Brower Design. You can send samples to *The Nation* and they will be forwarded.

Illustration Approached by 50 illustrators/year. Buys 1-3 illustrations/issue. Works with 15 illustrators/year. Has featured illustrations by Peter O. Zierlien, Ryan Inzana, Tim Robinson and Karen Caldecott. Buys illustrations mainly for spots and feature spreads. Works on assignment only. Considers all media.

First Contact & Terms Send e-mail. Samples are filed or are returned by SASE. Responds only if interested. Buys first rights. Pays $135 for color inside. Originals are returned after publication upon request.

Tips "On top of a defined style, artist must have a strong and original political sensibility."

THE NATIONAL NOTARY

9350 De Soto Ave., Chatsworth CA 91313-2402. (800)876-6827. Fax: (818)700-1942 (Attn: Editorial Department). E-mail: publications@nationalnotary.org. Website: www.nationalnotary.org. **Managing Editor:** Philip W. Browne. Editorial Supervisor: Consuelo Israelson. Emphasizes "notaries public and notarization—goal is to impart knowledge, understanding and unity among notaries nationwide and internationally." Readers are notaries of varying primary occupations (legal, government, real estate and financial), as well as state and federal officials and foreign notaries. Bimonthly. Circ. 300,000. Original artwork not returned after publication. Sample copy $5.

- Also publishes *Notary Bulletin*.

Cartoons Approached by 5-8 cartoonists/year. Cartoons "must have a notarial angle"; single or multiple panel with gagline, b&w line drawings.

Illustration Approached by 3-4 illustrators/year. Uses about 3 illustrations/issue; buys all from local freelancers. Works on assignment only. Themes vary, depending on subjects of articles. 100% of freelance work demands knowledge of Illustrator, QuarkXPress or FreeHand.

First Contact & Terms Cartoonists: Send samples of style. Illustrators: Send business card, samples and tearsheets to be kept on file. Samples not returned. Responds in 6 weeks. Call for appointment. Buys all rights. Negotiates pay.

Tips "We are very interested in experimenting with various styles of art in illustrating the magazine. We generally work with Southern California artists, as we prefer face-to-face dealings."

NATION'S RESTAURANT NEWS

425 Park Ave., 6th Floor, New York NY 10022-3506. (212)756-5000. Fax: (212)756-5215. Website: www.nrn.com. **Art Director:** Joe Anderson. Assistant Art Director: Alexis Henry. Estab. 1967. Weekly 4-color trade publication/tabloid. Circ. 100,000.

Illustration Buys 2-3 illustrations/year. Features illustrations of business subjects in the food service industry. Prefers pastel and bright colors. Assigns 5% of illustrations to well-known or "name" illustrators; 70% to experienced but not well-known illustrators; 25% to new and emerging illustrators. 20% of freelance illustration demands knowledge of Illustrator or Photoshop.

First Contact & Terms Illustrators: Send postcard sample or other nonreturnable samples, such as tearsheets. Accepts MAC-compatible disk submissions. Send EPS files. Samples are filed. Will contact artist for portfolio review if interested. Buys one-time rights. Pays on publication; $1,000-1,500 for color cover; $300-400 for b&w inside; $275-350 for color inside; $450-500 for spots. Finds illustrators through *Creative Black Book* and *LA Work Book*, *Directory of Illustration* and *Contact USA*.

NEW HAMPSHIRE MAGAZINE

150 Dow St., Manchester NH 03101. (603)624-1442. Fax: (603)624-1310. E-mail: slaughlin@nh.com. Website: www.nhmagazine.com. **Creative Director:** Susan Laughlin. Estab. 1990. Monthly 4-color magazine emphasizing New Hampshire lifestyle and related content. Circ. 26,000.

Illustration Approached by 300 illustrators/year. Has featured illustrations by Brian Hubble and Stephen Sauer. Features lifestyle illustration, charts & graphs and spot illustration. Prefers conceptual illustrations to accompany articles. Assigns 50% to experienced but not well-known illustrators; 50% to new and emerging illustrators.

First Contact & Terms Send postcard sample and follow-up postcard every 3 months. Samples are filed. Portfolio review not required. Negotiates rights purchased. Pays on publication. Pays $75-250 for color inside; $150-500 for 2-page spreads; $125 for spots.

Tips "Lifestyle magazines want 'uplifting' lifestyle messages, not dark or disturbing images."

NEW MOON: THE MAGAZINE FOR GIRLS AND THEIR DREAMS

2 W. First St. #101, Duluth MN 55802. (218)728-5507. Fax: (218)728-0314. E-mail: girl@newmoon.org. Website: www.newmoon.org. **Executive Editor:** Kate Freeborn. Estab. 1992. Bimonthly 4-color cover, 4-color inside consumer magazine. Circ. 30,000. Sample copies are $7.00.

Illustration Buys 3-4 illustrations/issue. Has featured illustrations by Andrea Good, Liza Ferneyhough, Liza Wright. Features realistic illustrations, informational graphics and spot illustrations of children, women and girls. Prefers colored work. Assigns 30% of illustrations to new and emerging illustrators.

First Contact & Terms Illustrators: Send postcard sample or other nonreturnable samples. Final work can be submitted electronically or as original artwork. Send EPS files at 300 dpi or greater, hi-res. Samples are filed. Responds only if interested. Portfolio review not required. Buys one-time rights. Pays on publication; $400 maximum for color cover; $200 maximum for inside.

Tips "Be very familiar with the magazine and our mission. We are a magazine for girls ages 8-14 and look for illustrators who portray people of all different shapes, sizes and ethnicities in their work. Women and girl artists preferred. See cover art guidelines at www.newmoon.org.

NURSEWEEK

860 Santa Teresa Blvd., San Jose CA 95119. (408) 249-5877. Fax: (408) 574-1207. Website: www.nurse.com. **Art Director:** Young Kim. "Nurseweek is a biweekly 4-color letter size magazine mailed free to registered nurses nationwide. Combined circulation of all publications is over 1 million. Nurseweek provides readers with nursing-related news and features that encourage and enable them to excel in their work and that enhance the profession's image by highlighting the many diverse contributions nurses make. In order to provide a complete and useful package, the publication's article mix includes late-breaking news stories, news features with analysis (including in-depth bimonthly special reports), interviews with industry leaders and achievers, continuing education articles, career option pieces and reader dialogue (Letters, Commentary, First Person)." Sample copy $3. Art guidelines not available. Needs computer-literate freelancers for production. 90% of freelance work demands knowledge of Quark, PhotoShop, Illustrator, Adobe Acrobat.

Illustration Approached by 10 illustrators/year. Buys 1 illustration/year. Prefers pen ink, watercolor, airbrush, marker, colored pencil, mixed media and pastel. Needs medical illustration.

Design Needs freelancers for design. 60% of design demands knowledge of Photoshop CS2, QuarkXPress 6.1, Indesign. Prefers local freelancers. Send query letter with brochure, resume, SASE and tear sheets. Photographs: Stock photograph used 80%

O&A MARKETING NEWS

Kal Publications, 559 S. Harbor Blvd., Suite A, Anaheim CA 92805-4525. (714)563-9300. Fax: (714)563-9310. Website: www.kalpub.com. **Editor:** Kathy Laderman. Estab. 1966. Bimonthly trade publication about the service station/petroleum marketing industry. Circ. 6,000.

Cartoons Approached by 10 cartoonists/year. Buys 1-2 cartoons/issue. Prefers humor that relates to service station industry. Prefers single panel, humorous, b&w line drawings.

First Contact & Terms Cartoonists: Send b&w photocopies, roughs or samples and SASE. Samples are returned by SASE. Responds in 1 month.Buys one-time rights. Pays on acceptance; $10 for b&w.

Tips "We run a cartoon (at least one) in each issue of our trade magazine. We're looking for a humorous take on business-specifically the service station/petroleum marketing/carwash/quick lube industry that we cover."

OHIO MAGAZINE

1422 Euclid Ave., Cleveland OH 44115. (216)771-2833 or (800)210-7923. Fax: (216) 781-6318. E-mail: lblake@ohiomagazine.com. Website: www.ohiomag.com/magazine. **Art Director:** Lesley Blake. 12 issues/year focusing on the beauty, adventure and fun in Ohio. Circ. 90,000. Previously published work OK. Original artwork returned after publication. Sample copy $2.50; Artist Guidelines available at www.ohiomagazine.com/photo.

Illustration Approached by 70 + illustrators/year. Use as needed. Works on assignment only. Has featured illustrations by A.G. Ford, Ellyn Lusis, D. Brent Campbell, Jeff Suntala and Daniel Casconcellos. Assigns 10% of illustrations to new and emerging illustrators. Considers pen, ink, watercolor, acrylic, marker, colored pencil, oil mixed media and pasted. 20% of freelance work demands knowledge of Illustrator, InDesign, and Photoshop and Illustrator CS2 or higher.

Design Needs freelancers for design and production. 100% of freelance work demands knowledge of InDesign, Photoshop and Illustrator CS2 or higher.

Tips Please have acknowledge of magazine and audience before submitting.

ON EARTH

40 W. 20th St., New York NY 10011. (212)727-2700. Fax: (212)727-1773. E-mail: nrdcinfo@nrdc.org. Website: www.nrdc.org. **Art Director:** Gail Ghezzi. Associate Art Director: Irene Huang. Estab. 1979. Quarterly "award-winning environmental magazine exploring politics, nature, wildlife, science and solutions to problems." Circ. 140,000.

Illustration Buys 4 illustrations/issue.

First Contact & Terms Illustrators: Send postcard sample. "We will accept work compatible with QuarkXPress, Illustrator 8.0, Photoshop 5.5 and below." Responds only if interested. Buys one-time rights. Also may ask for electronic rights. Pays $100-300 for b&w inside. Payment for spots varies. Finds artists through sourcebooks and submissions.

Tips "We prefer 4-color. Our illustrations are often conceptual, thought-provoking, challenging. We enjoy thinking artists, and we encourage ideas and exchange."

THE OPTIMIST

4494 Lindell Blvd., St. Louis MO 63108-2404. (314)371-6000. Fax: (314)371-6006. Website: www.optimist.org. **Graphics Coordinator:** Melissa Budrow. Quarterly 4-color magazine with 4-color cover that emphasizes activities relating to Optimist

clubs in U.S. and Canada (civic-service clubs). "Magazine is mailed to all members of Optimist clubs. Average age is 42; most are management level with some college education." Circ. 100,000. Sample copy available for SASE.

Cartoons Buys 2 cartoons/issue. Has featured cartoons by Joe Engesssei, Randy Glasbergen and Tim Oliphant. Prefers themes of general interest family-orientation, sports, kids, civic clubs. Prefers color, single-panel, with gagline. No washes.

First Contact & Terms Send query letter with samples. Send art on a disk if possible (Macintosh compatible). Submissions returned by SASE. Buys one-time rights. **Pays on publication:** $30 for b&w or color.

Tips "Send clear cartoon submissions, not poorly photocopied copies."

OREGON QUARTERLY

204 Alder Building, 5228 University of Oregon, Eugene OR 97403-5228. (541)346-5047. Fax: (541)346-5571. E-mail: quarterly@uoregon.edu. Website: www.oregonquarterly. com. **Art Director:** Tim Jordan. Editor: Guy Maynard. Estab. 1919. Quarterly 4-color alumni magazine. Emphasizes regional (Northwest) issues and events as addressed by University of Oregon faculty members and alumni. Circ. 91,000. Sample copies available for SASE with first-class postage.

Illustration Approached by 25 illustrators/year. Buys 1-2 illustrations/issue. Prefers story-related themes and styles. Interested in all media.

First Contact & Terms Illustrators: Send query letter with résumé, SASE and tearsheets. Samples are filed unless accompanied by SASE. Responds only if interested. Portfolio review not required. Buys one-time rights for print and electronic versions. **Pays on acceptance**; rates negotiable. Accepts previously published artwork. Originals are returned at job's completion.

Tips "Send postcard or URL, not portfolio."

ORT AMERICA

75 Maiden Lane, 10th Floor, New York NY 10038. (212)505-7700. Fax: (212)674-3057. E-mail: info@ortamerica.org. Website: www.ortamerica.org. **National Director of Communications:** Sarina Roffé. Estab. 1966.

Illustration Works on assignment only. Prefers contemporary art. Considers pen & ink, mixed media, watercolor, acrylic, oil, charcoal, airbrush, collage and marker.

First Contact & Terms Send postcard sample or query letter with brochure, SASE and photographs. Samples are filed. Responds only if interested. Rights purchased vary according to project. Pays on publication: $150 and up, depending on work.

OUR STATE: DOWN HOME IN NORTH CAROLINA

P.O. Box 4552, Greensboro NC 27404. (336)286-0600. Fax: (336)286-0100. E-mail: art_director@ourstate.com. Website: www.ourstate.com. **Art Director:** Deanne O'Connor. Estab. 1933. Monthly 4-color consumer magazine featuring travel, history

and culture of North Carolina. Circ. 130,000. Art guidelines free for #10 SASE with first-class postage.

Illustration Approached by 6 illustrators/year. Buys 1-10 illustrations/issue. Features representations of towns in North Carolina in every issue, plus various illustrations for "down home" North Carolina stories. Prefers vintage/antique/literary look. Assigns 100% to new and emerging illustrators. 100% of freelance illustration demands knowledge of Illustrator.

First Contact & Terms Illustrators: Send postcard sample or nonreturnable samples. Samples are not filed and are not returned. Portfolio review not required. Buys one-time rights. Pays on publication: $400-600 for color cover; $75-350 for b inside; $75-350 for color inside; $350 for 2-page spreads. Finds illustrators through web searches/marketing mailings/resource books.

OUT OF THE BOXX

P.O. Box 2158, Daly City CA 94017-2158. Phone/fax: (650)755-4827. E-mail: outoftheboxx@earthlink.net. Website: www.outoftheboxx.lookscool.com. **Editor:** Joy Miller. Art Director/Publisher: L.A. Miller. Estab. 2007. Monthly trade journal for cartoonists, humor writers, art collectors. Sample copy available for $5.0 0 ($8 foreign). Art guidelines available for #10 SASE with first-class postage.

Cartoons Buys front cover cartoon. Slant toward cartooning or the cartoonist. Black & White. Pays = $25/On Acceptance. Inside spot cartoons, general slants. Pays = $15-20/On Acceptance.

Illustration Buys 1-2 illustrations/issue. Has featured work by Jack Cassady, Steve Langille, Art McCourt, Thom Bluemel and Brewster Allison. Considers pen & ink, mixed media.

First Contact & Terms Send query letter with business card, promo sheet, photocopied samples, SASE. Include all contact information (name, postal mail & e-mail addresses, URL, phone/fax numbers). Samples are filed. Responds in 1-2 months. Buys reprint rights. Works on assignment only. **Pays on acceptance.** Pays cartoonists $20/front cover, $15/inside spots; pays illustrators $20-30.

Tips "We welcome both professional and amateur cartoonist."

OVER THE BACK FENCE MAGAZINE

2947 Interstate Pkwy., Brunswick OH 44212. (330)220-2483. Fax: (330)220-3083. E-mail: rockya@longpointmedia.com. Website: www.backfencemagazine.com. **Creative Director:** Rocky Alten. Estab. 1994. Bi-monthly consumer magazine emphasizing southern Ohio topics. Circ. 15,000. Sample copy available for $5; illustrator's guidelines can be found on the website.

Illustration Features humorous and realistic illustration; informational graphics and spot illustration. Assigns 50% of illustration to experienced but not well-known illustrators; 50% to new and emerging illustrators.

First Contact & Terms Illustrators: Send query letter with photocopies, tearsheets and SASE. See guidelines on website. Samples are occasionally filed or returned by SASE. Responds in 3 months. Creative director will contact artist for portfolio review if interested. Buys one-time rights. Pays $100 for b&w and color covers; $25-100 for b&w and color inside; $25-200 for 2-page spreads; $25-100 for spots. Finds illustrators through word of mouth and submissions.

Tips Our readership enjoys our warm, friendly approach. The artwork we select will possess the same qualities.

PARADE MAGAZINE

711 Third Ave., New York NY 10017-4014. (212)450-7000. Fax: (212)450-7284. E-mail: ira_yoffe@parade.com. Website: www.parade.com. **Creative Director:** Ira Yoffe. Weekly emphasizing general-interest subjects. Circ. 36 million. Sample copies available. Art guidelines available for SASE with first-class postage.

Illustration Works on assignment only.

Design Needs freelancers for design. 100% of freelance work demands knowledge of Photoshop, Illustrator, InDesign and QuarkXPress. Prefers local freelancers.

First Contact & Terms Illustrators: Send query letter with brochure, résumé, business card, postcard and/or tearsheets to be kept on file. Designers: Send query letter with résumé. Call or write for appointment to show portfolio. Responds only if interested. Buys first rights, occasionally all rights. Pays for design by the project, by the day or by the hour depending on assignment.

Tips "Provide a good balance of work."

PC MAGAZINE

DIGITAL EDITION Ziff Davis Media, 28 E. 28th St., 11th Floor, New York NY 10016. (212)503-3500. Fax: (212)503-5580. Website: www.pcmag.com. **Art Director:** Richard Demler. Estab. 1983. Monthly consumer magazine featuring comparative lab-based reviews of current PC hardware and software. Circ. 125,000 subscribers. Sample copies available.

Illustration Approached by 100 illustrators/year. Buys 2-3 illustrations/issue. Considers all media.

First Contact & Terms Send postcard sample and/or printed samples, photocopies, tearsheets. Accepts CD or e-mail submissions. Samples are filed. Portfolios may be dropped off and should include tearsheets and transparencies; art department keeps for one week to review. **Pays on acceptance.** Payment negotiable for cover and inside; $350 for spots.

PERSIMMON HILL

Published by the National Cowboy & Western Heritage Museum, 1700 NE 63rd

St., Oklahoma City OK 73111. (405)478-6404. Fax: (405)478-4714. E-mail: editor@ nationalmuseum.org. Website: www.nationalcowboymuseum.org. **Director of Publications:** Judy Hilovsky. Estab. 1970. Quarterly 4-color journal of western heritage "focusing on both historical and contemporary themes. It features nonfiction articles on notable persons connected with pioneering the American West; art, rodeo, cowboys, floral and animal life; or other phenomena of the West of today or yesterday. Lively articles, well written, for a popular audience. Contemporary design follows style of Architectural Digest and European Travel and Life. Circ. 15,000. Original artwork returned after publication. Sample copy for $10.50.

Illustration Fine art only.

First Contact & Terms Send query letter with tearsheets, SASE, slides and transparencies. Samples are filed or returned by SASE if requested. Publication will contact artist for portfolio review if interested. Portfolio should include original/final art, photographs or slides. Buys first rights. Requests work on spec before assigning job. Payment varies. Finds artists through word of mouth and submissions.

Tips "We are a western museum publication. Most illustrations are used to accompany articles. Work with our writers, or suggest illustrations to the editor that can be the basis for a freelance article or a companion story. More interest in the West means we have to provide more contemporary photographs and articles about what people in the West are doing today. Study the magazine first at least four issues."

PHI DELTA KAPPAN

408 N. Union Street, Bloomington IN 47405-3800. (812)339-1156. Fax: (812)339-0018. Website: www.pdkintl.org/kappan/kappan.htm. **Design Director:** Carol Bucheri. Journal covers issues in education, policy, research findings and opinion. Readers include members of the education organization Phi Delta Kappa as well as non-member subscribers — school administrators, teachers, and policy makers. Published 10 times/year, September-June. Circ. 50,000. Sample copy available for $8 plus $5.50 S&H. Journal is available in most public and university libraries.

Cartoons Approached by over 100 cartoonists/year. Looks for well-drawn cartoons that reflect our multi-racial, multi-ethnic, non-gender-biased world. Cartoon content must be related to education. Submit packages of 10-25 cartoons, 1 per 8 × 11 sheet, with SASE. Allow 2 months for review. Do not send submissions April 1-May 30. Note that we do not accept electronic submissions of cartoons.

Illustration Approached by over 100 illustrators/year. We have moved away from using much original illustration and now rely primarily on stock illustration to supplement an increased use of photography. Send plain-text e-mail with link to your online portfolio. Look for serious conceptual art to illustrate complex and often abstract themes. We also use humorous illustrations. Purchases royalty-free stock and one-time print and electronic rights for original work. Submission guidelines available online at website.

PN/PARAPLEGIA NEWS

2111 E. Highland Ave., Suite 180, Phoenix AZ 85016-4702. (602)224-0500. Fax: (602)224-0507. E-mail: anns@pnnews.com. Website: www.pn-magazine.com. **Art Director:** Ann Santos. Estab. 1947. Monthly 4-color magazine emphasizing wheelchair living for wheelchair users, rehabilitation specialists. Circ. 30,000. Accepts previously published artwork. Original artwork not returned after publication. Sample copy free for large-size SASE with $3 postage.

Cartoons Buys 3 cartoons/issue. Prefers line art with wheelchair theme. Prefers single panel b&w line drawings with or without gagline.

Illustration Prefers wheelchair living or medical and financial topics as themes. 50% of freelance work demands knowledge of QuarkXPress, Photoshop or Illustrator.

First Contact & Terms Cartoonists: Send query letter with finished cartoons to be kept on file. Responds only if interested. Buys all rights. **Pays on acceptance.** Illustrators: Send postcard sample. Accepts disk submissions compatible with Illustrator 10.0 or Photoshop 7.0. Send EPS, TIFF or JPEG files. Samples not filed are returned by SASE. Publication will contact artist for portfolio review if interested. Portfolio should include final reproduction/product, color and b&w tearsheets, photostats, photographs. Pays on publication. Pays cartoonists $10 for b&w. Pays illustrators $250 for color cover; $25 for b&w inside, $50 for color inside.

Tips "When sending samples, include something that shows a wheelchair user. We regularly purchase cartoons that depict wheelchair users."

POCKETS

P.O. Box 340004, 1908 Grand AV, Nashville TN 37203-0004. (615)340-7333. Fax: (615)340-7267. E-mail: pockets@upperroom.org. Website: www.pockets.org. **Editor:** Lynn W. Gilliam. Devotional magazine for children 6-12. 4-color. Monthly except January/February. Circ. 100,000. Accepts one-time previously published material. Original artwork returned after publication. Sample copy for 9 × 12 or larger SASE with 4 first-class stamps.

Illustration Approached by 50-60 illustrators/year. Features humorous, realistic and spot illustration. Assigns 15% of illustrations to new and emerging illustrators. Uses variety of styles; 4-color, flapped traditional art or digital, appropriate for children. Realistic, fable and cartoon styles.

First Contact & Terms Illustrators: Send postcard sample, brochure, photocopies, and tearsheets with SASE. No fax submissions accepted. Also open to more unusual art forms cut paper, embroidery, etc. Samples not filed are returned by SASE only. No response without SASE." Buys one-time and reserves or reprint rights. **Pays on acceptance;**$600 flat fee for 4-color covers; $75-350 for color inside.

Tips "Assignments made in consultation with out-of-house designer. Send samples to our designer Chris Schechner, Schechner & Associates, 408 Inglewood Dr., Richardson, TX 75080."

THE PORTLAND REVIEW

P.O. Box 347, Portland OR 97207. (503)725-4533. Fax: (503)725-5860. E-mail: submit.pdxreview@gmail.com. Website: www.portlandreview.org. **Contact:** Chris Cottrell, editor. Estab. 1954. Quarterly student-run arts journal. Circ. 1,500. Sample copies available for $9. Art guidelines available free with SASE or on website.

Illustration Approached by 50 illustrators/year. We don't pay contributors. Features art illustrations and photography. Currently prefer Portland-based artists.

First Contact & Terms Cartoonists/Illustrators: Send postcard sample or query letter with b&w photocopies and SASE. Accepts e-mail submissions with link to website or with image file. Prefers Mac-compatible. Samples are not filed and not returned. Responds with acceptance in 2 months. Portfolio not required.

PRESBYTERIANS TODAY

100 Witherspoon St., Louisville KY 40202. (502)569-5175. Fax: (502)569-8632. E-mail: today@pcusa.org. Website: www.pcusa.org/today. **Art Director:** Shellee Marie Layman. Estab. 1830. 4-color; official church magazine emphasizing Presbyterian news and informative and inspirational features. Publishes 10 issues year. Circ. 50,000. Originals are returned after publication if requested. Some feature illustrations may appear on website. Sample copies for SASE with first-class postage.

Cartoons Approached by 20-30 cartoonists/year. Buys 1 freelance cartoon/issue. Prefers general religious material; single panel. Illustration Approached by more than 50 illustrators/year. Buys 1-2 illustrations/issue, 15 illustrations/year from freelancers. Works on assignment only. Media varies according to need.

First Contact & Terms Cartoonists: Send roughs and/or finished cartoons. Responds in 1 month. Rights purchased vary according to project. Illustrators: Send query letter with tearsheets or online portfolio. Samples are filed and not returned. Responds only if interested. Buys one-time and web-usage rights. May buy expanded rights depending on project. Pays cartoonists $25, b&w; $40, color. Pays illustrators $350-500, cover; $75-300, inside.

PRINT MAGAZINE

F+W Media, Inc., 38 E. 29th St., 3rd Floor, New York, NY 10016. (212)447-1400. Fax: (212)447-5231. E-mail: alice.cho@printmag.com. Website: ww.printmag.com. Art Director: Alice Cho. Estab. 1940. Bimonthly magazine for "designers, art directors, photographers, Illustrators, web designers, typographers, and design enthusiasts of all stripes." Circ. 38,000.

First Contact & Terms Illustrators/designers/typographers: Send postcard sample, printed samples, and/or tearsheets to the attention of the art director, either by mail or by e-mail. Samples are filed and art director will respond only if interested. Portfolios may also be dropped off in the office, and artists are responsible for retrieving them.

Buys first North America serial rights. Pays on publication. Finds illustrators through agents, sourcebooks, word of mouth, and submissions.

Tips "Read the magazine to see what kind of design, typography, illustration, and photography we showcase. We're also interested in individual creative approaches to design problems. Note: We have themed issues; please download our editorial calendar from www.printmag.com."

⚡ PRISM INTERNATIONAL

University of British Columbia, Buchanan E462, 1866 Main Mall, Vancouver BC V6T 1Z1 Canada. (604)822-2514. Fax: (604)822-3616. E-mail: prism@interchange.ubc. ca. Website: www.prism.arts.ubc.ca. Estab. 1959. Quarterly literary magazine. "We use cover art for each issue." Circ. 1,200. Sample copies available for $10 each; art guidelines free for SASE with first-class Canadian postage.

Illustration Buys 1 cover illustration/issue. Has featured illustrations by Mark Ryden, Mark Mothersbaugh, Annette Allwood, The Clayton Brothers, Maria Capolongo, Mark Korn, Scott Bakal, Chris Woods, Kate Collie and Angela Grossman. Features representational and nonrepresentational fine art. Assigns 50% of illustrations to experienced but not well-known illustrators; 50% to new and emerging illustrators. "Most of our covers are full color artwork and sometimes photography; on occasion we feature a black & white cover."

First Contact & Terms Illustrators: Send postcard sample. Accepts submissions on disk compatible with CorelDraw 5.0 (or lower) or other standard graphical formats. Most samples are filed; those not filed are returned by SASE if requested by artist. Responds in 6 months. Portfolio review not required. Buys first rights. "Image may also be used for promotional purposes related to the magazine." Pays on publication: $250 Canadian and 4 copies of magazine. Original artwork is returned to the artist at job's completion. Finds artists through word of mouth and going to local exhibits.

Tips "We are looking for fine art suitable for the cover of a literary magazine. Your work should be polished, confident, cohesive and original. Please send postcard samples of your work. As with our literary contest, we will choose work that is exciting and which reflects the contemporary nature of the magazine."

REFORM JUDAISM

633 Third Ave., 7th Floor, New York NY 10017-6778. (212)650-4240. Fax: (212)650-4249. E-mail: rjmagazine@urj.org. Website: www.reformjudaismmag.org. **Managing Editor:** Joy Weinberg. Estab. 1972. Quarterly magazine. "The official magazine of the Reform Jewish movement. It covers developments within the movement and interprets world events and Jewish tradition from a Reform perspective." Circ. 310,000. Accepts previously published artwork. Originals returned at jobs completion. Sample copies available for $3.50.

Cartoons Prefers political themes tying into editorial coverage.

Illustration Buys 5-8 illustrations/issue. Works on assignment. 10% of freelance work demands computer skills.

First Contact & Terms Cartoonists: Send query letter with copy of finished cartoons that do not have to be returned. Send with self-addressed stamped postcard offering 3 choices: Yes, we are interested; No, unfortunately we will pass on publication; Maybe, we will consider and be back in touch with you. Illustrators: Send query letter with brochure and/or tearsheets. Samples are filed and artists are contacted when the right fit presents itself. **Pays on publication**; varies according to project. Finds artists' submissions.

RESTAURANT HOSPITALITY

1300 E. Ninth St., Cleveland OH 44114. (216)931-9942. Fax: (216)696-0836. **Group Creative Director:** Chris Roberto. Circ. 123,000. Estab. 1919. Monthly trade publication emphasizing restaurant management ideas, business strategies and foodservice industry trends. Readers are independent and chain restaurant operators, executives and chefs.

Illustration Approached by 150 illustrators/year. Buys 3-5 illustrations per issue (combined assigned and stock). Prefers food- and business-related illustration in a variety of styles. Has featured illustrations by Mark Shaver, Paul Watson and Brian Raszka. Assigns 10% of illustrations to well-known or "name" illustrators; 60% to experienced but not well-known illustrators; and 30% to new and emerging illustrators. Welcomes stock submissions.

First Contact & Terms Illustrators: Postcard samples preferred. Follow-up card every 3-6 months. Buys one-time rights. **Pays on acceptance.** Payment range varies for full page or covers; $300-350 quarter-page; $250-350 for spots. Finished illustrations must be delivered as hi-res digital. E-mail or FTP preferred.

Tips "I am always open to new approaches-contemporary, modern visuals that explore various aspects of the restaurant industry and restaurant experience. Please include a web address on your sample so I can view an online portfolio."

RICHMOND MAGAZINE

2201 W. Broad St., Suite 105, Richmond VA 23220. (804)355-0111. Fax: (804)355-5442. E-mail: steveh@richmag.com. Website: www.richmag.com. **Creative Director:** Steve Hedberg. Estab. 1980. Monthly 4-color regional consumer magazine focusing on Richmond lifestyles. Circ. 35,000. Art guidelines available.

Illustration Approached by 30 illustrators/year. Buys 2-4 illustrations/issue. Has featured illustrations by Robert Megmack, Sterling Hundley, Ismael Roldan, and Doug Thompson. Features realistic, conceptional and spot illustrations. Assigns 25% of illustrations to new and emerging illustrators. Uses mostly Virginia-based illustrators.

First Contact & Terms Illustrators: Send postcard sample or query letter with photocopies, tearsheets or other nonreturnable samples. Send follow-up postcard every 3 months. Send JPEG files. Samples are not returned. Will contact artist for portfolio review if interested. Pays on publication. Pays $150-350 for color cover; $100-300 for color inside. Buys one-time rights for print and web usage. Finds illustrators through promo samples, word of mouth, regional sourcebooks.

Tips "Be dependable, on time and have strong concepts."

RURAL HERITAGE

Dept. AGDM, P.O. Box 2067, Cedar Rapids IA 52406-2067. (319)362-3027. Fax: (319)362-3046. E-mail: editor@ruralheritage.com. Website: www.ruralheritage.com. **Editor:** Gail Damerow. Estab. 1976. Bimonthly farm magazine "published in support of modern-day farming and logging with draft animals (horses, mules, oxen)." Circ. 8,000. Sample copy for $8 postpaid; art guidelines not available.

- Editor stresses the importance of submitting cartoons that deal only with farming and logging using draft animals.

Cartoons Approached by "not nearly enough" cartoonists who understand our subject. Buys 2 or more cartoons/issue. Prefers bold, clean, minimalistic draft animals and their relationship with the teamster. "No unrelated cartoons!" Prefers single panel, humorous, b&w line drawings with or without gagline.

First Contact & Terms Cartoonists: Send query letter with finished cartoons and SASE. Samples accepted by US mail only. Samples are not filed (unless we plan to use them—then we keep them on file until used) and are returned by SASE. Responds in 2 months. Buys first North American serial rights or all rights rarely. Pays on publication; $10 for one-time rights; $20 for all rights.

Tips "Know draft animals (horses, mules, oxen, etc.) well enough to recognize humorous situations intrinsic to their use or that arise in their relationship to the teamster. Our best contributors read *Rural Heritage* and get their ideas from the publication's content."

THE SCHOOL ADMINISTRATOR

801 N. Quincy St., Suite 700, Arlington VA 22203-1730. (703)875-0753. Fax: (703)528-2146. E-mail: info@aasa.org. Website: www.aasa.org. **Managing Editor:** Liz Griffin. Monthly association magazine focusing on education. Circ. 22,000.

Cartoons Approached by 15 editorial cartoonists/year. Buys 11 cartoons/year. Prefers editorial/humorous, b&w line drawings only. Humor should be appropriate to a CEO of a school system, not a classroom teacher or parent."

Illustration Approached by 60 illustrators/year. Buys 2-3 illustrations/issue. Has featured illustrations by Ralph Butler, Paul Zwolak, and Heidi Younger. Features spot and computer illustrations. Preferred subjects education K-12 and leadership. Assigns 90% of illustrations to our existing stable of illustrators. Considers all media.

Requires willingness to work within tight budget. **Contact & Terms** Cartoonists: Send photocopies and SASE. Buys one-time rights. **Pays on acceptance.** Send nonreturnable samples. Samples are filed and not returned. Responds only if interested. Print rights purchased. Pays on publication. Pays illustrators $800 for color cover. Finds illustrators through word of mouth, stock illustration source and Creative Sourcebook.

Tips Check out our website. Send illustration samples to: Melissa Kelly, Auras Design, 8435 Georgia Ave., Silver Spring MD 20910."

SCRAP

1615 L St. NW, Suite 600, Washington DC 20036-5664. (202)662-8547. Fax: (202)626-0947. E-mail: kentkiser@scrap.org. Website: www.scrap.org. **Publisher:** Kent Kiser. Estab. 1987. Bimonthly 4-color trade publication that covers all aspects of the scrap recycling industry. Circ. 11,559.

Cartoons "We occasionally run single-panel cartoons that focus on the recycling theme/business."

Illustration Approached by 100 illustrators/year. Buys 0-2 illustrations/issue. Features realistic illustrations, business/industrial/corporate illustrations and international/financial illustrations. Prefered subjects business subjects. Assigns 10% of illustrations to new and emerging illustrators.

First Contact & Terms Illustrators: Send postcard sample. Samples are filed. Portfolio review not required. Buys first North American serial rights. **Pays on acceptance**; $1,200-2,000 for color cover; $300-1,000 for color inside. Finds illustrators through creative sourcebook, mailed submissions, referrals from other editors, and "direct calls to artists whose work I see and like."

Tips "We're always open to new talent and different styles. Our main requirement is the ability and willingness to take direction and make changes if necessary. No prima donnas, please. Send a postcard to let us see what you can do."

SEATTLE MAGAZINE

1518 1st Ave S., Suite 500, Seattle WA 98134. (206)284-1750. Fax: (206)284-2550. E-mail: sue.boylan@tigeroak.com. Website: www.seattlemag.com. **Art Director:** Sue Boylan. Estab. 1992. Monthly urban lifestyle magazine covering Seattle. Circ. 48,000. E-mail art director directly for art guidelines.

Illustration Approached by hundreds of illustrators/year. Buys 2 illustrations/issue. Considers all media. "We can scan any type of illustration."

First Contact & Terms Illustrators: Prefers e-mail submissions. Samples are filed. Responds only if interested. Art director will contact artist for portfolio review of color, final art and transparencies if interested. Buys one-time rights. Sends payment on 25th of month of publication. Pays on publication; $150-1,100 for color cover; $50-400 for b $50-1,100 for color inside; $50-400 for spots. Finds illustrators through

agents, sourcebooks such as *Creative Black Book*, *LA Workbook*, online services, magazines, word of mouth, artist's submissions, etc.

Tips "Good conceptual skills are the most important quality that I look for in an illustrator as well as unique skills."

SIERRA MAGAZINE

85 Second St., 2nd Floor, San Francisco CA 94105-3441. (415)977-5572. Fax: (415)977-5794. E-mail: sierra.magazine@sierraclub.org. Website: www.sierraclub.org. **Art Director:** Martha Geering. Bimonthly consumer magazine featuring environmental and general interest articles. Circ. 750,000.

Illustration Buys 8 illustrations/issue. Considers all media. 10% of freelance illustration demands computer skills.

First Contact & Terms Send postcard samples or printed samples, SASE and tearsheets, or link to web portfolio. Samples are filed and are not returned. Responds only if interested. Art director will contact artist for portfolio review if interested. Buys one-time rights. Finds illustrators through illustration and design annuals, illustration websites, sourcebooks, submissions, magazines, word of mouth.

SKILLSUSA CHAMPIONS

14001 SkillsUSA Way, P.O. Box 3000, Leesburg VA 20177. (703)777-8810. Fax: (703)777-8999. Website: www.skillsusa.org. **Editor:** Tom Hall. Estab. 1965. Quarterly 4-color magazine. "SkillsUSA Champions is primarily a features magazine that provides motivational content by focusing on successful members. SkillsUSA is an organization of 300,000 students and teachers in technical, skilled and service careers. Circ. 300,000. Sample copies available.

Illustration Approached by 4 illustrators/year. Works on assignment only. Prefers positive, youthful, innovative, action-oriented images. Considers pen & ink, watercolor, collage, airbrush and acrylic.

Design Needs freelancers for design. 100% of freelance work demands knowledge of Adobe CS.

First Contact & Terms Illustrators: Send postcard sample. Designers: Send query letter with brochure. Accepts disks compatible with FreeHand 5.0, Illustrator CS3, PageMaker 7.0 and InDesign CS3. Send Illustrator, FreeHand and EPS files. Portfolio should include printed samples, b&w and color tearsheets and photographs. Accepts previously published artwork. Originals returned at job's completion (if requested). Rights purchased vary according to project. **Pays on acceptance.** Pays illustrators $200-300 for color; $100-300 for spots. Pays designers by the project.

Tips "Send samples or a brochure. These will be kept on file until illustrations are needed. Don't call! Fast turnaround helpful. Due to the unique nature of our audience, most illustrations are not re-usable; we prefer to keep art."

SKIPPING STONES

P.O. Box 3939, Eugene OR 97403-0939. (541)342-4956. E-mail: Info@SkippingStones. org. Website: www.SkippingStones.org. **Editor:** Arun Toke. Estab. 1988. Bimonthly b&w (with 4-color cover) consumer magazine. International nonprofit multicultural awareness and nature education magazine for today's youth. Circ. 2,000 (and on the Web). Sample copy available for $5. Art guidelines are free for SASE with first-class postage.

Cartoons Prefers multicultural, social issues, nature/ecology themes. Requests b&w washes and line drawings. Has featured cartoons by Lindy Wojcicki of Florida. Prefers cartoons by youth under age 19.

Illustration Approached by 100 illustrators/year. Buys 10-20 illustrations/year. Has featured illustrations by Sarah Solie, Wisconsin; Alvina Kong, California; Elizabeth Wilkinson, Vermont; Inna Svjatova, Russia; Jon Bush, Massachusetts. Features humorous illustration, informational graphics, natural history and realistic, authentic illustrations. Preferred subjects children and teens. Prefers pen & ink. Assigns 80% of work to new and emerging illustrators. Recent issues have featured Multicultural artists—their life and works.

First Contact & Terms Cartoonists: Send b&w photocopies and SASE. Illustrators: Send nonreturnable photocopies and SASE. Samples are filed or returned by SASE. Responds in 3 months if interested. Portfolio review not required. Buys first rights, reprint rights. Pays on publication 1-4 copies, NO $$s. Finds illustrators through word of mouth, artists' promo samples.

Tips "We are a gentle, non-glossy, ad-free magazine not afraid to tackle hard issues. We are looking for work that challenges the mind, charms the spirit, warms the heart; handmade, nonviolent, global, for youth 8-15 with multicultural/nature content. Please, no aliens or unicorns. We are especially seeking work by young artists under 19 years of age! People of color and international artists are especially encouraged."

SLACK PUBLICATIONS

6900 Grove Rd., Thorofare NJ 08086-9447. (856)848-1000. Fax: (856)853-5991. E-mail: pslack@slackinc.com. Website: www.slackinc.com. **Creative Director:** Linda Baker. Estab. 1960. Publishes 22 medical publications dealing with clinical and lifestyle issues for people in the medical professions. Accepts previously published artwork. Originals returned at job's completion. Art guidelines not available.

Illustration Approached by 50 illustrators/year. Buys 2 illustrations/issue. Works on assignment only. Features stylized and realistic illustration; charts & graphs; informational graphics; medical, computer and spot illustration. NO CARTOONS. Assigns 5% of illustrations to well-known or "name" illustrators; 90% to experienced but not well-known illustrators; 5% to new and emerging illustrators. Prefers digital submissions.

First Contact & Terms Send query letter with tearsheets, photographs, photocopies, slides and transparencies. Samples are filed and are returned by SASE if requested by artist. Responds to the artist only if interested. To show a portfolio, mail b&w and color tearsheets, slides, photostats, photocopies and photographs. Negotiates rights purchased. Pays on publication; $400-600 for color cover; $100-200 for b&w inside; $100-350 for color inside; $50-150 for spots.

Tips "Send samples."

SPIDER®

Cricket Magazine Group, Carus Publishing, 70 E. Lake St., Suite 300, Chicago IL 60601. Website: www.cricketmag.com. **Contact:** Art Submissions Coordinator. Managing Art Director: Suzanne Beck. Estab. 1994. Monthly literary and activity magazine for children ages 6-9. Circ. 70,000. Art guidelines available on website.

- See also listings in this section for other magazines published by the Cricket Magazine Group: *Babybug, Ladybug, Cricket* and *Cicada*.

Illustration Buys 20 illustrations/issue; 240 illustrations/year. Uses color artwork only. Works on assignment only.

First Contact & Terms Send photocopies, photographs or tearsheets to be kept on file. Samples are returned by SASE if requested. Responds in 3 months. Buys all rights. Pays 45 days after acceptance: $750 for color cover; $250 for color full page; $100 for color spots; $50 for b&w spots.

Tips "Before attempting to illustrate for *Spider*, be sure to familiarize yourself with this age group, and read several issues of the magazine. Please do not query first."

SPORTS 'N SPOKES

2111 E. Highland Ave., Suite 180, Phoenix AZ 85016-4702. (602)224-0500. Fax: (602)224-0507. E-mail: anns@pnnews.com. Website: www.sportsnspokes.com. **Art and Production Director:** Ann Santos. Published 6 times a year. Consumer magazine with emphasis on sports and recreation for the wheelchair user. Circ. 15,000. Accepts previously published artwork. Sample copies for large SASE and $3.00 postage.

Cartoons Buys 3-5 cartoons/issue. Prefers humorous cartoons; single panel b&w line drawings with or without gagline. Must depict some aspect of wheelchair sport and/or recreation.

Illustration Works on assignment only. Considers pen & ink, watercolor and computer-generated art. 50% of freelance work demands knowledge of Illustrator, QuarkXPress or Photoshop.

First Contact & Terms Cartoonists: Send query letter with finished cartoons. Responds in 3 months. Buys all rights. **Pays on acceptance**; $10 for b&w. Illustrators: Send postcard sample or query letter with résumé and tearsheets. Accepts CD submissions compatible with Illustrator 10.0 or Photoshop 7.0. Send EPS, TIFF or JPEG files.

Samples are filed or returned by SASE if requested by artist. Responds to the artist only if interested. Publication will contact artist for portfolio review if interested. Portfolio should include color tearsheets. Buys one-time rights and reprint rights. Pays on publication; $250 for color cover; $25 for b&w inside; $50 for color inside.

Tips "We have not purchased an illustration or used a freelance designer for many years. We regularly purchase cartoons with wheelchair sports/recreation theme."

▣ SUB-TERRAIN MAGAZINE

P.O. Box 3008, MPO, Vancouver BC V6B 3X5 Canada. (604)876-8710. Fax: (604)879-2667. E-mail: subter@portal.ca. Website: www.subterrain.ca. **Editor:** Brian Kaufman. Estab. 1988. Published 3 times a year. Partial full colour literary magazine featuring contemporary literature of all genres.

Cartoons Prefers single panel cartoons.

Illustration Assigns 50% of illustrations to new and emerging illustrators.

First Contact & Terms Send us links to your web site or send us a few sample jpegs. Responds if interested. Portfolio review not required. Buys first rights, first North American serial rights, one-time rights or reprint rights. Pays $50-150 (Canadian), plus contributor copies.

Tips "Take the time to look at an issue of the magazine to get an idea of the kind of material we publish."

SUN VALLEY MAGAZINE

111 1st Ave., N. Meriwether Building, #1M, Hailey, ID 83333. (208)788-0770. Fax: (208)788-3881. E-mail: art@sunvalleymag.com. Website: www.sunvalleymag.com. **Art Director:** Robin Leahy. Estab. 1971. Consumer magazine published 3 times/year "highlighting the activities and lifestyles of people of the Wood River Valley." Circ. 25,000. Sample copies available. Art guidelines free for #10 SASE with first-class postage.

Illustration Approached by 10 illustrators/year. Buys 3 illustrations/issue. Prefers forward, cutting edge styles. Considers all media.

First Contact & Terms Illustrators: Send query letter with SASE. Accepts disk submissions compatible with Macintosh, and/or InDesign. Send EPS files. Samples are filed. Does not report back. Artist should call. Art director will contact artist for portfolio review of b&w, color, final art, photostats, roughs, slides, tearsheets and thumbnails if interested. Buys first rights. **Pays on publication**; $ 350 cover; $80-240 inside.

Tips "Read our magazine. Send ideas for illustrations and examples."

TECHNICAL ANALYSIS OF STOCKS & COMMODITIES

Technical Analysis, Inc., 4757 California Ave. SW, Seattle WA 98116-4499. (206)938-

0570. Fax: (206)938-1307. E-mail: cmorrison@traders.com. Website: www.traders. com. Art Director: Christine Morrison. Estab. 1982. Monthly traders' magazine for stocks, bonds, futures, commodities, options, mutual funds. Circ. 66,000. Sample copies available for $5 each. Art guidelines on website.

- This magazine has received several awards, including the Step by Step Design Annual, American Illustration IX, XXIII, XIV, NY Society of Illustrators Annuals 40, 46, 48, 49. separate listing for Technical Analysis, Inc., in the Book Publishers section.)

Cartoons Approached by 10 cartoonists/year. Buys 1-4 cartoons/issue. Prefers humorous cartoons, single-panel b&w line drawings with gagline.

Illustration Approached by 100 illustrators/year. Buys 6 illustrations/issue. Works on assignment only. Features humorous, realistic, computer (occasionally) and spot illustrations.

First Contact & Terms Cartoonists: Send query letter with finished cartoons (non-returnable copies only) or email. Illustrators: Send e-mail JPEGs, brochure, tearsheets, photographs, photocopies, photostats, slides. Accepts disk submissions compatible with any Adobe products (TIFF or EPS files). Samples are filed and are not returned. Email portfolio for review if interested. Portfolio should include b&w and color art, slides, photostats, photocopies, final art and photographs. Buys one-time rights and reprint rights. Pays on publication. Pays cartoonists $35 for b&w. Pays illustrators $135-350 for color cover; $165-220 for color inside; $105-150 for b&w inside. Accepts previously published artwork.

Tips "Looking for creative, imaginative and conceptual types of illustration that relate to articles' concepts. Also interested in caricatures with market charts and computers. If I'm interested, I will call."

TEXAS PARKS & WILDLIFE

4200 Smith School Rd, Austin TX 78744. (512)387-8793. Fax: (512)389-8397. E-mail: magazine@tpwd.state.tx.us. Website: www.tpwmagazine.com. **Art Director:** Andres Carrasco. Estab. 1942. Monthly magazine "containing information on state parks, wildlife conservation, hunting and fishing, environmental awareness." Circ. 180,000. Sample copies for #10 SASE with first-class postage.

Illustration 100% of freelance illustration.

First Contact & Terms Illustrators: Send postcard sample. Samples are not filed and are not returned. Responds only if interested. Buys one-time rights. Pays on publication; negotiable. Finds illustrators through magazines, word of mouth, artist's submissions.

Tips "Read our magazine."

TIKKUN MAGAZINE

2342 Shattuck Ave., #1200, Berkeley CA 94704. (510)644-1200. Fax: (510)644-1255. E-mail: magazine@tikkun.org. Website: www.tikkun.org. **Managing Editor:** David Belden. Estab. 1986. Bimonthly Jewish critique of politics, culture and society; includes articles regarding Jewish and non-Jewish issues, left-of-center politics. Circ. 70,000. Sample copies available for $6 plus $2 postage.

Illustration Approached by 50-100 illustrators/year. Buys 10-12 illustrations/issue. Has featured illustrations by Julie Delton, David Ball and Jim Flynn. Features symbolic and figurative illustration and political cartoons in color and black and white. Assigns 90% of illustrations to experienced, but not well known illustrators; 10% to new and emerging illustrators. Prefers line drawings.

First Contact & Terms Prefer electronic submissions. Email web link or JPEGs. Do not send originals; unsolicited artwork will not be returned. Accepts previously published material. Often we hold onto line drawings for last-minute use. Pays on publication: $150 for color cover; $50 for b&w inside. Buys one-time rights.

Tips Prefer art with progressive religious and ethical themes. "We invite you to send us a sample of a Tikkun article we've printed, showing how you would have illustrated it."

TRAINS

P.O. Box 1612, 21027 Crossroads Circle, Waukesha WI 53187. (262)796-8776. Fax: (262)796-1778. Website: www.trains.com. **Art Director:** Thomas G. Danneman. Estab. 1940. Monthly magazine about trains, train companies, tourist RR, latest railroad news. Circ. 133,000. Art guidelines available.

 • Published by Kalmbach Publishing. Also publishes *Classic Toy Trains*, *Astronomy*, *Finescale Modeler*, *Model Railroader*, *Model Retailer*, *Classic Trains*, *Bead and Button*, *Birder's World*.

Illustration 100% of freelance illustration demands knowledge of Photoshop CS 5.0, Illustrator CS 8.0.

First Contact & Terms Illustrators: Send query letter with printed samples, photocopies and tearsheets. Accepts disk submissions (opticals) or CDs, using programs above. Samples are filed. Art director will contact artist for portfolio review of color tearsheets if interested. Buys one-time rights. Pays on publication.

Tips "Quick turnaround and accurately built files are a must."

UNIQUE OPPORTUNITIES

214 So 8th St., Suite 502, Louisville KY 40202-2738. (502)589-8250. Fax: (502)587-0848. E-mail: barbara@uoworks.com. Website: www.uoworks.com. **Publisher and Design Director**: Barbara Barry. Estab. 1991. Quarterly trade journal. Audience is 80,000 physicians who want to stay on top of career development topics, and might

be looking for a new practice. Editorial focus is on practice-related issues. Circ. 80,000. Prefers files in jpeg, tiff, or pdf format. **Illustration** Buys 1 illustrations/issue. Works on assignment and/or stock. Considers pen ink, mixed media, collage, pastel and computer illustration. Prefers computer illustration.

First Contact & Terms Views online portfolios. E-mail digital files. Buys first or one-time rights. Pays 30 days after publication; $700 for color cover; $150 for spots. Finds artists through Internet only. Do not send samples in the mail.

UROLOGY TIMES

24950 Country Club Blvd., North Olmsted OH 44070. (440)891-2708. Fax: (440)891-2643. E-mail: pseltzer@advanstar.com. Website: www.urologytimes.com. **Group Art Director:** Peter Seltzer. Estab. 1972. Monthly trade publication. The leading news source for urgologists. Circ. 10,000. Art guidelines available.

Illustration Buys 6 illustrations/year. Has featured illustrations by DNA Illustrations, Inc. Assigns 25% of illustrations to new and emerging illustrators. 90% of freelance work demands computer skills. Freelancers should be familiar with Illustrator, Photoshop. E-mail submissions accepted with link to website. Prefers TIFF, JPEG, GIF, EPS. Samples are filed. Art director will contact artist for portfolio review if interested. Portfolio should include finished art and tearsheets. Pays on publication. Buys multiple rights. Finds freelancers through artists' submissions.

First Contact & Terms Illustrators: Send postcard sample with photocopies.

UTNE READER

12 N. 12th St., #400, Minneapolis MN 55403. (612)338-5040. Fax: (612)338-6043. Website: www.utne.com. **Art Director:** Stephanie Glaros. Estab. 1984 by Eric Utne. Bimonthly digest featuring articles and reviews from the best of alternative media; independently published magazines, newsletters, books, journals and websites. Topics covered include national and international news, history, art, music, literature, science, education, economics and psychology. Circ. 250,000.

- *Utne Reader* seeks to present a lively diversity of illustration and photography "voices." We welcome artistic samples which exhibit a talent for interpreting editorial content.

First Contact & Terms "We are always on the lookout for skilled artists with a talent for interpreting editorial content, and welcome examples of your work for consideration. Because of our small staff, busy production schedule, and the volume of samples we receive, however, we ask that you read and keep in mind the following guidelines. We ask that you not call or e-mail seeking feedback, or to check if your package has arrived. We wish we could be more generous in this regard, but we simply don't have the staff or memory capacity to recall what has come in (SASEs and reply cards will be honored. Send samples that can be quickly viewed and

tacked t a bulletin board. Single-sided postcards are preferred. Make sure to include a link to your online portfolio, so we can easily view more samples of your work. DO NOT SEND cover letters, résumés, and gallery or exhibition lists. Be assured, if your art strikes us as a good fit for the magazine, we will keep you in mind for assignments. Clearly mark your full name, address, phone number, website address and e-mail address on everything you send. Please do not send original artwork or original photographs of any kind."

◪ VANCOUVER MAGAZINE

2608 Granville St., Suite 560, Vancouver BC V6H 3V3 Canada. (604)877-7732. Fax: (604)877-4848. E-mail: rwatson@vancouvermagazine.com. Website: www. vancouvermagazine.com. **Art Director:** Randall Watson. Monthly 4-color city magazine. Circ. 50,000.

Illustration Approached by 100 illustrators/year. Buys 4 illustrations/issue. Has featured illustrations by Melinda Beck, Jordin Isip, Geoffrey Grahn, Craig Larotonda, Christopher Silas Neal, Nate Williams and Juliette Borda. Features editorial and spot illustrations. Prefers conceptual, modern, original, alternative, bright and graphic use of color and style. Assigns 10% of work to new and emerging illustrators.

First Contact & Terms Send e-mail with website and contact link. Send postcard or other nonreturnable samples and follow-up samples every 3 months. Samples are filed. Responds only if interested. Portfolio may be dropped off every Tuesday and picked up the following day. Buys one-time and Internet rights. **Pays on acceptance**; negotiable. Finds illustrators through magazines, agents, *Showcase*.

Tips "We stick to tight deadlines. Aggressive, creative, alternative solutions encouraged. No phone calls, please."

VEGETARIAN JOURNAL

P.O. Box 1463 Dept. IN, Baltimore MD 21203-1463. (410)366-8343. E-mail: vrg@ vrg.org. Website: www.vrg.org. **Editor:** Debra Wasserman. Estab. 1982. Quarterly nonprofit vegetarian magazine that examines the health, ecological and ethical aspects of vegetarianism. "Highly educated audience including health professionals." Circ. 20,000. Accepts previously published artwork. Originals returned at job's completion upon request. Sample copies available for $3.

Cartoons Approached by 4 cartoonists/year. Buys 1 cartoon/issue. Prefers humorous cartoons with an obvious vegetarian theme; single panel b&w line drawings.

Illustration Approached by 20 illustrators/year. Buys 6 illustrations/issue. Works on assignment only. Prefers strict vegetarian food scenes (no animal products). Considers pen & ink, watercolor, collage, charcoal and mixed media.

First Contact & Terms Cartoonists: Send query letter with roughs. Illustrators: Send query letter with photostats. Samples are not filed and are returned by SASE if requested by artist. Responds in 2 weeks. Portfolio review not required. Rights

purchased vary according to project. **Pays on acceptance.** Pays cartoonists $25 for b&w. Pays illustrators $25-50 for b&w/color inside. Finds artists through word of mouth and job listings in art schools.

Tips Areas most open to freelancers are recipe section and feature articles. "Review magazine first to learn our style. Send query letter with photocopy sample of line drawings of food."

WATERCOLOR ARTIST

(formerly *Watercolor Magic*), F+W Media, Inc., 4700 E. Galbraith Rd., Cincinnati OH 45236. (513)531-2690. Fax: (513)531-2902. E-mail: wcamag@fwmedia.com. Website: www.artistsnetwork.com/watercolorartist. **Art Director:** Cindy Rider. Editor: Kelly Kane. Estab. 1995. Bi-monthly 4-color consumer magazine for artists to explore and master watermedia. Circ. 92,000. Art guidelines free for #10 SASE with first-class postage.

First Contact & Terms Illustration: Pays on publication. Finds illustrators through word of mouth, visiting art exhibitions, unsolicited queries, reading books.

Tips "We are looking for watermedia artists who are willing to teach special aspects of their work and their techniques to our readers."

WESTWAYS

3333 Fairview Rd., A327, Costa Mesa CA 92808. (714)885-2396. Fax: (714)885-2335. E-mail: vaneyke.eric@aaa-calif.com. **Creative Director:** Eric Van Eyke. Estab. 1918. Bimonthly lifestyle and travel magazine. Circ. 3,000,000 + .

Illustration Approached by 20 illustrators/year. Buys 2-6 illustrations/year. Works on assignment only. Preferred style is "arty—tasteful, colorful." Considers pen & ink, watercolor, collage, airbrush, acrylic, colored pencil, oil, mixed media and pastel.

First Contact & Terms Illustrators: Send e-mail with link to website or query letter with brochure, tearsheets and samples. Samples are filed. Responds only if interested; "could be months after receiving samples." Buys first rights. **Pays on acceptance of final art:** $250 minimum for color inside. Original artwork returned at job's completion.

WOODENBOAT MAGAZINE

P.O. Box 78, Brooklin ME 04616-0078. (207)359-4651. Fax: (207)359-8920. E-mail: olga@woodenboat.com. Website: www.woodenboat.com. **Art Director:** Olga Lange. Estab. 1974. Bimonthly magazine for wooden boat owners, builders and designers. Circ. 106,000. Previously published work OK. Sample copy for $6. Art guidelines free for SASE with first-class postage.

Illustration Approached by 10-20 illustrators/year. Buys 2-10 illustrations/issue on wooden boats or related items. Uses some illustration, usually by several regularly appearing artists, but occasionally featuring others.

Design Not currently using freelancers.

First Contact & Terms Illustrators: Send postcard sample or query letter with printed samples and tearsheets. Designers: Send query letter with tearsheets, résumé and slides. Samples are filed. Does not report back. Artist should follow up with call. Pays on publication. Pays illustrators $50-$400 for spots.

Tips "We work with several professionals on an assignment basis, but most of the illustrative material that we use in the magazine is submitted with a feature article. When we need additional material, however, we will try to contact a good freelancer in the appropriate geographic area."

WRITER'S DIGEST

F+W Media, Inc., 4700 E. Galbraith Rd., Cincinnati OH 45236. E-mail: writersdig@ fwmedia.com. Website: www.writersdigest.com. **Art Director:** Jessica Boonstra. Bimonthly magazine emphasizing freelance writing for freelance writers. Circ. 140,000. Art guidelines free for SASE with first-class postage.

- Submissions are also considered for inclusion in annual *Writer's Yearbook* and other one-shot publications.

Illustration Buys 2-4 feature illustrations/issue. Theme: the writing life. Works on assignment only. Send postcard or any printed/copied samples to be kept on file (no larger than 8½ × 11).

First Contact & Terms Prefers postal mail submissions to keep on file. Final art may be sent via e-mail. Prefers EPS, TIFF or JPEG files, 300 dpi. Buys one-time rights. **Pays on acceptance:** $500-1,000 for color cover; $100-800 for color inside.

Tips "I like having several samples to look at. Online portfolios are great."

Book Publishers

Walk into any bookstore and start counting the number of images you see on books and calendars. The illustrations you see on covers and within the pages of books are, for the most part, created by freelance artists. Publishers rarely have enough artists on staff to generate such a vast array of styles. If you like to read and work creatively to solve problems, the world of book publishing could be a great market for you.

The artwork appearing on a book cover must grab readers' attention and make them want to pick up the book. It must show at a glance what type of book it is and who it is meant to appeal to. In addition, the cover has to include basic information such as title, the author's name, the publisher's name, blurbs and price.

Most assignments for freelance work are for jackets/covers. The illustration on the cover, combined with typography and the layout choices of the designer, announce to the prospective readers at a glance the style and content of a book. Suspenseful spy novels tend to feature stark, dramatic lettering and symbolic covers. Fantasy and science fiction novels, as well as murder mysteries and historical fiction, might show a scene from the story on their covers. Visit a bookstore and then decide which kinds of books interest you and would be best for your illustration style.

Book interiors are also important. The page layouts and illustrations direct readers through the text and complement the story, particularly in children's books and textbooks. Many publishing companies hire freelance designers with computer skills to design interiors on a contract basis. Look within each listing for the subheading Book Design to find the number of jobs assigned each year and how much is paid per project.

Finding your best markets

The first paragraph of each listing describes the types of books each publisher specializes in. You should submit only to publishers who specialize in the types

Publishing Terms to Know

Important

- **Mass market** paperbacks are sold at supermarkets, newsstands, drugstores, etc. They include romance novels, diet books, mysteries and novels by popular authors like Stephen King.

- **Trade books** are the hardcovers and paperbacks found only in bookstores and libraries. The paperbacks are larger than those on the mass market racks, and are printed on higher-quality paper and often feature matte-paper jackets.

- **Textbooks** contain plenty of illustrations, photographs and charts to explain their subjects.

- **Small press** books are produced by small, independent publishers. Many are literary or scholarly in theme and often feature fine art on their covers.

- **Backlist titles** or **reprints** refer to publishers' titles from past seasons that continue to sell year after year. These books are often updated and republished with freshly designed covers to keep them up to date and attractive to readers.

of books you want to illustrate or design. There's no use submitting to a publisher of literary fiction if you want to illustrate children's picture books.

The publishers in this section are just the tip of the iceberg. You can find additional publishers by visiting bookstores and libraries and looking at covers and interior art. When you find covers you admire, write down the name of the books' publishers in a notebook. If the publisher is not listed in *Artist's & Graphic Designer's Market*, go to your public library and ask to look at a copy of *Literary Market Place*, also called *LMP*, published annually by Information Today, Inc. The cost of this large directory is prohibitive to most freelancers, but you should become familiar with it if you plan to work in the book publishing industry. Though it won't tell you how to submit to each publisher, it does give art directors' names. Also be sure to visit publishers' websites—many offer artist's guidelines.

How to submit

Send one to five nonreturnable samples along with a brief letter. Never send originals. Most art directors prefer samples that can fit in file drawers. Bulky submissions are considered a nuisance. After sending your initial introductory mailing, you should follow up with postcard samples (which include your website) every few months to

Helpful Resources

For More Info

If you decide to focus on book publishing, become familiar with *Publishers Weekly*, the trade magazine of the industry. Its website, www.publishersweekly.com will keep you abreast of new imprints, publishers that plan to increase their title selection, and the names of new art directors. You should also look for articles on book illustration and design in *HOW* (www.howdesign.com), *PRINT* (www.printmag.com) and other graphic design magazines. Helpful books include *By Its Cover: Modern American Book Cover Design* (Princeton Architectural Press), *Front Cover: Great Book Jacket and Cover Design* (Mitchell Beazley), and *Jackets Required: An Illustrated History of American Book Jacket Design, 1920-1950* (Chronicle Books).

keep your name in front of art directors. Also, check the publishers' preferences to see if they will accept submissions of TIFF or JPEG files via e-mail.

Getting paid

Payment for design and illustration varies depending on the size of the publisher, the type of project and the rights purchased. Most publishers pay on a per-project basis, although some publishers of highly illustrated books (such as children's books) pay an advance plus royalties. Small, independent presses may only pay in copies.

Children's book illustration

Working in children's books requires a specific set of skills. You must be able to draw the same characters in a variety of poses and situations. Many publishers are expanding their product lines to include multimedia projects. While a number of children's book publishers are listed in this book, *Children's Writer's & Illustrator's Market*, also published by Writer's Digest Books, is an invaluable resource if you enter this field. See page 502 for more information, or visit www.writersdigestshop.com to order the most recent edition. You may also want to consider joining the Society of Children's Book Writers and Illustrators (www.scbwi.org), an international organization that offers support, information, networking opportunities, and conferences.

HARRY N. ABRAMS, INC.

115 W. 18th St., New York NY 10011. (212)206-7715. Fax: (212)519-1210. Website: www.hnabooks.com. **Director, Art and Design:** Mark LaRiviere. Estab. 1951. Publishes hardcover originals, trade paperback originals and reprints. Types of books include fine art and illustrated books. Publishes 240 titles/year. 60% require freelance design. Visit website for art submission guidelines.

Needs Uses freelance designers to design complete books including jackets and sales materials. Uses illustrators mainly for maps and occasional text illustration. 100% of freelance design and 50% of illustration demands knowledge of Illustrator, InDesign or QuarkXPress and Photoshop. Works on assignment only.

First Contact & Terms Send query letter with résumé, tearsheets, photocopies. Accepts disk submissions or Web address. Samples are filed "if work is appropriate." Samples are returned by SASE if requested by artist. Portfolio should include printed samples, tearsheets and/or photocopies. Originals are returned at job's completion, with published product. Finds artists through word of mouth, submissions, attending art exhibitions and seeing published work.

Design Assigns several freelance design jobs/year. Pays by the project.

ACROPOLIS BOOKS, INC.

553 Constitution Ave, Camerillo CA 93012-8510. (805) 322-9010. Fax: (800)-843-6960 E-mail: acropolisbooks@mindspring.com. Website: www.acropolisbooks.com. **Vice President Operations:** Christine Lindsey. Imprints include Awakening. Publishes hardcover originals and reprints; trade paperback originals and reprints. Types of books include mysticism and spiritual. Specializes in books of higher consciousness. Recent titles: *The Journey Back to the Fathers Home* and *Showing Forth the Presence of God* by Joel S. Goldsmith. Publishes 4 titles/year. 30% require freelance design. Catalog available.

Needs Approached by 7 illustrators and 5 designers/year. Works with 2-3 illustrators and 2-3 designers/year. Knowledge of Photoshop and QuarkXPress useful in freelance illustration and design,

First Contact & Terms Designers: Send brochure and résumé. Illustrators: Send query letter with photocopies and résumé. Samples are filed. Responds in 2 months. Will contact artist for portfolio review if interested. Buys all rights.

Design Assigns 3-4 freelance design jobs/year. Pays by the project.

Jackets/Covers Assigns 3-4 freelance design jobs/year. Pays by the project.

Tips "We are looking for people who are familiar with our company and understand our focus."

ADAMS MEDIA

F+W Media, Inc., 57 Littlefield St., Avon, MA 02322. (508)427-7116. Fax: (508)427-

6790. E-mail: frank.rivera@fwmedia.com. Website: www.adamsmedia.com. **Art Director:** Frank Rivera. Estab. 1980. Publishes hardcover originals; trade paperback originals and reprints. Types of books include biography, business, gardening, pet care, cookbooks, history, humor, instructional, New Age, nonfiction, reference, self-help and travel. Specializes in business and careers. Recent titles: *1001 Books to Read for Every Mood*; *Green Christmas*; *The Bride's Survival Guide*. Publishes 260 titles/year. 20% require freelance illustration. Book catalog free by request.

- Imprints include Polka Dot Press, Platinum Press and Provenance Press. See also separate listing for F+W Publications, Inc., in this section

Needs Works with 8 illustrators and 7-10 designers/year. Buys less than 100 freelance illustrations/year. Uses freelancers mainly for jacket/cover illustration, text illustration and jacket/cover design. 100% of freelance work demands computer skills. Freelancers should be familiar with InDesign, Illustrator and Photoshop.

First Contact & Terms Send postcard sample of work. Samples are filed. Art director will contact artist for portfolio review if intereted. Portfolio should include earsheets. Rights purchased vary according to project, but usually buys all rights.

Jackets/Covers Assigns 50 freelance design jobs/year. Pays by the project, $500-1,100.

Text Illustration Assigns 30 freelance illustration jobs/year.

ALLYN & BACON PUBLISHERS

75 Arlington St., Suite 300, Boston MA 02116. (617)848-7328. E-mail: linda.knowles @ablongman.com. Website: www.ablongman.com. **Art Director:** Linda Knowles. Estab. 1868. Publishes more than 300 hardcover and paperback college textbooks/year. 60% require freelance cover designs. R Subject areas include education, psychology and sociology, political science, theater, music and public speaking. Recent titles: *Abnormal Psychology and Modern Life*, and *Public Relations: Strategies and Tactics*.

Needs Designers must be strong in book cover design and contemporary type treatment. 50% of freelance work demands knowledge of Illustrator, Photoshop and FreeHand.

Jackets/Covers Assigns 100 design jobs and 2-3 illustration jobs/year. Pays for design by the project, $500-1,000. Pays for illustration by the project, $500-1,000. Prefers sophisticated, abstract style in pen & ink, airbrush, charcoal/pencil, watercolor, acrylic, oil, collage and calligraphy.

Tips "Keep stylistically and technically up to date. Learn *not* to over-design. Read instructions and ask questions. Introductory letter must state experience and include at least photocopies of your work. If I like what I see, and you can stay on budget, you'll probably get an assignment. Being pushy closes the door. We primarily use designers based in the Boston area."

AMERICAN JUDICATURE SOCIETY

2700 University Ave., Des Moines IA 50311. (773)973-0145. Fax: (773)338-9687. E-mail: drichert@ ajs.org. Website: www.ajs.org. **Editor:** David Richert. Estab. 1913. Publishes journals and books. Specializes in courts, judges and administration of justice. Publishes 2 titles/year; 75% require freelance illustration. Catalog available on web site.

Needs Approached by 20 illustrators and 6 designers/year. Works with 3-4 illustrators and 1 designer/year. Prefers local designers. Uses freelancers mainly for illustration. 100% of freelance design demands knowledge of QuarkXPress, FreeHand, Photoshop and Illustrator.

First Contact & Terms Designers and illustrators: Submit samples electronically to drichert@ajs.org. Will contact artist for portfolio review of photocopies, roughs and tearsheets if interested. Buys one-time rights.

Design Assigns 1-2 freelance design jobs/year. Pays by the project, $500-1,000.

Text Illustration Assigns 10 freelance illustration jobs/year. Pays by the project, $75-375.

AMHERST MEDIA, INC.

175 Rano St., Suite 200, Buffalo NY 14207. (716)874-4450. Fax: (716)874-4508. Website: www.AmherstMedia.com. **Publisher:** Craig Alesse. Estab. 1974. Company publishes trade paperback originals. Types of books include instructional and reference. Specializes in photography, how-to. Publishes 30 titles/year. Recent titles include: *Portrait Photographer's Handbook*; *Creating World Class Photography*. 20% require freelance illustration; 80% require freelance design.

Needs Approached by 12 freelancers/year. Works with 3 freelance illustrators and 3 designers/year. Uses freelance artists mainly for illustration and cover design. Also for jacket/cover illustration and design and book design. 80% of freelance work demands knowledge of QuarkXPress or Photoshop. Works on assignment only.

First Contact & Terms Send brochure, résumé and photographs. Samples are filed. Responds only if interested. Art director will contact artist for portfolio review if interested. Rights purchased vary according to project. Originals are returned at job's completion. Finds artists through word of mouth.

Design Assigns 12 freelance design jobs/year. Pays for design by the hour $25 minimum; by the project $2,000.

Jackets/Covers Assigns 12 freelance design and 4 illustration jobs/year. Pays $200-1200. Prefers computer illustration (QuarkXPress/Photoshop).

Text Illustration Assigns 12 freelance illustration jobs/year. Pays by the project. Only accepts computer illustration (QuarkXPress).

ANDREWS MCMEEL PUBLISHING

LLCAndrews McMeel Universal, 4520 Main St., Kansas City MO 64111-7701. (816)932-6700. Fax: (816)932-6781. E-mail: tlynch@amuniversal.com. Website: www.andrewsmcmeel.com. **Art Director:** Tim Lynch. Estab. 1972. Publishes hardcover originals and reprints; trade paperback originals and reprints. Types of books include humor, gift, instructional, nonfiction, reference, cooking. Specializes in calendars and comic strip collection books. Recent titles include ModMex, Nobu West, The Blue Day Book and Complete Calvin and Hobbes. Publishes 200 titles/year; 10% require freelance illustration; 80% require freelance design.

Needs Prefers freelancers experienced in book jacket design. Freelance designers must have knowledge of Illustrator, Photoshop, QuarkXPress, or InDesign. Food photographers experienced in cook book photography.

First Contact & Terms Send sample sheets and Web address or contact through artists' rep. Samples are filed and not returned. Responds only if interested. Portfolio review not required. Rights purchased vary according to project.

Design Assigns 60 freelance design jobs and 20 illustration jobs/year. Pays for design $600-3,000.

Tips "We want designers who can read a manuscript and design a concept for the best possible cover. Communicate well and be flexible with design." Designer portfolio review once a year in New York City.

ANTARCTIC PRESS

7272 Wurzbach, Suite 204, San Antonio TX 78240. (210)614-0396. Fax: (210)614-5029. E-mail: rod_espinosa@antarctic-press.com or apcog@hotmail.com. Website: www.antarctic-press.com. **Contact:** Rod Espinosa, submissions editor. Estab. 1985. Publishes CD ROMs, mass market paperback originals and reprints, trade paperback originals and reprints. Types of books include adventure, comic books, fantasy, humor, juvenile fiction. Specializes in comic books. Publishes 18 titles/year. Recent titles include: *Ninja High School*; *Gold Digger*; *Twilight X*. 50% requires freelance illustration. Book catalog free with 9 × 12 SASE ($3 postage). Submission guidelines on website.

Needs Approached by 60-80 illustrators/year. Works with 12 illustrators/year. Prefers local illustrators. 100% of freelance illustration demands knowledge of Photoshop.

First Contact & Terms Do not send originals. Send copies only. Accepts e-mail submissions from illustrators. Prefers Mac-compatible, Windows-compatible, TIFF, JPEG files. Samples are filed or returned by SASE. Portfolios may be dropped off every Monday-Friday. Portfolio should include b&w, color finished art. All submissions must include finished comic book art, 10 pages minimum. Buys first rights. Rights purchased vary according to project. Finds freelancers through anthologies published, artist's submissions, Internet, word of mouth. Payment is made on royalty basis after publication.

Text Illustration Negotiated.

Tips "You must love comics and be proficient in doing sequential art."

ATHENEUM BOOKS FOR YOUNG READERS

Imprint of Simon & Schuster Children's Publishing Division. 1230 Avenue of the Americas, New York NY 10020. (212)698-7000. Fax: (212)698-2798. Website: www. simonsayskids.com. **Executive Art Director:** Ann Bobco. Publishes hardcover originals, picture books for young kids, nonfiction for ages 8-12 and novels for middle-grade and young adults. Types of books include biography, historical fiction, history, nonfiction. Recent titles: *Olivia Saves the Circus* by Ian Falconer; *Zeely* by Virginia Hamilton. Publishes 60 titles/year. 100% require freelance illustration. Book catalog free by request.

Needs Approached by hundreds of freelance artists/year. Works with 40-50 illustrators/year. "We are interested in artists of varying media and are trying to cultivate those with a fresh look appropriate to each title."

First Contact & Terms Send postcard sample of work or send query letter with tearsheets, résumé and photocopies. Samples are filed. Responds only if interested. Art Director will contact artist for portfolio review if interested. Portfolio should include final art if appropriate, tearsheets, and folded and gathered sheets from any picture books you've had published. Rights purchased vary according to project. Originals are returned at job's completion. Finds artists through submissions, magazines ("I look for interesting editorial illustrators"), word of mouth.

BAEN BOOKS

P.O. Box 1403, Riverdale NY 10471. (919)570-1640. Fax: (919)570-1644. E-mail: artdirector@baen.com. Website: www.baen.com. **Art Director:** Toni Weisskopf. Estab. 1983. Publishes science fiction and fantasy. Recent titles include 1634: The Baltic War and By Slanderous Tongues. Publishes 60-70 titles/year; 90% require freelance illustration/design. Book catalog free on request.

Needs Approached by 500 freelancers/year. Works with 10 illustrators and 3 designers/year. 50% of work demands computer skills.

First Contact & Terms Designers: Send query letter with résumé, color photocopies, color tearsheets and SASE. Illustrators: Send query letter with color photocopies, slides, color tearsheets and SASE. Samples are filed. Originals are returned to artist at job's completion. Buys exclusive North American book rights.

Jackets/Covers Assigns 64 design and 64 illustration jobs/year. Pays by the project. Pays designers $200 minimum; pays illustrators $1,000 minimum.

Tips Wants to see samples within science fiction/fantasy genre only. "Do not send black & white illustrations or surreal art. Please do not waste our time and your postage with postcards. Serious submissions only."

BECKER&MAYER!

11120 NE 33rd Place, Suite 101, Bellevue WA 98004-1444. (425)827-7120. Fax: (425)828-9659. E-mail: infobm@beckermayer.com. Website: www.beckermayer. com. **Contact:** Adult or juvenile design department. Estab. 1973. Publishes nonfiction biography, humor, history and coffee table books. Recent titles: *The Art of Wine Tasting*; *Stan Lee's Amazing Marvel Universe*; *World War II Aircraft*; *The Secret World of Fairies*; *Disney Trivia Challenge*. Publishes 100+ titles/year. 10% require freelance design; 75% require freelance illustration. Book catalog available on website.

- becker&mayer! is spelled in all lower case letters with an exclamation mark. Publisher requests that illustration for children's books be sent to Juvenile Submissions. All other illustration should be sent to Adult Submissions.

Needs Works with 6 designers and 20-30 illustrators/year. Freelance design work demands skills in FreeHand, InDesign, Illustrator, Photoshop, QuarkXPress. Freelance illustration demands skills in FreeHand, Illustrator, Photoshop.

First Contact & Terms Designers: Send query letter with résumé and tearsheets. Illustrators: Send query letter, nonreturnable postcard sample, résumé and tearsheets. After introductory mailing, send follow-up postcard every 6 months. Does not accept e-mail submissions. Samples are filed. Responds only if interested. Will request portfolio review of color finished art, roughs, thumbnails and tearsheets, only if interested. Rights purchased vary according to project.

Text Illustration Assigns 30 freelance illustration jobs a year. Pays by the project.

Tips "Our company is divided into adult and juvenile divisions; please send samples to the appropriate division. No phone calls!"

BLOOMSBURY CHILDREN'S BOOKS USA

175 Fifth Avenue, 8th Floor, New York NY 10011. (212)727-8300. Fax: (212)727-0984. E-mail: bloomsbury.kids@bloomsburyusa.com. Website: www.bloomsburyusa. com. **Senior Designer:** Lizzy Bromley. Estab. 2001. Publishes hardcover and trade paperback originals and reprints. Types of books include children's picture books, fantasy, humor, juvenile and young adult fiction. Recent titles: *Ruby Sings the Blues*; *The Last Burp of Mac McGerp*. Publishes 50 titles/year. 50% require freelance design; 100% require freelance illustration. Book catalog not available.

Needs Works with 5 designers and 20 illustrators/year. Prefers local designers. 100% of freelance design work demands knowledge of Illustrator, QuarkXPress and Photoshop.

First Contact & Terms Designers: Send postcard sample or query letter with brochure, résumé, tearsheets. Illustrators: Send postcard sample or query letter with brochure, photocopies and SASE. After introductory mailing, send follow-up postcard sample every 6 months. Samples are filed or returned by SASE. Responds only if interested. Will contact artist for potfolio review if interested. Buys all rights. Finds freelancers through word of mouth.

Jackets/Covers Assigns 5 freelance cover illustration jobs/year.

BLUE DOLPHIN PUBLISHING, INC.

P.O. Box 8, Nevada City CA 95959. (530)477-1503. Fax: (530)477-8342. E-mail: bdolphin@bluedolphinpublishing.com. Website: www.bluedolphinpublishing.com. **President:** Paul M. Clemens. Estab. 1985. Publishes hardcover and trade paperback originals. Types of books include biography, cookbooks, humor and self-help. Specializes in comparative spiritual traditions, lay psychology and health. Recent titles: *Vegan Inspiration*; *Consciousness Is All*; *Embracing the Miraculous*; *Mary's Message to the World*; *The Fifth Tarot*; and *The Fifth Gospel*. Publishes 20 titles/year; 25% require freelance illustration; 30% require freelance design. Books are "high quality on good paper, with laminated dust jacket and color covers." Book catalog free upon request.

Needs Works with 5-6 freelance illustrators and designers/year. Uses freelancers mainly for book cover design; also for jacket/cover and text illustration. "More hardcovers and mixed media are requiring box design as well." 50% of freelance work demands knowledge of PageMaker, QuarkXPress, FreeHand, Illustrator, Photoshop, CorelDraw, InDesign and other IBM-compatible programs. Works on assignment only.

First Contact & Terms Send postcard sample or query letter with brochure and photocopies. Samples are filed or are returned by SASE if requested. Responds "whenever work needed matches portfolio." Originals are returned to artist at job's completion. Sometimes requests work on spec before assigning job. Considers project's budget when establishing payment. Negotiates rights purchased. Considers buying second rights (reprint rights) to previously published work.

Design Assigns 3-5 jobs/year. Pays by the hour, $10-15; or by the project, $300-900.

Jackets/Covers Assigns 5-6 design and 5-6 illustration jobs/year. Pays by the hour, $10-15; or by the project, $300-900.

Text Illustration Assigns 1-2 jobs/year. Pays by the hour, $10-15; or by the project, $300-900.

Tips "Send query letter with brief sample of style of work. We usually use local people, but are always looking for something special. Learning good design is more important than designing on the computer, but we are very computer-oriented. Basically we look for original artwork of any kind that will fit the covers for the subjects we publish. Please see our online catalog of over 250 titles to see what we have selected so far."

BOYDS MILLS PRESS

815 Church St., Honesdale PA 18431. (570)253-1164. Fax: (570)253-0179. Website: www.boydsmillspress.com. **Art Director:** Tim Gillner. Estab. 1990. Trade division of Highlights for Children, Inc. Publishes hardcover originals and reprints. Types of books include fiction, nonfiction, picture books and poetry. Recent titles: *A Splendid Friend, Indeed,* by Suzanne Bloom; *Wings of Light: The Migration of the Yellow Butterfly,* by

Stephen R. Swinburne (illustrated by Bruce Hiscock); *All Aboard! Passenger Trains Around the World,* by Karl Zimmermann (photographs by the author). Publishes 50 titles/year. 25% require freelance illustration/design.

Needs Works with 25-30 freelance illustrators and 5 designers/year. Prefers illustrators with book experience, but also uses illustrators of all calibers of experience. Uses freelancers mainly for picture books, poetry books, and jacket art. Works on assignment only.

First Contact & Terms Send sample tearsheets, color photocopies, postcards, or electronic submissions. If electronic samples are submitted, low-res JPEGs or links to websites are best. Samples are not returned. Samples should include color and b&w. Rights purchased vary according to project. Originals are returned at job's completion. Finds artists through submissions, sourcebooks, agents, Internet, and other publications.

Design Assigns 2-3 design/illustration jobs/year. Pays by the project.

Jackets/Covers Assigns 2-3 design/illustration jobs/year. Pays by the project.

Text Illustration Pays by the project.

Tips "Please don't send samples that need to be returned."

CANDLEWICK PRESS

99 Dover St., Somerville MA 02144. (617)661-3330. Fax: (617)661-0565. Website: www.candlewick .com. **Art Aquisitions:** Art Resources Coordinator. Estab. 1992. Publishes hardcover, trade paperback children's books. Publishes 200 titles/year. 100% require freelance illustration. Book catalog not available.

Needs Works with 170 illustrators and 1-2 designers/year. 100% of freelance design demands knowledge of Photoshop, Illustrator or QuarkXPress.

First Contact & Terms Send non-returnable, color samples (no original artwork) a brief cover letter and a resume detailing relevant professional and publishing experience.

Text Illustration Finds illustrators through agents, sourcebooks, word of mouth, submissions, art schools.

Tips "We generally use illustrators with prior trade book experience."

CENTERSTREAM PUBLISHING

P.O. Box 17878, Anaheim Hills CA 92817-7878. (714)779-9390. Fax: (714)779-9390. E-mail: centerstrm@aol.com. Website: www.centerstream-usa.com. **Production:** Ron Middlebrook. Estab. 1978. Publishes DVDs, audio tapes, and hardcover and softcover originals. Types of books include music reference, biography, music history and music instruction. Recent titles: *Melodic Lines for the Intermediate Guitarist* (book/CD pack); *The Banjo Music of Tony Ellis*; *The Early Minstrel Banjo*; and More Dobro (DVD). Publishes 10-20 titles/year; 100% require freelance illustration. Book catalog free for 6 × 9 SAE with 2 first-class stamps.

Needs Approached by 12 illustrators/year. Works with 3 illustrators/year.

First Contact & Terms Illustrators: Send postcard sample or tearsheets. Accepts Mac-compatible disk submissions. Samples are not filed and are returned by SASE. Responds only if interested. Buys all rights, or rights purchased vary according to project.

CHILDREN'S BOOK PRESS

965 Mission St., Suite 425, San Francisco CA 94103-2961. (866)935-2665. Fax: (415)543-2665. E-mail: submissions@childrensbookpress.org. Website: www. childrensbookpress.org. **Contact:** Submissions. Estab. 1975. Nonprofit publishing house that "promotes cooperation and understanding through multicultural and bilingual literature, offering children a sense of their culture, history and importance." Publishes hardcover originals and trade paperback reprints. Types of books include juvenile picture books only. Specializes in multicultural. Publishes 4 titles/year. 100% require freelance illustration and design.

Needs Approached by 1,000 illustrators and 20 designers/year. Works with 2 illustrators and 2 designers/year. Prefers local designers experienced in QuarkXPress (designers) and previous children's picture book experience (illustrators). Uses freelancers for 32-page picture book design. 100% of freelance design demands knowledge of Photoshop, Illustrator and QuarkXPress.

First Contact & Terms Send query letter with color photocopies, résumé, bio and SASE. Responds in 8-10 weeks, only if interested or if SASE is included. Will contact artist for portfolio review if interested. Buys all rights.

Design Assigns 2 freelance design jobs/year. Pays by the project.

Text Illustration Assigns 2 freelance illustration jobs/year. Pays royalty.

Tips "We look for a multicultural experience. We are especially interested in the use of bright colors and non-traditional instructive approach."

CHOWDER BAY BOOKS

P.O. Box 5542, Lake Worth FL 33466-5534. E-mail: info@chowderbaybooks.com. Website: www.chowderbaybooks.com. **Acquisitions Editor:** Anna Valencia. Estab. 2007. Publishes hardcover originals, trade paperback originals and reprints. Types of books include mainstream fiction, experimental fiction, fantasy, humor, juvenile, young adult, preschool, instructional, biography. Publishes 8-10 titles/year. 100% require freelance design and illustration. Book catalog available on website.

Needs Approached by 200 designers and 480 illustrators/year. Works with 2 designers and 4 illustrators/year. 80% of freelance design work demands skills in Photoshop and QuarkXPress. 80% of freelance illustration work demands skills in FreeHand and Photoshop.

First Contact & Terms Send postcard sample with URL. Accepts e-mail submissions

with link to website. Prefers Windows-compatible JPEG, TIFF or GIF files. Samples are filed and are not returned. Responds only if interested. Rights purchased vary according to project. Finds freelancers through submissions, word of mouth, magazines, Internet.

Jackets/Covers Assigns 8 illustration jobs/year. Pays by the project; varies.

Text Illustration Assigns 4 illustration jobs/year. Pays by the project; varies.

Tips "We're always willing to look at online portfolios. The best way to direct us there is via a simple postcard with URL. We are a young company with serious goals and a focus on creativity. While we are unable to respond directly to all inquiries or submissions, we do review everything that hits our inboxes (both e-mail and snail mail). Look for us at industry exhibits and conferences. We often seek new talent at industry events."

CHURCH PUBLISHING, INC.

4775 Linglestown Rd., Harrisburg PA 17112. E-mail: dperkins@cpg.org. Website: www.church publishing.org. Estab. 1884. Company publishes trade paperback and hardcover originals and reprints. Books are religious. Specializes in spirituality, Christianity/contemporary issues. Publishes 30 titles/year. Recent titles: *A Wing and a Prayer*, by Katharine Jefferts Schori; *God of the Sparrow*, by Jaroslau Vajda, illustrated by Preston McDaniels. Book catalog free by request.

Needs Works with 1-2 illustrators/year. Prefers freelancers with experience in religious (particularly Christian) topics. Also uses original art all media. Works on assignment only.

First Contact & Terms Send query letter with résumé and photocopies. Samples are filed. Portfolio review not required. Usually buys one-time rights. Finds artists through freelance submissions, *Literary Market Place* and mostly word of mouth.

Text Illustration Assigns 1-2 freelance illustration jobs/year.

Tips "Prefer using freelancers who are located in central Pennsylvania and are available for meetings when necessary."

THE COUNTRYMAN PRESS

(Division of W.W. Norton & Co., Inc.), Box 748, Woodstock VT 05091. (802)457-4826. Fax: (802)457-1678. E-mail: countrymanpress@wwnorton.com. Website: www.countrymanpress.com. **Contact:** Managing Editor. Estab. 1976. Book publisher. Publishes hardcover originals and reprints, and trade paperback originals and reprints. Types of books include history, cooking, travel, nature and recreational guides. Specializes in recreational (biking/hiking) guides. Publishes 60 titles/year. Titles include: *The King Arthur Flour Baker's Companion*; and *Maine: An Explorer's Guide*. 10% require freelance illustration; 60% require freelance cover design. Book catalog free by request.

Needs Works with 7 designers/year. Uses freelancers for jacket/cover and book design. Works on assignment only. Prefers working with computer-literate artists/designers with knowledge of Photoshop, Illustrator, QuarkXPress and InDesign.

First Contact & Terms Send query letter with appropriate samples. Samples are filed. Responds to the artist only if interested. To show portfolio, e-mail PDF. Negotiates rights purchased.

Design Assigns 10 freelance design jobs/year. Pays for design by the project, $1,000-1,500.

Jackets/Covers Assigns 10 freelance design jobs/year. Pays for design $1,000-1,500.

CRC PROSERVICES

2850 Kalamazoo Ave. SE, Grand Rapids MI 49560. (616)224-0780. Fax: (616)224-0834. Website: www.crcna.org. **Art Director:** Dean Heetderks. Estab. 1866. Publishes hardcover and trade paperback originals and magazines. Types of books include instructional, religious, young adult, reference, juvenile and preschool. Specializes in religious educational materials. Publishes 8-12 titles/year. 85% require freelance illustration. 5% require freelance art direction.

Needs Approached by 30-45 freelancers/year. Works with 12-16 freelance illustrators/year. Prefers freelancers with religious education, cross-cultural sensitivities. Uses freelancers for jacket/cover and text illustration. Works on assignment only.

First Contact & Terms Send query letter with brochure, résumé, tearsheets, photographs, photocopies, slides and transparencies. Submissions will not be returned. Illustration guidelines are available on website. Samples are filed. Portfolio should include thumbnails, roughs, finished samples, color slides, tearsheets, transparencies and photographs. Buys one-time rights. Originals are returned at job's completion.

Jackets/Covers Assigns 2-3 freelance illustration jobs/year. Pays by the project, $200-1,000.

Text Illustration Assigns 50-100 freelance illustration jobs/year. Pays by the project, $75-100. "This is high-volume work. We publish many pieces by the same artist."

Tips "Be absolutely professional. Know how people learn and be able to communicate a concept clearly in your art."

DARK HORSE

10956 SE Main St., Milwaukie OR 97222. (503)652-8815. Fax: (503)654-9440. E-mail: dhcomics@ darkhorse.com. Website: www.darkhorse.com. **Contact:** Submissions. Estab. 1986. Publishes mass market and trade paperback originals. Types of books include comic books and graphic novels. Specializes in comic books. Recent titles include: Star Wars: Invasion #1; Blood + : Adagio Volume 1; Buffy the Vampire Slayer Season 8; The Umbrella Academy: Dallas; Hellboy: The Wild Hunt, and more. Book catalog available on website.

First Contact & Terms Send photocopies (clean, sharp, with name, address and phone number written clearly on each page). Samples are not filed and not returned. Responds only if interested. Company will contact artist for portfolio review interested.

Tips "If you're looking for constructive criticism, show your work to industry professionals at conventions."

JONATHAN DAVID PUBLISHERS, INC.

68-22 Eliot Ave., Middle Village NY 11379. (718)456-8611. Fax: (718)894-2818. E-mail: submissions @jdbooks.com. Website: www.jdbooks.com. **Contact:** Editorial Review. Estab. 1948. Publishes hardcover and paperback originals. Types of books include biography, religious, young adult, reference, juvenile and cookbooks. Specializes in Judaica. Titles include: *Drawing a Crowd*; and *The Presidents of the United States & the Jews*. Publishes 25 titles/year. 50% require freelance illustration; 75% require freelance design.

Needs Approached by numerous freelancers/year. Works with 5 freelance illustrators and 5 designers/year. Prefers freelancers with experience in book jacket design and jacket/cover illustration. 100% of design and 5% of illustration demand computer literacy. Works on assignment only.

First Contact & Terms Designers: Send query letter with résumé and photocopies. Illustrators: Send postcard sample and/or query letter with photocopies, résumé. Samples are filed. Production coordinator will contact artist for portfolio review if interested. Portfolio should include color final art and photographs. Buys all rights. Originals are not returned. Finds artists through submissions.

Design Assigns 15-20 freelance design jobs/year. Pays by the project.

Jackets/Covers Assigns 15-20 freelance design and 4-5 illustration jobs/year. Pays by the project.

Tips First-time assignments are usually book jackets, mechanicals and artwork.

DC COMICS

Time Warner Entertainment, 1700 Broadway, 5th Floor, New York NY 10019. (212)636-5400. Fax: (212)636-5481. Website: www.dccomics.com. **Vice President of Design and Retail Produce Development:** Georg Brewer. Estab. 1948. Publishes hardcover originals and reprints, mass market paperback originals and reprints, trade paperback originals and reprints. Types of books include adventure, comic books, fantasy, horror, humor, juvenile, science fiction. Specializes in comic books. Publishes 1,000 titles/year.

• DC Comics does not accept unsolicited submissions.

DIAL BOOKS FOR YOUNG READERS

Penguin Group USA, 375 Hudson St., New York NY 10014. (212)414-3412. Fax: (212)414-3398. Website: http://us.penguingroup.com. **Art Director:** Lily Malcom. Specializes in juvenile and young adult hardcover originals. Recent titles: *Snowmen at Night*, by Caralyn and Mark Buchner; *The Surprise Visitor*, by Juli Kangas. Publishes 50 titles/year. 100% require freelance illustration. Books are "distinguished children's books."

Needs Approached by 400 freelancers/year. Works with 40 freelance illustrators/year. Prefers freelancers with some book experience. Works on assignment only.

First Contact & Terms Send query letter with photocopies, tearsheets and SASE. Samples are filed or returned by SASE. Responds only if interested. Considers complexity of project, skill and experience of artist and project's budget when establishing payment. Rights purchased vary.

Jackets/Covers Assigns 8 illustration jobs/year. Pays by the project.

Text Illustration Assigns 40 freelance illustration jobs/year. Pays by the project.

Tips "Never send original art. Never send art by e-mail, fax or CD. Please do not phone, fax or e-mail to inquire after your art submission."

EDUCATIONAL IMPRESSIONS, INC.

116 Washington Ave., Hawthorne NJ 07507. (973)423-4666. Fax: (973)423-5569. E-mail: awpeller @optionline.net. Website: www.awpeller.com. **Art Director:** Karen Birchak. Estab. 1983. Publishes original workbooks with 2-4 color covers and b&w text. Types of books include instructional, juvenile, young adult, reference, history and educational. Specializes in all educational topics. Publishes 4-12 titles/year. Recent titles include: *September, October and November*, by Rebecca Stark; *Tuck Everlasting* and *Walk Two Moons* Lit Guides. Books are bright and bold with eye-catching, juvenile designs/illustrations.

Needs Works with 1-5 freelance illustrators/year. Prefers freelancers who specialize in children's book illustration. Uses freelancers for jacket/cover and text illustration. Also for jacket/cover design. 50% of illustration demands knowledge of QuarkXPress and Photoshop. Works on assignment only.

First Contact & Terms Send query letter with tearsheets, SASE, résumé and photocopies. Samples are filed. Art director will contact artist for portfolio review if interested. Buys all rights. Interested in buying second rights (reprint rights) to previously published work. Originals are not returned. Prefers line art for the juvenile market. Sometimes requests work on spec before assigning a job.

Design Pays by the project, $20 minimum.

Jackets/Covers Pays by the project, $20 minimum.

Text Illustration Pays by the project, $20 minimum.

Tips "Send juvenile-oriented illustrations as samples."

F+W MEDIA

4700 E. Galbraith Rd., Cincinnati OH 45236. Website: www.fwmedia.com. **Art Directors:** Grace Ring, Marissa Bowers, Wendy Dunning, Michelle Thompson, Claudean Wheeler. Publishes 120 books/year for writers, artists, graphic designers and photographers, plus selected trade (humor, lifestyle, home improvement) titles. Books are heavy on type-sensitive design.

- Imprints include Writer's Digest Books, HOW Books, Betterway Books, North Light Books, IMPACT Books, Popular Woodworking Books, Memory Makers Books, Adams Media, David & Charles, Krause Publications. See separate listings for Adams, IMPACT and North Light in this section for recent titles and specific guidelines. See also F+W's listing in the Magazines section.

Needs Works with 10-20 freelance illustrators and less than 5 designers/year. Uses freelancers for jacket/cover design and illustration, text illustration, direct mail and book design. Works on assignment only.

First Contact & Terms Send nonreturnable photocopies of printed work to be kept on file. Art director will contact artist for portfolio review if interested. Considers buying second rights (reprint rights) to previously published illustrations. "We like to know where art was previously published." Finds illustrators and designers through word of mouth and submissions/self promotions.

Design Pays by the project, $600-1,000.

Jackets/Covers Pays by the project, $750.

Text Illustration Pays by the project, $100 minimum.

Tips "Don't call. Send appropriate samples we can keep. Clearly indicate what type of work you are looking for."

FANTAGRAPHICS BOOKS, INC.

7563 Lake City Way NE, Seattle WA 98115. (206)524-1967. Fax: (206)524-2104. E-mail: fbicomix @fantagraphics.com. Website: www.fantagraphics.com. **Contact:** Submissions Editor. Estab. 1976. Publishes hardcover and trade paperback originals and reprints. Types of books include contemporary, experimental, mainstream, historical, humor and erotic. "All our books are comic books or graphic stories." Recent titles: *Love & Rockets*; *Hate*; *Eightball*; *Acme Novelty Library*; *The Three Paradoxes*. Publishes 100 titles/year. 10% require freelance illustration. Book catalog free by request. Art submission guidelines available on website.

- See additional listing in the Magazines section.

Needs Approached by 500 freelancers/year. Works with 25 freelance illustrators/year. Must be interested in and willing to do comics. Uses freelancers for comic book interiors and covers.

First Contact & Terms Send query letter addressed to Submissions Editor with résumé, SASE, photocopies and finished comics work. Samples are not filed and are returned by SASE. Responds only if interested. Call or write for appointment to show

portfolio of original/final art and b&w samples. Buys one-time rights or negotiates rights purchased. Originals are returned at job's completion. Pays royalties.

Tips "We want to see completed comics stories. We don't make assignments, but instead look for interesting material to publish that is pre-existing. We want cartoonists who have an individual style, who create stories that are personal expressions."

FULCRUM PUBLISHING

4690 Table Mountain Drive, Suite 100, Golden CO 80403. (303)277-1623. Fax: (303)279-7111. Website: www.fulcrum-books.com. **Contact:** Art Director. Estab. 1984. Book publisher. Publishes hardcover originals and trade paperback originals and reprints. Types of books include biography, Native American, reference, history, self help, children's, teacher resource books, travel, humor, gardening and nature. Specializes in history, nature, teacher resource books, travel, Native American, environmental and gardening. Publishes 50 titles/year. Recent titles: *Broken Trail*, by Alan Geaffrion; *Anton Wood: The Boy Murderer*, by Dick Kreck. 15% requires freelance illustration; 15% requires freelance design. Book catalog free by request.

Needs Uses freelancers mainly for cover and interior illustrations for gardening books. Also for other jacket/covers, text illustration and book design. Works on assignment only.

First Contact & Terms Send query letter with tearsheets, photographs, photocopies and photostats. Samples are filed. Responds to artist only if interested. To show portfolio, mail b&w photostats. Buys one-time rights. Originals are returned at job's completion.

Design Pays by the project.

Jackets/Covers Pays by the project.

Text Illustration Pays by the project.

Tips Previous book design experience a plus.

GALISON BOOKS/MUDPUPPY PRESS

28 W. 44th St., New York NY 10036. (800)670-7441. Fax: (212)391-4037. E-mail: carole@galison.com. Website: www.galison.com. **Art Director:** Carole Otypka. Publishes note cards, journals, stationery, children's products. Publishes 120 titles/year.

Needs Works with 20 illustrators. Assigns 5-10 freelance cover illustrations/year. Some freelance design demands knowledge of Photoshop, Illustrator and QuarkXPress.

First Contact & Terms Send photocopies, printed samples, tearsheets or e-mail with link to website. Samples are filed or returned by SASE. Will contact artist for portfolio review if interested. Rights purchased vary according to project.

GEM GUIDES BOOK CO.

315 Cloverleaf Dr., Suite F, Baldwin Park CA 91706. (626)855-1611. Fax: (626)855-1610. E-mail: gembooks@aol.com. Website: www.gemguidesbooks.com. **Editors:** Kathy Mayerski and Nancy Fox. Estab. 1964. Book publisher and wholesaler of trade paperback originals and reprints. Types of books include rocks and minerals, guide books, travel, history and regional (western U.S.). Specializes in travel and local interest (western Americana). Recent titles: *Geodes: Nature's Treasures*, by Brad L. Cross and June Culp Zeither; *Baby's Day Out in Southern California: Fun Places to Go with Babies and Toddlers*, by Jobea Holt; *Fee Mining and Rockhounding Adventures in the West*, by James Martin and Jeannette Hathaway Monaco; and *Moving to Arizona*, by Dorothy Tegeler. Publishes 7 titles/year; 100% require freelance cover design.

Needs Approached by 12 freelancers/year. Works with 1 designer/year. Uses freelancers mainly for covers. 100% of freelance work demands knowledge of Quark, Illustrator, Photoshop. Works on assignment only.

First Contact & Terms Send query letter with brochure, résumé and SASE; or e-mail. Samples are filed. Editor will contact artist for portfolio review if interested. Requests work on spec before assigning a job. Buys all rights. Originals are not returned. Finds artists through word of mouth and "our files."

Jackets/Covers Pays by the project.

GIBBS SMITH, PUBLISHER

P.O. Box 667, Layton UT 84041. (801)544-9800. Fax: (801)546-8853. E-mail: duribe@gibbs-smith.com. Website: www.gibbs-smith.com. Estab. 1969. Imprints include Sierra Book Club for Children and Hill Street Press. Company publishes hardcover and trade paperback originals. Types of books include children's activity books, architecture and design books, cookbooks, humor, juvenile, western. Publishes 100 titles/year. Recent titles: *Pink Princess Tea Parties*; and *The Pocket Guide to Mischief*. 10% requires freelance illustration; 90% requires freelance design.

Needs Approached by 250 freelance illustrators and 50 freelance designers/year. Works with 5 freelance illustrators and 15 designers/year. Designers may be located anywhere with Broadband service. Uses freelancers mainly for cover design and book layout, cartoon illustration, children's book illustration. 100% of freelance design demands knowledge of QuarkXPress or Indesign. 70% of freelance illustration demands knowledge of Photoshop, Illustrator and FreeHand.

Design Assigns 90 freelance design jobs/year. Pays by the project, $12-15/page.

Jackets/Covers Assigns 90 freelance design jobs and 5 illustration jobs/year. Pays for design by the project, $500-800. Pays for illustration by the project.

Text Illustration Assigns 1 freelance illustration job/year. Pays by the project.

THE GRADUATE GROUP

P.O. Box 370351, West Hartford CT 06137-0351. (860)233-2330. E-mail: graduategroup@ hotmail.com. Website: www.graduategroup.com. **President:** Mara Whitman. Estab. 1967. Publishes trade paperback originals. Types of books include instructional and reference. Specializes in internships and career planning. Recent titles: *Create Your Ultimate Résumé, Portfolio, and Writing Samples: An Employment Guide for the Technical Communicator*, by Mara W. Cohen Ioannides. Publishes 35 titles/year; 10% require freelance illustration and design. Book catalog free by request.

Needs Approached by 20 freelancers/year. Works with 1 freelance illustrator and 1 designer/year. Prefers local freelancers only. Uses freelancers for jacket/cover illustration and design; direct mail, book and catalog design. 5% of freelance work demands computer skills. Works on assignment only.

First Contact & Terms Send query letter with brochure and résumé. Samples are not filed. Responds only if interested. Write for appointment to show portfolio.

⚇ GUERNICA EDITIONS

P.O. Box 117, Station P, Toronto ON M5S 2S6 Canada. (416)658-9888. Fax: (416)657-8885. E-mail: guernicaeditions@cs.com. Website: www.guernicaeditions.com. **Publisher/Editor:** Antonio D'Alfonso. Estab. 1978. Book publisher and literary press specializing in translation. Publishes trade paperback originals and reprints. Types of books include contemporary and experimental fiction, biography and history. Specializes in ethnic/multicultural writing and translation of European and Quebecois writers into English. Recent titles: *Peace Tower*, by F.G. Paci (artist Hono Lulu); and *Medusa Subway*, by Clara Blackwood (artist Normand Cousineau). Publishes 20-25 titles/year; 40-50% require freelance illustration. Book catalog available for SAE; include IRC if sending from outside Canada.

Needs Approached by 6 freelancers/year. Works with 6 freelance illustrators/year. Uses freelancers mainly for jacket/cover illustration.

First Contact & Terms Send query letter with résumé, SASE (or SAE with IRC), tearsheets, photographs and photocopies. Samples are filed or are returned by SASE if requested by artist. Responds only if interested. To show portfolio, mail photostats, tearsheets and dummies. Buys one-time rights. Originals are not returned at job completion. Does not accept or respond to e-mail enquiries about manuscripts.

Jackets/Covers Assigns 10 freelance illustration jobs/year. Pays by the project, $150-200.

Tips "We really believe that the author should be aware of the press they work with. Try to see what a press does and offer your own view of that look. We are looking for strong designers. We have three new series of books, so there is a lot of place for art work."

HAY HOUSE, INC.

P.O. Box 5100, Carlsbad CA 92018-5100. (760)431-7695 or (800)431-7695. Fax: (760)431-6948. E-mail: csalinas@hayhouse.com. Website: www.hayhouse.com. **Art Director:** Christy Salinas. Publishes hardcover originals and reprints, trade paperback originals and reprints, CDs, DVDs and VHS tapes. Types of books include self-help, mind-body-spirit, psychology, finance, health and fitness, nutrition, astrology. Recent titles: *Inspiration, Your Ultimate Calling*, by Wayne Dyer; *If You Could See What I See*, by Sylvia Browne; *Left to Tell*, by Immaculee Illibagiza. Publishes 175 titles/year; 40% require freelance illustration; 30% require freelance design.

- Hay House is also looking for people who design for the gift market.

Needs Approached by 50 illustrators and 5 designers/year. Works with 20 illustrators and 2-5 designers/year. Uses freelancers mainly for cover design and illustration. 80% of freelance design demands knowledge of Photoshop, Illustrator, QuarkXPress. 20% of titles require freelance art direction.

First Contact & Terms Send e-mail to csalinas@hayhouse.com or send non-returnable samples to the address above. Art director will contact if interested. Buys all rights. Finds freelancers through word of mouth and submissions.

Tips "We look for freelancers with experience in graphic design, desktop publishing, printing processes, production and illustrators with strong ability to conceptualize."

HEAVY METAL

100 N. Village Rd., Suite 12, Rookvill Center NY 11570. Website: www.metaltv.com. **Contact:** Submissions. Estab. 1977. Publishes trade paperback originals. Types of books include comic books, fantasy and erotic fiction. Specializes in fantasy. Recent titles: *The Universe of Cromwell*; *Serpieri Clone*. Art guidelines available on website.

- See additional listing in the Magazines section.

First Contact & Terms Send contact information (mailing address, phone, fax, e-mail), photocopies, photographs, SASE, slides. Samples are returned only by SASE. Responds in 3 months.

Tips "Please look over the kinds of work we publish carefully so you get a feel for what we are looking for."

HIPPOCRENE BOOKS INC.

171 Madison Ave., New York NY 10016. (718)454-2366. Fax: (718)228-6355. E-mail: info@hippocrenebooks.com. Website: www.hippocrenebooks.com. **Editor:** Priti Gress. Estab. 1971. Publishes hardcover originals and trade paperback reprints. Types of books include cookbooks, history, nonfiction, reference, travel, dictionaries, foreign language, bilingual. Specializes in dictionaries, cookbooks. Publishes 60 titles/year. Recent titles: *Hippocrene Children's Illustrated Foreign Language Dictionaries*; *St. Patrick's Secrets*; *American Proverbs*.

Needs Approached by 150 illustrators and 50 designers/year. Works with 2 illustrators and 3 designers/year. Prefers local freelancers experienced in line drawings.

First Contact & Terms Designers: Send query e-mail with small attachment or website link.

Jackets/Covers Assigns 4 freelance design and 2 freelance illustration jobs/year. Pays by the project.

Text Illustration Assigns 4 freelance illustration jobs/year. Pays by the project.

Tips "We prefer traditional illustrations appropriate for gift books and cookbooks."

HOLIDAY HOUSE

425 Madison Ave., New York NY 10017. (212)688-0085. Fax: (212)421-6134. Website: www.holidayhouse.com. **Director of Art and Design:** Claire Counihan. Editor-in-Chief: Mary Cash. Specializes in hardcover children's books. Recent titles: *Washington at Valley Forge,* by Russell Freedman; *Tornadoes*, by Gail Gibbons; and *The Carbon Diaries*, by Saci Lloyd. Publishes 70 titles/year. 75% require illustration. Art submission guidelines available on website.

Needs Accepts art suitable for children and young adults only. Works on assignment only.

First Contact & Terms Send cover letter with photocopies and SASE. Samples are filed or are returned by SASE. Request portfolio review in original query. Responds only if interested. Originals are returned at job's completion. Finds artists through submissions and agents.

Jackets/Covers Assigns 5-10 freelance illustration jobs/year. Pays by the project, $900-1,200.

Text Illustration Assigns 35 freelance jobs/year (picture books). Pays royalty.

HOMESTEAD PUBLISHING

P.O. Box 193, Moose WY 83012. Phone/fax: (307)733-6248. Website: www.homesteadpublishing.net. **Contact:** Art Director. Estab. 1980. Publishes hardcover and paperback originals. Types of books include art, biography, history, guides, photography, nonfiction, natural history, and general books of interest. Recent titles: *Cubby in Wonderland*; *Windswept*; *Banff-Jasper Explorer's Guide*. Publishes more than 6 print, 100 online titles/year. 75% require freelance illustration. Book catalog free for SAE with 4 first-class stamps.

Needs Works with 20 freelance illustrators and 10 designers/year. Prefers pen & ink, airbrush, pencil and watercolor. 25% of freelance work demands knowledge of PageMaker or FreeHand. Works on assignment only.

First Contact & Terms Send query letter with printed samples to be kept on file or write for appointment to show portfolio. For color work, slides are suitable; for b&w, technical pen, photostats. Samples not filed are returned by SASE only if requested. Responds in 10 days. Rights purchased vary according to project. Originals are not returned.

Design Assigns 6 freelance design jobs/year. Pays by the project, $50-3,500.

Jackets/Covers Assigns 2 freelance design and 4 illustration jobs/year. Pays by the project, $50-3,500.

Text Illustration Assigns 50 freelance illustration jobs/year. Prefers technical pen illustration, maps (using airbrush, overlays, etc.), watercolor illustrations for children's books, calligraphy and lettering for titles and headings. Pays by the hour, $5-20; or by the project, $50-3,500.

Tips "We are using more graphic, contemporary designs and looking for exceptional quality."

IDEALS PUBLICATIONS INC.

A division of Guideposts, 2636 Elm Hill Pike, Suite 120, Nashville TN 37214. (615)333-0478. Website: www.idealsbooks.com. **Publisher:** Patricia Pingry. Art Director: Eve DeGrie. Estab. 1944. Imprints include: Candy Cane Press, Williamson Books. Company publishes hardcover originals and Ideals magazine. Specializes in nostalgia and holiday themes. Publishes 100 book titles and 6 magazine issues/year. Recent titles include: *Blessings of a Husband's Love*; *Dear Santa*. 50% require freelance illustration. Guidelines free for #10 SASE with 1 first-class stamp or on website.

Needs Approached by 100 freelancers/year. Works with 10-12 freelance illustrators/year. Prefers freelancers with experience in illustrating people, nostalgia, botanical flowers. Uses freelancers mainly for flower borders (color), people and spot art. Also for text illustration, jacket/cover and book design. Works on assignment only.

First Contact & Terms Send tearsheets which are filed. Responds only if interested. Buys all rights. Finds artists through submissions.

Text Illustration Assigns 75 freelance illustration jobs/year. Pays by the project. Prefers watercolor or gouache.

Tips "Looking for illustrations with unique perspectives, perhaps some humor, that not only tells the story but draws the reader into the artist's world. We accept all styles."

IMAGE COMICS

2134 Allston Way, 2nd Floor, Berkeley CA 94704. E-mail: submissions@imagecomics.com. Website: www.imagecomics.com. **Contact:** Eric Stephenson, publisher. Estab. 1992. Publishes comic books, graphic novels. Recent titles include: *Athena Inc.*; *Noble Causes Family Secrets #2*; *Powers #25*. See this company's website for detailed guidelines.

Needs "We are looking for good, well-told stories and exceptional artwork that run the gamut in terms of both style and genre."

First Contact & Terms Send proposals only. See website for guidelines. No e-mail submissions. All comics are creator-owned. Image only wants proposals for comics, not "art submissions." Proposals/samples not returned. Do not include SASE. Responds as soon as possible.

Tips "Please do not try to 'impress' us with all the deals you've lined up or testimonials from your Aunt Matilda. We are only interested in the comic."

IMPACT BOOKS

F+W Media, Inc., 4700 E. Galbraith Rd., Cincinnati OH 45236. (513)531-2690. Fax: (513)531-2686. E-mail: pam.wissman@fwmedia.com. Website: www.impact-books.com. **Editorial Director:** Pam Wissman. Publishes trade paperback originals. Specializes in illustrated art instruction books. Recent titles: *GRAFF: The Art and Technique of Graffiti*, by Scape Martinez; *DragonArt Fantasy Characters*, by Jessica Peffer; *Mechanika*, by Doug Chiang. Publishes 10 titles/year. Book catalog free with 9 × 12 SASE (6 first-class stamps).

- IMPACT Books publishes titles that emphasize illustrated how-to-draw-graffiti, fantasy and comics art instruction. Currently emphasizing fantasy art, traditional American comics styles, including humor; and Japanese-style (manga and anime). This market is for experienced artists who are willing to work with an IMPACT editor to produce a step-by-step how-to book about the artist's creative process. See also separate listing for F+W Publications, Inc., in this section.

Needs Approached by 30 author-artists/year. Works with 10 author-artists/year. First Contact Terms Send query letter or e-mail; digital art, tearsheets, photocopies; resume, SASE and URL. Accepts Mac-compatible e-mail submissions (TIFF or JPEG). Samples may be filed but are usually returned. Responds only if interested. Company will contact artist for portfolio review of color finished art, digital art, roughs, photographs, tearsheets if interested. Buys all rights. Finds freelancers through submissions, conventions, Internet and word of mouth.

Tips Submission guidelines available online at www.impact-books.com/submit_work.asp.

INNER TRADITIONS INTERNATIONAL/BEAR & COMPANY

One Park St., Rochester VT 05767. (802)767-3174. Fax: (802)767-3726. E-mail: peri@inner traditions.com. Website: www.innertraditions.com. **Art Director:** Peri Ann Swan. Estab. 1975. Publishes hardcover originals and trade paperback originals and reprints. Types of books include self-help, psychology, esoteric philosophy, alternative medicine, Eastern religion, and art books. Recent titles: *Mystery of the Crystal Skulls*; *Thai Yoga Massage*; and *Science and the Akashic Field*. Publishes 65 titles/year; 10% require freelance illustration; 5% require freelance design. Book catalog free by request.

Needs Works with 3-4 freelance illustrators and 3-4 freelance designers/year. 100% of freelance design demands knowledge of QuarkXPress, InDesign or Photoshop. Buys 10 illustrations/year. Uses freelancers for jacket/cover illustration and design. Works on assignment only.

First Contact & Terms Send query letter with résumé, tearsheets, photocopies, photographs, slides and SASE. Accepts disc submissions. Samples are filed if interested; returned by SASE if requested by artist. Responds only if interested. To show portfolio, mail tearsheets, photographs, slides and transparencies. Rights purchased vary according to project. Originals returned at job's completion. Pays by the project.

Jackets/Covers Assigns approximately 10 design and illustration jobs/year. Pays by the project.

KAEDEN BOOKS

P.O. Box 16190, Rocky River OH 44116. (440)617-1400. Fax: (440)617-1403. Website: www.kaeden.com. Estab. 1989. Publishes children's books. Types of books include picture books and early juvenile. Specializes in elementary educational content. Recent titles: *Adventures of Sophie Bean: The Red Flyer Roller Coaster*; *Sammy Gets a Bath*; *Where is Muffin*; and *A Skateboard for Alex*. Publishes 8-20 titles/year; 90% require freelance illustration. Book catalog available upon request.

- Kaeden Books is now providing content for ThinkBox.com and the TAE KindlePark Electronic Book Program.

Needs Approached by 100-200 illustrators/year. Works with 5-10 illustrators/year. Prefers freelancers experienced in juvenile/humorous illustration and children's picture books. Uses freelancers mainly for story illustration.

First Contact & Terms Designers: Send query letter with brochure and résumé. Illustrators: Send postcard sample or query letter with photocopies, photographs, printed samples or tearsheets, no larger than 8½ × 11. Samples are filed and not returned. Responds only if interested. Art director will contact artist for portfolio review if interested. Buys all rights.

Text Illustration Assigns 8-20 jobs/year. Pays by the project. Looks for a variety of styles.

Tips "We look for professional-level drawing and rendering skills, plus the ability to interpret a juvenile story. There is a tight correlation between text and visual in our books, plus a need for attention to detail. Drawings of children are especially needed. Please send only samples that pertain to our market."

KALMBACH PUBLISHING CO.

21027 Crossroads Circle, P.O. Box 1612, Waukesha WI 53187. (262)796-8776. Fax: (262)796-1142. E-mail: tford@kalmbach.com. Website: www.kalmbach.com. **Books Art Director:** Tom Ford. Estab. 1934. Types of books include reference and how-to books for serious hobbyists in the railfan, model railroading, plastic modeling, and toy train collecting/operating hobbies. Also publishes books and booklets on jewelry-making, beading and general crafts. Publishes 50+ new titles/year. Recent

titles: *Legendary Lionel Trains*, by John Grams and Terry Thompson; *The Model Railroader's Guide to Industries Along the Tracks*, by Jeff Wilson; *Tourist Trains 2005—The 40th Annual Guide to Tourist Railroads and Museums*; and *Chic&Easy Beading, 100 Fast and Fun Fashion Jewelry Projects*, edited by Alice Korach.

Needs 10-20% require freelance illustration; 10-20% require freelance design. Book catalog free upon request. Approached by 25 freelancers/year. Works with 2 freelance illustrators and 2 graphic designers/year. Prefers freelancers with experience in the hobby field. Uses freelance artists mainly for book layout/design and line art illustrations. Freelancers should have the most recent versions of Adobe InDesign, Photoshop and Illustrator. Projects by assignment only.

First Contact & Terms Send query letter with résumé, tearsheets and photocopies. No phone calls please. Samples are filed and will not be returned. Art Director will contact artist for portfolio review. Finds artists through word of mouth, submissions. Assigns 10-12 freelance design jobs/year. Pays by the project, $500-3,000. Assigns 3-5 freelance illustration jobs/year. Pays by the project, $250-2,000.

Tips First-time assignments are usually illustrations or book layouts. Complex projects (i.e., track plans, 100+ page books) are given to proven freelancers. Admires freelancers who present an organized and visually strong portfolio that meet deadlines and follow instructions carefully.

☒ KIDZUP PRODUCTIONS INC./TORMONT PUBLICATIONS INC.

5532 St. Patrick, Montreal QC H4E 1A8 Canada. (514)954-1441. Fax: (514)954-1443. E-mail: Liliana.Martinez@tormont.ca. **Art Director**: Liliana Martinez Szwarcberg Estab. 1986. Publisher and packager of children's activity and novelty books, and educational music CDs.

Needs Always on the lookout for creative freelance illustrators, layout artists and graphic designers, with experience in children's book publishing. Experience using Illustrator, In Design, and Photoshop are a must

First Contact & Terms Send portfolio by e-mail or postal mail. Art Director will contact artist only if there is interest. We buy the rights to all art.

Tips KIDZUP/Tormont create children's products, with a special focus on toddlers to 8 year olds.

KIRKBRIDE BIBLE CO. INC.

B.B. Kirkbride Bible **Co., Inc.**, 335 W. 9th St., Indianapolis IN 46202-0606. (317)633-1900. Fax: (317)633-1444. E-mail: gage@kirkbride.com. Website: www.kirkbride. com. **President:** Michael B. Gage. Estab. 1915. Publishes Thompson Chain-Reference Bible hardcover originals and quality leather bindings styles and translations of the Bible. Types of books include reference and religious. Specializes in reference and study material. Publishes 6 main titles/year. Recent titles: *The Thompson Student*

Bible; and *The Thompson Chain-Reference Centennial Edition*. 2% require freelance illustration; 10% require freelance design. Catalog available.

Needs Approached by 1-2 designers/year. Works with 1-2 designers/year. Prefers freelancers experienced in layout and cover design. Uses freelancers mainly for artwork and design. 100% of freelance design and most illustration demands knowledge of PageMaker, Indesign, Photoshop, Illustrator and QuarkXPress. 5-10% of titles require freelance art direction.

First Contact & Terms Designers: Send query letter with portfolio of recent works, printed samples and resume. Illustrators: Send query letter with Photostats, printed samples and resume. Accepts disk submissions compatible with QuarkXPress or Photoshop files 4.0 or 3.1. Samples are filed. Responds only if interested. Rights purchased vary according to project.

Design Assigns 1 freelance design job/year. Pays by the hour $100 minimum.

Jackets/Covers Assigns 1-2 freelance design jobs and 1-2 illustration jobs/year. Pays for design by the project, $100-1,000. Pays for illustration by the project, $100-1,000. Prefers modern with traditional text.

Text Illustration Assigns 1 freelance illustration/year. Pays by the project, $100-1,000. Prefers traditional. Finds freelancers through sourcebooks and references.

Tips "Quality craftsmanship is our top concern, and it should be yours also!"

LEE & LOW BOOKS

95 Madison Ave., #1205, New York NY 10016-7801. (212)779-4400. Fax: (212)532-6035. E-mail: general@leeandlow.com. Website: www.leeandlow.com. **Editor-in-Chief:** Louise May. Estab. 1991. Publishes hardcover originals for the juvenile market. Specializes in multicultural children's books. Titles include: *Bird,* by Zetta Elliot; *Honda: The Boy Who Dreamed of Cars*, by Mark Weston; and *Hiromi's Hands*, by Lynne Batasch. Publishes 12-15 titles/year. 100% require freelance illustration and design. Book catalog available.

Needs Approached by 100 freelancers/year. Works with 12-15 freelance illustrators and 4-5 designers/year. Uses freelancers mainly for illustration of children's picture books. 100% of design work demands computer skills. Works on assignment only.

First Contact & Terms Contact through artist rep or send query letter with brochure, résumé, SASE, tearsheets or photocopies. Samples of interest are filed. Art director will contact artist for portfolio review if interested. Portfolio should include color tearsheets and dummies. Rights purchased vary according to project. Originals are returned at job's completion.

Design Pays by the project.

Text Illustration Pays by the project.

Tips "We want an artist who can tell a story through pictures and who is familiar with the children's book genre. We are now also developing materials for older children, ages 8-12, so we are interested in seeing work for this age group, too. Lee & Low

Books makes a special effort to work with writers and artists of color and encourages new talent. We prefer filing samples that feature children, particularly from diverse backgrounds."

LERNER PUBLISHING GROUP

241 First Ave. N., Minneapolis MN 55401. (612)332-3344. Fax: (612)332-7615. E-mail: info@lerner books.com. Website: www.lernerbooks.com. **Art Director:** Zach Marell. Estab. 1959. Publishes educational books for young people. Subjects include animals, biography, history, geography, science and sports. Publishes 200 titles/year. 100% require freelance illustration. Recent titles: *Colorful Peacocks*; *Ethiopia in Pictures*. Book catalog free on request. Art submission guidelines available on website.
Needs Uses 10-12 freelance illustrators/year. Uses freelancers mainly for book illustration; also for jacket/cover design and illustration, book design and text illustration.
First Contact & Terms Submit samples that show skill specifically in children's book illustration. Do not send original art. Submit slides, JPEG, or .pdf files on disk, color photocopies of full-color artwork, photocopies of black and white line work, or tear sheets.
Tips "Send samples showing active children, not animals or still life. Don't send original art. Look at our books to see what we do."

MENNONITE PUBLISHING HOUSE/HERALD PRESS

616 Walnut Ave., Scottdale PA 15683. (724)887-8500. Fax: (724)887-3111. E-mail: hp@mph.org. Website: www.heraldpress.com. Estab. 1918. Publishes hardcover and paperback originals and reprints; textbooks and church curriculum. Specializes in religious, inspirational, historical, juvenile, theological, biographical, fiction and nonfiction books. Publishes 17 titles/year. Recent titles: *Walk in Peace; Julia's Words*; *Timna*. Books are "fresh and well illustrated." 30% require freelance illustration. Catalog available free by request.
Needs Approached by 150 freelancers each year. Works with 4-6 illustrators/year. Prefers oil, pen & ink, colored pencil, watercolor, and acrylic in realistic style. "Prefer artists with experience in publishing guidelines who are able to draw faces and people well." Uses freelancers mainly for book covers. 10% of freelance work demands knowledge of Illustrator, QuarkXPress or PhotoShop. Works on assignment only.
First Contact & Terms Send query letter with résumé, tearsheets, photostats, photocopies, photographs. Samples are filed ("if we feel freelancer is qualified"). Responds only if interested. Art director will contact artist for portfolio review of final art, photographs, roughs and tearsheets. Buys one-time or reprint rights. Originals are not returned at job's completion "except in special arrangements." To show portfolio, mail photostats, tearsheets, final reproduction/product, photographs and also approximate

time required for each project. Considers complexity of project, skill and experience of artist and project's budget when establishing payment. Buys all rights.

Jackets/Covers Assigns 4-6 illustration jobs/year. Pays by the project, $200 minimum. "Any medium except layered paper illustration will be considered."

Text Illustration Assigns 6 jobs/year. Pays by the project. Prefers b&w, pen & ink or pencil.

Tips "Design we use is colorful, realistic and religious. When sending samples, show a wide range of styles and subject matter—otherwise you limit yourself."

MITCHELL LANE PUBLISHERS, INC.

P.O. Box 196, Hockessin DE 19707. (302)234-9426. Fax: (302)234-4742. Website: www. mitchelllane.com. **Publisher:** Barbara Mitchell. Estab. 1993. Publishes library bound originals. Types of books include biography. Specializes in multicultural biography for young adults. Recent titles: *Disaster in the Indian Ocean*; and *Tsunami 2004*. Publishes 85 titles/year; 50% require freelance illustration; 50% require freelance design.

Needs Approached by 20 illustrators and 5 designers/year. Works with 2 illustrators/year. Prefers freelancers experienced in illustrations of people. Looks for cover designers and interior book designers.

First Contact & Terms Send query letter with printed samples, photocopies. Interesting samples are filed and are not returned. Will contact artist for portfolio review if interested. Buys all rights.

Jackets/Covers Prefers realistic portrayal of people.

MODERN PUBLISHING

155 E. 55th St., New York NY 10022. (212)826-0850. Fax: (212)759-9069. E-mail: ewhite@ modernpublishing.com. Website: www.modernpublishing.com. **Art Director:** Erik White. Specializes in children's coloring and activity books, novelty books, hardcovers, paperbacks (both generic and based on licensed characters). Recent titles include Fisher Price books, Hello Kitty, Disney, America's Next Top Model, Looney Tunes, My Little Pony, Project Runway, Planet Earth, and more. Publishes approximately 200 titles/year.

Needs Approached by 15-30 freelancers/year. Works with 25-30 freelancers/year. Works on assignment and royalty.

First Contact & Terms Send query letter with resume and samples. Samples are not filed and are returned by SASE only if requested. Responds only if interested. Originals not returned. Considers turnaround time, complexity of work and rights purchased when establishing payment.

Jackets/Covers Pays by the project, $100-250/cover, usually 2-4 books/series.

Text Illustration Pays by the project, $35-75/page; line art, 24-384 pages per book, usually 2-4 books/series. Pays $50-125/page; full-color art.

MOUNTAIN PRESS PUBLISHING CO.

P.O. Box 2399, Missoula MT 59806. (406)728-1900. Fax: (406)728-1635. E-mail: info@mtnpress.com. Website: www.mountain-press.com. **Design and Production**: Kim Ericsson and Jeannie Painter. Estab. 1960s. Company publishes trade paperback originals and reprints; some hardcover originals and reprints. Types of books include western history, geology, natural history/nature. Specializes in geology, natural history, history, horses, western topics. Publishes 20 titles/year. Book catalog free by request.

Needs Approached by 100 freelance artists/year. Works with 2-5 freelance illustrators/year. Buys 5-10 freelance illustrations/year. Prefers artists with experience in book illustration and design, book cover illustration. Uses freelance artists for jacket/cover illustration, text illustration and maps. 100% of design work demands knowledge of InDesign, Photoshop, Illustrator. Works on assignment only.

First Contact & Terms Send query letter with résumé, SASE and any samples. Samples are filed or are returned by SASE. Responds only if interested. Project editor will contact artist for portfolio review if interested. Buys one-time rights or reprint rights depending on project. Originals are returned at job's completion. Finds artists through submissions, word of mouth, sourcebooks and other publications.

Design Pays by the project.

Jackets/Covers Assigns 0-1 freelance design and 3-6 freelance illustration jobs/year. Pays by the project.

Text Illustration Assigns 0-1 freelance illustration jobs/year. Pays by the project.

Tips First-time assignments are usually book cover/jacket illustration or map drafting; text illustration projects are given to "proven" freelancers.

NEW ENGLAND COMICS (NEC PRESS)

732 Washington St., Norwood MA 02062-3548. (781)769-3470. Fax: (781)769-2853. E-mail: office@ newenglandcomics.com. Website: www.newenglandcomics.com. Types of books include comic books and games. Book catalog available on website.

Needs Seeking pencillers and inkers. Not currently interested in new stories.

First Contact & Terms Send SASE and 2 pages of pencil or ink drawings derived from the submissions script posted on website. Responds in 2 weeks (with SASE only).

Tips Visit website for submissions script. Do not submit original characters or stories. Do not call.

NORTH LIGHT BOOKS

F+W Media, Inc., 4700 E. Galbraith Rd., Cincinnati OH 45236. (513)531-2690. Fax: (513)531-2686. E-mail: jamie.markle@fwmedia.com; christine.doyle@fwmedia.com; pam.wissman@fwmedia.com. Website: www.fwmedia.com. **Publisher:** Jamie

Markle. **Editorial Craft Director:** Christine Doyle. **Editorial Director Fine Art:** Pam Wissman. Publishes trade paperback and hardback originals. Specializes in fine art, craft and decorative painting instruction books. Recent titles: *Acrylic Revolution*; *Watercolor in Motion*; *Oil Painter's Solution Book: Landscapes*; *Knit One, Embellish Too*; *Taking Flight*; *Warm Fuzzies*. Publishes 75 titles/year. Book catalog available for SASE with 6 first-class stamps.

- This market is for experienced fine artists and crafters who are willing to work with a North Light editor to produce a step-by-step how-to book about the artist's creative process. See also separate listing for F+W Media, Inc., in this section.

Needs Approached by 100 author-artists/year. Works with 50 artists/year.

First Contact & Terms Send query letter with photographs, digital images. Accepts e-mail submissions. Samples are not filed and are returned. Responds only if interested. Company will contact artist for portfolio review if interested. Buys all rights. Finds freelancers through art competitions, art exhibits, submissions, Internet and word of mouth.

Tips "Include 30 examples of artwork, book idea, outline and a step-by-step demonstration. Submission guidelines posted on website."

OCP (OREGON CATHOLIC PRESS)

5536 NE Hassalo, Portland OR 97213-3638. E-mail: gust@ocp.org. Website: www.ocp.org. **Creative Director:** Gus Torres. Division estab. 1997. Publishes religious and liturgical books specifically for, but not exclusively to, the Roman Catholic market. Publishes 2-5 titles/year; 30% require freelance illustration. Book catalog available for 9 × 12 SASE with first-class postage.

- OCP (Oregon Catholic Press) is a nonprofit publishing company, producing music and liturgical publications used in parishes throughout the United States, Canada, England and Australia. See additional listings in the Magazines and Record Labels sections.

Tips "I am always looking for appropriate art for our projects. We tend to use work already created on a one-time-use basis, as opposed to commissioned pieces. I look for tasteful, not overtly religious art."

OCTAMERON PRESS

1900 Mount Vernon Avenue, Alexandria VA 22301. (703)836-5480. Fax: (703)836-5650. E-mail: octameron@aol.com. Website: www.octameron.com. **Editorial Director:** Karen Stokstod. Estab. 1976. Publishes paperback originals. Specializes in college financial and college admission guides. Recent titles: *College Match*; *The Winning Edge*. Publishes 9 titles/year.

Needs Approached by 25 freelancers/year. Works with 1-2 freelancers/year. Works on assignment only.

First Contact & Terms Send query letter with brochure showing art style or résumé and photocopies. Samples not filed are returned if SASE is included. Considers complexity of project and project's budget when establishing payment. Rights purchased vary according to project.

Jackets/Covers Works with 1-2 designers and illustators/year on 15 different projects. Pays by the project, $500-1,000.

Text Illustration Works with variable number of artists/year. Pays by the project, $35-75. Prefers line drawings to photographs.

Tips "The look of the books we publish is friendly! We prefer humorous illustrations."

PALACE PRESS

3160 Kerner Blvd., Unit 108, San Rafael CA 94901. (415)526-1370. Fax: (415)884-0500. E-mail: info@insighteditions.com. Website: www.insighteditions.com. **Contact:** Lisa Fitzpatrick, acquiring editor. Estab. 1987. Publishes art and photography books, calendars, journals, postcards and greeting card box sets. Types of books include pop culture, fine art, photography, spiritual, philosophy, art, biography, coffee table books, cookbooks, instructional, religious, travel, and nonfiction. Specializes in art books, spiritual. Publishes 12 titles/year. Recent titles include: *Ramayana: A Tale of Gods & Demons*; *Prince of Dharma: The Illustrated Life of the Buddha*. 100% requires freelance design and illustration. Book catalog free on request.

Needs Approached by 50 illustrators/year. Works with 12 designers and 12 illustrators/year. Location of designers/illustrators not a concern.

First Contact & Terms Send photographs and résumé. Accepts disk submissions from designers and illustrators. Prefers Mac-compatible, TIFF and JPEG files. Samples are filed. Responds only if interested. Company will contact artist for portfolio review if interested. Buys first, first North American serial, one-time and reprint rights. Rights purchased vary according to project. Finds freelancers through artist's submissions, word of mouth.

Jackets/Covers Assigns 3 freelance cover illustration jobs/year. Pays for illustration by the project.

Text Illustration Assigns 2 freelance illustration jobs/year. Pays by the project.

Tips "Look at our published books and understand what we represent and how your work could fit."

PAPERCUTZ

40 Exchange Place, Suite 1308, New York NY 10005. (212)643-5407. Fax: (212)643-1545. E-mail: salicrup@papercutz.com. Website: www.papercutz.com. **Editor-in-Chief:** Jim Salicrup. Estab. 2005. "Independent publisher of graphic novels based on popular existing properties aimed at the teen and tween market." Publishes hardcover and paperback originals, distributed by Holtzbrinck Publishers. Recent

titles: Nancy Drew; The Hardy Boys; Tales from the Crypt. Publishes 10 + titles/year. Book catalog free upon request.

Needs Uses licensed characters/properties aimed at teen/tween market. "Looking for professional comics writers able to write material for teens and tweens without dumbing down the work, and comic book artists able to work in animated or manga styles." Also has a need for inkers, colorists, letterers.

First Contact & Terms Send low-res files of comic art samples or a link to website. Attends New York comic book conventions, as well as the San Diego Comic-Con, and will review portfolios if time allows. Responds in 1-2 weeks. Pays an advance against royalties.

Tips "Be familiar with our titles—that's the best way to know what we're interested in publishing. If you are somehow attached to a successful teen or tween property and would like to adapt it into a graphic novel, we may be interested."

PARENTING PRESS, INC.

P.O. Box 75267, Seattle WA 98175. (206)364-2900. Fax: (206)364-0702. E-mail: office@parenting press.com. Website: www.parentingpress.com. **Contact:** Carolyn Threadgill, publisher. Estab. 1979. Publishes trade paperback originals and hardcover originals. Types of books include nonfiction; instruction and parenting. Specializes in parenting and social skill building books for children. Recent titles: *The Way I Feel*; *Is This a Phase?*; *What About Me?* 100% requires freelance design; 100% requires freelance illustration. Book catalog free on request.

Needs Approached by 10 designers/year and 100 illustrators/year. Works with 2 designers/year. Prefers local designers. 100% of freelance design work demands knowledge of Photoshop, QuarkXPress, and InDesign.

First Contact & Terms Send query letter with brochure, SASE, postcard sample with photocopies, photographs and tearsheets. After introductory mailing, send follow-up postcard sample every 6 months. Accepts e-mail submissions. Prefers Windows-compatible, TIFF, JPEG files. Samples returned by SASE if not filed. Responds only if interested. Company will contact artist for portfolio review if interested. Portfolio should include b&w or color tearsheets. Rights purchased vary according to project.

Jackets/Covers Assigns 4 freelance cover illustrations/year. Pays for illustration by the project $300-1,000. Prefers appealing human characters, realistic or moderately stylized.

Text Illustration Assigns 3 freelance illustration jobs/year. Pays by the project or shared royalty with author.

Tips "Be willing to supply 2-4 roughs before finished art."

PAULINE BOOKS & MEDIA

50 Saint Paul's Ave., Jamaica Plain, MA 02130-3491. (617)522-8911. Fax: (617)541-

9805. E-mail: design@paulinemedia.com. Website: www.pauline.org. **Art Director:** Sr. Mary Joseph Peterson. Estab. 1932. Publishes hardcover and trade paperback originals. Religious publishers; types of books include instructional biography/lives of the saints, reference, history, self-help, prayer, children's fiction. For Adults, teens and children. Also produces music and spoken recordings. Publishes 30-40 titles/year. Art guidelines available. Send requests and art samples with SASE using first-class postage.

Needs Approached by 50 freelancers/year. Works with 10-20 freelance illustrators/year. Knowledge and use of QuarkXPress, InDesign, Illustrator, Photoshop, etc., is valued.

First Contact & Terms Postcards, tearsheets, photocopies, include web site address if you have one. Samples are filed or returned by SASE. Responds only if interested. Rights purchased; work for hire or exclusive rights.

Jackets/Covers Assigns 3-4 freelance illustration jobs/year. Pays by the project.

Text Illustration Assigns 6-10 freelance illustration jobs/year. Pays by the project.

PAULIST PRESS

997 Macarthur Blvd., Mahwah NJ 07430. (201)825-7300. Fax: (201)825-8345. E-mail: pmcmahon @paulistpress.com. Website: www.paulistpress.com. **Managing Editor:** Paul McMahon. Estab.1857. Publishes hardcover and trade paperback originals, juvenile and textbooks. Types of books include religion, theology, and spirituality. Specializes in academic and pastoral theology. Recent titles include A Time for Leaving, He Said Yes, Ewe, and The Life of St. Paul. Publishes 90 titles/year; 5% require freelance illustration; 5% require freelance design.

• Paulist Press also publishes the general trade imprint Hiddenspring.

Needs Prefers local freelancers particularly for juvenile titles, jacket/cover, and text illustration. Prefers knowledge of QuarkXPress. Works on assignment only.

First Contact & Terms Send query letter with brochure, resume and tearsheets. Samples are filed. Portfolio review not required. Originals are returned at job's completion if requested. **Cover Design:** Pays by the project, $400-800.

PEACHTREE PUBLISHERS

1700 Chattahoochee Ave., Atlanta GA 30318. (404)876-8761. Fax: (404)875-2578. E-mail: hello@ peachtree-online.com. Website: www.peachtree-online.com. We are also on Facebook and Twitter. **Art Director:** Loraine Joyner. **Production Manager:** Melanie McMahon Ives. Estab. 1977. Publishes hardcover and trade paperback originals. Types of books include children's picture books, young adult fiction, early reader fiction, middle reader fiction and nonfiction, parenting, regional. Specializes in children's and young adult titles. Publishes 24-30 titles/year. 100% require freelance illustration. Call for catalog.

Needs Approached by 750 illustrators/year. Works with 15-20 illustrators. Normally do not use book designers. "When possible, send samples that show your ability to depict subjects or characters in a consistent manner. See our website to view styles of artwork we utilize."

Jackets/Covers Assigns 18-20 illustration jobs/year. Prefers acrylic, oils, watercolor, or mixed media on flexible material for scanning, or digital files. Pays for illustration by the project.

Text Illustration Assigns 4-6 freelance illustration jobs/year. Pays by the project.

Tips We are an independent, award-winning, high-quality house with a limited number of new titles per season, therefore each book must be a jewel. We expect the illustrator to bring creative insights which expand the readers' understanding of the storyline through visual clues not necessarily expressed within the text itself."

PELICAN PUBLISHING CO.

1000 Burmaster, Gretna LA 70053. (504)368-1175. Fax: (504)368-1195. E-mail: tcallaway @pelicanpub.com. Website: www.pelicanpub.com. **Contact:** Production Manager. Publishes hardcover and paperback originals and reprints. Publishes 70 titles/year. Types of books include travel guides, cookbooks, business/motivational, architecture, golfing, history and children's books. Books have a "high-quality, conservative and detail-oriented" look. Recent titles: *Finn McCool's Football Club*; *CRAZY About Cherries*; *Foods and Flavors of San Antonio*; *A Dream of Pilots*.

Needs Approached by 2000 freelancers/year. Works with 20 freelance illustrators/year. Uses freelancers for illustration and photo projects. Works on assignment only. 100% of design and 50% of illustration demand knowledge of Indesign, Photoshop, Illustrator.

First Contact & Terms Designers: Send photocopies, photographs, SASE, slides and tearsheets. Illustrators: Send postcard sample or query letter with photocopies, SASE, slides and tearsheets. Samples are not returned. Responds on future assignment possibilities. Buys all rights. Originals are not returned.

Design Pays by the project, $500 minimum.

Jackets/Covers Pays by the project, $150-500.

Text Illustration Pays by the project, $50-250.

Tips "Show your versatility. We want to see realistic detail and color samples."

PEN NOTES, INC.

9580 North Belfort Circle, Suite 105, Tamarac FL 33321. (954)726-0006. E-mail: pennotes-FL@att.net. Website: www.PenNotes.com. **President**: Lorette Konezny. Produces learning books for children ages 3 and up. Clients Bookstores, toy stores and parents.

Needs Prefers artists with book or advertising experience. Works on assignment only. Each year assigns 1-2 books (with 24 pages of art) to freelancers. Uses freelancers

for children's illustration, P-O-P display and design and mechanicals for catalog sheets for children's books. 100% of freelance design and up to 50% of illustration demands computer skills. Prefers knowledge of press proofs on first printing. Prefers imaginative, realistic style with true perspective and color. 100% of titles require freelance art direction.

First Contact & Terms Designers: Send brochure, resume 9, SASE, tearsheets and photocopies. No e-mails. Illustrators: Send sample with tearsheets. Samples are filed. Call or write for appointment to show portfolio or mail final reproduction/product, color and b&w tearsheets and photostats. Pays for design by the hour, $15-36; by the project, $60-125. Pays for illustration by the project, $60-500/page. Buys all rights.

Tips "Everything should be provided digitally. The style must be geared for children's toys. Looking for realistic/cartoon outline with flat color. You must work on deadline schedule set by printing needs. Must have full range of professional and technical experience for press proof. All work is property of Pen Notes, copyright property of Pen Notes."

PENGUIN GROUP (USA) INC.

375 Hudson St., New York NY 10014. (212)366-2000. Fax: (212)366-2666. Website: www.penguin group.com. **Art Director:** Paul Buckley. Publishes hardcover and trade paperback originals.

Needs Works with 100-200 freelance illustrators and 100-200 freelance designers/year. Uses freelancers mainly for jackets, catalogs, etc.

First Contact & Terms Send query letter with tearsheets, photocopies and SASE. Rights purchased vary according to project.

Design Pays by the project; amount varies.

Jackets/Covers Pays by the project; amount varies.

◪ PEREGRINE

40 Seymour Ave., Toronto ON M4J 3T4 Canada. (416)461-9884. Fax: (416)461-4031. E-mail: peregrine @peregrine-net.com. Website: www.peregrine-net.com. **Creative Director:** Kevin Davies. Estab. 1993. Publishes role-playing game books, audio music, and produces miniatures supplements. Game styles/genres include science fiction, cyberpunk, mythology, fantasy, military, horror and humor. Game/product lines include: Murphy's World (role-playing game); Bob, Lord of Evil (role-playing game); Adventure Areas (miniatures supplements); Grit Multi-Genre Miniatures Rules; Adventure Audio. Publishes 1-2 titles or products/year. 90% require freelance illustration; 10% require freelance design. Art guidelines available on website.

Needs Approached by 20 illustrators and 2 designers/year. Works with 2-5 artists/year. Uses freelance artists mainly for interior art (b&w, grayscale) and covers (color). Prefers freelancers experienced in anatomy, structure, realism, cartoon and

grayscale. 100% of freelance design demands knowledge of Illustrator, Photoshop, InDesign and QuarkXPress.

First Contact & Terms Send query letter with résumé, business card. Illustrators: Send photocopies and/or tearsheets (5-10 samples). Accepts digital submissions in Mac format via CD or e-mail attachment as EPS, TIFF or JPEG files at 72-150 ppi (for samples) and 300 ppi (for finished work). Paper and digital samples are filed and are not returned. Responds only if interested. Send self-promotion photocopy and follow-up postcard every 9-12 months. Portfolio review not required. Rights purchased vary according to project. Finds freelancers through conventions, Internet and word of mouth.

Text Illustration Assigns 1-5 illustration jobs/year (grayscale/b&w). Pays $50-100 for full page; $10-25 for half page. "Payment varies with detail of image required and artist's experience."

Tips "Check out our existing products on our website. Make sure at least half of the samples you submit reflect the art styles we're currently publishing. Other images can be provided to demonstrate your range of capability."

PRO LINGUA ASSOCIATES

P.O. Box 1348, Brattleboro VT 05302-1348. (802)257-7779. Fax: (802)257-5117. E-mail: andy@Pro LinguaAssociates.com. Website: www.ProlinguaAssociates. com. **President:** Arthur A. Burrows. Estab. 1980. Publishes textbooks. Specializes in language textbooks. Recent titles: *Writing Strategies*; *Dictations for Discussion*. Publishes 3-8 titles/year. Most require freelance illustration. Book catalog free by request.

Needs Approached by 10 freelance artists/year. Works with 2-3 freelance illustrators/year. Uses freelance artists mainly for pedagogical illustrations of various kinds; also for jacket/cover and text illustration. Works on assignment only.

First Contact & Terms Send postcard sample and/or query letter with brochure, photocopies and photographs. Samples are filed. Responds in 1 month. Portfolio review not required. Buys all rights. Originals are returned at job's completion if requested. Finds artists through word of mouth and submissions.

Text Illustration Assigns 5 freelance illustration jobs/year. Pays by the project, $200-1,200.

QUITE SPECIFIC MEDIA GROUP LTD.

7373 Pyramid Place, Hollywood CA 90046. (323)851-5797. Fax: (323)851-5798. E-mail: info@ quitespecificmedia.com. Website: www.quitespecificmedia.com. **President:** Ralph Pine. Estab. 1967. Publishes hardcover originals and reprints, trade paperback reprints and textbooks. Specializes in costume, fashion, theater and performing arts books. Recent titles: *Understanding Fashion History*; *The Medieval Tailor's Assistant*.

Publishes 12 titles/year. 10% require freelance illustration; 60% require freelance design.

- Imprints of Quite Specific Media Group Ltd. include Drama Publishers, Costume & Fashion Press, By Design Press, EntertainmentPro and Jade Rabbit.

Needs Works with 2-3 freelance designers/year. Uses freelancers mainly for jackets/ covers; also for book, direct mail and catalog design and text illustration. Works on assignment only.

First Contact & Terms Send query letter with brochure and tearsheets. Samples are filed. Responds only if interested. Rights purchased vary according to project. Originals not returned. Pays by the project.

RAINBOW BOOKS, INC.

P.O. Box 430, Highland City FL 33846-0430. (863)648-4420. Fax: (863)647-5951. E-mail: info@Rain bowBooksInc.com. Website: www.rainbowbooksinc.com. **Media Buyer:** Betsy A. Lampe. Estab. 1979. Publishes hardcover and trade paperback originals. Types of books include instruction, adventure, biography, travel, self-help, mystery and reference. Specializes in nonfiction, self-help, mystery fiction, and how-to. Recent titles: *Teen Grief Relief*; and *Building Character Skills in the Out-of-Control Child*. Publishes 15-20 titles/year.

Needs Approached by hundreds of freelance artists/year. Works with 2 illustrators/ year. Prefers freelancers with experience in cover design and line illustration. Uses freelancers for jacket/cover illustration/design and text illustration. Needs computer-literate freelancers for design, illustration and production. 90% of freelance work demands knowledge of draw or design software programs. Works on assignment only.

First Contact & Terms Send brief query, tearsheets, photographs and book covers or jackets. Samples are not returned. Responds in 2 weeks. Art director will contact artist for portfolio review if interested. Portfolio should include b&w and color tearsheets, photographs and book covers or jackets. Rights purchased vary according to project. Originals are returned at job's completion.

Jackets/Covers Assigns 10 freelance illustration jobs/year. Pays by the project, $250-1,000.

Text Illustration Pays by the project. Prefers pen & ink or electronic illustration.

Tips "Nothing Betsy Lampe receives goes to waste. After consideration for Rainbow Books, Inc., artists/designers are listed for free in her newsletter (Florida Publishers Association *Sell More Books!* Newsletter), which goes out to over 100 independent presses. Then, samples are taken to the art department of a local school to show students how professional artists/designers market their work. Send samples (never originals); be truthful about the amount of time needed to complete a project; learn to use the computer. Study the competition (when doing book covers); don't try to write cover copy; learn the publishing business (attend small-press seminars, read

books, go online, make friends with the local sales reps of major book manufacturers). Pass along what you learn. Do not query via e-mail attachment."

RANDOM HOUSE CHILDREN'S BOOKS

Random House, Inc., 1745 Broadway, 10th Floor, New York NY 10019. (212)782-9000. Fax: (212)782-9452. Website: www.randomhouse.com/kids. Largest English-language children's trade book publisher. Specializes in books for preschool children through young adult readers, in all formats from board books to activity books to picture books and novels. Recent titles: *How Many Seeds in a Pumpkin?*; *How Not to Start Third Grade*; *Spells & Sleeping Bags*; *The Power of One*. Publishes 250 titles/year. 100% require freelance illustration.

- The Random House publishing divisions hire their freelancers directly. To contact the appropriate person, send a cover letter and résumé to the department head at the publisher as follows: "Department Head" (e.g., Art Director, Production Director), "Publisher/Imprint" (e.g., Knopf, Doubleday, etc.), 1745 Broadway New York, NY 10019. See http://www.random house.com/kids/about/imprints. html for details of imprints.

Needs Works with 100-150 freelancers/year. Works on assignment only.

First Contact & Terms Send query letter with résumé, tearsheets and printed samples; no originals. Samples are filed. Negotiates rights purchased.

Design Assigns 5 freelance design jobs/year. Pays by the project.

Text Illustration Assigns 150 illustration jobs/year. Pays by the project.

⚟ RED DEER PRESS

195 Allstate Pkwy, Markham ON L3R 4T8 Canada. (403)509-0800. Fax: (403)228-6503. Please send queries by e-mail only. E-mail: rdp@reddeerpress.com. Website: www. reddeerpress.com. **Publisher:** Richard Dionne. Estab. 1975. Publishes hardcover and trade paperback originals. Types of books include contemporary and mainstream fiction, fantasy, biography, preschool, juvenile, young adult, sports, political science, and humor. Specializes in contemporary adult and juvenile fiction, picture books and natural history for children. Recent titles: *Broken Arrow*; and *The Book of Michael*. 100% of titles require freelance illustration; 30% require freelance design. Book catalog available for SASE with Canadian postage.

Needs Approached by 50-75 freelance artists/year. Works with 10-12 freelance illustrators and 2-3 freelance designers/year. Buys 50 freelance illustrations/year. Prefers artists with experience in book and cover illustration. Also uses freelance artists for jacket/cover and book design and text illustration. Works on assignment only.

First Contact & Terms Send query letter with résumé by e-mail only. Terms on project basis.

Design Assigns 3-4 design and 6-8 illustration jobs/year. Pays by the project.

Jackets/Covers Assigns 6-8 design and 10-12 illustration jobs/year. Pays by the project, $300-1,000 Canadian.

Text Illustration Assigns 3-4 design and 4-6 illustration jobs/year. Pays by the project. May pay advance on royalties.

Tips Looks for freelancers with a proven track record and knowledge of Red Deer Press. "Send a quality portfolio, preferably with samples of book projects completed."

RED WHEEL/WEISER

500 Third St., Suite 230, San Francisco CA 94107. (415)978-2665. Fax: (415)869-1022. E-mail: dlinden @redwheelweiser.com. Website: www.redwheelweiser.com. **Creative Director:** Donna Linden. Publishes trade hardcover and paperback originals and reprints. Imprints: Red Wheel (spunky self-help); Weiser Books (metaphysics/oriental mind-body-spirit/esoterica); Conari Press (self-help/inspirational). Publishes 50 titles/year.

Needs Uses freelancers for jacket/text design and illustration.

First Contact & Terms Designers: Send résumé, photocopies and tearsheets. Illustrators: Send photocopies, photographs, SASE and tearsheets. "We can use art or photos. I want to see samples I can keep." Samples are filed or are returned by SASE only if requested by artist. Responds only if interested. Originals are returned to artist at job's completion. To show portfolio, mail tearsheets, color photocopies. Considers complexity of project, skill and experience of artist, project's budget, turnaround time and rights purchased when establishing payment. Buys one-time nonexclusive royalty-free rights. Finds most artists through references/word of mouth, portfolio reviews and samples received through the mail.

Jackets/Covers Assigns 20 design jobs/year. Must have trade book design experience in the subjects we publish.

Tips "Send samples by mail, preferably in color. We work electronically and prefer digital artwork or scans. Do not send drawings of witches, goblins and demons for Weiser Books; we don't put those kinds of images on our covers. Please take a moment to look at our books before submitting anything; we have characteristic looks for all three imprints."

SCHOOL GUIDE PUBLICATIONS

210 North Ave., New Rochelle NY 10801. (800)433-7771. Fax: (914)632-3412. E-mail: info@school guides.com. Website: www.schoolguides.com. **Art Director:** Melvin Harris. Assistant Art Director: Tory Ridder. Estab. 1935. Types of books include reference and educational directories. Specializes in college recruiting publications. Recent titles include School Guide; Graduate School Guide; College Transfer Guide; Armed Services Veterans Education Guide; College Conference Manual. 25% requires freelance illustration; 75% requires freelance design.

Needs Approached by 10 illustrators and 10 designers/year. Prefers local freelancers. Prefers freelancers experienced in book cover and brochure design. 100% of freelance design and illustration demands knowledge of Illustrator, Photoshop, QuarkXPress.

First Contact & Terms Send query letter with printed samples. Accepts Mac-compatible disk submissions. Send EPS files. Samples are filed. Responds only if interested. Will contact artist for portfolio review if interested. Rights purchased vary according to project. Finds freelancers through word of mouth.

Design Assigns 2 freelance design and 2 art direction projects/year.

Jackets/Covers Assigns 1 freelance design jobs/year.

SOUNDPRINTS

353 Main Ave., Norwalk CT 06851-1552. (203)846-2274. Fax: (203)846-1776. E-mail: soundprints @soundprints.com. Website: www.soundprints.com. **Art Director:** Meredith Campbell Britton. Estab. 1989. Publishes hardcover originals. Types of books include juvenile. Specializes in wildlife, worldwide habitats, social studies and history. Recent titles: *Black Bear Cub at Sweet Berry Trail*, by Laura Gates Galvin; *Hermit Crab's Home: Safe in a Shell*, by Janet Halfmann. Publishes 30 titles/year; 100% require freelance illustration. Book catalog available for 9 × 12 SASE with $1.21 postage.

Needs Works with 8-10 illustrators/year. Prefers freelancers with experience in realistic wildlife illustration and children's books. Heavy visual research required of artists. Uses freelancers for illustrating children's books (covers and interiors).

First Contact & Terms E-mail samples. Art director will contact artist if interested. Originals are returned at job's completion. Finds artists through agents, sourcebooks, reference, unsolicited submissions.

Text Illustration Assigns 12-14 freelance illustration jobs/year.

Tips "We want realism, not cartoons. Animals illustrated are not anthropomorphic. Artists who love to produce realistic, well-researched wildlife and habitat illustrations, and who care deeply about the environment, are most welcome."

TORAH AURA PRODUCTIONS; ALEF DESIGN GROUP

4423 Fruitland Ave., Los Angeles CA 90058. (323)585-7312. Fax: (323)585-0327. E-mail: misrae@ torahaura.com. Website: www.torahaura.com. **Art Director**: Jane Golub. Estab. 1981. Publishes Jewish educational textbooks. Types of books include textbooks. Specializes in textbooks for Jewish schools. Recent titles: *Artzeinu: An Israel Encounter*; *Celebrating the Jewish Year 5768 Calendar*. Publishes 15 titles/year. 85% require freelance illustration. Book catalog free for 9x12 SAE with 10 first-class stamps.

Needs Approached by 50 illustrators and 20 designers/year. Works with 3 illustrators/year.

First Contact & Terms Illustrators: Send postcard sample and follow-up postcard every 6 months, printed samples, photocopies. Accepts Windows-compatible disk submissions. Samples are filed. Will contact artist for portfolio review if interested. Rights purchased vary according to project. Finds freelancers through submission packets.

TREEHAUS COMMUNICATIONS, INC.

906 W. Loveland Ave., P.O. Box 249, Loveland OH 45140. (513)683-5716. Fax: (513)683-2882. E-mail: treehaus@treehaus1.com. Website: www.treehaus1.com. **President:** Gerard Pottebaum. Estab. 1973. Publisher. Specializes in books, periodicals, texts, TV productions. Product specialties are social studies and religious education. Recent titles: *The Stray*; *Rosanna The Rainbow Angel* (for children ages 4-8).

Needs Approached by 12-24 freelancers/year. Works with 2 or 3 freelance illustrators/year. Prefers freelancers with experience in illustrations for children. Works on assignment only. Uses freelancers for all work. 5% of work is with print ads. Needs computer-literate freelancers for illustration.

First Contact & Terms Send query letter with résumé, transparencies, photocopies and SASE. Samples sometimes filed or returned by SASE if requested by artist. Responds in 1 month. Art director will contact artist for portfolio review if interested. Portfolio should include final art, tearsheets, slides, photostats and transparencies. Pays for design and illustration by the project. Rights purchased vary according to project. Finds artists through word of mouth, submissions and other publisher's materials.

Tips "We are looking for original style that is developed and refined. Whimsy helps."

TYNDALE HOUSE PUBLISHERS, INC.

351 Executive Dr., Carol Stream IL 60188. E-mail: talindaiverson@tyndale.com. Website: www.tyndale.com. **Art Buyer:** Talinda Iverson. Estab. 1962. Publishes hardcover and trade paperback originals. Specializes in children's books on "Christian beliefs and their effect on everyday life." Publishes 150 titles/year. 15% require freelance illustration.

Needs Approached by 200-250 freelance artists/year. Works with 5-7 illustrators.

First Contact & Terms Send query letter and tearsheets only. Samples are filed or are returned by SASE. Responds only if interested. Considers complexity of project, skill and experience of artist, project's budget and rights purchased when establishing payment. Negotiates rights purchased. Originals are returned at job's completion except for series logos.

Jackets/Covers Assigns 5-10 illustration jobs/year. Prefers progressive but friendly style. Pays by the project, no royalties.

Text Illustration Assigns 1-5 jobs/year. Prefers progressive but friendly style. Pays by the project.

Tips "Only show your best work. We are looking for illustrators who can tell a story with their work and who can draw the human figure in action when appropriate."

UNIVERSITY OF PENNSYLVANIA PRESS

3905 Spruce St., Philadelphia PA 19104-4112. (215)898-6261. Fax: (215)898-0404. E-mail: wmj@ pobox.upenn.edu. Website: www.upenn.edu/pennpress/. **Design Director:** John Hubbard. Estab. 1920. Publishes hardcover originals. Types of books include biography, history, nonfiction, landscape architecture, art history, anthropology, literature and regional history. Publishes 80 titles/year. Recent titles: *The Man Who Had Been King.* 10% requires freelance design.

Needs Works with 4 designers/year. 100% of freelance work demands knowledge of Illustrator, Photoshop and QuarkXPress.

First Contact & Terms Designers: Send query letter with photocopies. Illustrators: Send postcard sample. Accepts Mac-compatible disk submissions. Samples are not filed or returned. Will contact artist for portfolio review if interested. Portfolio should include book dummy and photocopies. Rights purchased vary according to project. Finds freelancers through submission packets and word of mouth.

Design Assigns 2 freelance design jobs/year. Pays by the project, $600-1,000.

Jackets/Covers Assigns 6 freelance design jobs/year. Pays by the project, $600-1,000.

⊡ WEIGL EDUCATIONAL PUBLISHERS LIMITED

6325-10th St. SE, Calgary AB T2H 2Z9 Canada. (403)233-7747. Fax: (403)233-7769. E-mail: Linda @weigl.com. Website: www.weigl.com. **Contact:** Managing Editor. Estab. 1979. Textbook and library series publisher catering to juvenile and young adult audience. Specializes in social studies, science-environmental, life skills, multicultural American and Canadian focus. Titles include: *The titles are Structural Wonders*; *Backyard Animals and Learning to Write.* Publishes over 100 titles/year. Book catalog free by request.

Needs Approached by 300 freelancers/year. Uses freelancers only during peak periods. Prefers freelancers with experience in children's text illustration in line art/watercolor. Uses freelancers mainly for text illustration or design; also for direct mail design. Freelancers should be familiar with QuarkXPress 5.0, Illustrator 10.0 and Photoshop 7.0.

First Contact & Terms Send résumé for initial review prior to selection for interview. Limited freelance opportunities. Graphic designers required on site. Extremely limited need for illustrators. Samples are returned by SASE if requested by artist. Responds only if interested. Write for appointment to show portfolio of original/

final art (small), b&w photostats, tearsheets and photographs. Rights purchased vary according to project.

Text Illustration Pays on per-project basis, depending on job. Prefers line art and watercolor appropriate for elementary and secondary school students.

WHITE MANE PUBLISHING COMPANY, INC.

73 W. Burd St., P.O. Box 708, Shippensburg PA 17257. (717)532-2237. Fax: (717)532-6110. Website: www.whitemane.com. **Vice President:** Harold Collier. Estab. 1987. Publishes hardcover originals and reprints, trade paperback originals and reprints. Types of books include historical biography, biography, history, juvenile, nonfiction and young adult. Publishes 10 titles/year. 40% require freelance illustration. Book catalog free with SASE.

Needs Works with 2-3 illustrators and 2 designers/year.

First Contact & Terms Send query letter with printed samples. Samples are filed. Interested only in historic artwork. Responds only if interested. Will contact artist for portfolio review if interested. Rights purchased vary according to project. Finds freelancers through submission packets and postcards.

Jackets/Covers Assigns 4 illustration jobs/year. Pays for design by the project.

Tips Uses art for covers only-realistic historical scenes for young adults.

ALBERT WHITMAN & COMPANY

6340 Oakton, Morton Grove IL 60053-2723. (847)581-0033. Fax: (847)581-0039. E-mail: mail@ awhitmanco.com. Website: www.albertwhitman.com. **Art Director:** Carol Gildar. Publishes hardcover originals. Specializes in juvenile fiction and nonfiction—many picture books for young children. Recent titles: *Callie Cat, Ice Skater*, by Eileen Spinelli, art by Anne Kennedy; *The Frog with the Big Mouth*, by Teresa Bateman, art by Will Terry. *Bravery Soup*, by Maryann Cocca-Leffle. Publishes 35 titles/year; 100% require freelance illustration.

Needs Prefers working with artists who have experience illustrating juvenile trade books. Works on assignment only.

First Contact & Terms Illustrators: Send postcard sample and tearsheets. "One sample is not enough. We need at least three. Do *not* send original art through the mail." Accepts disk submissions. Samples are not returned. Responds "if we have a project that seems right for the artist. We like to see evidence that an artist can show the same children and adults in a variety of moods, poses and environments." Rights purchased vary. Original work returned at job's completion.

Tips Books need "a young look—we market to preschoolers and children in grades 1-3." Especially looks for "an artist's ability to draw people (especially children) and to set an appropriate mood for the story. Please do NOT submit cartoon art samples or flat digital illustrations."

WILSHIRE BOOK CO.

9731 Variel Ave., Chatsworth CA 91311. (818)700-1522. E-mail: mpowers@mpowers. com. Website: www.mpowers.com. **President:** Melvin Powers. Publishes trade paperback originals and reprints. Types of books include Internet marketing, humor, instructional, New Age, psychology, self-help, inspirational and other types of nonfiction. Recent titles: *Think Like a Winner!*; *The Dragon Slayer with a Heavy Heart*; and *The Knight in Rusty Armor*. Publishes 25 titles/year; 100% require freelance design.

Needs Uses freelancers mainly for book covers.

First Contact & Terms Send query letter with fee schedule, tearsheets, photostats, photocopies (copies of previous book covers).

Design Assigns 25 freelance design jobs/year.

Jackets/Covers Assigns 25 cover jobs/year.

Greeting Cards, Gifts & Products

The companies listed in this section contain some great potential clients for you. Although greeting card publishers make up the bulk of the listings, you'll also find many businesses that need images for all kinds of other products. We've included manufacturers of everyday items such as paper plates, napkins, banners, shopping bags, T-shirts, school supplies, personal checks and calendars, as well as companies looking for fine art for limited edition collectibles.

TIPS FOR GETTING STARTED

1. Read the listings carefully to learn exactly what products each company makes and the specific styles and subject matter they use.

2. Browse store shelves to see what's out there. Take a notebook and jot down the types of cards and products you see. If you want to illustrate greeting cards, familiarize yourself with the various categories of cards and note which images tend to appear again and again in each category.

3. Pay attention to the larger trends in society, such as diversity, patriotism, and the need to feel connected to others. Fads such as reality TV and scrapbooking, as well as popular celebrities, often show up in images on cards and gifts. Trends can also be spotted in movies and on websites.

GUIDELINES FOR SUBMISSION

- Do *not* send originals. Companies want to see photographs, photocopies, printed samples, computer printouts, tearsheets or slides. Many also accept digital files on disc or via e-mail.
- Artwork should be upbeat, brightly colored, and appropriate to one of the major categories or niches popular in the industry.
- Make sure each sample is labeled with your name, address, phone number, e-mail address and website.

Greeting Card Basics

Important

- **Approximately 7 billion** greeting cards are purchased annually, generating more than $7.5 billion in retail sales.

- **Women** buy more than 80% of all greeting cards.

- **Seasonal cards** express greetings for more than 20 different holidays, including Christmas, Easter and Valentine's Day. Christmas cards account for 60% of seasonal greeting card sales.

- **Everyday cards** express non-holiday sentiments. The "everyday" category includes get well cards, thank you cards, sympathy cards, and a growing number of person-to-person greetings. There are cards of encouragement that say "Hang in there!" and cards to congratulate couples on staying together, or even getting divorced! There are cards from "the gang at the office" and cards to beloved pets. Check store racks for possible "everyday" occasions.

- **Categories** are further broken down into the following areas: **traditional, humorous** and **alternative.** "Alternative" cards feature quirky, sophisticated or offbeat humor.

- **There are more than 2,000 greeting card publishers in America,** ranging from small family businesses to major corporations.

- Send three to five appropriate samples of your work to the contact person named in the listing. Include a brief cover letter with your initial mailing.
- Enclose a self-addressed, stamped envelope if you need your samples back.
- Within six months, follow up with another mailing to the same listings and additional card and gift companies you have researched.

Don't overlook the collectibles market

Limited edition collectibles, such as ornaments, figurines and collector plates, appeal to a wide audience and are a lucrative niche for artists. To do well in this field, you have to be flexible enough to take suggestions. Companies test-market products to find out which images will sell the best, so they will guide you in the creative process. For a collectible plate, for example, your work must fit into a circular format or you'll be asked to extend the painting out to the edge of the plate.

Popular themes for collectibles include animals (especially kittens and puppies), children, dolls, TV nostalgia, and patriotic, Native American, wildlife, religious (including madonnas and angels), gardening, culinary and sports images.

Helpful Resources

For More Info

Greetings etc. (www.greetingsmagazine.com) is the official publication of the **Greeting Card Association** (www.greetingcard.org). Subscribe online, and sign up for a free monthly e-newsletter.

Party & Paper is a trade magazine focusing on the party niche. Visit www.partypaper.com for industry news and subscription information.

The National Stationery Show is the "main event" of the greeting card industry. Visit www.nationalstationeryshow.com to learn more.

E-cards

If you are at all familiar with the Internet, you know that electronic greeting cards are very popular. Many can be sent for free, but they drive people to websites and can, therefore, be a smart marketing tool. The most popular e-cards are animated, and there is an increasing need for artists who can animate their own designs for the Web, using Flash animation. Search the Web and visit sites such as www.hallmark.com, www.bluemountain.com and www.americangreetings.com to get an idea of the variety of images that appear on e-cards. Companies often post their design needs on their websites.

PAYMENT AND ROYALTIES

Most card and product companies pay set fees or royalty rates for design and illustration. Card companies almost always purchase full rights to work, but some are willing to negotiate for other arrangements, such as greeting card rights only. If the company has ancillary plans in mind for your work (calendars, stationery, party supplies or toys), they will probably want to buy all rights. In such cases, you may be able to bargain for higher payment.

KURT S. ADLER, INC.

7 W. 34th St., Suite 100, New York NY 10001-3019. (212)924-0900. Fax: (212)807-0575. E-mail: info@kurtadler.com. Website: www.kurtadler.com. **President:** Howard Adler. Estab. 1946. Manufacturer and importer of Christmas ornaments and giftware products. Produces collectible figurines, decorations, gifts, ornaments.

Needs Prefers freelancers with experience in giftware. Considers all media. Will consider all styles appropriate for Christmas ornaments and giftware. Produces material for Christmas, Halloween.

First Contact & Terms Send query letter with brochure, photocopies, photographs. Responds within 1 month. Will contact for portfolio review if interested. Payment negotiable.

Tips "We rely on freelance designers to give our line a fresh, new approach and innovative new ideas."

ALEF JUDAICA, INC.

13310 S. Figueroa St., Los Angeles CA 90061. (310)202-0024. Fax: (310)202-0940. E-mail: alon@alefjudaica.com. Website: www.alefjudaica.com. **President:** Alon Rozov. Estab. 1979. Manufacturer and distributor of a full line of Judaica, including menorahs, Kiddush cups, greeting cards, giftwrap, tableware, etc.

Needs Approached by 15 freelancers/year. Works with 10 freelancers/year. Buys 75-100 freelance designs and illustrations/year. Prefers local freelancers with experience. Works on assignment only. Uses freelancers for new designs in Judaica gifts (menorahs, etc.) and ceramic Judaica. Also for calligraphy, pasteup and mechanicals. All designs should be upper scale Judaica.

First Contact & Terms Mail brochure, photographs of final art samples. Art director will contact artist for portfolio review if interested, or portfolios may be dropped off every Friday. Sometimes requests work on spec before assigning a job. Pays $300 for illustration/design; pays royalties of 10%. Considers buying second rights (reprint rights) to previously published work.

ALLPORT EDITIONS

2337 NW York St., Portland OR 97210-2112. (503)223-7268. Fax: (503)223-9182. E-mail: art@allport.com. Website: www.allport.com. **Contact:** Creative Director. Estab. 1983. Produces greeting cards. Specializes in regional designs (American Cities and States). Currently only working with hand-rendered art (pen and ink, watercolor, acrylic, etc.). Does not use any photography. Art guidelines available on website.

Needs Approached by 200 freelancers/year. Works with 3- 5 freelancers/year. Licenses 60 freelance designs and illustrations/year. Prefers art scaleable to card size. Produces material for holidays, birthdays and everyday. Submit seasonal material 1 year in advance.

First Contact & Terms Send query letter with photocopies and SASE. Accepts submissions on disk compatible with PC-formatted TIFF or JPEG files. Samples are filed or returned by SASE. Responds in 4-5 months if response is requested. Rights purchased vary according to project. All contracts on royalty basis.

Tips "Submit enough samples for us to get a feel for your style/collection. Two is probably too few; forty is too many."

AMCAL, INC.

MeadWestvaco Consumer & Office Products, 4751 Hempstead Station Dr., Kettering OH 45429. (937)495-6323. Fax: (937)495-3192. E-mail: calendars@meadwestvaco. com. Website: www.amcalart.com or www.meadwestvaco.com. Publishes calendars, note cards, Christmas cards and other stationery items and books. Markets to a broad distribution channel, including better gifts, books, department stores and larger chains throughout U.S. Some sales to Europe, Canada and Japan. "We look for illustration and design that can be used in many ways: calendars, note cards, address books and more, so we can develop a collection. We license art that appeals to a widely female audience."

Needs Prefers work in horizontal format. No gag humor or cartoons. Art guidelines available for SASE with first-class postage or on website.

First Contact & Terms Send query letter with brochure, résumé, photographs, slides, tearsheets and transparencies. Include a SASE for return of material. Responds within 6 weeks. Will contact artist for portfolio review if interested. Pays for illustration by the project, advance against royalty.

Tips "Research what is selling and what's not. Go to gift shows and visit lots of stationery stores. Read all the trade magazines. Talk to store owners."

AMERICAN GREETINGS CORPORATION

One American Rd., Cleveland OH 44144. (216)252-7300. Fax: (216)252-6778. E-mail: dan.weiss@amgreetings.com. Website: www.americangreetings.jobs.Estab. 1906. Produces greeting cards, stationery, calendars, paper tableware products, giftwrap and ornaments. Also recruiting for AG Interactive.

Needs Prefers designers with experience in illustration, graphic design, surface design and calligraphy. Also looking for skills in motion graphics, Photoshop, animation and strong drawing skills. Usually works from a list of 100 active freelancers.

First Contact & Terms Apply online. "Do not send samples." Pays $300 and up based on complexity of design. Does not offer royalties.

Tips "Get a BFA in graphic design with a strong emphasis on typography."

ANW CRESTWOOD; THE PAPER COMPANY; PAPER ADVENTURES

510 Ryerson Rd., Lincoln Park NJ 07035. (973)406-5000. Fax: (973)709-9494.

E-mail: katey@anwcrestwood.com. Website: www.anwcrestwood.com. **Creative Department Contact:** Katey Franceschini. Estab. 1901. Produces stationery, scrapbook and paper crafting. Specializes in stationery, patterned papers, stickers and related paper products.

Needs Approached by 100 freelancers/year. Works with 20 freelancers/year. Buys or licenses 150 freelance illustrations and design pieces/year. Prefers freelancers with experience in illustration/fine art, stationery design/surface design. Works on assignment only. Considers any medium that can be scanned.

First Contact & Terms Mail or e-mail nonreturnable color samples. Company will call if there is a current or future project that is relative. Accepts Mac-compatible disk and e-mail submissions. Samples are filed for future projects. Will contact artist for more samples and to discuss project. Pays for illustration by the project, $100 and up. Also considers licensing for complete product collections. Finds freelancers through trade shows and *Artist's & Graphic Designer's Market*.

Tips "Research the craft and stationery market and send only appropriate samples for scrapbooking, cardcrafting and stationery applications. Send lots of samples, showing your best, neatest and cleanest work with a clear concept."

APPLEJACK ART PARTNERS

P.O. Box 1527, Manchester Center VT 05255. (802)362-3662. Fax: (802)362-3286. E-mail: jess@applejackart.com. Website: www.applejackart.com. Art Director: Jess Rogers. Licenses art for bookmarks, calendars, collectible figurines, decorative housewares, decorations, games, giftbags, gifts, giftwrap, greeting cards, limited edition plates, mugs, ornaments, paper tableware, party supplies, personal checks, posters, prints, school supplies, stationery, T-shirts, textiles, toys, wallpaper, etc.

- Long-established poster companies Bernard Fine Art, Hope Street Editions and Rose Selavy of Vermont are divisions of Applejack Art Partners. Applejack publishes art for decorative wall decor and fine art.

Needs Seeking extensive artwork for use on posters and a wide cross section of product categories. Looking for variety of styles and subject matter. Art guidelines free for SASE with first-class postage. Considers all media and all styles. Produces material for all holidays.

First Contact & Terms Send color photocopies, photographs, tearsheets, CD-ROM. No e-mail submissions. Accepts disk submissions compatible with Mac. Samples are filed or returned by SASE only. Responds in 1 month. Will contact artist for portfolio review if interested.

AR-EN PARTY PRINTERS, INC.

8225 N. Christiana Ave., Skokie IL 60076. (847)673-7390. Fax: (847)673-7379. E-mail: info@ar-en.net. Website: www.ar-en.com. **Owner:** Gary Morrison. Estab.

1978. Produces stationery and paper tableware products. Makes personalized party accessories for weddings and all other affairs and special events.

Needs Works with 1-2 freelancers/year. Buys 10 freelance designs and illustrations/year. Works on assignment only. Uses freelancers mainly for new designs; also for calligraphy. Looking for contemporary and stylish designs, especially b&w line art (no grayscale) to use for hot stamping dyes. Prefers small (2 × 2) format.

First Contact & Terms Send query letter with brochure, résumé and SASE. Samples are filed or returned by SASE if requested by artist. Responds in 2 weeks. Will contact artist for portfolio review if interested. Rights purchased vary according to project. Pays by the hour, $40 minimum; by the project, $750 minimum.

Tips "My best new ideas always evolve from something I see that turns me on. Do you have an idea/style that you love? Market it. Someone out there needs it."

ARTFUL GREETINGS

P.O. Box 52428, Durham NC 27717. (919)484-0100. Fax: (919)484-3099. E-mail: myw@artfulgreetings.com. Website: www.artfulgreetings.com. **Vice President of Operations:** Marian Whittedalderman. Estab. 1990. Produces bookmarks, greeting cards, T-shirts and magnetic notepads. Specializes in multicultural subject matter, all ages.

Needs Approached by 200 freelancers/year. Works with 10 freelancers/year. Buys 20 freelance designs and illustrations/year. No b&w art. Uses freelancers mainly for cards. Considers bright color art, no photographs. Looking for art depicting people of all races. Prefers a multiple of 2 sizes: 5 × 7 and 5½ × 8. Produces material for Christmas, Mother's Day, Father's Day, graduation, Kwanzaa, Valentine's Day, birthdays, everyday, sympathy, get well, romantic, thank you, woman-to-woman and multicultural. Submit seasonal material 1 year in advance.

First Contact & Terms Designers: Send photocopies, SASE, slides, transparencies (call first). Illustrators: Send photocopies (call first). May send samples and queries by e-mail. Samples are filed. Artist should follow up with call or letter after initial query. Will contact for portfolio review of color slides and transparencies if interested. Negotiates rights purchased. Pays for illustration by the project, $50-100. Finds freelancers through word of mouth, NY Stationery Show.

Tips "Don't sell your one, recognizable style to all the multicultural card companies."

ART LICENSING INTERNATIONAL INC.

1022 Hancock Ave., Sarasota FL 34232. (941)966-4042. E-mail: artlicensing@comcast. net. Website: www.out-of-the-blue.us. **President:** Michael Woodward. Licenses art and photography for fine art prints, canvas giclees for hotels and offices, wall decor, calendars, paper products and greeting cards.

- See additional listings for this company in the Posters & Prints and Artists' Reps sections. See also listing for Out of the Blue in this section.

BARTON-COTTON INC.

2615 Tyrone Rd., Westminster MD 21158 (410)247-4800. Fax: (410)-247-2548. E-mail: tammy.severe@bartoncotton.com. Website: www.bartoncotton.com. **Art Buyer:** Tammy Severe. Produces religious greeting cards, commercial all-occasion, Christmas cards, wildlife designs and spring note cards. Licenses wildlife art, photography, traditional Christmas art for note cards, Christmas cards, calendars and all-occasion cards.

Needs Buys 150-200 freelance illustrations/year. Submit seasonal work any time. Free art guidelines for SASE with first-class postage and sample cards; specify area of interest (religious, Christmas, spring, etc.). **First Contact & Terms** Send query letter with résumé, tearsheets, photocopies or slides. Submit full-color work only (watercolor, gouache, pastel, oil and acrylic). Previously published work and simultaneous submissions accepted. Responds in 1 month. Pays by the project. Pays on acceptance. **Tips** "Good draftsmanship is a must. Spend some time studying current market trends in the greeting card industry. There is an increased need for creative ways to paint traditional Christmas scenes with up-to-date styles and techniques."

BEISTLE COMPANY

1 Beistle Plaza, Shippensburg PA 17257-9623. (717)532-2131. Fax: (717)532-7789. E-mail: beistle@cvn.net. Website: www.beistle.com. Art Director: Rick Buterbaugh. Estab. 1900. Manufacturer of paper and plastic decorations, party goods, gift items, tableware and greeting cards. Targets general public, home consumers through P-O-P displays, specialty advertising, school market and other party good suppliers.

Needs Approached by 250-300 freelancers/year. Works with 50 freelancers/year. Prefers artists with experience in designer gouache illustration. Also needs digital art (Macintosh platform or compatible). Art guidelines available. Looks for full-color, camera-ready artwork for separation and offset reproduction. Works on assignment only. Uses freelance artists mainly for product rendering and brochure design and layout. Prefers digital art using various styles and techniques. 50% of freelance design and 50% of illustration demand knowledge of QuarkXPress, Illustrator, Photoshop or Painter.

First Contact & Terms Send query letter with résumé and color reproductions with SASE. Samples are filed or returned by SASE. Art director will contact artist for portfolio review if interested. Sometimes requests work on spec before assigning a job. Pays by the project. Considers buying second rights (reprint rights) to previously published work. Finds artists through word of mouth, magazines, submissions/self-

promotions, sourcebooks, agents, visiting artists' exhibitions, art fairs and artists' reps.

Tips "Our primary interest is in illustration; often we receive freelance propositions for graphic designbrochures, logos, catalogs, etc. These are not of interest to us as we are manufacturers of printed decorations. Send color samples rather than b&w."

BERGQUIST IMPORTS, INC.

1412 Hwy. 33 S., Cloquet MN 55720. (800)328-0853. Fax: (218)879-0010. E-mail: bergquistimports@ecloquetmn.com. Website: www.bergquistimports.com. **President:** Barry Bergquist. Estab. 1948. Produces paper napkins, mugs and tile. Wholesaler of mugs, decorator tile, plates and dinnerware.

Needs Approached by 25 freelancers/year. Works with 5 freelancers/year. Buys 50 designs and illustrations/year. Prefers freelancers with experience in Scandinavian designs. Works on assignment only. Also uses freelancers for calligraphy. Produces material for Christmas, Valentine's Day and everyday. Submit seasonal material 6-8 months in advance.

First Contact & Terms Send query letter with brochure, tearsheets and photographs. Samples are returned, not filed. Responds in 2 months. Request portfolio review in original query. Artist should follow up with a letter after initial query. Portfolio should include roughs, color tearsheets and photographs. Rights purchased vary according to project. Originals are returned at job's completion. Requests work on spec before assigning a job. Pays by the project, $50-300; average flat fee of $100 for illustration/design; or royalties of 5%. Finds artists through word of mouth, submissions/self-promotions and art fairs.

GENE BLILEY STATIONERY

12011 Sherman Rd., N. Hollywood CA 91605. (800)998-0323. Fax: (866)998-5808. E-mail: info@chatsworthcollection.com. Website: www.chatsworthcollection.com. **Art Director:** Mark Brown. General Manager: Gary Lainer. Sales Manager: Ron Pardo. Estab. 1967. Produces stationery, family-oriented birth announcements and invitations for most events and Christmas cards.

- This company also owns Editions Limited and Frederick Beck Originals. One submission will be seen by both companies. See listing for Editions Limited/Frederick Beck.

BLOOMIN' FLOWER CARDS

4734 Pearl St., Boulder CO 80301. (800)894-9185. Fax: (303)545-5273. E-mail: flowers@bloomin.com. Website: http://bloomin.com. **President:** Don Martin. Estab. 1995. Produces greeting cards, stationery and gift tags—all embedded with seeds.

Needs Approached by 100 freelancers/year. Works with 5-8 freelancers/year. Buys

5-8 freelance designs and illustrations/year. Art guidelines available. Uses freelancers mainly for card images. Considers all media. Looking for florals, garden scenes, holiday florals, birds, and butterflies—bright colors, no photography. Produces material for Christmas, Easter, Mother's Day, Father's Day, Valentine's Day, Earth Day, birthdays, everyday, get well, romantic and thank you. Submit seasonal material 8 months in advance.

First Contact & Terms Designers: Send query letter with color photocopies and SASE or electronic files. Illustrators: Send postcard sample of work, color photocopies or e-mail. Samples are filed or returned with letter if not interested. Responds if interested. Portfolio review not required. Rights purchased vary according to project. Pays royalties for design. Pays by the project or royalties for illustration. Finds freelancers through word of mouth, submissions, and local artists' guild.

Tips "All submissions MUST be relevant to flowers and gardening."

BLUE MOUNTAIN ARTS, INC

P.O. Box 4959, Boulder CO 80306. (303) 449-0536. Fax: (800) 545-8573. E-mail:editorial@sps.co. Website: www.sps.com. **Art Director:** Jody Kauflin. Estab. 1970. Produces books, bookmarks, calendars, greeting cards, mugs and prints. Specializes in handmade-looking greeting cards, calendars and books with inspirational or whimsical messages accompanied by colorful hand-painted illustrations.

Needs Art guidelines free with SASE and first-class postage or on website. Uses freelancers mainly for hand-painted illustrations. Considers all media. Product categories include alternative cards, alternative/humor, conventional, cute, inspirational and teen. Submit seasonal material 10 months in advance. Art size should be 5 × 7 vertical format for greeting cards.

First Contact & Terms Send query letter with photocopies, photographs, SASE and tearsheets. Send no more than 5 illustrations initially. No phone calls, faxes or e-mails. Samples are filed or are returned by SASE. Responds in 2 months. Portfolio not required. Buys all rights. Pays freelancers flat rate: $150-250/illustration if chosen. Finds freelancers through submissions and word of mouth.

Tips "We are an innovative company, always looking for fresh and unique art styles to accompany our sensitive or whimsical messages. We also welcome illustrated cards accompanied with your own editorial content. We strive for a handmade look. We love color! We don't want photography! We don't want slick computer art! Do in-store research to get a feel for the look and content of our products. We want illustrations for printed cards, NOT E-CARDS! We want to see illustrations that fit with our existing looks, and we also want fresh, new and exciting styles and concepts. Remember that people buy cards for what they say. The illustration is a beautiful backdrop for the message."

ASHLEIGH BRILLIANT ENTERPRISES

117 W. Valerio St., Santa Barbara CA 93101. (805)682-0531. **President:** Ashleigh Brilliant. Publishes postcards.

Needs Buys up to 300 designs/year. Freelancers may submit designs for word-and-picture postcards, illustrated with line drawings.

First Contact & Terms Submit 5½ × 3½ horizontal b&w line drawings and SASE. Responds in 2 weeks. Buys all rights. Pays $60 minimum.

Tips "Since our approach is very offbeat, it is essential that freelancers first study our line. Otherwise, you will just be wasting our time and yours. We supply a catalog and sample set of cards for $2 plus SASE."

BRISTOL GIFT CO., INC.

P.O. Box 425, Washingtonville NY 10992. (845)496-2821. Fax: (845)496-2859. E-mail: bristol6@frontiernet.net. Website: www.bristolgift.net. **President:** Matthew Ropiecki. Estab. 1988. Specializes in framed pictures for inspiration and religious markets. Art guidelines available for SASE.

Needs Approached by 5-10 freelancers/year. Works with 2 freelancers/year. Buys 15-30 freelance designs and illustrations/year. Works on assignment only. Uses freelancers mainly for design; also for calligraphy, P-O-P displays, Web design and mechanicals. Prefers 16 × 20 or smaller. 10% of design and 60% of illustration require knowledge of PageMaker or Illustrator. Produces material for Christmas, Mother's Day, Father's Day and graduation. Submit seasonal material 6 months in advance.

First Contact & Terms Send query letter with brochure and photocopies. Samples are filed or returned. Responds in 2 weeks. Will contact artist for portfolio review if interested. Portfolio should include roughs. Requests work on spec before assigning a job. Originals are not returned. Pays by the project, $30-50 or royalties of 5-10%. Rights purchased vary according to project. Interested in buying second rights (reprint rights) to previously published artwork.

CAN CREATIONS, INC.

Box 848576, Pembroke Pines FL 33084. (954)581-3312. Website: www.cancreations.com. **President:** Judy Rappoport. Estab. 1984. Manufacturer of Cello wrap.

Needs Approached by 8-10 freelance artists/year. Works with 2-3 freelance designers/year. Assigns 5 freelance jobs/year. Prefers local artists only. Works on assignment only. Uses freelance artists mainly for "design work for cello wrap." Also uses artists for advertising design, illustration and layout; brochure design; posters; signage; magazine illustration and layout. "We are not looking for illustrators at the present time. Most designs we need are graphic and we also need designs which are geared toward trends in the gift industry. Looking for a graphic website designer for graphics on website only."

First Contact & Terms Send query letter with tearsheets and photostats. Samples are not filed and are returned by SASE only if requested by artist. Responds in 2 weeks. Call or write to schedule an appointment to show a portfolio, which should include roughs and b&w tearsheets and photostats. Pays for design by the project, $75 minimum. Pays for illustration by the project, $150 minimum. Considers client's budget and how work will be used when establishing payment. Negotiates rights purchased.

Tips "We are looking for simple designs geared to a high-end market."

CANETTI DESIGN GROUP INC.

P.O. Box 57, Pleasantville NY 10570. (914)238-1359. Fax: (914)238-0106. E-mail: tech@canettidesigngroup.com. Website: www.canettidesigngroup.com. **Marketing Vice President:** M. Berger. Estab. 1982. Produces photo frames, writing instruments, kitchen accessories and product design.

Needs Approached by 50 freelancers/year. Works with 10 freelancers/year. Works on assignment only. Uses freelancers mainly for illustration/computer. Also for calligraphy and mechanicals. Considers all media. Looking for contemporary style. Needs computer-literate freelancers for illustration and production. 80% of freelance work demands knowledge of Illustrator, Photoshop, Quark.

First Contact & Terms Send postcard-size sample of work and query letter with brochure. Samples are not filed. Portfolio review not required. Buys all rights. Originals are not returned. Pays by the hour. Finds artists through agents, sourcebooks, magazines, word of mouth and artists' submissions.

CAPE SHORE, INC.

Division of Downeast Concepts, 86 Downeast Dr., Yarmouth ME 04096. (800)343-2424. Fax: (800)457-7087. E-mail: webmail@downeastconcepts.com. Website: www.downeastconcepts.com. **Contact:** Melody Martin-Robie, creative director. Estab. 1947. "Cape Shore is concerned with seeking, manufacturing and distributing a quality line of gifts and stationery for the souvenir and gift market." Licenses art by noted illustrators with a track record for paper products and giftware. Guidelines available on website.

Needs Approached by 100 freelancers/year. Works with 50 freelancers/year. Buys 400 freelance designs and illustrations/year. Prefers artists and product designers with experience in gift product, hanging ornament and stationery markets. Art guidelines available free for SASE. Uses freelance illustration for boxed note cards, Christmas cards, ornaments, home accessories, ceramics and other paper products. Considers all media. Looking for skilled wood carvers with a warm, endearing folk art style for holiday gift products.

First Contact & Terms "Do not telephone; no exceptions." Send query letter with

color copies. Samples are filed or are returned by SASE. Art director will contact artist for portfolio review if interested. Portfolio should include finished samples, printed samples. Pays for design by the project, advance on royalties or negotiable flat fee. Buys varying rights according to project.

Tips "Cape Shore is looking for realistic detail, good technique, and traditional themes or very high quality contemporary looks for coastal as well as inland markets. We will sometimes buy art for a full line of products, or we may buy art for a single note or gift item. Proven success in the giftware field a plus, but will consider new talent and exceptional unpublished illustrators."

CARDMAKERS

P.O. Box 236, Lyme NH 03768. Phone/fax: (603)795-4422. E-mail: info@cardmakers. com. Website: www.cardmakers.com. **Principal:** Peter Diebold. Estab. 1978. Produces greeting cards. "We produce cards for special interests and greeting cards for businesses—primarily Christmas. We also publish everyday cards for stockbrokers and boaters."

- CardMakers requests if you send submissions via e-mail, please keep files small. When sending snail mail, please be aware they will only respond if SASE is included.

Needs Approached by more than 300 freelancers/year. Works with 5-10 freelancers/year. Buys 20-40 designs and illustrations/year. Prefers professional-caliber artists. Art guidelines available on website only. "Please do not e-mail us for same." Works on assignment only. Uses freelancers mainly for greeting card design and calligraphy. Considers all media. "We market 5 × 7 cards designed to appeal to individual's specific interest—boating, building, cycling, stocks and bonds, etc." Prefers an upscale look. Submit seasonal ideas 6-9 months in advance.

First Contact & Terms Designers: Send brief sample of work. Illustrators: Send postcard sample or query letter with brief sample of work. "One good sample of work is enough for us. A return postcard with boxes to check off is wonderful. Phone calls are out; fax is a bad idea." Samples are filed. Responds only if interested. Portfolio review not required. Pays flat fee of $100-300, depending on many variables. Rights purchased vary according to project. Interested in buying second rights (reprint rights) to previously published work, if not previously used for greeting cards. Finds artists through word of mouth, exhibitions and *Artist's & Graphic Designer's Market* submissions.

Tips "We like to see new work in the early part of the year. It's important that you show us samples *before* requesting submission requirements. Getting published and gaining experience should be the main objective of freelancers entering the field. We favor fresh talent (but do also feature seasoned talent). PLEASE be patient waiting to hear from us! Make sure your work is equal to or better than that which is commonly found in use presently. Go to a large greeting card store. If you think you're as good or better than the artists there, continue!"

CAROLE JOY CREATIONS, INC.

1087 Federal Rd., Unit #8, Brookfield CT 06804. Fax: (203)740-4495. Website: www.carolejoy.com. **President:** Carole Gellineau. Estab. 1985. Produces greeting cards. Specializes in cards, notes and invitations for people who share an African heritage.

Needs Approached by 200 freelancers/year. Works with 5-10 freelancers/year. Buys 100 freelance designs, illustrations and calligraphy/year. Will license design where appropriate. Also interested in licensing 12 coordinated images for calendars. Prefers artists "who are thoroughly familiar with, educated in and sensitive to the African-American culture." Works on assignment only. Uses freelancers mainly for greeting card art; also for calligraphy. Considers full color only. Looking for realistic, traditional, Afrocentric, colorful and upbeat style. Prefers 11 × 14. 20% of freelance design work demands knowledge of Illustrator, Photoshop and QuarkXPress. Produces material for Christmas, Easter, Mother's Day, Father's Day, graduation, Kwanzaa, Valentine's Day, birthdays and everyday; also for sympathy, get well, romantic, thank you, serious illness and multicultural cards. Submit seasonal material 1 year in advance.

First Contact & Terms Send query letter with brochure, photocopies, photographs and SASE. No phone calls or slides. No e-mail addresses. Responds to street address only. Calligraphers: send samples and compensation requirements. Samples are not filed and are returned with SASE only within 6 months. Responds only if interested. Portfolio review not required. Buys all rights. Pays for illustration by the project. Does not pay royalties; will license at one-time flat rate.

Tips "Excellent illustration skills are necessary, and designs should be appropriate for African-American social expression. Writers should send verse that is appropriate for greeting cards and avoid lengthy, personal experiences. Verse and art should be uplifting. We need coordinated themes for calendars."

CENTRIC CORP.

6712 Melrose Ave., Los Angeles CA 90038. (323)936-2100. Fax: (323)936-2101. E-mail: centric@juno.com. Website: www.centriccorp.com. **President:** Sammy Okdot. Estab. 1986. Produces products such as watches, pens, T-shirts, pillows, clocks, and mugs. Specializes in products that feature nostalgic, humorous, thought-provoking images or sayings on them and some classic licensed celebrities.

Needs Looking for freelancers who know Photoshop, QuarkXPress and Illustrator well.

First Contact & Terms Send examples of your work. Pays when project is completed.

Tips "Research the demographics of buyers who purchase Elvis, Lucy, Marilyn Monroe, James Dean, Betty Boop and Bettie Page products to know how to 'communicate a message' to the buyer."

CHARTPAK/FRANCES MEYER, INC.

1 River Road, Leeds MA 01053. (800)628-1910. Fax: (800)584-6781. E-mail:info@ chartpak.co. Website: www.chartpak.com. **Contact:** Lana Casiello, creative director. Estab. 1979. Produces scrapbooking products, stickers and stationery.

- Acquired by Chartpak, Inc. in 2003, the Frances Meyer brand produces scrapbooking and paper crafting products including patterned paper, stickers and paper.

Needs We currently work with 5-6 illustrators a year and accept hand rendered pieces as well as digital artwork. Work on assignment as well as altering existing works only shown outside the paper crafting market. Looking for children's themes, seasonal themes, holiday, baby, wedding, graduation, party themes and more.

First Contact & Terms Send query letter with examples or tearsheets, SASE, and as much information as is necessary to show diversity of style and creativity. No originals please. No response or return of samples without SASE with appropriate postage. Company will contact artist for portfolio review if interested. Responds in 2-3 months. All artwork will be used for presentation, in which the illustrator may request a fee. Complete payment for artwork and royalty options are negotiable and due to the illustrator once the piece goes into production.

Tips "Generally, we are looking to work with a few talented and committed artists for an extended period of time. We show our buyers designs on an ongoing basis for nine months out of the year, and it may take up to nine months to determine whether a piece will make it to the production stage of the process. If an item sells, it will remain in the line.

CITY MERCHANDISE INC.

228 40th St., Brooklyn NY 11232. (718)832-2931. Fax: (718)832-2939. E-mail: city@ citymerchandise.com. **Executive Assistant:** Martina Santoli. Produces calendars, collectible figurines, gifts, mugs, souvenirs of New York.

Needs Works with 6-10 freelancers/year. Buys 50-100 freelance designs and illustrations/year. "We buy sculptures for our casting business." Prefers freelancers with experience in graphic design. Works on assignment only. Uses freelancers for most projects. Considers all media. 50% of design and 80% of illustration demand knowledge of Photoshop, QuarkXPress, Illustrator. Does not produce holiday material.

First Contact & Terms Designers: Send query letter with brochure, photocopies, résumé. Illustrators and/or cartoonists: Send postcard sample of work only. Sculptors: Send résumé and slides, photos or photocopies of their work. Samples are filed. Include SASE for return of samples. Responds in 2 weeks. Portfolios required for sculptors only if interested in artist's work. Buys all rights. Pays by project.

CLAY ART

239 Utah Ave., South San Francisco CA 94080-6802. (650)244-4970. Fax: (650)244-4979. Website: www.clayart.net. **Art Director:** Jenny McClain Doores. Estab. 1979. Produces giftware and home accessory products cookie jars, salt & peppers, mugs, pitchers, platters and canisters. Line features innovative, contemporary or European tableware and hand-painted designs.

Needs Approached by 70 freelancers/year. Prefers freelancers with experience in 3-D design of giftware and home accessory items. Works on assignment only. Uses freelancers mainly for illustrations and 3-D design. Seeks humorous, whimsical, innovative work.

First Contact & Terms Send query letter with résumé, SASE, tearsheets and photocopies. Samples are filed. Responds only if interested. Call for appointment to show portfolio of thumbnails, roughs, final art, color photostats, tearsheets, slides and dummies. Negotiates rights purchased. Originals are returned at job's completion. Pays by project. Prefers buying artwork outright.

CLEO, INC.

4025 Viscount Ave., Memphis TN 38118. (901)369-6657 or (800)289-2536. Fax: (901)369-6376. E-mail: sales@cleowrap.com. Website: www.cleowrap.com. **Senior Director of Creative Resources:** Claude Patat. Estab. 1953. Produces giftwrap and gift bags. "Cleo is the world's largest Christmas giftwrap manufacturer. Other product categories include some seasonal product. Mass market for all age groups."

Needs Approached by 25 freelancers/year. Works with 40-50 freelancers/year. Buys more than 200 freelance designs and illustrations/year. Uses freelancers mainly for giftwrap and gift bags (designs). Also for calligraphy. Considers most any media. Looking for fresh, imaginative as well as classic quality designs for Christmas. 30" repeat for giftwrap. Art guidelines available. Submit seasonal material at least a year in advance.

First Contact & Terms Send query letter with slides, SASE, photocopies, transparencies and speculative art. Accepts submissions on disk. Samples are filed if interested or returned by SASE if requested by artist. Responds only if interested. Rights purchased vary according to project; usually buys all rights. Pays flat fee. Also needs package/product designers, pay rate negotiable. Finds artists through agents, sourcebooks, magazines, word of mouth and submissions.

Tips "Understand the needs of the particular market to which you submit your work."

COMSTOCK CARDS, INC.

600 S. Rock Blvd., Suite 15, Reno NV 89502. (775)856-9400. Fax: (775)856-9406. E-mail: production@comstockcards.com. Website: www.comstockcards.com.

Contact: Production Assistant. Estab. 1986. Produces greeting cards, giftbags and invitations. Styles include alternative and adult humor, outrageous and shocking themes. Art guidelines available for SASE with first-class postage.

Needs Approached by 250-350 freelancers/year. Works with 30-35 freelancers/year. "Especially seeking artists able to produce outrageous adult-oriented cartoons." Uses freelancers mainly for cartoon greeting cards. No verse or prose. Gaglines must be brief. Prefers 5 × 7 final art. Produces material for all occasions. Submit holiday concepts 6 months in advance.

First Contact & Terms Send query letter with SASE, tearsheets or photocopies. Samples are not usually filed and are returned by SASE if requested. Responds only if interested. Portfolio review not required. Originals are not returned. Pays royalties of 5%. Pays by the project, $50-150 minimum; may negotiate other arrangements. Buys all rights.

CONCORD LITHO

92 Old Turnpike Rd., Concord NH 03301. (603)225-3328 or (800)258-3662. Fax: (603)225-6120. Website: www.concordlitho.com. **Contact:** Art Librarian. Estab. 1958. Produces greeting cards, stationery, posters, giftwrap, specialty paper products for nonprofit direct mail fundraising.

Needs Licenses artwork, illustration and photography. Considers all media but prefers watercolor. Art needs range from all-occasion and holiday greeting cards to religious subjects, wildlife, florals, nature, scenics, cute and whimsical. Always looking for traditional religious art. Produces printed material for Christmas, Valentine's Day, Mother's Day, Father's Day, Easter, Thanksgiving, New Year, birthdays, everyday and other religious dates. Submit seasonal material minimum 6-8 months in advance.

First Contact & Terms Send introductory letter with with nonreturnable photographs, samples, or photocopies of work. Will keep samples that have strong potential for use on file. Also accepts submissions on disk. "Indicate whether work is for style only and if it is available." Responds in 3 months. Portfolio review not required. Rights purchased vary according to project. Pays by the project, $200-800. "No phone calls, please."

Tips Send quality samples or copies.

COURAGE CARDS

P.O. Box 1563., Saint Cloud, MN 56302. (800)873-1771. E-mail: couragecusterv@courage.org. Website: www.couragecards.org. **Art and Production Manager:** Laura Brooks. Estab. 1970. Courage Cards are holiday cards that are produced to support the programs of Courage Center, a nonprofit provider of rehabilitation services that helps people with disabilities live more independently.

Needs Seeking holiday art appropriate for greeting cards—including traditional,

winter, nostalgic, religious, ethnic and world peace designs. Features artists with disabilities, but all artists are encouraged to enter the annual Courage Card Art Search. Submission guidelines available on website.

First Contact & Terms Call or e-mail name and address to receive Art Search guidelines, which are mailed in early May for the July 31 entry deadline. Artist retains ownership of the art. Pays $400 licensing fee in addition to nationwide recognition through distribution of more than 500,000 catalogs and promotional pieces, Internet, TV, radio and print advertising.

Tips "Do not send originals. Entries should be sent with a completed Art Search guidelines form. The Selection Committee chooses art that will reproduce well as a card. We need colorful contemporary and traditional images for holiday greetings. Participation in the Courage Cards Art Search is a wonderful way to share your talents and help people live more independently."

CREATIF LICENSING

31 Old Town Crossing, Mt. Kisco NY 10549. (914)241-6211. Website: www.creatifusa. com. **Licensing Contact:** Marcie Silverman. Estab. 1975. "Creatif is a licensing agency that represents artists and brands." Licensing art for commercial applications on consumer products in the gift, stationery and home furnishings industries.

Needs Looking for unique art styles and/or concepts that are applicable to multiple products and categories.

First Contact & Terms Send query letter with photocopies, photographs, SASE or tearsheets. Does not accept e-mail attachments but will review website links. Responds in 2 months. Samples are returned with SASE. Creatif will obtain licensing agreements on behalf of the artists, negotiate and manage the licensing programs and pay royalties. Artists are responsible for filing all copyright and trademark. Requires exclusive representation of artists.

Tips "We are looking to license talented and committed artists. It is important to understand current trends, and design with specific products in mind."

✠ CREEGAN CO., INC.

The Creegan Animation Factory, 508 Washington St., Steubenville OH 43952. (740)283-3708. Fax: (740)283-4117. E-mail: creegans@weir.net. Website: www. creegans.com. **President:** Dr. G. Creegan. Estab. 1961. "The Creegan Company designs and manufactures animated characters, costume characters and life-size audio animatronic air-driven characters. All products are custom made from beginning to end."

• Recently seen on the Travel Channel and Made in America with John Ratzenberger.

Needs Prefers local artists with experience in sculpting, latex, oil paint, molding,

etc. Artists sometimes work on assignment basis. Uses freelancers mainly for design comps. Also for mechanicals. Produces material for all holidays and seasons, Christmas, Valentine's Day, Easter, Thanksgiving, Halloween and everyday. Submit seasonal material 3 months in advance.

First Contact & Terms Send query letter with résumé and nonreturnable photos or other samples. Samples are filed. Responds. Write for appointment to show portfolio of final art, photographs. Originals returned. Rights purchased vary according to project.

SUZANNE CRUISE CREATIVE SERVICES, INC.

7199 W. 98th Terrace, Suite #110, Overland Park KS 66212. (913)648-2190. Fax: (913)648-2110. E-mail: artagent@cruisecreative.com. Website: www.cruisecreative. com. **President:** Suzanne Cruise. Estab. 1990. Art agent representing artists for licensing in categories such as calendars, craft papers, decorative housewares, fabric giftbags, gifts, giftwrap, greeting cards, home decor, keychains, mugs, ornaments, prints, scrap booking, stickers, tabletop, and textiles. "We are a full-service licensing agency, as well as a full-service creative agency representing both licensed artists and children's book illustrators. "Our services include, but are not limited to, screening manufacturers for quality and distribution, negotiating rights, overseeing contracts and payments, sending artists' samples to manufacturers for review, and exhibiting artists' work at major trade shows annually." Art guidelines available on website.

Needs Seeks established and emerging artists with distinctive styles suitable for the ever-changing consumer market. Looking for artists that manufacturers cannot find, or artist who are looking for a well-established licensing agency to fully represent their work. We represent established licensing artists as well as artists whose work has the potential to become a classic license. "We work with artists who offer a variety of styles, and we license their work to manufacturers of goods that include, but are not limited to: gifts, home decor, greeting cards, gift wrap and bags, paper party ware and textiles. We look for work that has popular appeal and we prefer that portfolio contain both seasonal as well as every day images. It can be traditional, whimsical, floral, juvenile, cute or contemporary in style."

First Contact & Terms Send query letter with color copies, a lo res disc with color copies, samples or lo res JPEGs. Please send no original art. Samples are returned only if accompanied by SASE. Responds only if interested. Portfolio required. Request portfolio review in original query.

Tips "Walk a few trade shows and familiarize yourself with the industries you want your work to be in. Attend a few of the panel.discussions that are put on during the shows to get to know the business a little better."

CSI CHICAGO INC.

4353 N. Lincoln Ave., Chicago IL 60618. (773)665-2226. Fax: (773)665-2228. E-mail: csichicago1@yahoo.com. Website: www.custom-studios.com. **President:** Gary Wing. Estab. 1966. We specialize in designing and screen printed custom T-shirts, coffee mugs, bumper stickers, balloons and over 1,000 other products for schools, business promotions, fundraising and for our own line of stock designs for retail sale.

Needs Works with 7 freelance illustrators/year. Assigns 10-12 freelance jobs/year. Needs b&w illustrations (some original and some from customer's sketch). Uses artists for direct mail and brochures/fliers, but mostly for custom and stock T-shirt designs. We are open to new stock design ideas the artist may have."

First Contact & Terms Send query letter with résumé, e-mail black & white and color PDF, TIF or EPS art files to be kept on file. We will not return mailes originals or samples." Responds in 1 week-to a month. Pays for design and illustration by the hour, $20-35; by the project, $50-150. Considers turnaround time and rights purchased when establishing payment. For designs submitted to be used as stock T-shirt designs, pays 5-10% royalty. Stock designs should be something that the general public would buy and especially Chicago type designs for souvenir shirts. Rights purchased vary according to project.

Tips Send 5-10 good copies of your best work. We would like to see more PDF illustrations or copies, not originals. Do not get discouraged if your first designs sent are not accepted."

CURRENT, INC.

1005 E. Woodmen Rd., Colorado Springs CO 80920. (719)594-4100. Fax: (719)531-2564. Website: www.currentcatalog.com, www.colorfulimages.com, www.LillianVernon. com, www.PaperDirect.com Art and Licensing. **Creative Business Manager:** Dana Grignano. Estab. 1950. Produces bookmarks, calendars, collectible plates, decorative housewares, decorations, giftbags, gifts, giftwrap, greeting cards, mugs, ornaments, school supplies, stationery, T-shirts. Specializes in seasonal and everyday social expressions products and personalized paper products.

Needs Works with hundreds of freelancers/year. Buys 700 freelance designs and illustrations/year. Prefers freelancers with experience in greeting cards and textile industries. Uses freelancers mainly for cards, wraps, calendars, gifts, calligraphy. Considers all media. Product categories include business, conventional, cute, cute/ religious, juvenile, religious, teen. Freelancers should be familiar with Photoshop, Illustrator and FreeHand. Produces material for all holidays and seasons and everyday. Submit seasonal material year-round. Looking for artists who can draw 3-D designs for custom made ornaments, wall decor, and gifts.

First Contact & Terms Send query letter with photocopies, tearsheets, brochure and photographs. Samples are filed. Responds only if interested. Will contact artist for portfolio review if interested. Buys all rights. Pays by the project; $50-500. Finds

freelancers through agents, submissions, sourcebooks.

Tips "Review website or catalog prior to sending work."

DESIGNER GREETINGS, INC.

11 Executive Ave., Edison, NJ 08817. E-mail: submissions@designergreetings.com .
Website: www.designergreetings.com. **Creative Director:** Andy Epstein. "We produce
all types of greeting cards including holiday, religious, alternative, general, informal,
inspirational, contemporary, juvenile, humorous, studio cards and gift wrap.

Needs Works with 16 freelancers/year. Buys 250-300 designs and illustrations/year.
Art guidelines on web site. Uses both traditionally and digitally created art. Works on
assignment only. Seasonal art created 6 months in advance.

First Contact & Terms Send query e-mail with JPEG attachments of samples or link
to website. Responds in 2 months if interested. Pays flat fee buyout for greeting card
usage.

Tips Currently we are looking for general birthday humor cards. Most of our designs
skew towards more traditional subject matter and treatments.\lang1024\lang1033

DLM STUDIO

2563 Princeton Rd., Cleveland OH 44118. (216)881-8888. Fax: (216)274-9308. E-mail:
pat@dlmstudio.com. Website: www.dlmstudio.com. **Vice President:** Pat Walker.
Estab. 1984. Produces fabrics/packaging/wallpaper. Specializes in wallcovering,
border and mural design, entire package with fabrics, also ultra-wide "mural"
borders. Also licenses artwork for wall murals.

Needs Approached by 40-80 freelancers/year. Works with 20-40 freelancers/year.
Buys hundreds of freelance designs and illustrations/year. Art guidelines free for
SASE with first-class postage. Works on assignment and some licensing. Uses
freelancers mainly for designs, color work. Looking for traditional, country, floral,
texture, woven, menswear, children's and novelty styles. 50% of freelance design
work demands computer skills. Wallcovering CAD experience a plus. Produces
material for everyday.

First Contact & Terms Illustrators: Send query letter with photocopies, examples
of work, résumé and SASE. Accepts disk submissions compatible with Illustrator or
Photoshop files (Mac), also accepts digital files on CD or DVD. Samples are filed or
returned by SASE on request. Responds in 1 month. Request portfolio review of color
photographs and slides in original query, follow-up with letter after initial query.
Rights purchased vary according to project. Pays by the project, $500-1,500, "but it
varies." Finds freelancers through agents and local ads, word of mouth.

Tips "Send great samples, especially childrens and novelty patterns, and also modern,
organic textures and bold conteporary graphic work and digital files are very helpful.
Study the market closely; do very detailed artwork."

EDITIONS LIMITED/FREDERICK BECK

12011 Sherman Road., N. Hollywood CA 91605. (800)998-0323. Fax: (866)998-5808. E-mail: mark@chatsworthcollection.com. Website: www.chatsworthcollection.com. **Art Director:** Mark Brown. Estab. 1958. Produces holiday greeting cards, personalized and box stock and stationery.

- Editions Limited joined forces with Frederick Beck Originals. The company also runs Gene Bliley Stationery. See editorial comment under Frederick Beck Originals for further information. Mark Brown is the art director for all three divisions.

Needs Approached by 100 freelancers/year. Works with 20 freelancers/year. Buys 50-100 freelance designs and illustrations/year. Prefers freelancers with experience in silkscreen. Art guidelines available. Uses freelancers mainly for silkscreen greeting cards. Also for separations and design. Considers offset, silkscreen, thermography, foil stamp. Looking for traditional holiday, a little whimsy, contemporary designs. Size varies. Produces material for Christmas, graduation, Hannukah, New Year, Rosh Hashanah and Valentine's Day. Submit seasonal material 15 months in advance.

First Contact & Terms Designers: Send query letter with brochure, photocopies, photographs, résumé, tearsheets. Samples are filed. Responds in 1 month. Will contact artist for portfolio review of b&w, color, final art, photographs, photostats, roughs if interested. Buys all rights. Pays $150-300/design. Finds freelancers through word of mouth, past history.

ENCORE STUDIOS, INC.

17 Industrial West, Clifton NJ 07012. (800)526-0497. Website: www.encorestudios. com. Estab. 1979. Produces personalized wedding, bar/bat mitzvah, party and engraved invitations, birth announcements, stationery, and holiday cards.

Needs Approached by 50-75 freelance designers/year. Works with 20 freelancers/ year. Prefers freelancers with experience in creating concepts for holiday cards, invitations, announcements and stationery. "We are interested in designs for any category in our line. Looking for unique type layouts, textile designs and initial monograms for stationery and weddings, holiday logos, Hebrew monograms for our bar/bat mitzvah line, and religious art for Bar/Bat Mitzvah." Considers b&w or full-color art. Looking for "elegant, graphic, sophisticated contemporary designs." 50% of freelance work demands knowledge of Macintosh, Illustrator, Photoshop, Quark XPress. Submit seasonal material all year.

First Contact & Terms Send e-mail with Jpg. or Pdf. attachments or send query letter with brochure, résumé, SASE, tearsheets, photographs, photocopies or slides. Samples are filed or are returned by SASE if requested by artist. Responds in 2 weeks only if interested. Write for appointment to show portfolio, or mail appropriate materials. Portfolio should include roughs, finished art samples, b&w photographs or slides. Pays by the project. Negotiates rights purchased.

ENESCO GROUP INC.

225 Windsor Dr., Itasca IL 60143-1225. (630)875-5300. Fax: (630)875-5350. Website: www.enesco.com. **Contact:** New Submissions/Licensing. Producer and importer of fine gifts, home decor and collectibles, such as resin, porcelain bisque and earthenware figurines, plates, hanging ornaments, bells, picture frames, decorative housewares. Clients gift stores, card shops and department stores.

Needs Works with multiple freelance artists/year. Prefers artists with experience in gift product and packaging development. Uses freelancers for rendering, illustration and sculpture. 50% of freelance work demands knowledge of Photoshop, QuarkXPress or Illustrator.

First Contact & Terms Send query letter with résumé, tearsheets and/or photographs. Samples are filed or are returned. Responds in 2 weeks. Pays by the project. Submittor may be required to sign a submission agreement.

Tips "Contact by mail only. It is better to send samples and/or photocopies of work instead of original art. All will be reviewed by Senior Creative Director, Executive Vice President and Licensing Director. If your talent is a good match to Enesco's product development, we will contact you to discuss further arrangements. Please do not send slides. Have a well-thought-out concept that relates to gift products before mailing your submissions."

EPIC PRODUCTS INC.

2801 S. Yale St., Santa Ana CA 92704. (800)548-9791. Fax: (714)641-8217. E-mail: mdubow@epicproductsinc.com. Website: www.epicproductsinc.com. Estab. 1978. Produces paper tableware products and wine and spirits accessories. "We manufacture products for the gourmet/housewares market; specifically products that are wine-related. Many have a design printed on them."

Needs Approached by 50-75 freelance artists/year. Works with 10-15 freelancers/year. Buys 25-50 designs and illustrations/year. Prefers artists with experience in gourmet/housewares, wine and spirits, gift and stationery.

First Contact & Terms Send query letter with résumé and photocopies. Samples are filed. Write for appointment to show portfolio. Portfolio should include thumbnails, roughs, final art, b&w and color. Buys all rights. Originals are not returned. Pays by the project.

EQUITY MARKETING, INC.

6330 San Vicente, Los Angeles CA 90048. (323)932-4300. Website: www.equity-marketing.com. **President, Chief Creative Director:** Kim Thomsen. Specializes in design, development and production of promotional, toy and gift items, especially licensed properties from the entertainment industry. Clients include Tyco, Applause, Avanti and Ringling Bros. and worldwide licensing relationships with Disney, Warner Bros., 20th Century Fox and Lucas Film.

Needs Needs product designers, sculptors, packaging and display designers, graphic designers and illustrators. Prefers local freelancers only with whimsical and cartoon styles. Products are typically targeted at children. Works on assignment only.

First Contact & Terms Send résumé and nonreturnable samples. Will contact for portfolio review if interested. Rights purchased vary according to project. Pays for design by the project, $50-1,200. Pays for illustration by the project, $75-3,000. Finds artists through word of mouth, network of design community, agents/reps.

Tips "Gift items will need to be simply made, priced right and of quality design to compete with low prices at discount houses."

FANTAZIA MARKETING CORP.

65 N. Chicopee St., Chicopee MA 01020. (413)534-7323. Fax: (413)534-4572. E-mail: fantazia@charter.net. Website: www.fantaziamarketing.com. **President:** Joel Nulman. Estab. 1979. Produces toys and high-end novelty products (lamps, banks and stationery items in over-sized form).

Needs Will review anything. Prefers artists with experience in product development. "We're looking to increase our molded products." Uses freelancers for P-O-P displays, paste-up, mechanicals, product concepts. 50% of design requires computer skills.

First Contact & Terms Send query letter with résumé. Samples are filed. Responds in 2 weeks. Call for appointment to show portfolio. Portfolio should include roughs and dummies. Originals not returned. Rights purchased vary according to project. Pays by project. Royalties negotiable.

FENTON ART GLASS COMPANY

700 Elizabeth St., Williamstown WV 26187. (304)375-6122. Fax: (304)375-7833. E-mail: AskFenton@FentonArtGlass.com. Website: www.Fentonartglass.com. **Design Director:** Nancy Fenton. Estab. 1905. Produces collectible figurines, gifts. Largest manufacturer of handmade colored glass in the US.

• Design Director Nancy Fenton says this company rarely uses freelancers because they have their own staff of artisans. "Glass molds aren't very forgiving," says Fenton. Consequently it's a difficult medium to work with. There have been exceptions. "We were really taken with Linda Higdon's work," says Fenton, who worked with Higdon on a line of historical dresses.

Needs Uses freelancers mainly for sculpture and ceramic projects that can be translated into glass collectibles. Considers clay, ceramics, porcelain figurines. Looking for traditional artwork appealing to collectibles market.

First Contact & Terms Send query letter with brochure, photocopies, photographs, résumé and SASE. Samples are filed. Responds only if interested. Negotiates rights purchased. Pays for design by the project; negotiable.

FIDDLER'S ELBOW

101 Fiddler's Elbow Rd., Middle Falls NY 12848. (518)692-9665. Fax: (518)692-9186. E-mail: Inquiries@fiddlerselbow.com. Website: www.fiddlerselbow.com. **Art and Licensing Coordinator:** Christy Phelan. Estab. 1974. Produces decorative housewares, gifts, pillows, totes, soft sculpture, doormats,kitchen textiles, and and pet feeding mats.

Needs Introduces 100 + new products/year. Currently uses freelance designs and illustrations. Looking for adult contemporary, traditional, dog, cat, horse, botanical and beach themes. Main images with supporting art helpful in producing collections.

First Contact & Terms Send digital or hardcopy submissions by mail. Samples are filed or returned by SASE. Responds generally within 4 months if interested. "Please, no phone calls."

Tips "Please visit website first to see if art is applicable to current lines and products."

FISHER-PRICE

636 Girard Ave., E. Aurora NY 14052. (716)687-3983. Fax: (716)687-5281. Website: www.fisher-price.com. **Director of Product Art:** Henry Schmidt. Estab. 1931. Manufacturer of toys and other children's products.

Needs Approached by 10-15 freelance artists/year. Works with 25-30 freelance illustrators and sculptors and 15-20 freelance graphic designers/year. Assigns 100-150 jobs to freelancers/year. Prefers artists with experience in children's style illustration and graphics. Works on assignment only. Uses freelancers mainly for product decoration (label art). Prefers all media and styles except loose watercolor. Also uses sculptors. 25% of work demands knowledge of FreeHand, Illustrator, Photoshop and FreeForm (sculptors).

First Contact & Terms Send query letter with nonreturnable samples showing art style or photographs. Samples are filed. Responds only if interested. Call to schedule an appointment to show a portfolio. Portfolio should include original, final art and color photographs and transparencies. Pays for design and illustration by the hour, $25-50. Buys all rights.

FOTOFOLIO, INC.

561 Broadway, New York NY 10012. (212)226-0923. Fax: (212)226-0072. E-mail: contact@fotofolio.com. Website: www.fotofolio.com. Estab. 1976. Publishes art and photographic postcards, greeting cards, notecards, books, t-shirts and postcards books.

Needs Buys 60-120 freelance designs and illustrations/year. Reproduces existing works. Primarily interested in photography and contemporary art. Produces material for Christmas, Valentine's Day, birthday and everyday. Submit seasonal material 8 months in advance. Art guidelines for SASE with first-class postage.

First Contact & Terms Send query letter with SASE c/o Editorial Dept. Samples are filed or are returned by SASE if requested by artist. Editorial Coordinator will contact artist for portfolio review if interested. Originals are returned at job's completion. Pays by the project, 7½-15% royalties. Rights purchased vary according to project. Finds artists through word of mouth, magazines, submissions/self-promotions, sourcebooks, agents, visiting artist's exhibitions, art fairs and artists' reps.

Tips "When submitting materials, present a variety of your work (no more than 40 images) rather than one subject/genre."

THE FRANKLIN MINT

Franklin Center PA 19091-0001. (610)459-7975. Fax: (610)459-6463. Website: www. franklinmint.com. **Artist Relations Manager:** Cathy La Spada. Estab. 1964. Direct response marketing of high-quality collectibles. Produces collectible porcelain plates, prints, porcelain and coldcast sculpture, figurines, fashion and traditional jewelry, ornaments, precision diecast model cars, luxury board games, engineered products, heirloom dolls and plush, home decor items and unique gifts. Clients general public worldwide, proprietary houselist of 8 million collectors and 55 owned-and-operated retail stores. Markets products in countries worldwide, including USA, Canada, United Kingdom and Japan.

Needs Approached by 3,000 freelance artists/year. Contracts 500 artists/sculptors per year to work on 7,000-8,000 projects. Uses freelancers mainly for illustration and sculpture. Considers all media. Considers all styles. 80% of freelance design and 50% of illustration demand knowledge of PageMaker, FreeHand, Photoshop, Illustrator, QuarkXPress and 3D Studio Eclipse (2D). Accepts work in SGI format. Produces material for Christmas and everyday.

First Contact & Terms Send query letter, résumé, SASE and samples (clear, professional full-color photographs, transparencies, slides, greeting cards and/or brochures and tearsheets). Sculptors send photographic portfolios. Do not send original artwork. Samples are filed or returned by SASE. Responds in 2 months. Portfolio review required for illustrators and sculptors. Company gives feedback on all portfolios submitted. Payment varies.

Tips "In search of artists and sculptors capable of producing high quality work. Those willing to take art direction and to make revisions of their work are encouraged to submit their portfolios."

GALLANT GREETINGS CORP.

4300 United Parkway, Schiller Park IL 60176. (847)671-6500. Fax: (847)233-5900. E-mail: info@gallantgreetings.com. Website: www.gallantgreetings.com. **Vice President Product Development:** Joan Lackouitz. Estab. 1966. Creator and publisher of seasonal and everyday greeting cards, gift wrap and gift bags as well as stationery products.

First Contact & Terms Samples are filed or returned. Will respond within 3 weeks if interested. Do not send originals.

GALLERY GRAPHICS, INC.

7601 W. 93rd St., P.O. Box 8135, Overland Park, KS 66212. (913)207-1407. Fax: (913)383-8796. Website: gallerygraphics.com. **Art Director:** Olivia Jacob. Estab. 1979. Produces calendars, gifts, greeting cards, stationery, prints, notepads, notecards. Gift company specializing primarily in nostalgic, country and other traditional designs.

Needs Approached by 100 freelancers/year. Works with 10 freelancers/year. Buys 100 freelance illustrations/year. Art guidelines free for SASE with first-class postage. Uses freelancers mainly for illustration. Considers any 2-dimensional media. Looking for country, teddy bears, florals, traditional. Prefers 16 × 20 maximum. Produces material for Christmas, Valentine's Day, birthdays, sympathy, get well, thank you. Submit seasonal material 8 months in advance.

First Contact & Terms Accepts printed samples or Photoshop files. Send TIFF or EPS files. Samples are filed or returned by SASE. Will contact artist for portfolio review of color photographs, photostats, slides, tearsheets, transparencies if interested. Payment negotiable. Finds freelancers through submissions and word of mouth.

Tips "Be flexible and open to suggestions."

C.R. GIBSON, CREATIVE PAPERS

404 BNA Drive, Building 200, Suite 600, Nashville TN 37217. (615)724-2900. Fax: (615)391-3166. Website: www.crgibson.com. **Vice President of Creative:** Ann Cummings. Producer of stationery and gift products, baby, kitchen and wedding collections. Specializes in baby, children, feminine, floral, wedding and kitchen-related subjects, as well as holiday designs. 80% require freelance illustration; 15% require freelance design. Gift catalog free by request.

Needs Approached by 200-300 freelance artists/year. Works with 30-50 illustrators and 10-30 designers/year. Assigns 30-50 design and 30-50 illustration jobs/year. Uses freelancers mainly for covers, borders and cards. 50% of freelance work demands knowledge of QuarkXPress, FreeHand and Illustrator. Works on assignment only.

First Contact & Terms Send query letter with brochure, résumé, tearsheets and photocopies. Samples are filed or are returned. Responds only if interested. Request portfolio review in original query. Portfolio should include thumbnails, finished art samples, color tearsheets and photographs. Return of original artwork contingent on contract. Sometimes requests work on spec before assigning a job. Interested in buying second rights (reprint rights) to previously published work. "Payment varies due to complexity and deadlines." Finds artists through word of mouth, magazines, artists' submissions/self-promotion, sourcebooks, agents, visiting artist's exhibitions, art fairs and artists' reps.

Tips "The majority of our mechanical art is executed on the computer with discs and laser runouts given to the engraver. Please give a professional presentation of your work."

GLITTERWRAP, INC.

701 Ford Rd., Rockaway NJ 07866. (201)625-4200, ext. 265. Fax: (201)625-9641. **Creative Director:** Melissa Camacho. Estab. 1987. Produces giftwrap, gift totes and allied accessories. Also photo albums, diaries and stationery items for all ages—party and special occasion market.

Needs Approached by 50-100 freelance artists/year. Works with 10-15 artists/year. Buys 10-30 designs and illustrations/year. Art guidelines available. Prefers artists with experience in textile design who are knowledgeable in repeat patterns or surface, or designers who have experience with the gift industry. Uses freelancers mainly for occasional on-site Mac production at hourly rate of $15-25. Freelance work demands knowledge of QuarkXPress, Illustrator and Photoshop. Considers many styles and mediums. Style varies with season and year. Consider trends and designs already in line, as well as up and coming motifs in gift market. Produces material for baby, wedding and shower, florals, masculine, Christmas, graduation, birthdays, Valentine's Day, Hanukkah and everyday. Submit seasonal material 6-8 months in advance.

First Contact & Terms Send query letter with brochure, tearsheets, or color copies of work. Do not send original art, photographs, transparencies or oversized samples. Samples are not returned. Responds in 3 weeks. "To request our submission guidelines send SASE with request letter. To request catalogs send 11 × 14 SASE with $3.50 postage. Catalogs are given out on a limited basis." Rights purchased vary according to project.

Tips "Giftwrap generally follows the fashion industry lead with respect to color and design. Adult birthday and baby shower/birth are fast-growing categories. There is a need for good/fresh/fun typographic birthday general designs in both adult and juvenile categories."

GLOBAL GRAPHICS & GIFTS LLC.

16781 Chagrin Blvd. #333, Cleveland OH 44120. E-mail: fredw@globalgraphics-gifts. com. Website: www.globalgraphics-gifts.com. President: Fred Willingham. Estab. 1995. Produces calendars, e-cards, giftbags, giftwrap/wrapping paper, greeting cards, party supplies and stationery. Specializes in all types of cards including traditional, humorous, inspirational, juvenile and whimsical.

Needs Works with 5-10 freelancers/year. Buys 50-100 freelance designs and/or illustrations/year. Uses freelancers mainly for illustration and photography. Product categories include African American, alternative/humor, conventional, cute, cute/religious, Hispanic, inspirational, juvenile, religious and teen. Produces material

for baby congrats, birthday, Christmas, congratulations, Easter, everyday, Father's Day, First Communion/Confirmation, get-well/sympathy, graduation, Mother's Day, Valentine's Day and wedding/anniversary. Submit seasonal material 1 year in advance. Art size should be 12 × 18 or less. 5% of freelance digital art and design work demands knowledge of FreeHand, Illustrator, InDesign, Photoshop.

First Contact & Terms Send postcard sample with brochure, photocopies and tearsheets. Send follow-up postcard every 3 months. Samples are filed. Responds only if interested. Portfolio not required. Buys all rights. Pays freelancers by the project $150 minimum-$400 maximum. Finds freelancers through agents, artists' submissions and word of mouth.

Tips "Make sure artwork is clean. Our standards for art are very high. Only send upbeat themes, nothing depressing. Only interested in wholesome images."

GOES LITHOGRAPHING COMPANY SINCE 1879

42 W. 61st St., Chicago IL 60621-3999. (773)684-6700. E-mail: sales@goeslitho.com. Website: www.goeslitho.com. **Contact:** Eric Goes. Estab. 1879. Produces stationery/letterheads, custom calendars to sell to printers and office product stores.

Needs Approached by 5-10 freelance artists/year. Works with 2-3 freelance artists/year. Buys 4-30 freelance designs and illustrations/year. Art guidelines for SASE with first-class postage. Uses freelance artists mainly for designing holiday letterheads. Considers pen & ink, color, acrylic, watercolor. Prefers final art 17 × 22, CMYK color compatible. Produces material for Christmas, Halloween and Thanksgiving.

First Contact & Terms " Send non-returnable examples for your ideas." Responds in 1-2 months if interested. Pays $100-200 on final acceptance. Buys first rights and reprint rights.

Tips "Keep your art fresh and be aggressive with submissions."

GRAHAM & BROWN

3 Corporate Dr., Cranbury NJ 08512. (609)395-9200. Fax: (609)395-9676. Website: www.grahambrown.com. Estab. 1946. Produces residential wall coverings and home decor products.

Needs Prefers freelancers for designs. Also for artwork. Produces material for everyday.

First Contact & Terms Designers: Send query letter with photographs. Illustrators: Send postcard sample of work only to the attention of Nicole Caucino. Samples are filed or returned. Responds only if interested. Buys all rights. For illustration pays a variable flat fee.

GREAT AMERICAN PUZZLE FACTORY

(Division of Fundex Games Ltd)P.O. Box 421309., Indianapolis IN 46242. (800)486-

9787. Fax: (317)248-1086. Website: www.greatamericanpuzzle.com. **President:** Pat Duncan. Licensing: Patricia Duncan. Estab. 1975. Produces jigsaw puzzles and games for adults and children. Licenses various illustrations for puzzles (children's and adults').

Needs Approached by 200 freelancers/year. Works with 80 freelancers/year. Buys 70 designs and illustrations/year. Uses freelancers mainly for puzzle material. Looking for "fun, busy and colorful" work. 100% of graphic design requires knowledge of QuarkXPress, Illustrator or Photoshop.

First Contact & Terms Send postcard sample and/or 3 representative samples via e-mail. Do not send seasonal material. Also accepts e-mail submissions. Do not send originals or transparencies. Samples are filed or are returned. Art director will contact artist for portfolio review if interested. Original artwork is returned at job's completion. Pays flat fee of $600-1,000, work for hire. Royalties of 5-6% for licensed art (existing art only). Interested in buying second rights (reprint rights) to previously published work.

Tips "All artwork should be *bright*, cheerful and eye-catching. 'Subtle' is not an appropriate look for our market. Decorative motifs not appropriate. Visit stores and visit websites for appropriateness of your art. No black and white. Looking for color, detail, and emotion."

GREAT ARROW GRAPHICS

2495 Main St., Suite 457, Buffalo NY 14214. (716)836-0408. Fax: (716)836-0702. E-mail: info@greatarrow.com. Website: www.greatarrow.com. **Art Director:** Lisa Samar. Estab. 1981. Produces greeting cards and stationery. "We produce silkscreened greeting cards—seasonal and everyday—to a high-end design-conscious market."

Needs Approached by 150 freelancers/year. Works with 75 freelancers/year. Buys 350-500 images/year. Art guidelines can be downloaded at www.greatarrow.com/guidelines.asp. Prefers freelancers with experience in silkscreen printing process. Uses freelancers for greeting card design only. Considers all 2-dimensional media. Looking for sophisticated, classic, contemporary or cutting edge styles. Requires knowledge of Illustrator or Photoshop. Produces material for all holidays and seasons. Submit seasonal material 1 year in advance.

First Contact & Terms Send query letter with photocopies. Accepts submissions on disk compatible with Illustrator or Photoshop or e-mail jpegs. Samples will not be returned, do not send originals until the images are accepted. Responds in 6 weeks if we are interested. Art director will contact artist for portfolio review if interested. Portfolio should include color roughs, final art, photographs and transparencies. Originals are returned at job's completion. Pays royalties of 5% of net sales. Rights purchased vary according to project.

Tips "We are interested in artists familiar with the assets and limitations of screenprinting, but we are always looking for fun new ideas and are willing to give

help and guidance in the silkscreen process. Be original, be complete with ideas. Don't be afraid to be different... forget the trends... do what you want. Make your work as complete as possible at first submission. The National Stationery Show in New York City is a great place to make contacts."

HALLMARK CARDS, INC.

P.O. Box 419034, Kansas City MO 64141-6580. Website: www.hallmark.com. Estab. 1931.

- Because of Hallmark's large creative staff of full-time employees and their established base of freelance talent capable of fulfilling their product needs, they do not accept unsolicited freelance submissions.

HARLAND CLARKE

(formerly Clarke American), P.O. Box 460, San Antonio TX 78292-0460. (210)694-1473. Fax: (210)558-9265. Website: www.clarkeamerican.com. **Product Marketing Manager:** Ashley Collins. Estab. 1874. Produces checks and other products and services sold through financial institutions. "We're a national printer seeking original works for check series, consisting of one, three or five scenes. Looking for a variety of themes, media and subjects for a wide market appeal."

Needs Uses freelancers mainly for illustration and design of personal checks. Considers all media and a range of styles. Prefers to see art at twice the size of a standard check.

First Contact & Terms Send postcard sample or query letter with résumé and brochure (or Web address if work is online). "Indicate whether the work is available; do not send original art." Samples are filed and are not returned. Responds only if interested. Rights purchased vary according to project. Payment for illustration varies by the project.

Tips "Keep red and black in the illustration to a minimum for image processing."

HEART STEPS INC.

E. 502 Highway 54, Waupaca WI 54981. (715)258-8141. Fax: (715)256-9170. **Contact:** Debra McCormick. Estab. 1993. Produces greeting cards, marble and bronze plaques, photo frames, gift boxes, framed art, scrapbooking items and stationery. Specializes in inspirational items.

Needs Prefers freelancers with experience in watercolor. Works on assignment only. Uses freelancers mainly for completing the final watercolor images. Considers original art. Looking for watercolor fine art, floral, juvenile and still life. Prefers 10 × 14. Produces material for Christmas, Mother's Day, Father's Day, graduation, birthday, everyday, inspirational, encouragement, woman-to-woman. Submit seasonal material 8 months in advance.

First Contact & Terms Designers: Send query letter with brochure, photocopies, photographs, résumé and SASE. Illustrators: Send query letter with photocopies and résumé. Samples are filed. Responds in 2 months. Request portfolio review in original query. Rights purchased vary according to project. Pays by the project for design; $100-300 for illustration. Finds freelancers through gift shows and word of mouth.

Tips "Don't overlook opportunities with new, small companies!"

MARIAN HEATH GREETING CARDS

9 Kendrick Rd., Wareham MA 02571. (800)688-9998. Fax: (800)762-7426. E-mail: talktous@rencards.com. Website: www.marianheath.com. **Creative Director:** Molly DelMastro. Estab. 1950. Greeting card company supporting independent card and gift shop retailers. Produces greeting cards, giftbags, giftwrap, stationery and ancillary products.

Needs Approached by 100 freelancers/year. Works with 35-45 freelancers/year. Buys 500 freelance designs and illustrations/year. Prefers freelancers with experience in social expression. Art guidelines free for SASE with first-class postage or e-mail requesting guidelines. Uses freelancers mainly for greeting cards. Considers all media and styles. Generally 5¼ × 7¼ unless otherwise directed. Will accept various sizes due to digital production/manipulation. 30% of freelance design and illustration work demands knowledge of Photoshop, Illustrator, QuarkXPress. Produces material for all holidays and seasons and everyday. Submit seasonal material 1 year in advance.

First Contact & Terms Designers: Send query letter with photocopies, résumé and SASE. OK to send slides, tearsheets and transparencies if necessary. Illustrators: Send query letter with photocopies, résumé, tearsheets and SASE. Accepts Mac-formatted JPEG disk submissions. Samples are filed or returned by SASE. Responds within 1-3 months. Will contact artist for portfolio review of color, final art, slides, tearsheets and transparencies. Pays for illustration by the project; flat fee or royalties; varies per project. Finds freelancers through agents, reps, submissions, licensing and design houses.

HIGH RANGE DESIGNS

P.O. Box 346, Victor ID 83455-0346. (208)787-2277. Fax: (208)787-2276. **President:** Hondo Miller. Estab. 1989. Produces T-shirts. "We produce screen-printed garments for recreational sport-oriented markets and resort markets, which includes national parks. Subject matter includes, but is not limited to, skiing, climbing, hiking, biking, fly fishing, mountains, out-of-doors, nature, canoeing and river rafting, Native American, wildlife and humorous sayings that are text only or a combination of text and art. Our resort market customers are men, women and kids looking to buy a souvenir of their vacation experience or activity. People want to identify with the message and/or the art on the T-shirt."

- According to High Range Designs art guidelines, it is easiest to break into HRD with designs related to fly fishing, downhill skiing, snowboarding or river rafting. The guidelines suggest that your first submission cover one or more of these topics. The art guidelines for this company are detailed and include suggestions on where to place design on the garment.

Needs Approached by 20 freelancers/year. Works with 3-8 freelancers/year. Buys 10-20 designs and illustration/year. Prefers artists with experience in screen printing. Uses freelancers mainly for T-shirt ideas, artwork and color separations.

First Contact & Terms Send query letter with résumé, SASE and photocopies. Accepts submissions on disk compatible with FreeHand 8.0 and Illustrator 8.0. Samples are filed or are returned by SASE if requested by artist. Responds in 6 months. Company will contact artist for portfolio review if interested. Portfolio should include b&w thumbnails, roughs and final art. Originals are returned at job's completion. Pays by the project, royalties of 5% based on actual sales. Buys garment rights.

Tips "Familiarize yourself with screen printing and T-shirt art that sells. Must have knowledge of color separations process. We look for creative design styles and interesting color applications. Artists need to be able to incorporate the colors of the garments as part of their design thinking, as well as utilize the screen-printing medium to produce interesting effects and textures. However, sometimes simple is best. Four-color process will be considered if highly marketable. Be willing to work with us on design changes to get the most marketable product. Know the industry. Art that works on paper will not necessarily work on garments. No cartoons please."

HOFFMASTER GROUP, INC.

2920 N. Main St., Oshkosh WI 54903. (920)235-9330. Fax: (920)235-1642. **Art and Marketing Services Manager:** Paul Zuehlke. Produces decorative disposable paper tableware including: placemats, plates, tablecloths and napkins for institutional and consumer markets. Printing includes offset, letterpress and up to six color flexographic napkin printing.

Needs Approached by 10-15 freelancers/year. Works with 4-6 freelancers/year. Prefers freelancers with experience in paper tableware products. Art guidelines and specific design needs based on current market are available from Creative Managers. Looking for trends and traditional styles. Prefers 9" round artwork with coordinating 5" square image. Produces material for all holidays and seasons and everyday. Special need for seasonal material.

First Contact & Terms Send query letter with photocopies, résumé, appropriate samples by mail or fax only. Ideas may be sent in a color rough sketch. Accepts disk submissions compatible with Adobe Creative Suite 2. Samples are filed or returned by SASE if requested by artist. Responds in 90 days, only if interested. Creative Manager will contact artist for portfolio review if interested. Prefers to buy artwork outright. Rights purchased vary according to project. Pays by the project: $350-

1,500. Amounts vary according to project. May work on a royalty arrangement for recognized properties. Finds freelancers through art fairs and artists' reps.

Tips Looking for new trends and designs appropriate for plates and napkins.

IGPC

460 W. 34th St., 10th Floor, New York NY 10001. (212)629-7979. Fax: (212)629-3350. E-mail: artdept@igpc.net. Website: www.igpc.net. Art Director: Aviva Darab. Agent to foreign governments. "We produce postage stamps and related items on behalf of 40 different foreign governments."

Needs Approximately 10 freelance graphic artists. Prefers artists within metropolitan New York or tri-state area. Must have extremely sophisticated computer, design and composition and prepress skills, as well as keen research ability. Artwork must be focused and alive (4-color). Artist's pricing needs to be competitive. Works on assignment only. Uses artists for postage stamp art. Must have expert knowledge of Photoshop and Quark/InDesign. Illustrator a plus.

First Contact & Terms E-mail only. Send samples as PDFs or link to a web portfolio. Art Director will contact artist for portfolio review if interested. Portfolio should contain "4-color illustrations of realistic, flora, fauna, technical subjects, autos or ships." Sometimes requests work on spec before assigning a job. Pays by the project. Consider government allowance per project when establishing payment.

Tips "Artists considering working with IGPC must have excellent drawing and/or rendering abilities in general or specific topics, i.e., flora, fauna, transport, famous people, etc.; typographical skills; the ability to create artwork with clarity and perfection. Familiarity with printing process and print call-outs a plus. Generally, the work we require is realistic art. In some cases, we supply the basic layout and reference material; however, we appreciate an artist who knows where to find references and can present new and interesting concepts. Initial contact should be made by appointment. Have fun!"

THE IMAGINATION ASSOCIATION/THE FUNNY APRON COMPANY

P.O. Box 1780, Lake Dallas TX 75065-1780. (940)498-3308. Fax: (940)498-1596. E-mail: ellice@funnyaprons.com. Website: www.funnyaprons.com. **Creative Director:** Ellice Lovelady. Estab. 1992. Our primary focus is now on our subdivision, The Funny Apron Company, that manufactures humorous culinary-themed aprons and T-shirts for the gourmet marketplace."

Needs Works with 6 freelancers/year. Artists must be fax/e-mail accessible and able to work on fast turnaround. Check website to determine if your style fits our art direction. 100% of freelance work DEMANDS knowledge of Illustrator, Corel Draw, or programs with ability to electronically send vector-based artwork. (Photoshop alone is not sufficient.) Currently not accepting text or concepts.

First Contact & Terms Send query letter with brochure, photographs, SASE and photocopies. E-mail inquiries must include a LINK to a website to view artwork. Do not send unsolicited attachments, they are automatically deleted. Samples are filed or returned by SASE if requested by artist. Company will contact artist if interested. Negotiates rights and payment terms. Finds artists via word of mouth from other freelancers or referrals from publishers.

Tips Looking for artist "with a style we feel we can work with and a professional attitude. Understand that sometimes we require several revisions before final art, and all under tight deadlines. Even if we can't use your style, be persistent! Stay true to your creative vision and don't give up!"

⊞ INCOLAY STUDIOS INCORPORATED

12927 S. Budlong Ave., Gardena CA 90247. (800)462-6529. E-mail: info@incolayusa.com. Website: www.incolayusa.com. **Art Director:** Louise Hartwell. Estab. 1966. Manufacturer. "We reproduce antiques in Incolay Stone, all handcrafted here at the studio."

Needs Prefers local artists with experience in carving bas relief. Uses freelance artists mainly for carvings; also for product design and model making.

First Contact & Terms Send query letter with résumé, or call to discuss. Samples not filed are returned. Responds in 1 month. Call for appointment to show portfolio. Pays 5% of net sales. Negotiates rights purchased.

Tips "Let people know that you are available and want work. Do the best you can. Discuss the concept and see if it is right for your talent."

INKADINKADO, INC.

1801 North 12th St., Reading PA 19604. (610)939-9900 or (800)523-8452. Fax: (610)939-9666. E-mail: inkacustomerservice@eksuccess.com. Website: www. inkadinkado.com. **Creative Director:** Mark Nelson, licensing contact. Pamela Keller, designer relations coordinator. Estab. 1978. Creates artistic rubber stamps, craft kits, and craft accessories. Also offers licenses to illustrators depending upon number of designs interested in producing and range of style by artist. Distributes to craft, gift and toy stores and specialty catalogs.

Needs Works mainly with in house illustrators and designers. Uses freelancers mainly for illustration, lettering, line drawing, type design. Considers pen & ink. Themes include animals, education, holidays and nature. Prefers small; about 3 × 3. work demands knowledge of Photoshop, Illustrator and in Design. Produces material for all holidays and seasons. Submit seasonal material 6-8 months in advance.

First Contact & Terms Designers and Illustrators: Send query letter with 6 nonreturnable samples. Accepts submissions on disk. Samples are filed and not returned. Responds only if interested. Company will contact artist for portfolio review

of b&w and final art if interested. Pays for illustration by the project, $100-250/piece. Rights purchased vary according to project. Stamps, pays $50-100/project.

Tips "Work small. The average size of an artistic rubber stamp is 3 × 3 line art without color stands the best chance of acceptance."

INTERCONTINENTAL GREETINGS LTD.

38 West 32nd Street, Suite 910, New York NY 10001. (212)683-5830. Fax: (212)779-8564. Website: www.intercontinental-ltd.com. **Creative Director:** Jerra Parfitt. Estab. 1967. Sells reproduction rights of designs to manufacturers of multiple products around the world. Rep resents artists in 50 different countries. "Our clients specializ e in greeting cards, giftware, giftwrap, calendars, postcards, prints, posters, stationery, paper goods, food tins, playing cards, tabletop, bath and service ware and much more. "

• See additional listing in the Posters & Prints section.

Needs Approached by several hundred artists/year. Seeking creative decorative art in traditional and computer media (Photoshop and Illustrator work accepted). Prefers artwork previously made with few or no rights pending. Graphics, sports, occasions (i.e., Christmas, baby, birthday, wedding), humorous, "soft touch," romantic themes, animals. Accepts seasonal/holiday material any time. Prefers artists/designers experienced in greeting cards, paper products, tabletop and giftware.

First Contact & Terms Query with samples. Send unsolicited CDs or DVDs by mail. "Please do not send original artwork." Upon request, submit portfolio for review. Provide résumé, business card, brochure, flier, tearsheets or slides to be kept on file for possible future assignments. "Once your art is accepted, we require original color art—Photoshop files on disc (Mac, TIFF, 300 dpi); 4 × 5, 8 × 10 transparencies; 35mm slides. We will respond only if interested (will send back nonaccepted artwork in SASE if provided)." Pays on publication. No credit line given. Offers advance when appropriate. Sells one-time rights and exclusive product rights. Simultaneous submissions and previously published work OK. "Please state reserved rights, if any."

Tips Recommends the annual New York SURTEX and Licensing shows. In portfolio samples, wants to see "a neat presentation, thematic in arrangement, consisting of a series of interrelated images (at least 6). In addition to having good drawing/painting/designing skills, artists should be aware of market needs and trends."

JILLSON & ROBERTS

3300 W. Castor St., Santa Anna CA 92704-3908. (714)424-0111. Fax: (714)424-0054. E-mail: janel.kaeden@jillsonroberts.com. Website: www.jillsonroberts.com. **Art Director:** Janel Doran. Estab. 1974. Specializes in gift wrap, totes, printed tissues and accessories using recycled/recyclable products. Art guidelines available on website.

Needs Works with 10 freelance artists/year. Prefers artists with experience in giftwrap design. Considers all media. "We are looking for colorful graphic designs as well as humorous, sophisticated, elegant or contemporary styles." Produces material for Christmas, Valentine's Day, Hanukkah, Halloween, graduation, birthdays, baby announcements and everyday. Submit 3-6 months before holiday.

First Contact & Terms Send color copies or photocopies. Samples are kept on file. Responds in up to 2 months. Simultaneous submissions to other companies is acceptable. "If your work is chosen, we will contact you to discuss final art preparation, procedures and payment."

Tips "We are particularly interested in baby shower and wedding shower designs."

KALAN LP

97 S. Union Ave., Lansdowne PA 19050. (610)623-1900 ext. 341. Fax: (610)623-0366. Website: www.kalanlp.com. **Art Director:** Chris Wiemer. Copywriter: David Umlauf. Estab. 1973. Produces giftbags, greeting cards, school supplies, stationery and novelty items such as keyrings, mouse pads, shot glasses and magnets.

Needs Approached by 50-80 freelancers/year. Buys 100 freelance designs and illustrations/year. Art guidelines are available. Uses freelancers mainly for fresh ideas, illustration and design. Considers all media and styles. Some illustration demands knowledge of Photoshop 7.0 and Illustrator 10. Produces material for major holidays such as Christmas, Mother's Day, Valentine's Day; plus birthdays and everyday. Submit seasonal material 9-10 months in advance.

First Contact & Terms Designers: Send query letter with photocopies, photostats and résumé. Illustrators and cartoonists: Send query letter with photocopies and résumé. Accepts disk submissions compatible with Illustrator 10 or Photoshop 7.0. Send EPS files. Samples are filed. Responds in 1 month if interested in artist's work. Will contact artist for portfolio review of final art if interested. Buys first rights. Pays by the project, $75 and up. Finds freelancers through submissions and newspaper ads.

KEMSE AND COMPANY

P.O. Box 14334, Arlington TX 76094. (888)656-1452. Fax: (817)446-9986. E-mail: info@kemseandcompany.com. Website: www.kemseandcompany.com. **Contact:** Kimberly See. Estab. 2003. Produces stationery. Specializes in multicultural stationery and invitations.

Needs Approached by 10-12 freelancers/year. Works with 5-6 freelancers/year. Buys 15-20 freelance designs and/or illustrations/year. Considers all media. Product categories include African American and Hispanic. Produces material for all holidays and seasons, birthday, graduation and woman-to-woman. Submit seasonal material 8 months in advance. 75% of freelance work demands knowledge of FreeHand, Illustrator, QuarkXPress and Photoshop.

First Contact & Terms Send query letter with photocopies, résumé and SASE. Accepts e-mail submissions with image file. Prefers Windows-compatible, JPEG files. Samples are filed. Responds only if interested. Company will contact artist for portfolio review if interested. Portfolio should include color, finished art, roughs and thumbnails. Buys all rights and reprint rights. Pays freelancers by the project. Finds freelancers through submissions.

KID STUFF MARKETING

929 SW University Blvd., Suite B-1, Topeka KS 66619-0235. (785)862-3707. Fax: (785)862-1424. E-mail: michael@kidstuff.com. Website: www.kidstuff.com. **Senior Director of Creative:** Michael Oden. Estab. 1982. Produces collectible figurines, toys, kids' meal sacks, edutainment activities and cartoons for restaurants and entertainment venues worldwide.

Needs Approached by 50 freelancers/year. Works with 10 freelancers/year. Buys 30-50 freelance designs and illustrations/year. Works on assignment only. Uses freelancers mainly for illustration, activity or game development and sculpting toys. Looking for humorous, child-related styles. Freelance illustrators should be familiar with Photoshop, Illustrator and InDesign. Produces material for Christmas, Easter, Halloween, Thanksgiving, Valentine's Day and everyday. Submit seasonal material 6 months in advance.

First Contact & Terms Illustrators and Cartoonists: Send query letter with photocopies or e-mail JPEG files. Sculptors, calligraphers: Send photocopies. Samples are filed or returned by SASE. Responds only if interested. Portfolio review not required. Pays by the project, $250-5,000 for illustration or game activities. Finds freelancers through word of mouth and artists' submissions.

THE LANG COMPANIES

P.O. Box 55, Delafield WI 53018. (262)646-3399. Website: www.lang.com. **Product Development Coordinator:** Yvonne Moroni. Estab. 1982. Produces high-quality linen-embossed greeting cards, stationery, calendars, boxes and gift items. Art guidelines available for SASE.

Needs Approached by 300 freelance artists/year. Works with 40 freelance artists/year. Uses freelancers mainly for card and calendar illustrations. Considers all media and styles. Looking for traditional and nonabstract country-inspired, folk, contemporary and fine art styles. Produces material for Christmas, birthdays and everyday. Submit seasonal material 6 months in advance.

First Contact & Terms Send query letter with SASE and brochure, tearsheets, photostats, photographs, slides, photocopies or transparencies. Samples are returned by SASE if requested by artist. Responds in 6 weeks. Pays royalties based on net wholesale sales. Rights purchased vary according to project.

Tips "Research the company and submit compatible art. Be patient awaiting a response."

LEGACY PUBLISHING GROUP

75 Green St., Clinton MA 01510. (800)322-3866 or (978)368-8711. Fax: (978)368-7867. Website: legacypublishinggroup.com. **Contact:** Art Department. Produces bookmarks, calendars, gifts, Christmas and seasonal cards and stationery pads. Specializes in journals, note cards, address and recipe books, coasters, placemats, magnets, book marks, albums, calendars and grocery pads.

Needs Works with 8-10 freelancers/year. Buys 25-30 freelance designs and illustrations/year. Prefers traditional art. Art guidelines available for SASE. Works on assignment only. Uses freelancers mainly for original art for product line. Considers all color media. Looking for traditional, contemporary, garden themes and Christmas. Produces material for Christmas, everyday (note cards) and cards for teachers.

First Contact & Terms Illustrators: Send query letter with photocopies, photographs, résumé, tearsheets, SASE and any good reproduction or color copy. We accept work compatible with Adobe or QuarkXPress plus color copies. Samples are filed. Responds in 2 weeks. Company will contact artist for portfolio review if interested. Portfolio should include color photographs, slides, tearsheets and printed reproductions. Buys all rights. Pays for illustration by the project, $600-1,000. Finds freelancers through word of mouth and artists' submissions.

Tips "Get work out to as many potential buyers as possible. *Artist's & Graphic Designer's Market* is a good source. Initially, plan on spending 80% of your time on self-promotion."

▣ THE LEMON TREE STATIONERY CORP.

95 Mahan St., West Babylon NY 11704. (631)253-2840. Fax: (631)253-3369. Website: www.lemontreestationery.com. **Contact:** Lucy Mlexzko. Estab. 1969. Produces birth announcements, Bar Mitzvah and Bat Mitzvah invitations and wedding invitations.

Needs Buys 100-200 pieces of calligraphy/year. Prefers local designers. Works on assignment only. Uses Mac designers. Also for calligraphy, mechanicals, paste-up, P-O-P. Looking for traditional, contemporary. 50% of freelance work demands knowledge of Photoshop, QuarkXPress, Illustrator.

First Contact & Terms Send query letter with résumé. Calligraphers send photocopies of work. Samples are not filed and are not returned. Responds only if interested. Company will contact artist for portfolio review of final art, photostats, thumbnails if interested. Pays for design by the project. Pays flat fee for calligraphy.

Tips "Look around at competitors' work to get a feeling of the type of art they use."

Greeting Cards & Gifts

LIFE GREETINGS

P.O. Box 468, Little Compton RI 02837. (401)635-8535. **Editor:** Kathy Brennan. Estab. 1973. Produces greeting cards. Religious, inspirational greetings.

Needs Approached by 25 freelancers/year. Works with 5 freelancers/year. Uses freelancers mainly for greeting card illustration. Also for calligraphy. Considers all media but prefers pen & ink and pencil. Prefers 4½ × 6¼—no bleeds. Produces material for Christmas, religious/liturgical events, baptism, first communion, confirmation, ordination, etc.

First Contact & Terms Send query letter with photocopies. Samples are filed or returned by SASE if requested by artist. Responds only if interested. Portfolio review not required. Originals are not returned. Pays by the project. **"We pay on acceptance."** Finds artists through submissions.

LPG GREETINGS, INC.

813 Wisconsin Street, Walworth WI 53184. (262)275-5600. Fax: (262)275-5609. E-mail: judy@lpggreetings.com. Website: www.lpggreetings.com. **Creative Director:** Judy Cecchi. Estab. 1992. Produces greeting cards. Specializes in boxed Christmas cards.

Needs Approached by 50-100 freelancers/year. Works with 20 freelancers/year. Buys 70 freelance designs and illustrations/year. Art guidelines can be found on LPG's website.Uses freelancers mainly for original artwork for Christmas cards. Considers any media. Looking for traditional and humorous Christmas. Greeting cards can be vertical or horizontal; 5 × 7 or 6 × 8. Usually prefers 5 × 7. Submit seasonal material 1 year in advance.

First Contact & Terms Send query letter with photocopies. Samples are filed if interested or returned by SASE. Portfolio review not required. Will contact artist for portfolio if interested. Rights purchased vary according to project. Pays for design by the project. For illustration: pays flat fee. Finds freelancers through word of mouth and artists' submissions. Please do not send unsolicited samples via e-mail; they will not be considered.

Tips "Be creative with fresh new ideas."

NOVO CARD PUBLISHERS INC.

7570 N. Croname Road, Niles IL 60714. (847)588-3220. Fax: (847)588-3508. E-mail: art@novocard.net. Website: www.novocard.net. Estab. 1927. Produces all categories of greeting cards.

Needs Approached by 200 freelancers/year. Works with 30 freelancers/year. Buys 300 or 400 pieces/year from freelance artists. Art guidelines free for SASE with first-class postage. Uses freelancers mainly for illustration and text. Also for calligraphy. Considers all media. Prefers crop size 5 × 7¾, bleed 5¼ × 8. Knowledge of Photoshop, Illustrator and QuarkXPress, and Indesign helpful. Produces material for all holidays and seasons and everyday. Submit seasonal material 8 months in advance.

First Contact & Terms Designers: Send brochure, photocopies, photographs and SASE. Illustrators and Cartoonists: Send photocopies, photographs, tearsheets and SASE. Calligraphers: Send b&w copies. Accepts disk submissions compatible with Macintosh QuarkXPress 4.0 and Windows 95. Art samples are not filed and are returned by SASE only. Written samples retained on file for future assignment with writer's permission. Responds in 2 months. Pays for design and illustration by the project, $75-200.

OATMEAL STUDIOS

P.O. Box 138, Rochester VT 05767. (802)767-3171. Fax: (802)767-9890. E-mail: sales@ oatmealstudios.com. Website: www.oatmealstudios.com. **Creative Director:** Helene Lehrer. Estab. 1979. Publishes humorous greeting cards and notepads, creative ideas for everyday cards. Art guidelines available for SASE with first-class postage.

Needs Approached by approximately 300 freelancers/year. Buys 100-150 freelance designs and illustrations/year. Considers all media.

First Contact & Terms Write for art guidelines; send query letter with SASE, slides, roughs, printed pieces or brochure/flyer to be kept on file. "If brochure/flyer is not available, we ask to keep one slide or printed piece; color or b&w photocopies also acceptable for our files." Samples are returned by SASE. Responds in 6 weeks. Negotiates payment.

Tips "We're looking for exciting and creative, humorous (not cutesy) illustrations and single-panel cartoons. If you can write copy and have a humorous cartoon style all your own, send us your ideas! We do accept artwork without copy, too."

PORTERFIELD'S FINE ART LICENSING

437 Tuttle Avenue, Suite 410, Sarasota, FL 34243. (800)660-8345. E-mail: art@ porterfieldsfineart.com. Website: www.porterfieldsfineart.com. **President:** Lance J. Klass. Licenses representational, Christmas, holiday, seasonal, Americana, and many other subjects. We're a major, nationally recognized full-service licensing agency." Estab. 1994. Functions as a full-service licensing representative for individual artists wishing to license their work into a wide range of consumer-oriented products. We are one of the fastest growing art licensing agencies in North America, as well as the best-known art licensing site on the Internet, rated #1 in art licensing by Google for over 8 years, and recently #1 on MSN, Yahoo and Ask.com as well. Stop by our site for more information about how to become a Porterfield's artist and have us represent you and your work for licenses in wall and home decor, home fabrics, stationery and all paper products, crafts, giftware and many other fields."

Needs Approached by more than 1,000 artists/year. Licenses many designs and illustrations/year. Prefers commercially oriented artists who can create beautiful pieces of art that people want to look at again and again, and that will help sell

products to the core consumer, that is, women over 30 who purchase 85% of all consumer goods in America." Art guidelines listed on website. Considers existing works first. Considers any media\'98oil, pastel, watercolor, acrylics, digital. "We are seeking artists who have exceptional artistic ability and commercial savvy, who study the market for trends and who would like to have their art and their talents introduced to the broad public. Artists must be willing to work hard to produce art for the market."

Tips "We are impressed first and foremost by level of ability, even if the subject matter is not something we would use. Thus, a demonstration of competence is the first step; hopefully the second would be that demonstration using subject matter that we believe would be commercially marketable onto a wide and diverse array of consumer products. We work with artists to help them with the composition of their pieces for particular media. We treat artists well, and actively represent them to potential licensees. Instead of trying to reinvent the wheel yourself and contact everyone 'cold,' we suggest you look at getting a licensing agent or rep whose particular abilities complement your art. We specialize in the application of art to home decor and accessories, home fabrics, prints and wall decor, and also print media such as cards, stationery, calendars, and many other products. The trick is to find the right rep whom you feel you can work with "someone who really loves your art (whatever it is), who is interested in investing financially in promoting your work, and whose specific contacts and abilities can help further your art in the marketplace."

PRIZM INC.

P.O. Box 80, Wamego KS 66547. (785)776-1613. Fax: (785)776-6550. E-mail: info@prizm-inc.com. Website: http://www.pipka.com/content/22.htm. **President of Product Development:** Michele Johnson. Produces and markets figurines, decorative housewares, gifts, and ornaments. Manufacturer of exclusive figurine lines.

Needs Approached by 20 freelancers/year. Art guidelines free for SASE with first-class postage. Works on assignment only. Uses freelancers mainly for figurines, home decor items. Also for calligraphy. Considers all media. Looking for traditional, old world style, sentimental, folkart. Produces material for Christmas, Mother's Day, everyday. Submit seasonal material 1 year in advance.

First Contact & Terms Send query letter with photocopies, résumé, SASE, slides, tearsheets. Samples are filed. Responds in 2 months if SASE is included. Will contact for portfolio review of color, final art, slides. Rights purchased vary according to project. Pays royalties plus payment advance; negotiable. Finds freelancers through artist submissions, decorative painting industry.

Tips "People seem to be more family oriented—therefore more wholesome and positive images are important. We are interested in looking for new artists and lines to develop. Send a few copies of your work with a concept."

PRUDENT PUBLISHING

65 Challenger Rd., Ridgefield Park NJ 07660. (201)641-7900. Fax: (201)641-9356. Website: www.gallerycollection.com. **Creative Coordinator:** Marian Francesco. Estab. 1928. Produces greeting cards. Specializes in business/corporate all-occasion and holiday cards. Art guidelines available.

Needs Buys calligraphy. Uses freelancers mainly for card design, illustrations and calligraphy. Considers traditional media. Prefers no cartoons or cute illustrations. Prefers 5½ × 7⅞ horizontal format (or proportionate). Produces material for Christmas, Thanksgiving, birthdays, everyday, sympathy, get well and thank you.

First Contact & Terms Designers, illustrators and calligraphers: Send query letter with brochure, photostats, photocopies, tearsheets. Samples are filed or returned by SASE if requested. Responds ASAP. Portfolio review not required. Buys all rights. No royalty or licensing arrangements. Payment is negotiable. Finds freelancers through submissions, magazines, sourcebooks, agents and word of mouth.

P.S. GREETINGS, INC.

5730 N. Tripp Ave., Chicago IL 60646. (773)267-6150. Fax: (773)267-6055. E-mail: artdirector@psgreetings.com. Website: www.psgreetings.com. **Contact:** Art Director. Manufacturer of boxed greeting and counter cards. Artists' guidelines are posted on website, or send SASE.

Needs Receives submissions from 300-400 freelance artists/year. Works with 50-100 artists/year on greeting card designs. Publishes greeting cards for everyday and holidays. 70% of work demands knowledge of InDesign, Illustrator and Photoshop.

First Contact & Terms All requests as well as submissions must be accompanied by SASE. "Samples will *not* be returned without SASE!" Responds in 1 month. Pays flat fee. Buys exclusive worldwide rights for greeting cards and stationery.

Tips "Our line includes a whole spectrum from everyday needs (florals, scenics, feminine, masculine, humorous, cute) to every major holiday (from New Year's to Thanksgiving) with a very extensive Christmas line. We continue to grow every year and are always looking for innovative talent."

RITE LITE LTD., THE JACOB ROSENTHAL JUDAICA COLLECTION

333 Stanley Ave., Brooklyn NY 11207. (718)498-1700. Fax: (718)498-1251. E-mail: products@ritelite.com. Website: www.ritelite.com. Estab. 1948. Manufacturer and distributor of a full range of Judaica. Clients include department stores, galleries, gift shops, museum shops and jewelry stores.

Needs Looking for new menorahs, mezuzahs, children's Judaica, Passover and matza plates. Works on assignment only. Must be familiar with Jewish ceremonial objects or design. Also uses artists for illustration, and product design. Most of freelance work requires knowledge of Illustrator and Photoshop. Produces material for Hannukkah,

Passover and other Jewish Holidays. Submit seasonal material 1 year in advance.

First Contact & Terms Designers: Send query letter with brochure or resume and photographs. Illustrators: Send photocopies. Do not send originals. Samples are filed. Responds in 1 month, only if interested. Art Director will contact for portfolio review if interested. Portfolio should include color tear sheets, photographs and slides. Pays flat fee per design. Buys all rights. Finds artists through word of mouth.

Tips "Be open to the desires of the consumers. Don't force your preconceived notions on them through the manufacturers. Know that there is one retail price, one wholesale price and one distributor price."

ROMAN, INC.

472 Brighton Dr., Bloomingdale IL 60108-3100. (630)705-4600. Fax: (630)705-4601. E-mail: cborzych@roman.com. Website: www.roman.com. **Vice President:** Julie Puntch. Estab. 1963. Produces collectible figurines, decorative housewares, decorations, gifts, limited edition plates, ornaments. Specializes in collectibles and giftware to celebrate special occasions.

Needs Approached by 25-30 freelancers/year. Works with 3-5 freelancers/year. Uses freelancers mainly for graphic packaging design, illustration. Considers variety of media. Looking for traditional-based design. Roman also has an inspirational niche. 80% of freelance design and illustration demands knowledge of Photoshop, QuarkXPress, Illustrator. Produces material for Christmas, Mother's Day, graduation, Thanksgiving, birthdays, everyday. Submit seasonal material 1 year in advance.

First Contact & Terms Send query letter with photocopies. Samples are filed or returned by SASE. Responds in 2 months if artist requests a reply. Portfolio review not required. Pays by the project. Finds freelancers through submissions and word of mouth.

SPARROW & JACOBS

6701 Concord Park Dr., Houston TX 77040. (713)329-9400. Fax: (713)744-8799. E-mail: sparrowart@gabp.com. **Contact:** Product Merchandiser. Estab. 1986. Produces calendars, greeting cards, postcards and other products for the real estate industry.

Needs Buys up to 300 freelance photographs and illustrations/year including illustrations for postcards and greeting cards. Considers all media. Looking for new product ideas featuring residential front doors, homes and home-related images, flowers, landscapes, cute animals, holiday themes and much more. Emphasis on home-related photographs and illustrations. Produces material for Christmas, Easter, Mother's Day, Father's Day, Halloween, New Year, Thanksgiving, Valentine's Day, July 4th, birthdays, everyday, time change. Submit seasonal material 6 months in advance.

First Contact & Terms Send letter with color photocopies, photographs or tearsheets.

We also accept e-mail submissions of low-resolution images. If sending slides, do not send originals. We are not responsible for slides lost or damaged in the mail. Samples are filed or returned in your SASE.

SYRACUSE CULTURAL WORKERS

P.O. Box 6367, Syracuse NY 13217. (315)474-1132. Fax: (877)265-5399. E-mail: karenk@syracuseculturalworkers.com. Website: www.syracuseculturalworkers. com. **Art Director:** Karen Kerney. Estab. 1982. Produces posters, note cards, postcards, greeting cards, T-shirts and calendars that are feminist, progressive, radical, multicultural, lesbian/gay allied, racially inclusive and honoring of elders and children. Publishes and distributes peace and justice resources through their Tools For Change catalog.

- See additional listing in the Posters & Prints section.

Needs Approached by many freelancers/year. Works with 50 freelancers/year. Buys 40-50 freelance fine art images and illustrations/year. Considers all media. Art guidelines available on website or free for SASE with first-class postage. Specifically seeking artwork celebrating peace-making diverstiy, people's history and community building. "Our mission is to help sustain a culture that honors diversity and celebrates community; that inspires and nurtures justice, equality and freedom; that respects our fragile Earth and all its beings; that encourages and supports all forms of creative expression." Themes include environment, positive parenting, positive gay and lesbian images, multiculturalism and cross-cultural adoption.

First Contact & Terms Send query letter with sample of work and SASE. Samples are filed or returned by SASE. Responds in 1 month with SASE. Will contact for portfolio review if interested. Buys one-time rights. Pays flat fee, $85-450; royalties of 4-6% gross sales. Finds artists through submissions and word of mouth.

Tips "Please do NOT send original art. Rather, send photocopies, printed samples or duplicate slides. Also, one postcard sample is not enough for us to judge whether your work is right for us. Include return postage if you would like your artwork/slides returned. December and January are major art selection months." Please visit our web site to get a sense of what we chosen to publish in past www. syracuseculturalworkers.com.

WARNER PRESS, INC.

1201 E. Fifth St., Anderson IN 46012. (800)741-7721. E-mail: krhodes@warnerpress. org. Website: www.warnerpress.org. **Creative Director:** Curtis Corzine. Estab. 1884. Warner Press is the publication board for the Church of God. Produces church bulletins and church supplies such as postcards and children's materials. "We produce products for the Christian market. Our main markets are the Church and Christian bookstores. We provide products for all ages." Art submission guidelines on website.

Needs Approached by 50 freelancers/year. Works with 15-20 freelancers/year. Buys 200 freelance designs and illustrations/year. Works on assignment only. Uses freelancers for all products, including bulletins and coloring books. Considers all media and photography. 100% of production work demands knowledge of Photoshop, Illustrator and InDesign.

First Contact & Terms Send postcard or query letter with samples. Do not send originals. Creative Director will contact artist for portfolio review if interested. Samples are filed or returned if SASE included. Pays by the project. Buys all rights (occasionally varies).

Tips "Subject matter must be appropriate for Christian market. Most of our art purchases are for children's materials."

CAROL WILSON FINE ARTS, INC.

Box 17394, Portland OR 97217. (503)261-1860. E-mail: info@carolwilsonfinearts. com. Website: www.carolwilsonfinearts.com. **Contact:** Gary Spector. Estab. 1983. Produces greeting cards and fine stationery products.

Needs Romantic floral and nostalgic images. "We look for artists with high levels of training, creativity and ability."

First Contact & Terms Write or call for art guidelines. No original artwork on initial inquiry. Samples not filed are returned by SASE.

Tips "We are seeing an increased interest in romantic fine arts cards and very elegant products featuring foil, embossing and die-cuts."

Posters & Prints

Have you ever noticed, perhaps at the opening of an exhibition or at an art fair, that though you have many paintings on display, everybody wants to buy the same one? Do friends, relatives and co-workers ask you to paint duplicates of work you've already sold? Many artists turn to the print market because they find certain images have a wide appeal and will sell again and again. This section lists publishers and distributors who can produce and market your work as prints or posters. It is important to understand the difference between the terms "publisher" and "distributor" before you begin your research. Art *publishers* work with you to publish a piece of your work in print form. Art *distributors* assist you in marketing a pre-existing poster or print. Some companies function as both publisher and distributor. Look in the first paragraph of each listing to determine if the company is a publisher, distributor or both.

RESEARCH THE MARKET

Some listings in this section are fine art presses, and others are more commercial. Read the listings carefully to determine which companies create editions for the fine art market or for the decorative market. Visit galleries, frame shops, furniture stores and other retail outlets that carry prints to see where your art fits in. You may also want to visit designer showrooms and interior decoration outlets.

To further research this market, check each company's website or send for their catalog. Some publishers will not send their catalogs because they are too expensive, but you can often ask to see one at a local poster shop, print gallery, upscale furniture store or frame shop. Examine the colors in the catalogs to make sure the quality is high.

What to send

To approach a publisher, send a brief query letter, a short bio, a list of galleries

Your Publishing Options

Important

① **Working with a commercial poster manufacturer or art publisher.** If you don't mind creating commercial images and following current trends, the decorative market can be quite lucrative. On the other hand, if you work with a fine art publisher, you will have more control over the final image.

② **Working with a fine art press.** Fine art presses differ from commercial presses in that press operators work side by side with you every step of the way, sharing their experience and knowledge of the printing process. You may be charged a fee for the time your work is on the press and for the expert advice of the printer.

③ **Working at a co-op press.** Instead of approaching an art publisher, you can learn to make your own hand-pulled original prints—such as lithographs, monoprints, etchings or silk-screens. If there is a co-op press in your city, you can rent time on a press and create your own editions. It can be rewarding to learn printing skills and have the hands-on experience. You also gain total control of your work. The drawback is you have to market your images yourself by approaching galleries, distributors and other clients.

④ **Self-publishing.** Several national printing companies advertise heavily in artists' magazines, encouraging artists to publish their own work. If you are a savvy marketer who understands the ins and outs of trade shows and direct marketing, this is a viable option. However, it takes a large investment up front, whether you work with a printing company or choose to do everything on your own. If you contract with a printer, you could end up with a thousand prints taking up space in your basement. On the other hand, if you are a good marketer, you could end up selling them all and making a much larger profit than if you had gone through an art publisher or poster company.

Another option is to create the prints yourself, from your computer, using a high-quality digital printer and archival paper. You can make the prints as needed, which will save money.

⑤ **Marketing through distributors.** If you choose the self-publishing route but don't have the resources to market your prints, distributors will market your work in exchange for a percentage of sales. Distributors have connections with all kinds of outlets like retail stores, print galleries, framers, college bookstores and museum shops.

that represent your work, and five to 10 slides or whatever samples they specify in their listing. It helps to send printed pieces or tearsheets as samples, as these show publishers that your work reproduces well and that you have some understanding of the publication process. Most publishers will accept digital submissions via e-mail or CD.

Signing and numbering your editions

Before you enter the print arena, follow the standard method of signing and numbering your editions. You can observe how this is done by visiting galleries and museums and talking to fellow artists.

If you are creating a limited edition—with a specific, set number of prints—all prints should be numbered, such as 35/100. The largest number is the total number of prints in the edition; the smaller number is the sequential number of the actual print. Some artists hold out ten percent as artist's proofs and number them separately with AP after the number (e.g., 5/100 AP). Many artists sign and number their prints in pencil.

Types of prints

Original prints. Original prints may be woodcuts, engravings, linocuts, mezzotints, etchings, lithographs or serigraphs (see Glossary on page 509 for definitions). What distinguishes them is that they are produced by hand by the artist (and consequently often referred to as hand-pulled prints). In a true original print, the work is created specifically to be a print. Each print is considered an original because the artist creates the artwork directly on the plate, woodblock, etching stone or screen. Original prints are sold through specialized print galleries, frame shops and high-end decorating outlets, as well as fine art galleries.

Offset reproductions and posters. Offset reproductions, also known as posters and image prints, are reproduced by photochemical means. Since plates used in offset reproductions do not wear out, there are no physical limits on the number of prints that can be made. Quantities, however, may still be limited by the publisher in order to add value to the edition.

Giclée prints. As color-copier technology matures, inkjet fine art prints, also called giclées, are gaining popularity. Iris prints, images that are scanned into a computer and output on oversized printers, are even showing up in museum collections.

Canvas transfers. Canvas transfers are becoming increasingly popular. Instead of, and often in addition to, printing an image on paper, the publisher transfers the image onto canvas so the work has the look and feel of a painting. Some publishers market limited editions of 750 prints on paper, along with a smaller edition of 100 of the same image on canvas. The edition on paper might sell for $150 per print, while the canvas transfer would be priced higher, perhaps selling for $395.

Pricing criteria for limited editions and posters

Because original prints are always sold in limited editions, they command higher prices than posters, which are not numbered. Since plates for original prints are made by hand, and as a result can only withstand a certain amount of use, the number of prints pulled is limited by the number of impressions that can be made before the plate wears out. Some publishers impose their own limits on the number of impressions to increase a print's value. These limits may be set as high as 700 to 1,000 impressions, but some prints are limited to just 250 to 500, making them highly prized by collectors.

A few publishers buy work outright for a flat fee, but most pay on a royalty basis. Royalties for hand-pulled prints are usually based on retail price and range from 5 to 20 percent, while percentages for posters and offset reproductions are lower (from 2½ to 5 percent) and are based on the wholesale price. Be aware that some publishers may hold back royalties to cover promotion and production costs; this is not uncommon.

Prices for prints vary widely depending on the quantity available; the artist's reputation; the popularity of the image; the quality of the paper, ink and printing process. Because prices for posters are lower than for original prints, publishers tend to select images with high-volume sales potential.

Negotiating your contract

As in other business transactions, ask for a contract and make sure you understand and agree to all the terms before you sign. Make sure you approve the size, printing

Insider Tips

Tips

- Read industry publications, such as *DECOR* magazine (www. decormagazine.com) and *Art Business News* (www.artbusinessnews. com), to get a sense of what sells.

- To find out what trade shows are coming up in your area, check the event calendars in industry trade publications. Many shows, such as the DECOR Expo (www.decor-expo.com), coincide with annual stationery or gift shows, so if you work in both the print and greeting card markets, be sure to take that into consideration. Remember, traveling to trade shows is a deductible business expense, so don't forget to save your receipts!

- Consult *Business and Legal Forms for Fine Artists*, by Tad Crawford (Allworth Press) for sample contracts.

method, paper, number of images to be produced, and royalty terms. Other things to watch for include insurance terms, marketing plans, and a guarantee of a credit line or copyright notice.

Always retain ownership of your original work. Negotiate an arrangement in which you're selling publication rights only. You'll also want to sell rights only for a limited period of time. That way you can sell the image later as a reprint or license it for other use (e.g., as a calendar or note card). If you are a perfectionist about color, make sure your contract gives you final approval of your print. Stipulate that you'd like to inspect a press proof prior to the print run.

MORE INDUSTRY TIPS

Find a niche. Consider working within a specialized subject matter. Prints with Civil War themes, for example, are avidly collected by Civil War enthusiasts. But to appeal to Civil War buffs, every detail, from weapons and foliage in battlefields to uniform buttons, must be historically accurate. Signed limited editions are usually created in a print run of 950 or so and can average about $175-200; artist's proofs sell from between $195-250, with canvas transfers selling for $400-500. The original paintings from which images are taken often sell for thousands of dollars to avid collectors.

Sport art is another lucrative niche. There's a growing trend toward portraying sports figures from football, basketball and racing (both sports car and horse racing) in prints that include both the artist's and the athlete's signatures. Movie stars and musicians from the 1950s (such as James Dean, Marilyn Monroe and Elvis) are also cult favorites, but any specialized style (such as science fiction/fantasy or wildlife art) can be a marketable niche. See the index starting on page 529 for more ideas.

Work in a series. It is easier to market a series of small prints exploring a single theme than to market single images. A series of similar prints works well in long hospital corridors, office meeting rooms or restaurants. "Paired" images also are rather profitable. Hotels often purchase two similar prints for each of their rooms.

Study trends. If you hope to get published by a commercial art publisher or poster company, realize your work will have a greater chance of acceptance if you use popular colors and themes.

Attend trade shows. Many artists say it's the best way to research the market and make contacts. It's also a great way for self-published artists to market their work. DECOR Expo is held each year in four cities: Atlanta, New York, Orlando and Los Angeles. For more information, call (888)608-5300 or visit www.decor-expo. com Artexpo is held every spring in New York, and now also every fall in Las Vegas. The SOLO Independent Artists' Pavilion, a special section of Artexpo dedicated to showcasing the work of emerging artists, is the ultimate venue for artists to be discovered. See www.artexpos.com for more information.

ACTION IMAGES INC.

7148 N. Ridgeway, Lincolnwood IL 60712. (847)763-9700. Fax: (847)763-9701. E-mail: actionim@aol.com. Website: www.actionimagesinc.com. **President:** Tom Green. Estab. 1989. Art publisher of sport art. Publishes limited edition prints, open edition posters as well as direct printing on canvas. Specializes in sport art prints for events such as the Super Bowl, Final Four, Stanley Cup, etc. Clients include retailers, distributors, sales promotion agencies.

Needs "Ideally seeking sport artists/illustrators who are accomplished in both traditional and computer-generated artwork as our needs often include tight deadlines, exacting attention to detail and excellent quality. Primary work relates to posters and T-shirt artwork for retail and promotional material for sporting events." Considers all media. Artists represented include Cheri Wenner, Andy Wenner, Ken Call, Konrad Hack and Alan Studt. Approached by approximately 25 artists/year.

Contact & Terms Send JPEG or PDF files via e-mail or mailed disk (compatible with Mac) and color printouts. Samples are filed. Responds only if interested. If interested in samples, will ask to see more of artist's work. Pays flat fee: $1,000-2,000. Buys exclusive reproduction rights. Rarely acquires original painting. Provides insurance while work is at firm and outbound in-transit insurance. Promotional services vary depending on project. Finds artists through recommendations from other artists, word of mouth and submissions.

Tips "If you're a talented artist/illustrator and know your PhotoShop/Illustrator software, you have great prospects."

ARNOLD ART STORE & GALLERY

210 Thames St., Newport RI 02840. (401)847-2273 or (800)352-2234. Fax: (401)848-0156. E-mail: info@arnoldart.com. Website: www.arnoldart.com. **Owner:** Bill Rommel. Estab. 1870. Poster company; art publisher/distributor; gallery specializing in marine art. Publishes/distributes limited and unlimited editions, fine art prints, offset reproductions and posters.

Needs Seeking creative, fashionable, decorative art for the serious collector, commercial and designer markets. Considers oil, acrylic, watercolor, mixed media, pastel, pen & ink, sculpture. Prefers sailing images—Americas Cup or other racing images. Artists represented include Kathy Bray, Thomas Buechner and James DeWitt. Editions are created by working from an existing painting. Approached by 100 artists/year. Publishes/distributes the work of 10-15 established artists/year.

Contact & Terms Send query letter with 4-5 photographs. Samples are filed or returned by SASE. Call to arrange portfolio review. Pays flat fee, royalties or consignment. Negotiates rights purchased; rights purchased vary according to project. Provides advertising and promotion. Finds artists through word of mouth.

🌐 THE ART GROUP

91-94 Saffron Hill, London UK EC1N 8QP. 44 207 504 7111. Fax: 44 207 428 1705. E-mail: mail@artgroup.com. Website: www.artgroup.com. **Contact:** Research Dept. Rights Director. Fine art card and poster publisher/distributor handling posters for framers, galleries, museums, department stores and gift shops. Current clients include IKEA, Habitat, Ann Viney ARGOS, Next, WH Smith, Paper Chase.

Needs Considers all media and broad subject matter. Fine art contemporary; digitally created artwork. Publishes the work of 100-200 mid-career and 200-400 established artists/year. Distributes the work of more than 2,000 artists/year.

Contact & Terms Send query letter with brochure, photostats, photographs, photocopies, slides and transparencies. Samples are filed or are returned. Responds in 1 month. Publisher/Distributor will contact artists for portfolio review if interested.

Tips "Send only relevant samples of work. Visit poster and card shops to understand the market a little more before submitting ideas. Be clear and precise."

ART IMPRESSIONS, INC.

23586 Calabasas Rd., Suite 210, Calabasas CA 91302. (818)591-0105. Fax: (818)591-0106. E-mail: info@artimpressionsinc.com. Website: www.artimpressionsinc.com. **Creative Director:** Jennifer Ward. Estab. 1990. Licensing agent. Clients: major manufacturers worldwide. Current clients include Tripp NYC, Lounge Fly, Random House, Springs Industries, 3M and Mead Westvaco.

Needs Seeking art for the commercial market, "especially art geared towards fashion/streetwear market." Considers oil, acrylic, mixed media, pastel and photography. No abstracts or nudes. Artists represented include Skelanimals, Corky Mansfield, Jessica Louise, Schim Schimmel, Valerie Tabor-Smith, Celine Dion and Josephine Wall. Approached by over 70 artists/year.

Contact & Terms Send query letter with photocopies, photographs, slides, transparencies or tearsheets and SASE. Accepts disk submissions. Samples are not filed and are returned by SASE. Responds in 2 months. Will contact artist for portfolio review if interested. Artists are paid percentage of licensing revenues generated by their work. No advance. Requires exclusive representation of artist. Provides advertising, promotion, written contract and legal services. Finds artists through art exhibitions, word of mouth, publications and submissions.

Tips "Artists should have at least 25 images available and be able to reproduce new collections several times a year. Artwork must be available on disc and be of reproduction quality."

🔲 ART IN MOTION

2000 Brigantine Dr., Coquitlam BC V3K 7B5 Canada. (604)525-3900 or (800)663-1308. Fax: (604)525-6166 or (877)525-6166. E-mail: artistrelations@artinmotion.com.

Website: www.artinmotion.com. **Contact:** Artist Relations. Publishes, licenses and distributes open edition reproductions. Licenses all types of artwork for all industries, including wallpaper, fabric, stationery and calendars. Clients: galleries, high-end retailers, designers, distributors (worldwide) and picture frame manufacturers.

Needs "Our collection of imagery reflects today's interior decorating tastes; we publish a wide variety of techniques. View our collection online before submitting. However, we are always interested in new looks, directions and design concepts." Considers oil and mixed media.

Contact & Terms Submit portfolio for review. Pays royalties of 10%. Royalties paid monthly. "Art In Motion covers all associated costs to reproduce and promote your artwork."

Tips "We are a world leader in fine art publishing with distribution in over 72 countries. The publishing process utilizes the latest technology and state-of-the-art printing equipment and uses the finest inks and papers available. Artist input and participation are highly valued and encouraged at all times. We warmly welcome artist inquiries. Contact us via e-mail, or direct us to your website; also send slides or color copies of your work (all submissions will be returned)."

THE ART PUBLISHING GROUP

165 Chubb Ave., Lyndhurst NJ 07071. (201)842-8500 or (800)760-3058. Fax: (201)842-8546. E-mail: contact@theartpublishinggroup.com. Website: www. theartpublishinggroup.com. **Contact:** Artist Submissions. Estab. 1973. Publisher and distributor of limited editions, open editions, and fine art prints and posters. Clients: galleries and custom frame shops worldwide.

- Divisions of The Art Publishing Group include APG Collection, Front Line Art Publishing, Modernart Editions and Scafa Art. See website for details of each specific line. Submission guidelines are the same for all.

Needs Seeking decorative art for the commercial and designer markets. Considers oil, watercolor, mixed media, pastel and acrylic. Prefers fine art, abstract and contemporary, floral, representational, still life, decorative, collage, mixed media. Size: 16 × 20. Editions are created by collaborating with the artist or by working from an existing painting. Approached by 200 artists/year. Publishes the work of 10-15 emerging artists/year. Distributes the work of 100 emerging artists/year.

Contact & Terms Submit no more than 4 JPEGs (maximum 300KB each) via e-mail. Also accepts CDs, color copies, photographs "or any any other medium that best represents your art. DO NOT send original art, transparencies or slides. If you want your samples returned, be sure to include a SASE." Responds in 6 weeks. Will contact artist for portfolio review if interested. Pays flat fee of $200-300 or royalties of 10%. Offers advance against royalties. Provides insurance while work is at firm, shipping to firm and written contract.

Tips "If you want your submission to be considered for a specific line within The Art Publishing Group, please indicate that in your cover letter."

OUT OF THE BLUE

1022 Hancock Ave., Ste 1, Sarasota FL 34232. (941)966-4042. E-mail: outoftheblue. us@mac.com. Website: www.out-of-the-blue.us. **President:** Michael Woodward. Estab. 1986. "We are looking for fine art, decorative art photography that we can license for product categories such as posters and fine art prints, limited edition giclées, greeting cards, calendars, stationery, gift products and the home decor market. We specialize particularly in the fine art print/poster market."

- This Company is a division of Art Licensing International, Inc. (See separate listings in the Posters Prints and Artist's Reps sections as well as in the section)

Needs Collections of art or photography that have wide consumer appeal. "CD or e-mail presentations only. Keep files to 250K or below."

Contact & Terms Send samples on CD (JPEG files) send SASE if you want CD returning. E-mail submissions also accepted. "Terms are 50/50 with no expense of artist as long as artist can provide high-res digital files if we agree on representation." Submission guidelines are available on website at www.out-of-the-blue.us/submissions.html.

Tips Pay attention to trends and color palettes. Artists need to consider actual products when creating new art. Look at products in retail outlets and get a feel for what is selling well. Get to know the markets you want to sell your work to."

⚡ WINN DEVON ART GROUP

110-6311 Westminster Hwy., Richmond BC V7C 4V4 Canada. (604)276-4551. Fax: (604)276-4552. E-mail: artsubmission@encoreartgroup.com. Website: www. winndevon.com. Art publisher. Publishes open and limited editions, offset reproductions, giclées and serigraphs. Clients: mostly trade, designer, decorators, galleries, retail frame shops. Current clients include Pier 1, Z Gallerie, Intercontinental Art, Chamton International, Bombay Co.

Needs Seeking decorative art for the designer market. Considers oil, watercolor, mixed media, pastel, pen & ink and acrylic. Artists represented include Buffet, Lourenco, Jardine, Hall, Goerschner, Lovelace, Bohne, Romeu and Tomao. Editions are created by working from an existing painting. Approached by 300-400 artists/year. Publishes and distributes the work of 0-3 emerging, 3-8 mid-career and 8-10 established artists/year.

Contact & Terms Send query letter with brochure, slides, photocopies, résumé, photostats, transparencies, tearsheets or photographs. Samples are returned by SASE if requested by artist. Responds in 4-6 weeks. Publisher will contact artist for portfolio review if interested. Portfolio should include "whatever is appropriate to communicate the artist's talents." Payment is based on royalties. Copyright remains with artist. Provides written contract. Finds artists through art exhibitions, agents, sourcebooks, publications, submissions.

Tips Advises artists to attend WCAF Las Vegas and DECOR Expo Atlanta. "I would advise artists to attend just to see what is selling and being shown, but keep in mind that this is not a good time to approach publishers/exhibitors with your artwork."

Advertising, Design & Related Markets

This section offers a glimpse at one of the most lucrative markets for artists. Because of space constraints, the companies listed are just the tip of the proverbial iceberg. There are thousands of advertising agencies and public relations, design and marketing firms across the country and around the world. All rely on freelancers. Look for additional firms in industry directories such as *The Black Book* and *Workbook*. Find local firms in the yellow pages and your city's business-to-business directory. You can also pick up leads by reading *Adweek*, *HOW*, *PRINT*, *STEP inside design*, *Communication Arts* and other design and marketing publications.

Find your best clients

Read listings carefully to identify firms whose clients and specialties are in line with the type of work you create. (You'll find clients and specialties in the first paragraph of each listing.) For example, if you create charts and graphs, contact firms whose clients include financial institutions. Fashion illustrators should approach firms whose clients include department stores and catalog publishers. Sculptors and modelmakers might find opportunities with firms specializing in exhibition design.

Payment and copyright

You will most likely be paid by the hour for work done on the firm's premises (in-house), and by the project if you take the assignment back to your studio. Most checks are issued 40-60 days after completion of assignments. Fees depend on the client's budget, but most companies are willing to negotiate, taking into consideration the experience of the freelancer, the lead time given, and the complexity of the project. Be prepared to offer an estimate for your services, and ask for a purchase order (P.O.) before you begin an assignment.

Some art directors will ask you to provide a preliminary sketch on speculation or "on spec" which, if approved by the client, can land you a plum assignment.

If you are asked to create something "on spec" be aware that you may not receive payment beyond an hourly fee for your time if the project falls through. Be sure to ask upfront about payment policy before you start an assignment.

If you're hoping to retain usage rights to your work, you'll want to discuss this upfront, too. You can generally charge more if the client is requesting a buyout. If research and travel are required, make sure you find out ahead of time who will cover these expenses.

ADVANCED DESIGNS CORPORATION

1169 W. Second St., Bloomington IN 47403. (812)333-1922. Fax: (812)333-2030. Website: www.doprad.com. **President:** Matt McGrath. Estab. 1982. AV firm. Specializes in TV news broadcasts. Product specialties are the Doppler Radar and Display Systems.

Needs Prefers freelancers with experience. Works on assignment only. Uses freelancers mainly for TV/film (weather) and cartographic graphics. Needs computer-literate freelancers for production. 100% of freelance work demands skills in ADC Graphics.

First Contact & Terms Send query letter with résumé and SASE. Samples are not filed and are returned by SASE. Pays for design and illustration by the hour, $7 minimum. Will contact artist for portfolio review if interested. Rights purchased vary according to project. Finds artists through classifieds.

◩ BEDA DESIGN

P.O. Box 16, Lake Villa IL 60046. E-mail: bedadesign@earthlink.net. **President:** Lynn Beda. Estab. 1971. **Design firm:** Specializes in packaging, print material, publishing, film and video documentaries. Current clients include business-to-business accounts, producers to writers, directors and artists. Approximate annual billing: $300,000

Needs Web page builders in Mac platforms. Use skilled Mac freelancers for Retouching, Technical, Illustration, Production, Photoshop, QuarkXPress, Illustrator, Premiere, and Go Live. Use film and editorial writers and photographers.

First Contact & Terms Designers: Send query letter with brochure, photocopies and résumé. Illustrators: Send postcard samples and/or photocopies. Samples are filed and are not returned. Will contact for portfolio review if interested.

BOOKMAKERS LTD.

P.O. Box 1086, Taos NM 87571. (575)776-5435. Fax: (575)776-2762. E-mail: gayle@ bookmakersltd.com. Website: www.bookmakersltd.com. **President:** Gayle McNeil. Estab. 1975. Full-service design and production studio. "We provide design and

production services to the publishing industry. We also represent a group of the best children's book illustrators in the business. We welcome authors who are interested in self-publishing."

• This company is also listed in the Artists' Reps section.

Tips The most common mistake illustrators make in presenting samples or portfolios is "too much variety, not enough focus."

BRAMSON + ASSOCIATES

7400 Beverly Blvd., Los Angeles CA 90036. (323)938-3595. Fax: (323)938-0852. E-mail: gbramson@aol.com. **Principal/Senior Creative Director**: Gene Bramson. Estab. 1970. Number of employees 20. Approximate annual billing more than $4 million. Advertising agency. Specializes in corporate communications, branding, magazine branding ads, collateral, ID, signage, graphic design, imaging, campaigns. Product specialties are healthcare, consumer, business to business. Clients include Johnson & Johnson, Chiron Vision, Lawry's and Sumitomo Metal / Mining.

Needs Approached by 150 freelancers/year. Works with 10 freelance illustrators, 2 animators and 5 designers/year. Prefers local freelancers but work internationally. Works on assignment only. Uses freelancers for brochure and print ad design; brochure, technical, medical and print ad illustration, storyboards, mechanicals, retouching, lettering, logos. 30% of work is with print ads. 50% of freelance work" knowledge of Illustrator, Photoshop, Freehand or 3-D Studio and In Design.

First Contact & Terms Send query letter with brochure, photocopies, resume, photographs, tearsheets, SASE. Samples are filed. Will contact artist for portfolio review if interested. Portfolio should include roughs, color tearsheets. Sometimes requests work on spec before assigning job. Pays for design by the hour, $20-75. Pays for illustration by the project, $250-2,000. Buys all rights or negotiates rights purchased. Finds artists thr ough sourcebooks.

Tips "We look for very unique talent only. Price and availability are also important."

BRIGHT IDEAS

A.W. Peller and Associates, Inc., 116 Washington Ave., Hawthorne NJ 07507. (800)451-7450. Fax: (973)423-5569. E-mail: awpeller@optonline.net. Website: www. awpeller.com. **Art Director:** Karen Birchak. Estab. 1973. Number of employees: 12. AV producer. Serves clients in education. Produces children's educational materials—videos, sound filmstrips, read-along books, cassettes and CD-ROMs.

Needs Works with 1-2 freelance illustrators/year. "While not a requirement, a freelancer living in the same geographic area is a plus." Works on assignment only, "although if someone had a project already put together, we would consider it." Uses freelancers mainly for illustrating children's books; also for artwork for filmstrips, sketches for

books and layout work. 50% of freelance work demands knowledge of QuarkXPress and Photoshop.

First Contact & Terms Send query letter with résumé, tearsheets, SASE, photocopies and photographs. Will contact artist for portfolio review if interested. "Include child-oriented drawings in your portfolio." Requests work on spec before assigning a job. Pays for design and illustration by the project, $20 minimum. Originals not returned. Buys all rights. Finds artists through submissions.

BRIGHT LIGHT PRODUCTIONS, INC.

602 Main St., Suite 810, Cincinnati OH 45202. (513)721-2574. Fax: (513)721-3329. E-mail: info@brightlightusa.com. Website: www.brightlightusa.com. **Contact:** Ken Sharp, HR coordinator. Estab. 1976. "We are a full-service film/video communications firm producing TV commercials and corporate communications."

Needs Works on assignment only. Uses artists for editorial, technical and medical illustration and brochure and print ad design, storyboards, slide illustration, animatics, animation, TV/film graphics and logos. Needs computer-literate freelancers for design and production. 50% of freelance work demands knowledge of Photoshop, Illustrator and After Effects.

First Contact & Terms Send query letter with brochure and résumé. Samples not filed are returned by SASE only if requested by artist. Request portfolio review in original query. Portfolio should include roughs and photographs. Pays for design and illustration by the project. Negotiates rights purchased. Finds artists through recommendations.

Tips "Our need for freelance artists is growing."

CARNASE, INC.

300 East Malino Rd., Palm Springs CA 92262. E-mail: carnase@carnase.com. Website: www.carnase.com. **President:** Tom Carnase. Estab. 1978. Specializes in annual reports, brand and corporate identity, display, landscape, interior, direct mail, package and publication design, signage and technical illustration. Clients: agencies, corporations, consultants. Current clients include Brooks Brothers, Fortune Magazine, Calvin Klein, Saks Fifth Avenue.

Needs Approached by 60 freelance artists/year. Works with 2 illustrators and 1 designer/year. Prefers artists with 5 years experience. Works on assignment only. Uses artists for brochure, catalog, book, magazine and direct mail design and brochure and collateral illustration. Needs computer-literate freelancers. 50% of freelance work demands skills in QuarkXPress or Illustrator.

First Contact & Terms Send query letter with brochure, résumé and tearsheets. Samples are filed. Responds in 10 days. Will contact artist for portfolio review if interested. Portfolio should include photostats, slides and color tearsheets. Negotiates

payment. Rights purchased vary according to project. Finds artists through word of mouth, magazines, submissions/self-promotions, sourcebooks and agents.

DEFOREST CREATIVE

300 W. Lake St., Elmhurst IL 60126. (630)834-7200. Fax: (630)279-8410. E-mail: info@ deforestgroup.com. Website: www.deforestgroup.com. **Art Director:** Nick Chapman. Estab. 1965. Number of employees: 15. Marketing solutions, graphic design and digital photography firm.

Needs Approached by 50 freelance artists/year. Works with 3-5 freelance designers/ year. Prefers artists with experience in PhotoShop, Illustrator and InDesign.

First Contact & Terms Send query letter with résumé and samples. Samples are filed or returned by SASE if requested by artist. To arrange for portfolio review artist should fax or e-mail. Pays for production by the hour, $25-75. Finds designers through word of mouth and artists' submissions.

Tips "Be hardworking, honest, and good at your craft."

DESIGN ASSOCIATES GROUP, INC.

1828 Asbury Ave., Evanston IL 60201-3504. (847)425-4800. E-mail: info@ designassociatesinc.com. Website: www.designassociatesinc.com. **Contact:** Paul Uhl. Estab. 1986. Number of employees: 5. Specializes in text and trade book design, annual reports, corporate identity, website development. Clients corporations, publishers and museums. Client list available upon request.

Needs Approached by 10-20 freelancers/year. Works with 100 freelance illustrators and 2 designers/year. Uses freelancers for design and production. 100% of freelance work demands knowledge of Illustrator, Photoshop and InDesign.

First Contact & Terms Send query letter with samples that best represent work. Accepts disk submissions. Samples are filed. Will contact artist for portfolio review if interested. Portfolio should include b&w and color samples.

☒ DESIGN COLLABORATIVE

1617 Lincoln Ave., San Rafael CA 94901-5400. (415)456-0252. Fax: (415)479-2001. E-mail: bford@neteze.com. Website: www.designco.com. **Creative Director:** Bob Ford. Estab. 1987. Number of employees 7. Approximate annual billing $350,000. Ad agency/design firm. Specializes in publication design, package design, environmental graphics. Product specialty is consumer. Current clients include B of A, Lucas Film Ltd., Broderbund Software. Client list available upon request. Professional affiliations AAGD, PINC, AAD.

Needs Approached by 20 freelance illustrators and 60 designers/year. Works with 15 freelance illustrators and 20 designers/year. Prefers local designers with experience in package design. Uses freelancers mainly for art direction production. Also for brochure

design and illustration, mechanicals, multimedia projects, signage, web page design. 25% of work is with print ads. 80% of design and 85% of illustration demand skills in PageMaker, FreeHand, Photoshop, QuarkXPress, Illustrator, PageMill.

First Contact & Terms Designers: Send query letter with photocopies, résumé, color copies. Illustrators: Send postcard sample and/or query letter with photocopies and color copies. After introductory mailing send follow-up postcard samples. Accepts disk submissions. Send EPS files. Samples are filed or returned. Responds in 1 week. Artist should call. Portfolio review required if interested in artist's work. Portfolios of final art and transparencies may be dropped off every Monday. Pays for design by the hour, $40-80. Pays for illustration by the hour, $40-100. Buys first rights. Rights purchased vary according to project. Finds artists through creative sourcebooks.

Tips "Listen carefully and execute well."

DESIGN RESOURCE CENTER

424 Fort Hill Dr., Suite 118, Naperville IL 60540. (630)357-6008. Fax: (630)357-6040. E-mail: info@drcchicago.com. Website: www.drcchicago.com. Principals: John Norman and Chuck Bokar. Estab. 1990. Number of employees: 18. Approximate annual billing: $2,500,000. Specializes in strategic branding and package design. Clients include corporations, manufacturers, private labels.

Needs Approached by 5-10 freelancers/year. Works with 5-10 freelance designers and production artists and 5-10 designers/year. Uses designers mainly for Macintosh or concepts. Also uses freelancers for P-O-P design and illustration, lettering, logos and package design. Needs computer-literate freelancers for design, illustration and production. 100% of freelance work demands knowledge of Illustrator, QuarkXPress and Photoshop.

First Contact & Terms Send query letter with brochure, photocopies, photographs and resume. Samples are filed. Artist should follow up. Portfolio review sometimes required. Portfolio should include b&w and color final art, photographs, roughs and thumbnails. Pays for design by the hour or per project. Pays for illustration by the project. Buys all rights. Finds artists through word of mouth and referrals.

DEVER DESIGNS

14203 Park Center Dr. Suite 308, Laurel MD 20707. (301)776-2812. Fax: 1-866-665-1196. E-mail: info@deverdesigns.com. Website: www.deverdesigns.com. **President:** Jeffrey Dever. Marketing Director: Holly Hagen. Estab. 1985. Number of employees 8. Specializes in annual reports, corporate identity and publication design. Clients: associations, nonprofit organizations, educational institutions, museums, government agencies.

Needs Approached by 100 freelance illustrators/year. Works with 20-40 freelance illustrators/year. Prefers artists with experience in editorial illustration. Uses illustrators mainly for publications.

First Contact & Terms Send postcard, samples or query letter with photocopies, resume and tearsheets. Accepts PDFs and disk submissions compatible with Photoshop, Illustrator or InDesign, but prefers hard copy samples which are filed. Will contact artist for portfolio review if interested. Portfolio should include b/w and/or color photocopies for files. Pays for illustration by the project. Rights purchased vary according to project. Finds artists through referrals and sourcebooks.

Tips Impressed by and consistent quality.

EVENTIV

10116 Blue Creek North, Whitehouse OH 43571. E-mail: jan@eventiv.com. Website: www.eventiv.com. **President/Creative Director:** Janice Robie. Agency specializing in graphics, promotions and tradeshow marketing.

Needs Assigns freelance jobs. Works with illustrators and designers on assignment only. Uses freelancers for brochures, P-O-P displays, AV presentations, posters and illustrations (technical and/or creative) electronic authoring,animation, web design. Require computer skills.

First Contact & Terms E-mail samples. Responds only interested. Pays by the hour or by the project. Considers client's budget and skill and experience of artist when establishing payment. Retains rights purchased.

GRAPHIC DESIGN CONCEPTS

15329 Yukon Ave., El Camino Village CA 90260-2452. (310)978-8922. **President:** C. Weinstein. Estab. 1980. Specializes in package, publication and industrial design, annual reports, corporate identity, displays and direct mail. Current clients include Trust Financial Financial Services (marketing materials). Current projects include new product development for electronic, hardware, cosmetic, toy and novelty companies.

Needs Works with 15 illustrators and 25 designers/year. "Looking for highly creative idea people, all levels of experience." All styles considered. Uses illustrators mainly for commercial illustration. Uses designers mainly for product and graphic design. Also uses freelancers for brochure, P-O-P, poster and catalog design and illustration; book, magazine, direct mail and newspaper design; mechanicals; retouching; airbrushing; model-making; charts/graphs; lettering; logos. Also for multimedia design, program and content development. 50% of freelance work demands knowledge of PageMaker, Illustrator, QuarkXPress, Photoshop or FreeHand.

First Contact & Terms Send query letter with brochure, résumé, tearsheets, photostats, photocopies, slides, photographs and/or transparencies. Accepts disc submissions compatible with IBM Windows. Samples are filed, or returned if accompanied by SASE. Responds in 10 days with SASE. Portfolio should include thumbnails, roughs, original/final art, final reproduction/product, tearsheets, transparencies and

references from employers. Pays by the hour, $15-50. Considers complexity of project, client's budget, skill and experience of artist, how work will be used, turnaround time, and rights purchased when establishing payment.

Tips "Send a résumé if available. Send samples of recent work or *high quality* copies. Everything sent to us should have a professional look. After all, it is the first impression we will have of you. Selling artwork is a business. Conduct yourself in a business-like manner."

GRETEMAN GROUP

1425 E. Douglas Ave., Wichita KS 67211. (316)263-1004. Fax: (316)263-1060. E-mail: info@gretemangroup.com. Website: www.gretemangroup.com. **Owner:** Sonia Greteman. Estab. 1989. Number of employees 24. Capitalized billing $20 million. Creative agency. Specializes in corporate identity, advertising, annual reports, signage, website design, interactive media, brochures, collateral. Professional affiliations AIGA.

Needs Approached by 20 illustrators and 20 designers/year. Works with 2 illustrators/year. 10% of work is with print ads. 30% of illustration demands computer skills in photoshop and illustrator.

First Contact & Terms Send query letter with brochure and résumé. Accepts disk submissions. Send EPS files. Samples are filed. Will contact for portfolio review of b&w and color final art and photostats if interested. Pays for illustration by the project. Rights purchased vary according to project.

HANSEN BELYEA

1809 Seventh Ave., Suite 1250, Seattle WA 98101. (206)682-4895. Fax: (206)623-8912. Website: www.hansenbelyea.com. Estab. 1988. Creative agency specializes in branding, marketing and communication programs including corporate identity, websites and videos, marketing collateral. Clients: B2B and B2C-professional services, education, manufacturers. Current clients include PEMCO Insurance, University of Washington, Washington Global Health Alliance, Robbins Tunnel Boring Machines.

Needs Approached by 20-30 freelancers/year. Works with 1-3 freelance illustrators/photographers and no designers/year. Works on assignment only. Also uses freelancers for calligraphy.

First Contact & Terms Direct mail and electronic communication accepted. Responds only if interested. Pays for illustration by the project. Rights purchased vary according to project. Finds artists through submissions and referral by other professionals.

Tips "Illustrators and photographers must deliver digital files. Illustrators must develop a style that make them unique in the marketplace. When pursuing potential clients, send something (one or more) distinctive. Follow up. Be persistent (it can take one or two years to get noticed) but not pesky."

HORNALL ANDERSON

710 Second Ave., Suite 1300, Seattle WA 98104. (206)467-5800. Fax: (206)467-6411. E-mail: info@hadw.com. Website: www. hornallanderson.com. Estab. 1982. Number of employees: 100 + Integrated branding firm. Specializes in full-range integrated brand and communications strategy, corporate identity, digital and interactive experience design, packaging, corporate literature, collateral, retail and environmental graphics. Current clients include Holland America Line, Widmer Brothers Brewery, Redhook Brewery, T-Mobile, Microsoft, Madison Square Garden, Starbucks, Willis Tower, and Frito Lays. Professional affiliations: AIGA, Seattle Design Association, Art Directors Club.

- This firm has received numerous awards and honors, including the International Mobius Awards, London International Advertising Awards, ADDY Awards, Communication Arts, AIGA, Clio Awards, Webby Awards, and Graphis Awards.

Needs Interested in all levels, from senior print and interactive design personnel to interns with design experience. Additional illustrators and freelancers are used on an as needed basis in design and online media projects.

First Contact & Terms Designers: Send query letter with photocopies and résumé or E-mail. Illustrators: Send query letter with brochure or E-mail. Accepts disk submissions compatible with Illustrator or Photoshop. Samples are filed. Responds only if interested. Portfolios may be dropped off. Rights purchased vary according to project. Finds designers through word of mouth and submissions; illustrators through sourcebooks, reps and submissions.

KIZER INCORPORATED ADVERTISING & COMMUNICATIONS

4513 N Classen Blvd., Oklahoma City OK 73118. (405)858-4906. E-mail: bill@ kizerincorporated.com. Website: www.kizerincorporated.com. **Principal:** William Kizer. Estab. 1998. Number of employees 3. Ad agency. Specializing in magazine ads, print ads, copywriting, design/layout, collateral material. Professional affiliations OKC Ad Club, AMA, AIGA.

Needs Approached by 20 illustrators/year. Works with 3 illustrators and 3 designers/ year. 50% of work is with print ads. 100% of design demands knowledge of InDesign, Photoshop. 50% of illustration demands knowledge of FreeHand, Photoshop.

First Contact & Terms Designers: Send or e-mail query letter with samples. Illustrators: Send or e-mail query letter with samples. Accepts disk submissions compatible with InDesign or Photoshop file. Samples are filed and are not returned. Responds only if interested. To show portfolio, artist should follow up with call. Portfolio should include "your best work." Pays by the project. Rights purchased vary according to project. Finds artists through agents, sourcebooks, online services, magazines, word of mouth, artist's submissions.

LOHRE & ASSOCIATES

2330 Victory Pkwy., Suite 701, Cincinnati OH 45206. (877)608-1736. E-mail: sales@ lohre.com. Website: www.lohre.com. **President:** Chuck Lohre, LEEDAP. Number of employees: 6. Approximate annual billing: $1 million. Ad agency. Specializes in industrial firms. Professional affiliation: SMPS, U.S. Green Building, Council Cincinnati, Regional Chapter.

Needs Approached by 24 freelancers/year. Works with 10 freelance illustrators and 10 designers/year. Works on assignment only. Uses freelance artists for trade magazines, direct mail, P-O-P displays, multimedia, brochures and catalogs. 100% of freelance work demands knowledge of PageMaker, FreeHand, Photoshop and Illustrator.

First Contact & Terms Send postcard sample or e-mail. Accepts submissions on disk, any Mac application. Pays for design and illustration by the hour, $10 minimum.

Tips Looks for artists who "have experience in chemical and mining industry, can read blueprints and have worked with metal fabrication." Also needs "Macintosh-literate artists who are willing to work at office, during day or evenings."

JODI LUBY & COMPANY, INC.

808 Broadway, New York NY 10003. (212)473-1922. E-mail: jluby@jodiluby.com. Website: www.jodiluby.com. **President:** Jodi Luby. Estab. 1983. Specializes in branding, direct marketing, corporate id and web design. Clients include major magazines, startup businesses, and corporate clients.

Needs Approached by 10-20 freelance artists/year. Works with 5-10 illustrators/ year. Uses freelancers for production and Web production. 100% of freelance work demands computer skills.

First Contact & Terms Send e-mail samples only. Samples are not filed and are not returned. Will contact artist for portfolio review if interested.

MICHAEL MAHAN GRAPHICS

P.O. Box 642, Bath ME 04530-0642. (207)443-6110. E-mail: ldelorme@mahangraphics. com. Website: www.mahangraphics.com. **Contact:** Linda Delorme. Estab. 1986. Number of employees 5. Approximate annual billing $500,000. Design firm. Specializes in publication design—catalogs and direct mail. Product specialties are furniture, fine art and high tech. Current clients include Bowdoin College, Bath Iron Works and College of the Atlantic. Client list available upon request. Professional affiliations G.A.G., AIGA and Art Director's Club-Portland, ME.

Needs Approached by 5-10 illustrators and 10-20 designers/year. Works with 2 illustrators and 2 designers/year. Uses freelancers mainly for production. Also for brochure, catalog and humorous illustration and lettering. 5% of work is with print ads. 100% of design demands skills in Photoshop and QuarkXPress.

First Contact & Terms Designers: Send query letter with photocopies and résumé.

Illustrators: Send query letter with photocopies. Accepts disk submissions. Samples are filed and are not returned. Responds only if interested. Art director will contact artist for portfolio review of final art roughs and thumbnails if interested. Pays for design by the hour, $15-40. Pays for illustration by the hour, $18-60. Rights purchased vary according to project. Finds artists through word of mouth and submissions.

MARKETING BY DESIGN

2012 19th St., Suite 200, Sacramento CA 95818. (916)441-3050. E-mail: creative@mbdstudio.com. Website: www.mbdstudio.com. **Creative Director:** Joel Stinghen. Estab. 1977. Specializes in corporate identity and brochure design, publications, direct mail, trade shows, signage, display and packaging. Clients: associations and corporations. Client list not available.

Needs Approached by 50 freelance artists/year. Works with 6-7 freelance illustrators and 1-3 freelance designers/year. Works on assignment only. Uses illustrators mainly for editorial; also for brochure and catalog design and illustration, mechanicals, retouching, lettering, ad design and charts/graphs.

First Contact & Terms Send query letter with brochure, résumé, tearsheets. Samples are filed and are not returned. Does not respond. Artist should follow up with call. Call for appointment to show portfolio of roughs, color tearsheets, transparencies and photographs. Pays for design by the hour, $10-30; by the project, $50-5,000. Pays for illustration by the project, $50-4,500. Rights purchased vary according to project. Finds designers through word of mouth; illustrators through sourcebooks.

SUDI MCCOLLUM DESIGN

3244 Cornwall Dr., Glendale CA 91206. (818)243-1345. Fax: (818)243-2344. E-mail: sudimccollum@earthlink.net. Website: sudimccollum.com. **Contact**: Sudi McCollum. Specializes in home fashion design and illustration. Majority of clients are medium- to large-size businesses in home fashion industry and graphic design industry." Clients: home furnishing and giftware manufacturers, advertising agencies and graphic design studios.

Needs Uses freelance production people either on computer or with painting and product design skills. Potential to develop into fulltime job.

First Contact & Terms Send query letter or whatever you have that's Convenient. Samples are filed. Responds only if interested.

MEDIAGRAPHICS (TM), DIV OF DEV.KINNEY/MEDIAGRAPHICS, INC

P.O. Box 820525, Memphis TN 38182-0525. (901)324-1658. Fax: (901)323-7214. E-mail: mediagraphics@devkinney.com. Website: www.devkinney.com. **CEO:** J. Kinney. Estab. 1973. Integrated marketing communications agency. Specializes in all visual

communications. Product specialties are financial, fundraising, retail, business-to-business. Client list available upon request. Professional affiliations: Memphis Area chamber, B.B.B.

- This firm reports they are looking for top illustrators only. When they find illustrators they like, they generally consider them associates and work with them on a continual basis.

First Contact & Terms Send query letter with résumé and tearsheets. Accepts disk submissions compatible with Mac or PC. E-mail 1 sample JPEG, 265 K maximum; prefer s HTML reference or small PDF file. Samples are filed and are not returned. Will contact artist for portfolio review on Web or via e-mail if interested. Rights purchased vary according to project.

Tips Chooses illustrators based on "portfolio, availability, price, terms and compatibility with project."

MITCHELL STUDIOS DESIGN CONSULTANTS

1499 Sherwood Drive, East Meadow, NY 11554. (516)832-6230. Fax: (516)832-6232. E-mail: msdcdesign@aol.com. **Principals:** Steven E. Mitchell and E.M. Mitchell. Estab. 1922. Specializes in brand and corporate identity, displays, direct mail and packaging. Clients: major corporations.

Needs Works with 5-10 freelance designers and 20 illustrators/year. "Most work is started in our studio." Uses freelancers for design, illustration, mechanicals, retouching, airbrushing, model-making, lettering and logos. 100% of design and 50% of illustration demands skills in Illustrator, Photoshop and QuarkXPress. Needs technical illustration and illustration of food, people.

First Contact & Terms Send query letter with brochure, résumé, business card, photographs and photocopies to be kept on file. Accepts nonreturnable disk submissions compatible with Illustrator, QuarkXPress, FreeHand and Photoshop. Responds only if interested. Call or write for appointment to show portfolio of roughs, original/final art, final reproduction/product and color photostats and photographs. Pays for design by the hour, $25 minimum; by the project, $250 minimum. Pays for illustration by the project, $250 minimum.

Tips "Call first. Show actual samples, not only printed samples. Don't show student work. Our need has increased—we are very busy."

◼ NOVUS VISUAL COMMUNICATIONS, INC.

121 E. 24th St., 12th Floor, New York NY 10010-2950. (212)473-1377. Fax: (212)505-3300. E-mail: novuscom@aol.com. Website: www.novuscommunications.com. **President:** Robert Antonik. Managing Director, Denis Payne. Estab. 1984. An Integrated marketing and multi-channel communications company. Specializing in strategic planning, social and personalization marketing. Website marketing and development,

annual reports, brand and corporate identity, multimedia displays, targeted direct mail, luxury marketing, package and publication design, technical illustration. Clients are business-to-business, venture capitalists, non profits healthcare, software developers, telecommunications and consumer products companies.

Needs Approached by 12 freelancers illustrators, designers and consultants a year. Prefers local artists. Use freelancers and consultants for all principles of creation to completion. All freelance or consultants have skills in writing, web applications, Illustrator, Photoshop, InDesign.

First Contact & Terms Direct contact by mail. Send postcard sample of work with web address. Responds ASAP. Follow up with call. Pays for designer web work by the hour, $35-75; by the day, $200-300; by the project, $200-1,500. or more. Pays for illustration by the project, $150-1,750. Rights purchased vary according to project. Finds artists through Creative resources through Illustration sites agents and submissions.

Tips "First impressions are important; a website, promotion or portfolio should represent the best, whether it's 4 samples or 12." Advises freelancers or consultants entering the field to always show your best creative work. "You don't need to overwhelm your prospective client. it's always a good idea to send a thank-you or follow-up phone call. It works! Self promotion is very important. You need a website and on going postcard mailings. E-mail doesn't work as well."

▣ OAKLEY DESIGN STUDIOS

519 SW Park Avenue., Portland OR 97205. (503)241-3705. E-mail: oakleyds@ oakleydesign.com. Website: oakleydesign.com. Blog site: oakleydesign.blogspot.com. **Creative Director:** Tim Oakley. Estab. 1992. Specializes in brand and corporate identity, display, package, feature film design, along with advertising. Clients: advertising agencies, record companies, motion picture studios, surf apparel manufacturers, mid-size businesses. Current clients include Patrick Lamb Productions, Metro Computerworks, Tiki Nights Entertainment, Hui Nalu Brand Surf, Stona Winery, Mt Hood Jazz Festival, Think AV, Audient Events, & Kink FM 102. Professional affiliations: GAG, AIGA, PAF, Type Directors Club, Society of Illustrators.

Needs Approached by 3-5 freelancers/year. Works with 3 freelance illustrators and 2 designers/year. Prefers local artists with experience in technical & freehand illustration, airbrush. Uses illustrators mainly for advertising. Uses designers mainly for brand and corporate identity. Also uses freelancers for ad and P-O-P illustration, airbrushing, catalog illustration, lettering and retouching. 60% of design and 30% of illustration demands skills in CS2 Illustrator, CS2 Photoshop and CS2 InDesign.

First Contact & Terms Contact through artist rep or send query letter with brochure, photocopies, photographs, plus resume. Samples are filed or returned by SASE if requested by artist. Request portfolio review in original query. Will contact artist for portfolio review if interested. Portfolio should include b&w and color final art,

photocopies, photostats, roughs and/or slides. Pays for design by the project, $200 minimum. Pays for illustration by the project. Rights purchased vary according to project. Finds artists through design workbooks.

Tips "Just be yourself—and bring coffee."

THE O'CARROLL GROUP

300 E. McNeese St., Suite 2-B, Lake Charles LA 70605. (337)478-7396. Fax: (337)478-0503. E-mail: pocarroll@ocarroll.com. Website: www.ocarroll.com. **President:** Peter O'Carroll. Estab. 1978. Ad agency/PR firm. Specializes in newspaper, magazine, outdoor, radio and TV ads. Product specialty is consumer. Client list available upon request.

Needs Approached by 1 freelancer/month. Works with 1 illustrator every 3 months. Prefers freelancers with experience in computer graphics. Works on assignment only. Uses freelancers mainly for time-consuming computer graphics. Also for brochure and print ad illustration and storyboards. Needs website developers. 65% of work is with print ads. 50% of freelance work demands skills in Illustrator and Photoshop.

First Contact & Terms Send query e-mail with electronic samples. Responds only if interested. Will contact artist for portfolio review if interested. Pays for design by the project. Pays for illustration by the project. Rights purchased vary according to project. Find artists through viewing portfolios, submissions, word of mouth, American Advertising Federation district conferences and conventions.

OUTSIDE THE BOX INTERACTIVE LLC

150 Bay St., Suite 706, Jersey City NJ 07302-5917. (201)610-0625. Fax: (201)610-0627. E-mail: theoffice@outboxin.com. Website: www.outboxin.com. **Partner, Creative Services:** Lauren Schwartz. Estab. 1995. Number of employees: 6. Interactive Design & Marketing firm. For over a decade we have been providing strategic and integrated solutions for branding, advertising, and corporate communications. "Our skills lie in creating active experiences versus passive messages. We focus on the strengths of each particular delivery platform, whether multimedia, web or print, to create unique solutions that meet our client's needs. Our strategies are as diverse as our clients but our focus is the same: to maximize the full potential of integrated marketing, combining the best in new media and traditional assets. We offer a unique blend of creativity, technology, experience and commitment." Clients include Society of Illustrators, Dereckfor Shipyards, Educational Testing Service, Nature's Best.

Needs Approached by 5-10 illustrators and 5-10 designers/year. Works with 2-5 freelance illustrators and 4-6 designers/year. Freelancers must be digitally fluent. Uses freelancers for airbrushing, animation, brochure and humorous illustration, logos, model-making, multimedia projects, posters, retouching, storyboards, TV/film graphics, Web page design. 90% of design demands skills in Photoshop,

QuarkXPress, Illustrator, Director HTML, Java Script and any 3D program. 60% of illustration demands skills in Photoshop, QuarkXPress, Illustrator, any animation and 3D program.

First Contact & Terms Send query letter with brochure, photocopies, photographs, résumé, SASE, slides, tearsheets, transparencies. Send follow-up postcard every 3 months. Accepts DVD/CD submissions. Samples are filed and are returned by SASE. Will contact if interested. Pays by the project. Rights purchased vary according to project.

PAPAGALOS STRATEGIC COMMUNICATIONS

7330 N. 16th St., Suite B102, Phoenix AZ 85020. (602)279-2933. Fax: (602)277-7448. Website: www.papagalos.com. **Creative Director:** Nicholas Papagalos. Specializes in advertising, brochures, annual corporate identity, displays, packaging, publications and signage. Clients major regional, consumer and business-to-business. Clients include Perini, American Hospice Foundation, McMillan Fiberglass Stocks, Schuff Steel.

Needs Works with 6-20 freelance artists/year. Works on assignment only. Uses artists for illustration, retouching, design and production. Needs computer-literate freelancers, HTML programmers and Web designers for design, illustration and production. 100% of freelance work demands skills in Illustrator, QuarkXPress, InDesign or Photoshop.

First Contact & Terms Mail résumé and appropriate samples. Pays for design by the hour or by the project. Pays for illustration by the project. Considers complexity of project, client's budget, skill and experience of artist, how work will be used, turnaround time and rights purchased when establishing payment. Rights purchased vary according to project.

Tips In presenting samples or portfolios, "two samples of the same type/style are enough."

▣ PRECISION ARTS ADVERTISING INC.

57 Fitchburg Rd., Ashburnham MA 01430. (978)827-4552. E-mail: web@precisionarts. com. Website: www.precisionarts.com. **President:** Terri Adams. Estab. 1985. Number of employees: 2. Full-service Web/print ad agency. Specializes in Internet marketing strategy, website/print design, graphic design.

Needs Approached by 5 illustrators and 5 designers/year. Works with 1 freelance illustrator and 1 designer/year. Prefers local freelancers. website design is now 75% and print marketing is 25% of the business. Freelance Web skills required in Macintosh DreamWeaver and Photoshop; freelance print skills required in QuarkXPress, Photoshop, Illustrator and Pre-Press.

First Contact & Terms Send résumé with links to artwork and suggested hourly rate.

PRO INK

2826 NE 19th Dr., Gainesville FL 32609-3391. (352)377-8973. Fax: (352)373-1175. E-mail: terry@proink.com. Website: www.proink.com. **President:** Terry Van Nortwick. Estab. 1979. Number of employees: 5. Specializes in publications, marketing, healthcare, engineering, development and ads. Professional affiliations: Public Relations Society of America, Society of Professional Journalists, International Association of Business Communicators, Gainesville Advertising Federation, Florida Public Relations Association.

Needs Works with 3-5 freelancers/year. Works on assignment only. Uses freelancers for brochure/annual report illustration and lettering. 100% of freelance work demands knowledge of Illustrator, InDesign, or Photoshop. Needs editorial, medical and technical illustration.

First Contact & Terms Send résumé, samples, tearsheets, photostats, photocopies, slides and photography. Samples are filed or are returned if accompanied by SASE. Responds only if interested. Call or write for appointment to show portfolio of original/final art. Pays for design and illustration by the project, $50-500. Rights purchased vary according to project.

GERALD & CULLEN RAPP

420 Lexington Ave., Suite 3100, New York NY 10170. (212)889-3337. Fax: (212)889-3341. E-mail: info@rappart.com. Website: www.rappart.com. Estab. 1944. Clients: ad agencies, corporations and magazines. Client list not available. Professional affiliations: GAG, S.I.

Needs Approached by 500 freelance artists/year. Exclusive rpresentations of freelance illustrators. Works on assignment only. Uses freelance illustrators for editorial advertising and corporate illustration.

First Contact & Terms E-mail query letter with samples or website link. Will contact artist for portfolio review if intersted. Responds in 2 weeks. Pays for illustration by the project, $500-40,000. Negotiates fees and rights purchased with clients on per-project basis.

⬩ REALLY GOOD COPY CO.

92 Moseley Terrace, Glastonbury CT 06033. (860)659-9487. E-mail: copyqueen@aol.com. Website: www.reallygoodcopy.com. **President:** Donna Donovan. Estab. 1982. Number of employees: 1. Ad agency; full-service multimedia firm. Specializes in direct response, and catalogs and collateral. Product specialties are medical/health care, business services, consumer products and services. Current clients include Eastern Connecticut Health Network, WSHU Public Radio, Wellspring, That's Amore Gelato Cafes, Glastonbury Chamber of Commerce. Professional affiliations: Connecticut Art Directors Club, New England Mail Order Association, Glastonbury Chamber of Commerce.

Needs Approached by 40-50 freelancers/year. Works with 1-2 freelance illustrators and 6-8 designers/year. Prefers local freelancers whenever possible. Works on assignment only. Uses freelancers for all projects. "There are no on-staff artists." 50% print, 50% Web. 100% of design and 50% of illustration demand knowledge of InDesign or QuarkXPress, Illustrator or Photoshop and HTML.

First Contact & Terms Designers: send query letter with resume. Illustrators: send postcard samples. Accepts CD submissions, EPS or JPEG files only. Samples are filed or are returned by SASE, only if requested. Responds only if interested. Portfolio review not required, but portfolio should include roughs and original/final art. Pays for design by the hour, $50-125. Pays by the project or by the hour.

Tips "Continue to depend upon word of mouth from other satisfied agencies and local talent. I'm fortunate to be in an area that's overflowing with good people. Send two or three good samples-not a bundle."

THOMAS SEBASTIAN COMPANIES

(formerly ArtOnWeb), 508 Bluffs Edge Dr., McHenry IL 60051. (815)578-9171. E-mail: sebastiancompanies@mac.com. Website: www.thomassebastiancompanies.com. **Creative Director:** Pete Secker. Owner: Thomas Sebastian. Estab. 1996. Number of employees: 10. Integrated marketing communications agency and Internet service. Specializes in website and graphic design for print materials. Client list available upon request.

Needs Approached by 12 illustrators and 12 designers/year. Works with 2-3 illustrators and 1-2 designers/year. Uses freelancers mainly for design and computer illustration; also for humorous illustration, lettering, logos and Web page design. 5% of work is with print ads. 90% of design and 70% of illustration demands knowledge of Photoshop, Illustrator, QuarkXPress.

First Contact & Terms Query via e-mail. Send follow-up postcard samples every 6 months. Accepts Mac-compatible submissions on CD-ROM or DVD. Samples are filed and are not returned. Responds only if interested. Will contact artist for portfolio review if interested. Pays by the project. Negotiates rights purchased. Finds freelancers through *The Black Book*, creative sourcebooks, Internet.

STEVEN SESSIONS INC.

5177 Richmond, Suite 500, Houston TX 77056. (713)850-8450. Fax: (713)850-9324. E-mail: Steven@Sessionsgroup.com. Website: www.sessionsgroup.com. **President, Creative Director:** Steven Sessions. Estab. 1981. Number of employees 8. Approximate annual billing $2.5 million. Specializes in annual reports; brand and corporate identity; fashion, package and publication design. Clients corporations and ad agencies. Current clients are listed on website. Professional affiliations AIGA, Art Directors Club, American Ad Federation.

Needs Approached by 50 freelancers/year. Works with 10 illustrators and 2 designers/year. Uses freelancers for brochure, catalog and ad design and illustration; poster illustration; lettering; and logos. 100% of freelance work demands knowledge of Illustrator, InDesign, QuarkXPress, Photoshop. Needs editorial, technical and medical illustration.

First Contact & Terms Designers: Send query letter with brochure, tearsheets, CD's, PDF files and SASE. Illustrators: Send postcard sample or other nonreturnable samples. Samples are filed. Responds only if interested. To show portfolio, mail slides. Payment depends on project, ranging from $1,000-30,000/illustration. Rights purchased vary according to project.

TASTEFUL IDEAS, INC.

7638 Bell Dr., Shawnee KS 66217. (913)722-3769. Fax: (913)722-3967. E-mail: john@ tastefulideas.com. Website: www.tastefulideas.com. **President:** John Thomsen. Estab. 1986. Number of employees: 4. Approximate annual billing: $500,000. Design firm. Specializes in consumer packaging. Product specialties are largely, but not limited to, food and foodservice.

Needs Approached by 15 illustrators and 15 designers/year. Works with 3 illustrators and 3 designers/year. Prefers local freelancers. Uses freelancers mainly for specialized graphics; also for airbrushing, animation, humorous and technical illustration. 10% of work is with print ads. 75% of design and illustration demand skills in Photoshop and Illustrator.

First Contact & Terms Designers: Send query letter with photocopies. Illustrators: Send non-returnable promotional sample. Accepts submissions compatible with Illustrator, Photoshop (Mac based). Samples are filed. Responds only if interested. Art director will contact artist for portfolio review of final art if interested. Pays by the project. Finds artists through submissions.

BRANDON TAYLOR DESIGN

5405 Morehouse Dr. Suite 280, San Diego CA 92121. (858)623-9084. Fax: (858)452-6970. E-mail: dennis@brandontaylor.com. Website: www.brandontaylor.com. **Principal:** Dennis Gillaspy. Estab. 1977. Specializes in corporate identity, displays, direct mail, package and publication design and signage. Clients corporations and manufacturers. Client list available upon request.

Needs Approached by 20 freelance artists/year. Works with 15 freelance illustrators and 10 freelance designers/year. Prefers local artists. Works on assignment only. Uses freelance illustrators mainly for technical and instructional spots. Uses freelance designers mainly for logo design, books and ad layouts. Also uses freelance artists for brochure, catalog, ad, P-O-P and poster design and illustration, retouching, airbrushing, logos, direct mail design and charts/graphs.

First Contact & Terms Send query letter with brochure, résumé, photocopies and

photostats. Samples are filed. Responds in 2 weeks. Write to schedule an appointment to show a portfolio or mail thumbnails, roughs, photostats, tearsheets, comps and printed samples. Pays for design by the assignment. Pays for illustration by the project, $400-1,500. Rights purchased vary according to project.

UNICOM

9470 N. Broadmoor Rd., Bayside WI 53217. (414)352-5070. Fax: (414)352-4755. Website: www.litteratibooks.com. **Senior Partner:** Ken Eichenbaum. Estab. 1974. Specializes in annual reports, brand and corporate identity, display, direct, package and publication design and signage. Clients: corporations, business-to-business communications, and consumer goods. Client list available upon request.

Needs Approached by 5-10 freelancers/year. Works with 1-2 freelance illustrators/year. Works on assignment only. Uses freelancers for brochure, book and poster illustration, pre-press composition.

First Contact & Terms Send query letter with brochure. Samples not filed or returned. Does not reply; send nonreturnable samples. Write for appointment to show portfolio of thumbnails, photostats, slides and tearsheets. Pays by the project, $200-3,000. Rights purchased vary according to project.

VISUAL HORIZONS

180 Metro Park, Rochester NY 14623. (585)424-5300. Fax: (585)424-5313. E-mail: cs@visualhorizons.com. Website: www.visualhorizons.com. Estab. 1971. AV firm; full-service multimedia firm. Specializes in presentation products, digital imaging of 35mm slides. Current clients include U.S. government agencies, corporations and universities.

Needs Works on assignment only. Uses freelancers mainly for web design. 5% of work is with print ads. 100% of freelance work demands skills in Photoshop.

First Contact & Terms Send query letter with tearsheets. Samples are not filed and are not returned. Responds if interested. Portfolio review not required. Pays for design and illustration by the hour or project, negotiated. Buys all rights.

WALKER DESIGN GROUP

421 Central Ave., Great Falls MT 59401. (406)727-8115. Fax: (406)791-9655. E-mail: info@walkerdesigngroup.com. Website: www.walkerdesigngroup.com. **President:** Duane Walker. Number of employees: 6. Design firm. Specializes in annual reports and corporate identity. Professional affiliations: AIGA and Ad Federation.

Needs Uses freelancers for animation, annual reports, brochure, medical and technical illustration, catalog design, lettering, logos and TV/film graphics. 80% of design and 90% of illustration demand skills in PageMaker, Photoshop and Illustrator.

First Contact & Terms Send query letter with brochure, photocopies, post cards,

résumé, and/or tearsheets. Accepts digital submissions. Samples are filed and are not returned. Responds only if interested. To arrange portfolio review, artist should follow up with call or letter after initial query. Portfolio should include color photographs, photostats and tearsheets. Pays by the project; negotiable. Finds artists through *Workbook*.

Tips "Stress customer service and be very aware of deadlines."

WARNE MARKETING & COMMUNICATIONS

65 Overlea Blvd, Suite 112, Toronto ON M4H 1P1 Canada. (416)927-0881. Fax: (416)927-1676. E-mail: info@warne.com. Website: www.warne.com. **Studio Manager:** John Coljee. Number of employees: 9. Approximate annual billing: $2.5 million. Specializes in business-to-business marketing and communications. Current clients include ACTRA Fraternal Benefits Society, Extrude-A-Trim, Junior Achievement of Canada, Johnston Equipment and NRB Modular Building Systems. Professional affiliations: CIM, BMA, INBA.

Needs Works with 1-2 freelance illustrators and 1-3 designers/year. Works on assignment only. Uses freelancers for design and technical illustrations, advertisements, brochures, catalogs, P-O-P displays, posters, direct mail packages, logos and interactive. Artists should have concept thinking.

First Contact & Terms Send query letter with résumé and photocopies. Samples are not returned. Responds only if interested. No e-mails please. Pays for design by the hour, or by the project. Considers complexity of project, client's budget, and skill and experience of artist when establishing payment. Buys all rights.

WAVE DESIGN WORKS

P.O. Box 995, Norfolk MA 02056. (508)541-9171. E-mail: ideas@wavedesignworks.com. Website: www.wavedesignworks.com. **Principal:** John Buchholz. Estab. 1986. Specializes in corporate identity and display, package and publication design. Clients corporations primarily biotech and software.

Needs Approached by 24 freelance graphic artists/year. Works with 1-5 freelance illustrators and 1-5 freelance designers/year. Works on assignment only. Uses freelancers for brochure, catalog, poster and ad illustration; lettering; and charts/graphs. 100% of design and 50% of illustration demand knowledge of QuarkXPress, Indesign, Illustrator or Photoshop.

First Contact & Terms Designers send query letter with brochure, résumé, photocopies, photographs and tearsheets. Illustrators send postcard promo. Samples are filed. Responds only if interested. Artist should follow up with call and/or letter after initial query. Portfolio should include b&w and color thumbnails and final art. Pays for illustration by the project. Rights purchased vary according to project. Finds artists through submissions and sourcebooks.

WEST CREATIVE, INC.

10780 S. Cedar Niles Circle., Olathe KS 66210-6061. (913)839-2176. Fax: (913)498-8627. E-mail: stan@westcreative.com. Website: www.westcreative.com. **Creative Director:** Stan Chrzanowski. Estab. 1974. Number of employees 8. Approximate annual billing $600,000. Design firm and agency. Full-service, multimedia firm. Client list available upon request. Professional affiliation AIGA.

Needs Approached by 50 freelancers/year. Works with 4-6 freelance illustrators and 1-2 designers/year. Uses freelancers mainly for illustration. Also for animation, lettering, mechanicals, model-making, retouching and TV/film graphics. 20% of work is with print ads. Needs computer-literate freelancers for design, illustration and production. 95% of freelance work demands knowledge of FreeHand, Photoshop, QuarkXPress and Illustrator. Full service web design capabilities.

First Contact & Terms Send postcard-size sample of work or send query letter with brochure, photocopies, résumé, SASE, slides, tearsheets and transparencies. Samples are filed or returned by SASE if requested by artist. Responds only if interested. Portfolios may be dropped off every Monday-Thursday. Portfolios should include color photographs, roughs, slides and tearsheets. Pays for illustration by the project; pays for design by the hour, $25-60. "Each project is bid." Rights purchased vary according to project. Finds artists through *Creative Black Book* and *Workbook*.

WISNER CREATIVE

18200 NW Sauvie Island Rd., Portland OR 97231-1338. (503)282-3929. Fax: (503)282-0325. E-mail: wizbiz@wisnercreative.com. Website: www.wisnercreative.com. **Creative Director:** Linda Wisner. Estab. 1979. Number of employees: 1. Specializes in brand and corporate identity, book design, publications and exhibit design. Clients: small businesses, manufacturers, restaurants, service businesses and book publishers.

Needs Works with 3-5 freelance illustrators/year. Prefers experienced freelancers and "fast, accurate work." Works on assignment only. Uses freelancers for technical and fashion illustration and graphic production. Knowledge of QuarkXPress, Photoshop, Illustrator and other software required.

First Contact & Terms Send query letter or e-mail with résumé and samples. Prefers "examples of completed pieces that show the fullest abilities of the artist." Samples not kept on file are returned by SASE, only if requested. Will contact artist for portfolio review if interested. Pays for illustration by the hour, $30-45 average, or by the project, by bid. Pays for computer work by the hour, $25-35.

SPENCER ZAHN & ASSOCIATES

2015 Sansom St., Philadelphia PA 19103. (215)564-5979. Fax: (215)564-6285. E-mail: szahn@erols.com. **President:** Spencer Zahn. Business Manager Brian Zahn. Estab.

1970. Number of employees 5. Specializes in brand and corporate identity, direct mail design, marketing, retail and business to business advertising.P.O.S. Clients: corporations, manufacturers, etc.

Needs Approached by 15 freelancers/year. Works with freelance illustrators and designers. Prefers artists with experience in Macintosh computers. Uses freelancers for design and illustration; direct mail design; and mechanicals. Needs computer-literate freelancers for design, illustration and production. 80% of freelance work demands knowledge of Illustrator, Photoshop, FreeHand and QuarkXPress.

First Contact & Terms Send query letter with samples. Samples are not filed and are returned by SASE if requested by artist. Responds only if interested. Artist should follow up with call. Portfolio should include final art and printed samples. Buys all rights.

Syndicates & Cartoon Features

Syndicates are agents who sell comic strips, panels and editorial cartoons to newspapers and magazines. If you want to see your comic strip in the funny papers, you must first get the attention of a syndicate. They promote and distribute comic strips and other features in exchange for a cut of the profits.

The syndicate business is one of the hardest markets to break into. Newspapers are reluctant to drop long-established strips for new ones. Consequently, spaces for new strips do not open up often. When they do, syndicates look for a "sure thing," a feature they'll feel comfortable investing more than $25,000 in for promotion and marketing. Even after syndication, much of your promotion will be up to you.

To crack this market, you have to be more than a fabulous cartoonist—the art won't sell if the idea isn't there in the first place. Work worthy of syndication must be original, salable and timely, and characters must have universal appeal to attract a diverse audience.

Although newspaper syndication is still the most popular and profitable method of getting your comic strip to a wide audience, the Internet has become an exciting new venue for comic strips and political cartoons. With the click of your mouse, you can be introduced to *The Boiling Point* by Mikhaela Reid, *Overboard* by Chip Dunham, and *Strange Brew* by John Deering. (GoComics. com provides a great list of online comics.)

Such sites may not make much money for cartoonists, but it's clear they are a great promotional tool. It is rumored that scouts for the major syndicates have been known to surf the more popular comic strip sites in search of fresh voices.

HOW TO SUBMIT TO SYNDICATES

Each syndicate has a preferred method for submissions, and most have guidelines you can send for or access online. Availability is indicated in the listings.

To submit a strip idea, send a brief cover letter (50 words or less is ideal) summarizing your idea, along with a character sheet (the names and descriptions of your major characters) and photocopies of 24 of your best strip samples on 8½ × 11 paper, six daily strips per page. Sending at least one month of samples shows that you're capable of producing consistent artwork and a long-lasting idea. Never submit originals; always send photocopies of your work. Simultaneous submissions are usually acceptable. It is often possible to query syndicates online, by attaching art files or links to your website. Response time can take several months. Syndicates understand it would be impractical for you to wait for replies before submitting your ideas to other syndicates.

Editorial cartoons

If you're an editorial cartoonist, you'll need to start out selling your cartoons to a base newspaper (probably in your hometown) and build up some clips before approaching a syndicate. Submitting published clips proves to the syndicate that you have a following and are able to produce cartoons on a regular basis. Once you've built up a good collection of clips, submit at least 12 photocopied samples of your published work along with a brief cover letter.

Payment & contracts

If you're one of the lucky few to be picked up by a syndicate, your earnings will depend on the number of publications in which your work appears. It takes a minimum of about 60 interested newspapers to make it profitable for a syndicate to distribute a strip. A top strip such as *Garfield* may be in as many as 2,000 papers worldwide.

Newspapers pay in the area of $10-15 a week for a daily feature. If that doesn't sound like much, multiply that figure by 100 or even 1,000 newspapers. Your payment

Helpful Resources

For More Info

You'll get an excellent overview of the field by reading *Your Career in Comics* by Lee Nordling (Andrews McMeel), a comprehensive review of syndication from the viewpoints of the cartoonist, the newspaper editor and the syndicate. *Successful Syndication: A Guide for Writers and Cartoonists*, by Michael H. Sedge (Allworth Press) also offers concrete advice to aspiring cartoonists.

Another great source of information is Stu's Comic Strip Connection at www.stus.com/index2.htm . Here you'll find links to most syndicates and other essential sources, including helpful books, courtesy of Stu Rees.

will be a percentage of gross or net receipts. Contracts usually involve a 50/50 split between the syndicate and cartoonist. Check the listings for more specific payment information.

Before signing a contract, be sure you understand the terms and are comfortable with them.

Self-syndication

Self-syndicated cartoonists retain all rights to their work and keep all profits, but they also have to act as their own salespeople, sending packets to newspapers and other likely outlets. This requires developing a mailing list, promoting the strip (or panel) periodically, and developing a pricing, billing and collections structure. If you have a knack for business and the required time and energy, this might be the route for you. Weekly suburban or alternative newspapers are the best bet here. (Daily newspapers rarely buy from self-syndicated cartoonists.)

◩ ARTIZANS.COM

11136-75A St., NW, Edmonton Alberta T5B 2C5 Canada. E-mail: submissions@ artizans.com. Website: www.artizans.com. **Submission Editor:** Malcolm Mayes. Estab. 1998. Artist agency and syndicate providing commissioned artwork, stock illustrations, political cartoons, gag cartoons, global caricatures and humorous illustrations to magazines, newspapers, websites, corporate and trade publications and ad agencies. Submission guidelines available on website. Artists represented include Jan Op De Beeck, Chris Wildt, Aaron Bacall and Dusan Petricic.

Needs Works with 30-40 artists/year. Buys 30-40 features/year. Needs single-panel cartoons, caricatures, illustrations, graphic and stock art. Prefers professional artists with track records who create artwork regularly, and artists who have archived work or a series of existing cartoons, caricatures and/or illustrations.

First Contact & Terms Send cover letter and copies of cartoons or illustrations. Send 6-10 low-res images if sending via e-mail; 18 if sending via snail mail. "In your cover letter, tell us briefly about your career. This should inform us about your training, what materials you use and where your work has been published." Résumé and samples of published cartoons would be helpful but are not required. E-mail submission should include a link to other online examples of your work. Responds in 2 months. Artist receives 50-75%. Payment varies depending on artist's sales. Artist retains copyright. "Our clients purchase a variety of rights from the artists."

Tips "We are only interested in professional artists with a track record. See our website for guidelines."

CONTINENTAL FEATURES/CONTINENTAL NEWS SERVICE

501 W. Broadway, Plaza A, PMB# 265, San Diego CA 92101. (858)492-8696. E-mail: continentalnewsservice@yahoo.com. Website: www.continentalnewsservice.com. **Editor-in-Chief:** Gary P. Salamone. Parent firm established 1981. Syndicate serving 3 outlets—house publication, publishing business, and the general public—through the Continental Newstime general-interest news magazine. Features include Portfolio, a collection of cartoon and caricature art. Guidelines available for #10 SASE with first-class postage.

Needs Approached by up to 200 cartoonists/year. Number of new strips introduced each year varies. Considers comic strips and gag cartoons. Does not consider highly abstract, computer-produced or stick-figure art. Prefers single-panel with gagline. Maximum size of artwork: 8 × 10; must be reducible to 65% of original size.

First Contact & Terms Sample package should include cover letter and photocopies (10-15 samples). Samples are filed or are returned by SASE if requested by artist. Responds in 1 month, only if interested or if SASE is received. To show portfolio, mail photocopies and cover letter. Pays 70% of gross income on publication. Rights purchased vary according to project. Minimum length of contract is 1 year. The artist owns the original art and the characters.

Tips "We need single-panel cartoons and comic strips appropriate for English-speaking, international audience, including cartoons that communicate feelings or predicaments, without words. Do not send samples reflecting the highs and lows and different stages of your artistic development. CF/CNS wants to see consistency and quality, so you'll need to send your best samples."

CREATORS SYNDICATE, INC.

5777 W. Century Blvd., Suite 700, Los Angeles CA 90045. (310)337-7003. Fax: (310)337-7625. E-mail: info@creators.com. Website: www.creators.com. **President:** Richard S. Newcombe. Director of Operations: Andrea Fryrear. Estab. 1987. Serves 2,400 daily newspapers, weekly and monthly magazines worldwide. Guidelines on website.

Needs Syndicates 100 writers and artists/year. Considers comic strips, caricatures, editorial or political cartoons and "all types of newspaper columns." Recent introductions: *Speedbump* by Dave Coverly; *Strange Brew* by John Deering.

First Contact & Terms Send query letter with brochure showing art style or résumé and "anything but originals." Does not accept e-mail submissions. Samples are not filed and are returned by SASE. Responds in a minimum of 10 weeks. Considers salability of artwork and client's preferences when establishing payment. Negotiates rights purchased.

Tips "If you have a cartoon or comic strip you would like us to consider, we will need to see at least four weeks of samples, but not more than six weeks of dailies and two Sundays. If you are submitting a comic strip, you should include a note about the

Syndicates

characters in it and how they relate to each other. As a general rule, drawings are most easily reproduced if clearly drawn in black ink on white paper, with shading executed in ink wash or Benday or other dot-transfer. However, we welcome any creative approach to a new comic strip or cartoon idea. Your name(s) and the title of the comic or cartoon should appear on every piece of artwork. If you are already syndicated elsewhere, or if someone else owns the copyright to the work, please indicate this."

PLAIN LABEL PRESS

P.O. Box 240331, Ballwin MO 63024. E-mail: mail@plainlabelpress.com. Website: www.plainlabel press.com. **Submissions Editor:** Laura Meyer. Estab. 1989. Syndicate serving over 100 weekly magazines, newspapers and Internet sites. Guidelines available on website.

Needs Approached by 500 cartoonists and 100 illustrators/year. Buys from 2-3 artists/year. Introduces 1-2 new strips/year. Strips introduced include *Barcley & Co.* and *The InterPETS!* by Todd Schowalter. Considers cartoons (single, double and multiple panel), comic strips, editorial/political cartoons and gag cartoons. Prefers comics with cutting edge humor, NOT mainstream. Maximum size of artwork: 8½ × 11; artwork must be reducible to 25% of original size.

First Contact & Terms Sample package should include cover letter, character descriptions, 3-4 weeks of material (18-24 samples on photocopies or disk, no original art) and SASE if you would like your materials returned. Samples are not filed and are returned by SASE if requested by artist. Pays on publication: 60% of net proceeds. Responds to submissions in 2-4 months. Contract is open and may be cancelled at any time by the creator and/or by Plain Label Press. Artist owns original art and original characters.

Tips "Be FUNNY! Remember that readers *read* the comics as well as look at them. Don't be afraid to take risks. Plain Label Press does not wish to be the biggest syndicate, just the funniest. A large portion of our material is purchased for use online, so a good knowledge of digital color and imaging puts a cartoonist at an advantage. Good luck!"

Record Labels

Record labels hire freelance artists to create packaging, merchandising material, store displays, posters and even T-shirts. But for the most part, you'll be creating work for CD booklets and covers. Your greatest challenge in this market will be working within the size constraints. Most CD covers are 4¾ × 4¾ inches, packaged in a 5 × 5-inch jewel case. Often there are photographs of the recording artist, illustrations, liner notes, titles, credit lines and lyrics all placed into that relatively small format.

It's not unusual for an art director to work with several freelancers on one project. For example, one freelancer might handle typography, another illustration; a photographer is sometimes used, and a designer can be hired for layout. Labels also turn to outside creatives for display design, promotional materials, collateral pieces or video production.

LANDING THE ASSIGNMENT

Check the listings in this section to see how each label prefers to be approached and what type of samples to send. Disk and e-mail submissions are encouraged by many of the companies. Check also to see what type of music they produce. Assemble a portfolio of your best art and design in case an art director wants to see more of your work.

Be sure your portfolio includes quality samples. It doesn't matter if the work is of a different genre—quality is key. If you don't have any experience in the industry, create your own CD package, featuring one of your favorite recording artists or groups. Send a cover letter with your samples, asking for a portfolio review. If you are not contacted within a couple of months, send a follow-up postcard or sample to the art director or other contact person.

Once you nail down an assignment, get an advance and a contract. Independent labels usually provide an advance and payment in full when a project is done. When negotiating a contract, ask for a credit line on the finished piece and samples for your portfolio.

You don't have to live in one of the recording capitals to land an assignment, but it does help to familiarize yourself with the business. Visit record stores and study the releases of various labels. Read industry publications such as *Billboard*, *Blender*, *Music Connection*, *Rolling Stone* and *Spin*.

ALBATROSS RECORDS; RN'D PRODUCTIONS

P.O. Box 540102, Houston TX 77254-0102. (713)521-2616. Fax: (713)529-4914. E-mail: rpds2405@aol.com. Website: www.rnddistribution.com. **Art Director:** Victor Ivey. National Sales Director: Darin Dates. Estab. 1987. Produces CDs, DVDs; country, jazz, R&B, rap, rock and pop by solo artists and groups. Recent releases: *I Love The Bay*, by Too Short; *Gangsters and Strippers*, by Too Short.

Needs Produces 22 releases/year. Works with 3 freelancers/year. Prefers freelancers with experience in Photoshop. Uses freelancers for cassette cover design and illustration; CD booklet design; CD cover design and illustration; poster design; Web page design; advertising design/illustration. 50% of freelance work demands knowledge of QuarkXPress, FreeHand, Photoshop.

Contact & Terms Send postcard sample of work. Samples are filed and not returned. Will contact for portfolio review of b&w and color final art if interested. Pays for design by the project, $400 maximum. Pays for illustration by the project, $250 maximum. Buys all rights. Finds freelancers through word of mouth.

ALEAR RECORDS

25 Troubadour Lane, Berkeley Springs WV 25411. (304)258-8314. E-mail: mccoytroubadour @aol.com. Website: www.troubadourlounge.com. **Owner:** Jim McCoy. Estab. 1973. Produces CDs, cassettes; country/western. Releases: *The Taking Kind*, by J.B. Miller; *If I Throw away My Pride*, by R.L. Gray; *Portrait of a Fool*, by Kevin Wray.

Needs Produces 12 solo artists and 6 groups/year. Works with 3 freelancers/year. Works on assignment only. Uses artists for CD cover design and cassette cover illustration.

Contact & Terms Send query letter with résumé and SASE. Samples are filed. Responds in 1 month. To show portfolio, mail roughs and b&w samples. Pays by the project, $50-250.

ARIANA RECORDS

1312 S. Avenida Polar #A-8, Tucson AZ 85710. (520)790-7324. Website: www.arianarecords.net. **President:** James M. Gasper, president. Vice President (pop, rock): Tom Dukes. Partners: Tom Privett (funk, experimental, rock); Scott Smith

(pop, rock, AOR). Labels include Smart Monkey Records, The MoleHole Studio, Chumway Studios. Estab. 1980. Produces CDs, low-budget films; rock, funk, strange sounds, soundtracks for films.

Needs Produces 4-6 music releases/year; 2 films/year. Prefers freelancers with experience in cover design. Uses artwork for CD covers, posters, flyers, T-shirts; design, illustration, multimedia projects. "We are looking to work with new cutting-edge artists."

Contact & Terms Send postcard sample of work or link to website. "Everything is filed. We will contact you if interested." Responds in 2-3 months. Pays by the project.

Tips "Send your best! Simple but cool!"

ASTRALWERKS RECORDS

101 Avenue of the Americas, 10th Floor, New York NY 10013-1943. E-mail: sara. reden@astralwerks.com. Website: www.astralwerks.com. **Contact:** Sara Reden. Estab. 1993. Produces CDs, DVDs, vinyl albums; alternative, progressive, rap, reggae, rock by solo artists and groups. Recent release: *Paper Tigers*, by Caesars.

Needs Produces 60-100 releases/year. Works with 2 freelancers/year. Prefers local freelancers. Uses freelancers for CD booklet illustration, CD cover design and illustration. 90% of design work demands knowledge Illustrator, Photoshop, InDesign and QuarkXPress. 10% of illustration work demands knowledge of FreeHand.

Contact & Terms Send postcard sample or query letter. Samples are filed. Responds only if interested. Request portfolio review in original query. Portfolio should include color finished and original art, photographs and roughs. Pays by the project, $100-500. Rights purchased vary according to project. Finds freelancers through word of mouth.

ATLAN-DEC/GROOVELINE RECORDS

2529 Green Forest Court, Snellville GA 30078-4183. (770)985-1686. E-mail: atlandec@ prodigy.net. Website: www.atlan-dec.com. **Art Director:** Wileta J. Hatcher. Estab. 1994. Produces CDs and cassettes; gospel, jazz, pop, R&B and rap by solo artists and groups. Recent releases: *Stepping Into the Light*, by Mark Cocker.

Needs Produces 2-4 releases/year. Works with 1-2 freelancers/year. Prefers freelancers with experience in CD and cassette cover design. Uses freelancers for album cover, cassette cover, CD booklet and poster design. 80% of freelance work demands knowledge of Photoshop.

Contact & Terms Send postcard sample of work or query letter with brochure, photocopies, photographs and tearsheets. Samples are filed. Will contact for portfolio review of b&w, color, final art if interested. Pays for design by the project, negotiable. Negotiates rights purchased. Finds artists through submissions.

🌐 BIG BEAR RECORDS

P.O. Box 944, Birmingham B16 8UT United Kingdom. (0121)454-7020. Fax (0121)454-9996. E-mail: admin@bigbearmusic.com. Website: www.bigbearmusic.com. **Managing Director:** Jim Simpson. Produces CDs and cassettes; jazz, R&B. Recent releases: *Hey Puerto Rico!*, by King Pleasure and The Biscuit Boys; *The Marbella Jazz Suite*, by Alan Barnes All Stars.

Needs Produces 4-6 records/year. Works with 2-3 illustrators/year. Uses freelancers for album cover design and illustration. Needs computer-literate freelancers for illustration.

Contact & Terms Works on assignment only. Send query letter with photographs or photocopies to be kept on file. Samples not filed are returned only by SAE (include IRC if outside UK). Negotiates payment. Considers complexity of project and how work will be used when establishing payment. Buys all rights. Interested in buying second rights (reprint rights) to previously published work.

BLACK DIAMOND RECORDS-IHP MEDIA WORLD EEENTERTAINMENT GROUPS LLC. INCORPORATED

P.O. Box 222, Pittsburg CA 94565. (888) 566-6421 pin 1570775. Fax:(510)540-0497. E-mail: blk diamondrec@aol.com. Website: www.blackdiamondrecord.com or www. blackdiamondrecords .snn.gr, www.californiaflight.snn.gr, www.pacificcoastjazz. com, www.californiaflight1.com. **President:** Jerry J. Johnson a.k.a Bobelli. Estab. 1981. Produces DVD movies; distributes DVDs, CDs and vinyl 12-inch records.

Needs Produces 1 solo artists and 2 groups/year. Works with 2 freelancers/year. Prefers freelancers with experience in album cover and insert design. Uses freelancers for CD/cassette cover and advertising design and illustration; direct mail packages; and posters. Needs computer-literate freelancers for production. 90% of freelance work demands knowledge of PageMaker and FreeHand.

Contact & Terms Send query letter with résumé. Samples are filed or returned. Responds in 4 months. Write for appointment to show portfolio of b&w roughs and photographs. Pays for design by the hour, $200; by the project, varies. Rights purchased vary according to project.

Tips "Be unique, simple and patient. Most of the time success comes to those whose artistic design is unique and has endured rejection after rejection. Stay focused, stay humble."

BLUE NOTE, ANGEL AND MANHATTAN RECORDS

1290 Avenue of the Americas, 42nd Floor, New York NY 10104. (212)786-8600. Website: www.bluenote.com and www.angelrecords.com. **Creative Director:** Gordon H. Jee. Creative Assistant: Geri Francis. Estab. 1939. Produces albums, CDs, cassettes, advertising and point-of-purchase materials. Produces classical, jazz, pop and world music by solo artists and groups. Recent releases by Earl Klugh, Al Green and Terrance Blanchard.

Part of the EMI music group.

Needs Produces approximately 200 releases in US/year. Works with about 10 freelancers/year. Prefers designers with experience in QuarkXPress, Illustrator, Photoshop who own Macs. Uses freelancers for album cover design and illustration; cassette cover design and illustration; CD booklet and cover design and illustration; poster design. Also for advertising. 100% of design demands knowledge of Illustrator, QuarkXPress, Photoshop (most recent versions on all).

Contact & Terms Send postcard sample of work. Samples are filed. Responds only if interested. Portfolios may be dropped off every Thursday and should include b&w and color final art, photographs and tearsheets. Pays for design by the hour, $12-20; by the project, $1,000-5,000. Pays for illustration by the project, $750-2,500. Rights purchased vary according to project. Finds artists and designers through submissions, portfolio reviews, networking with peers.

CHERRY STREET RECORDS, INC.

P.O. Box 52626, Tulsa OK 74152. (918)742-8087. Fax (918) 925-9736. E-mail: ryoung@ cherrystreetrecords.com. Website: www.cherrystreetrecords.com. **President:** Rodney Young. Estab. 1989. Produces CDs and Downloads; rock, R&B, soul, country/western and folk by solo and group artists. Recent releases: Land of the Living, by Richard Elkerton; Find You Tonight, by Brad Absher; RhythmGypsy, by Steve Hardin.

Needs Produces 2 solo artists/year. Approached by 10 designers and 25 illustrators/ year. Works with 2 designers and 2 illustrators/year. Prefers freelancers with experience in CD and cassette design. Works on assignment only. Uses freelancers for CD cover design and illustration; catalog design; multimedia projects and advertising illustration. 100% of design and 50% of illustration demand knowledge of Illustrator and CorelDraw for Windows.

Contact & Terms Send postcard sample or query letter with photocopies and SASE. Accepts disk submissions compatible with Windows 'XP and Office 2003 in above programs. Samples are filed or are returned by SASE. Responds only if interested. Write for appointment to show portfolio of printed samples, b&w and color photographs. Pays by the project, up to $1,250. Buys all rights.

Tips "Compact disc covers and cassettes are small; your art must get consumer attention. Be familiar with CD music layout on computer in either Adobe or Corel. Be familiar with UPC bar code portion of each program. Be under $500 for layout to include buyout of original artwork and photographs. Copyright to remain with Cherry Street; no reprint rights or negatives retained by illustrator, photographer or artist."

DM/BELLMARK/CRITIQUE RECORDS

15421 W. Dixie Highway Bay 8, N. Miami Beach, FL 33162. (561)988-1820. Fax: (561)988-1821. E-mail: mark@dmrecords.com. Website: www.dmrecords.com. **Art**

Director: Deryck Ragoonan. Estab. 1983. Produces albums, CDs and cassettes country, gospel, urban, pop, R&B, rap, rock. Recent releases *Beautiful Experience*, by Prince; *The Bluegrass Sessions*, by Len Anderson; *Certified Crunk*, by Lil' John and the Eastside Boys.

• This label recently bought Ichiban Records.

Needs Approached by 6 designers and 12 illustrators/year. Works with 4 illustrators/year. Uses freelancers for album, cassette and CD booklet and cover illustration. 100% of design and 50% of illustration demand knowledge of PageMaker, Illustrator, QuarkXPress, Photoshop, FreeHand.

Contact & Terms Send postcard sample of work. Samples are filed. Will contact for portfolio review if interested. Pays for illustration by the project, $250-500. Buys all rights. Finds artists through magazines.

Tips "Style really depends on the performing artist we are pushing. I am more interested in illustration than typography when hiring freelancers."

EARACHE RECORDS

43 W. 38th St., New York NY 10018. (212)840-9090. Fax: (212)840-4033. E-mail: usaproduction@ earache.com. Website: www.earache.com. **Product Manager:** Tim McVicker. UK estab. 1986; US estab. 1993. Produces albums, CDs, CD-ROMs, cassettes, 7", 10" and 12" vinyl rock, industrial, heavy metal techno, death metal, grind core. Recent releases *The Haunted Made Me Do It*, by The Haunted; *Gateways to Annihilation*, by Morbid Angel.

Needs Produces 18 releases/year. Works with 4-6 freelancers/year. Prefers designers with experience in music field who own Macs. Uses freelancers for album cover design; cassette cover illustration; CD booklet and cover design and illustration; CD-ROM design. Also for advertising and catalog design. 90% of freelance work demands knowledge of Illustrator 7.0, QuarkXPress 4.0, Photoshop 5.0, FreeHand 7.

Contact & Terms Send postcard sample of work. Samples are filed and not returned. Does not reply. Artist should follow up with call and/or letter after initial query. Will contact artist for portfolio review of color, final art, photocopies, photographs if interested. Pays by the project. Buys all rights.

Tips "Know the different packaging configurations and what they are called. You must have a background in music production/manufacturing."

FOREFRONT RECORDS

P.O. Box 5085, Brentwood TN 37024-5085. E-mail: info@forefrontrecords.com. Website: www.fore frontrecords.com. **Contact:** Creative Services Manager. Estab. 1989. Produces CDs, CD-ROMs, cassettes; Christian alternative rock by solo artists and groups. Recent releases: *Adios*, by Audio Adrenaline; *If I Had One Chance to Tell You Something*, by Rebecca St. James; *Portable Sounds*, by Toby Mac.

Needs Produces 15-20 releases/year. Works with 5-10 freelancers/year. Prefers designers who own Macs and have experience in cutting edge graphics and font styles/layout, have the ability to send art via e-mail, and pay attention to detail and company spec requirements. Uses freelancers for cassette cover design and illustration; CD booklet design and illustration; CD cover design and illustration; CD-ROM design and packaging; poster design. 100% of freelance design and 50% of illustration demands knowledge of Illustrator, QuarkXPress, Photoshop.

Contact & Terms Send postcard sample or query letter with résumé, photostats, transparencies, photocopies, photographs, slides, SASE, tearsheets. Accepts disk submissions compatible with Mac/Quark, Photoshop or Illustrator, EPS files. Samples are filed or returned by SASE if requested by artist. Responds only if interested. Will contact artist for portfolio review if interested. Payment depends on each project's budgeting allowance. Negotiates rights purchased. Finds artists through submissions, sourcebooks, Internet, reps, word of mouth.

Tips "I look for cutting edge design and typography along with interesting use of color and photography. Illustrations must show individual style and ability to be conceptual."

HARD HAT RECORDS AND CASSETTE TAPES

519 N. Halifax Ave., Daytona Beach FL 32118-4017. (386)252-0381. Fax: (386)252-0381. E-mail: hardhatrecords@aol.com. Website: www.hardhatrecords.com. **CEO:** Bobby Lee Cude. Produces rock, country/western, folk and educational recordings by group and solo artists. Also publishes high school/college marching band arrangements. Recent releases: *Broadway USA* (3-volume CD program of new and original music); *Times-Square Fantasy Theatre* (CD release with 46 tracks of new and original Broadway-style music).

• Also owns Blaster Boxx Hits.

Needs Produces 6-12 records/year. Works with 2 designers and 1 illustrator/year. Works on assignment only. Uses freelancers for album cover design and illustration; advertising design; and sheet music covers. Prefers "modern, up-to-date, on the cutting edge" promotional material and cover designs that fit the music style. 60% of freelance work demands knowledge of Photoshop.

Contact & Terms Send query letter with brochure to be kept on file for one year. Samples not filed are returned by SASE. Responds in 2 weeks. Write for appointment to show portfolio. Sometimes requests work on spec before assigning a job. Pays by the project. Buys all rights.

HOTTRAX RECORDS

1957 Kilburn Dr., Atlanta GA 30324. (770)662-6661. E-mail: hotwax@hottrax.com. Website: www.hottrax.com. **Publicity and Promotion:** Teri Blackman. Estab. 1975.

Produces CDs and cassettes; rock, R&B, country/western, jazz, pop and blues/ novelties by solo and group artists.

Needs Produces 2 solo artists and 4 groups/year. Approached by 90-100 designers and 30 illustrators/year. Works with 6 designers and 3 illustrators/year. Prefers freelancers with experience in multimedia and caricatures. Uses freelancers for CD/cassette cover, catalog and advertising design and illustration; posters. 25% of freelance work demands knowledge of PageMaker, Illustrator and Photoshop.

Contact & Terms Send postcard samples. Accepts disk submissions compatible with Illustrator and CorelDraw. Some samples are filed. If not filed, samples are not returned. Responds only if interested. Pays by the project, $150-1,250 for design; $1,000 maximum for illustration. Buys all rights.

Tips "Digital downloads of single tracks have reduced the demand for CD artwork and graphics. It is our belief that this is only a temporary problem for artists and designers. Hottrax will continue to preserve this medium as an integral part of its album/CD production. We file all samples that interest us even though we may not respond until the right project arises. We like simple designs for blues and jazz, including cartoons/caricatures; abstract for New Age; and fantasy for heavy metal and hard rock."

HULA RECORDS

99-139 Waiua Way, Unit #56, Aiea HI 96701. (808)485-2294. Fax: (808)485-2296. E-mail: info@hularecords.com. Website: www.hawaiian-music.com. **President:** Donald P. McDiarmid III. Produces educational and Hawaiian records; group and solo artists.

Needs Produces 1-2 soloists and 3-4 groups/year. Works on assignment only. Uses artists for album cover design and illustration, brochure and catalog design, catalog layout, advertising design and posters.

Contact & Terms Send query letter with tearsheets and photocopies. Samples are filed or are returned only if requested. Responds in 2 weeks. Write for appointment to show portfolio. Pays by the project, $50-350. Considers available budget and rights purchased when establishing payment. Negotiates rights purchased.

⊞ IDOL RECORDS

P.O. Box 720043, Dallas TX 75372. (214)321-8890. E-mail: info@idolrecords.com. Website: www.idolrecords.com. **Contact:** Miles. Estab. 1993. Produces CDs; rock by solo artists and groups. Recent releases: *We Are the Os*, by The Os; *Movements*, recorded by Black Tie Dynasty.

Needs Produces 10-20 releases/year. Prefers local designers/illustrators. Uses freelancers for CD booklet illustration; cover design; poster design.

Contact & Terms Send photocopies, photographs, résumé and sample CD booklet.

Samples are filed and not returned. Responds only if interested. Will contact artist for portfolio review if interested. Pays by the project. Buys all rights. Finds freelancers through word of mouth.

IMAGINARY ENTERTAINMENT CORP.

P.O. Box 66, Whites Creek TN 37189. E-mail: jazz@imaginaryrecords.com. Website www.imaginaryrecords.com. **Proprietor:** Lloyd Townsend. Estab. 1982. Produces CDs, cassettes and LPs; rock, jazz, classical, folk and spoken word. Recent releases: Kaki by S.P. Somtow;: *Fifth House*, by The New York Trio Project; *Triologue*, by Stevens, Siegel and Ferguson.
Needs Produces 1-2 solo artists and 1-2 groups/year. Works with 1-2 freelancers/year. Works on assignment only. Uses artists for CD/LP/cassette cover design and illustration.
Contact & Terms Prefers first contact through e-mail with link to online portfolio; otherwise send query letter with brochure, tearsheets, photographs, and SASE if samples need to be returned. Samples are filed or returned by SASE if requested by artist. Responds in 3 months. To show portfolio, mail thumbnails, roughs and photographs. Pays by the project, $25-500. Negotiates rights purchased.
Tips "I always need one or two dependable artists who can deliver appropriate artwork within a reasonable time frame."

INTERSCOPE GEFFEN A&M RECORDS

2220 Colorado Ave., Santa Monica CA 90404. (310)865-1000. Website: www.interscope.com. **Contact:** Director of Creative Services. Produces CDs, cassettes, vinyl, DVD a variety of music by solo artists and groups. Recent releases include Black Eyed Peas, U2, Beck, M.I.A, and more. Art guidelines available with project.
Needs Prefers local designers/illustrators with experience in music. Uses freelancers for cassette illustrations and design; CD booklet and cover illustration and design. 100% of design work demands knowledge of Illustrator, Photoshop and QuarkXpress. 100% of illustration work demands knowledge of FreeHand and Illustrator.
Contact & Terms Send postcard sample. Samples are filed. Responds only if interested. Portfolio should include b&w and color finished art, original art and photographs. Pays by the project. Rights purchased vary according to project. Finds freelancers through magazines, sourcebooks and word of mouth.

IRISH MUSIC CORPORATION

P.O. Box 1515 Green Island NY 12183. (518)266-0765. Fax: (518) 833-0277. E-mail: rego@eIrish.com. Website: www.regorecords.com. **Managing Director:** T. Julian McGrath. Estab. 19 16. Produces CDs, DVD—Irish, Celtic, folk.
Needs Produces 12 releases/year. Works with 2 freelancers/year. Prefers local

designers. Uses freelancers for CD booklet and cover design; poster design. 100% of illustration demands computer skills.

Contact & Terms Send query letter with brochure, résumé, tearsheets. Samples are filed if genre compatible. Will contact artist if interested. Pays by the project, $ 400 maximum. Assumes all rights.

LIVING MUSIC

P.O. Box 72, Litchfield CT 06759. (860)567-8796. Fax (860)567-4276. E-mail: info@ livingmusic.com. Website: www.livingmusic.com. **Director of Communications:** Christina Andersen. Estab. 1980. Produces CDs and cassettes; classical, jazz, folk, progressive, world, New Age. Recent releases: *Celtic Solstice*, by Paul Winter & Friends; *Journey with the Sun*, by Paul Winter and the Earth Band; *Every Day is a New Life*, by Arto Tunchboyaciyan; *Brazilian Days*, by Oscar Castro-Neves and Paul Winter; and *Silver Solstice*, by Winter & Friends.

Needs Produces 1-3 releases/year. Works with 1-5 freelancers/year. Uses freelancers for CD/cassette cover and brochure design and illustration; direct mail packages; advertising design; catalog design, illustration and layout; and posters. 70% of freelance work demands knowledge of PageMaker, Illustrator, QuarkXPress, Photoshop, FreeHand.

Contact & Terms Send postcard sample of work or query letter with brochure, transparencies, photographs, slides, SASE, tearsheets. Samples are filed or returned by SASE if requested by artist. Responds only if interested. Art director will contact artist for portfolio review of b&w and color roughs, photographs, slides, transparencies and tearsheets. Pays for design by the project. Rights purchased vary according to project.

Tips "We look for distinct 'earthy' style." Prefers nature themes.

JIM MCCOY MUSIC

25 Troubadour Lane, Berkeley Springs WV 25411. (304)258-9381. E-mail: mccoytroubadour @aol.com. Website: www.troubadourlounge.com. **Owner:** Bertha McCoy. Estab. 1972. Produces CDs, cassettes; country/western. Recent releases: Mysteries of Life by Carroll County Ramblers.

Needs Publishes 20 songs/year; publishes 3-5 new songwriters/year. Works on assignment only. Uses artists for CD cover design and illustration; cassette cover illustration.

METAL BLADE RECORDS, INC.

2828 Cochran St., Suite 302, Simi Valley CA 93065. (805)522-9111. Fax: (805)522-9380. E-mail: metalblade@metalblade.com. Website: www.metalblade.com. **Senior Vice President/General Manager:** Tracy Vera. Estab. 1982. Produces CDs and tapes

rock by solo artists and groups. Recent releases: *Lust in Space*, by Gwar; *Ruination*, by Job For A Cowboy; *Evangelion*, by Behemoth.

Needs Produces 30-50 releases/year. Approached by 10 designers and 10 illustrators/year. Works with 1 designer and 1 illustrator/year. Prefers freelancers with experience in album cover art. Uses freelancers for CD cover design and illustration. Needs computer-literate freelancers for design and illustration. 80% of freelance work demands knowledge of PageMaker, Illustrator, QuarkXPress, Photoshop.

Contact & Terms Send postcard sample of work or query letter with brochure, résumé, photostats, photocopies, photographs, SASE, tearsheets. Samples are filed or returned by SASE if requested by artist. Responds only if interested. Art director will contact artist for portfolio review if interested. Portfolio should include b&w and color, final art, photocopies, photographs, photostats, roughs, slides, tearsheets. Pays for design and illustration by the project. Buys all rights. Finds artists through *Black Book*, magazines and artists' submissions.

Tips "Please send samples of work previously done. We are interested in any design."

🌐 NERVOUS RECORDS

5 Sussex Crescent, Northolt, Middx UB5 4DL United Kingdom. 44(020)8423 7373. Fax: 44(020)8423 7773. E-mail: nervous@compuserve.com. Website: www.nervous. co.uk. **Contact:** R. Williams. Produces CDs, rockabilly and psychobilly. Recent releases: *Hot 'N Wild Rockabilly Cuts*, by Mystery Gang; *Rockabillies Go Home*, by Blue Flame Combo.

Needs Produces 9 albums/year. Approached by 4 designers and 5 illustrators/year. Works with 3 designers and 3 illustrators/year. Uses freelancers for album cover, brochure, catalog and advertising design and multimedia projects. 50% of design and 75% of illustration demand knowledge of Page Plus II and Microsoft Word 6.0.

Contact & Terms Send query letter with postcard samples; material may be kept on file. Write for appointment to show portfolio. Accepts disk submissions compatible with PagePlus and Microsoft Word. Samples not filed are returned by SAE (nonresidents include IRC). Responds only if interested. Original art returned at job's completion. Pays for design by the project, $50-200. Pays for illustration by the project, $10-100. Considers available budget and how work will be used when establishing payment. Buys first rights.

Tips "We have noticed more imagery and caricatures in our field so fewer actual photographs are used." Wants to see "examples of previous album sleeves, keeping with the style of our music. Remember, we're a rockabilly label."

NORTH STAR MUSIC INC.

338 Compass Circle A1, North Kingstown RI 02852. (401)886-8888. Fax: (401)886-8880. E-mail: info @northstarmusic.com. Website: www.northstarmusic.com.

President: Richard Waterman. Estab. 1985. Produces CDs; jazz, classical, folk, traditional, contemporary, world beat and New Age by solo artists and groups. Recent release: *Sundown*, by Stewart Dudley.

Needs Produces 4 solo artists and 4 groups/year. Works with 2 freelancers/year. Prefers freelancers with experience in CD cover design. Works on assignment only. Uses artists for CD cover and brochure design and illustration; catalog design, illustration and layout; direct mail packages. 80% of design and 20% of illustration demand knowledge of QuarkXPress 4.0.

Contact & Terms Send postcard sample or query letter with brochure, photocopies and SASE. Accepts disk submissions compatible with QuarkXPress 4.0. Send EPS or TIFF files. Samples are filed. Responds only if interested. To show portfolio, mail color roughs and final art. Pays for design by the project, $500-1,000. Buys first rights, one-time rights or all rights.

Tips "Learn about our label's style of music/art. Send appropriate samples."

ONE STEP TO HAPPINESS MUSIC

Jacobson & Colfin, P.C., 60 Madison Ave., Suite 1026, New York NY 10010-1666. (212)691-5630. Fax: (212)645-5038. E-mail: bruce@thefirm.com. Website: www. thefirm.com. **Attorney:** Bruce E. Colfin. Produces CDs, cassettes and albums; reggae by solo artists and groups. Recent release: *Make Place for the Youth*, by Andrew Tosh.

Needs Produces 1-2 solo artists and 1-2 groups/year. Works with 1-2 freelancers/ year on assignment only. Uses artists for CD/album/cassette cover design and illustration.

Contact & Terms Send query letter with brochure, résumé and SASE. Samples are filed or returned by SASE if requested by artist. Responds in 2 months. Call or write for appointment to show portfolio of tearsheets. Pays by the project. Rights purchased vary according to project.

Ⓝ PAPER + PLASTICK

E-mail: rev@revbee.com. Website: http://paperandplastick.com. Estab. 2008.

Needs CD booklet illustration, CD cover design, CD cover illustration. See website for more information and contact.

PPL ENTERTAINMENT GROUP

468 North Camden Drive, Suite 200, Beverly Hills CA 90210. (310)860-7499. Fax: (310)860-7400. E-mail: pplzmi@aol.com. Website: www.pplzmi.com. **Art Director:** Kaitland Diamond. Estab. 1979. Produces albums, CDs, cassettes; country, pop, R&B, rap, rock and soul by solo artists and groups. Recent releases: Return of the *Playazz*, by JuzCuz; *American Dream*, by Riki Hendrix.

Needs Produces 12 releases/year. Works with 2 freelancers/year. Prefers designers who own Mac or IBM computers. Uses freelancers for CD booklet design and illustration; CD/album/cassette cover design and illustration; CD-ROM design and packaging; poster design; Web page design. Freelance work demands knowledge of PageMaker, Illustrator, Photoshop, QuarkXPress.

Contact & Terms Send query letter with brochure, photocopies, tearsheets, résumé, photographs, photostats, slides, transparencies and SASE. Accepts disc submissions. Samples are filed or returned by SASE if requested by artist. Responds in 2 months. Request portfolio review in original query. Pays by the project, monthly.

ROTTEN RECORDS

P.O. Box 56, Upland CA 91786. (909)920-4567. Fax (909)920-4577. E-mail: rotten@ rottenrecords.com. Website: www.rottenrecords.com. **President:** Ron Peterson. Estab. 1988. Produces CDs and tapes rock by groups. Recent releases: *Paegan Terrorism*, by Acid Bath; and *Kiss the Clown*, by Kiss the Clown.

Needs Produces 4-5 releases/year. Works with 3-4 freelancers/year. Uses freelancers for CD/tape cover design; and posters. Needs computer-literate freelancers for desigin, illustration, production.

Contact & Terms Send postcard sample of work or query letter with photocopies, tearsheets (any color copies samples). Samples are filed and not returned. Responds only if interested. Artist should follow up with call. Portfolio should include color photocopies. Pays for design and illustration by the project.

SAHARA RECORDS AND FILMWORKS ENTERTAINMENT

10573 W. Pico Blvd. #352, Los Angeles CA 90064. (310)948-9652. E-mail: info@ edmsahara.com. Fax: (310)474-7705. Website: www.edmsahara.com. **Marketing Director:** Dwayne Woolridge. Estab. 1981. Produces CDs, cassettes; jazz, pop, R&B, rap, rock, soul, TV-film music by solo artists and groups. Recent releases: *Pay the Price* and *Rice Girl* film soundtracks; *Dance Wit Me*, by Steve Lynn.

Needs Produces 25 releases/year. Works with 2 freelancers/year. Uses freelancers for CD booklet design and illustration; CD cover design and illustration; poster design and animation.

Contact & Terms Contact only through artist rep. Samples are filed. Responds only if interested. Payment negotiable. Buys all rights. Finds artists through agents, submissions, *The Black Book* and *Directory of Illustration*.

SILVER WAVE RECORDS

P.O. Box 7943, Boulder CO 80306. (303)443-5617. Fax: (303)443-0877. E-mail: valerie@ silverwave.com. Website: www.silverwave.com. **Art Director:** Valerie Sanford. Estab. 1986. Produces CDs and cassettes; Native American, New Age

and World music. Recent releases: *Out of the Ashes*, by Shelley Morningsong; *10 Questions for the Dalai Lama*, by Peter Kater; Grammy winner *Sacred Place*, by Mary Youngblood; *Come to Me Great Mystery: Native American Healing Songs*.

Needs Produces 4 releases/year. Works with 4-6 illustrators, artists, photographers/year. Uses illustrators for CD cover illustration.

Contact & Terms Send postcard sample or query letter with 2 or 3 samples. Samples are filed. Will contact for portfolio review if interested. Pays by the project. Rights purchased vary according to project.

Tips "Develop some good samples and experience. I look in galleries, art magazines, *Workbook*, *The Black Book* and other trade publications. I visit artists' booths at Native American 'trade shows.' Word of mouth is effective. We will call if we like work or need someone." When hiring freelance illustrators, this company looks for a specific style for a particular project. "Currently we are producing contemporary Native American music and look for art that expresses that."

◪ SOMERSET ENTERTAINMENT

20 York Mills Rd., Suite 600., Toronto ON M2P 2C2 Canada. (416)510-2800. Fax: (416)510-3070. E-mail: elahman@somersetent.com. Website: www.somersetent.com. **Art Director:** Elliot Lahman. Estab. 1994. Produces CDs, cassettes and enhanced CDs classical, country, folk, jazz, soul, children's music, solo artists and groupssome enhanced by nature sounds. Recent releases: *Jazz*, by Twilight; *Shorelines-Classical Guitar*; *Spring Awakening*, by Dan Gibson and Joan Jerberman.

SUGAR BEATS ENTERTAINMENT

12129 Maxwellton Ave, Studio City CA 91604. (818)358-2408. Fax: (818)358-2407. E-mail: support@sugarbeats.com. Website: www.sugarbeats.com. **Vice President Marketing:** Bonnie Gallanter. Estab. 1993. Produces CDs, cassettes children's music by groups. Recent releases: *A Sugar Beats Christmas*.

Needs Produces 1 release/year. Works with 1-2 freelancers/year. Prefers local freelancers who own Macs with experience in QuarkXPress, Photoshop, Illustrator and web graphics. Uses freelancers for album cover design; cassette cover design and illustration; CD booklet design and illustration; CD cover design and illustration; poster design; Web page design. Also for ads, sell sheets and postcards. 100% of freelance design demands knowledge of Illustrator, QuarkXPress, Photoshop, FreeHand.

Contact & Terms Send postcard sample or query letter with brochure, tearsheets, résumé and photographs. Accepts Mac-compatible disk submissions. Will contact artist for portfolio review of b&w and color art. Pays by the project. Rights purchased vary according to project. Finds freelancers through referrals.

▓ TANGENT RECORDS

P.O. Box 383, Reynoldsburg OH 43068-0383. (614)751-1962. Fax: (614)751-6414. E-mail: info@tangentrecords.com. Website: www.tangentrecords.com. **President:** Andrew J. Batchelor. Estab. 1986. Produces CDs, DVDs, CD-ROMs, cassettes, videos; contemporary, classical, jazz, progressive, rock, electronic, world beat and New Age fusion. Recent releases: *Moments Edge,* by Andrew Batchelor.

Needs Produces 20 releases/year. Works with 5 freelancers/year. Prefers local illustrators and designers who own computers. Uses freelancers for CD booklet design and illustration; CD cover design and illustration; CD-ROM design and packaging; poster design; Web page design; advertising and brochure design/illustration and multimedia projects. Most freelance work demands knowledge of Illustrator, QuarkXPress, Photoshop, FreeHand and PageMaker.

Contact & Terms Send postcard sample or query letter with résumé, brochure, one-sheets, photocopies, tearsheets, photographs. Accepts both Mac- and IBM-compatible digital submissions. Send JPEG files on 3.5" diskette, CD-ROM or Superdisk 120MB. Samples are filed and not returned. Will contact artist for portfolio review if interested. Portfolio should include b&w, color, final art, photocopies, photographs, photostats, slides, tearsheets, thumbnails, transparencies. Pays by the project. "Amount varies by the scope of the project." Negotiates rights purchased. Finds artists through college art programs and referrals.

Tips Looks for "creativity and innovation."

▓ VALARIEN PRODUCTIONS

15332 Antioch St., #105A, Pacific Palisades CA 90272. (310)445-7737. Fax: (310)455-7737. E-mail: valarien@gte.net. Website: www.valarien.com. **Owner:** Eric Reyes. Estab. 1990. Produces CDs; ambient, acoustic guitar, New Age, DJ/dance/electronica, progressive rock and metal, soundtracks and sound design by solo artists.

Needs Produces 1-4 releases/year. Works with 1-2 freelancers/year. Prefers local freelancers who own Macs. Uses freelancers for CD/album cover design and illustration; animation; CD booklet design and illustration; advertising. 100% of freelance work demands knowledge of Illustrator, QuarkXPress.

Contact & Terms Send postcard sample of work. Samples are filed and not returned. Will contact artist for portfolio review of b&w, color, final art if interested. Pays by the project. Rights purchased vary according to project. Finds artists through word of mouth, submissions, sourcebooks.

VAN RICHTER RECORDS

100 S. Sunrise Way, Suite 219, Palm Springs CA 92262. (858)412-4329. Fax: (270)342-1052. E-mail: manager@vanrichter.net. Website: www.vanrichter.net. **Label Manager:** Paul Abramson. Estab. 1993. Produces CDs; rock, industrial. Recent releases: *Nightmare,* by Girls Under Glass.

Needs Produces 3-4 releases/year. Works with 2-3 freelancers/year. Prefers freelancers with experience in production design. Uses freelancers for CD booklet and cover design and illustration; posters/pop. 100% of freelance work demands knowledge of Illustrator, QuarkXPress, Photoshop.

Contact & Terms Send postcard sample or query letter with brochure, tearsheets, photographs, print samples. Accepts Mac-compatible disk submissions. Samples are not filed and are returned by SASE if requested by artist. Will contact artist for portfolio review of final art if interested. Payment negotiable. Buys all rights. Finds artists through Internet and submissions.

Tips "You may have to work for free until you prove yourself/make a name."

VARESE SARABANDE RECORDS

11846 Ventura Blvd., Suite 130, Studio City CA 91604. (818)753-4143. Fax: (818)753-7596. E-mail: publicity@varesesarabande.com. Website: www.varesesarabande.com. **Vice President:** Robert Townson. Estab. 1978. Produces CDs; film music soundtracks. Recent releases: *Star Trek*, by Michael Giacchino; *Frost/Nixon*, by Hans Zimmer; *The Changeling*, by Clint Eastwood; *Wolverine*, by Harry Gregson-Williams; *Grey Gardens*, by Rachel Portman; *Hellboy 2*, by Danny Elfman.

Needs Works on assignment only. Uses artists for CD cover illustration and promotional material.

Contact & Terms Send query letter with photostats, slides and transparencies. Samples are filed. Responds only if interested. Pays by the project.

Tips "Be familiar with the label's output before approaching us."

VERVE MUSIC GROUP

1755 Broadway, 3rd Floor, New York NY 10019. (212)331-2000. Fax: (212)331-2065. E-mail: contact@vervemusicgroup.com. Website: www.vervemusicgroup.com. **Associate Director:** Sherniece Johnson-Smith. Produces albums and CDs; jazz, progressive by solo artists and groups. Recent release: *The Girl in the Other Room*, by Diana Krall.

• Verve Music Group houses the Verve, GRP, Impulse! and Verve Forecast record labels.

Needs Produces 120 releases/year. Works with 20 freelancers/year. Prefers designers with experience in CD cover design who own Macs. Uses freelancers for album cover design and illustration; CD booklet design and illustration; CD cover design and illustration. 100% of freelance design demands computer skills.

Contact & Terms Send nonreturnable postcard sample of work. Samples are filed. Does not reply. Portfolios may be dropped off Monday through Friday. Will contact artist for portfolio review if interested. Pays for design by the project, $1,500 minimum; pays for illustration by the project, $2,000 minimum.

VIRGIN RECORDS

1750 Vine St., Los Angeles CA 90028. (323)692-1100. Fax: (310)278-6231. Website: www.virginrecords.com. New York office: 150 5th Ave., 3rd Floor, New York NY 10016. (212)786-8200 Fax:(212)786-8343. **Contact:** Creative Dept. Uses freelancers for CD and album cover design and illustration. Send query letter with samples. Portfolios may be dropped off on Wednesdays between 10 a.m. and 5 p.m. Samples are filed. Responds only if interested.

• Virgin Records is a subsidiary of EMI.

WARNER BROS. RECORDS

3300 Warner Blvd., Burbank CA 91505. (818)846-9090. Fax: (818)953-3232. Website: www.warnerbros.com. **Art Dept. Assistant:** Michelle Barish. Produces artwork for CDs, cassettes and sometimes albums; rock, jazz, hip-hop, alternative, rap, R&B, soul, pop, folk, country/western by solo and group artists. Releases: *Greatest Hits and Videos*, by Red Hot Chili Peppers; *Closer*, by Josh Groban; *In Time, Best of R.E.M. 1988-2003*, by R.E.M. Releases approximately 200 total packages/year.

Needs Works with freelance art directors, designers, photographers and illustrators on assignment only. Uses freelancers for CD cover design and illustration; brochure design and illustration; catalog design, illustration and layout; advertising design and illustration; and posters. 100% of freelance work demands knowledge of QuarkXPress, FreeHand, Illustrator or Photoshop.

Contact & Terms Send query letter with résumé, brochure, tearsheets, slides and photographs. Samples are filed or are returned by SASE if requested by artist. Responds only if interested. Will contact artist for portfolio review if interested. Portfolio should include roughs, printed samples and b&w and color tearsheets, photographs, slides and transparencies. "Any of these are acceptable. Do not submit original artwork." Pays by the project.

Tips "We tend to use artists or illustrators with distinct/stylized work. Rarely do we call on the illustrators to render likenesses; more often we are looking for someone with a conceptual or humorous approach."

Artists' Reps

Many artists find leaving promotion to a rep allows them more time for the creative process. In exchange for actively promoting an artist's career, the representative receives a percentage of sales (usually 25-30%). Reps generally focus on either the fine art market or commercial market, rarely both.

Fine art reps promote the work of fine artists, sculptors, craftspeople and fine art photographers to galleries, museums, corporate art collectors, interior designers and art publishers. Commercial reps help illustrators and graphic designers obtain assignments from advertising agencies, publishers, magazines and other art buyers. Some reps also act as licensing agents.

What reps do

Reps work with artists to bring their portfolios up to speed and actively promote their work to clients. Usually a rep will recommend advertising in one of the many creative directories such as *Showcase* (www.showcase.com) or *Workbook* (www.workbook.com) so that your work will be seen by hundreds of art directors. (Expect to make an initial investment in costs for duplicate portfolios and mailings.) Reps also negotiate contracts, handle billing and collect payments.

Getting representation isn't as easy as you might think. Reps are choosy about who they represent—not just in terms of talent but also in terms of marketability and professionalism—reps will only take on talent they know will sell.

What to send

Once you've gone through the listings in this section and compiled a list of art reps who handle your type and style of work, contact them with a brief query letter and nonreturnable copies of your work. Check each listing for specific guidelines and requirements.

Learn About Reps

For More Info

The Society of Photographers and Artists Representatives (SPAR) is an organization for professional representatives. SPAR members are required to maintain certain standards and follow a code of ethics. For more information, write to SPAR, 60 E. 42nd St., Suite 1166, New York NY 10165, or visit www.spar.org.

AMERICAN ARTISTS REP., INC.

380 Lexington Ave., 17th floor, New York NY 10168. (212)682-2462. Fax: (212)582-0090. Website: www.aareps.com. Commercial illustration representative. Estab. 1930. Member of SPAR. Represents 40 illustrators. Markets include advertising agencies, corporations/client direct, design firms, editorial/magazines, paper products/greeting cards, publishing/books, sales/promotion firms.

Handles Illustration, design.

Terms Rep receives 30% commission. "All portfolio expenses billed to artist." Advertising costs are split: 70% paid by talent; 30% paid by representative. "Promotion is encouraged; portfolio must be presented in a professional manner—8 × 10, 4 × 5, tearsheets, etc." Advertises in *American Showcase*, *The Black Book*, *RSVP*, *Workbook*, medical and Graphic Artist Guild publications.

How to Contact Send query letter, direct mail flier/brochure, tearsheets. Responds in 1 week if interested. After initial contact, drop off or mail appropriate materials for review. Portfolio should include tearsheets, slides. Obtains new talent through recommendations from others, solicitation, conferences.

ART LICENSING INTERNATIONAL INC.

1022 Hancock Ave., Sarasota FL 34232. (941)966-4042. E-mail: artlicensing@comcast.net. Website: www.out-of-the-blue.us. **President:** Michael Woodward, author of *Licensing Art 101*. Licensing agent. Estab. 1986. Represents fine artists, designers, photographers and concept designers. Handles collections of work submitted by artists for licensing across a range of product categories, such as fine art for interior design market, wall decor, greeting cards, stationery and gift products.

- See additional listings for this company in the Greeting Cards, Gifts & Products and Posters & Prints sections. See also listing for Out of the Blue in the Greeting Cards, Gifts & Products section.

Handles Prefers collections of art, or photography that have good consumer appeal.

Terms Send samples on CD (JPEG files) with SASE if you want CD returned. Fine

artists should send short bio. "Terms are 50/50 with no expenses to artist as long as artist can provide high-res digital files if we agree on representation. Our agency specializes in fine art and photography including sepia and B&W and we are always looking for fresh contemporary florals, contemporary Abstracts, landscapes with trees, Tuscan landscapes, tranquil lake and river scenes, coastal scenes and bold edgy decorative images. We are only interested in series or groups of artworks or concepts that commercial appeal."

Tips "Artists need to consider actual products when creating new art. Look at products in retail outlets and get a feel for what is selling well. Get to know the markets you are trying to sell your work to."

ARTINFORMS (A DIVISION OF MARTHA PRODUCTIONS)

7550 W. 82nd St., Playa Del Rey CA 90293. (310)670-5300. Fax: (310)670-3644. E-mail: contact@artinforms.com. Website: www.artinforms.com. **President:** Martha Spelman. Commercial illustration representative. Estab. 2000. Represents 9 illustrators. Specializes in illustrators who create informational graphics and technical drawings, including maps, charts, diagrams, cutaways, flow charts and more.

• See listing for Martha Productions in this section.

ARTISAN CREATIVE, INC.

1633 Stanford St., 2nd Floor, Santa Monica CA 90404. (310)312-2062. Fax: (310)312-0670. E-mail: lainfo@artisancreative.com. Website: www.artisancreative.com. **Creative Contact:** Jamie Grossman. Estab. 1996. Represents creative directors, art directors, graphic designers, illustrators, animators (3D and 2D), storyboarders, packaging designers, photographers, Web designers, broadcast designers and flash developers. Markets include advertising agencies, corporations/client direct, design firms, entertainment industry.

• Artisan Creative has another location at 850 Montgomery St., C-50, San Francisco CA 94133. (415)362-2699. **Contact:** Wayne Brown.

Handles Web design, multimedia, illustration, photography and production. Looking for Web, packaging, traditional and multimedia-based graphic designers.

Terms 100% of advertising costs paid by the representative. For promotional purposes, talent must provide PDFs of work. Advertises in magazines for the trade, direct mail and the Internet.

How to Contact For first contact, e-mail résumé to Creative Staffing Department. "You will then be contacted if a portfolio review is needed." Portfolio should include roughs, tearsheets, photographs, or color photos of your best work.

Tips "Have at least two years' working experience and a great portfolio."

ARTREPS

22287 Mulholland Hwy., Suite 133, Calabasas CA 91302-5157. (818)888-0825 or (800)959-6040. E-mail: info@artrepsart.com. Website: www.artrepsart.com. **Art Director:** Phoebe Batoni. Fine art representative, art consultant, publisher. Estab. 1993. Represents fine artists. Specializes in working with royalty publishers for posters, open editions, limited edition giclées; and galleries, interior designers and licensing agents. Markets include art publishers, corporate collections, galleries, interior decorators. Represents Barbara Cleary, Lili Maglione, Peter Colvine, Ann Christensen, Peter Wilkinson and Ron Peters.

• This agency attends Artexpo and DECOR Expo to promote its clients.

Handles Fine art: works on paper, canvas and mixed media; no sculpture.

Terms Negotiated on an individual basis. For promotional purposes, talent must provide "adequate materials."

How to Contact Send query letter with résumé, bio, direct mail flier/brochure, tearsheets, slides, photographs, photocopies or photostats and SASE (for return of materials). Will look at CD or website but prefers to review artwork in a tangible form. Responds in 2 weeks.

Tips "We're interested in fine art with universal mainstream appeal. Check out the kind of art that's selling at your local frame shop and fine art galleries or at retailers like Pier One Imports and Bed Bath & Beyond. Presentation counts, so make sure your submission looks professional."

ARTVISIONS

Bellevue WA. Website: www.artvisions.com. Estab. 1993. Licenses fine art and professional photography.

Handles Fine art and professional photography licensing only.

Terms Royalties are split 50/50. Exclusive worldwide representation for licensing is required (the artist is free to market original art). Written contract provided.

How to Contact Review guidelines on website. "Not currently seeking new talent. However, we are always willing to view the work of top-notch established artists. If you fit this category, please contact ArtVisions via e-mail (from our website) and include a link to a website where your art can be seen. Or, you may include a few small samples attached to your e-mail as JPEG files."

Tips "To gain an idea of the type of art we license, please view our website. Artist MUST be able to provide high-resolution, professionally made scans of artwork on CD. We are firmly entrenched in the digital world, if you are not, then we cannot represent you. If you need advice about marketing your art, please visit: www.artistsconsult. com."

ARTWORKS ILLUSTRATION

325 W. 38th St., New York NY 10018. (212)239-4946. Fax: (212)239-6106. E-mail: artworks illustration@earthlink.net. Website: www.artworksillustration.com. **Owner:** Betty Krichman. Commercial illustration representative. Estab. 1990. Member of Society of Illustrators. Represents 30 illustrators. Specializes in publishing. Markets include advertising agencies, design firms, paper products/greeting cards, movie studios, publishing/books, sales/promotion firms, corporations/client direct, editorial/magazines, video games. Artists include Dan Brown, Dennis Lyall, Jerry Vanderstelt and Chris Cocozza.

Handles Illustration. Looking for interesting juvenile, digital sci-fi/fantasy & romance images.

Terms Rep receives 30% commission. Exclusive area representation required. Advertising costs are split: 75% paid by artist; 25% paid by rep. Advertises in *American Showcase* and on www.theispot.com.

How to Contact For first contact, send e-mail samples. Responds only if interested.

ASCIUTTO ART REPS., INC.

1712 E. Butler Circle, Chandler AZ 85225. (480)899-0600. Fax: (480)899-3636. E-mail: aartreps@cox.net. Website: www.aartreps.com. **Contact:** Mary Anne Asciutto. Children's illustration representative. Estab. 1980. Specializes in children's illustration for books, magazines, posters, packaging, etc. Markets include publishing/packaging/advertising.

Handles Illustration only.

Terms Rep receives 25% commission. Advertising costs are split: 75% paid by talent; 25% paid by representative. For promotional purposes, talent should provide color prints or originals in an 8.5 × 11 size format. Electronic samples via e-mail or cd rom.

How to Contact E-mail or send sample work with an SASE.

Tips "Be sure to connect with an agent who handles the kind of accounts you *want*."

CAROL BANCROFT & FRIENDS

P.O. Box 2030, Danbury CT 06813. (203)730-8270. Fax: (203)730-8275. E-mail: cb_friends 8270@sbcglobal.net. Website: www.carolbancroft.com. **Owner:** Joy Elton Tricarico. Founder: Carol Bancroft. Illustration representative for children's publishing. Estab. 1972. Member of Society of Illustrators, Graphic Artists Guild, SCBWI and National Art Education Association. Represents over 30 illustrators. Specializes in, but not limited to, representing artists who illustrate for children's publishing—text, trade and any children's-related material. Clients include Scholastic, Harcourt, HarperCollins, Random House, Penguin USA, Simon & Schuster. Artist list available upon request.

Handles Illustration for children of all ages.

Terms Rep receives 25% commission. Advertising costs are split: 75% paid by talent; 25% paid by representative. For promotional purposes, artist should provide "Web address in an e-mail or samples via mail (laser copies, not slides; tearsheets, promo pieces, books, good color photocopies, etc.); 6 pieces or more; narrative scenes with children and/or animals interacting." Advertises in *Picture Bookand Directory of Illustration*.

How to Contact Send samples and SASE. "Artists may call no sooner than one month after sending samples."

Tips "We look for artists who can draw animals and people with imagination and energy, depicting engaging characters with action in situational settings."

BERNSTEIN & ANDRIULLI

58 W. 40th St., New York NY 10018. (212)682-1490. Fax: (212)286-1890. E-mail: info@ ba-reps.com. Website: www.ba-reps.com. **Contact:** Louisa St. Pierre. Commercial illustration and photography representative. Estab. 1975. Member of SPAR. Represents 100 illustrators, 40 photographers. Markets include advertising agencies, corporations/client direct, design firms, editorial/magazines, paper products/greeting cards, publishing/books, sales/promotion firms.

Handles Illustration, New Media and Photography.

Terms Rep receives a commission. Exclusive career representation is required. No geographic restrictions. Advertises in *The Black Book*, *Workbook*, *Bernstein Andriulli International Illustration*, *CA Magazine*, *Archive*, American Illustration/ Photography.

How to Contact Send query e-mail with website or digital files. Call to schedule an appointment before dropping off portfolio.

JOANIE BERNSTEIN, ART REP

756 8th Avenue South, Naples FL 34102. (239)403-4393. Fax: (239)403-0066. E-mail: joanie @joaniebrep.com. Website: www.joaniebrep.com. **Contact:** Joanie. Commercial illustration representative. Estab. 1984.

Handles Illustration. Looking for an unusual, problem-solving style. Clients include advertising, design, books, music, product merchandising, developers, movie studios, films, private collectors.

Terms Rep receives 25% commission. Exclusive representation required.**How to Contact** E-mail samples.

Tips "I'd strongly advise an updated website. Also add "What's New"—show off work that you are currently doing."

BOOKMAKERS LTD.

P.O. Box 1086, 40 Mouse House Rd., Taos NM 87571. (575)776-5435. Fax: (575)776-2762. E-mail: gayle@bookmakersltd.com. Website: www.bookmakersltd.com. **President:** Gayle McNeil. Estab. 1975. "We represent professional, experienced children's book illustrators. We welcome authors who are interested in self-publishing."

- See additional listing in the Advertising, Design & Related Markets section.

BROWN INK GALLERY

222 E. Brinkerhoff Ave., Palisades Park NJ 07650. (201) 461-6571. Fax: (201)461-6571. E-mail: robert229artist@juno.com@juno.com. Website: www.browninkonline.com. **President/Owner:** Bob Brown. Digital fine art publisher and distributor. Estab. 1979. Represents 5 fine artists, 2 illustrators. Specializes in advertising, magazine editorials and book publishing, fine art. Markets include advertising agencies, corporations/client direct, design firms, editorial/magazines, galleries, movie studios, paper products/greeting cards, publishing/books, record companies, sales/promotion firms.

Handles Fine art, illustration, digital fine art, digital fine art printing, licensing material. Looking for professional artists who are interested in making a living with their art. Art samples and portfolio required.

Terms Rep receives 25% commission on illustration assignment; 50% on publishing (digital publishing) after expenses. "The only fee we charge is for services rendered (scanning, proofing, printing, etc.). We pay for postage, labels and envelopes." Exclusive area representation required (only in the NY, NJ, CT region of the country). Advertising costs are paid by artist or split: 75% paid by artist; 25% paid by rep. Artists must pay for their own promotional material. For promotional purposes, talent must provide a full-color direct mail piece, an 11 × 14 flexible portfolio, digital files and CD. Advertises in *Workbook*.

How to Contact For first contact, send bio, direct mail flier/brochure, photocopies, photographs, résumé, SASE, tearsheets, slides, digital images/CD, query letter (optional). Responds only if interested. After initial contact, call to schedule an appointment, drop off or mail portfolio, or e-mail. Portfolio should include b&w and color finished art, original art, photographs, slides, tearsheets, transparencies (35mm, 4 × 5 and 8 × 10).

Tips "Be as professional as possible! Your presentation is paramount. The competition is fierce, therefore your presentation (portfolio) and art samples need to match or exceed that of the competition."

✺ CONTACT JUPITER INC.

5 Laurier St., St. Eustache QC J7R 2E5 Canada. Phone/fax: (450)491-3883. E-mail:

info@ contactjupiter.com. Website: www.contactjupiter.com. **President:** Oliver Mielenz. Commercial illustration representative. Estab. 1996. Represents 17 illustrators, 7 photographers. Specializes in publishing, children's books, magazines, advertising. Licenses illustrators, photographers. Markets include advertising agencies, paper products/greeting cards, record companies, publishing/books, corporations/client direct, editorial/magazines.

Handles Illustration, multimedia, music, photography, design.

Terms Rep receives 15-25% and rep fee. Advertising costs are split: 90% paid by artist; 10% paid by rep. Exclusive representation required. For promotional purposes, talent must provide electronic art samples only. Advertises in *Directory of Illustration*.

How to Contact Send query by e-mail with a few JPEG samples. Responds only if interested. After initial contact, e-mail to set up an interview or portfolio review. Portfolio should include b&w and color tearsheets.

Tips "One specific style is easier to sell. Focus, focus, focus. Initiative, I find, is very important in an artist."

CORNELL & MCCARTHY, LLC

2-D Cross Hwy., Westport CT 06880. (203)454-4210. Fax: (203)454-4258. E-mail: contact@ cmartreps.com. Website: www.cmartreps.com. **Contact:** Merial Cornell. Children's book illustration representative. Estab. 1989. Member of SCBWI and Graphic Artists Guild. Represents 30 illustrators. Specializes in children's books—trade, mass market, educational.

Handles Illustration.

Terms Agent receives 25% commission. Advertising costs are split: 75% paid by talent; 25% paid by representative. For promotional purposes, talent must provide 10-12 strong portfolio pieces relating to children's publishing.

How to Contact For first contact, send query letter, direct mail flier/brochure, tearsheets, photocopies and SASE. Responds in 1 month. Obtains new talent through recommendations, solicitation, conferences.

Tips "Work hard on your portfolio."

CWC INTERNATIONAL, INC.

611 Broadway, Suite 730, New York NY 10012-2649. (646)486-6586. Fax: (646)486-7622. E-mail: agent@cwc-i.com. Website: www.cwc-i.com. **VP/Executive Creative Agent:** Koko Nakano. Estab. 1999. Commercial ilustration representative. Represents 23 illustrators. Specializes in advertising, fashion. Markets include advertising agencies, corporations/client direct, design firms, editorial/magazines, galleries, paper products/greeting cards, publishing/books, record companies. Artists include Jeffrey Fulvimari, Stina Persson, Chris Long and Kenzo Minami.

Handles Fine art, illustration.

Terms Exclusive area representation required.

How to Contact Send query letter with direct mail flier/brochure, photocopies (3-4 images) and résumé via postal mail or e-mail. Please put "rep query" as the subject of the e-mail. Responds only if interested.

Tips "Please do not call. When sending any image samples by e-mail, be sure the entire file will not exceed 300K."

LINDA DE MORETA REPRESENTS

1511 Union St., Alameda CA 94501. (510)769-1421. Fax: (419)710-8298. E-mail: linda@ linda reps.com. Website: www.lindareps.com. **Contact:** Linda de Moreta or Ron Lew. Commercial illustration, calligraphy/handlettering and photography representative. Estab. 1988. Represents 10 illustrators, 2 photographers. Markets include advertising agencies; design firms; corporations/client direct; editorial/magazines; paper products/greeting cards; publishing/books. Represents Chuck Pyle, Pete McDonnell, Monica Dengo, John Howell, Shannon Abbey, Craig Hannah, Shan O'Neill, Ron Miller, and Doves.

Handles Photography, illustration, lettering/title design, storyboards/comps.

Terms Commission, exclusive representation requirements and advertising costs are according to individual agreements. Materials for promotional purposes vary with each artist. Advertises in *Workbook*, *Directory of Illustration*, and on www.theispot. com.

How to Contact For first contact, e-mail samples or link to website; or send direct mail flier/brochure. "Please do *not* send original art. Include SASE for any items you wish returned." Responds to any inquiry in which there is an interest. Portfolios are individually developed for each artist.

Tips Obtains new talent through client and artist referrals primarily, some solicitation. "We look for great creativity, a personal vision and style combined with professionalism, and passion."

THE DESKTOP GROUP

420 Lexington Ave., 21st Fl., New York NY 10170. (212)490-7400. Fax: (212)867-1759. E-mail: info@tempositions.com. Website: www.thedesktopgroup.com. Estab. 1991. Specializes in recruiting and placing creative talent on a freelance basis. Markets include advertising agencies, design firms, publishers (book and magazine), corporations, and banking/financial firms.

Handles Artists with Macintosh (and Windows) software and multimedia expertise—graphic designers, production artists, pre-press technicians, presentation specialists, traffickers, art directors, Web designers, content developers, project managers, copywriters, and proofreaders.

How to Contact For first contact, e-mail résumé, cover letter and work samples.

Tips "Our clients prefer working with talented artists who have flexible, easy-going personalities and who are very professional."

ROBERT GALITZ FINE ART & ACCENT ART

166 Hilltop Court, Sleepy Hollow IL 60118. (847)426-8842. Fax: (847)426-8846. E-mail: robert@ galitzfineart.com. Website: www.galitzfineart.com. **Owner:** Robert Galitz. Fine art representative. Estab. 1985. Represents 100 fine artists (including 2 sculptors). Specializes in contemporary/abstract corporate art. Markets include architects, corporate collections, galleries, interior decorators, private collections. Represents Roland Poska, Jan Pozzi, Diane Bartz and Louis De Mayo.

• See additional listings in the Galleries and Posters & Prints sections.

Handles Fine art.

Terms Agent receives 25-40% commission. No geographic restrictions; sells mainly in Chicago, Illinois, Wisconsin, Indiana and Kentucky. For promotional purposes, talent must provide "good photos and slides." Advertises in monthly art publications and guides.

How to Contact Send query letter, slides, photographs. Responds in 2 weeks. After initial contact, call for appointment to show portfolio of original art. Obtains new talent through recommendations from others, solicitation, conferences.

Tips "Be confident and persistent. Never give up or quit."

ANITA GRIEN REPRESENTING ARTISTS

155 E. 38th St., New York NY 10016. E-mail: anita@anitagrien.com. Website: www. anitagrien.com. Representative not currently seeking new talent.

CAROL GUENZI AGENTS, INC.

(DBA ArtAgent.com) 865 Delaware St., Denver CO 80204. (303)820-2599. E-mail: art@ artagent.com. Website: www.artagent.com. **President**: Carol Guenzi. Commercial illustration, photography, new media and film/animation representative. Estab. 1984. Represents 25 illustrators, 6 photographers, 4 film/animation developers, and 3 multimedia developers. Specializes in a "worldwide selection of talent in all areas of visual communications." Markets include advertising agencies, corporations/ client direct, design firms, editorial/magazines, paper products/greeting cards, sales/ promotions firms. Clients include Coors, Celsestail Seasonings, Audi, Northface, Whole Foods, Western Union, Gambro, Vicorp, Miller, Coke-cola, Bacardi, First Data, Quiznos, etc. client list available upon request. Represents Christer Eriksson, Juan Alvarez, Jeff Pollard, Kelly Hume, Capstone Studios and many more.

Handles Illustration, photography. Looking for "unique style application."

Terms Rep receives 25-30% commission. Exclusive area representation is required. Advertising costs are split: 70-75% paid by talent; 25-30% paid by rep. For promotional purposes, talent must provide "promotional material; some restrictions on portfolios." Advertises in Directory of Illustration, Workbook, social marketing.

How to Contact For first contact, e-mail PDFs or JPEGs with link to URL, or send

direct mail flier/brochure. Responds only if interested. E-mail or call for phone appointment or mail in appropriate materials for review. Portfolio should include promotional material or electronic files. Obtains new talent through solicitation, art directors' referrals, and active pursuit by individual artists.

Tips "Show your strongest style and have at least 12 samples of that style before introducing all your capabilities. Be prepared to add additional work to your portfolio to help round out your style. Have a digital background."

GUIDED IMAGERY DESIGN & PRODUCTIONS

2995 Woodside Rd., Suite 400, Woodside CA 94062. (650)324-0323. Email:murals4u2c@aol.com. Website: www.guided-imagery.com. **Owner/Director**:Linda Hoffman. Fine art representative. Estab. 1978. Member of Hospitality Industry Association. Represents 3 illustrators, 12 fine artists. Specializes in large art production; perspective murals (trompe l'oiel); unusual paintedfurniture/screens. Markets include design firms, interior decorators, & hospitality industry. Handles Looking for " mural artists (realistic or trompe l'oeil) with good understanding of perspectives."

Terms Rep receives 33-50% commission. 100% of advertising costs paid by representative. For promotional purposes, talent must provide a direct mail piece to preview work, along with color copies of work, and SASE. Advertises in Hospitality Design, Traditional Building Magazine and Design Journal.

How to Contact For first contact, send query letter, résumé, photographs, photocopies and SASE. Response in 1 month. After initial contact, mail appropriate materials. Portfolio should include photographs.

Tips Wants artists with talent, references, and follow-through. Send color copies of original work that display your artistic style. Never send original artwork. My focus is 3D murals. Client references very helpful. Please, no cold calls.

PAT HACKETT, ARTIST REPRESENTATIVE

7014 N. Mercer Way, Mercer Island WA 98040. (206)447-1600. Fax: (206)447-0739. E-mail: pat@pathackett.com. Website: www.pathackett.com. **Contact:** Pat Hackett. Commercial illustration and photography representative. Estab. 1979. Represents 12 illustrators, 1 photographer. Markets include advertising agencies; corporations/client direct; design firms; editorial/magazines.

Handles Illustration and photography.

Terms Rep receives 25-33% commission. Advertising costs are split: 75% paid by talent; 25% paid by representative. For promotional purposes, talent must provide "standardized portfolio, i.e., all pieces within the book are the same format. Reprints are nice, but not absolutely required." Advertises in Showcase, Workbook, and on www.theispot.com and www.portfolios.com.

How to Contact For first contact, send direct mail flier/brochure. Responds in 1 week,

only if interested. After initial contact, drop off or mail in appropriate materials—tearsheets, slides, photographs, photostats, photocopies. Obtains new talent through "recommendations and calls/letters."

Tips Looks for "experience in the *commercial* art world, professional presentation in both portfolio and person, cooperative attitude and enthusiasm."

HOLLY HAHN & CO.

1806 W. Greenleaf., Chicago IL 60626. (312)371-0500. E-mail: holly@hollyhahn. com. Website: www.hollyhahn.com. Commercial illustration and photography representative. Estab. 1988.

Handles Illustration, photography.

How to Contact Send direct mail flier/brochure and tearsheets.

BARB HAUSER, ANOTHER GIRL REP

P.O. Box 421443, San Francisco CA 94142-1443. (415)647-5660. E-mail: barb@girlrep. com. Website: www.girlrep.com. Estab. 1980. Represents 8 illustrators. Markets include primarily advertising agencies and design firms; corporations/client direct.

Handles Illustration.

Terms Rep receives 25-30% commission. Exclusive representation in the San Francisco area is required.

How to Contact For first contact, "please e-mail. If you wish to send samples, please send no more than three very small JPEGs; but please note, I am not presently accepting new talent."

JOANNE HEDGE/ARTIST REPRESENTATIVE

1415 Garden St., Glendale CA 91201. (818) 244-0110. E-mail: hedgegraphics@ earthlink.com. Website: www.hedgereps.com. **Contact:** J. Hedge. Commercial illustration representative. Estab. 1975. Represents 10 illustrators. Specializes in quality painterly and realistic illustration, digital art and lettering, icons; also vintage and period styles. Markets include packaging, especially food and beverage, advertising agencies, design firms, package design firms, display companies, and interactive clients.

Handles Illustration. Seeks established artists compatible with Hedge Graphics group.

Terms Rep receives 30% commission. Handles all negotiations and billing. Artist expected to appear on hedgereps.com and link Hedge as agent in his or her own site. Advertising costs are split: 75% paid by talent; 25% paid by representative. For promotional purposes, talent should provide reprint flyers, produce a new one on Hedge template, and CDs. Advertises in Workbook and at workbook.com.

How to Contact E-mail with samples attached or website address to view your work. Responds if interested.

Tips Obtains new talent after talent sees Workbook directory ad, or through referrals from art directors or other talent. As much experience as possible and zero or one other rep.

HERMAN AGENCY

350 Central Park West, New York NY 10025. (212)749-4907. E-mail: ronnie@ hermanagencyinc.com. Website: www.HermanAgencyInc.com. **Owner/President:** Ronnie Ann Herman. Illustration representative for children's market. Estab. 1999. Member of SCBWI, Graphic Artists' Guild. Represents 33 illustrators. Artists include Seymour Chwast, Alexi Natchev, Joy Allen, and Jago.

Handles Illustration. Looking for artists with strong history of publishing in the children's market.

Terms Rep receives 25% commission. Exclusive representation required. Advertising costs are split: 75% paid by the artist; 25% paid by rep. Advertises in direct mailing.

How to Contact For first contact, send bio, photocopies, SASE, tearsheets, list of published books or email and direct me to you web site. Responds in 4 weeks. Portfolio should include b&w and color tearsheets, copies of published books.

Tips "Check our website to see if you belong with our agency."

SCOTT HULL ASSOCIATES

4 West Franklin St., Suite 200, Dayton OH 45459. (937)433-8383. Fax: (937)433-0434. E-mail: scott@scotthull.com. Website: www.scotthull.com. **Contact:** Scott Hull. Specialized illustration representative. Estab. 1981. Represents 25+ illustrators.

How to Contact Send e-mail samples or appropriate materials for review. No original art. Follow up with e-mail. Responds in one week.

Tips Looks for interesting talent with a passion to grow, as well as strong in-depth portfolio.

ICON ART REPS (A DIVISION OF MARTHA PRODUCTIONS)

7550 W. 82nd St., Playa Del Rey CA 90293. (310)670-5300. Fax: (310)670-3644. E-mail: contact@ marthaproductions.com. Website: www.iconartreps.com. **President:** Martha Spelman. Commercial illustration representative. Estab. 1998. Represents 14 illustrators. Specializes in artists doing character design and development for advertising, promotion, publishing and licensed products.

• See listing for Martha Productions in this section.

KIRCHOFF/WOHLBERG, ARTISTS REPRESENTATION DIVISION

320 E 57th St., 10B New York, NY 10022. (212)935-8068. Website: www.libbyford. com Represents over 45 illustrators. Specializes in children's trade books, young



adult and educational markets. Please send all correspondence to lford@libbyford.com. Portfolios samples should be sent electronically. Will contact you for additional materials.

CLIFF KNECHT—ARTIST REPRESENTATIVE

309 Walnut Rd., Pittsburgh PA 15202. (412)761-5666. Fax: (412)894-8175. E-mail: mail@artrep1 .com. Website: www.artrep1.com. **Contact:** Cliff Knecht. Commercial illustration representative. Estab. 1972. Represents more than 20 illustrators. Markets include advertising agencies, corporations/client direct, design firms, editorial/magazines, paper products/greeting cards, publishing/books, sales/promotion firms.

Handles Illustration.

Terms Rep receives 25% commission. No geographic restrictions. Advertising costs are split: 75% paid by the talent; 25% paid by representative. For promotional purposes, talent must provide a direct mail piece. Advertises in *Graphic Artists Guild Directory of Illustration*.

How to Contact Send résumé, direct mail flier/brochure, tearsheets, and send jpegs samples by e-mail. Responds in 1 week. After initial contact, call for appointment to show portfolio of original art, tearsheets, slides, photographs. Obtains new talent directly or through recommendations from others.

ANN KOEFFLER ARTIST REPRESENTATION

4636 Cahuenga Blvd. Suite #204, Toluca Lake CA 91602. (818)260-8980. Fax: (818)260-8990. E-mail: annartrep@aol.com. Website: www.annkoeffler.com. **Owner/Operator:** Ann Koeffler. Commercial illustration representative. Estab. 1984. Represents 15 illustrators. Markets include advertising agencies, corporations/client direct, design firms, editorial/magazines, paper products/greeting cards, publishing/books, individual small business owners.

Handles Interested in reviewing illustration. Looking for artists who are digitally adept.

Terms Rep receives 25-30% commission. Advertising costs 100% paid by talent. For promotional purposes, talent must provide an initial supply of promotional pieces and a committment to advertise regularly. Advertises in *Workbook* and *Folio Planet*.

How to Contact For first contact, send tearsheets or send images digitally. Responds in 1 week. Portfolio should include photocopies, 4 × 5 chromes.

Tips "I only carry artists who are able to communicate clearly and in an upbeat and professional manner. I am only taking on people who are substantially different from the ones I represent and have years of experience."

SHARON KURLANSKY ASSOCIATES

192 Southville Rd., Southborough MA 01772. (508)460-6058. Fax: (508)480-9221. E-mail: Sharon @laughing-stock.com. Website: www.laughing-stock.com. **Contact:** Sharon Kurlansky. Commercial illustration representative. Estab. 1978. Represents illustrators. Markets include advertising agencies; corporations/client direct; design firms; editorial/magazines; paper products/greeting cards; publishing/books; sales/promotion firms. Client list available upon request. Represents Tim Lewis, Bruce Hutchison and Blair Thornley. Licenses stock illustration for 150 illustrators at www.laughing-stock.com in all markets.

Handles Illustration.

Terms Rep receives 25% commission. Exclusive area representation is required. Advertising costs are split: 75% paid by talent; 25% paid by representative. "Will develop promotional materials with talent. Portfolio presentation formated and developed with talent also."

How to Contact For first contact, send direct mail flier/brochure, tearsheets, slides and SASE or e-mail with website address/online portfolio. Responds in 1 month if interested. After initial contact, call for appointment to show portfolio of tearsheets, photocopies.

LANGLEY CREATIVE

333 N. Michigan Ave., Suite 1322, Chicago IL 60601. (312)782-0244. Fax: (312)782-1535. E-mail: s.langley@langleycreative.com or j.blasco@langleycreative.com. Website: www.langleycreative.com. **Contact:** Sharon Langley or Jean Blasco. Commercial illustration representative. Estab. 1988. Represents 44 internationally acclaimed illustrators. Markets include advertising agencies; corporations; design firms; editorial/magazines; publishing/books; promotion. Clients include "every major player in the United States."

Handles Illustration. "We are receptive to reviewing samples by enthusiastic up-and-coming artists. E-mail samples and/or your website address."

Terms Rep receives 25% commission. Exclusive area representation is preferred. For promotional purposes, talent must provide printed promotional pieces and a well organized, creative portfolio. "If your book is not ready to show, be willing to invest in a new one." Advertises in *Workbook*. Directory of Illustration, Folio Planet, Theispot.

How to Contact For first contact, send samples via e-mail, or printed materials that do not have to be returned. Responds only if interested. Obtains new talent through recommendations from art directors, referrals and submissions.

Tips "You need to be focused in your direction and style. Be willing to create new samples. Be a 'team player.' The agent and artist form a bond, and the goal is success. Don't let your ego get in the way. Be open to constructive criticism. If one agent turns you down quickly move to the next name on your list."

MAGNET REPS

(310)733-1234. E-mail: art@magnetreps.com. Website: www.magnetreps.com. **Director:** Paolo Rizzi. Commercial illustration representative. Estab. 1998. Represents 16 illustrators. Markets include advertising agencies, corporations/client direct, design firms, editorial/magazines, movie studios, paper products/greeting cards, publishing/books, record companies, character development. Represents Red Nose Studio and Shawn Barber.

Handles Illustration. "Looking for artists with the passion to illustrate every day, an awareness of cultural trends in the world we live in, and a basic understanding of the business of illustration."

Terms Exclusive representation required. Advertising costs are split. For promotional purposes, talent must provide a well-developed, consistent portfolio. Advertises in *Workbook* and others.

How to Contact Submit a Web link to portfolio, or 2 sample low-res JPEGs for review via e-mail only. Responds in 1 month. "We do not return unsolicited submissions." Will contact artist via e-mail if interested. Portfolio should include color printouts, good quality.

Tips "Be realistic about how your style matches our agency. We do not represent scientific, technical, medical, sci-fi, fantasy, military, hyper-realistic, story boarding, landscape, pin-up, cartoon or cutesy styles. We do not represent graphic designers. We will not represent artists that imitate the style of one of our existing artists."

MARLENA AGENCY

322 Ewing St., Princeton NJ 08540. (609)252-9405. Fax: (609)252-1949. E-mail: marlena@marlena agency.com. Website: www.marlenaagency.com. Commercial illustration representative. Estab. 1990. Represents approx. 30 illustrators from France, Poland, Germany, Hungary, Italy, Spain, Canada and U.S. "We speak English, French, Spanish and Polish." Specializes in conceptual illustration. Markets include advertising agencies, corporations/client direct, design firms, editorial/magazines, publishing/ books, theaters.

Handles Illustration, fine art and prints.

Terms Rep receives 30% commission; 35% if translation needed. Costs are shared by all artists. Exclusive area representation is required. Advertising costs are split: 70% paid by talent; 30% paid by representative. For promotional purposes, talent must provide a-mailed and direct mail pieces, 3-4 portfolios. Advertises in *Workbook*. Many of the artists are regularly featured in *CA* Annuals, The Society of Illustrators Annuals, and American Illustration Annuals. Agency produces promotional materials for artists, such as wrapping paper, calendars, and brochures.

How to Contact Send tearsheets or e-mail low-resolution images. Responds in 1 week, only if interested. After initial contact, drop off or mail appropriate materials. Portfolio should include tearsheets.

Tips Wants artists with "talent, good concepts-intelligent illustration, promptness in keeping up with projects, deadlines, etc."

MARTHA PRODUCTIONS, INC.

7550 W. 82nd St., Playa Del Rey CA 90293. (310)670-5300. Fax: (310)670-3644. E-mail: contact@ marthaproductions.com. Website: www.marthaproductions. com. **President:** Martha Spelman. Commercial illustration representative. Estab. 1978. Represents 45 illustrators. Also licenses the work of illustrators. Specializes in illustration in various styles and media. Markets include advertising agencies; corporations/client direct; design firms; developers; editorial/magazines; paper products/greeting cards; publishing/books; record companies; sales/promotion firms.

• See also listings for ArtInForms, Icon Art Reps and Retro Reps in this section.

Handles Illustration.

Terms Rep receives 30% commission. Advertising costs are split: 70% paid by talent; 30% paid by representative. For promotional purposes, talent must be on our website. Advertises in *Workbook*.

How to Contact For first contact, e-mail a few small JPEG files. Responds only if interested. Portfolio shold include b&w and color samples. Obtains new talent through recommendations and solictation.

Tips "An artist seeking representation should have a strong portfolio with pieces relevant to advertising, corporate collateral or publishing markets. Check the rep's website or ads to see the other talent they represent to determine whether the artist could be an asset to that rep's group or if there may be a conflict. Reps are looking for new artists who already have a portfolio of salable pieces, a willingness to invest advertising of their own work and experience working in commercial art."

MB ARTISTS

(Previously known as HK Portfolio), 10 E. 29th St., Suite 40G, New York NY 10016. (212)689-7830. Fax: (212)689-7829. E-mail: mela@mbartists.com. Website: www. mbartists.com. **Contact**: Mela Bolinao. Juvenile illustration representative. Estab. 1986. Member of SPAR, Society of Illustrators and SCBWI. Represents over 45 illustrators. Specializes in illustration for juvenile markets. Markets include advertising agencies; editorial/magazines; publishing/books; toys/games.

Handles Illustration.

Terms Exclusive representation required. Rep receives 25% commission. No geographic restrictions. Advertising costs are split: 75% paid by talent; 25% paid by representative. Advertises in Picture Book, Directory of Illustration, Play Directory, Workbook, folioplanet.com, and theIspot.com.

How to Contact E-mail query letter with website address or send portfolio with flier/

brochure, tear sheets, published books if available, and SASE. Responds in 1 week. Portfolio should include at least 10-15 images exhibiting a consistent style.

Tips Leans toward "highly individual personal styles."

MORGAN GAYNIN INC.

194 Third Ave., New York NY 10003. (212)475-0440. Fax: (212)353-8538. E-mail: submissions@ morgangaynin.com. Website: www.morgangaynin.com. **Partners:** Vicki Morgan and Gail Gaynin. Illustration representatives. Estab. 1974. Markets include advertising agencies; corporations/client direct; design firms; magazines; books; sales/promotion firms.

Handles Illustration.

Terms Rep receives 30% commission. Exclusive area representation is required. No geographic restrictions. Advertising costs are split: 70% paid by talent; 30% paid by representative. Advertises in directories, on the Web, direct mail.

How to Contact Follow submission guidelines on website.

THE NEWBORN GROUP, INC.

115 W. 23rd St., Suite 43A, New York NY 10011. (212)989-4600. Fax: (212)989-8998. Website: www.newborngroup.com. **Owner:** Joan Sigman. Commercial illustration representative. Estab. 1964. Member of Society of Illustrators; Graphic Artists Guild. Represents 12 illustrators. Markets include advertising agencies, design firms, editorial/magazines, publishing/books. Clients include Leo Burnett, Penguin Putnam, Time Inc., Weschler Inc.

Handles Illustration.

Terms Rep receives 30% commission. Exclusive area representation is required. Advertising costs are split: 70% paid by talent; 30% paid by representative. Advertises in *Workbook* and *Directory of Illustration*.

How to Contact "Not reviewing new talent."

Tips Obtains new talent through recommendations from other talent or art directors.

PAINTED WORDS

310 W. 97th St. #24, New York NY 10025. E-mail: lori@painted-words.com. Website: www.painted-words.com. Estab. 1993. Represents 40 illustrators. Markets include advertising agencies; design firms; editorial/magazines; publishing/books; children's publishing.

Handles Illustration and author/illustrators.

Terms Rep receives 20-35% commission. Cost for direct mail promotional pieces is paid by illustrator. Exclusive area representation is required. Advertising costs are split: 75% paid by talent; 25% paid by representative.

How to Contact For first contact, send non-returnable tearsheets, or e-mail a link to your website. Samples are not returned. "Do not phone, do not e-mail attachments; will contact if interested."

Tips Wants artists with consistent style. "We are aspiring to build a larger children's publishing division and specifically looking for author/illustrators for children's publishing."

CHRISTINE PRAPAS/ARTIST REPRESENTATIVE

8402 SW Woods Creek Court, Portland OR 97219. E-mail: christine@christineprapas. com. Website: www.christineprapas.com. **Contact:** Christine Prapas. Commercial illustration and photography representative. Estab. 1978. Member of AIGA and Graphic Artists Guild. "Promotional material welcome."

GERALD & CULLEN RAPP—ARTIST REPRESENTATIVES

420 Lexington Ave., Penthouse, New York NY 10170. (212)889-3337. Fax: (212)889-3341. E-mail: info@rappart.com. Website: www.rappart.com. Commercial illustration representative. Estab. 1944. Member of The Society of Illustrators and Graphic Artists Guild. Represents 60 illustrators. Markets include advertising agencies, corporations/client direct, design firms, editorial/magazines, paper products/greeting cards, publishing/books, sales/promotion firms.

Handles Illustration.

Terms Exclusive area representation is required. No geographic restrictions. Split of advertising costs is negotiated. Advertises in Workbook, The Graphic Artists Guild Directory of Illustration and CA and PRINT magazines. Conducts active direct mail program and advertises on the Internet.

How to Contact Send e-mail with a website link. Responds within 1 week if interested. Obtains new talent through recommendations from others, solicitations.

REMEN-WILLIS DESIGN GROUP

2964 Colton Rd., Pebble Beach CA 93953. (831)655-1407. Fax: (831)655-1408. E-mail: remenwillis@comcast.net. Website: www.annremenwillis.com. **Art Rep:** Ann Remen-Willis. Children's book illustration representative. Estab. 1984. Member of SCBWI. Represents 15 illustrators. Specializes in children's books trade and text. Markets include design firms, editorial/magazines, paper products/greeting cards, publishing/books.

Handles Illustration—children's books only; no advertising.

Terms Rep receives 25% commission. Advertising costs are split: 50% paid by artist; 50% paid by rep. Advertises in *Picturebook* and postcard mailings.

How to Contact For first contact, send query letter with tearsheets. Responds in one week. After initial contact, call to schedule an appointment. Portfolio should include

b&w and color tearsheets.

Tips "Fill portfolio with samples of art you want to continue receiving as commissions. Do not include that which is not a true representation of your style and capability."

RETRO REPS (A DIVISION OF MARTHA PRODUCTIONS)

7550 W. 82nd St., Playa Del Rey CA 90293. (310)670-5300. Fax: (310)670-3644. E-mail: contact@ marthaproductions.com. Website: www.retroreps.com. **President:** Martha Spelman. Commercial illustration representative. Estab. 1998. Represents 22 illustrators. Specializes in artists working in vintage or retro styles from the 1920s through 1970s.

- See listing for Martha Productions in this section.

LILLA ROGERS STUDIO

E-mail: info@lillarogers.com. Website: www.lillarogers.com. **Agents:** Lilla Rogers, Ashley Lorenz, Susan McCabe. Commercial illustration representatives. Estab. 1984. Represents 30 illustrators. Markets include advertising agencies, corporations/client direct, design firms, editorial/magazines, paper products, publishing/books, prints and posters, sales/promotion firms, children's books, surface design. Artists include Lisa DeJhon, Matte Stephens, Carolyn Gavin, Bonnie Dain, Susy Pllgrim Waters.

- Lilla provides mentoring and frequent events for the artists, including classes and guest art director lunches.

Handles Illustration.

Terms Rep receives 35% commission. Exclusive representation required. Promotions include *PRINT Magazine*, Design*Sponge blog, SURTEX NYC trade show, Printsource NYC trade show and other events; also runs extensive direct mail & e-mail newsletter campaigns.

How to Contact For first contact, e-mail 3-5 JPEGs or a link to your web site. Responds only if interested.

Tips "It's good to check out the agency's website to see if you feel like it's a good fit. Explain in your e-mail why you want an agent and why you think we are a good match. No phone calls, please."

ROSENTHAL REPRESENTS

3850 Eddingham Ave., Calabasas CA 91302. (818)222-5445. Fax: (818)222-5650. E-mail: elise@ rosenthalrepresents.com. Website: www.rosenthalrepresents.com. **Contact**: Elise Rosenthal or Neil Sandler, neilsandler72@hotmail.com. Primarily licensing agents. Estab. 1979. Prevously Members, Society of Illustrators, Graphic Artists Guild. Presently members of Women in Design and LIMA, a licensing organization. Rosenthal. Represents 25 artists and designers geared for creating products, such as dinnerware, rugs, placemats, rugs, cutting boards, coasters,

kitchen and bath textiles, bedding, wall hangings, children's and baby products, stationary, and more. Specializes in licensing, merchandising art. Markets include manufacturers of tabletop products, rugs, kitchen and bath textiles, paper products/ greeting cards, and more.

Handles product designers and artists. Must know adobe photoshop and other computer programs to help artist adapt art into product mockups.

Terms Rep receives 50% as a licensing agent. Exclusive licensing representation is required. No geographic restrictions. Artist contributes $800 once a year to exhibit with RR at our two all important trade shows, Surtex and Licensing Shows. For promotional purposes, talent must provide CD of artwork designs and website link if available. We advertise in Total Art Licensing. Only contact us if you have done product design and if you are willing to work hard, give the agent lots of new work all the time. Must be willing to accept critiques and are willing to make corrections.

How to Contact Send email, and computer link, or direct mail flier/brochure, tearsheets, photocopies, and SASE. Responds in 1 week. After initial contact, call for appointment to show portfolio of tearsheets, photographs, photocopies. Obtains new talent through seeing their work in trade shows, in magazines and through referrels.

THE SCHUNA GROUP

1503 Briarknoll Dr., Arden Hills MN 55112. (651)631-8480. E-mail: joanne@ schunagroup.com. Website: www.schunagroup.com. **Contact:** JoAnne Schuna. Commercial illustration representative. Represents 15 illustrators. Specializes in illustration. Markets include advertising agencies, corporations/client direct, design firms, editorial/magazines, paper products/greeting cards, publishing/books, sales/ promotion firms.

Terms Rep receives 25% commission. Exclusive representation required. Advertising costs are split: 75% paid by artist; 25% paid by rep. Advertises in various mediums.

How to Contact For first contact, send 2-3 digital samples via e-mail or link to your web site. Will respond via e-mail within a few weeks if interested."

Tips "Listing your website in your e-mail is helpful, so I can see more if interested."

THOSE 3 REPS

501 2nd Ave., Suite A-600, Dallas TX 75226. (214)871-1316. Fax: (214)880-0337. E-mail: moreinfo @those3reps.com. Website: www.those3reps.com. **Contact:** Debbie Bozeman, Carol Considine. Artist representative. Estab. 1989. Member of Dallas Society of Visual Community, ASMP, SPAR and Dallas Society of Illustrators. Represents 15 illustrators, 8 photographers. Specializes in commercial art. Markets include advertising agencies; corporations/client direct; design firms; editorial/ magazines.

Handles Illustration, photography (including digital).

Terms Rep receives 30% commission; 30% for out-of-town jobs. Exclusive area representation is required. Advertising costs are split 70% paid by talent; 30% paid by representative. For promotional purposes, talent must provide 2 new pieces every 2 months, national advertising in sourcebooks and at least 1 mailer. Advertises in *Workbook*, own book.

How to Contact For first contact, send query letter and tearsheets. Responds in days or weeks only if interested. After initial contact, call to schedule an appointment, drop off or mail in appropriate materials. Portfolio should include tearsheets, photostats, transparencies, digital prints.

Tips Wants artists with "strong unique consistent style."

THREE IN A BOX INC.

67 Mowat Ave Suite 236 Toronto, ON Canada M6K 3E3. (416)367-2446. Fax: (416)367-3362. E-mail: info@threeinabox.com. Website: www.threeinabox.com. **Managing Director:** Holly Venable. Commercial illustration representative. Estab. 1990. Member of Graphic Artists Guild. Represents 53 illustrators, 2 photographers. Specializes in illustration. Licenses illustrators and photographers. Markets include advertising agencies, corporations/client direct, design firms, editorial/magazines, paper products/greeting cards, publishing/books, record companies, sales/promotion firms.

How to Contact For first contact, send query letter and URL to info@threeinabox.com. Responds in 1 week. After initial contact, rep will call if interested. Send only links to website.

CHRISTINA A. TUGEAU: ARTIST AGENT

3009 Margaret Jones Lane, Williamsburg VA 23185. E-mail: chris@catugeau.com. Website: www.catugeau.com. **Owner:** Chris Tugeau. Children's publishing market illustration representative (K-12). Estab. 1994. Member of SCBWI. Represents 35 illustrators. Specializes in children's book publishing and educational market and related areas. Represents Stacey Schuett, Larry Day, Melissa Iwai, Keiko Motoyama, Jason Wolff, Jeremy Tugeau, Priscilla Burris, John Kanzler, Martha Aviles, Ana Ochoa and Daniel J. Mahoney.

Handles Illustration. Must be proficient at illustrating children and animals in a variety of interactive situations, backgrounds, full color/b&w, and with a strong narrative sense.

Terms Rep receives 25% commission. Exclusive USA representation is required. For promotional purposes, talent must provide direct mail promo(s), 8-10 good "back up" samples (multiples), 3 strong portfolio pieces.

How to Contact For first contact, e-mail a few JPEG samples or send direct mail flier/brochure, tearsheets, photocopies, books, SASE, "No slides! No originals." Responds within 2 weeks.

Tips "You should have a style uniquely and comfortably your own. Be a cooperative team player and be great with deadlines. Will consider young, new artists to the market with great potential and desire, and of course published, more experienced illustrators. Best to study and learn the market standards and expectations by representing yourself for a while when new to the market."

GWEN WALTERS

1801 S. Flagler Dr. #1202, West Palm Beach FL 33401. (561)805-7739. Fax: (561)805-9731. E-mail: artincgw@aol.com. Website: www.gwenwaltersartrep.com. Commercial illustration representative. Estab. 1976. Represents 60 + illustrators. Markets include advertising agencies; corporations/client direct; editorial/magazines; paper products/greeting cards; publishing/books; sales/promotion firms. "I lean more toward book publishing." Represents Gerardo Suzan, Rosario Valderrama, Lane Gregory, Susan Spellman, Judith Pfeiffer, Yvonne Gilbert, Gary Torrisi, Larry Johnson, Pat Paris, Scott Wakefield, Tom Barrett, Linda Pierce and many more.
Handles Illustration.
Terms Rep receives 30% commission. Charges for color photocopies. For promotional purposes, talent must provide direct mail pieces.
How to Contact For first contact, send résumé, bio, direct mail flier/brochure. After initial contact, representative will call. Portfolio should include "as much as possible."
Tips "You need to pound the pavement for a couple of years to get some experience under your belt. Don't forget to sign all artwork. So many artists forget to stamp their samples."

THE WILEY GROUP

1535 Green St., Suite #301, San Francisco CA 94123. (415)441-3055. Fax: (415)520-0999. E-mail: info@thewileygroup.com. Website: www.thewileygroup.com. **Owner:** David Wiley. Commercial artist and fine art illustration and photography representative. Estab. in 1984 as an artist agency that promotes and sells the work of illustrators for commercial use worldwide. He has over 24 years of experience in the industry, and an extensive knowledge about the usage, pricing and marketing of commercial art. Currently, David represents 13 illustrators. The artist's work is all digital. The artist agency services accounts in advertising, design and publishing as well as corporate accounts. **Partial client list:** Disney, Coca Cola, Smithsonian, Microsoft, Nike, Oracle, Google, Random house, Eli Lilly Pharmaceuticals, National Geographic, Kraft Foods, FedEx, Nestle Corp., Apple Computers.
Terms Rep receives 25% commission with a bonus structure. No geographical restriction. Artist is responsible for all portfolio costs. Artist pays 75% of sourcebook ads, postcard/tearsheet mailings. Agent will reimburse artist for 25% of costs. Each

year the artists are promoted using online agencies, bimonthly postcard mailings, and monthly e-cards (e-mail postcards).

How to Contact For first contact, e-mail website URL and one visual image representing your style. If interested, agent will e-mail or call back to discuss representation.

Tips "The bottom line is that a good agent will get you *more* work at *better rates* of pay."

DEBORAH WOLFE LTD.

731 N. 24th St., Philadelphia PA 19130. (215)232-6666. Fax: (215)232-6585. E-mail: info@ illustrationOnLine.com. Website: www.illustrationOnLine.com. **Contact**: Deborah Wolfe. Commercial illustration representative. Estab. 1978. Represents 30 illustrators. Markets include advertising agencies, corporations/client direct, design firms, editorial/magazines, publishing/books.

Handles Illustration.

Terms Rep receives 25% commission. Advertises in *Workbook*, *Directory of Illustration*, *Picturebook* and *The Medical Sourcebook*.

How to Contact For first contact, send an e-mail with samples or a Web address. Responds in 3 weeks.

Art Fairs

How would you like to sell your art from New York to California, showcasing it to thousands of eager art collectors? Art fairs (also called art festivals or art shows) are not only a good source of income for artists but an opportunity to see how people react to their work. If you like to travel, enjoy meeting people, and can do your own matting and framing, this could be a great market for you.

Many outdoor fairs occur during the spring, summer and fall months to take advantage of warmer temperatures. However, depending on the region, temperatures could be hot and humid, and not all that pleasant! And, of course, there is always the chance of rain. Indoor art fairs held in November and December are popular because they capitalize on the holiday shopping season.

To start selling at art fairs, you will need an inventory of work—some framed, some unframed. Even if customers do not buy the framed paintings or prints, having some framed work displayed in your booth will give buyers an idea of how your work looks framed, which could spur sales of your unframed prints. The most successful art fair exhibitors try to show a range of sizes and prices for customers to choose from.

When looking at the art fairs listed in this section, first consider local shows and shows in your neighboring cities and states. Once you find a show you'd like to enter, visit its website or contact the appropriate person for a more detailed prospectus. A prospectus is an application that will offer additional information not provided in the art fair's listing.

Ideally, most of your prints should be matted and stored in protective wraps or bags so that customers can look through your inventory without damaging prints and mats. You will also need a canopy or tent to protect yourself and your wares from the elements as well as some bins in which to store the prints. A display wall will allow you to show off your best framed prints. Generally, artists will have 100 square feet of space in which to set up their tents and

canopies. Most listings will specify the dimensions of the exhibition space for each artist.

If you see the (🔽) icon before a listing in this section, it means that the art fair is a juried event. In other words, there is a selection process artists must go through to be admitted into the fair. Many art fairs have quotas for the categories of exhibitors. For example, one art fair may accept the mediums of photography, sculpture, painting, metal work and jewelry. Once each category fills with qualified exhibitors, no more will be admitted to the show that year. The jurying process also ensures that the artists who sell their work at the fair meet the sponsor's criteria for quality. So, overall, a juried art fair is good for artists because it means they will be exhibiting their work along with other artists of equal caliber.

Be aware there are fees associated with entering art fairs. Most fairs have an application fee or a space fee, or sometimes both. The space fee is essentially a rental fee for the space your booth will occupy for the art fair's duration. These fees can vary greatly from show to show, so be sure to check this information in each listing before you apply to any art fair.

Most art fair sponsors want to exhibit only work that is handmade by the artist, no matter what medium. Unfortunately, some people try to sell work that they purchased elsewhere as their own original artwork. In the art fair trade, this is known as "buy/sell." It is an undesirable situation because it tends to bring down the quality of the whole show. Some listings will make a point to say "no buy/sell" or "no manufactured work."

For more information on art fairs, pick up a copy of *Sunshine Artist* or *Art Calendar*, and consult online sources such as www.artfairsource.com, www.artcalendar.com and www.festival.net.

⚑ 49TH ARTS EXPERIENCE

P.O. Box 1326, Palatine IL 60078. (847)991-4748 or (312)751-2500. E-mail: asoa@ webtv.net. Website: www.americansocietyofartists.org. Estab. 1979. Fine arts & crafts show held in summer. Outdoors. Accepts photography, paintings, graphics, sculpture, quilting, woodworking, fiber art, hand-crafted candles, glass works, jewelry, etc. Juried by 4 slides/photo representative of work being exhibited; 1 photo of display set-up, #10 SASE, résumé with 7 show listings helpful. Number of exhibitors: 50. Free to public. Artists should apply by submitting jury material and indicate you are interested in this particular show. If you wish to jury online please see our website and follow directions given there. When you pass the jury, you will receive jury approval number and application you requested. Deadline for entry: 2 months prior to show or earlier if space is filled. Space fee: to be announced. Exhibition space: 100 sq. ft. for single space; other sizes are available. For more information, artists should send SASE to submit jury material.

• Event held in Chicago, Illinois.

Tips "Remember that at work in your studio, you are an artist. When you are at a show, you are a business person selling your work."

⚑ AFFAIRE IN THE GARDENS ART SHOW

Greystone Park, 501 Doheny Rd., Beverly Hills CA 90210-2921. (310)550-4796. Fax: (310)858-9238. E-mail: kmclean@beverlyhills.org. Website: www.beverlyhills.org. **Contact:** Karen Fitch McLean, art show coordinator. Estab. 1973. Fine arts & crafts show held biannulay 3rd weekend in May and 3rd weekend in October. Outdoors. Accepts photography, painting, sculpture, ceramics, jewelry, digital media. Juried. Awards/prizes: 1st Place in category, cash awards, Best in Show cash award; Mayor's Purchase Award in October show. Number of exhibitors: 225. Public attendance: 30,000-40,000. Free to public. Deadline for entry: end of February, May show; end of July, October show. Application fee: $30. Space fee: $300. Exhibition space: 10 × 12 ft. For more information, artists should e-mail, visit website, call or send SASE.

Tips "Art fairs tend to be commercially oriented. It usually pays off to think in somewhat commercial terms—what does the public usually buy? Personally, I like risky and unusual art, but the artists who produce esoteric art sometimes go hungry! Be nice and have a clean presentation."

⚑ AKRON ARTS EXPO

1615 W. Market St., Akron OH 44313. (330)375-2836. Fax: (330)375-2883. E-mail: readni@ci.akron.oh.us. Website: www.akronartsexpo.org. **Contact:** Nicole Read, community event planner. Estab. 1979. Fine art & craft show held annually in July. Outdoors. Accepts photography, 3D, 2D art, functional craft, ornamental. Juried by "5 jurors from the art community brought in to select the artists." See website for

application information. Awards/prizes: $1,600 in cash awards and ribbons. Number of exhibitors: 165. Public attendance: 30,000. Free to public. Deadline for entry: March 31. Space fee: $180. Exhibition space: 10 × 10 ft. For more information, artists should e-mail, call, or visit website.

Tips "Make sure you send in slides that are in good condition and show your work properly. If you wish to send a sample, this is helpful as well. Make sure you fill out the application correctly."

☙ ALLENTOWN ART FESTIVAL

P.O. Box 1566, Ellicott Station, Buffalo NY 14205-1566. (716)881-4269. E-mail: Allentown artfestival@verizon.net. Website: www.allentownartfestival.com. **Contact:** Mary Myszkiewicz, president. Estab. 1958. Fine arts & crafts show held annually 2nd full weekend in June. Outdoors. Accepts photography, painting, watercolor, drawing, graphics, sculpture, mixed media, clay, glass, acrylic, jewelry, creative craft (hard/soft). Slides juried by hired professionals that change yearly. Awards/prizes: $17,925 in 40 cash prizes; Best of Show. Number of exhibitors: 450. Public attendance: 300,000. Free to public. Artists should apply by downloading application from website. Deadline for entry: January 31. Application fee: $15. Space fee: $250. Exhibition space: 13 × 10 ft. For more information, artists should e-mail, visit website, call or send SASE.

Tips "Artists must have attractive booth and interact with the public."

☙ AMISH ACRES ARTS & CRAFTS FESTIVAL

1600 W Market St., Nappanee IN 46550. (574)773-4188. Fax: (574)773-4180. E-mail: amishacres@amishacres.com. Website: www.amishacres.com. **Contact:** Jenni Wysong, marketplace coordinator. Estab. 1962. Arts & crafts show held annually first weekend in August. Outdoors. Accepts photography, crafts, floral, folk, jewelry, oil, acrylic, sculpture, textiles, watercolors, wearable, wood. Juried by 5 images, either 35mm slides or digital images e-mailed. Awards/prizes: $10,000 cash including Best of Show and $1,500 Purchase Prizes. Number of exhibitors: 350. Public attendance: 60,000. Public admission: $6; children under 12 free. Artists should apply by sending SASE or printing application from website. Deadline for entry: April 1. Space fee: 10 × 10 ft. $475; 15 × 12 ft. $675; 20 × 12 ft. $1,095; 30 × 12 ft. $1,595. Exhibition space: from 120-300 sq. ft. Average gross sales/exhibitor: $7,000. For more information, artists should e-mail, visit website, call or send SASE.

Tips "Create a vibrant, open display that beckons to passing customers. Interact with potential buyers. Sell the romance of the purchase."

☙ ANACORTES ARTS FESTIVAL

505 O Ave., Anacortes WA 98221. (360)293-6211. Fax: 360-299-0722. E-mail: info@

anacortes artsfestival.com. Website: www.anacortesartsfestival.com. **Contact:** Mary Leone. Fine arts & crafts show held annually 1st full weekend in August. Accepts photography, painting, drawings, prints, ceramics, fiber art, paper art, glass, jewelry, sculpture, yard art, woodworking. Juried by projecting 3 images on a large screen. Works are evaluated on originality, quality and marketability. Each applicant must provide 3 high-quality digital images or slides—2 of the product and 1 of the booth display. Awards/prizes: over $4,000 in prizes. Number of exhibitors: 250. Artists should apply by visiting website for online submission or by mail (there is a $25 processing fee for application by mail). Deadline for entry: early March. Booth fee: $300. For more information, artists should see website.

ANN ARBOR'S SOUTH UNIVERSITY ART FAIR

P.O. Box 4525, Ann Arbor MI 48106. (734)663-5300. Fax: (734)663-5303. Website: www.a2 southu.com. **Contact:** Maggie Ladd, director. Estab. 1960. Fine arts & crafts show held annually 3rd Wednesday through Saturday in July. Outdoors. Accepts photography, clay, drawing, digital, fiber, jewelry, metal, painting, sculpture, wood. Juried. Awards/prizes: $3,000. Number of exhibitors: 190. Public attendance: 750,000. Free to public. Deadline for entry: January. Application fee: $25. Space fee: $700-1500. Exhibition space: 10 × 10 to 20 × 10 ft. Average gross sales/exhibitor: $7,000. For more information artists should e-mail, visit website or call.

Tips "Research the market, use a mailing list, advertise in *Art Fair Guide* (150,000 circulation).

⚡ ANN ARBOR STREET ART FAIR

P.O. Box 1352, Ann Arbor MI 48106. (734)994-5260. Fax: (734)994-0504. E-mail: production@artfair.org. Website: www.artfair.org. **Contact:** Jeannie Uh, production coordinator. Estab. 1958. Fine arts & crafts show held annually 3rd Saturday in July. Outdoors. Accepts photography, fiber, glass, digital art, jewelry, metals, 2D and 3D mixed media, sculpture, clay, painting, drawing, printmaking, pastels, wood. Juried based on originality, creativity, technique, craftsmanship and production. Awards/prizes: cash prizes for outstanding work in any media. Number of exhibitors: 175. Public attendance: 500,000. Free to the public. Artists should apply through www.zapplication.org. Deadline for entry: January. Application fee: $30. Space fee: $595. Exhibition space: 10 × 20 ft. or 10 × 12 ft. Average gross sales/exhibitor: $7,000. For more information, artists should e-mail, visit website, call.

⚡ ANNUAL ALTON ARTS & CRAFTS EXPRESSIONS

P.O. Box 1326, Palatine IL 60078. (847)991-4748 or (312)751-2500. E-mail: asoa@webtv.net. Website: www.americansocietyofartists.org. **Contact:** American Society of Artists—"anyone in the office can help." Estab. 1979. Fine arts & crafts show

held annually indoors in spring and fall, usually March and September. Outdoors. Accepts quilting, fabric crafts, artwear, photography, sculpture, jewelry, glass works, woodworking and more. Juried by 4 slides or photos of your work and 1 slide or photo of your display; SASE (No. 10); a resume or show listing is helpful. "See our website for online jury information." Number of exhibitors: 50. Free to the public. Artists should apply by submitting jury materials. If you want to jury via internet see our website and follow directions given there. If juried in, you will receive a jury/approval number. Deadline for entry: 2 months prior to show or earlier if spaces fill. Space fee: $125. Exhibition space: approximately 100 sq. ft for single space; other sizes available. For more information, artists should send SASE, submit jury material.

• Event held in Alton, Illinois.

Tips "Remember that when you are at work in your studio, you are an artist. But when you are at a show, you are a business person selling your work."

☑ ANNUAL ARTS & CRAFTS ADVENTURE

P.O. Box 1326, Palatine IL 60078. (847)991-4748 or (312)751-2500. E-mail: asoa@webtv.net. Website: www.americansocietyofartists.org. **Contact:** American Society of Artists—"anyone in the office can help." Estab. 1991. Fine arts & crafts show held annually in early May and mid-September. Outdoors. Accepts photography, pottery, paintings, sculpture, glass, wood, woodcarving. Juried by 4 slides or photos of work and 1 slide or photo of display; SASE (No. 10); a résumé or show listing is helpful. See our website for on-line jury. Number of exhibitors: 75. Free to the public. Artists should apply by submitting jury materials. If juried in, you will receive a jury/approval number. Deadline for entry: 2 months prior to show or earlier if spaces fill. Space fee: $80. Exhibition space: approximately 100 sq. ft. for single space; other sizes available. For more information, artists should send SASE, submit jury material.

• Event held in Park Ridge, Illinois.

Tips "Remember that when you are at work in your studio, you are an artist. But when you are at a show, you are a business person selling your work."

☑ ANNUAL ARTS & CRAFTS FAIR

Pend Oreille Arts Council, P.O. Box 1694, Sandpoint ID 83864. (208)263-6139. E-mail: art@sandpoint.net. Website: www.ArtinSandpoint.org. Estab. 1962. Arts & crafts show held annually in August. Outdoors. Accepts photography and all handmade, noncommercial works. Juried by 8-member jury. Number of exhibitors: 100. Public attendance: 5,000. Free to public. Artists should apply by sending in application. Deadline for entry: May 1. Application fee: $15. Space fee: $150-230, no commission. Exhibition space: 10 × 10 ft. or 10 × 15 ft. For more information, artists should e-mail, visit website, call or send SASE.

◪ ANNUAL ARTS ADVENTURE

Annual Society of Artists, P.O. Box 1326, Palatine IL 60078. (847)991-4748 or (312)571-2500. E-mail: asoa@webtv.net. Website: www.americansocietyofartists.org. **Contact:** American Society of Artists—"anyone in the office can help." Estab. 2001. Fine arts & crafts show held annually the end of July. Event held in Chicago, Illinois. Outdoors. Accepts photography, paintings, pottery, sculpture, jewelry and more. Juried. Send 4 slides or photos of your work and 1 slide or photo of your display; SASE (No. 10); a resume or show listing is helpful. See our website for on-line jury. Number of exhibitors: 50. Free to the public. Artists should apply by submitting jury materials. If juried in, you will receive a jury/approval number. Deadline for entry: 2 months prior to show or earlier if spaces fill. Entry fee: $135. Exhibition space: approximately 100 sq. ft. for single space; other sizes available. For more information, artsits should send SASE, submit jury material.

- Event held in Chicago, Illinois.

Tips "Remember that when you are at work in your studio, you are an artist. But when you are at a show, you are a business person selling your work."

◪ ANNUAL EDENS ART FAIR

American Society of Artists, P.O. Box 1326, Palatine IL 60078. (847)991-4748 or (312)2500. E-mail: asoa@webtv.net. Website: www.americansocietyofartists.org. **Contact:** American Society of Artists—"anyone in the office can help." Estab. 1995 (after renovation of location; held many years prior to renovation). Fine arts & fine selected crafts show held annually in mid-July. Outdoors. Accepts photography, paintings, sculpture, glass works, jewelry. Juried. Send 4 slides or photos of your work and 1 slide or photo of your display; SASE (No. 10); a resume or show listing is helpful. Number of exhibitors: 50. Free to the public. Artists should apply by submitting jury materials. If you wish to jury online please see our website and follow directions given there. If juried in, you will receive a jury/approval number. Deadline for entry: 2 months prior to show or earlier if spaces fill. Entry fee: $145. Exhibition space: approximately 100 sq. ft. for single space; other sizes available. For more information, artists should send SASE, submit jury material.

- Event held in Willamette, Illinois.

Tips "Remember that when you are at work in your studio, you are an artist. But when you are at a show, you are a business person selling your work."

◪ ANNUAL HYDE PARK ARTS & CRAFTS ADVENTURE

American Society of Artists, P.O. Box 1326, Palatine IL 60078. (847)991-4748 or (312)751-2500. E-mail: asoa@webtv.net. Website: www.americansocietyofartists.org. **Contact:** American Society of Artists—"anyone in the office can help." Estab. 2006. Arts & crafts show held twice a year in late September. Outdoors. Accepts photography,

paintings, glass, wood, fiber arts, hand-crafted candles, quilts, sculpture and more. Juried by 4 slides or photos of work and 1 slide or photo of display; SASE (No. 10); a résumé or show listing is helpful. Number of exhibitors: 50. Free to the public. Artists should apply by submitting jury materials. If juried in, you will receive a jury/approval number. See website for jurying on-line. Deadline for entry: 2 months prior to show or earlier if spaces fill. Entry fee: $155. Exhibition space: approximately 100 sq. ft. for single space; other sizes are available. For more information, artists should send SASE, submit jury material.

• Event held in Chicago, Illinois.

Tips "Remember that when you are at work in your studio, you are an artist. But when you are at a show, you are a business person selling your work."

◪ ANNUAL OAK PARK AVENUE-LAKE ARTS & CRAFTS SHOW

American Society of Artists, P.O. Box 1326, Palatine IL 60078. (847)991-4748 or (312)751-2500. E-mail: asoa@webtv.net. Website: www.americansocietyofartists. org. **Contact:** American Society of Artists—"anyone in the office can help." Estab. 1974. Fine arts & crafts show held annually in mid-August. Outdoors. Accepts photography, paintings, graphics, sculpture, glass, wood, paper, fiber arts, mosaics and more. Juried by 4 slides or photos of work and 1 slide or photo of display; SASE (No. 10); a resume or show listing is helpful. Number of exhibitors: 150. Free to the public. Artists should apply by submitting jury materials. If you want to jury online please see our website and follow directions given there. If juried in, you will receive a jury/approval number. Deadline for entry: 2 months prior to show or earlier if spaces fill. Entry fee: $170. Exhibition space: approximately 100 sq. ft. for single space; other sizes available. For more information, artists should send SASE, submit jury material.

• Event held in Oak Park, Illinois.

Tips "Remember that when you are at work in your studio, you are an artist. But when you are at a show, you are a business person selling your work."

◪ ANNUAL VOLVO MAYFAIRE-BY-THE-LAKE

Polk Museum of Art, 800 E. Palmetto St., Lakeland FL 33801. (863)688-7743, ext. 237. Fax: (863)688-2611. E-mail: info@polkmuseumofart.org; Mayfaire@PolkMuseumofArt. org. Website: www.PolkMuseumOfArt.org. Estab. 1971. Fine arts & crafts show held annually in May on Mother's Day weekend. Outdoors. Accepts photography, oil, acrylic, watercolor, drawing & graphics, sculpture, clay, jewelry, glass, wood, fiber, mixed media. Juried by a panel of jurors who will rank the artist's body of work based on 3 slides of works and 1 slide of booth setup. Awards/prizes: 2 Best of Show, 3 Awards of Excellence, 8 Merit awards, 10 Honorable Mentions, Museum Purchase Awards, Collectors Club Purchase Awards, which equal over $25,000. Number of

exhibitors: 185. Public attendance: 65,000. Free to public. Artists should download application from website to apply. Deadline for entry: March 1. Application fee: $25. Space fee: $145. Exhibition space: 10 × 10 ft. For more information, artists should visit website or call.

◩ ART & JAZZ ON BROADWAY

P.O. Box 583, Philipsburg MT 59858. **Contact:** Sherry Armstrong at hitchinpost@blackfoot.net or (406)859-0366, or Connie Donlan at coppersok2@aol.com or (406)859-0165. Estab. 2000. Fine arts/jazz show held annually in August. Outdoors. Accepts photography and handcrafted, original, gallery-quality fine arts and crafts made by selling artist. Juried by Flint Creek Valley Arts Council. Number of exhibitors: 75. Public attendance: 1,500-2,000. Admission fee: donation to Flint Creek Valley Arts Council. Artists should visit www.artinphilipsburg.com, e-mail, or call for more information. Application fee: $55. Exhibtion space: 10 × 10 ft. For more information, artists should e-mail or call for more information.

Tips "Be prepared for temperatures of 100 degrees or rain. Display in a professional manner. Friendliness is crucial; fair pricing is essential."

◩ ART IN THE HEART OF THE CITY

171 E. State St., PMB #136, Ithaca NY 14850. (607)277-8679. Fax: (607)277-8691. E-mail: idp@downtownithaca.com. Website: www.downtownithaca.com. **Contact:** Phil White, office manager/event coordinator. Estab. 1999. Sculpture exhibition held annually in early June. Primarily outdoors; limited indoor pieces. Accepts photography, wood, ceramic, metal, stone. Juried by Public Arts Commission. Number of exhibitors: 28-35. Public attendance: 100,000 +. Free to public. Artists should apply by submitting application, artist statement, slides/photos. Deadline for entry: May. Exhibition space depends on placement. For more information, artists should e-mail. This year we are having a "Green Exhibition, a pioneering step for public art across the country. We will focus on only (3) artists, and publicize their work broadly. The stipend has been increased to $1500. Per artist. We're creating a new online gallery and we're collaborating with area arts, sustainability and education groups for public programs. Art in the heart '09 is asking for you to use the 'Green" interpretation as a starting point- and, through your submissions, help us.

Tips "Be sure there is a market and interest for your work, and advertise early."

◩ ART IN THE PARK

P.O. Box 748, Sierra Vista AZ 85636-0247. (520) 803-8981. E-mail: artinthepark@msm.com. Website: www.huachuca-art.com. **Contact:** Vendor Committee. Estab. 1972. Fine arts & crafts show held annually 1st full weekend in October. Outdoors. Accepts photography, all fine arts and crafts created by vendor. Juried by 3-6 typical

customers. Artists submit 6 photos. Number of exhibitors: 240. Public attendance: 20,000. Free to public. Artists should apply by calling, e-mailing or sending SASE between February and May; application package available online at HAA website. Deadline for entry: postmarked by June 27. Application fee: $10 included in space fee. Space fee: $175, includes jury fee. Exhibition space: 15 × 35 ft. For more information, artists should e-mail, call or send SASE.

☙ ART IN THE PARK FALL FOLIAGE FESTIVAL

16 S. Main St., Rutland VT 05701. (802)775-0356. Fax: (802)773-4401. E-mail: beyondmarketing@yahoo.com. Website: www.chaffeeartcenter.org. **Contact:** Sherri Birkheimer Rooker, event coordinator. Estab. 1961. Fine arts & crafts show held annually in October. 2009 dates: October 10 and 11. Accepts photography, clay, fiber, floral, glass, art, specialty foods, wood, jewelry, handmade soaps, lampshades, baskets, etc. Juried by a panel of 10-15 judges who perform a blind review of slide submissions. Number of exhibitors: 130. Public attendance: 8,000. Public admission: voluntary donation. Artists should submit three slides of work and one of booth (photos upon pre-approval). Deadline for entry: on-going but to receive discount for doing both shows, must apply by May 31; $25 late fee after that date. Space fee: $190-$340. For more information, artists should e-mail, visit website, or call.
Tips "Have a good presentation and variety, if possible (in pricing also), to appeal to a large group of people."

☙ ART IN THE PARK

P.O. Box 1540, Thomasville GA 31799. (229)227-7020. Fax: (229)227-3320. E-mail: roseshow fest@rose.net. Website: www.downtownthomasville.com. **Contact:** Felicia Brannen, festival coordinator. Estab. 1998-1999. Arts in the park (an event of Thomasville's Rose Show and Festival) is a 1 day arts & crafts show held annually in April. Outdoors. Accepts photography, handcrafted items, oils, acrylics, woodworking, stained glass, other varieties. Juried by a selection committee. Number of exhibitors: 60. Public attendance: 2,500. Free to public. Artists should apply by application. Deadline for entry: February 1. Space fee: $75, varies by year. Exhibition space: 20 × 20 ft. For more information, artists should e-mail or call.
Tips "Most important, be friendly to the public and have an attractive booth display."

☙ ART IN THE PARK

8707 Forest Ct., Warren MI 48093. (586)795-5471. E-mail: wildart@wowway.com. Website: www.warrenfinearts.org. **Contact:** Paula Wild, chairperson. Estab. 1990. Fine arts & crafts show held annually 2nd weekend in July. Indoors and outdoors. Accepts photography, sculpture, basketry, pottery, stained glass. Juried. Awards/

prizes: 2D & 3D monetary awards. Number of exhibitors: 75. Public attendance: 7,500. Free to public. Deadline for entry: May 16. Jury fee: $20. Space fee: $100/outdoor; $150/indoor. Exhibition space: 12 × 12 ft./tent; 12 × 10 ft./atrium. For more information, artists should e-mail, visit website or send SASE.

☑ ART IN THE PARK SUMMER FESTIVAL

16 South Main St., Rutland VT 05701.802-775-0356. Fax: 802-773-4401. E-mail: beyondmarketing@yahoo.com. Website: www.chaffeartcenter.org. Sherri Birkheimer Rooker, event coordinator. Estab. 1961. Fine arts and crafts show held outdoors annually in August. 2010 dates: August 14 and 15. Accepts photography, clay, fiber, floral, glass, art, specialty foods, wood, jewelry, handmade soaps, lampshades, baskets, etc. Juried by a panel of 10-15 judges who perform a blind review of slide submissions. Number of exhibitors: 130. Public attendance: 8,000. Public admission: voluntary donation. Artists should submit three slides of work and one of booth (photos upon pre-approval). Deadline for entry: on-going but to receive discount for doing both shows, must apply by March 31; $25 late fee after that date. Space fee: $190-$340. For more information, artists should e-mail, visit website, or call.

Tips "Have a good presentation, variety if possible (in price ranges, too) to appeal to a large group of people."

☑ AN ARTS & CRAFTS AFFAIR, AUTUMN & SPRING TOURS

P.O. Box 184, Boys Town NE 68010. (402)331-2889. Fax: (402)445-9177. E-mail: hpifestivals@cox.net. Website: www.hpifestivals.com. **Contact:** Huffman Productions. Estab. 1983. An arts & crafts show that tours different cities and states. The Autumn Festival tours annually October-November; Spring Festival tours annually in April. Artists should visit website to see list of states and schedule. Indoors. Accepts photography, pottery, stained glass, jewelry, clothing, wood, baskets. All artwork must be handcrafted by the actual artist exhibiting at the show. Juried by sending in 2 photos of work and 1 of display. Awards/prizes: 4 $30 show gift certificates; $50, $100 and $150 certificates off future booth fees. Number of exhibitors: 300-500 depending on location. Public attendance: 15,000-35,000. Public admission: $7-8/adults; $6-7/seniors; 10 & under, free. Artists should apply by calling to request an application. Deadline for entry: varies for date and location. Space fee: $400-650. Exhibition space: 8 × 11 ft. up to 8 × 22 ft. For more information, artists should e-mail, visit website, call or send SASE.

Tips "Have a nice display, make sure business name is visible, dress professionally, have different price points, and be willing to talk to your customers."

☑ ART'S ALIVE

4001 Coastal Highway, Ocean City MD 21842-2247. (410)250-0125. Fax: (410)250-

5409. E-mail: Bmoore@ococean.com. Website: www.ococean.com. **Contact:** Brenda Moore, event coordinator. Estab. 2000. Fine art show held annually in mid-June. Outdoors. Accepts photography, ceramics, drawing, fiber, furniture, glass, printmaking, jewelry, mixed media, painting, sculpture, fine wood. Juried. Awards/prizes: $5,000 in cash prizes. Number of exhibitors: 110. Public attendance: 10,000. Free to pubic. Artists should apply by downloading application from website or call. Deadline for entry: February 28. Space fee: $75. Jury Fee: $25. Exhibition space: 10x10 ft. For more information, artists should e-mail, visit website, call or send SASE. Tips: "Apply early."

☙ ARTS IN THE PARK

302 2nd Ave. East, Kalispell MT 59901. (406)755-5268. Fax: (405)755-2023. E-mail: hockaday@centurytel.net. Website: www.hockadaymuseum.org/artpark.htm. Estab. 1968. Fine arts & crafts show held annually 4th weekend in July. Outdoors. Accepts photography, jewelry, clothing, paintings, pottery, glass, wood, furniture, baskets. Juried by a panel of 5 members. Artwork is evaluated for quality, creativity and originality. Jurors attempt to achieve a balance of mediums in the show. Awards/prizes: $100, Best Booth Award. Number of exhibitors: 100. Public attendance: 10,000. Public admission: $5/weekend pass; $3/day pass; under 12, free. Artists should apply by completing the application form, entry fee, a SASE and a CD containing 5 images in JPEG format; 4 images of work and 1 of booth. Deadline for entry: May 1. Application fee: $25. Space fee: $160-425 per location. Exhibition space: 10 × 10 ft-10 × 20 ft. For more information artists should e-mail, visit website or call.

☙ ARTS ON FOOT

Downtown DC BID, 1250 H St., NW, Suite 1000, Washington DC 20005. (202)661-7592. E-mail: artsonfoot@downtowndc.org. Website: www.artsonfoot.org. **Contact:** Ashley Neeley. Fine arts & crafts show held annually in September. Outdoors. Accepts photography, painting, sculpture, fiber art, furniture, glass, jewelry, leather. Juried by 5 color images of the artwork. Send images as 35mm slides, TIFF or JPEG files on CD or DVD. Also include artist's résumé and SASE for return of materials. Free to the public. Deadline for entry: July. Exhibition space: 10 × 10 ft. "Arts on Foot will pay participating artists a $25 gratuity to help cover out-of-pocket expenses (such as transportation and food) each artist may incur during Arts on Foot." For more information, artists should call, e-mail, visit website.

☙ ARTS ON THE GREEN

P.O. Box 752, LaGrange KY 40031. 502-222-3822. Fax: 502-222-3823. E-mail: AOGdir@aaooc.org. Website: www.oldhamcountyarts.org. **Contact:** Marion Gibson, show coordinator. Estab. 2001. Fine arts & crafts show held annually 1st weekend in June.

Outdoors. Accepts photography, painting, clay, sculpture, metal, wood, fabric, glass, jewelry. Juried by a panel. Awards/prizes: cash prizes for Best of Show and category awards. Number of exhibitors: 100. Public attendance: 7,500. Free to the public. Artists should apply online or call. Deadline for entry: March 15. Jury fee: $15. Space fee: $125. Electricity fee: $15. Exhibition space: 12 × 12 ft. For more information, artists should e-mail, visit website, call.

Tips "Make potential customers feel welcome in your space. Don't overcrowd your work. Smile!"

▨ AUTUMN FESTIVAL, AN ARTS & CRAFTS AFFAIR

P.O. Box 184, Boys Town NE 68010.(402)331-2889. Fax: (402)445-9177. E-mail: hpifestivals@cox.net. Website: www.hpifestivals.com. **Contact:** Huffman Productions. Estab. 1983. Fine arts & craft show held annually in October. Indoors. Accepts photography, pottery, stained glass, jewelry, clothing, furniture, paintings, baskets, etc. All must be handcrafted by the exhibitor. Juried by 2 photos of work and 1 of display. Awards/prizes: $420 total cash awards. Number of exhibitors: 400. Public attendance: 20,000. Public admission: $6-8. Artists should apply by calling for an application. Deadline: Until a category is juried full. Space fee: $600. Exhibition space: 8 × 11 ft. ("We provide pipe and drape plus 500 watts of power.") For more information, artists should e-mail, visit website, call, send SASE.

Tips "Make sure to send good, crisp photos that show your current work and display. This gives you the best chance with jurying in a show."

▨ AVON FINE ART & WINE AFFAIRE

15648 N. Eagles Nest Dr., Fountain Hills AZ 85268-1418. (480)837-5637. Fax: (480)837-2355. E-mail: info@thunderbirdartists.com. Website: www.thunderbirdartists.com. **Contact:** Denise Colter, vice president. Estab. 1993. Fine arts & crafts show and wine tasting held annually in mid-July. Outdoors. Accepts photography, painting, mixed media, bronze, metal, copper, stone, stained glass, clay, wood, paper, baskets, jewelry, scratchboard. Juried by 4 slides of work and 1 slide of booth. Number of exhibitors: 150. Public attendance: 3,000-6,000. Free to public. Artists should apply by sending application, fees, 4 slides of work, 1 slide of booth and 2 SASEs. Deadline for entry: March 27. Application fee: $20. Space fee: $360-1,080. Exhibition space: 10 × 10 ft.-10 × 30 ft. For more information, artists should visit website.

▨ BLACK SWAMP ARTS FESTIVAL

P.O. Box 532, Bowling Green OH 43402. (419)354-2723. E-mail: info@blackswamparts. org. Website: www.blackswamparts.org.

Tips "Offer a range of prices, from $5 to $500."

☒ CAIN PARK ARTS FESTIVAL

40 Severance Circle, Cleveland Heights OH 44118-9988. (216)291-3669. Fax: (216)3705. E-mail: jhoffman@clvhts.com. Website: www.cainpark.com. **Contact:** Janet Hoffman, administrative assistant. Estab. 1976. Fine arts & crafts show held annually 2nd full week in July. Outdoors. Accepts photography, painting, clay, sculpture, wood, jewelry, leather, glass, ceramics, clothes and other fiber, paper, block printing. Juried by a panel of professional artists; submit 5 slides. Awards/prizes: cash prizes of $750, $500 and $250; also Judges' Selection, Director's Choice and Artists' Award. Number of exhibitors: 155. Public attendance: 60,000. Free to the public. Artists should apply by requesting an application by mail, visiting website to download application or by calling. **Deadline for entry**: March 1. Application fee: $25. Space fee: $350. Exhibition space: 10 × 10 ft. Average gross sales/exhibitor: $4,000. For more information, artists should e-mail, visit website, or call.
Tips "Have an attractive booth to display your work. Have a variety of prices. Be available to answer questions about your work."

CALABASAS FINE ARTS FESTIVAL

100 Civic Center Way, Calabasas CA 91302. (818)224-1657 ext. 270. E-mail: artscouncil @cityofcalabasas.com. Website: www.calabasasartscouncil.com. Estab. 1997. Fine arts & crafts show held annually in late April/early May. Outdoors. Accepts photography, painting, sculpture, jewelry, mixed media. Juried. Number of exhibitors: 250. Public attendance: 10,000 + . Free to public; parking: $5. For more information, artists should visit website or e-mail.

☒ CEDARHURST CRAFT FAIR

P.O. Box 923, Mt. Vernon IL 62864. (618)242-1236 ext. 234. Fax: (618)242-9530. E-mail: linda@cedarhurst.org. Website: www.cedarhurst.org. **Contact:** Linda Wheeler, coordinator. Estab. 1977. Arts & crafts show held annually in September. Outdoors. Accepts photography, paper, glass, metal, clay, wood, leather, jewelry, fiber, baskets, 2D art. Juried. Awards/prizes: Best of each category. Number of exhibitors: 125. Public attendance: 14,000. Public admission: $3. Artists should apply by filling out application form. Deadline for entry: March. Application fee: $25. Space fee: $275. Exhibition space: 10 × 15 ft. For more information, artists should e-mail, visit website.

CENTERVILLE/WASHINGTON TOWNSHIP AMERICANA FESTIVAL

P.O. Box 41794, Centerville OH 45441-0794. (937)433-5898. Fax: (937)433-5898. E-mail: americanafestival@sbcglobal.net. Website: www.americanafestival.org. **Contact:** Patricia Fleissner, arts & crafts chair. Estab. 1972. Arts & crafts show held annually on the Fourth of July except when the 4th falls on a Sunday, when the

festival is held on Monday the 5th. Festival includes entertainment, parade, food, car show and other activities. Accepts photography and all mediums. "No factory-made items accepted." Awards/prizes: 1st Place; 2nd Place; 3rd Place; certificates and ribbons for most attractive displays. Number of exhibitors: 275-300. Public attendance: 70,000. Free to the public. Artists should send SASE for application form. Deadline for entry: June 26, 2010. "Main Street is usually full by early June." Space fee: $50. Exhibition space: 12 × 10 ft. For more information, artists should e-mail, visit website, call.

Tips "Artists should have moderately priced items; bring business cards; and have an eye-catching display."

◪ CHATSWORTH CRANBERRY FESTIVAL

P.O. Box 286, Chatsworth NJ 08019-0286. (609)726-9237. Fax: (609)726-1459. E-mail: lgiamalis@aol.com. Website: www.cranfest.org. **Contact:** Lynn Giamalis, chairperson. Estab. 1983. Arts & crafts show held annually in October. Outdoors. Accepts photography. Juried. Number of exhibitors: 200. Public attendance: 75,000-100,000. Free to public. Artists should apply by sending SASE to above address. Deadline for entry: September 1. Space fee: $200. Exhibition space: 15 × 15 ft. For more information, artists should visit website.

◪ CHUN CAPITOL HILL PEOPLE'S FAIR

1290 Williams St., Suite 101, Denver CO 80218. (303)830-1651. Fax: (303)830-1782. E-mail: chun@chundenver.org. Website: www.peoplesfair.com; www.chundenver. org. Estab. 1971. Arts & crafts show held annually 1st weekend in June. Outdoors. Accepts photography, ceramics, jewelry, paintings, wearable art, glass, sculpture, wood, paper, fiber. Juried by professional artisans representing a variety of mediums and selected members of fair management. The jury process is based on originality, quality and expression. Awards/prizes: Best of Show. Number of exhibitors: 300. Public attendance: 250,000. Free to public. Artists should apply by downloading application from website. Deadline for entry: March. Application fee: $35. Space fee: $300. Exhibition space: 10 × 10 ft. For more information, artists should e-mail, visit website or call.

◪ CHURCH STREET ART & CRAFT SHOW

P.O. Box 1409, Waynesville NC 28786. (828)456-3517. Fax: (828)456-2001. E-mail: downtown waynesville@charter.net. Website: www.downtownwaynesville.com. **Contact:** Ronald Huelster, executive director. Estab. 1983. Fine arts & crafts show held annually 2nd Saturday in October. Outdoors. Accepts photography, paintings, fiber, pottery, wood, jewelry. Juried by committee: submit 4 slides or photos of work and 1 of booth display. Awards/prizes: $1,000 cash prizes in 1st, 2nd, 3rd and

Honorable Mentions. Number of exhibitors: 100. Public attendance: 15,000-18,000. Free to public. Deadline for entry: August 15. Application fee: $20; space fee: $100-195. Exhibition space: 10 × 12 ft.-12 × 20 ft. For more information and application, see website.

Tips Recommends "quality in work and display."

☑ CITY OF FAIRFAX FALL FESTIVAL

10455 Armstrong St., Fairfax VA 22030. (703)385-7949. Fax: (703)246-6321. E-mail: klewis@ fairfaxva.gov. website: www.fairfaxva.gov/SpecialEvents/FallFestival/FallFestival.asp. **Contact:** Kathy Lewis, special events coordinator. Estab. 1975. Arts & crafts show held annually 2nd Saturday in October. Outdoors. Accepts photography, jewelry, glass, pottery, clay, wood, mixed media. Juried by a panel of 5 independent jurors. Number of exhibitors: 400. Public attendance: 25,000. Public admission: $5 for age 18 and older. Artists should apply by contacting Leslie Herman for an application. Deadline for entry: March. Application fee: $10. Space fee: $150. Exhibition space: 10 × 10 ft. For more information, artists should e-mail.

Tips "Be on-site during the event. Smile. Price according to what the market will bear."

☑ CITY OF FAIRFAX HOLIDAY CRAFT SHOW

10455 Armstrong St., Fairfax VA 22030. (703)385-7949. Fax: (703)246-6321. E-mail: klewis@fairfax va.gov. Website: www.fairfaxva.gov. **Contact:** Leslie Herman, special events coordinator. Estab. 1985. Arts & crafts show held annually 3rd weekend in November. Indoors. Accepts photography, jewelry, glass, pottery, clay, wood, mixed media. Juried by a panel of 5 independent jurors. Number of exhibitors: 247. Public attendance: 10,000. Public admission: $5 for age 18 an older. Artists should apply by contacting Leslie Herman for an application. Deadline for entry: March. Application fee: $10. Space fee: 10 × 6 ft.: $175; 11 × 9 ft.: $250; 10 × 10 ft.: $250. For more information, artists should e-mail. Currently full.

Tips "Be on-site during the event. Smile. Price according to what the market will bear."

☑ COLORSCAPE CHENANGO ARTS FESTIVAL

P.O. Box 624, Norwich NY 13815. (607)336-3378. E-mail: info@colorscape.org. Website: www.colorscape.org. **Contact:** Peggy Finnegan, festival director. Estab. 1995. Fine arts & crafts show held annually the weekend after Labor Day. Outdoors. Accepts photography and all types of mediums. Juried. Awards/prizes: $5,000. Number of exhibitors: 80-85. Public attendance: 14,000-16,000. Free to public. Deadline for entry: March. Application fee: $15/jury fee. Space fee: $150. Exhibition space: 12 × 12 ft. For more information, artists should e-mail, visit website, call or send SASE.

Tips "Interact with your audience. Talk to them about your work and how it is created. Don't sit grumpily at the rear of your booth reading a book. People like to be involved in the art they buy and are more likely to buy if you involve them."

☙ CONYERS CHERRY BLOSSOM FESTIVAL

1996 Centennial Olympic Parkway, Conyers GA 30013. (770)860-4190. Fax: (770)602-2500. E-mail: rebecca.hill@conyersga.com. Website: www.conyerscherryblossomfest. com. **Contact:** Rebecca Hill, event manager. Estab. 1981. Arts & crafts show held annually in late March. Outdoors. Accepts photography, paintings. Juried. Number of exhibitors: 300. Public attendance: 40,000. Free to public; $5 parking fee. **Deadline** for entry: December. Space fee: $125/booth. Exhibition space: 10 × 10 ft. For more information, artists should e-mail, visit website or call.

☙ CRAFT FAIR AT THE BAY

Castleberry Fairs & Festivals, 38 Charles St., Rochester NH 03867. (603)332-2616. E-mail: info@castleberryfairs.com. Website: www.castleberryfairs.com. **Contact:** Terry Mullen, event coordinator. Estab. 1988. Arts & crafts show held annually in July in Alton Bay, New Hampshire. Outdoors. Accepts photography and all other mediums. Juried by photo, slide or sample. Number of exhibitors: 85. Public attendance: 7,500. Free to the public. Artists should apply by downloading application from website. Deadline for entry: until full. Space fee: $250. Exhibition space: 100 sq. ft. Average gross sales/exhibitor: "Generally, this is considered an 'excellent' show, so I would guess most exhibitors sell ten times their booth fee, or in this case, at least $2,500 in sales." For more information, artists should visit website.

Tips "Do not bring a book; do not bring a chair. Smile and make eye contact with everyone who enters your booth. Have them sign your guest book; get their e-mail address so you can let them know when you are in the area again. And, finally, make the sale—they are at the fair to shop, after all."

☙ CRAFTS AT RHINEBECK

P.O. Box 389, Rhinebeck NY 12572. (845)876-4000. Fax: (845)876-4003. E-mail: vimperati@ dutchessfair.com. Website: www.craftsatrhinebeck.com. **Contact:** Vicki Imperati, event coordinator. Estab. 1981. Fine arts & crafts show held biannually in late June and early October. Indoors and outdoors. Accepts photography, fine art, ceramics, wood, mixed media, leather, glass, metal, fiber, jewelry. Juried by 3 slides of work and 1 of booth display. Number of exhibitors: 350. Public attendance: 25,000. Public admission: $7. Artists should apply by calling for application or downloading application from website. Deadline for entry: February 1. Application fee: $20. Space fee: $300-730. Exhibition space: inside: 10 × 10 ft. and 10 × 20 ft.; outside: 15 × 15 ft. For more information, artists should e-mail, visit website or call.

Tips "Presentation of work within your booth is very important. Be approachable and inviting."

⚜ CUNEO GARDENS ART FESTIVAL

3417 R.F.D., Long Grove IL 60047. Phone/Fax: (847)726-8669. E-mail: dwevents@comcast.net. Website: www.dwevents.org. **Contact:** D & W Events, Inc. Estab. 2005. Fine arts & crafts show held outdoors in May. Accepts photography, fiber, oil, acrylic, watercolor, mixed media, jewelry, sculpture, metal, paper, painting. Juried by 3 jurors. Awards/prizes: Best of Show; First Place and awards of excellence. Number of exhibitors: 75. Public attendance: 10,000. Free to public. Artists should apply by downloading application from website, e-mail or call. Deadline for entry: March 1. Application fee: $25. Space fee: $275. Exhibition space: 100 sq. ft. For more information, artists should e-mail, visit website, call.

Tips "Artists should display professionally and attractively, and interact positively with everyone."

⚜ DEERFIELD FINE ARTS FESTIVAL

3417 R.F.D., Long Grove IL 60047. Phone/Fax: (847)726-8669. E-mail: dwevents@comcast.net. Website: www.dwevents.org. **Contact:** D & W Events, Inc. Estab. 2000. Fine arts & crafts show held annually in early June. Outdoors. Accepts photography, fiber, oil, acrylic, watercolor, mixed media, jewelry, sculpture, metal, paper, painting. Juried by 3 jurors. Awards/prizes: Best of Show; First Place, awards of excellence. Number of exhibitors: 150. Public attendance: 35,000. Free to public. Artists should apply by downloading application from website, e-mail or call. Deadline for entry: March 1. Application fee: $25. Space fee: $275. Exhibition space: 100 sq. ft. For more information artists should e-mail, visit website, call.

Tips "Artists should display professionally and attractively, and interact positively with everyone."

⚜ DELAWARE ARTS FESTIVAL

P.O. Box 589, Delaware OH 43015. (740-)363-2695. E-mail: info@delawareartsfestival.org. Website: www.delawareartsfestival.org. **Contact:** Tom King. Estab. 1973. Fine arts & crafts show held annually the Saturday and Sunday after Mother's Day. Outdoors. Accepts photography; all mediums, but no buy/sell. Juried by committee members who are also artists. Awards/prizes: Ribbons, cash awards, free booth for the following year. Number of exhibitors: 160. Public attendance: 25,000. Free to the public. Artists should apply by visiting website for application. Application fee: $10. Space fee: $125. Exhibition fee: 120 sq. ft. For more information, artists should e-mail or visit website.

Tips "Have high-quality stuff. Engage the public. Set up a good booth."

DOWNTOWN FESTIVAL & ART SHOW

P.O. Box 490, Gainesville FL 32602. (352)334-5064. Fax: (352)334-2249. E-mail: piperlr@city ofgainesville.org. Website: www.gvlculturalaffairs.org. **Contact:** Linda Piper, festival director. Estab. 1981. Fine arts & crafts show held annually in November. Outdoors. Accepts photography, wood, ceramic, fiber, glass, and all mediums. Juried by 3 slides of artwork and 1 slide of booth. Awards/prizes: $14,000 in Cash Awards; $5,000 in Purchase Awards. Number of exhibitors: 250. Public attendance: 115,000. Free to the public. Artists should apply by mailing 4 slides. Deadline for entry: May. Space fee: $185. Exhibition space: 12 ft. × 12 ft. Average gross sales/exhibitor: $6,000. For more information, artists should e-mail, visit website, call, send SASE.

Tips "Submit the highest-quality slides possible. A proper booth slide is so important."

◪ EDWARDS FINE ART & SCULPTURE FESTIVAL

15648 N. Eagles Nest Dr., Fountain Hills AZ 85268-1418. (480)837-5637. Fax: (480)837-2355. E-mail: info@thunderbirdartists.com. Website: www.thunderbirdartists.com. **Contact:** Denise Colter, vice president. Estab. 1999. Fine arts & sculpture show held annually in late July. Outdoors. Accepts photography, painting, drawing, graphics, fiber sculpture, mixed media, bronze, metal, copper, stone, stained glass, clay, wood, baskets, jewelry. Juried by 4 slides of work and 1 slide of booth presentation. Number of exhibitors: 115. Public attendance: 3,000-6,000. Free to public. Artists should apply by sending application, fees, 4 slides of work, 1 slide of booth labeled and 2 SASE. Deadline for entry: March 29. Application fee: $25. Space fee: $410. Exhibition space: 10 × 10 ft. For more information, artists should visit website.

◪ ELIZABETHTOWN FESTIVAL

818 Jefferson, Moundsville WV 26041. (304)843-1170. Fax: (304)845-2355. E-mail: jvhblake @aol.com. Website: www.wvpentours.com. **Contact:** Sue Riggs at (304)843-1170 or Hilda Blake at (304)845-2552, co-chairs. Estab. 1999. Arts & crafts show held annually the 3rd weekend in May (Saturday and Sunday). Sponsored by the Moundsville Economic Development Council. Also includes heritage exhibits of 1800s-era food and entertainment. Indoors and outdoors within the walls of the former West Virginia Penitentiary. Accepts photography, crafts, wood, pottery, quilts, jewelry. "All items must be made by the craftspeople selling them; no commercial items." Juried based on design, craftsmanship and creativity. Submit 5 photos: 3 of your medium; 2 of your booth set-up. Jury fee: $10. Number of exhibitors: 70-75. Public attendance: 3,000-5,000. Public admission: $3. Artists should apply by requesting an application form by phone. Deadline for entry: April 1. Space fee: $50. Exhibition space: 100 sq. ft. For more information, artists should e-mail, visit website, call, send SASE.

Tips "Be courteous. Strike up conversations—do not sit in your booth and read! Have an attractive display of wares."

☑ ELMWOOD AVENUE FESTIVAL OF THE ARTS, INC.

P.O. Box 786, Buffalo NY 14213. (716)830-2484. E-mail: directoreafa@aol.com. Website: www.elmwoodartfest.org. **Contact:** Joe DiPasquale. Estab. 2000. Arts & crafts show held annually in late-August, the weekend before Labor Day weekend. Outdoors. Accepts photography, metal, fiber, ceramics, glass, wood, jewelry, basketry, 2D media. Juried. Awards/prizes: to be determined. Number of exhibitors: 170. Public attendance: 80,000-120,000. Free to the public. Artists should apply by e-mailing their contact information or by downloading application from website. Deadline for entry: April. Application fee: $20. Space fee: $200. Exhibition space: 150 sq. ft. Average gross sales/exhibitor: $3,000. For more information, artists should e-mail, visit website, call, send SASE.

Tips "Make sure your display is well designed, with clean lines that highlight your work. Have a variety of price points—even wealthy people don't always want to spend $500 at a booth where they may like the work."

☑ A FAIR IN THE PARK

4906 Yew St., Pittsburgh PA 15224. (412)370-0695. E-mail: info@craftsmensguild. org. Website: www.craftsmensguild.org. **Contact:** Leah Shannon, director. Estab. 1969. Contemporary fine arts & crafts show held annually the weekend after Labor Day outdoors. Accepts photography, clay, fiber, jewelry, metal, mixed media, wood, glass, 2D visual arts. Juried. Awards/prizes: 1 Best of Show and 4 Craftsmen's Guild Awards. Number of exhibitors: 115. Public attendance: 25,000 + . Free to public. Artists should apply by sending application with jury fee, booth fee and 5 digital images. Deadline for entry: May 1. Application fee: $25. Space fee: $250-300. Exhibition space: 11 × 12 ft. Average gross sales/exhibitor: $1,000 and up. For more information artists should e-mail, visit website or call.

Tips "It is very important for artists to present their work to the public, to concentrate on the business aspect of their artist career. They will find that they can build a strong customer/collector base by exhibiting their work and by educating the public about their artistic process and passion for creativity."

☑ FALL CRAFTS AT LYNDHURST

P.O. Box 28, Woodstock NY 12498. (845)331-7900. Fax: (845)331-7484. E-mail: crafts@ artrider.com. Website: www.artrider.com. **Contact:** Laura Kandel. Estab. 1984. Fine arts & crafts show held annually in mid-September. Outdoors. Accepts photography, wearable and nonwearable fiber, metal and nonmetal jewelry, clay, leather, wood, glass, painting, drawing, prints mixed media. Juried by 5 images of work and 1 of

booth, viewed sequentially. Number of exhibitors: 300. Public attendance: 14,000. Public admission: $10. Artists should apply by downloading application from www. artrider.com or can apply online at www.zapplication.org. Deadline for entry: January 1. Application fee: $45. Space fee: $795. Exhibition space: 10 × 10. For more information, artists should e-mail, visit website, call.

FALL FEST IN THE PARK

117 W. Goodwin St., Prescott AZ 86301-1147. (928)445-2000 ext 12. Fax: (928)445-0068. E-mail: scott @prescott.org. Website: www. prescott.org. **Contact:**Scott or Jill Currey (Special Events—Prescott Chamber of Commerce) Estab. 1981. Arts & crafts show held annually in mid-October. Outdoors. Accepts photography, ceramics, painting, sculpture, clothing, woodworking, metal art, glass, floral, home décor. " No resale." Juried. " Photos of work and artist creating work are required." Number of exhibitors: 150. Public attendance: 6,000-7,000. Free to public. Application can be printed from website or obtained by phone request. Deadline: Spaces are sold until show is full. Application fee: $50 deposit. Space fee: $225. Exhibition space; 10 × 15 ft. For more information, artists should e-mail, visit website or call.

⚑ FALL FINE ART & CRAFTS AT BROOKDALE PARK

12 Galaxy Court, Hillsborough NJ 08844. (908)874-5247. Fax: (908)874-7098. E-mail: info@rosesquared.com. Website: www.rosesquared.com. **Contact:** Janet Rose, president. Estab.1997. Fine arts & craft show held annually in mid-October. Outdoors. Accepts photography and all other mediums. Juried. Number of exhibitors: 180. Public attendance: 14,000. Free to the public. Artists should apply by downloading application from website or call for application. Deadline: 1 month before show date. Application fee: $15. Space fee: $310. Exhibition space: 120 sq. ft. For more information, artists should e-mail, visit website, call.

Tips "Create a professional booth that is comfortable for the customer to enter. Be informative, friendly and outgoing. People come to meet the artist."

⚑ FAUST FINE ARTS & FOLK FESTIVAL

15185 Olive St., St. Louis MO 63017. (314)615-8482. E-mail: toconnell@stlouisco. com. Website: www.stlouisco.com/parks. **Contact:** Tonya O'Connell, recreation supervisor. Fine arts & crafts show held biannually in May and September. Outdoors. Accepts photography, oil, acrylic, clay, fiber, sculpture, watercolor, jewelry, wood, floral, baskets, prints, drawing, mixed media, folk art. Juried by a committee. Awards/prizes: $100. Number of exhibitors: 90-100. Public attendance: 5,000. Public admission: $5. Deadline for entry: March, spring show; July, fall show. Application fee: $15. Space fee: $75. Exhibition space: 10 × 10 ft. For more information, artists should call.

◧ FERNDALE ART SHOW

Integrity Shows, 2102 Roosevelt, Ypsilanti MI 48197. (734)216-3958. Fax: (734)482-2070. E-mail: markloeb@aol.com. Website: www.michiganartshow.com. **Contact:** Mark Loeb, president. Estab. 2004. Fine arts & crafts show held annually in September. Outdoors. Accepts photography and all fine art and craft mediums; emphasis on fun, funky work. Juried by 3 independent jurors. Awards/prizes: Purchase Awards and Merit Awards. Number of exhibitors: 90. Public attendance: 30,000. Free to the public. Application is available in March. Deadline for entry: July. Application fee: $15. Space fee: $250. Exhibition space: 10 × 12 ft. For more information, artists should e-mail or call.
Tips "Enthusiasm. Keep a mailing list. Develop collectors."

◧ FESTIVAL IN THE PARK

1409 East Blvd. Charlotte NC 28203. (704)338-1060. Fax: (704)338-1061. E-mail: festival@festival inthepark.org. Website: www.festivalinthepark.org. **Contact:** Julie Whitney Austin, executive director. Estab. 1964. Fine arts & crafts/arts & crafts show held annually 3rd Thursday after Labor Day. Outdoors. Accepts photography, decorative and wearable crafts, drawing and graphics, fiber and leather, jewelry, mixed media, painting, metal, sculpture, wood. Juried by slides or photographs. Awards/prizes: $4,000 in cash awards. Number of exhibitors: 150. Public attendance: 100,000. Free to the public. Artists should apply by visiting website for application. Application fee: $25. Space fee: $350. Exhibition space: 10 × 10 ft. For more information, artists should e-mail, visit website, call.

◧ FILLMORE JAZZ FESTIVAL

P.O. Box 151017, San Rafael CA 94915. (800)310-6563. Fax: (414)456-6436. E-mail: art@fillmore jazzfestival.com. Website: www.fillmorejazzfestival.com. Estab. 1984. Fine arts & crafts show and jazz festival held annually 1st weekend of July in San Francisco, between Jackson & Eddy Streets. Outdoors. Accepts photography, ceramics, glass, jewelry, paintings, sculpture, metal clay, wood, clothing. Juried by prescreened panel. Number of exhibitors: 250. Public attendance: 90,000. Free to public. Deadline for entry: ongoing. Space fee: $350-600. Exhibition space: 8 × 10 ft. or 10 × 10 ft. Average gross sales/exhibitor: $800-11,000. For more information, artists should e-mail, visit website or call.

◧ FINE ART & CRAFTS AT ANDERSON PARK

12 Galaxy Ct., Hillsborough NJ 08844. (908)874-5247. Fax: (908)874-7098. E-mail: info@rose squared.com. Website: www.rosesquared.com. **Contact:** Janet Rose, president. Estab.1984. Fine arts & craft show held annually in mid-September. Outdoors. Accepts photography and all other mediums. Juried. Number of

exhibitors: 190. Public attendance: 16,000. Free to the public. Artists should apply by downloading application from website or call for application. Deadline: 1 month before show date. Application fee: $15. Space fee: $310. Exhibition space: 120 sq. ft. For more information, artists should e-mail, visit website, call.

Tips "Create a professional booth that is comfortable for the customer to enter. Be informative, friendly and outgoing. People come to meet the artist."

FINE ART & CRAFTS AT NOMAHEGAN PARK

12 Galaxy Ct., Hillsborough NJ 08844. (908)874-5247. Fax: (908)874-7098. E-mail: info@rose squared.com. Website: www.rosesquared.com. **Contact:** Janet Rose, president. Estab. 1987. Fine arts & craft show held annually in May. Outdoors. Accepts photography and all other mediums. Juried. Number of exhibitors: 110. Public attendance: 12,000. Free to the public. Artists should apply by downloading application from website or call for application. Deadline: 1 month before show date. Application fee: $15. Space fee: $310. Exhibition space: 120 sq. ft. For more information, artists should e-mail, visit website, call.

Tips "Create a professional booth that is comfortable for the customer to enter. Be informative, friendly and outgoing. People come to meet the artist."

FINE ART & CRAFTS FAIR AT VERONA PARK

12 Galaxy Ct., Hillsborough NJ 08844. (908)874-5247. Fax: (908)874-7098. E-mail: info@rose squared.com. Website: www.rosesquared.com. **Contact:** Janet Rose, president. Estab.1986. Fine arts & craft show held annually in May. Outdoors. Accepts photography and all other mediums. Juried. Number of exhibitors: 140. Public attendance: 14,000. Free to the public. Artists should apply by downloading application from website or call for application. Deadline: 1 month before show date. Application fee: $15. Space fee: $310. Exhibition space: 120 sq. ft. For more information, artists should e-mail, visit website, call.

Tips "Create a professional booth that is comfortable for the customer to enter. Be informative, friendly and outgoing. People come to meet the artist."

FOOTHILLS CRAFTS FAIR

2753 Lynn Rd. #A, Tryon NC 28782-7870. (828)859-7427. E-mail: info@ blueridgebbqfestival.com. Website: www.BlueRidgeBBQFestival.com. **Contact:** Julie McIntyre. Estab. 1994. Fine arts & crafts show and Blue Ridge BBQ Festival/Championship held annually 2nd Friday and Saturday in June. Outdoors. Accepts photography, arts and handcrafts by artist only; nothing manufactured or imported. Juried. Number of exhibitors: 50. Public attendance: 25,000+. Public admission: $8; 12 and under free. Artists should apply by downloading application from website or sending personal information to e-mail or mailing address. Deadline for entry: March

30. Jury fee: $25 nonrefundable. Space fee: $150. Exhibition space: 10 × 10 ft. For more information, artists should visit website.

Tips "Have an attractive booth, unique items, and reasonable prices."

▼ FOURTH AVENUE SPRING STREET FAIR

329 E. 7th St., Tucson AZ 85705.(520)624-5004. Fax: (520)624-5933. E-mail: kurt@ fourthavenue.org. Website: www.fourthavenue.org. **Contact:** Kurt Tallis, event director. Estab. 1970. Arts & crafts fair held annually in March. 2009 dates March 20-22. Outdoors. Accepts photography, drawing, painting, sculpture, arts and crafts. Juried by 5 jurors. Awards/prizes: Best of Show. Number of exhibitors: 400. Public attendance: 300,000. Free to the public. Artists should apply by completing the online application. Deadline for entry: December 17, 2008. Application fee: $35. Space fee: $470. Exhibition space: 10 × 10 ft. Average gross sales/exhibitor: $3,000. For more information, artists should e-mail, visit website, call, send SASE.

▼ FOURTH AVENUE WINTER STREET FAIR

329 E. 7th St., Tucson AZ 85705. (520)624-5004. Fax: (520)624-5933. E-mail: kurt@ fourthavenue.org. Website: www.fourthavenue.com. **Contact:** Kurt Tallis, event director. Estab. 1970. Arts & crafts fair held annually in December. 2008 dates December 12-14. Outdoors. Accepts photography, drawing, painting, sculpture, arts and crafts. Juried by 5 jurors. Awards/prizes: Best of Show. Number of exhibitors: 400. Public attendance: 300,000. Free to the public. Artists should apply by completing the online application. Deadline for entry: September. Application fee: $35. Space fee: $470. Exhibition space: 10 × 10 ft. Average gross sales/exhibitor: $3,000. For more information, artists should e-mail, visit website, call, send SASE.

▼ FOURTH STREET FESTIVAL FOR THE ARTS & CRAFTS

P.O. Box 1257, Bloomington IN 47402. (812) 335-3814. E-mail: info@4thstreet.org. Website: www.4thstreet.org. Estab. 1976. Fine arts & crafts show held annually Labor Day weekend. Outdoors. Accepts photography, clay, glass, fiber, jewelry, painting, graphic, mixed media, wood. Juried by a 4-member panel. Awards/prizes: Best of Show, 1st, 2nd, 3rd in 2D and 3D. Number of exhibitors: 105. Public attendance: 25,000. Free to public. Artists should apply by sending requests by snail mail, e-mail or download application from website. Deadline for entry: April 1. Application fee: $15. Space fee: $175. Exhibition space: 10 × 10 ft. Average gross sales/exhibitor: $2,700. For more information, artists should e-mail, visit website, call or send for information with SASE.

Tips "Be professional."

☑ FRANKFORT ART FAIR

P.O. Box 566, Frankfort MI 49635.(231)352-7251. Fax: (231)352-6750. E-mail: fcofc@frankfort-elberta.com. Website: www.frankfort-elberta.com. Estab. 1976. **Contact:** Joanne Bartley, executive director. Fine Art Fair held annually in August. Outdoors. Accepts photography, clay, glass, jewelry, textiles, wood, drawing/graphic arts, painting, sculpture, baskets, mixed media. Juried by 3 photos of work, one photo of booth display and one photo of work in progress. Prior exhibitors are not automatically accepted. No buy/sell allowed. Artists should apply by downloading application from website, e-mailing or calling. Deadline for entry: May 1. Jury fee: $15. Space fee: $105 for Friday and Saturday. Exhibition space: 12 × 12 ft. For more information, artists should e-mail, see website.

☑ GARRISON ART CENTER FINE ART & CRAFT FAIR

P.O. Box 4, 23 Camison's Landing, Garrison NY 10524. (845)424-3960. Fax: (845)424-4711. E-mail: info@garrisonartcenter.org. Website: www.garrisonartcenter.org. Estab. 1969. **Contact:** Carinda Swann, executive director. Fine arts & crafts show held annually 3rd weekend in August. Outdoors. Accepts all mediums. Juried by a committee of artists and community members. Number of exhibitors: 100. Public attendance: 10,000. Public admission: $8. Artists should call for application form or download from website. Deadline for entry: April. Application fee: $15. Space fee: $260; covered corner booth: $300. Exhibition space: 10 × 10 ft. For more information, artists should e-mail, visit website, call, send SASE.
Tips "Have an inviting booth and be pleasant and accessible. Don't hide behind your product—engage the audience."

GERMANTOWN FESTIVAL

P.O. Box 381741, Germantown TN 38183. (901)757-9212. E-mail: gtownfestival@ aol.com. Website: www.germantownfest.com. **Contact:** Melba Fristick, coordinator. Estab. 1971. Arts and crafts show held annually the weekend after Labor Day. Outdoors. Accepts photography, all arts & crafts mediums. Number of exhibitors: 400 + . Public attendance: 65,000. Free to public. Artists should apply by sending applications by mail. Deadline for entry: until filled. Application/space fee: $190-240. Exhibition space: 10 × 10 ft. For more information, artists should e-mail, call or send SASE.
Tips "Display and promote to the public. Price attractively."

☑ GLOUCESTER WATERFRONT FESTIVAL

Castleberry Fairs & Festivals, 38 Charles St., Rochester NH 03867. (603)332-2616. E-mail: info@castelberryfairs.com. Website: www.castleberryfairs.com. **Contact:** Terry Mullen, events coordinator. Estab. 1971. Arts & crafts show held 3rd weekend

in August in Gloucester, Massachusettes. Outdoors. Accepts photography and all other mediums. Juried by photo, slide or sample. Number of exhibitors: 300. Public attendance: 50,000. Free to the public. Artists should apply by downloading application from website. Deadline for entry: until full. Space fee: $350. Exhibition space: 100 sq. ft. Average gross sales/exhibitor: "Generally, this is considered an 'excellent' show, so I would guess most exhibitors sell ten times their booth fee, or in this case, at least $3,500 in sales." For more information, artists should visit website.

Tips "Do not bring a book; do not bring a chair. Smile and make eye contact with everyone who enters your booth. Have them sign your guest book; get their e-mail address so you can let them know when you are in the area again. And, finally, make the sale—they are at the fair to shop, after all."

GOLD RUSH DAYS

P.O. Box 774, Dahlonega GA 30533. (706)864-7247. Website: www.dahlonegajaycees. com. **Contact:** Gold Rush Chairman. Arts & crafts show held annually the 3rd full week in October. Accepts photography, paintings and homemade, handcrafted items. No digitally originated art work. Outdoors. Number of exhibitors: 300. Public attendance: 200,000. Free to the public. Artists should apply online under "Gold Rush," or send SASE to request application. Deadline: March. Space fee: $225, "but we reserve the right to raise the fee to cover costs." Exhibition space: 10 × 10 ft. Artists should e-mail, visit website for more information.

Tips "Talk to other artists who have done other shows and festivals. Get tips and advice from those in the same line of work."

GRADD ARTS & CRAFTS FESTIVAL

3860 US Hwy 60 W., Owensboro KY 42301. (270)926-4433. Fax: (270)684-0714. E-mail: bethgoetz@gradd.com. Website: www.gradd.com. **Contact:** Beth Goetz, festival coordinator. Estab. 1972. Arts & crafts show held annually 1st full weekend in October. Outdoors. Accepts photography taken by crafter only. Number of exhibitors: 180-200. Public attendance: 15,000 +. Free to public; $3 parking fee. Artists should apply by calling to be put on mailing list. Space fee: $100-150. Exhibition space: 10 × 12 ft. For more information, artists should e-mail, visit website or call.

Tips "Be sure that only hand-crafted items are sold. No buy/sell items will be allowed."

⚑ GRAND FESTIVAL OF THE ARTS & CRAFTS

P.O. Box 429, Grand Lake CO 80447-0429. (970)627-3402. Fax: (970)627-8007. E-mail: glinfo @grandlakechamber.com. Website: www.grandlakechamber.com. **Contact:** Cindy Cunningham, events coordinator; Elaine Arguien, office chamber. Fine arts

& crafts show held annually 1st weekend in June. Outdoors. Accepts photography, jewelry, leather, mixed media, painting, paper, sculpture, wearable art. Juried by chamber committee. Awards/prizes: Best in Show and People's Choice. Number of exhibitors: 50-55. Public attendance: 1,000 +. Free to public. Artists should apply by submitting slides or photos. Deadline for entry: May 1. Application fee: $125, includes space fee, security deposit and business license. Exhibition space: 10 × 10 ft. For more information, artists should e-mail or call.

☑ GREAT NECK STREET FAIR

P.O. Box 477, Smithtown NY 11787-0477.(631)724-5966. Fax: (631)724-5967. E-mail: showtiques@aol.com. Website: www.showtiques.com. **Contact:** Eileen. Estab. 1978. Fine arts & crafts show held annually in May. Outdoors. Accepts photography, all arts & crafts made by the exhibitor. Juried. Number of exhibitors: 250. Public attendance: 50,000. Free to public. Deadline for entry: until full. Space fee: $150-175. Exhibition space: 10 × 10 ft. For more information, artists should e-mail, visit website or call.

☒ ☑ GUILFORD CRAFT EXPO

P.O. box 28, Woodstock NY 12498.(845)331-7900. Fax: (845)331-7484. E-mail: crafts@artrider.com. Website: http://guilfordartcenter.org; www.artrider.com. **Contact:** Laura Kandel. Estab. 1957. Fine craft and art show held annually in mid-July. Outdoors. Accepts photography, wearable and nonwearable fiber, metal and nonmetal jewelry, clay, leather, wood, glass, painting, drawing, prints, mixed media. Juried by 5 images of work and 1 of booth, viewed sequentially. Number of exhibitors: 180. Public attendance: 14,000. Public admission: $7. Artists should apply by downloading application from www.artrider.com or can apply online at www.zapplication.org. Deadline for entry: January 1. Application fee: $45. Space fee: $630. Exhibition space: 10 × 12. For more information, artists should e-mail, visit website, call.

☑ GUNSTOCK SUMMER FESTIVAL

Castleberry Fairs & Festivals, 38 Charles St., Rochester NH 03867. (603)332-2616. E-mail: info@castelberryfairs.com. Website: www.castleberryfairs.com. **Contact:** Terry Mullen, events coordinator. Estab. 1971. Arts & crafts show held annually in July in Gilford, New Hampshire. Indoors and outdoors. Accepts photography and all other mediums. Juried by photo, slide or sample. Number of exhibitors: 100. Public attendance: 10,000. Free to the public. Artists should apply by downloading application from website. Deadline for entry: until full. Space fee: $200. Exhibition space: 100 sq. ft. For more information, artists should visit website.

Tips "Do not bring a book; do not bring a chair. Smile and make eye contact with everyone who enters your booth. Have them sign your guest book; get their e-mail

address so you can let them know when you are in the area again. And, finally, make the sale—they are at the fair to shop, after all."

✿ HIGHLAND MAPLE FESTIVAL

P.O. Box 223, Monterey VA 24465-0223. (540)468-2550. Fax:(540)468-2551. E-mail: info@highlandcounty.org. Website: www.highlandcounty.org. **Contact:** Carolyn Pottowsky, executive director. Estab. 1958. Fine arts & crafts show held annually the 2nd and 3rd weekends in March. Indoors and outdoors. Accepts photography, pottery, weaving, jewelry, painting, wood crafts, furniture. Juried by 3 photos or slides. Number of exhibitors: 150. Public attendance: 35,000-50,000. Public admission: $2. Deadline for entry: " There is a late fee after December 20, 2006. Vendors accepted until show is full." Space fee: $125-$150. Exhibition space: 10 × 10 ft. For more information, artists should e-mail, visit website, call.

Tips "Have quality work and good salesmanship."

✿ HINSDALE FINE ARTS FESTIVAL

22 E. First St., Hinsdale IL 60521. (630)323-3952. Fax: (630)323-3953. E-mail: info@hindsdalechamber.com. Website: www.hinsdalechamber.com. **Contact:** Jan Anderson, executive director. Fine arts show held annually in mid-June. Outdoors. Accepts photography, ceramics, painting, sculpture, fiber arts, mixed media, jewelry. Juried by 3 slides. Awards/prizes: Best in Show, Presidents Award and 1st, 2nd\ nosupersub and 3rd Place in 7 categories. Number of exhibitors: 150. Public attendance: 2,000-3,000. Free to public. Artists should apply by mailing or downloading application from website. Deadline for entry: March 2. Application fee: $25. Space fee: $250. Exhibition space: 10 × 10 ft. For more information, artists should e-mail or visit website.

Tips "Original artwork sold by artist. Artwork should be appropriately and reasonably priced."

✿ HOLIDAY ARTS & CRAFTS SHOW

60 Ida Lee Dr., Leesburg VA 20176. (703)777-1368. Fax: (703)737-7165. E-mail: lfountain@leesburgva.gov. Website: leesburgva.gov. **Contact:** Linda Fountain, program supervisor. Estab. 1990. Arts & crafts show held annually 1st weekend in December. Indoors. Accepts photography, jewelry, pottery, baskets, clothing, accessories. Juried. Number of exhibitors: 100. Public attendance: 4,000. Free to public. Artists should apply by downloading application from website. Deadline for entry: August 31. Space fee: $100-150. Exhibition space: 10 × 10 ft. For more information, artists should e-mail or visit website.

⚑ HOLIDAY CRAFTS AT MORRISTOWN

P.O. Box 28, Woodstock NY 12498. (845)331-7900. Fax: (845)331-7484. E-mail: crafts@ artrider.com. Website: www.craftsatmorristown.com; www.artrider.com. **Contact:** Laura Kandel. Estab. 1990. Fine arts & crafts show held annually in early December. Indoors. Accepts photography, wearable and nonwearable fiber, metal and nonmetal jewelry, clay, leather, wood, glass, painting, drawing, prints, mixed media. Juried by 5 images of work and 1 of booth, viewed sequentially. Number of exhibitors: 150. Public attendance: 5,000. Public admission: $7. Artists should apply by downloading application from www.artrider.com or can apply online at www.zapplication.org. Deadline for entry: July 1. Application fee: $45. Space fee: $475. Exhibition space: 10 × 10. For more information, artists should e-mail, visit website, call.

⊠ ⚑ HOLIDAY CRAFTS AT THE LEXINGTON AVENUE ARMORY

P.O. Box 28, Woodstock NY 12498.(845)331-7900. Fax: (845)331-7484. E-mail: crafts@artrider.com. Website: www.artrider.com. **Contact:** Laura Kandel. Estab. 1984. Fine craft and art show held annually in early December. Indoors. Accepts photography, wearable and nonwearable fiber, metal and nonmetal jewelry, clay, leather, wood, glass, painting, drawing, prints, mixed media. Juried by 5 images of work and 1 of booth, viewed sequentially. Number of exhibitors: 300. Public attendance: 14,000. Public admission: $10. Artists should apply by downloading application from www.artrider.com or can apply online at www.zapplication.org. Deadline for entry: July 1. Application fee: $45. Space fee: $1195. Exhibition space: 10 × 10. For more information, artists should e-mail, visit website, call.

⚑ HOLLY ARTS & CRAFTS FESTIVAL

P.O. Box 2122, Pinehurst NC 28370. (910)295-7462. E-mail: sbharrison@earthlink. net, pbguild@pinehurst.net. Website: www.pinehurstbusinessguild.com. **Contact:** Susan Harrison, Holly Arts & Crafts committee. Estab. 1978. Arts & crafts show held annually 3rd Saturday in October. Outdoors. Accepts quality photography, arts, and crafts. Juried based on uniqueness, quality of product, and overall display. Awards/ prizes: plaque given to Best in Show; 2 Honorable Mentions receive ribbons. Number of exhibitors: 200. Public attendance: 7,000. Free to the public. Artists should apply by filling out application form. Deadline for entry: March 31, 2010. Space fee: $75. Exhibition space: 10 × 10 ft. For more information, artists should e-mail, visit website, call, send SASE. Applications accepted after deadline if available space.

HOME, CONDO AND GARDEN ART & CRAFT FAIR

P.O. Box 486, Ocean City MD 21843. (410)524-7020. Fax: (410)524-0051. E-mail: oceanpromotions@beachin.net. Website: www.oceanpromotions.info. **Contact:** Mike, promoter; Starr, assistant. Estab. 1984. Fine arts & crafts show held annually

in March. Indoors. Accepts photography, carvings, pottery, ceramics, glass work, floral, watercolor, sculpture, prints, oils, pen & ink. Number of exhibitors: 125. Public attendance: 18,000. Public admission: $7/adults; $6/seniors & students; 13 and under free. Artists should apply by e-mailing request for info and aplication. Deadline for entry: Until full. Space fee: $250. Exhibition space: 10 × 10 ft. For more information, artists should e-mail, visit website or call.

HOME DECORATING & REMODELING SHOW

P.O. Box 230699, Las Vegas NV 89105-0699. (702)450-7984 or (800)343-8344. Fax: (702)451-7305. E-mail: spvandy@cox.net. Website: www.nashvillehomeshow.com. **Contact:** Vandy Richards, manager member. Estab. 1983. Home show held annually in September. Indoors. Accepts photography, sculpture, watercolor, oils, mixed media, pottery. Awards/prizes: Outstanding Booth Award. Number of exhibitors: 300-350. Public attendance: 25,000. Public admission: $8. Artists should apply by calling. Marketing is directed to middle and above income brackets. Deadline for entry: open until filled. Space fee: $900 + . Exhibition space: 9 × 10 ft. or complement of 9 × 10 ft. For more information, artists should call.

◪ STAN HYWET HALL & GARDENS WONDERFUL WORLD OF OHIO MART

714 N. Portage Path, Akron OH 44303-1399. (330)836-5533. Website: www. stanhywet.org. **Contact:** Lynda Grieves, exhibitor chair. Estab. 1966. Arts & crafts show held annually 1st full weekend in October. Outdoors. Accepts photography and all mediums. Juried 2 Saturdays in January and via mail application. Awards/prizes: Best Booth Display. Number of exhibitors: 115. Public attendance: 15,000-20,000. Public admission: $7. Deadline for entry: Mid-February. Space fee: $450. Exhibition space: 10 × 10 ft. For more information, artists should visit website or call.

◪ INTERNATIONAL FOLK FESTIVAL

P.O. Box 318, Fayetteville NC 28302-0318. (910)323-1776. Fax: (910)323-1727. E-mail: kelvinc@theartscouncil.com. Website: www.theartscouncil.com. **Contact:** Kelvin Culbreth, director of special events. Estab. 1978. Fine arts & crafts show held annually in late September. Outdoors. Accepts photography, painting of all mediums, pottery, woodworking, sculptures of all mediums. "Work must be original." Juried. Awards/prizes: $2,000 in cash prizes in several categories. Number of exhibitors: 120 + . Public attendance: 70,000. Free to public. Artists should apply on the website. Deadline for entry: September 1. Application fee: $60; includes space fee. Exhibition space: 10 × 10 ft. Average gross sales/exhibitor: $500. For more information, artists should e-mail or visit website.

Tips "Have reasonable prices."

☑ ISLE OF EIGHT FLAGS SHRIMP FESTIVAL

18 N. Second St., Ferninda Beach FL 32034. (904)271-7020. Fax: (904)261-1074. E-mail: mailbox@islandart.org. Website: www.islandart.org. **Contact:** Shrimp Festival Committee Chairperson. Estab. 1963. Fine arts & crafts show and community celebration held annually the 1st weekend in May. Outdoors. Accepts photography and all mediums. Juried. Awards/prizes: $9,700 in cash prizes. Number of exhibitors: 425. Public attendance: 150,000. Free to public. Artists should apply by downloading application from website. Deadline for entry: January 1. Application fee: $30. Space fee: $200. Exhibition space: 10 × 12 ft. Average gross sales/exhibitor: $1,500 + . For more information, artists should visit website.

Tips "Quality product and attractive display."

☑ JOHNS HOPKINS UNIVERSITY SPRING FAIR

3400 N Charles Street, Mattin Suite 210, Baltimore MD 21218. (410)513-7692. Fax: (410)516-6185. E-mail: springfair@gmail.com. Website: www.jhuspringfair.com. **Contact:** Catalina McCallum, arts & crafts chair. Estab. 1972. Fine arts & crafts, campus-wide, festival held annually in April. Outdoors. Accepts photography and all mediums. Juried. Number of exhibitors: 80. Public attendance: 20,000 + . Free to public. Artists should apply via website. Deadline for entry: March 1. Application fee: $200. Space fee: $200. Exhibition space: 10 × 10 ft. For more information, artists should e-mail, visit website or call.

Tips "Artists should have fun displays, good prices, good variety and quality pieces."

JUBILEE FESTIVAL

P.O. Drawer 310, Daphne AL 36526. (251)621-8222. Fax: (251)621-8001. E-mail: office@eschamber.com. Website: www.eschamber.com. **Contact:** Angela Kimsey, event coordinator. Estab. 1952. Fine arts & crafts show held in September in Olde Towne of Daphne, Alabama. Outdoors. Accepts photography and fine arts and crafts. Juried. Awards/prizes: ribbons and cash prizes. Number of exhibitors: 258. Public attendance: 200,000. Free to the public. Application fee: $25. Space fee: $265. Exhibition space: 10 ft. × 10 ft. For more information, artists should e-mail, call, see website.

☑ KIA ART FAIR (KALAMAZOO INSTITUTE OF ARTS)

314 S. Park St., Kalamazoo MI 49007-5102. (269)349-7775. Fax: (269)349-9313. E-mail: sjrodia@yahoo.com. Website: www.kiarts.org. **Contact:** Steve Rodia, artist coordinator. Estab. 1951. Fine arts & crafts show held annually the 1st Friday and Saturday in June. Outdoors. Accepts photography, prints, pastels, drawings, paintings, mixed media, ceramics (functional and nonfunctional), sculpture/metalsmithing,

wood, fiber, jewelry, glass, leather. Juried by no fewer than 3 and no more than 5 art professionals chosen for their experience and expertise. See prospectus for more details. Awards/prizes: 1st prize: $500; 2nd prize: 2 at $300 each; 3rd prize: 3 at $200 each. 10 category prizes at $100 each. Number of exhibitors: 200. Public attendance: 40,000-50,000. Free to the public. Artists should apply by filling out application form and submitting 3 digital images of their art and 1 digital image of their booth display. Deadline for entry: March 1. Application fee: $25, nonrefundable. Space fee: $110. Exhibition space: 10 × 12 ft. Height should not exceed 10 ft. in order to clear the trees in the park. For more information, artists should e-mail, visit website, call.

⚑ KINGS MOUNTAIN ART FAIR

13106 Skyline Blvd., Woodside CA 94062. (650)851-2710. E-mail: kmafsecty@ aol.com. **Contact:** Carrie German, administrative assistant. Website: www. kingsmountainartfair.org. Estab. 1963. Fine arts & crafts show held annually Labor Day weekend. Fundraiser for volunteer fire dept. Accepts photography, ceramics, clothing, 2D, painting, glass, jewelry, leather, sculpture, textile/fiber, wood. Juried. Number of exhibitors: 135. Public attendance: 10,000. Free to public. Deadline for entry: January 30. Application fee: $10. Space fee: $100 plus 15%. Exhibition space: 10 × 10 ft. Average gross sales/exhibitor: $3,000. For more information, artists should e-mail, visit website, call or send SASE.

⚑ KRASL ART FAIR ON THE BLUFF

707 Lake Blvd., St. Joseph MI 49085. (269)983-0271. Fax: (269)983-0275. E-mail: sshambarger @krasl.org. Website: www.krasl.org. **Contact:** Sara Shambarger, art fair director. Estab. 1962. Fine arts & crafts show held annually in July. Outdoors. Accepts photography, painting, digital art, drawing, pastels, wearable and nonwearable fiber art, glass, jewelry. Juried. (Returning artists do not have to re-jury or pay the $25 application fee.) Number of exhibitors: 216. Number of attendees: more than 70,000. Free to public. Artists should apply through Zapplication at www.zapplication.org. Deadline for entry: approximately mid-January. Application fee: $25. Space fee: $250. Exhibition space: 15 × 15 ft. or larger, $275. Average gross sales/exhibitor: $3,000. For more information, artists should e-mail or visit website.
Tips "Be willing to talk to people in your booth. You are your own best asset!"

⚑ LAKE CITY ARTS & CRAFTS FESTIVAL

P.O. Box 1147, Lake City CO 81235. (970)944-2706. E-mail: jlsharpe@centurytel. net. Website: www.lakecityarts.org. **Contact:** Laura Sharpe, festival director. Estab. 1975. Fine arts/arts & craft show held annually 3rd Tuesday in July. One-day event. Outdoors. Accepts photography, jewelry, metal work, woodworking, painting, handmade items. Juried by 3-5 undisclosed jurors. Prize: Winners are entered in a

drawing for a free both space in the following year's show. Number of Exhibitors: 85. Public Attendance: 500. Free to the public. Deadline for entry: entries must be postmarked April 25. Application fee: $75; nonrefundable jury fee: $10. Exhibition space: 12 × 12 ft. Average gross sales/exhibitor: $500-$1,000. For more information, artists should visit website.

Tips "Repeat vendors draw repeat customers. People like to see their favorite vendors each year or every other year. If you come every year, have new things as well as your best-selling products."

☑ LES CHENEAUX FESTIVAL OF ARTS

P.O. Box 30, Cedarville MI 49719. (906)484-2821. Fax: (906)484-6107. E-mail: lcha@ cedarville.net. Contact: A. Goehring, curator. Estab. 1976. Fine arts & crafts show held annually 2nd Saturday in August. Outdoors. Accepts photography and all other media; original work and design only; no kits or commercially manufactured goods. Juried by a committee of 10. Submit 4 slides (3 of the artwork; 1 of booth display). Awards/prizes: monetary prizes for excellent and original work. Number of exhibitors: 70. Public attendance: 8,000. Public admission: $7. Artists should fill out application form to apply. Deadline for entry: April 1. Application fee: $65. Exhibition space: 10 × 10 ft. Average gross sales/exhibitor: $5-$500. For more information, artists should call, send SASE.

☑ LILAC FESTIVAL ARTS & CRAFTS SHOW

333 N. Plymouth Av., Rochester NY 14608. (585)256-4960. Fax: (585)256-4968. E-mail: info@lilacfestival.com. Website: www.lilacfestival.com. **Contact:** Sue LeBeau, art show coordinator. Estab. 1985. Arts & crafts show held annually in May. Outdoors. Accepts photography, painting, ceramics, woodworking, metal sculpture, fiber. Juried by a panel. Number of exhibitors: 150. Public attendance: 25,000. Free to public. Deadline for entry: March 1. Application fee: $190. Space fee: $190. Exhibition space: 10 × 10 ft. For more information, artists should visit website or send SASE.

☑ LOMPOC FLOWER FESTIVAL

P.O. Box 723, Lompoc CA 93438. (805)735-9501. E-mail: web@willeyweb.com. Website: www.lompocvalleyartsassociation.com. **Contact:** Marie Naar, chairman. Estab. 1942. Fine arts & crafts show held annually last week in June. Event includes a parade, food booths, entertainment, beer garden and commercial center, which is not located near arts & crafts. Outdoors. Accepts photography, fine art, woodworking, pottery, stained glass, fine jewelry. Juried by 5 members of the Lompoc Valley Art Association. Vendor must submit 5 photos of their craft and a description on how to make the craft. Number of exhibitors: 95. Public attendance: 95,000 +. Free to

public. Artists should apply by calling the contact person for application or download application from website. Deadline for entry: April 1. Application fee: $173 plus insurance. Exhibition space: 16 × 16 ft. For more information, artists should visit website, call or send SASE.

Tips "Artists should have prices that are under $100 to succeed."

☘ LUTZ ARTS & CRAFTS FESTIVAL

P.O. Box 656, Lutz FL 33548-0656. (813)949-1937; (813)949-7060. Fax: (813)949-7060. **Contact:** Phyllis Hoedt, co-director; Shirley Simmons, co-director. Estab. 1979. Fine arts & crafts show held annually in December. Outdoors. Accepts photography, sculpture. Juried. Directors make final decision. Awards/prizes: $2,000 plus other cash awards. Number of exhibitors: 250. Public attendance: 35,000. Free to public. Deadline for entry: September 1 of each year or until category is filled. Application fee: $125. Exhibition space: 12 × 12 ft. For more information, artists should call or send SASE.

Tips "Have varied price range."

☘ MASON ARTS FESTIVAL

P.O. Box 381, Mason OH 45040. ((513)573-9376. E-mail: pgast@cinci.rr.com for Inside City Gallery; mraffel@cinci.rr.com for outdoor art festival. Website: www.masonarts. org. **Contact:** Pat Gastreich, City Gallery Chairperson. Fine arts and crafts show held annually in September. Indoors and outdoors. Accepts photography, graphics, printmaking, mixed media; painting and drawing; ceramics, metal sculpture; fiber, glass, jewelry, wood, leather. Juried. Awards/prizes: $3,000 + . Number of exhibitors: 75-100. Public attendance: 3,000-5,000. Free to the public. Artists should apply by visiting website for application, e-mailing mraffel@cinci.rr.com, or calling (513)573-0007. Deadline for entry: June. Application fee: $25. Space fee: $75 for single space; $135 for adjoining spaces. Exhibition space: 12 × 12 ft.; artist must provide 10 × 10 ft. pop-up tent.

- City Gallery show is held indoors; these artists are not permitted to participate outdoors and vice versa. City Gallery is a juried show featuring approximately 30-50 artists who may show up to 2 pieces.

Tips "Photographers are required to disclose both their creative and printing processes. If digital manipulation is part of the composition, please indicate."

☘ MEMORIAL WEEKEND ARTS & CRAFTS FESTIVAL

Castleberry Fairs & Festivals. 38 Charles St., Rochester NH 03867. (603)332-2616. E-mail: info@castleberryfairs.com. Website: www.castleberryfairs.com. **Contact:** Terry Mullen, event coordinator. Estab. 1989. Arts & crafts show held annually on Memorial Day weekend in Meredith, New Hampshire. Outdoors. Accepts photography

and all other mediums. Juried by photo, slide or sample. Number of exhibitors: 85. Public attendance: 7,500. Free to the public. Artists should apply by downloading application from website. Deadline for entry: until full. Space fee: $300. Exhibition space: 100 sq. ft. Average gross sales/exhibitor: "Generally, this is considered an 'excellent' show, so I would guess most exhibitors sell ten times their booth fee, or in this case, at least $3,000 in sales." For more information, artists should visit website.

Tips "Do not bring a book; do not bring a chair. Smile and make eye contact with everyone who enters your booth. Have them sign your guest book; get their e-mail address so you can let them know when you are in the area again. And, finally, make the sale—they are at the fair to shop, after all."

◪ MICHIGAN STATE UNIVERSITY SPRING ARTS & CRAFTS SHOW

322 MSU Union, East Lansing MI 48824. (517)355-3354. E-mail: uab@hfs.msu. edu. Website: www.uabevents.com. Contact: Kate Lake, assistant manager. Estab. 1963. Arts & crafts show held annually in mid-May. Outdoors. Accepts photography, basketry, candles, ceramics, clothing, sculpture, soaps, drawings, floral, fibers, glass, jewelry, metals, painting, graphics, pottery, wood. Juried by a panel of judges using the photographs submitted by each vendor to eliminate commercial products. They will evaluate on quality, creativity and crowd appeal. Number of exhibitors: 329. Public attendance: 60,000. Free to public. Artists can apply online beginning in February. Online applications will be accepted until show is filled. Application fee: $240. Exhibition space: 10x10 ft. For more information, artists should visit website or call.

◪ MID-MISSOURI ARTISTS CHRISTMAS ARTS & CRAFTS SALE

P.O. Box 116, Warrensburg MO 64093. (660)747-6092. E-mail: rlimback@iland.net. **Contact:** Beverly Smith. Estab. 1970. Holiday arts & crafts show held annually in November. Indoors. Accepts photography and all original arts and crafts. Juried by 3 good-quality color photos (2 of the artwork, 1 of the display). Number of exhibitors: 50. Public attendance: 1,200. Free to the public. Artists should apply by e-mailing or calling for an application form. Deadline for entry: November 1. Space fee: $50. Exhibition space: 10 × 10 ft. For more information, artists should e-mail or call.

Tips "Items under $100 are most popular."

◪ MOUNT GRETNA OUTDOOR ART SHOW

P.O. Box 637, Mount Gretna PA 17064. (717)964-3270. Fax: (717)964-3054. E-mail: mtgretnaart @comcast.net. Website: www.mtgretnaarts.com. **Contact:** Linda Bell, show committee chairperson. Estab. 1974. Fine arts & crafts show held annually 3rd full weekend in August. Outdoors. Accepts photography, oils, acrylics, watercolors,

mixed media, jewelry, wood, paper, graphics, sculpture, leather, clay/porcelain. Juried by 4 professional artists who assign each applicant a numeric score. The highest scores in each medium are accepted. Awards/prizes: Judges' Choice Awards: 30 artists are invited to return the following year, jury exempt; the top 10 are given a monetary award of $250. Number of exhibitors: 250. Public attendance: 15,000-19,000. Public admission: $7; children under 12: free. Artists should apply via www.zapplication. org. Deadline for entry: April 1. Application fee: $20 jury fee. Space fee: $300-350. Exhibition space: 10 × 12 ft. For more information, artists should e-mail, visit website, call.

⚑ NAPA WINE & CRAFTS FAIRE

1310 Napa Town Center, Napa CA 94559. (707)257-0322. Fax: (707)257-1821. E-mail: info@napa downtown.com. Website: www.napadowntown.com. **Contact:** Craig Smith, executive director. Wine and crafts show held annually in September. Outdoors. Accepts photography, jewelry, clothing, woodworking, glass, dolls, candles and soaps, garden art. Juried based on quality, uniqueness, and overall craft mix of applicants. Number of exhibitors: over 200. Public attendance: 20,000-30,000. Artists should apply by contacting the event coordinator, Marla Bird, at (707)299-0712 to obtain an application form. Application forms are also available on website. Application fee: $15. Space fee: $200. Exhibition space: 10 × 10 ft. For more information, artists should e-mail, visit website or call.

Tips "Electricity is available, but limited. There is a $40 processing fee for cancellations."

N ⚑ NEW ENGLAND ARTS & CRAFTS FESTIVAL

Castleberry Fairs & Festivals, 38 Charles St., Rochester NE 03867. (603)322-2616. E-mail: info@castleberryfairs.com. Website: www.castleberryfairs.com. **Contact:** Terry Mullen, event coordinator. Estab. 1988. Arts & crafts show held annually on Labor Day weekend in Topsfield, Massachusetts. Indoors and outdoors. Accepts photography and all other mediums. Juried by photo, slide or sample. Number of exhibitors: 250. Public attendance: 25,000. Public admission: $5 for adults: free for 13 and under. Artists should apply by downloading application from website. Deadline for entry: until full. Space fee: $350. Exhibition space: 100 sq. ft. Average gross sales/ exhibitor: "Generally, this is considered an 'excellent' show, so I would guess most exhibitors sell ten times their booth fee, or in this case, at least $3,500 in sales." For more information, artists should visit website.

Tips "Do not bring a book; do not bring a chair. Smile and make eye contact with everyone who enters your booth. Have them sign your guest book; get their e-mail address so you can let them know when you are in the area again. And, finally, make the sale—they are at the fair to shop, after all."

◪ NEW ENGLAND CRAFT & SPECIALTY FOOD FAIR

Castleberry Fairs & Festivals, 38 Charles Rd., Rochester NH 03867. (603)332-2616. E-mail: info@castleberryfairs.com. Website: www.castleberryfairs.com. **Contact:** Terry Mullen, event coordinator. Estab. 1995. Arts & crafts show held annually on Veteran's Day weekend in Salem, New Hampshire. Indoors. Accepts photography and all other mediums. Juried by photo, slide or sample. Number of exhibitors: 200. Public attendance: 15,000. Admissions: $6. Artists should apply by downloading application from website. Deadline for entry: until full. Space fee: $300. Exhibition space: 100 sq. ft. Average gross sales/exhibitor: "Generally, this is considered an 'excellent' show, so I would guess most exhibitors sell ten times their booth fee, or in this case, at least $3,000 in sales." For more information, artists should visit website.

Tips "Do not bring a book; do not bring a chair. Smile and make eye contact with everyone who enters your booth. Have them sign your guest book; get their e-mail address so you can let them know when you are in the area again. And, finally, make the sale—they are at the fair to shop, after all."

◪ NEW MEXICO ARTS & CRAFTS FAIR

P.O. Box 7279, Albuquerque NM 87194. (505)884-9043. Fax: (505)247-0608. E-mail: info@nm artsandcraftsfair.org. Website: www.nmartsandcraftsfair.org. **Contact:** Trish Behrmann, office manager. Estab. 1962. Fine arts & craft show held annually in June. Indoors and outdoors. Accepts photography, ceramics, fiber, digital art, drawing, jewelry—precious and nonprecious, printmaking, sculpture, wood, mixed media. **Only New Mexico residents 18 years and older are eligible.** Additional details for 2010 to be announced; see website for more details.

◪ OFFICIAL TEXAS STATE ARTS & CRAFTS FAIR

4000 Riverside Dr., Kerrville TX 78028. (830)896-5711. Fax: (830)896-5569. E-mail: fair@tacef.org. Website: www.tacef.org.

Tips "Market and advertise."

◪ ORCHARD LAKE FINE ART SHOW

P.O. Box 79, Milford MI 48381-0079. (248)684-2613. Fax: (248)684-0195. E-mail: patty@hot works.org. Website: www.hotworks.org. **Contact:** Patty Narozny, show director. Estab. 2002. Fine arts & crafts show held annually late July/early August. Outdoors. Accepts photography, clay, glass, fiber, wood, jewelry, painting, prints, drawing, sculpture, metal, multimedia. Juried by 3 art professionals who view 3 slides of work and 1 of booth. Awards/prizes: $2,500 in awards: 1 Best of Show: $1,000; 2 Purchase Awards: $500 each; 5 Awards of Excellence: $100 each. Free to the public; parking: $5. Artists can obtain an application on the website, or they

can call the show director who will mail them an application. Deadline for entry: March. Application fee: $25. Space fee: starts at $300. Exhibition space: 12 × 3 ft. "We allow room on either side of the tent, and some space behind the tent." For more information, artists should e-mail, visit website, call, send SASE.

Tips "Be attentive to your customers. Do not ignore anyone."

PANOPLY ARTS FESTIVAL, PRESENTED BY THE ARTS COUNCIL, INC.

700 Monroe St. SW, Suite 2, Huntsville AL 35801. (256)519-2787. Fax: (256)533-3811. E-mail: tac@panoply.org. Website: www.panoply.org; www.artshuntsville.org. Estab. 1982. Fine arts show held annually the last weekend in April. Also features music and dance. Outdoors. Accepts photography, painting, sculpture, drawing, printmaking, mixed media, glass, fiber. Juried by a panel of judges chosen for their in-depth knowledge and experience in multiple mediums, and who jury from slides or disks in January. During the festival 1 judge awards the various prizes. Awards/prizes: Best of Show: $1,000; Award of Distinction: $500; Merit Awards: 5 awards, $200 each. Number of exhibitors: 60-80. Public attendance: 140,000 + . Public admission: weekend pass: $10; 1-day pass: $5; children 12 and under: free. Artists should e-mail, call or write for an application form, or check online through November 1. Deadline for entry: January 2008. Application fee: $30. Space fee: $175 for space only; $375 including tent rental. Exhibition space: 10 × 10 ft. Average gross sales/exhibitor: $2,500. For more information, artists should e-mail.

PARADISE CITY ARTS FESTIVALS

30 Industrial Dr. E., Northampton MA 01060-2351. (800)511-9725. Fax: (413)587-0966. E-mail: artist@paradisecityarts.com. Website: www.paradisecityarts.com. **Contact:** Katherine Sanderson. Estab. 1995. Five fine arts & crafts shows held annually in March, April, May, October and November. Indoors. Accepts photography, all original art and fine craft media. Juried by 5 slides or digital images of work and an independent board of jury advisors. Number of exhibitors: 150-275. Public attendance: 5,000-20,000. Public admission: $12. Artists should apply by submitting name and address to be added to mailing list or print application from website. Deadline for entry: September 9. Application fee: $30-45. Space fee: $650-1,500. Exhibition space:8' to 10' deep; 10 to 20' wide. For more information, artists should e-mail, visit website or call.

PASEO ARTS FESTIVAL

3022 Paseo, Oklahoma City OK 73103. (405)525-2688. Website: www.ThePaseo. com. **Contact:** Lori Oden, executive director. Estab. 1976. Fine arts & crafts show held annually Memorial Day weekend. Outdoors. Accepts photography and all fine

art mediums. Juried by submitting 3 slides or CD. Awards/prizes: $1,000, Best of Show; $350, 2D; $350, 3D; $350, Best New Artist. Number of exhibitors: 75. Public attendance: 50,000-60,000. Free to public. Artists should apply by calling for application form. Deadline for entry: March 1. Application fee: $25. Space fee: $250. Exhibition space: 10 × 10 ft. For more information, artists should visit website, call or send SASE.

☑ PATTERSON APRICOT FIESTA

P.O. Box 442, Patterson CA 95363. (209)892-3118. Fax: (209)892-3388. E-mail: makecontact @patterson-ca.com. Website: www.patterson-ca.com. **Contact:** Chris Rodriguez, chairperson. Estab. 1984. Arts & crafts show held annually in May/June. Outdoors. Accepts photography, oils, leather, various handcrafts. Juried by type of product; number of artists already accepted; returning artists get priority. Number of exhibitors: 140-150. Public attendance: 25,000. Free to the public. Deadline for entry: approximately April 15. Application fee/space fee: $130. Exhibition space: 12 × 12 ft. For more information, artists should call, send SASE.

Tips "Please get your applications in early!"

☑ PETERS VALLEY ANNUAL CRAFT FAIR

19 Kuhn Rd., Layton NJ 07851. (973)948-5200. Fax: (973)948-0011. E-mail: craft.fair@ peters valley.org. Website: www.petersvalley.org. Contact: Gail Leypoldt, craft fair coordinator. Estab. 1970. Arts & crafts show held annually in late September at the Sussex County Fair Grounds in Augusta, New Jersey. Indoors. Accepts photography, ceramics, fiber, glass, basketry, metal, jewelry, sculpture, printmaking, paper book art, drawing, painting. Juried. Awards/prizes: cash awards. Number of exhibitors: 180. Public attendance: 8,000-10,000. Public admission: $7. Artists should apply by downloading application from website. Deadline for entry: May 15. Application fee: $30. Space fee: $385. Exhibition space: 10x10 ft. Average gross sales/exhibitor: $2,000-5,000. For more information artists should e-mail, visit website, call or send SASE.

PUNGO STRAWBERRY FESTIVAL

P.O. Box 6158, Virginia Beach VA 23456. (757)721-6001. Fax: (757)721-9335. E-mail: pungo festival@aol.com. Website: www.PungoStrawberryFestival.info. **Contact:** Janet Dowdy, secretary of board. Estab. 1983. Arts & crafts show held annually on Memorial Day Weekend. Outdoors. Accepts photography and all media. Number of exhibitors: 60. Public attendance: 120,000. Free to Public; $5 parking fee. Artists should apply by calling for application or downloading a copy from the website and mail in. Deadline for entry: March 1; applications accepted from that point until all spaces are full. Application fee: $50 refundable deposit. Space fee: $175. Exhibition space: 10 × 10 ft. For more information, artists should e-mail, visit website or call.

🔲 RILEY FESTIVAL

312 E. Main St. #C, Greenfield IN 46140. (317)462-2141. Fax: (317)467-1449. E-mail: info@rileyfestival.com. Website: www.rileyfestival.com. **Contact:** Sarah Kesterson, office manager. Estab. 1970. Fine arts & crafts show held October 7-10, 2010. Outdoors. Accepts photography, fine arts, home arts, quilts. Juried. Awards/prizes: small monetary awards and ribbons. Number of exhibitors: 450. Public attendance: 75,000. Free to public. Artists should apply by downloading application on website. Deadline for entry: August 15. Space fee: $185. Exhibition space: 10 × 10 ft. For more information, artists should visit website.

Tips "Keep arts priced for middle-class viewers."

🔲 RIVERBANK CHEESE & WINE EXPOSITION

6618 Third St., Riverbank CA 95367. (209)863-9600. Fax: (209)863-9601. E-mail: events@river bankcheeseandwine.or. Website: www.riverbankcheeseandwine.org. **Contact:** Suzi DeSilva. Estab. 1977. Arts & crafts show and food show held annually 2nd weekend in October. Outdoors. Accepts photography, other mediums depends on the product. Juried by pictures and information about the artists. Number of exhibitors: 400. Public attendance: 70,000-80,000. Free to public. Artists should apply by calling and requesting an application. Deadline for entry: June 30. Space fee: $260/arts & crafts; $380/commercial. Exhibition space: 10 × 12 ft. For more information, artists should e-mail, visit website, call or send SASE.

Tips "Make sure your display is pleasing to the eye."

ROYAL OAK OUTDOOR ART FAIR

PO Box 64, Royal Oak MI 48068-0064. (248)246-3180. Fax: (248)246-3007. E-mail: artfaire@ci.royal-oak.mi.us. Website: www.ci.royal-oak.mi.us/rec/r7.html. **Contact**: Recreation Office Staff. Events & Membership. Estab. 1970. Fine arts & crafts show held annually in July. Outdoors. Accepts photography, collage, jewelry, clay, drawing, painting, glass, wood, metal, leather, soft sculpture. Juried. Number of exhibitors: 110. Public attendance: 25,000. Free to pubic. Artists should apply with application form and 3 slides of current work. Deadline for entry: March 1. Application fee: $20. Space fee: $250. Exhibition space: 15 × 15 ft. For more information, artists should e-mail or call.

Tips "Be sure to label your slides on the front with name, size of work and 'top'."

🔲 SACO SIDEWALK ART FESTIVAL

P.O. Box 336, 146 Main St., Saco ME 04072. (207)286-3546. E-mail: sacospirit@hotmail.com. Website: www.sacospirit.com.

Tips "Offer a variety of pieces priced at various levels."

⚐ SANDY SPRINGS FESTIVAL

Heritage Sandy Springs, 6110 Bluestone Rd., Sandy Springs GA 30328. (404)851-9111. Fax: (404)851-9807. E-mail: info@sandyspringsfestival.org. Website: www.sandyspringsfestival.com. **Contact:** Christy Nickles, special events director. Estab. 1985. Fine arts & crafts show held annually in mid-September. Outdoors. Accepts photography, painting, sculpture, jewelry, furniture, clothing. Juried by area professionals and nonprofessionals who are passionate about art. Awards/prizes: change annually; usually cash with additional prizes. Number of exhibitors: 100 +. Public attendance: 20,000. Public admission: $5. Artists should apply via application on website. Application fee: $10 ($35 for late registration). Space fee: $150. Exhibition space: 10 × 10 ft. Average gross sales/exhibitor: $1,000. For more information, artists should visit website.

Tips "Most of the purchases made at Sandy Springs Festival are priced under $100. The look of the booth and its general attractiveness are very important, especially to those who might not 'know' art."

⚐ SANTA CALI GON DAYS FESTIVAL

210 W. Truman Road, Independence MO 64051. (816)252-4745. Fax: (816)252-4917. E-mail: tfreeland@independencechamber.org. Website: www.santacaligon.com. **Contact:** Teresa Freeland, special projects assistant. Estab. 1973. Market vendors show held annually Labor Day weekend. Outdoors. Accepts photography, all other mediums. Juried by committee. Number of exhibitors: 240. Public attendance: 225,000. Free to public. Artists should apply by requesting application. Application requirements include completed application, application fee, 4 photos of product/art and 1 photo of display. Deadline for entry: March 6-April 7. Application fee: $20. Space fee: $330-430. Exhibition space: 8 × 8 ft.-10 × 10 ft. For more information, artists should e-mail, visit website or call.

⚐ SAUSALITO ART FESTIVAL

P.O. Box 10, Sausalito CA 94966. (415)332-3555. Fax: (415)331-1340. E-mail: info@ sausalitoartfestival.org; apply@sausalitoartfestival.org. Website: www.sausalitoartfestival.org. **Contact:** Tracy Bell Redig, festival coordinator. Estab. 1952. Fine arts & crafts show held annually Labor Day weekend. Outdoors. Accepts painting, photography, 2D and 3D mixed media, ceramics, drawing, fiber, functional art, glass, jewelry, printmaking, sculpture, watercolor, woodwork. Juried. Jurors are elected by their peers from the previous year's show (1 from each category). They meet for a weekend at the end of March and give scores of 1, 2, 3, 4 or 5 to each applicant (5 being the highest). Awards/prizes: $500 for each 1st and 2nd Place in each category; optional $1,000 for Best in Show. Number of exhibitors: 270. Public attendance: 40,000. Public admission: $20; seniors (age 62 +): $10; children (under 6): $5. Artists

should apply by visiting website for instructions and application. Applications are through Juried Art Services. Deadline for entry: March. Application fee: $50. Space fee: $1050-2,800. Exhibition space: 100 or 200 sq. ft. Average gross sales/exhibitor: $14,000. For more information, artists should visit website.

▨ ▨ SCOTTSDALE ARTS FESTIVAL

7380 E. 2nd St., Scottsdale AZ 85251. (480)994-2787. Fax: (480)874-4699. E-mail: festival @sccarts.org. Website: www.scottsdaleartsfestival.org. **Contact:** Debbie Rauch, artist coordinator. Estab. 1970. Fine arts & crafts show held annually in March. Outdoors. Accepts photography, jewelry, ceramics, sculpture, metal, glass, drawings, fiber, paintings, printmaking, mixed media, wood. Juried. Awards/prizes: 1st, 2nd, 3rd Places in each category and Best of Show. Number of exhibitors: 200. Public attendance: 40,000. Public admission: $7. Artists should apply through www. zapplication.org. Deadline for entry: October. Application fee: $25. Space fee: $415. Exhibition space: 100 sq. ft. For more information, artists should visit website.

▨ SIERRA MADRE WISTARIA FESTIVAL

37 Auburn Ave., Suite 1, Sierra Madre CA 91024. (626)355-5111. Fax: (626)306-1150. E-mail: info@sierramadrechamber.com. Website: www.SierraMadrechamber.com. Estab. 100 years ago. Fine arts, crafts and garden show held annually in March. Outdoors. Accepts photography, anything handcrafted. Juried. Craft vendors send in application and photos to be juried. Most appropriate are selected. Awards/prizes: Number of exhibitors: 175. Public attendance: 12,000. Free to public. Artists should apply by sending completed and signed application, 3-5 photographs of their work, application fee, license application, space fee and 2 SASEs. Deadline for entry: December 20. Application fee: $25. Space fee: $175 and a city license fee of $29. Exhibition space: 10 × 10 ft. For more information, artists should e-mail, visit website or call.
Tips "Have a clear and simple application. Be nice."

▨ SOLANO AVENUE STROLL

1563 Solano Ave. #PMB 101, Berkeley CA 94707. (510)527-5358. E-mail: SAA@ solano avenueassn.org. Website: www.solanoave.org. **Contact:** Allen Cain, executive director. Estab. 1974. Fine arts & crafts show held annually 2nd Sunday in September. Outdoors. Accepts photography and all other mediums. Juried by board of directors. Jury fee: $10. Number of exhibitors: 140 spaces for crafts; 600 spaces total. Public attendance: 300,000. Free to the public. Artists should apply online after April 1, or send SASE. Deadline for entry: June 1. Space fee: $10. Exhibition space: 10 × 10 ft. For more information, artists should e-mail, visit website, send SASE.
Tips "Artists should have a clean presentation; small-ticket items as well as large-ticket items; great customer service; enjoy themselves."

⚑ SPRING CRAFTS AT LYNDHURST

P.O. Box 28, Woodstock NY 12498. (845)331-7900. Fax: (845)331-7484. E-mail: crafts@ artrider.com. Website: www.craftsatlyndhurst.com; www.artrider.com. **Contact:** Laura Kandel. Estab. 1984. Fine arts & crafts show held annually in early May. Outdoors. Accepts photography, wearable and nonwearable fiber, metal and nonmetal jewelry, clay, leather, wood, glass, painting, drawing, prints, mixed media. Juried by 5 images of work and 1 of booth, viewed sequentially. Number of exhibitors: 300. Public attendance: 14,000. Public admission: $10. Artists should apply by downloading application from www.artrider.com or can apply online at www.zapplication.org. Deadline for entry: January 1. Application fee: $45. Space fee: $750. Exhibition space: 10 × 10. For more information, artists should e-mail, visit website, call.

⚑ SPRING CRAFTS AT MORRISTOWN

P.O. Box 28, Woodstock NY 12498. (845) 331 -7900. E-mail: crafts@artrider.com. Website: www.craftsatmorristown.com; www.artrider.com. **Contact:** Laura Kandel. Estab. 1990. Fine arts & crafts show held annually beginning of April. Indoors. Accepts photography, wearable and nonwearable fiber, metal and nonmetal jewelry, clay, leather, wood, glass, painting, drawing, prints, mixed media. Juried by 5 images of work and 1 of booth, viewed sequentially. Number of exhibitors: 150. Public attendance: 5,000. Public admission: $7. Artists should apply by downloading application from www.artrider.com or apply online at www.zapplication.org. Deadline for entry: January 1. Application fee: $45. Space fee: $475. Exhibition space: 10 × 10 ft. For more information, artists should e-mail, visit website, call.

SPRINGFEST

P.O. Box 831, Southern Pines NC 28388. (910)315-6508. E-mail: spba@earthlink.net. Website: www.southernpines.biz. **Contact:** Susan Harrison, booth coordinator. Estab. 1979. Arts & crafts show held annually last Saturday in April. Outdoors. Accepts photography and crafts. Number of exhibitors: 200. Public attendance: 8,000. Free to the public. Artists should apply by filling out application form. Deadline for entry: March 15, 2010. Space fee: $75. Exhibition space: 10 × 12 ft. For more information, artists should e-mail, visit website, call, send SASE. Application online in fall 2009.

SPRINGFEST AND SEPTEMBERFEST

PO Box 677, Nyack NY 10960-0677. (845)353-2221. Fax: (845)353-4204. Website: www.nyack-ny.com. **Contact:** Lorie Reynolds, executive director. Estab. 1980. Arts & crafts show held annually in April and September. Outdoors. Accepts photography, pottery, jewelry, leather, clothing. Number of exhibitors: 220. Public attendance: 30,000. Free to public. Artists should apply by submitting application, fees, permits, photos of product and display. Deadline for entry: 15 days before show. Space fee:

$175. Exhibition space: 10 × 10 ft. For more information, artists should visit website, call or send SASE.

Ⓝ ⓩ SPRING FESTIVAL, AN ARTS & CRAFTS AFFAIR

P.O. Box 184, Boys Town NE 68010. (402)331-2889. Fax: (402)445-9177. E-mail: hpifestivals@cox.net. Website: www.hpifestivals.com. **Contact:** Huffman Productions. Estab. 1983. Fine arts & craft show held annually in April. Indoors. Accepts photography, pottery, stained glass, jewelry, clothing, furniture, paintings, baskets, etc. All must be handcrafted by the exhibitor. Juried by 2 photos of work and 1 of display. Awards/prizes: $420 total cash awards. Number of exhibitors: 400. Public attendance: 15,000. Public admission: $6-8. Artists should apply by calling for an application. **Deadline:** Until a category is full. Space fee: $400. Exhibition space: 8 × 11 ft. ("We provide pipe and drape.") For more information, artists should e-mail, visit website, call, send SASE.

Tips "Make sure to send good, crisp photos that show your current work and display. This gives you your best chance with jurying a show."

ⓩ SPRING FINE ART & CRAFTS AT BROOKDALE PARK

12 Galaxy Court, Hillsborough NJ 08844. (908)874-5247. Fax: (908)874-7098. E-mail: rosesquared@patmedia.net. Website: www.rosesquared.com. **Contact:** Janet Rose, president. **Contact:** Estab.1988. Fine arts & craft show held annually in mid-June. Outdoors. Accepts photography and all other mediums. Juried. Number of exhibitors: 180. Public attendance: 16,000. Free to the public. Artists should apply by downloading application from website or call for application. Deadline: 1 month before show date. Application fee: $15. Space fee: $310. Exhibition space: 120 sq. ft. For more information, artists should e-mail, visit website, call.

Tips "Create a professional booth that is comfortable for the customer to enter. Be informative, friendly and outgoing. People come to meet the artist."

ⓩ ST. CHARLES FINE ART SHOW

213 Walnut St., St. Charles IL 60174. (630)513-5386. Fax: (630)513-6310. E-mail: david@dtown.org. Website: www.stcharlesfineartshow.com. Estab. 1999. Fine art fair held annually in late May. Outdoors. Accepts photography, painting, sculpture, glass, ceramics, jewelry, nonwearable fiber art. Juried by committee: submit 4 slides of art and 1 slide of booth/display. Awards/prizes: Cash awards of $3,500 awarded in several categories. Purchase Award Program: $14,000 of art has been purchased through this program since its inception in 2005. Number of exhibitors: 100. Free to the public. Artists should apply by downloading application or call for application. Deadline for entry: February. Jury fee: $25. Space fee: $200. Exhibition space: 12 × 12 ft. For more information, artists should e-mail, visit website, call.

STEPPIN' OUT

P.O. Box 233, Blacksburg VA 24063. (540)951-0454. E-mail: dmob@ downtownblacksburg.com. Website: www.downtownblacksburg.com. **Contact:** Laureen Blakemore, director. Estab. 1981. Arts & crafts show held annually 1st Friday and Saturday in August. Outdoors. Accepts photography, pottery, painting, drawing, fiber arts, jewelry, general crafts. Number of exhibitors: 170. Public attendance: 45,000. Free to public. Artists should apply by e-mailing, calling or by downloading application on website. Space fee: $150. For more information, artists should e-mail, visit website or call.

Tips "Visit shows and consider the booth aesthetic—what appeals to you. Put the time, thought, energy and money into your booth to draw people in to see your work."

ST. JAMES COURT ART SHOW

P.O. Box 3804, Louisville KY 40201. (502)635-1842. Fax: (502)635-1296. E-mail: mesrock@ stjamescourtartshow.com. Website: www.stjamescourtartshow.com. **Contact:** Marguerite Esrock, executive director. Estab. 1957. Annual fine arts & crafts show held the first full weekend in October. Accepts photography; has 16 medium categories. Juried in March; there is also a street jury held during the art show. Awards/prizes: Best of Show—3 places; $7,500 total prize money. Number of exhibitors: 300. Public attendance: 275,000. Free to the public. Artists should apply by visiting website and printing out an application or via www.zapplication.org. Deadline for entry in 2010 show: March 31, 2010. Application fee: $30. Space fee: $500. Exhibition space: 10 × 12 ft. For more information, artists should e-mail or visit website.

Tips "Have a variety of price points. Don't sit in the back of the booth and expect sales."

STOCKLEY GARDENS FALL ARTS FESTIVAL

801 Boush St., Norfolk VA 23510. (757)625-6161. Fax: (757)625-7775. E-mail: skaplan@hope-house.org. Website: www.hope-house.org. **Contact:** Stephanie Kaplan, development coordinator. Estab. 1984. Fine arts & crafts show held annually 3rd weekend in October. Outdoors. Accepts photography and all major fine art mediums. Juried. Number of exhibitors: 150. Public attendance: 30,000. Free to the public. Artists should apply by submitting application, jury and booth fees, 5 slides. Deadline for entry: July. Application fee: $15. Space fee: $225. Exhibition space: 10 × 10 ft. For more information, artists should e-mail, visit website, call.

STONE ARCH FESTIVAL OF THE ARTS

219 Main St. SE, Suite 304, Minneapolis MN 55414. (612)623-8347. Fax: (612)623-

8348. E-mail: info@kemteck.com. Website: www.stonearchfestival.com. **Contact:** Sara Collins, manager. Estab. 1994. Fine arts & crafts show and culinary arts show held annually Father's Day weekend. Outdoors. Accepts photography, painting, ceramics, jewelry, fiber, printmaking, wood, metal. Juried by committee. Awards/prizes: free booth the following year; $100 cash prize. Number of exhibitors: 230. Public attendance: 80,000. Free to public. Artists should apply by application found on website or through www.zapplication.org. Deadline for entry: March 15. Application fee: $20 jury. Space fee: $250-300. Exhibition space: 10 × 10 ft. For more information, artists should e-mail, visit website, call or send SASE.

Tips "Have an attractive display and variety of prices."

STRAWBERRY FESTIVAL

2815 2nd Ave. N., Billings MT 59101. (406)294-5060. Fax: (406)294-5061. E-mail: lisaw@ downtownbillings.com. Website: www.strawberryfun.com. **Contact:** Lisa Woods, executive director. Estab. 1991. Fine arts & crafts show held annually 2nd Saturday in June. Outdoors. Accepts photography. Juried. Number of exhibitors: 76. Public attendance: 15,000. Free to public. Artists should apply by application available on the website. Deadline for entry: April 14. Exhibition space: 12 × 12 ft. For more information, artists should visit website.

STREET FAIRE AT THE LAKES

PO Box 348, Detroit Lakes MN 56502. (800)542-3992. Fax: (218)847-9082. E-mail: dlchamber @visitdetroitlakes.com. Website: www.dlstreetfaire.com. **Contact:** Sue Braun, artist coordinator. Estab. 2001. Fine arts & crafts show held annually 1st weekend after Memorial Day. Outdoors. Accepts photography, handmade/original artwork, wood, metal, glass, painting, fiber. Juried by anonymous scoring. Submit 4 digital images, 3 of work and 1 of booth display. Top scores are accepted. Number of exhibitors: 125. Public attendance: 15,000. Free to public. Artists should apply by downloading application from website. Deadline for entry: January 15. Application fee: $150-175. Exhibition space: 11 × 11 ft. For more information, artists should e-mail or call.

SUMMER ARTS & CRAFTS FESTIVAL

Castleberry Fairs & Festivals, 38 Charles St., Rochester NH 03867. (603)332-2616. Fax: (603)332-8413. E-mail: info@castleberryfairs.com. Website: www.castleberryfairs.com. **Contact:** Terry Mullen, events coordinator. Estab. 1992. Arts & crafts show held annually 2nd weekend in August in Lincoln, New Hampshire. Outdoors. Accepts photography and all other mediums. Juried by photo, slide or sample. Number of exhibitors: 100. Public attendance: 7,500. Free to the public. Artists should apply by downloading application from website. Deadline for entry: until full. Space fee: $200. Exhibition space: 100 sq. ft. For more information, artists should visit website.

Tips "Do not bring a book; do not bring a chair. Smile and make eye contact with everyone who enters your booth. Have them sign your guest book; get their e-mail address so you can let them know when you are in the area again. And, finally, make the sale—they are at the fair to shop, after all."

⚑ SUMMERFAIR

7850 Five Mile Road, Cincinnati OH 45230. (513)531-0050. Fax:(513)531-0377. E-mail: exhibitors@summerfair.org. Website: www.summerfair.org. **Contact:** Sharon Strubbe. Estab. 1968. Fine arts & crafts show held annually the weekend after Memorial Day. Outdoors. Accepts photography, ceramics, drawing/printmaking, fiber/leather, glass, jewelry, painting, sculpture/metal, wood. Juried by a panel of judges selected by Summerfair, including artists and art educators with expertise in the categories offered at Summerfair, including artists and art educators with expertise in the categories offered at Summerfair. Submit application with 5 digital images (no booth image) through ZAPPlication. Awards/prizes: $10,000 in cash awards. Number of exhibitors: 300. Public attendance: 20,000. Public admission: $10. Artists should apply through ZAPP (available in December). Deadline: February. Application fee: $30. Space fee: $375, single space; $750, double space; $75 canopy fee (optional—exhibitors can rent a canopy for all days of the fair.). Exhibition space: 10 × 20 ft. for single space; 10 × 20 for double space. For more information, artists should e-mail, visit website, call.

⚑ TARPON SPRINGS FINE ARTS FESTIVAL

11 E. Orange St., Tarpon Springs FL 34689. (727)937-6109. Fax: (727)937-2879. E-mail: chamber @tarponspringschamber.org. Website: www.tarponsprings.com. **Contact:** Sue Thomas, president. Estab. 1974. Fine arts & crafts show held annually in April. Outdoors. Accepts photography, acrylic, oil, ceramics, fiber, glass, graphics, drawings, pastels, jewelry, leather, metal, mixed media, sculpture, watercolor, wood. Juried by CD. Awards/prizes: cash and ribbons. Number of exhibitors: 250. Public attendance: 20,000. Public admission: $2; under 16 free. Artists should apply by submitting signed application, slides, fees and SASE. Deadline for entry: mid-December. Jury fee: $25 + . Space fee: $175 + . Exhibition space: 10 × 12 ft. For more information artists should e-mail, call or send SASE.
Tips "Produce good slides for jurors."

⚑ TUBAC FESTIVAL OF THE ARTS

P.O. Box 1866, Tubac AZ 85646. (520)398-2704. Fax: (520)398-1704. E-mail: artfestival@ tubacaz.com. Website: www.tubacaz.com. Estab. 1959. Fine arts & crafts show held annually in early February. Next date: February 10-14, 2010. Outdoors. Accepts photography and considers all fine arts and crafts. Juried. A 7-member panel

reviews digital images and artist statement. Jury process is blind—applicants' names are withheld from the jurists. Number of exhibitors: 170. Public attendance: 80,000. Free to the public; parking: $6. Applications for the 2009 festival will be available and posted on website mid-summer 2009. Deadline for entry: October 30. Application fee: $25. Space fee: $575 for 10 × 10 ft. space. For more information, artists should e-mail, visit website, call, send SASE.

☑ TULIP FESTIVAL STREET FAIR

P.O. Box 1801, Mt. Vernon WA 98273. (360)336-3801. E-mail: exmvdt@cnw.com. Website: www.mountvernondowntown.org. **Contact:** Executive Director. Estab. 1984. Arts & crafts show held annually 3rd weekend in April. Outdoors. Accepts photography and original artists' work only. No manufactured work. Juried by a board. Jury fee: $10 with application and prospectus. Number of exhibitors: 215-220. Public attendance: 20,000-25,000. Free to public. Artists should apply by calling or e-mailing. Deadline for entry: January 30. Application fee: $10. Flat fee: $300. Exhibition space: 10 × 10 ft. Average gross sales/exhibitor: $2,500-4,000. For more information, artists should e-mail, visit website, call or send SASE.

Tips "Keep records of your street fair attendance and sales for your résumé. Network with other artists about which street fairs are better to return to or apply for."

☑ TULSA INTERNATIONAL MAYFEST

P.O. Box 521146, Tulsa OK 74103. (918)582-6435. Fax: (918)587-7721. E-mail: comments @tulsamayfest.org. Website: www.tulsamayfest.org. Estab. 1972. Fine arts & crafts show annually held in May. Outdoors. Accepts photography, clay, leather/fiber, mixed media, drawing, pastels, graphics, printmaking, jewelry, glass, metal, wood, painting. Juried by a blind jurying process. Artists should apply online at www.zapplication.org and submit 4 photos of work and 1 of booth set-up. Awards/prizes: Best in Category and Best in Show. Number of exhibitors: 120. Public attendance: 350,000. Free to public. Artists should apply by downloading application in late November. Deadline for entry: January 16. Application fee: $35. Space fee: $300. Exhibition space: 10 × 10 ft. For more information, artists should e-mail or visit website.

☑ UPTOWN ART FAIR

1406 West Lake St., Suite 202, Minneapolis MN 55408. (612)823-4581. Fax: (612)823-3158. E-mail: info@uptownminneapolis.com. Website: www.uptownminneapolis.com. **Contact:** Cindy Fitzpatrick. Estab. 1963. Fine arts & crafts show held annually 1st full weekend in August. Outdoors. Accepts photography, painting, printmaking, drawing, 2D and 3D mixed media, ceramics, fiber, sculpture, jewelry, wood. Juried by 4 images of artwork and 1 of booth display. Awards/prizes: Best in Show in each

category; Best Artist. Number of exhibitors: 350. Public attendance: 375,000. Free to the public. Artists should apply by visiting www.zapplication.com. Deadline for entry: March. Application fee: $30. Space fee: $450 for 10 × 10 space; $900 for 10 × 20 space. For more information, artists should call or visit website.

◪ A VICTORIAN CHAUTAUQUA

1101 E Market St., P.O. Box 606, Jeffersonville IN 47131-0606. (812) 283-3728. Fax: (812)283-6049. E-mail: hsmsteam@aol.com. Website: www.steamboatmuseum.org. **Contact:** Yvonne Knight, administrator. Estab. 1993. Fine arts & crafts show held annually 3rd weekend in May. Outdoors. Accepts photography, all mediums. Juried by a committee of 5. Awards/prizes: $100, 1st Place; $75, 2nd Place; $50, 3rd Place. Number of exhibitors: 80. Public attendance: 3,000. Public admission: $3. Deadline for entry: March 31. Space fee: $40-60. Exhibition space: 12 × 12 ft. For more information, artists should e-mail or call.

◪ VIRGINIA CHRISTMAS SHOW

(24th Annual) P.O. Box 305, Chase City VA 23924. (434)372-3996. Fax: (434)372-3410. E-mail: vashowsinc@aol.com. **Contact:** Patricia Wagstaff, coordinator. Estab. 1986. Holiday arts & crafts show held annually 1st week in November in Richmond, Virginia. Indoors at The Showplace. Accepts photography and other arts and crafts. Juried by 3 slides of artwork and 1 of display. Awards/prizes: Best Display. Number of exhibitors: 350. Public attendance: 25,000. Public admission: $7. Artists should apply by writing or e-mailing for an application. Space fee: $400. Exhibition space: 10 × 10 ft. For more information, artists should e-mail, send SASE.

Tips "If possible, attend the shows before you apply. 22nd annual Virginia Spring show March 12-14, 2010 is held at the same facility. Fee is $300. Requirements same as above."

◪ VIRGINIA SPRING SHOW

11050 Branch Rd., Glen Allen VA 23059. (804)253-6284. Fax: (804)253-6285. E-mail: vashowsinc.@aol.com. **Contact:** Bill Wagstaff, coordinator. Estab. 1988. Holiday arts & crafts show held annually 2nd weekend in March in Richmond, Virginia. Indoors at the Showplace Exhibition Center. Accepts photography and other arts and crafts. Juried by 3 slides of artwork and 1 of display. Awards/prizes: Best Display. Number of exhibitors: 300. Public attendance: 20,000. Public admission: $7. Artists should apply by writing or e-mailing for an application. Space fee: $300. Exhibition space: 10 × 10 ft. For more information, artists should e-mail.

Tips "If possible, attend the show before you apply."

☑ WASHINGTON SQUARE OUTDOOR ART EXHIBIT

P.O. Box 1045, New York NY 10276. (212)982-6255. Fax: (212)982-6256. E-mail: jrm.wsoae@ gmail.com. Website: www.washingtonsquareoutdoorartexhibit.org. **Contact:** Margot J. Lufitg, executive director. Estab. 1931. Fine arts & crafts show held semiannually Memorial Day weekend and the following weekend in May/ early June and Labor Day weekend and following weekend in September. Outdoors. Accepts photography, oil, watercolor, graphics, mixed media, sculpture, crafts. Juried by submitting 5 slides of work and 1 of booth. Awards/prizes: certificates, ribbons and cash prizes. Number of exhibitors: 200. Public attendance: 200,000. Free to public. Artists should apply by sending a SASE or downloading application from website. Deadline for entry: March, Spring Show; July, Fall Show. Application fee: $20. Exhibition space: 10 × 5 ft. For more information, artists should call or send SASE.

Tips "Price work sensibly."

☑ WESTMORELAND ART NATIONALS

252 Twin Lakes Rd., Latrobe PA 15650-3554. (724)834-7474. E-mail: info@ artsandheritage.com. Website: www.artsandheritage.com. **Contact:** Diana Morreo, executive director. Estab. 1975. Fine arts & crafts show held annually in July. Photography displays are indoors. Accepts photography, all mediums. Juried: 2 jurors review slides. Awards/prizes: $5,000 + in prizes. Number of exhibitors: 200. Public attendance: 100,000. Free to public. WAN exhibits shown at Westmoreland County Community College June 1-12 and Westmoreland Arts & Heritage Festival Juli 1-4. Artists should apply by downloading application from website. Application fee: $35/ craft show vendors; $25/fine art/photography exhibitors. Space fee: $350. Vendor/ exhibition space: 10 × 10 ft. For more information, artists should visit website or call Festival office.

☑ WHITEFISH ARTS FESTIVAL

P.O. Box 131, Whitefish MT 59937. (406)862-5875. Fax: (406)862-3515. Website: www.whitefishartsfestival.org. **Contact:** Rachael Knox, coordinator. Estab. 1979. Fine arts & crafts show held annually 1st full weekend in July. Outdoors. Accepts photography, pottery, jewelry, sculpture, paintings, woodworking. Juried. Art must be original and handcrafted. Work is evaluated for creativity, quality and originality. Awards/prizes: Best of Show awarded half-price booth fee for following year with no application fee. Number of exhibitors: 100. Public attendance: 3,000. Free to public. Deadline for entry: April 14. Application fee: $20. Space fee: $195. Exhibition space: 10 × 10 ft. For more information, artists should e-mail, visit website or call.

Tips Recommends "variety of price range, professional display, early application for special requests."

◪ WILD WIND FOLK ART & CRAFT FESTIVAL

719 Long Lake, New York NY 12847. (814)723-0707 or (518)624-6404. E-mail: wildwind craftshow@yahoo.com. Website: www.wildwindfestival.com. **Contact:** Liz Allen or Carol Jilk, promoters. Estab. 1979. Fine arts & traditional crafts show held annually the weekend after Labor Day at the Warren County Fairgrounds in Pittsfield, Pennsylvania. Barn locations and outdoors. Accepts photography, paintings, pottery, jewelry, traditional crafts, prints, stained glass. Juried by promoters. Three photos or slides of work plus one of booth, if available. Number of exhibitors: 140. Public attendance: 8,000. Public admission: $6/adult; $4/seniors; 12 & under free. Artists should apply by visiting website and filling out application request, calling or sending a written request.

◪ WILMETTE FESTIVAL OF FINE ARTS

P.O. Box 902, Wilmette IL 60091-0902. Phone/fax: (847)256-2080. E-mail: wilmettearts guild@gmail.com. Website: www.wilmetteartsguild.org. **Contact:** Julie Ressler, president. Estab. 1992. Fine arts & crafts show held annually in September. Outdoors. Accepts photography, paintings, prints, jewelry, sculpture, ceramics, and any other appropriate media; no wearable. Juried by a committee of 6-8 artists and art teachers. Awards/prizes: 1st Place: $1,000; 2nd Place: $750; 3rd Place: $500; People's Choice: $50; local merchants offer purchase awards. Number of exhibitors: 100. Public attendance: 4,000. Free to the public. Deadline for entry: April. Application fee: $120. Space fee: $195. Exhibition space: 12 × 12 ft. For more information, artists should e-mail, visit website, call, send SASE.

Tips "Maintain a well-planned, professional appearance in booth and person. Greet viewers when they visit the booth. Offer printed bio with photos of your work. Invite family, friends and acquaintances."

◈ ◪ WYANDOTTE STREET ART FAIR

3131 Biddle Ave., Wyandotte MI 48192. (734)324-4505. Fax: (734)324-4505. E-mail: info@wyan.org. Website: www.wyandottestreetartfair.org. **Contact:** Lisa Hooper, executive director, Wyandotte Downtown Development Authority. Estab. 1961. Fine arts & crafts show held annually 2nd week in July. Outdoors. Accepts photography, 2D mixed media, 3D mixed media, painting, pottery, basketry, sculpture, fiber, leather, digital cartoons, clothing, stitchery, metal, glass, wood, toys, prints, drawing. Juried. Awards/prizes: Best New Artist: $500; Best Booth Design Award: $500; Best of Show: $1,200. Number of exhibitors: 300. Public attendance: 200,000. Free to the public. Artists may apply online or request application. Deadline for entry: February. Application fee: $20 jury fee. Space fee: $225/single space; $450/double space. Exhibition space: 10 × 10 ft. Average gross sales/exhibitor: $2,000-$4,000. For more information, artists should e-mail, visit website, call, send SASE.

◪ ZIONSVILLE COUNTY MARKET

135 S. Elm St., Zionsville IN 46077. (317)873-3836. **Contact:** Ray Cortopassi, executive director. Estab. 1975. Fine arts & crafts show held annually the Saturday after Mother's Day. Outdoors. Accepts photography, arts, crafts, antiques, apparel. Juried by sending 5 pictures. Number of exhibitors: 150-160. Public attendance: 8,000-10,000. Free to public. Artists should apply by requesting application. Deadline for entry: March 29. Space fee: $145. Exhibition space: 10 × 8 ft. For more information, artists should call.

Tips "Display is very important. Make it look good."

Grants

State & Provincial

Arts councils in the United States and Canada provide assistance to artists in the form of fellowships or grants. These grants can be substantial and confer prestige upon recipients; however, only state or province residents are eligible. Because deadlines and available support vary annually, query first (with a SASE) or check websites for guidelines.

UNITED STATES ARTS AGENCIES

Alabama State Council on the Arts, 201 Monroe St., Montgomery AL 36130-1800. (334)242-4076. E-mail: staff@arts.alabama.gov. Website: www.arts.state.al.us.

Alaska State Council on the Arts, 411 W. Fourth Ave., Suite 1-E, Anchorage AK 99501-2343. (907)269-6610 or (888)278-7424. E-mail: aksca_info@eed.state.ak.us. Website: www.eed. state.ak.us/aksca.

Arizona Commission on the Arts, 417 W. Roosevelt St., Phoenix AZ 85003-1326. (602)771-6501. E-mail: info@azarts.gov. Website: www.azarts.gov.

Arkansas Arts Council, 1500 Tower Bldg., 323 Center St., Little Rock AR 72201. (501)324-9766. E-mail: info@arkansasarts.com. Website: www.arkansasarts.com.

California Arts Council, 1300 I St., Suite 930, Sacramento CA 95814. (916)322-6555. E-mail: info@caartscouncil.com. Website: www.cac.ca.gov.

Colorado Council on the Arts, 1625 Broadway, Suite 2700, Denver CO 80202. (303)892-3802. E-mail: online form. Website: www.coloarts.state.co.us.

Commonwealth Council for Arts and Culture (Northern Mariana Islands), P.O. Box 5553, CHRB, Saipan MP 96950. (670)322-9982 or (670)322-9983. E-mail: galaidi@vzpacifica.net. Website: www.geocities.com/ccacarts/ccacwebsite.html.

Connecticut Commission on Culture & Tourism, Arts Division, One Financial Plaza, 755 Main St., Hartford CT 06103. (860)256-2800. Website: www.cultureandtourism. org.

Delaware Division of the Arts, Carvel State Office Bldg., 4th Floor, 820 N. French St., Wilmington DE 19801. (302)577-8278 (New Castle County) or (302)739-5304 (Kent or Sussex Counties). E-mail: delarts@state.de.us. Website: www.artsdel. org.

District of Columbia Commission on the Arts & Humanities, 2901 14th St. NW, 1st Floor, Washington DC 20010. (202)724-5613. E-mail: cah@dc.gov. Website: www.dcarts.dc.gov.

Florida Division of Cultural Affairs, R.A. Gray Building, 3rd Floor, 500 S. Bronough St., Tallahassee FL 32399-0250. (850)245-6470. E-mail: info@florida-arts.org. Website: www.florida-arts.org.

Georgia Council for the Arts, 260 14th St. NW, Suite 401, Atlanta GA 30318. (404)685-2787. E-mail: gaarts@gaarts.org. Website: www.gaarts.org.

Guam Council on the Arts & Humanities, P.O. Box 2950, Tiyan GU 96932. (671)475-2242. E-mail: arts@ns.gov.nu. Website: www.guam.net.

Hawai'i State Foundation on Culture & the Arts, 250 S. Hotel St., 2nd Floor, Honolulu HI 96813. (808)586-0300. E-mail: ken.hamilton@hawaii.gov. Website: www.state.hi.us/sfca.

Idaho Commission on the Arts, P.O. Box 83720, Boise ID 83720-0008. (208)334-2119 or (800)278-3863. E-mail: info@arts.idaho.gov. Website: www.arts.idaho.gov.

Illinois Arts Council, James R. Thompson Center, 100 W. Randolph, Suite 10-500, Chicago IL 60601. (312)814-6750. E-mail: iac.info@illinois.gov. Website: www. state.il.us/agency/iac.

Indiana Arts Commission, 150 W. Market St., Suite 618, Indianapolis IN 46204. (317)232-1268. E-mail: IndianaArtsCommission@iac.in.gov. Website: www. in.gov/arts.

Iowa Arts Council, 600 E. Locust, Des Moines IA 50319-0290. (515)281-6412. Website: www.iowaartscouncil.org.

Kansas Arts Commission, 700 SW Jackson, Suite 1004, Topeka KS 66603-3761. (785)296-3335. E-mail: kac@arts.ks.gov. Website: http://arts.state.ks.us.

Kentucky Arts Council, 21st Floor, Capital Plaza Tower, 500 Mero St., Frankfort KY 40601-1987. (502)564-3757 or (888)833-2787. E-mail: kyarts@ky.gov. Website: www.artscouncil.ky.gov.

Louisiana Division of the Arts, P.O. Box 44247, Baton Rouge LA 70804. (225)342-6083. E-mail: arts@crt.state.la.us. Website: www.crt.state.la.us/arts.

Maine Arts Commission, 193 State St., 25 State House Station, Augusta ME 04333-0025. (207)287-2724. E-mail: MaineArts.info@maine.gov. Website: http:// mainearts.maine.gov.

Maryland State Arts Council, 175 W. Ostend St., Suite E, Baltimore MD 21230. (410)767-6555. E-mail: msac@msac.org. Website: www.msac.org.

Massachusetts Cultural Council, 10 St. James Ave., 3rd Floor, Boston MA 02116-3803. (617)727-3668. E-mail: mcc@art.state.ma.us. Website: www.massculturalcouncil. org.

Michigan Council for Arts & Cultural Affairs, 702 W. Kalamazoo St., P.O. Box 30705, Lansing MI 48909-8205. (517)241-4011. E-mail: artsinfo@michigan.gov. Website: www.michigan.gov/hal/0,1607,7-160-17445_19272—-,00.html.

Minnesota State Arts Board, Park Square Court, Suite 200, 400 Sibley St., St. Paul MN 55101-1928. (651)215-1600 or (800)866-2787. E-mail: msab@arts.state.mn.us. Website: www.arts.state.mn.us.

Mississippi Arts Commission, 501 N. West St., Suite 701B, Woolfolk Bldg., Jackson MS 39201. (601)359-6030. Website: www.arts.state.ms.us.

Missouri Arts Council, 815 Olive St., Suite 16, St. Louis MO 63101-1503. (314)340-6845 or (866)407-4752. E-mail: moarts@ded.mo.gov. Website: www. missouriartscouncil.org.

Montana Arts Council, 316 N. Park Ave., Suite 252, Helena MT 59620-2201. (406)444-6430. E-mail: mac@mt.gov. Website: http://art.mt.gov.

National Assembly of State Arts Agencies, 1029 Vermont Ave. NW, 2nd Floor, Washington DC 20005. (202)347-6352. E-mail: nasaa@nasaa-arts.org. Website: www.nasaa-arts.org.

Nebraska Arts Council, 1004 Farnam St., Plaza Level, Omaha NE 68102. (402)595-2122 or (800)341-4067. Website: www.nebraskaartscouncil.org.

Nevada Arts Council, 716 N. Carson St., Suite A, Carson City NV 89701. (775)687-6680. E-mail: online form. Website: http://dmla.clan.lib.nv.us/docs/arts.

New Hampshire State Council on the Arts, 2½ Beacon St., 2nd Floor, Concord NH 03301-4974. (800)735-2964. Website: www.nh.gov/nharts.

New Jersey State Council on the Arts, 225 W. State St., P.O. Box 306, Trenton NJ 08625. (609)292-6130. Website: www.njartscouncil.org.

New Mexico Arts, Dept. of Cultural Affairs, P.O. Box 1450, Santa Fe NM 87504-1450. (505)827-6490 or (800)879-4278. Website: www.nmarts.org.

New York State Council on the Arts, 175 Varick St., New York NY 10014. (212)627-4455. Website: www.nysca.org.

North Carolina Arts Council, 109 East Jones St., Cultural Resources Building, Raleigh NC 27601. (919)807-6500. E-mail: ncarts@ncmail.net. Website: www.ncarts.org.

North Dakota Council on the Arts, 1600 E. Century Ave., Suite 6, Bismarck ND 58503. (701)328-7590. E-mail: comserv@state.nd.us. Website: www.state.nd.us/ arts.

Ohio Arts Council, 727 E. Main St., Columbus OH 43205-1796. (614)466-2613. Website: www.oac.state.oh.us.

Oklahoma Arts Council, Jim Thorpe Building, 2101 N. Lincoln Blvd., Suite 640, Oklahoma City OK 73105. (405)521-2931. E-mail: okarts@arts.ok.gov. Website: www.arts.state.ok.us.

Oregon Arts Commission, 775 Summer St. NE, Suite 200, Salem OR 97301-1280. (503)986-0082. E-mail: oregon.artscomm@state.or.us. Website: www. oregonartscommission.org.

Pennsylvania Council on the Arts, 216 Finance Bldg., Harrisburg PA 17120. (717)787-6883. Website: www.pacouncilonthearts.org.

Institute of Puerto Rican Culture, P.O. Box 9024184, San Juan PR 00902-4184. (787)724-0700. E-mail: www@icp.gobierno.pr. Website: www.icp.gobierno.pr.

Rhode Island State Council on the Arts, One Capitol Hill, Third Floor, Providence RI 02908. (401)222-3880. E-mail: info@arts.ri.gov. Website: www.arts.ri.gov.

American Samoa Council on Culture, Arts and Humanities, P.O. Box 1540, Office of the Governor, Pago Pago AS 96799. (684)633-4347. Website: www.prel.org/ programs/pcahe/PTG/terr-asamoa1.html.

South Carolina Arts Commission, 1800 Gervais St., Columbia SC 29201. (803)734-8696. E-mail: info@arts.state.sc.us. Website: www.southcarolinaarts.com.

South Dakota Arts Council, 711 E. Wells Ave., Pierre SD 57501-3369. (605)773-3301. E-mail: sdac@state.sd.us. Website: www.artscouncil.sd.gov.

Tennessee Arts Commission, 401 Charlotte Ave., Nashville TN 37243-0780. (615)741-1701. Website: www.arts.state.tn.us.

Texas Commission on the Arts, E.O. Thompson Office Building, 920 Colorado, Suite 501, Austin TX 78701. (512)463-5535. E-mail: front.desk@arts.state.tx.us. Website: www.arts.state.tx.us.

Utah Arts Council, 617 E. South Temple, Salt Lake City UT 84102-1177. (801)236-7555. Website: http://arts.utah.gov.

Vermont Arts Council, 136 State St., Drawer 33, Montpelier VT 05633-6001. (802)828-3291. E-mail: online form. Website: www.vermontartscouncil.org.

Virgin Islands Council on the Arts, 5070 Norre Gade, St. Thomas VI 00802-6872. (340)774-5984. Website: http://vicouncilonarts.org.

Virginia Commission for the Arts, Lewis House, 223 Governor St., 2nd Floor, Richmond VA 23219. (804)225-3132. E-mail: arts@arts.virginia.gov. Website: www.arts.state.va.us.

Washington State Arts Commission, 711 Capitol Way S., Suite 600, P.O. Box 42675, Olympia WA 98504-2675. (360)753-3860. E-mail: info@arts.wa.gov. Website: www.arts.wa.gov.

West Virginia Commission on the Arts, The Cultural Center, Capitol Complex, 1900 Kanawha Blvd. E., Charleston WV 25305-0300. (304)558-0220. Website: www.wvculture.org/arts.

Wisconsin Arts Board, 101 E. Wilson St., 1st Floor, Madison WI 53702. (608)266-0190. E-mail: artsboard@arts.state.wi.us. Website: www.arts.state.wi.us.

Wyoming Arts Council, 2320 Capitol Ave., Cheyenne WY 82002. (307)777-7742. E-mail: ebratt@state.wy.us. Website: http://wyoarts.state.wy.us.

CANADIAN PROVINCES ARTS AGENCIES

Alberta Foundation for the Arts, 10708 - 105 Ave., Edmonton AB T5H 0A1. (780)427-9968. Website: www.cd.gov.ab.ca/all_about_us/commissions/arts.

British Columbia Arts Council, P.O. Box 9819, Stn. Prov. Govt., Victoria BC V8W 9W3. (250)356-1718. E-mail: BCArtsCouncil@gov.bc.ca. Website: www. bcartscouncil.ca.

The Canada Council for the Arts, 350 Albert St., P.O. Box 1047, Ottawa ON K1P 5V8. (613)566-4414 or (800)263-5588 (within Canada). Website: www.canadacouncil. ca.

Manitoba Arts Council, 525-93 Lombard Ave., Winnipeg MB R3B 3B1. (204)945-2237 or (866)994-2787 (in Manitoba). E-mail: info@artscouncil.mb.ca. Website: www.artscouncil.mb.ca.

New Brunswick Arts Board (NBAB), 634 Queen St., Suite 300, Fredericton NB E3B 1C2. (506)444-4444 or (866)460-2787. Website: www.artsnb.ca.

Newfoundland & Labrador Arts Council, P.O. Box 98, St. John's NL A1C 5H5. (709)726-2212 or (866)726-2212. E-mail: nlacmail@nfld.net. Website: www.nlac. nf.ca.

Nova Scotia Department of Tourism, Culture, and Heritage, Culture Division, 1800 Argyle St., Suite 601, P.O. Box 456, Halifax NS B3J 2R5. (902)424-4510. E-mail: cultaffs@gov.ns.ca. Website: www.gov.ns.ca/dtc/culture.

Ontario Arts Council, 151 Bloor St. W., 5th Floor, Toronto ON M5S 1T6. (416)961-1660 or (800)387-0058 (in Ontario). E-mail: info@arts.on.ca. Website: www.arts. on.ca.

Prince Edward Island Council of the Arts, 115 Richmond St., Charlottetown PE C1A 1H7. (902)368-4410 or (888)734-2784. E-mail: info@peiartscouncil.com. Website: www.peiartscouncil.com.

Québec Council for Arts & Literature, 79 boul. René-Lévesque Est, 3e étage, Québec QC G1R 5N5. (418)643-1707 or (800)897-1707. E-mail: info@calq.gouv. qc.ca. Website: www.calq. gouv.qc.ca.

The Saskatchewan Arts Board, 2135 Broad St., Regina SK S4P 1Y6. (306)787-4056 or (800)667-7526 (Saskatchewan only). E-mail: sab@artsboard.sk.ca. Website: www.artsboard.sk.ca.

Yukon Arts Section, Cultural Services Branch, Dept. of Tourism & Culture, Government of Yukon, Box 2703 (L-3), Whitehorse YT Y1A 2C6. (867)667-8589 or (800)661-0408 (in Yukon). E-mail: arts@gov.yk.ca. Website: www.btc.gov.yk.ca/cultural/arts.

REGIONAL GRANTS & AWARDS

The following opportunities are arranged by state since most of them grant money to artists in a particular geographic region. Because deadlines vary annually, check websites or call for the most up-to-date information.

California

Flintridge Foundation Awards for Visual Artists, 1040 Lincoln Ave., Suite 100, Pasadena CA 91103. (626)449-0839 or (800)303-2139. Fax: (626)585-0011. Website: www.flintridgefoundation.org. For artists in California, Oregon and Washington only.

James D. Phelan Award in Photography, Kala Art Institute, Don Porcella, 1060 Heinz Ave., Berkeley CA 94710. (510)549-6914. Website: www.kala.org. For artists born in California only.

Connecticut

Martha Boschen Porter Fund, Inc., 145 White Hallow Rd., Sharon CT 06064. For artists in northwestern Connecticut, western Massachusetts and adjacent areas of New York (except New York City).

Idaho

Betty Bowen Memorial Award, c/o Seattle Art Museum, 100 University St., Seattle WA 98101. (206)654-3131. Website: www.seattleartmuseum.org/bettybowen/. For artists in Washington, Oregon and Idaho only.

Illinois

Illinois Arts Council, Artists Fellowship Program, James R. Thompson Center, 100 W. Randolph, Suite 10-500, Chicago IL 60601. (312)814-6750. Website: www.state.il.us/agency/iac/Guidelines/guidelines.htm. For Illinois artists only.

Kentucky

Kentucky Foundation for Women Grants Program, 1215 Heyburn Bldg., 332 W. Broadway, Louisville KY 40202. (502)562-0045. Website: www.kfw.org/grants.html. For female artists living in Kentucky only.

Massachusetts

See Martha Boschen Porter Fund, Inc., under Connecticut.

Minnesota

McKnight Photography Fellowships Program, University of Minnesota Dept. of Art, Regis Center for Art, E-201, 405 21st Ave. S., Minneapolis MN 55455. 612)626-9640. Website: www.mcknightphoto.umn.edu. For Minnesota artists only.

New York

A.I.R. Gallery Fellowship Program, 511 W. 25th St., Suite 301, New York NY 10001. (212)255-6651. E-mail: info@airnyc.org. Website: www.airnyc.org. For female artists from New York City metro area only.

Arts & Cultural Council for Greater Rochester, 277 N. Goodman St., Rochester NY 14607. (585)473-4000. Website: www.artsrochester.org.

Constance Saltonstall Foundation for the Arts Grants and Fellowships, P.O. Box 6607, Ithaca NY 14851 (include SASE). (607)277-4933. E-mail: info@saltonstall.org. Website: www.saltonstall.org. For artists in the central and western counties of New York.

New York Foundation for the Arts: Artists' Fellowships,155 Avenue of the Americas, 14th Floor, New York NY 10013-1507. (212)366-6900, ext. 217. E-mail: nyfaafp@nyfa.org. Website: www.nyfa.org. For New York artists only.

Oregon

See **Flintridge Foundation Awards for Visual Artists,** under California.

Pennsylvania

Leeway Foundation—Philadelphia, Pennsylvania Region, 123 S. Broad St., Suite 2040, Philadelphia PA 19109. (215)545-4078. E-mail: info@leeway.org. Website: www.leeway.org. For female artists in Philadelphia only.

Texas

Individual Artist Grant Program—Houston, Texas, Cultural Arts Council of Houston and Harris County, 3201 Allen Pkwy., Suite 250, Houston TX 77019-1800. (713)527-9330. E-mail: info@cachh.org. Website: www.cachh.org. For Houston artists only.

Washington

See **Flintridge Foundation Awards for Visual Artists,** under California.

Residencies & Organizations

RESIDENCIES

Artists' residencies (also known as communities, colonies or retreats) are programs that support artists by providing time and space for the creation of new work. There are over 250 residency programs in the United States, and approximately 200 in at least 40 other countries. These programs provide an estimated $36 million in support to independent artists each year.

Many offer not only the resources to *do* artwork, but also to have it *seen* by the public. While some communities are isolated in rural areas, others are located near urban centers and may provide public programming such as workshops and exhibitions. Spending time as a resident at an artists' community is a great way to network and cultivate relationships with other artists.

Alliance of Artists Communities: www.artistcommunities.org
 Offers an extensive list of international artists' communities and residencies.
Anderson Ranch Arts Center: www.andersonranch.org
 Nonprofit visual arts community located in Snowmass Village, Colorado.
Arrowmont School of Arts & Crafts: www.arrowmont.org
 Nationally renowned center of contemporary arts and crafts education located in Gatlinburg, Tennessee.
The Bogliasco Foundation/Liguria Study Center for the Arts & Humanities: www.liguriastudycenter.org
 Located on the Italian Riviera in the village of Bogliasco, the Liguria Study Center provides residential fellowships for creative or scholarly projects in the arts and humanities.
Fine Arts Work Center: www.fawc.org
 Nonprofit institution devoted to encouraging and supporting young artists, located in Provincetown, Massachusetts.
Hall Farm Center: www.hallfarm.org
 A 221-acre retreat in Townshend, Vermont, that offers residencies, workshops and other resources for emerging and established artists.

Kala Art Institute: www.kala.org

Located in the former Heinz ketchup factory in Berkeley, California, Kala provides exceptional facilities to professional artists working in all forms of printmaking, photography, digital media and book arts.

Lower Manhattan Cultural Council: www.lmcc.net

Creative hub for connecting residents, tourists and workers to Lower Manhattan's vast and vibrant arts community. Provides residencies, studio space, grants and professional development programming to artists.

The MacDowell Colony: www.macdowellcolony.org

A 100-year-old artists' community consisting of 32 studios located on a 450-acre farm in Peterborough, New Hampshire.

Pouch Cove Foundation: www.pouchcove.org

Not-for-profit organization in Newfoundland, Canada, providing retreat for artists from around the world.

Santa Fe Art Institute: www.sfai.org

Located on the College of Santa Fe campus in Santa Fe, New Mexico, SFAI is a nonprofit organization offering a wide range of programs to serve artists at various stages of their careers.

Vermont Studio Center: www.vermontstudiocenter.org

The largest international artists' and writers'residency program in the United States, located in Johnson, Vermont.

Women's Studio Workshop: www.wsworkshop.org

Visual arts organization in Rosendale, New York, with specialized studios in printmaking, hand papermaking, ceramics, letterpress printing, photography and book arts.

Yaddo: www.yaddo.org

Artists' community located on a 400-acre estate in Saratoga Springs, New York, offering residencies to professional creative artists from all nations and backgrounds.

ORGANIZATIONS

There are numerous organizations for artists that provide resources and information about everything from industry standards and marketing tips to contest announcements and legal advice. Included here are just a handful of groups that we at *Artist's & Graphic Designer's Market* have found useful.

American Association of Editorial Cartoonists: http://editorialcartoonists.com

Professional association concerned with promoting the interests of staff, freelance and student editorial cartoonists in the United States.

American Institute of Graphic Arts: www.aiga.org

AIGA is the oldest and largest membership association for professionals engaged in the discipline, practice and culture of designing.

Art Dealers Association of America: www.artdealers.org

Nonprofit membership organization of the nation's leading galleries in the fine arts.

The Art Directors Club: www.adcglobal.org

The ADC is the premier organization for integrated media and the first international creative collective of its kind. Founded in New York in 1920, the ADC is a self-funding, not-for-profit membership organization that celebrates and inspires creative excellence by connecting visual communications professionals from around the world.

Artists Unite: www.artistsunite-ny.org

Nonprofit organization dedicated to providing quality arts programming and to helping artists of all genres collaborate on projects.

The Association of Medical Illustrators: www.ami.org

International organization for anyone interested in the highly specialized niche of medical illustration.

The Association of Science Fiction and Fantasy Artists: www.asfa-art.org

Nonprofit association organized for artistic, literary, educational and charitable purposes concerning the visual arts of science fiction, fantasy, mythology and related topics.

Association International du Film d'Animation (International Animated Film Association): www.asifa.net

International organization dedicated to the art of animation, providing worldwide news and information on chapters of the group, as well as conferences, contests and workshops.

Association Typographique Internationale: www.atypi.org

Not-for-profit organization run by an elected board of type designers, type publishers, graphic and typographic designers.

Canadian Association of Photographers and Illustrators in Communications: www.capic.org

Not-for-profit association dedicated to safeguarding and promoting the rights and interests of photographers, illustrators and digital artists working in the communications industry.

Canadian Society of Children's Authors, Illustrators and Performers: www.canscaip.org

This organization supports and promotes all aspects of children's literature, illustration and performance.

College Art Association: www.collegeart.org

CAA promotes excellence in scholarship and teaching in the history and criticism of the visual arts and in creativity and technical skill in the teaching and practices of art. Membership is open to all individuals with an interest in art, art history or a related discipline.

The Comic Book Legal Defense Fund: www.cbldf.org

Nonprofit organization dedicated to the preservation of First Amendment rights for members of the comics community.

Friends of Lulu: www.friends-lulu.org

National organization whose main purpose is to promote and encourage female readership and participation in the comic book industry.

Graphic Artists Guild: www.gag.org

National union of illustrators, designers, production artists and other creatives who have come together to pursue common goals, share experiences and raise industry standards.

Greeting Card Association: www.greetingcard.org

Trade organization representing greeting card and stationery publishers, and allied members of the industry.

International Comic Arts Association: www.comicarts.org

Member-driven organization open to anyone with a love and appreciation of the comics art form and a desire to help support and further promote the industry.

National Cartoonists Society: www.reuben.org

Home of the famed Reuben Awards, this organization offers news and resources for cartoonists interested in everything from caricature to animation.

New York Foundation for the Arts: www.nyfa.org

NYFA offers information and financial assistance to artists and organizations that directly serve artists, by supporting arts programming in the community, and by building collaborative relationships with others who advocate for the arts in New York State and throughout the country.

Society of Children's Book Writers and Illustrators: www.scbwi.org

With chapters all over the world, SCBWI is the premier organization for professionals in children's publishing.

Society of Graphic Designers of Canada: www.gdc.net

Member-based organization of design professionals, educators, administrators, students and associates in communications, marketing, media and design-related fields.

The Society of Illustrators: www.societyillustrators.org

Since 1901, this nonprofit organization has been working to promote the interests of professional illustrators through exhibitions, lectures, education, and by fostering a sense of community and open discussion.

Type Directors Club: www.tdc.org

Organization dedicated to raising the standards of typography and related fields of the graphic arts through research, education, competitions and publications.

United States Artists: www.unitedstatesartists.org

Provides direct financial support to artists across all disciplines. Currently offers one grant program: USA Fellows.

US Regional Arts Organizations: www.usregionalarts.org
Six nonprofit entities created to encourage development of the arts and to support arts programs on a regional basis. Funded by the NEA, these organizations—Arts Midwest, Mid-America Arts Alliance, Mid Atlantic Arts Foundation, New England Foundation for the Arts, Southern Arts Federation, and Western States Arts Federation—provide technical assistance to their member state arts agencies, support and promote artists and arts organizations, and develop and manage arts initiatives on local, regional, national and international levels.

Publications, Websites & Blogs

In addition to the thousands of trade publications written for visual artists, there are now countless websites, blogs and online artists' communities intended to connect, inspire and support artists in their careers. Listed here are just a handful of books, magazines and online resources to get you started; most will lead to additional sources, especially websites that provide links to other sites.

BOOKS

AIGA Professional Practices in Graphic Design: The American Institute of Graphic Arts, edited by Tad Crawford (Allworth Press)

Art Marketing 101: A Handbook for the Fine Artist, by Constance Smith (ArtNetwork)

Business and Legal Forms for Fine Artists, by Tad Crawford (Allworth Press)

Business and Legal Forms for Graphic Designers, by Tad Crawford and Eva Doman Bruck (Allworth Press)

Business and Legal Forms for Illustrators, by Tad Crawford (Allworth Press)
The Business of Being an Artist by Daniel Grant (Allworth Press)

Career Solutions for Creative People: How to Balance Artistic Goals with Career Security, by Dr. Ronda Ormont (Allworth Press)

Children's Writer's & Illustrator's Market, edited by Alice Pope (Writer's Digest Books, F+W Media, Inc.)

Comics and Sequential Art, by Will Eisner (Poorhouse Press)

Creativity for Graphic Designers: A Real-World Guide to Idea Generation— From Defining Your Message to Selecting the Best Idea for Your Printed Piece, by Mark Oldach (North Light Books, F+W Media, Inc.)

Design Basics for Creative Results, by Bryan L. Peterson (HOW Books, F+W Media, Inc.)

The Fine Artist's Guide to Marketing and Self-Promotion, by Julius Vitali (Allworth Press)

Fingerprint: The Art of Using Handmade Elements in Graphic Design, by Chen Design Associates (HOW Books, F+W Media, Inc.)

A Gallery Without Walls: Selling Art in Alternative Venues, by Margaret Danielak (ArtNetwork)

Graphic Artists Guild Handbook: Pricing & Ethical Guidelines (Graphic Artists Guild)

The Graphic Designer's and Illustrator's Guide to Marketing and Promotion, by Maria Piscopo (Allworth Press)

The Graphic Designer's Guide to Clients: How to Make Clients Happy and Do Great Work, by Ellen Shapiro (Allworth Press)

Graphic Storytelling & Visual Narrative, by Will Eisner (Poorhouse Press)

Guide to Getting Arts Grants, by Ellen Liberatori (Allworth Press)

How to Draw and Sell Comics, by Alan McKenzie (IMPACT Books, F+W Media, Inc.)

How to Survive and Prosper as an Artist: Selling Yourself Without Selling Your Soul, by Caroll Michels (Owl Books)

Inside the Business of Illustration, by Steven Heller and Marshall Arisman (Allworth Press)

Legal Guide for the Visual Artist, by Tad Crawford (Allworth Press)

Licensing Art 101: Publishing and Licensing Artwork for Profit, by Michael Woodward (ArtNetwork)

Licensing Art & Design: A Professional's Guide to Licensing, and Royalty Agreements, by Caryn R. Leland (Allworth Press)

Logo, Font & Lettering Bible: A Comprehensive Guide to the Design, Construction and Usage of Alphabets and Symbols, by Leslie Cabarga (HOW Books, F+W Media, Inc.)

Making Comics: Storytelling Secrets of Comics, Manga and Graphic Novels, by Scott McCloud (HarperCollins)

Starting Your Career as a Freelance Illustrator or Graphic Designer, by Michael Fleishman (Allworth Press)

Successful Syndication: A Guide for Writers and Cartoonists, by Michael Sedge (Allworth Press)

The Word It Book: Speak Up Presents a Gallery of Interpreted Words, edited by Bryony Gomez-Palacio and Armin Vit (HOW Books, F+W Media, Inc.)

MAGAZINES

Advertising Age: www.adage.com

Weekly print magazine delivering news, analysis and data on marketing and media. website provides a database of advertising agencies as well as daily e-mail newsletters: *Ad Age Daily*, *Ad Age's Mediaworks* and *Ad Age Digital*.

Art Business News: www.artbusinessnews.com

Monthly magazine that reports on art trends, news and retailing issues. Offers profiles on emerging and established artists, as well as in-depth articles on merchandising and marketing issues.

Art Calendar: www.artcalendar.com

Business magazine devoted to connecting artists with income-generating opportunities and resources for a successful art career.

Art in America: www.artinamericamagazine.com

"The World's Premier Art Magazine," covering the visual art world both in the U.S. and abroad, but concentrating on New York City. Provides news and criticism of painting, sculpture, photography, installation art, performance art, video and architecture in exhibition reviews, artist profiles, and feature articles. Every August issue is the *Annual Guide to Museums, Galleries and Artists*.

ART PAPERS: www.artpapers.org

Dedicated to the examination, development and definition of art and culture in the world today.

ARTFORUM: www.artforum.com

International magazine widely known as a decisive voice in its field. Features in-depth articles and reviews of contemporary art, as well as book reviews and columns on cinema and popular culture.

The Artist's Magazine: www.artistsmagazine.com

Features color reproductions, interviews with artists, practical lessons in craft, and news of exhibitions and events.

ARTnews: www.artnews.com

Oldest and most widely circulated art magazine in the world. Reports on the art, personalities, issues, trends and events shaping the international art world.

Artweek: www.artweek.com

Offers critical reviews of West Coast exhibitions, as well as news, feature articles, interviews and opinion pieces focusing on contemporary art. Includes a comprehensive listing of regional, national and international competitions; classified ads for job opportunities, studio space, artists' services, supplies and equipment; exhibition listings of over 200 gallery and museum spaces.

Communication Arts Magazine: www.commarts.com

Leading trade journal for visual communications. Showcases the top work in graphic design, advertising, illustration, photography and interactive design.

Create Magazine: www.createmagazine.com

Quarterly publication offering creative professionals an insider's perspective on the people, news, trends and events that influence the advertising and creative production industries.

Creativity: http://creativity-online.com

Monthly magazine about the creative process. website features what its editors believe to be the best video, print and interactive ads.

Eye: The International Review of Graphic Design: www.eyemagazine.com

Published in the United Kingdom, this quarterly print magazine is for anyone involved in graphic design and visual culture.

Grafik: www.grafikmagazine.co.uk

Based in London, this monthly magazine serves the international design community with essential information, independent-minded editorial, unflinching reviews and outspoken opinion from industry personalities.

Graphic Design USA: www.gdusa.com

News magazine for graphic designers and other creative professionals.

Greetings etc.: www.greetingsmagazine.com

Official publication of the Greeting Card Association, featuring timely information for everyone doing business in the greeting card, stationery, and party goods markets.

HOW: www.howdesign.com

Provides graphic design professionals with essential business information; covers new technology and processes; profiles renowned and up-and-coming designers; details noteworthy projects; provides creative inspiration; and publishes special issues featuring the winners of its annual competitions. website is a trusted source for business advice, creative inspiration and tools of the trade.

I.D.: www.idonline.com

America's leading critical magazine covering the art, business and culture of design. Published seven times/year, including the Annual Design Review (America's oldest and most prestigious juried design-recognition program).

JUXTAPOZ: www.juxtapoz.com

Monthly art and culture magazine based in San Francisco, California. Features profiles and exhibition announcements of "lowbrow" or "underground" artists— art establishment conventions do not apply here.

PRINT: www.printmag.com

Bimonthly magazine about visual culture and design that documents and critiques commercial, social and environmental design from every angle.

Resources

Target Marketing: www.targetmarketingmag.com

The authoritative source for hands-on, how-to information concerning all direct response media, including direct mail, e-mail and the Web. Readers gain insight into topics such as using databases and lists effectively, acquiring new customers, upselling and cross-selling existing customers, fulfillment strategies and more.

WEBSITES & BLOGS

The Alternative Pick: www.altpick.com

"The best source for creatives on the Web." Allows artists to display samples of their work that can be searched by art buyers and directors. Offers industry news, classifieds, job postings and more.

Animation World Network: www.awn.com

Comprehensive and targeted coverage of the international animation community has made AWN the leading source of animation industry news in the world. It provides an industry database, job postings, education resources, discussion forums, newsletters and a host of other resources covering everything related to animation.

Art Deadlines List: www.artdeadlineslist.com

Great source for calls for entries, competitions, scholarships, festivals and plenty of other resources. Subscription is free, or you can purchase a premium edition for $24/year.

The Art List: www.theartlist.com

Offers an extensive listing of art contests, competitions and juried art shows, as well as other resources for visual artists looking for income opportunities or to gain exposure for their work. An annual subscription to The Art List's monthly e-mail newsletters is only $15. Each newsletter includes a link to a searchable database of art contests, competitions, residencies, fellowships, calls for public art, and juried exhibition announcements.

Art Schools: www.artschools.com

Free online directory with a searchable database of art schools all over the world. Also offers information on financial aid, majors and lots more.

Artbusiness.com: www.artbusiness.com

Provides art appraisals, art price data, news, articles and market information for art collectors, artists and fine arts professionals. Also consults on marketing, promotion, public relations, website construction, Internet selling, and career development for artists at all stages.

Artdeadline.com: www.artdeadline.com

"The Professional Artist's Resource," offering thousands of income and exhibition opportunities and resources for artists of all disciplines. Subscriptions start at $24/year, or you can get a 20-day trial for $14.

Artist Career Training: www.artistcareertraining.com
Offers valuable information to help you market your art and build your career. Sign up for a monthly newsletter and weekly tips.

Artist Help Network: www.artisthelpnetwork.com
Designed to help artists take control of their careers, the network assists artists in locating information, resources, guidance and advice on a comprehensive range of career-related topics.

Artists Network: http://forum.artistsnetwork.com
Interactive artists' community and forum for discussions of art-related topics including business tips and inspiration. Connect to *The Artist's Magazine*, *Watercolor Artist* (formerly *Watercolor Magic*) and *Pastel Journal*, as well as fine art book clubs and lots of other helpful resources.

Artleby: www.artleby.biz
Online arts exhibition space, run by artists for artists. A one-year subscription, payable in monthly installments of $5, provides you with a website to display up to 50 images as well as re'sume', biography, artist's statement, etc. The ability to create multiple portfolio categories according to media, themes, etc., allows you to direct your work to a specific audience/market.

Artlex Art Dictionary: www.artlex.com
Online dictionary that provides definitions, examples and cross-references for more than 3,600 art terms.

Artline: www.artline.com
Offers news and events from 7 reputable art dealer associations: Art Dealers Association of America, Art Dealers Association of Greater Washington, Association of International Photography Art Dealers, Chicago Art Dealers Association, International Fine Print Dealers Association, San Francisco Art Dealers Association, and The Society of London Art Dealers.

Children's Illustrators: www.childrensillustrators.com
Online networking community for children's illustrators, agents, publishing houses, advertising agencies and design groups from around the world.

The Comics Reporter: www.comicsreporter.com
Offers an overview of the history of comics, as well as resources and information about publishing comic books and syndicating comic strips.

Creative Talent Network: www.creativetalentnetwork.com
Online networking community of experienced animators, illustrators, designers, Web creators, production artists and other creatives.

The Drawing Board for Illustrators: www.members.aol.com/thedrawing
Information and resources for illustrators, including pricing guidelines, marketing tips, and links to publications, organizations and associations.

EBSQ: Self-Representing Artists: www.ebsqart.com

Online art association whose members represent their own work to the public. Membership is open to artists at all stages of their careers, and all media and styles are welcome.

Illustration Friday: www.illustrationfriday.com

Online forum for illustrators that offers a weekly challenge: a new topic is posted every Friday, and then participants have a week to submit an illustration of their own interpretation.

Theispot.com: www.theispot.com

Widely recognized as "the world's premier illustration site," allowing illustrators from all over the world to showcase and market their work.

The Medical Illustrators' Home Page: www.medartist.com

A site where medical illustrators can display and market their work.

The Nose: www.the-nose.com

A place for caricature artists to showcase their work.

Portfolios.com: www.portfolios.com

The first searchable creative directory on the Web. Through the Portfolios.com Partner Network, you can set up and manage one portfolio, but have it appear on multiple websites for one low price.

Starving Artists Law: www.starvingartistslaw.com

Start here for answers to your questions about copyright registration, trademark protection and other legal issues.

TalkAboutComics.com: www.talkaboutcomics.com

Provides a comprehensive list of all things comics related on the Web, as well as audio interviews with online comics creators.

Talkabout Design: www.talkaboutdesign.com

Online forum and blog for the design community.

UnderConsideration: www.underconsideration.com

A network of blogs (Speak Up, Brand New, Quipsologies, The Design Encyclopedia) dedicated to the progress of the graphic design profession and its practitioners, students and enthusiasts.

Volunteer Lawyers for the Arts: www.vlany.org

Provides education and other services relating to legal and business issues for artists and arts organizations in every discipline.

WetCanvas!: www.wetcanvas.com

Largest online community of visual artists, offering forums, critiques, art lessons and projects, marketing tools, a reference image library and more—all for FREE!

Glossary

Acceptance (payment on). An artist is paid for his/her work as soon as a buyer decides to use it.

Adobe Illustrator®. Drawing and painting computer software.

Adobe InDesign®. Revised, retooled version of Adobe PageMaker.

Adobe PageMaker®. Page-layout design software. Product relaunched as InDesign.

Adobe Photoshop®. Photo manipulation computer program.

Advance. Amount paid to an artist before beginning work on an assigned project. Often paid to cover preliminary expenses.

Airbrush. Small pencil-shaped pressure gun used to spray ink, paint or dye to obtain gradated tonal effects.

Anime. Japanese word for animation.

Art director. In commercial markets, the person responsible for choosing and purchasing artwork and supervising the design process.

Artist's Statement. A short essay, no more than a paragraph or two, describing an artist's mission and creative process.

Biannual. Occurring twice a year. See also semiannual.

Biennial. Occurring once every two years.

Bimonthly. Occurring once every two months.

Biweekly. Occurring once every two weeks.

Book. Another term for a portfolio.

Buyout. The sale of all reproduction rights (and sometimes the original work) by the artist; also subcontracted portions of a job resold at a cost or profit to the end client by the artist.

Calligraphy. The art of fine handwriting.

Camera-ready. Art that is completely prepared for copy camera platemaking.

Capabilities brochure. A brochure, similar to an annual report, outlining for prospective clients the nature of a company's business and the range of products or services it provides.

Caption. See gagline.

Carriage trade. Wealthy clients or customers of a business.

CD-ROM. Compact disc read-only memory; non-erasable electronic medium used for digitized image and document storage and retrieval on computers.

Collateral. Accompanying or auxiliary pieces, such as brochures, especially used in advertising.

Color separation. Photographic process of separating any multi-color image into its primary component parts (cyan, magenta, yellow and black) for printing.

Commission. 1) Percentage of retail price taken by a sponsor/salesman on artwork sold. 2) Assignment given to an artist.

Comprehensive. Complete sketch of layout showing how a finished illustration will look when printed; also called a comp.

Copyright. The exclusive legal right to reproduce, publish and sell the matter and form of a literary or artistic work.

Consignment. Arrangement by which items are sent by an artist to a sales agent (gallery, shop, sales rep, etc.) for sale with the understanding that the artist will not receive payment until work is sold. A commission is almost always charged for this service.

Direct mail package. Sales or promotional material that is distributed by mail. Usually consists of an outer envelope, a cover letter, brochure or flier, SASE, and postpaid reply card, or order form with business reply envelope.

DPI or dpi. Dots per inch. The unit of measure used to describe the scanning resolution of an image or the quality of an output device. See also resolution.

Dummy. A rough model of a book or multi-page piece, created as a preliminary step in determining page layout and length. Also, a rough model of a card with an unusual fold or die cut.

Edition. A set of identical prints published of one piece of art.

Engraving. A print made by cutting into the printing surface with a point. See also etching.

Environmental graphic design (EGD). The planning, designing and specifying of graphic elements in the built and natural environment; signage.

EPS. Encapsulated PostScript—a computer format used for saving or creating graphics.

Estimate. A ballpark figure given to a client by a designer anticipating the final cost of a project.

Etching. A print made by the intaglio process, creating a design in the surface of a metal or other plate with a needle and using a mordant to bite out the design.

Exclusive area representation. Requirement that an artist's work appear in only one outlet within a defined geographical area.

Finished art. A completed illustration, mechanical, photo or combination of the three that is ready to go to the printer. Also called camera-ready art.

Gagline. The words printed with a cartoon (usually directly beneath); also called a caption.

Giclée. Method of creating limited and unlimited edition prints using computer technology in place of traditional methods of reproducing artwork. Original artwork or transparency is digitally scanned, and the stored information is manipulated on screen using computer software (usually Photoshop). Once the image is refined on screen, it is printed on an Iris printer, a specialized ink-jet printer designed for making giclée prints.

GIF. Graphics Interchange Format—a computer format used for saving or creating graphics.

Gouache. Opaque watercolor with definite, appreciable film thickness and an actual paint layer.

Halftone. Reproduction of a continuous tone illustration with the image formed by dots produced by a camera lens screen.

Honorarium. Token payment—small amount of money and/or a credit line and copies of the publication in which an artist's work appears.

Informational graphics. Information, especially numerical data, visually represented with illustration and text; charts/graphs.

IRC. International Reply Coupon; purchased at the post office to enclose with artwork sent to a foreign buyer to cover his/her postage cost when replying.

Iris print. Limited and unlimited edition print or giclée output on an Iris or ink-jet printer (named after Iris Graphics of Bedford, Massachusetts, a leading supplier of ink-jet printers).

JPEG. Joint Photographic Experts Group—a computer format used for saving or creating graphics.

Keyline. An outline drawing on completed art for the purpose of indicating its shape, position and size.

Kill fee. Portion of an agreed-upon payment an artist receives for a job that was assigned, started, but then canceled.

Layout. Arrangement of photographs, illustrations, text and headlines for printed material.

Licensing. The process whereby an artist who owns the rights to his or her artwork permits (through a written contract) another party to use the artwork for a specific purpose for a specified time in return for a fee and/or royalty.

Linocut. A relief print made from linoleum fastened to a wooden block. See also relief.

Lithograph. A print made by drawing on fine-grained porous limestone or on a zinc plate with greasy material, then wetting the stone or plate and applying greasy ink, which will adhere only to the drawn lines. Dampened paper is applied to the stone and is rubbed over with a special press to make the final print.

Logo. Name or design of a company or product used as a trademark on letterhead, direct mail packages, in advertising, etc., to establish visual identity.

Mechanicals. Preparation of work for printing.

Mezzotint. A method of engraving in which the artist works from dark to light. The entire painting surface is first covered with a regular fine scratching made by using a rocking tool called a cradle. This takes the ink and appears as a black background. The design is burnished onto it, does not take the ink and therefore appears in white.

Multimedia. A generic term used by advertising, public relations and audiovisual firms to describe productions involving a combination of media such as animation, video, Web graphics or other visual effects. Also, a term used to reflect the varied in-house capabilities of an agency.

Offset. Printing process in which a flat printing plate is treated to be ink-receptive in image areas and ink-repellent in non-image areas. Ink is transferred from the printing plate to a rubber plate, and then to the paper.

On spec. Abbreviation for "on speculation." See also speculation.

Overlay. Transparent cover over copy, on which instruction, corrections or color location directions are given.

Panel. In cartooning, the boxed-in illustration; can be single panel, double panel or multiple panel.

PDF. Portable Document Format—Adobe® file format for representing documents in a manner that is independent of the original application software, hardware and operating system used to create those documents.

P-O-P. Point-of-purchase; in-store marketing display that promotes a product.

Print. An impression pulled from an original plate, stone, block screen or negative; also a positive made from a photographic negative.

Production artist. In the final phases of the design process, the artist responsible for mechanicals and sometimes the overseeing of printing.

Publication (payment on). An artist is not paid for his/her work until it is actually published, as opposed to payment on acceptance.

QuarkXPress. Page layout computer program.

Query. Letter to an art director or buyer eliciting interest in a work an artist wants to illustrate or sell.

Quote. Set fee proposed to a client prior to commencing work on a project.

Relief. 1) A composition or design made so that all or part projects from a flat surface. 2) The impression or illusion of three dimensions given by a painting.

Rendering. A drawn representation of a building, interior, etc., in perspective.

Resolution. The pixel density of an image, or the number of dots per inch a device is capable of recognizing or reproducing.

Retail. The sale of goods in small quantities directly to the consumer.

Roughs. Preliminary sketches or drawings.

Royalty. An agreed percentage paid by a publisher to an artist for each copy of a work sold.

SASE. Self-addressed, stamped envelope.

Self-publishing. In this arrangement, an artist coordinates and pays for printing, distribution and marketing of his/her own artwork and in turn keeps all ensuing profits.

Semiannual. Occurring twice a year. See also biannual.

Semimonthly. Occurring twice a month.

Semiweekly. Occurring twice a week.

Serigraph. Silkscreen; method of printing in which a stencil is adhered to a fine mesh cloth stretched over a wooden frame. Paint is forced through the area not blocked by the stencil.

Simultaneous submission. Sending the same artwork to more than one potential buyer at the same time.

Speculation. Creating artwork with no assurance that a potential buyer will purchase it or reimburse expenses in any way; referred to as work "on spec."

Spot illustration. Small illustration used to decorate a page of type or to serve as a column ending.

Storyboard. Series of panels that illustrate a progressive sequence or graphics and story copy of a TV commercial, film or filmstrip. Serves as a guide for the eventual finished product.

Tabloid. Publication whose format is an ordinary newspaper page turned sideways.

Tearsheet. Page containing an artist's published illustration, cartoon, design or photograph.

Thumbnail. A rough layout in miniature.

TIFF. Tagged Image File Format—a computer format used for saving or creating graphics.

Transparency. A photographic positive film such as a color slide.

Type spec. Type specification; determination of the size and style of type to be used in a layout.

Unsolicited submission. Sample(s) of artwork sent to a buyer without being requested.

Velox. Photoprint of a continuous tone subject that has been transformed into line art by means of a halftone screen.

Wash. Thin application of transparent color or watercolor black for a pastel or gray tonal effect.

Wholesale. The sale of commodities in large quantities usually for resale (as by a retail merchant).

Woodcut. A print made by cutting a design in side-grain of a block of wood, also called a woodblock print. The ink is transferred from the raised surfaces to paper.

Geographic Index

North Carolina

Niche Marketing Index

Children's Publications & Products

Collectibles

Informational Graphics

Science Fiction/Fantasy

Sports Art

General Index

N

O